Museum of American Folk Art
Encyclopedia of
Twentieth-Century American
Folk Art and Artists

Chuck and Jan Rosenak

Museum of American Folk Art Encyclopedia of Twentieth-Century American Folk Art and Artists

CONTRIBUTORS

Robert Bishop

Barbara Cate

Lee Kogan

Abbeville Press Publishers New York

TO
STERLING AND DOROTHY STRAUSER.
They taught us to see, *and that* seeing *could be fun.*

EDITOR: Susan Costello

DESIGNER: Nai Chang

PRODUCTION SUPERVISOR: Hope Koturo

PRODUCTION EDITOR: Cristine Mesch

PICTURE RESEARCHER: Lisa Rosen

JACKET FRONT: John William Dey, *Accupuncture Pitchfork Style,* c. 1974. See page 100.
JACKET BACK: Lawrence Lebduska, *Nude in Paradise,* 1963. See page 184.
JACKET SPINE: Leonard Willeto, *Navajo Doll,* c. 1980. See page 329.
END PAPERS: Simon Rodia, *Watts Towers* (detail), 1921–1954. See page 259.
PAGE 1: Felipe Benito Archuleta, *Bear with a Fish in His Mouth,* 1987. See page 37.
PAGE 2: Clementine Hunter, *Secret Garden,* 1955. Oil on wood panel, 46 x 42 in. Gasperi Folk Art Gallery, New Orleans, Louisiana.
PAGE 3: Mamie Deschillie, *Cow,* 1985. See page 99.
PAGE 4 *(above):* Maria and Julian Martinez, *Untitled,* c. 1942. Fired clay with matte decoration, 2 x 15 in. diameter. Millicent Rogers Museum, Taos, New Mexico.
PAGE 7: Jon Serl, *Aunt Nettie,* 1987. Oil on plywood, 59¼ x 19⅞ in. Chuck and Jan Rosenak.
PAGE 8: William Hawkins, *Neil House,* 1986. Enamel and composition material on Masonite, 72 x 48 in. Museum of American Folk Art, New York; Gift of Warner Communications.

Library of Congress Cataloging-in-Publication Data
Rosenak, Chuck.
 Museum of American Folk Art encyclopedia of twentieth-century American folk art and artists / Chuck and Jan Rosenak; contributors, Robert Bishop, Barbara Cate, Lee Kogan.
 p. cm.
 Includes bibliographical references and index.
 ISBN 1-55859-041-2
 1. Folk art—United States—History—20th century—Dictionaries. 2. Folk artists—United States—Biography—Dictionaries. I. Rosenak, Jan.
II. Museum of American Folk Art. III. Title.
IV. Title: Encyclopedia of twentieth-century American folk art and artists.
NK808.R6 1990
709′.2′2730904—dc20
[B] 90-43923

Contributors FROM THE MUSEUM OF AMERICAN FOLK ART

EXECUTIVE DIRECTOR OF THE ENCYCLOPEDIA **Robert Bishop,** director of the Museum of American Folk Art in New York City since 1976, is a well-known author, lecturer, and teacher in the fields of American art and antiques. His more than thirty books include *America's Quilts and Coverlets, American Decorative Art, 1620–1980, Expressions of a New Spirit,* and *The Romance of Double Wedding Ring Quilts.* Dr. Bishop established the first master's degree program in folk art studies at New York University.

DIRECTOR OF THE ENCYCLOPEDIA **Barbara Cate** is an associate professor of art history and, for fifteen years, the curator of exhibitions at Seton Hall University. She is also the director of the Folk Art Institute at the Museum of American Folk Art. Cate has served as the curator of "The Cutting Edge," an exhibition of twentieth-century folk art scheduled to open at the Museum of American Folk Art in December 1990 and to travel thereafter.

SENIOR RESEARCH CONSULTANT **Lee Kogan** is a graduate of the Folk Art Institute and is presently an assistant director of the school and a member of the faculty. A Senior Research Fellow of the Museum of American Folk Art, she is also a regular contributor to *The Clarion,* the museum's quarterly magazine. She is the curator of the Mose Tolliver exhibition to be held at the museum in 1993.

SENIOR EDITOR **Jacqueline M. Atkins** is a graduate of the Folk Art Institute and the author of *America's Quilts* as well as *Memories of Childhood,* published in association with the Museum of American Folk Art. Her twenty years of publishing experience include serving as the director of publications at the Alan Guttmacher Institute and at the National Association of Social Workers.

RESEARCH ASSISTANTS **Carolyn Kuhlthau, Brad Marcus, Jeanne Riger,** and **Ann Wrenn**

Acknowledgments

As enthusiasm for twentieth-century folk art has grown, most collectors, dealers, and museums have come to realize that further study of the artists is essential to public understanding and appreciation of folk art. Many artists and their families, folk art collectors, dealers, and institutions contributed to this book. We thank them all.

Robert Bishop, director of the Museum of American Folk Art, conceived this encyclopedia and the exhibition, "The Cutting Edge: Folk Art from the Rosenak Collection." Without his perseverance and unwavering loyalty, the project would still be unrealized.

We will be forever grateful to Frances Sirota Martinson, executive vice president of the Board of Trustees of the museum, and to her husband, Paul Martinson (whose cousin Joseph "Burt" Martinson was a founding trustee). I am ever mindful of the generosity of all the trustees of the Museum of American Folk Art:

BOARD OF TRUSTEES:

Executive Committee

Ralph O. Esmerian, President
Frances Sirota Martinson,
 Executive Vice President
Lucy C. Danziger, Vice President
George F. Shaskan, Jr., Treasurer
Mrs. Dixon Wecter, Secretary
Karen D. Cohen
Judith A. Jedlicka
Theodore L. Kesselman
Susan Klein
Kathryn Steinberg

Members

Florence Brody
Peter M. Ciccone
Daniel Cowin
David L. Davies
Barbara Johnson
Joan M. Johnson
William I. Leffler
George H. Meyer
Cyril I. Nelson
Cynthia V. A. Schaffner
William W. Schneck
Ronald K. Shelp
Bonnie Strauss
Maureen Taylor
Robert N. Wilson

Honorary Trustee

Eva Feld

Trustees Emeritus

Adele Earnest
Cordelia Hamilton
Herbert Waide Hemphill, Jr.
Dr. Louis C. Jones
Margery G. Kahn
Alice M. Kaplan
Jean Lipman

Jan and I relied on the encouragement of our friends, Barbara Cate and Tracy Cate. Their devotion to the study of twentieth-century folk art and Barbara's foreword were essential to this book. Barbara Cate's knowledge of the field is second to none, and she has the patience to share her understanding with her students.

Lee Kogan, senior research fellow and assistant director of the Museum of American Folk Art's Folk Art Institute, understood my frustration when biographical facts could not be found. Because of her persistence, she discovered a lot of new information. She devoted almost two years to this project, and we cannot thank her adequately. The following students of the Folk Art Institute, who undertook research assignments under the direction of Lee Kogan, should also be credited: Carolyn Kuhlthau, Brad Marcus, Jeanne Riger, and Ann Wrenn.

Ann F. Oppenhimer, president of the Folk Art Society of America, went out of her way to be helpful and rallied her members to the cause; many of them are included in the list that follows. Ann was always willing to share her in-depth knowledge of contemporary folk art during our many long telephone conversations.

LeRaye Bunn became our resident expert on Kentucky and Tennessee. She drove from Louisville, Kentucky to Monterey, Tennessee, to find out the birthdate of Dow Pugh—a small bit of data, but nobody had convinced him to reveal it. Only a special friend would be so helpful.

Every writer needs an editor. Ours was Jacqueline M. Atkins, who also writes articles in her own name. Her expertise is deeply appreciated.

Many of our friends contributed to this project. Most are well known in folk art collecting circles. Individuals who furnished material on particular artists are credited in the footnotes, but some contributed way beyond what was required to fill gaps in biographical information. They have our gratitude. If someone is inadvertently omitted, the fault is mine. I hope he or she will be forgiving.

Judith Alexander
Aarne Anton
Jim and Beth Arient
William Arnett
Jack Beasley
Bill Beaver
William Bengston
Liz Blackman
Ruth Braunstein
Gene Epstein
William Ferris
Richard Gasperi
Kurt A. Gitter and Alice Yelen
Bonnie Grossman
Carl Hammer
Butler and Lisa Hancock
Alice Hoffman
Allen W. and Barry G. Huffman
John Rice Irwin
William Jamison
Jay Johnson
Marianne and Robert Kapoun
Florence Laffal
Louanne LaRoche
Karen Lennox
Warren and Sylvia Lowe
Mia McEldowney
Anne Miller
Randall Morris
Leslie and Henri Muth
Henry Niemann
Jim Nutt and Gladys Nilsson
Pat Parsons
Theodore Rosenak
Luise Ross
Murray Smither
William Steen
Sterling and Dorothy Strauser
Jo Tartt
Tom Wells

I believe no other publication has attempted to compile so much information on the lives of twentieth-century folk artists. The format was developed with the assistance of Susan Costello of Abbeville Press. I'd like to thank Nai Chang, whose striking and perceptive design splendidly presents a vast amount of material. We extend our appreciation to other members of the marvelous team at Abbeville whose work on the encyclopedia was invaluable: Robin James, Cristine Mesch, and Lisa Rosen in the editorial department and Hope Koturo in production. We would also like to credit Virginia Croft for her skillful copyediting of the manuscript.

To all of the artists, we are indeed grateful.

And finally I'd like to make it clear that Jan contributed more than she will ever admit. Included here are examples from *our* collection, and this is *our* book, and *we* have been on the cutting edge together.

CHUCK ROSENAK

Contents

Preface

Chuck and Jan Rosenak have spent nearly two decades in their pursuit of twentieth-century American folk art and artists. With intelligence and diligence, they have assembled a remarkable collection of works by the very best of the contemporary folk painters, sculptors, quiltmakers, potters, and other self-taught artists of this century, many of whom are included in this volume.

Of even greater importance to the serious collector and student of folk art, however, is the Rosenaks' pursuit of first-hand documentation about these artists, including those who are considered as folk isolates and outsiders. Many taped personal interviews have preserved the voices of the artists and their ideas about the world they live in and how their art relates to it. In addition, the Rosenaks have photographed nearly all of the artists they have interviewed. They have recently given their tapes, photographs, personal letters to and from artists, and other relevant primary documents to the library of the Museum of American Folk Art, establishing a record of American creativity in the twentieth century that is unique.

In this encyclopedic work, the Rosenaks have challenged the traditions of the art world; they have created an extensive body of new information that for the first time is being presented for serious consideration in print. They have gone far beyond the parameters of their own collection—as extensive as it is—to review the work of many other artists, ones who worked at the beginning of the century as well as ones working as recently as today. From this immense creative pool, they have selected 257 artists working in various media to represent what folk art is today and has been throughout this period. Yet there is no question that this selection, large as it is, is noninclusive, and it is inevitable that many artists worthy of attention must be left out. The confines of time and space always force an arbitrary line to be drawn, but this only provides a starting point for the next work to be done in this area. This book should be viewed as a signpost along the road to discovery, not as its end.

When the Rosenaks first began to collect in this area, one of the difficult tasks they—like anyone who decides to build a collection—faced was to define their field or area of interest and to undertake a definitive assessment of the artistic, social, and economic implications of the endeavor. There were very few guidelines to help them. Only a handful of museum exhibitions of works by self-taught twentieth-century artists had been mounted, and there were almost no reference books or articles to guide the novice. However, because the Rosenaks had viewed extensively and collected im-

portant examples of modern art, their esthetic sensibilities were finely honed, a good preparation for their role as trailblazers, among the very first art collectors to discover and pursue what is now recognized as twentieth-century folk art.

One of the first books on the subject was *Twentieth-Century American Folk Art and Artists,* by Herbert W. Hemphill, Jr. and Julia Weissman, published in 1974. This book, controversial for its time, served to polarize the field of folk art. Some traditionalists who had collected eighteenth- and nineteenth-century folk art feared that appreciation of twentieth-century works would lessen attention accorded to older works in the marketplace as well as the museums. Others believed that the earlier pieces were rooted in the traditional crafts of the country and displayed a degree of craftsmanship that was missing from the newer works by self-taught artists—and in many instances this is true, although it does not detract from the innate creative impulse that is shown. Little did the field realize, however, that a new and parallel understanding of modern art was emerging in the most sophisticated galleries and museum presentations. Suddenly the rawness, expressiveness, and celebration of individual style and vision were acceptable to—even sought out by—an art world that had once been content with the predictable.

As more people became aware of and comfortable with this new look in art, museum exhibitions, articles in art journals, and finally magazines devoted exclusively to the field of twentieth-century folk art began to proliferate. Florence Laffal, in her publication *Folk Art Finder,* was one of the first to define and categorize the efforts of American naives working today. Ann F. Oppenhimer and the Folk Art Society of America have created a nationwide organization that publishes an impressive quarterly newsletter, the *Folk Art Messenger,* and the Museum of American Folk Art through its quarterly, *The Clarion: America's Folk Art Magazine,* under the editorship of Didi Barrett has done much to present twentieth-century folk art in a positive light to a larger audience. The museum has also helped lead the way by mounting several major exhibitions of works by the most outstanding of these contemporary artists as well.

Have the Rosenaks been successful in their endeavor to increase the appreciation of twentieth-century folk art? Even those who profess not to understand the art that Chuck and Jan have collected or the pieces that have been chosen to be included here would have to reply yes. The Rosenaks have labored tirelessly to prepare this text, document its accuracy, and find the best examples of the artists' works. Their research will and should challenge in many ways what every informed collector has come to believe as true. I salute the generosity of their time and effort and their commitment to a goal. They have produced a noble book, and it *will* make a difference.

ROBERT BISHOP, DIRECTOR
Museum of American Folk Art
New York City

Folk Art Comes of Age

In the beginning there was no distinction between the traditions of fine art and folk art; it was not even an issue. Thus, when we look back to seventeenth-century portraits, we see them as primitive, simple, and endearing. We may wonder how much, if any, training the artists had; however, we do not judge them as fine or folk artists.

Within another hundred years the line was firmly drawn between fine art and folk art. In the eighteenth and nineteenth centuries, it was usual for ambitious artists to study abroad and return to paint the leading families of the newly formed American society. In contrast, provincial artists with little or no academic training traveled from town to town and created their less elegant, but often no less important, folk portraits of rural society.

Folk artists were a prosaic lot. They were painters who "took likenesses" for modest fees; they were artisans who made shop signs and figureheads; they were girls and ladies who stitched samplers and quilts. Folk art flourished in the eighteenth and nineteenth centuries, but it was not acknowledged by historians, promoted by dealers, or acquired by collectors.

This book is about the folk art of our own century, and our folk art is radically different from that of the past. Ship figureheads, those talismen of good luck once so dear to sailors, disappeared with the advent of steel-hulled ships. Carefully worked samplers are no longer stitched by schoolgirls, who today are more comfortable with a computer than with a needle. The radical change in twentieth-century folk art, however, is due not just to new technology but rather to freedom of spirit. Today's folk artist is not bound by the rules of an academy nor by the constraints of society. The two expressions I hear most frequently from folk artists are "I am doing my own thing" and "I had it in me." Happily for these artists, the twentieth century is the era of the individual, and the public responds to the art of free spirits.

The first thirty years of this century were fairly quiet, a kind of dark age between the traditional art of the past and the fundamentally different folk art of our time. Perhaps because folk art held no rank or status before 1930, much was lost. There were artists working early in the century, however, such as Horace Pippin and John Kane, who are acclaimed as masters today but were not recognized until late in life.

Nineteen thirty was the watershed year for folk art. Before then folk art was nameless and homeless—it merely existed. But in 1930 a major institution, the Newark Museum, held an exhibition of eighty-three folk paintings, entitled "American Primitives," curated by Holger Cahill. Now

Simon Rodia, Watts Towers *(detail), 1921– 1954. Mixed-media environment (cement, bottles, dishes, seashells, mirrors, and steel rods), as high as 99½ ft., Los Angeles.*

*William Edmondson,
Lady with Two Pocket-
books, c. 1935. Carved
limestone, 13 × 10 × 4
in. Lee and Ed Kogan.*

wealthy patrons began to amass large collections of folk art that would eventually form the basis for folk art museums and for outstanding collections within national museums.

With the development of a folk art market and the growth of a folk art establishment replete with museums, historians, dealers, and teachers came a flood of definitions, and with every definition a flood of protests. The classic definition was given by Holger Cahill in 1931 when he said that folk art in its truest sense "is an expression of the common people and not an expression of a small cultured class. Folk art usually has not to do with the fashionable art of its period. It is never the product of art movements, but comes out of craft traditions, plus that personal something of the rare craftsman who is an artist by nature if not by training. This art is based not on measurements or calculations but on feeling, and it rarely fits in with the standards of realism. It goes straight to the fundamentals of art, rhythm, design, balance, proportion, which the folk artist feels instinctively" (*American Folk Sculpture*). If we excise the reference to craftsmen, since twentieth-century folk artists are rarely artisan-trained, and if we allow that while folk art has little to do with fashionable art, it has become fashionable itself, this sixty-year-old definition has held up remarkably well. There is none better.

Between 1930 and 1960 folk artists began to receive serious recognition. In 1937 the Museum of Modern Art showed twelve sculptures by William Edmondson, a retired laborer from Tennessee, who carved figures in stone because the Lord told him to do so. Dealer-scholar Sidney Janis not only included such artists as Morris Hirshfield and Grandma Moses in shows at the Museum of Modern Art but wrote a seminal book on American folk artists, *They Taught Themselves,* in 1942. The recognition given to these artists came, for the most part, from the cognoscenti and from avant-garde museums, not from the general public. It did little to change the lives of the artists, with one exception—Grandma Moses, whose appearance came at the right time and the right place. She became our first folk art celebrity.

In the fifties and sixties there emerged a sizable, identifiable group of artists who began their careers late in life. Never before in the history of art had there been a "school" of late-blooming artists who found in art an outlet for their energy. Their training was a lifetime of keen observation. The materials they used were simple and cheap, everything from old bottles in junkyards to the roots of trees. Their subject matter ranged from the traditional to the *sui generis*. Their motivations differed—some experienced visions in which God and the angels told them to make art; some were restless in retirement and painted to "keep from rocking and rocking and blowing away"; some were given paint or markers by their families or community centers. These artists were living proof that, although bones grow old, creativity knows no age.

Thus the years from 1930 to 1960 established folk art as a serious discipline. This art was no longer homeless, nor was it nameless. Amid vociferous support for such names as primitive art and naive art, the term *folk art*

Oscar William Peterson,
Fish Decoy, *c. 1940s.*
Carved and painted wood
with tin, lead, and tacks,
7¼ × 1½ × 1 in. Art
Kimball.

became so widely used that debate became moot. As a result, it has joined the pantheon of misleading terms in art history—along with Gothic, Romanesque, and Mannerist—all unsatisfactory but a part of the language.

Since the 1960s folk artists have continued the tradition of individualism and have become still freer spirits. There are many new voices and new identities. Folk art is not an esoteric process. It most often comes from the hands and hearts of persons with little formal education. While contemporary fine art may be arcane and incomprehensible to the uninitiated, folk art has a naïveté and simplicity that endear it to the beholder.

In the last few decades the folk art establishment has come to maturity. Dealers and collectors scour the country for unknown artists. They search everywhere. They discover folk art in inner cities, on Indian reservations, in backwater villages, and in front-yard gardens. The folk art market is booming, and many fear that the artists will be corrupted. The irony of our endeavor is that in cataloging and codifying folk art, in carrying forward the work of dealers, scholars, and curators, we may be polluting the very atmosphere in which folk art has been made. Yet I do not think so. Freedom of expression will always find new and unpredictable courses.

The intensive process of preparing this encyclopedia has given me new insights into the patterns and flow of twentieth-century folk art. For example, I have become aware that, in recent years, black artists comprise a significant percentage of the total number of folk artists. With the publication of the encyclopedia, a new profile of contemporary folk art can be drawn that takes into consideration demographics, ethnic origins, sex, religion, motivations to create art, levels of formal education of the artists, and so many other factors. An enormous amount of original research has gone into this volume. I hope it will serve as a major document for understanding the folk art of our century.

BARBARA CATE
Museum of American Folk Art
New York City

The Cutting Edge

My wife, Jan, and I started our adventure of collecting contemporary art in the early 1960s. We visited the major art markets of America and Europe and like all collectors went where art was made, shown, and sold. Then, in 1973, we discovered the new world of contemporary American folk art—what we came to regard as the cutting edge. Art historians and scholars of nineteenth-century folk art tried to discourage us, saying that folk art no longer existed because of television and universal education in America. Robert Bishop, director of the Museum of American Folk Art, did not share that view and encouraged us to go out into the country, saying, "it's out there." That's what we did, and what we found was astounding.

In our search we found the *real* America—not the blue-highway America of romantic fiction, but the dirt-track and South Bronx America. We ate local specialties wherever we were, from barbecue in Georgia to green chile stew in New Mexico. Our journeys led to assorted adventures: we were escorted by the local police out of Leland, Mississippi (where Son Ford Thomas lives); we drank the product of illicit mountain stills and heard the folk tales of Appalachia; we saw the Hopi and Navajo Indians ready to do battle over disputed lands. And wherever we went, we found art.

One hears a lot about the reclusive or hostile nature of folk artists (for instance, that Jon Serl lives alone in the desert and won't talk to strangers), but our experience proved far different. Every artist we met welcomed us and made us feel at home, a part of their lives and work. There is a universal desire to be "heard from," and that is as true of Silas Claw, a Navajo living on a ridge overlooking Cow Springs, Arizona, as of William Dawson, an old man who lived in a housing project in Chicago. Valued friendships developed—for example, Louis and Virginia Naranjo of the Cochiti Pueblo invited us not only to share a feast in their home but also to witness the ceremony of the River Men, one that has rarely been observed at first hand by "Anglos."

Whenever I could find an interested publisher, I wrote articles about the artists we came to know so well; I photographed them and their work and taped our interviews. We are grateful to our friends, and we are glad to present their work and their biographies in this book.

FREEDOM OF EXPRESSION

When we ventured into dirt-track America, we found a land of free souls, many of whom were passionately religious or patriotic. A number of these artists believe they converse with God, and some regard the American flag

Shields Landon Jones's Three Musicians are positioned in front of the freestanding fireplace in Chuck and Jan Rosenak's living room. Niches in the fireplace–wall display Native American works, among them a storyteller by Manuel Vigil and pottery by Silas Claw.

Philo Levi Willey,
Friends of Wildlife II,
1975. Oil on canvas, 35¾
× *39⅞ in. Museum of*
American Folk Art, New
York; Gift of Elias Getz.

as sacred. However, since folk artists have an enormous freedom of expression and range of subject matter, their depictions are often highly individualistic. The flag is rendered as they envision it; they may show bodily functions not usually acknowledged in "polite" company; they may use the name of the Lord in vain; they can ridicule heroes and politicians; and they can advocate the use of witchcraft. We felt privileged to be witness to this creative spirit: its warmth, its rebelliousness against injustice, its celebration of God's word, and its ability to find humor and good in the worst of times and places.

We were among the first collectors to visit many of the artists—for example, Johnson Antonio, Steve Ashby, Ted Gordon, S. L. Jones, Nellie Mae Rowe, and Faye Tso. In January 1977, I was also an early visitor of the Reverend Howard Finster. At that time he was not sure whether the Lord (who had appeared to him in a vision and directed him to "paint God's sermons") would allow him to sell to the unbaptized. So he baptized me, christened me Brother Chuck, and then was delighted to sell me about twenty paintings. It has been our pleasure to help artists gain recognition. Upon returning to Washington, where we then lived, we showed Finster's

work to a folk art dealer who, in the spring of 1978, began to promote the now legendary artist.

I hung Finster's *The Seven Days of Creation (Night and Day),* on the dull blue-gray wall of my government office in Washington. The general counsel of the Small Business Administration (where I then worked) thought the painting was blasphemous junk and ordered it removed from the building. I claimed First Amendment rights, and until I retired in 1984, *Night and Day* remained on my office wall.

The Native Americans we met in our travels are artists who have revived traditions and created new art forms. There are several thousand folk artists among the Pueblo Indians, Hopis, and Navajos of Arizona and New Mexico, but only a handful of collectors are interested in anything but their traditional crafts such as rugs, baskets, jewelry, and some pottery. The innovative work, however, will stand the test of time, and more will be heard of artists like Mamie Deschillie, the Willetos, Betty Manygoats, Alice Cling, Louis Naranjo, Art Vigil, Ida Sahmie, and Silas Claw, to name only a few.

FOLK ART HAS COME OF AGE

For decades there have been those who have believed that folk art was becoming obsolete. In 1943 many were saying that American folk art was only a thing of the past. Dealers turned their interest to Piet Mondrian, Max Ernst, and Constantin Brancusi, and such well-known collectors as Abby Aldrich Rockefeller and Col. and Mrs. Edgar William Garbisch concentrated on nineteenth-century folk art. It seemed we had become a sophisticated country that denied its backwoods origins and ignored the art of the common folk.

The concept that a self-taught, self-motivated artist—isolated from mainstream culture in an urban or rural pocket, with no grounding in either historical or contemporary traditions in art—could indeed be on the cutting edge of art was not an acceptable notion. Until the fall of 1970, with only a few exceptions, there was almost an unspoken consensus that twentieth-century folk art did not exist. Then, however, the Museum of American Folk Art launched its seminal show, "Twentieth-Century American Folk Art and Artists," curated by Herbert W. Hemphill, Jr., and the world slowly began to acknowledge a different vision.

Twelve years later, in January 1982, the Corcoran Gallery of Art in Washington, D.C., opened its important show, "Black Folk Art in America: 1930–1980," curated by Jane Livingston and John Beardsley. Since that show, as the listing in the appendices indicates, significant exhibitions of twentieth-century folk art have proliferated. When we began purchasing folk art in the 1970s, there were only a few galleries and other collectors that shared our interest. Today there are many collectors, galleries, and museums throughout the country that are adding contemporary folk art to

their collections. In scholarly texts as well as in popular articles, the folk art of our time is now recognized as a part of the art history of our century.

THE CREATION OF THIS PROJECT

This project began in New York City one day in the mid-1970s in one of the 53rd Street townhouses belonging to the Museum of American Folk Art. (The building has since been vacated in preparation for the construction of a new museum.) At that time Dr. Bishop had indicated his interest in showing contemporary folk art in the museum, even though the public was generally accustomed to viewing folk art of the nineteenth century.

During the summer of 1986, Dr. Bishop visited our home in Tesuque, New Mexico, bringing with him the welcome news that "the time had finally come for an exhibition in New York and a major book on twentieth-century folk art." The next summer Frances Martinson, executive vice president of the Board of Trustees of the Museum of American Folk Art, and her husband, Paul, invited us to join them for dinner in Santa Fe. They told us of a generous gift by Eva Feld that would enable the museum to build the Eva and Morris Feld Gallery at Lincoln Square in New York and solicited our support of a major project to present contemporary folk art.

Dr. Bishop, the Martinsons, and Eva Feld recommended that Barbara Cate, director of the Folk Art Institute of the Museum of American Folk Art, become the curator of the exhibition, "The Cutting Edge," which would feature art from our collection, and assist in the development of the book. Since Barbara Cate and her husband, Tracy, had been our friends for years, nothing could have pleased us more. The Cates should receive great credit; due to their hard work and ability to overcome obstacles, the project was completed on time.

SELECTION OF ARTISTS

Barbara Cate chose the artists and works to be included in the show, "The Cutting Edge." But we decided that the book should be an encyclopedia covering all the most important artists of the twentieth century rather than only those featured in the show.

Since biographies are a key element of this encyclopedia, anonymous works are necessarily excluded. In view of our purpose, to survey twentieth-century folk painting and sculpture, such specialized areas as quilts and decoys are also, for the most part, outside our scope. Only a few individuals whose work in these areas transcends a narrow definition of their specialty and thus may be considered in the broader realm of folk art are covered. Oscar Peterson, for example, a true master in the making of fish decoys, is included. And, for the first time, folk art by Native American artists is part of a general survey. This field is so large, however, that this book can serve only as an introduction to a wonderful area deserving of much further study.

The umbrella of folk art is very large, and no stylistic school is excluded, regardless of the personal preference of the authors. The artists selected for inclusion share some general characteristics. Each one has produced a recognizable body of work (even if it is limited, as in the case of Steve Harley or Edgar McKillop) and has gained critical recognition through public showings (museum exhibitions in most instances but gallery shows in a few cases), inclusion in permanent collections of museums, or in literature on the subject. In addition, major environmental artists such as Simon Rodia, Grandma Prisbrey, and Joseph Furey were selected because of their visual impact and enormous contribution to the field.

Jan Rosenak prepared lists, and Barbara Cate, Robert Bishop, and others at the Museum of American Folk Art contributed advice and expertise. The final list was approved by Dr. Bishop and Elizabeth Warren, museum curator. In all, after great soul-searching and a number of difficult decisions, we chose more than 250 twentieth-century folk artists for inclusion.

WORKING PROCEDURES

On our visits to folk artists since 1973, Jan and I have always brought along cameras and taping equipment. So we had already assembled biographical material on more than 100 of the artists on the final list, and during the course of the project we met and interviewed many others. We traveled from coast to coast, north to south, and sometimes to unexpected places. For example, in Texas we found Henry Ray Clark in the Walls Prison, Ike Morgan in the state hospital in Austin, and the unsung but truly marvelous work of the late Naomi Polk.

We had also developed an extensive network of friends, collectors, gallery owners, and museum curators on whom we relied for additional information. Ann F. Oppenhimer, president of the Folk Art Society of America, allowed us to call on the society's 450 members to help with additional field work. Lee Kogan, senior research fellow and assistant director of the Folk Art Institute at the Museum of American Folk Art, conducted research with the help of students at the Folk Art Institute. The museum's excellent folk art library, under the helpful supervision of Edith C. Wise, was also an important resource. And finally, Jacqueline M. Atkins, a writer and researcher associated with the Museum of American Folk Art, helped edit and polish the text.

Our original photographs and tapes have been donated to the Museum of American Folk Art and, with our consent, will be made available to scholars. In addition, the original research files for this book will be housed in the archives of the museum, where research on twentieth-century folk artists is ongoing.

VERIFICATION OF INFORMATION

Whenever biographical information and quotations are not attributed to

specific sources, they have been derived from extensive interviews in person or by telephone with the artists. We have attempted to double-check every name, place, and date from sources other than these oral accounts. Regional dialects and the inability of many artists to spell, speak English, or remember dates and localities have increased our burden. Sometimes state laws enacted to protect privacy prevented verification of vital information concerning birth and death dates. For instance, why is the date of death of William Doriani so elusive? He was supposed to have died in New York City and to have pursued a successful operatic career, yet his death date remains obscure. Certainly more liberal disclosure policies (assuming a valid reason for the inquiry) would be helpful to researchers.

We have discovered hundreds of discrepancies (which we have tried not to perpetuate) and no doubt we have made some mistakes of our own. But in every case we gave verification of data our best shot. Our hope is that information not yet discovered has not been irretrievably lost and will one day be included in subsequent works on these artists.

Hugh Newell Jacobsen, the architect who designed our house, has characterized our collection as a "happy" one. Dr. Bishop refers to "happiness" in American art as "homespun." Whatever the elusive quality is in American folk art, it has kept us on the cutting edge for seventeen wonderful years.

CHUCK ROSENAK
Tesuque, New Mexico

How to Use This Encyclopedia

The scope of the 255 illustrated accounts in this encyclopedia is wide-ranging and includes artists who create paintings, drawings, sculptures, pottery, or environments.

ORGANIZATION

The artists are listed alphabetically by last name and then by first name. When a father and son are both included, however, the father's entry precedes the son's; brothers are listed chronologically. While the coverage, because of space constraints, is necessarily selective, the list drawn up by the authors and the Museum of American Folk Art comprises a diverse group who are the most admired, representative, or innovative American folk artists of the twentieth century.

The encyclopedia contains four types of material: color plates; biographies of the artists; introductory essays; and extensive appendices with illustrations.

COLOR PLATES

If you are unfamiliar with the diversity of twentieth-century American folk artists, you may wish to browse through the color plates, reviewing the work of those artists who interest you visually.

There is at least one outstanding example in color to illustrate the work of each of the 257 artists included here. In some instances the artwork may be familiar, simply because it is the best example known or because the artist's output is limited. Although some works belong to museums and public collections, others belong to private collectors and are shown here for the first time.

A descriptive caption as well as a comment accompanies each color plate. In some cases more information about the artwork is given in the photo credits.

ARTISTS' BIOGRAPHIES

Each artist's entry is presented in a systematic way to provide you with consistent information. The heading in bold type gives the full name of the artist as well as the nickname, in quotation marks, if it is commonly used. In many instances, especially for those whom the authors interviewed, there is a quotation from the artist. Whenever the quotation is from another source, the source is identified by a note. The entries themselves are divided into six sections, as follows:

Biographical Data

This section gives general biographical information: birthdate; birthplace; education; marriages (maiden names are given if known); number of children; and date and place of death or present residence.

The source of biographical information is generally identified in a note to each article, but it is not given if vital statistics were supplied to the authors by the artists. In some cases, the information was verified from other sources, including public records. A note also appears if information in this section differs from previous accounts.

General Background

This section should be consulted for a general overview of an artist's life. Here the environment of the artist is emphasized, such as childhood experiences, education, and employment history.

Artistic Background

You should refer to this section for information about how the individual's artistic career began and progressed. The person best known for discovering an artist, the gallery representing the artist, and some important early exhibitions may be mentioned here. Other exhibitions may be listed under "Artistic Recognition" and in the appendices.

Subjects and Sources

Here you will find a description of the typical subject matter of the artist. For example, the artist may portray animals or landscapes or favor biblical or African-American themes. Sometimes the artist's subject matter is so varied that only the most frequently occurring subjects are mentioned. When known, there is a reference to the artist's source of inspiration—dreams, visions, magazine illustrations, or religious iconography, for example.

Materials and Techniques

The materials most often used by the artist are listed in this section. There may also be a description of the artist's various techniques and procedures, as well as data on the number of known works and their general or average dimensions, given in inches or feet. The base is included only if it is an integral part of a sculpture.

Artistic Recognition

The last section evaluates the artist's work and current reputation. Whether the artist is known nationwide or only in a particular region is noted, as are major awards and inclusion in significant exhibitions or museum collections.

INTRODUCTORY ESSAYS

To introduce yourself to the general subject of twentieth-century American folk artists, you may wish to read Robert Bishop's preface and Barbara Cate's essay, "Folk Art Comes of Age." The author's introduction, "The Cutting Edge," conveys the excitement and adventure of collecting modern folk art. In addition, "Describing Folk Art," following this essay, lists some of the terms the authors and

others have used to describe types of folk art. A familiarity with these definitions is helpful before reading the accounts, although the authors have avoided jargon.

APPENDICES

As supplementary material for those interested in a particular artist or for students of folk art, the appendices are invaluable, providing lists of outstanding exhibitions, public collections, notes, and a bibliography. Dozens of pictures of the artists, photographed by the authors (unless otherwise noted), are shown alphabetically throughout the appendices to complete this portrait of twentieth-century folk art in America.

Describing Folk Art

The general term *folk art* encompasses a wide range of paintings, sculptures (from massive stone works to tiny fish decoys), and environments created by individuals who did not study art formally and systematically.

To describe particular types or categories of folk art, a number of terms are commonly used. The reader should be aware, however, that exact definitions for these terms tend to be controversial and the terms may overlap. In addition, while there may be general agreement about how to classify certain artists (e.g., Grandma Moses as a memory painter), collectors, galleries, and museums may not agree in every instance.

Environmental Art. Sculptural, often large-scale works that are usually constructed outdoors in gardens, yards, and public and private spaces. The artists commonly use recycled materials such as tin, glass, and found objects. Unlike other types of art, environmental works are created primarily for display and are generally not for sale. A well-known example is Simon Rodia's *Watts Towers* in Los Angeles.

Isolate Art. The highly personal work of artists who are isolated—physically or emotionally—from the cultural mainstream. The art is sometimes referred to as "raw" or "primitive" in style.

Memory Painting. A style of painting that depicts disappearing life-styles. The scenes are often peaceful ones of rural America before the advent of complex farm machinery (see the entry for Queena Stovall, who stopped painting because "I can't draw all this big machinery that's in the fields now"). Among the best-known memory painters are Grandma Moses and Mattie Lou O' Kelly.

Naive or "Naïf" Art. A direct, simple, and unsophisticated style of expression. Such French artists as Henri Rousseau and Camille Bombois are often classified as naive or *naïf*. While these terms are today used most comonly in connection with untrained European artists, American artists like Grandma Moses are sometimes referred to as naive artists. Professionally trained artists who have adopted the simplicity of the folk art style are sometimes called neo-naives.

Outsider Art. Work that is highly personal and not derived from communal traditions; used interchangeably with *isolate art.* The term outsider art was first used by Roger Cardinal, a British writer, and his publisher as the English equivalent of Jean Dubuffet's French term *art brut,* used in Europe primarily to describe the art of the insane. In the United States the phrase has a broader meaning; collectors use it to distinguish it from more traditional or "sweeter" folk art, such as memory painting. Thus, institutionalized artists, such as Martin Ramirez and Ike Morgan, are categorized as outsider artists. But others, among them Henry Darger, Joseph Yoakum, Steven Ashby, Ted Gordon, and Bessie Harvey, are also placed in this category. Some folklorists use the term as a catch-all to describe idiosyncratic art not based on tradition.

Primitive Art. The art of primitive peoples in Africa, Asia, and Oceania. American folk artists generally do not like to be called primitive artists.

Visionary Art. Art that is often religious in theme and is frequently based on dreams, visions, or voices. Religious messages may accompany a work. Among the better-known artists often termed visionary are Minnie Evans, Sister Gertrude Morgan, and Alex Maldonado. *Visionary art* is also used in a broader sense to denote works by folk artists with a unique vision.

JESSE J. AARON—*"When I make it, I done what God told me to. I don't treasure it. He didn't tell me to love it, just make it."*[1]

BIOGRAPHICAL DATA
Born June 10, 1887, Lake City, Florida. Left school in the first grade. Married Lee Anna, 1912; she died December 25, 1985. Children and grandchildren.[2] Died October 17, 1979, Gainesville, Florida.

GENERAL BACKGROUND
A descendant of slaves and a Seminole Indian grandmother, Jesse Aaron was an imaginative carver dedicated to finding form in wood.

Before he completed first grade, Aaron's parents removed him from school and "hired him out" to do farm work at seven dollars a month. He served an apprenticeship as a baker when he was twenty-one or twenty-two years old and later operated several bake shops. He worked as a cook in the Hotel Thomas in Gainesville from 1933 to 1937, then for various hospitals, university fraternities, and the Seaboard System Railroad.

In the early 1930s Aaron built a house for his wife and family in Gainesville, Florida, where he would live for the remainder of his life. In the late 1960s he bought three acres east of Gainesville, where he lovingly operated a nursery for the next few years. Aaron was forced to sell the nursery in 1968 to pay for a cataract operation for his wife, and for the first time in his life, at eighty-one years of age, he was unemployed.

ARTISTIC BACKGROUND
After Aaron sold his nursery, according to the artist, "at three o'clock in the morning, July the 5th . . . the Spirit woke me up, and said 'Carve Wood .' . . . The Lord give me this gift and I just goes about . . . trying to please him."[3] He immediately began to carve, placing his finished pieces in his front yard.

In August of that year, Stuart R. Purser, a professor of art at the University of Florida, Gainesville, was captured by the sight of the sculpture in Aaron's yard and went to visit the artist. Purser and Aaron became friends, and Purser arranged for an exhibition of the artist's work at the university in October 1968.

In 1975 Aaron received a Visual Artists Fellowship from the National Endowment for the Arts.

SUBJECTS AND SOURCES
Jesse Aaron worked to bring out the figurations—animals, people, and faces—that he could see in a piece of wood. With a sly humor, an individualistic vision, and very little adornment, he could bring forth human and animal shapes that, to him if not to anyone else, already existed. First, Aaron would find the material and then the image developed. As he described it, "I can see faces on anything. I can look at a tree stump and I know just how it gonna look 'fore I start. It all depends on what God has put there in the wood."[4]

Jesse J. Aaron, Untitled, *c. 1973. Wood with eyes from stuffed animal, 58 × 18 × 8 in. Arnett Collection. "I can see faces on anything," said Jesse Aaron. This carving combines human and animal features and forms, topped off with the flourish of a hat.*

MATERIALS AND TECHNIQUES
Aaron preferred working with untreated hardwoods, cedar, and cyprus, "because bugs can't get into it."[5] He roughed out his shapes with a chain saw, then finished the work with hammers, chisels, and other woodworking tools.

Aaron cast polyester resin and used the castings for eyes and miscellaneous adornments for his figures. He also attached found objects—bits of bone, old pipes, hats—to add realism, but he did not paint his carvings.

The sculptures range in size from only a few inches in height or length to larger than life-size tree trunks.

Stuart Purser states that Aaron made "hundreds" of carvings and then again that he made "literally thousands."[6] The latter statement appears a bit exuberant. In any event, whatever the total output, only several hundred examples are known to have survived.

ARTISTIC RECOGNITION
The quality of the work Jesse Aaron completed from 1968

through 1979 is quite uniform. Other carvers may make stronger statements on the black experience in the rural South, but as the work of Aaron's generation is evaluated, his must be included as among the most interesting and original.

JOHN ABDULJAAMI—*"I want to smell the flowers while I can. I hope I don't have to wait until I'm dead to be famous."*

BIOGRAPHICAL DATA
Born John Stevens, August 17, 1941, Shawnee, Oklahoma. Attended Richmond High School, Richmond, California, through eleventh grade (received GED while in the service). Married Marion Carter, 1961; divorced 1967. Second marriage, 1970; divorced 1975. Married Patricia Freeman, 1977. Two sons, two daughters by Freeman; one son from second marriage. Now resides Oakland, California.

GENERAL BACKGROUND
"I have heavy ideas," explains John Abduljaami, a black sculptor. "I need large logs to be able to carve them all out."

Abduljaami's family moved to Richmond, California, in 1942. After quitting high school in 1961, Abduljaami joined the navy and was stationed in Japan for two years, where he worked as a jet mechanic. He returned to California in 1963 and worked in the Naval Weapons Station in Concord, California, until 1965. After that, Abduljaami "went into robbery," as he says, until he was arrested in 1967. He spent forty-six months in Soledad Central Prison, located near Salinas, California, before his discharge in 1971.

"I tried to find myself in prison," Abduljaami says. "I changed my name and joined the Nation of Islam [Black Muslims]. When I got out, I worked for the Nation driving a truck and in the bakery" from 1971 to 1976. He now operates his own truck, hauling scrap metal when he is not working on his sculpture.

ARTISTIC BACKGROUND
Abduljaami started "making things" when he was a small boy, but it was while he was in prison that, "I got deep into art." Since 1976 Abduljaami has been carving large-scale sculptural story-telling totems.

SUBJECTS AND SOURCES
Abduljaami is one of a number of young black artists working on political themes. His large allegorical carvings in vertical form are made from logs, and often several branches extend from the same base. Much of his work is based on current events, television, and newspaper stories, although he occasionally carves large animal figures as well. As he says, "I carve it like it is—fairy tales don't happen."

The artist finds his basic shapes in the wood. "It's got to be there or it won't come out."

John Abduljaami, The Stork and the Baby, *c. 1988. Painted wood, 49 × 18 × 22 in. MIA Gallery, Seattle, Washington. This massive, roughly carved and painted sculpture is described by the artist as a "heavy idea."*

MATERIALS AND TECHNIQUES
John Abduljaami carves his pieces from large logs, mostly black walnut, purchased from a "wood hustler" in Walnut Creek, California. The artist works with a double-headed ax, chisels, and gouges. He does not use sandpaper and applies paint only to highlight the features.

Abduljaami has made about 125 carvings, some of which range up to 10 feet in height.

ARTISTIC RECOGNITION
In the San Francisco Bay area Abduljaami is well known for his massive wooden figures, but he has not achieved any great degree of renown in the rest of the country, particularly on the East Coast. He was included in the exhibition "Cat and a Ball on a Waterfall: 200 Years of California Folk Painting and Sculpture" at the Oakland Museum of Art in 1986, and one of his large works was also purchased by that museum.

BEVERLY ("GAYLEEN") AIKEN—
"Selling paintings pays for the groceries and such." "When we camp around helping relatives with the properties, miss our old fancy chandeliers, wall paper, old long halls, our big porches, old country hills, and more. We might move back to one of our old heirloom country houses later. Music echoed nice in them. Once wanted museum there." (Poem prose on Aiken drawing)

BIOGRAPHICAL DATA
Born March 25, 1934, Barre, Vermont. Left school in the eighth grade. Single. No children. Now resides Barre, Vermont.

GENERAL BACKGROUND
Gayleen Aiken creates fantasy drawings that tell detailed stories. Often the artist prints words below the images to ensure that the meaning is clear.

Aiken claims that she was too busy camping around with her "Raimbilli Cousins" (who are imaginary), writing comic books, and playing music even to think about working. She refers to herself as an "artist, musician, camper" who likes "old nickelodeon music and large country houses."

In fact, Aiken stayed home to take care of her mother until her death in 1984. She presently lives in a basement apartment in Barre, Vermont, and receives welfare in addition to income earned from art sales. Aiken calls her apartment the "Music Box and Art Camp" and complains that it gets too hot.

ARTISTIC BACKGROUND
Gayleen Aiken has been drawing her Raimbilli Cousins

Beverly Aiken, Our Old Susie Cat Out in the Moonlight Out Back of Our Old Big House, *1989. China marker and crayon on paper, 14 × 17 in. GRACE (Grass Roots Art and Community Effort), Saint Johnsbury, Vermont. This work incorporates two of Aiken's favorite themes—beloved pets and hints of the artist's early life.*

Beverly Aiken, Raimbilli Cousins, *c. 1988. Cardboard and collage, ¾ life-size. GRACE (Grass Roots Art and Community Effort), Saint Johnsbury, Vermont. The "Raimbilli Cousins," illustrated here, have been the artist's imaginary companions since childhood, and in her drawings she often portrays their cheerful activities.*

since grade school ("I always thought it would be fun to make believe I had a lot of cousins"). But when her mother became sick in the early 1980s, she started to concentrate seriously on art.

Aiken was discovered by Pat Parsons, a folk art dealer who lives in Burlington, Vermont. Parsons wrote about Aiken and placed her in several important shows.

SUBJECTS AND SOURCES
At first glance Aiken's drawings appear to be memory paintings, but they are not. There is a sense of fantasy and unreality and a haunting presence that lurks just beneath the surface of the artist's work. Aiken's favorite subject is a band of smiling youngsters—her twenty-four Raimbilli Cousins—who are often shown playing assorted musical instruments. She also paints the Vermont landscape, with its granite quarries and its mills, as well as pictures of former pets, friends, and nickelodeons, sometimes including herself in the composition.

The themes of Aiken's stories are often explained through text or titles along the bottom of the drawings. Many of her paintings contain a brief autobiography in the lower right-hand corner.

MATERIALS AND TECHNIQUES
Aiken paints and draws with oil, crayon, and watercolor on paper and paperboard. The printed words on her paintings are usually done in blue and red.

Aiken has made many hundreds of drawings, most of them ranging from 10 by 8 inches to 14 by 15 inches. She has done a complete set of individual cardboard and cloth portraits of the Raimbilli Cousins that are almost life-size.

ARTISTIC RECOGNITION
The artist's work has been shown by GRACE (Grass Roots Art and Community Effort), and in 1986 she and her art were the subject of a documentary film, *Gayleen*.[1]

SYLVIA ALBERTS—*"The only thing I feel I have in common with other folk artists is that I'm self-taught —I call myself an artist."*

BIOGRAPHICAL DATA
Born Sylvia Seligman, June 10, 1928, New York City. Graduated from Northwestern University, Evanston, Illinois, 1950; completed some postgraduate work in English at New York University, New York City. Married Russell Roman, 1953; divorced 1958. Married Alan Alberts, April 8, 1962. No children. Now resides New York City.

GENERAL BACKGROUND
Sylvia Alberts' paintings show a highly refined yet deco-

Sylvia Alberts, Gym*, 1987. Oil on canvas, 22 × 24 in. Jay Johnson America's Folk Heritage Gallery, New York. By placing highly stylized figures reminiscent of turn-of-the-century photographs on a stark background, Alberts has produced an arresting work that appears to comment on the current mania for fitness.*

rative style that often bring the formal poses of Victorian photography to mind.

After graduating from college, Alberts moved to New York, where she worked as a secretary from 1950 until 1953. Then she became a free-lance graphics designer, a skill she learned from her first husband. "I can take a finished manuscript and turn it into an attractive pamphlet," she says.

Alberts and her husband, an architect, spend summers on Monhegan Island, off the coast of Maine, in very rural surroundings.

ARTISTIC BACKGROUND
In the early 1960s Alberts's husband gave her a box of casein paints as a birthday present. Between 1961 and 1963 she produced three meticulous copies of paintings of boats by the nineteenth-century marine painter James Bard (whose paintings she saw at the New-York Historical Society). She gave those first works to friends.

"I had the paints, but I couldn't think of what to do with them," she says. "Then I started using old portraits and photographs of cityscapes, and it became easier.

"My first showing was in 1968, at an upstate New York arts and crafts show. Joan Boeder, the wife of an artist, bought four of my works and became my patron. From there I found my way into various galleries."

SUBJECTS AND SOURCES
Alberts paints portraits of people from life and from photographs and still lifes—flower and fruit arrangements. Her portraits show men and women in stiff poses, reminiscent of old photographs. Another important category of her work comprises city and landscapes; as she says, "My work is 'protest' art. I am trying to capture the disappearing New York skyline and the American landscape."

MATERIALS AND TECHNIQUES
Alberts works in oils on canvas and also draws with pencils, oils, and casein on paper. She pays meticulous attention to detail, and her art reflects a personal sophistication and highly refined style.

At first Alberts worked from old photographs, but lately she has been taking her own. She also will set up her easel before a landscape or still life table setting: "If I can't see it, I can't paint it," Alberts explains.

Alberts has completed about 350 oils on canvas and about 150 miscellaneous works on paper. Her paintings may be as large as 40 inches square.

ARTISTIC RECOGNITION
Sylvia Alberts exemplifies a style of self-taught twentieth-century folk art that is extremely popular and very decorative. Her work has been exhibited at the Woodspring Museum, London (1976); the Mulvane Art Center, Topeka, Kansas (1979); and the Museum of Art, Science and Industry, Bridgeport, Connecticut (1988); and she is represented in the permanent collection of the American Museum in Bath, England.

LEROY ALMON, SR.—*"Either you got the gift to make folk art—or you ain't got it."*

Leroy Almon, Sr., Moses and Aaron, *1988. Polychromed wood relief with beads and paste diamond, 24 × 11¼ × ⅝ in. Lee and Ed Kogan. The story of Moses and Aaron, depicted here in Almon's distinctive polychrome style, may also be viewed as a comment on racism in society today.*

BIOGRAPHICAL DATA

Born November 18, 1938, Tallapoosa (northwest of Atlanta), Georgia. Attended Central High School, Cincinnati, Ohio. Married Etta Mae Lewis, 1962; divorced 1979. Married Mary Alice Grayson, 1984. Two sons (one by each wife). Now resides Tallapoosa, Georgia.

GENERAL BACKGROUND

Leroy Almon carves bas-reliefs based on current events and themes from the black American experience.

In 1945 Almon's father, a presser in a dry-cleaning establishment, moved the family from Georgia to Cincinnati, Ohio. After finishing high school, Almon became a shoe salesman for the Shoe Corporation of America. In 1961 he served in the armed forces for six months.

Almon first married in 1962 and obtained a job selling for the Coca-Cola Company in Columbus, Ohio. It was in Columbus that he met Elijah Pierce, a barber who was a famous black folk carver (see page 240). In 1979 Almon gave up his job with Coca-Cola and became an apprentice to Pierce. "He paid me a little somethin'," Almon explains, "and I ran his barber shop-museum. We had a spiritual sharing, and I learned folk art."

In 1982 Almon returned to his hometown, Tallapoosa, Georgia. He is currently a police radio dispatcher and works at his art.

ARTISTIC BACKGROUND

Leroy Almon proclaims that folk art is made by "special gifted persons." Because he believes he has "the gift," he deliberately schooled himself in the field through his apprenticeship to Elijah Pierce. Pierce served as a major source of inspiration and encouragement for Almon and, in fact, purchased some of Almon's early carvings between 1979 and 1982.

After Almon returned to Tallapoosa in 1982, he continued to work at what by then he considered his calling—folk art. "I just did it," he says, "and folks began buying. There's a family of people looking for black folk art—they'll find you, wherever you are."

In 1985 Almon received the Georgia Governor's Award in the Arts.

SUBJECTS AND SOURCES

"My theme," the artist states, "is the African-American experience—racism and how it affects black Americans."

Fred Alten, Dinosaur, *1915–1925. Carved and painted wood, 9⅜ × 24⅝ × 3½ in. Museum of American Folk Art, New York; Gift of Mr. and Mrs. Joseph E. Dumas. The fanciful dinosaur shown here is representative of this reclusive artist's direct, monochromatic style marked by minimal carving.*

Almon portrays scenes of popular biblical subjects and current events (the assassinations of John F. Kennedy and Martin Luther King, Jr., for instance) in bas-relief. He often works from newspaper and magazine illustrations.

MATERIALS AND TECHNIQUES

"I only carve bas-reliefs from flat boards—after the style of Elijah Pierce," Almon says. "I use hand chisels and pocket knives—that's what makes it folk art." The woods he uses are soft, primarily basswood and pine. The finished reliefs are painted with "messed-up paint from hardware stores, sold cheap." Almon sometimes attaches sequins, pearls, and other objects to his work.

ARTISTIC RECOGNITION

Almon's protest art and his art based on the black experience represent a type of folk art that is currently popular, especially among Southern collectors.

FRED ALTEN

BIOGRAPHICAL DATA

Born Lancaster, Ohio, 1871. Education is thought to have been minimal. Married Mary Ann Weidner around 1890; she died 1944. Five children, including twin daughters. Died June 8, 1945, Lancaster, Ohio.[1]

GENERAL BACKGROUND

Fred Alten carved in the quiet of his garage, accumulating a small menagerie of animals for his own pleasure. Not even members of his own family knew of the treasures hidden in that small building.

The son of German immigrants, Alten worked for many years in a Lancaster, Ohio, machine shop owned by his brother, Will. In 1912 he moved his family to Wyandotte,

Tobias Anaya, Man on Horse, *c. 1988. Wood, cloth, and Coors beer cans, 28 × 7 × 14 in. Bob and Marianne Kapoun. This chunky cowboy and his horse are typical of Anaya's whimsical wooden collages that recall activities and fantasies from his youth.*

In later years Anaya began to suffer from arthritis and could get around only with the aid of two canes. On November 29, 1988, he suffocated to death when smoke escaped from his wood-burning stove.

ARTISTIC BACKGROUND
Clara Anaya explains the short artistic career of Tobias Anaya: "When Mother died, Tobias [was] very lonely. He would rummage around for sticks and things in the Galisteo dump, and then go up to the old *campo santo* [local cemetery] and sit in the sun making things. If someone came by, he'd say, 'Tres pesos for a guitar player and I'll give you one free.'"

By 1986 Anaya's work could be found in a gallery in Santa Fe. Collectors would also sometimes venture out to the old Galisteo cemetery to look for his work.

SUBJECTS AND SOURCES
In his artwork Anaya made his memories of his team of horses and his guitar-playing youth come to life again. Guitar players were his favorite subjects, and as soon as he sold one guitar player, he was busy fashioning another. Anaya also made cowboys astride horses and local animals such as deer and snakes.

MATERIALS AND TECHNIQUES
Anaya would look for piñon and juniper tree branches or pine boards that had the rough shape of humans or animals. Then, with a few nails, a little drilling, a little whittling, some material found in the Galisteo dump, and a snip or two from a beer can, his sculpture would be complete. Anaya did not use paint on his pieces.

According to his sister-in-law, Anaya made about two hundred objects, some as large as 3 feet.

ARTISTIC RECOGNITION
Anaya's work, which is fairly uniform in quality, displays a sly sense of humor. There is no record of this type of folk art being made by any other Hispanic artist. Anaya is not well known except among collectors in New Mexico.

STEPHEN WARDE ANDERSON—
"I paint what fascinates me the most—women."

BIOGRAPHICAL DATA
Born July 16, 1953, Rockford, Illinois. Graduated from

Stephen Warde Anderson, Cleopatra, *1989. Tempera on cardboard, 27 × 20 in. Private collection. In his unique pointillistic portrait of Cleopatra, Anderson depicts two topics that fascinated him—ancient history and a fabled woman.*

Stephen Warde Anderson, The Seven Temptations,
1989. Tempera on cardboard, 24 × 48 in. Roger Brown.
Here, in a sepia-toned, allegorical work, the artist has
endowed each of his stylized figures with some of the
trappings of temptation.

Rockford West High School, 1971; spent one year at the
University of Chicago. Single. No children. Now resides
Rockford, Illinois.[1]

GENERAL BACKGROUND

Folk painter Stephen Warde Anderson always had a "feel-
ing" that he was destined to do something in the arts. After
a year's try at college, he joined the navy, serving on the
guided missile frigate U.S.S. *Richard L. Page* from 1972
through 1976. "I was stationed in Athens, Greece," he
said, "so I had a chance to see bits of old world history."

Anderson's father, a bricklayer, allowed his son to live
at home after his discharge in 1976 so that he would have
the chance to try to make art.

ARTISTIC BACKGROUND

"When I got out of the navy," Anderson says, "I tried to
paint. It took me a long time to discover my style, but by
1987 I was doing pretty good."

In 1988 Anderson had a one-man show at Highland
Community College in Freeport, Illinois. There William
Bengston of the Phyllis Kind Gallery in Chicago discov-
ered his work, and the gallery began to represent the artist.

SUBJECTS AND SOURCES

"I am fascinated by women in history," Anderson says.
He paints Greek goddesses (Athena, for example), imagi-
nary women (the Seven Temptations), and women who
have played a part in history (Cleopatra). All of his women
appear to be mature and well endowed. "I don't have a
model," he says. "They are my idea of perfect females."
The artist uses books on mythology and history as guides
in choosing his women.

MATERIALS AND TECHNIQUES

Anderson buys "lampshade cloth" and irons it onto Ma-
sonite; he claims that the bond is permanent and prefers
the cloth for painting because it has a finer texture than
linen canvas. He applies several layers of paint to the
bonded cloth with a brush, then sketches his subject in
pencil and outlines it in permanent ink.

The artist cuts strips from plastic food containers and
uses these strips (which he calls stiles) and nails to apply
paint. He paints with liquid tempera that is first allowed to
harden in bottle caps. "I have found," he says, "that my
saliva mixed with the hardened paint makes a paste that is
just right."

The paintings are made up of tiny dots of color. Some-
times Anderson creates an overall sepia effect, and at other
times he uses brilliant golds, reds, and greens for a totally
different look.

Anderson has completed seventy or eighty works, rang-
ing from 6 by 8 inches to 3 by 4 feet.

ARTISTIC RECOGNITION

Stephen Warde Anderson has developed an unusual poin-
tillistic style of painting, and his women are fascinating—
part human and part goddess. He is best known in the
Midwest, and even though he is still developing, his work
has found its way into many folk art collections.

JOHNSON ANTONIO—*"I don't make them*
for sale. I make them for myself, but I need the money.
Unfortunately, the cash will soon be gone, but the dolls will
live forever."

BIOGRAPHICAL DATA

Born April 15, 1931, to the *Kiiyas aamii* (Towering Rock) clan, near Lake Valley, the Navajo Nation, New Mexico. Attended Lake Valley School off and on until 1949. Married Lorena Henry, 1977. Four daughters and four sons. Now resides Lake Valley, the Navajo Nation, New Mexico.

GENERAL BACKGROUND

Johnson Antonio is a Navajo woodcarver whose dolls and animals depict familiar scenes from his own experience.

For twenty years (the summers of 1951 through 1971) Antonio was seasonally employed as a section hand for the Union Pacific Railroad. Now he herds sheep and goats in the Bisti, a vast, high, arid region that is virtually uninhabited except by a few Navajos. Most supplies, even potable water and cottonwood for carving, must be brought from Farmington, New Mexico, forty miles to the north. In recent years the family has replaced their horse-drawn wagon with a pickup truck, and they have joined the Native American Church.

ARTISTIC BACKGROUND

By tradition, Navajos are not carvers, although they will occasionally copy a Hopi Kachina. In 1982 or early in 1983, Antonio started carving "dolls," which is how he describes his art, although they are actually likenesses of the Navajos and their animals. "My dolls come from here," Antonio declares as he points to his heart.

He originally sold some of his dolls to Jack Beasley, an Indian trader in Farmington, who then sold them to shops and galleries in towns surrounding the Navajo Nation— Santa Fe, Taos, Gallup, Phoenix, and elsewhere. Beasley was so taken with Antonio's work that he also arranged for a showing of it, along with that of Mamie Deschillie (see page 98), at Santa Fe's Wheelwright Museum of the American Indian during the Christmas season of 1983.

SUBJECTS AND SOURCES

Antonio carves what he knows best. In his figure carvings of the Navajos and their animals, he manages to capture the difficulties of everyday life and the hardness of survival on the Bisti. He also occasionally makes carvings of the masked dancers who perform the *Yeibichai (Yéii bicheii),* or Night Chant, one of the most sacred of the Navajo ceremonies.

MATERIALS AND TECHNIQUES

Antonio carves his dolls from cottonwood. He uses an ax to give a rough shape to his work and a pocketknife to finish the detailing. He does not sand the pieces, and so they tend to appear a little crude. He paints them with commercial watercolors and house paint. Most of his whites are *dleesh* (a clay used by the Navajos to paint their bodies for ceremonies). *Dleesh* is, however, a very fragile pigment and is easily rubbed off or dissolved by water.

With the help of his wife, Lorena, Antonio makes realistic sheep and goats to accompany his Navajo figures; they have carved faces and real fur and horns on their bodies.

Johnson Antonio, Smoking Break, *c. 1986. Dleesh and watercolor on cottonwood, 28½ × 5 × 6 in. Chuck and Jan Rosenak. Johnson Antonio movingly captures the stoic character of the Navajos in this carving of a man engaged in a pedestrian activity—a smoking break.*

Some of the animals seen in southwestern galleries that are attributed to Johnson Antonio are fashioned by other Navajos who now attempt to imitate his style. Johnson's carvings are usually signed on the base by Lorena:

"J. Antonio, Box 298, Kirkland, New Mexico." (The post office box actually belongs to an Indian trader.)

Antonio has made about two hundred objects, some as large as 3 feet in height.

ARTISTIC RECOGNITION

Johnson Antonio's work is well known in the Southwest, and his early pieces—his first depictions of Navajos and their animals—are truly unique. Although he has repeated some of his more popular subjects to order, his technique continues to improve. His work is in the collections of the Museum of American Folk Art in New York City and in the Smithsonian Institution's National Museum of American Art in Washington, D.C.

FELIPE BENITO ARCHULETA—

"Oh, Lord! It is a headache—whatever you do—people want so much more from you."

BIOGRAPHICAL DATA

Born August 23, 1910, Santa Cruz (between Espanola and Taos), New Mexico. Attended three years of school, Santa Cruz, New Mexico. Married Isabel Herrera, 1937. Four sons, three daughters. Now resides Tesuque, New Mexico.

Felipe Benito Archuleta, Seated Tiger, *1970. Cottonwood, paint, and gesso, 30¾ × 16¾ × 35 in. Museum of American Folk Art, New York; Gift of Elizabeth Wecter. This perky tiger is a typical example of the artist's lively menagerie of wild animals.*

GENERAL BACKGROUND

When Felipe Archuleta is asked what it is like to be the founding father of a carving tradition, he replies, *"Señor, it is a headache. Everybody wants something from me."*

Fame was a long while coming to Felipe Archuleta. As a small boy, he went by wagon to Colorado (two days each way) to pick potatoes in the summer; he picked chilies in the fall. Later he herded sheep and, during the Depression, worked as a line cook in various CCC (Civilian Conservation Corps) camps. In 1939 Archuleta gave up his semi-nomadic life and moved to Santa Fe, where he took a job as "fry cook" at La Fonda Hotel. He also played drums with a Hispanic combo at dances and cabarets.

Archuleta learned carpentry and joined the United Brotherhood of Carpenters and Joiners of America in 1943. He took great pride in his work and always left his signature on each job site. In 1964, however, Archuleta had a major disagreement with the carpenters union. He had seven children to feed and felt that, because of his tenure in the union, he should be guaranteed steady work and not have to travel, but no guarantees were forthcoming. This marked a turning point in his life, and it was then that he began to carve.

Archuleta had inherited ten acres on Aqua Fria Street in Santa Fe from his grandmother. He sold the land in 1943 in order to have the funds to build his present home in Tesuque.

ARTISTIC BACKGROUND

According to Archuleta, during his period of conflict with the carpenters union, the Lord appeared to him and said, "Carve wood." Archuleta replied, "I am not worthy to be a *santero*.[1] So I will carve animals." He began to carve in response to his vision, and thus a new era in Hispanic art and tradition was born.

In the 1970s the Museum of International Folk Art in Santa Fe put an Archuleta menagerie on display, and soon he was beseiged by collectors of southwestern folk art. *"Caramba!"* the artist shouts. "I got too many orders."

Today Archuleta suffers from arthritis; he carved his last major work in the spring of 1987. What is not generally known is that in 1987, when Archuleta became too ill to carve, he made about two dozen complete drawings of animals, using color for the first time in his drawing.

SUBJECTS AND SOURCES

Archuleta carves animals—representations of domestic and wild animals that he has observed and animals that are pictured in books. He is known for making his animals seem rough and fierce; they often have long, sharp claws and snarling mouths filled with big white teeth.

Archuleta draws his inspiration from his memory and from pictures in such magazines as *National Geographic*.

Felipe Benito Archuleta, Bear with a Fish in His Mouth, *1987. Latex flat house paint on cottonwood with marbles, 27½ × 55½ × 28 in. Chuck and Jan Rosenak. This is Felipe Archuleta's last great carving—a glorious summation of his life's work.*

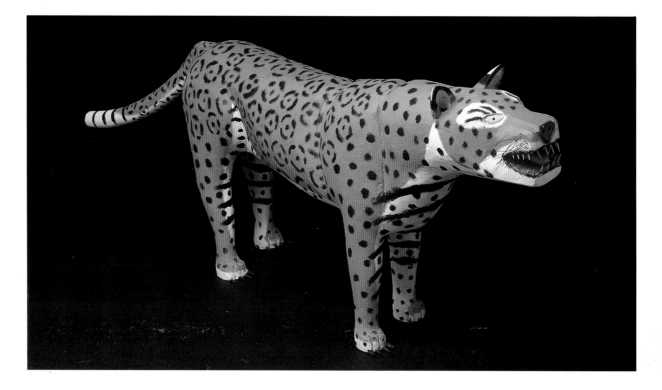

MATERIALS AND TECHNIQUES
Archuleta carves cottonwood, working from drawings he has made of the animals on scraps of paper. Since the late 1970s he has used a chain saw to rough out the animal's shape from the wood and hand tools to finish it off.

When the carving is done, Archuleta paints it with latex house paint. He adds realistic touches to some animals by attaching uncarded wool, hemp, rubber, marbles (for eyes), wire, nails, and even brush bristles. (Wool on his carvings should be sprayed to protect against moths.)

Archuleta's animals range in size from only 4 inches high to some life-size giraffes. No one—including the artist himself—is sure of the number of carvings he has produced, but it ranges in the many hundreds.

By the mid-1970s Archuleta had apprentices helping him make carvings and was complaining about "too many orders." Even so, he was still capable of producing unique pieces, and even his everyday work is much admired.

ARTISTIC RECOGNITION
Archuleta set the standard for the "Santa Fe style" by carving, for example, watermelons, snakes, and coyotes; he did them first and he did them better than anyone else. His early work (the carvings that came in response to the command of God) is Archuleta's best and includes sheep, lions, and the large menagerie that exhibited at and now form part of the collection of the Museum of International Folk Art. Archuleta received the New Mexico Governor's Award for Excellence and Achievement in the Arts in 1979.

Leroy Ramon Archuleta, Leopard, *1988. Cottonwood, paint, toothpicks, and brush bristles, 16 × 39 × 4 in. Mr. and Mrs. Robert E. Linton. Leroy Archuleta has given this fierce and fantastic wild cat the spots of a leopard and a jaguar as well as the stripes of a tiger.*

LEROY RAMON ARCHULETA—
"I learned by looking at him [his father, Felipe Archuleta]. I love to carve. Money is what keeps me doing it every day."

BIOGRAPHICAL DATA
Born January 9, 1949, Tesuque (just north of Santa Fe), New Mexico. Attended high school, Santa Fe, New Mexico. Single. No children. Now resides Tesuque, New Mexico.

GENERAL BACKGROUND
Leroy Archuleta is an outstanding representative of the second generation of Hispanic carvers following in the footsteps of his father.

After completing high school, Archuleta moved to Colorado, where he was a tree cutter for Blume Tree Service, then a laborer with Shell Chemical, and finally a worker in a Seven-Up bottling plant. In 1975 he returned to the family home in Tesuque to help his father, master carver Felipe Archuleta.[1] Soon he began making his own carvings.

"I fish and hunt deer, elk, and bear," he says, "but most of the time I carve cottonwood. From each carving I learn something, so I can do better next time."

ARTISTIC BACKGROUND

Although Archuleta returned to Tesuque to help his father, he quickly developed his own recognizable style and gained an enthusiastic following. "You can always tell [my carvings] from Dad's," he says; "I use sandpaper, for instance; he wouldn't take the time. Dad made animals his way—I make them mine."

SUBJECTS AND SOURCES

Archuleta sculpts in a shed with a wood-burning stove in back of his father's house. He carves animals that he has seen in the woods as well as animals pictured in books. (Both he and his father use the *National Geographic Book of Mammals* for source material.) Leroy Archuleta captures the character of an animal without romanticizing it; he is known for making his animals—tigers, lions, and even pigs—look extremely fierce by exposing their fangs or teeth.

Archuleta will often make carvings to order. In the late 1970s lynx—usually signed by his father—were popular made-to-order items; in the 1980s watermelons, snakes, and coyotes were the rage. However, he prefers to follow the dictates of the wood and carve what it tells him.

MATERIALS AND TECHNIQUES

Archuleta uses a chain saw to rough-shape the cottonwood, and then finishes the animals with hatchets, chisels, and other hand tools. He adds glass eyes, bottle caps, hemp, wool, leather, or other materials. Where there are cracks in the wood, he fills in with a mixture of glue and sawdust. Sometimes he uses skulls and antlers that he finds (or that come from animals he has hunted) on his carvings.

Archuleta estimates that he has made many hundreds of animals, ranging in size from 6 by 8 inches to life-size giraffes and elephants.

ARTISTIC RECOGNITION

Leroy Archuleta is among the best Hispanic carvers who are not following the *santero* tradition (his father is no longer carving). All his work is technically excellent and consistent, but the most interesting are his one-of-a-kind pieces—animals with real skulls and antlers, and large lions, tigers, and ponies (with saddles) that are big enough for children to ride.

ZEBEDEE ("Z.B.") ARMSTRONG, JR.

—*"The world's coming to an end—the* Titanic *will come up soon."*

BIOGRAPHICAL DATA

Born October 11, 1911, Thomson (30 miles west of Augusta), Georgia. Attended school through eighth grade, McDuffie County schools, Georgia. Married Ulamay Demmons, 1929; she died 1969. Two daughters. Now resides Thomson, Georgia.[1]

Zebedee Armstrong, Jr. BELOW LEFT: Star Calendar, *1987. Wood, paint, and felt-tip pen, 20 × 16 in.* BELOW RIGHT: Square Calendar, *c. 1985. Wood, paint, and felt-tip pen, 15 × 14 in. Red Piano Art Gallery, Hilton Head, South Carolina. Zebedee Armstrong's belief in the coming end of the world inspires his creation of calendar clocks that are intended to predict the actual date. To set the time of the predictions, the star on the clock at left and the hand on the one at right are moved.*

GENERAL BACKGROUND

Zebedee Armstrong is a black folk artist who creates complex, often boxlike calendars for predicting the end of the world.

Like his father before him, Armstrong worked for much of his life on the Mack McCormick farm picking cotton. After the death of his wife, Armstrong went to work for the Thomson Box factory and remained there until he retired in 1982.

ARTISTIC BACKGROUND

About 1972 an angel visited Zebedee Armstrong and proclaimed, "You have to stop wasting your time because the end of the world is coming." Armstrong took the angel at its word and began working night and day in order to devise a calendar to predict the occurrence of this catastrophic event.

Armstrong was discovered by Tom Wells, a dealer and collector in Thomson, Georgia, and he is now represented by the Red Piano Gallery in Hilton Head, South Carolina.

SUBJECTS AND SOURCES

Armstrong's compulsive theme is time, and his goal is the design of a calendar for the prediction of the end of the world. He has made hundreds of calendars over the years, all in different sizes and shapes.

MATERIALS AND TECHNIQUES

Some of Armstrong's calendars are constructed of wood, which he nails together into boxes that are irregular in shape. Others are done on flat paper or cardboard. The artist also paints on reclaimed objects such as mailboxes, urns, and vending machines. He paints the piece white, then lines it with grids that he calls "taping." Taping and lettering are done with permanent felt marker.

Some of the calendars have clocklike constructions with movable hands affixed to their faces (calendar wheels). The calendars contain lettered segments and divisions representing the past or the future and are colored mostly with black, red, white, and blue.

Armstrong has made about six hundred works, varying in size from a flat calendar that measures 6 by 11 inches to a large painted wardrobe.

ARTISTIC RECOGNITION

Although Zebedee Armstrong's work is not well known in the folk art community in general, collectors of southern black folk art have discovered him and prize his complicated, boxlike calendars. He has been shown at the High Museum of Art in Atlanta, Georgia.

EDDIE ARNING

BIOGRAPHICAL DATA

Born Carl Wilhelm Edward Arning, January 3, 1898, Germania (a farming community near Kenney), Texas. Attended about six years of school, one year of confirmation classes, St. James Lutheran School, New Wehdem, Texas. Single. No children. Now resides Austin, Texas.

GENERAL BACKGROUND

Eddie Arning is known for his bold interpretive drawings that often reflect a narrative style.

Raised in his grandmother's house in a German-speaking farming community in Texas, Arning lived and worked on his father's farm until he was thirty years old. In his middle twenties he showed the symptoms of mental illness; he had frequent bouts of depression and withdrawal as well as outbursts of violence, ultimately diagnosed as schizophrenia.

In 1928 a court declared Arning "dangerous by reason of insanity" and committed him to the state hospital in Austin, Texas. Although he was released in a year, in 1934 he was recommitted and spent the next thirty years in the hospital. Arning was furloughed to a nursing home in 1964; he was officially discharged from the hospital in 1970 but continued to live thereafter in nursing homes, partially supporting himself for a time by the sale of his drawings.

ARTISTIC BACKGROUND

Despite Eddie Arning's withdrawal from society, he "developed a powerful mature personal vision . . . interpreting the world around him."[1] Arning started drawing in 1964 while he was a resident in a nursing home, where he was encouraged by Helen Mayfield, an art teacher at the Austin State Hospital. She introduced him to the collector Alexander Sackton and some of his friends, who began supplying Arning with paper and other materials for his work.

Arning stopped drawing in 1973, when he had to leave his favorite nursing home because of bad conduct.

SUBJECTS AND SOURCES

Arning obtained his inspiration from magazine illustrations (he often attached his source—the illustration—to the back of his work). However, he invented an extremely personal iconographic way of seeing the ordinary objects depicted in popular magazines and allowed himself flights of fantasy into a dream world that was inspired by the original material.

MATERIALS AND TECHNIQUES

Arning filled his paper with bold colors and geometric designs that do not appear in the original illustrations. He drew on paper, often colored paper; he started drawing with wax crayons (Crayolas) but later changed to oil pastels (Cray-pas).

Arning's drawings range from 11 by 16 inches in size up to 28 by 32 inches. He made about two thousand drawings, a great many of which were purchased by his benefactor, Alexander Sackton.

ARTISTIC RECOGNITION

Eddie Arning's work ranges from geometric abstraction to the narrative, and he is best known for the latter style. Although magazine illustrations served as his source ma-

Eddie Arning, Nine Figures Climbing Trees, 1972. Oil
pastel and pencil on paper, 21½ × 31½ in. Museum of
American Folk Art, New York; Gift of Mr. and Mrs.
Alexander Sackton. Inspired by magazine illustrations,
Arning invented an imaginary world, as depicted in this work
with strong images and vivid colors.

terial, they were reinterpreted and transformed in his
highly original work.

Today Arning enjoys a reputation as an important folk
artist of this century. He is represented in all the foremost
museum collections of this type of material, as well as in
numerous private collections.

STEVEN ASHBY—*"I made my 'fixing-ups'; have*
to make 'em." "The house is going slowly down. Never have
no time for it no more—only for makin' 'fix-ups.' "

BIOGRAPHICAL DATA
Born July 2, 1904, Delaplane, Virginia.[1] Received very lit-
tle formal education (Ashby could neither read nor write).
Married Eliza (Liza) King, about 1925; she died, c1960. No
children (a "stepson," Earl Jordon[2]). Died June 13, 1980,
Delaplane, Virginia.[3]

GENERAL BACKGROUND
Steve Ashby was a black folk artist whose "fixing-ups"—
humorous, sometimes erotic figures—were made from
wood and found objects.

Ashby lived his life in the backwater culture of Fauquier
County, Virginia—thoroughbred horse and cattle country
and one of the most affluent counties in the United States.
The Ashby family was virtually indentured to the land; his
father had been a freed slave on the McCarty farm, one of
the farms where Ashby himself also worked.

When he was in his twenties, Ashby married Liza King,
who worked as a domestic and cook at the Calvert School,
an exclusive girls' boarding school. They lived in a two-
room schoolhouse that had been abandoned by the state of
Virginia in 1912 or 1914 and sold to the adjoining farm.
The rent was modest, and the Ashbys loved their little
house under the hickory trees. They had to depend on a
hand pump across the road for water and a wood-burning
stove to keep the house warm and cozy, but there was
plenty of room in the backyard for a vegetable garden.

Ashby could not drive an automobile and therefore had

to live within walking distance of the little country store at Delaplane. His credit was good there, and in winter, when he was too old to work, he could sit on a bench and chat with friends in front of the store's pot-bellied wood-burning stove. By the time Liza died, their "son," Earl Jordon, had already left home. Thus, during the 1970s, Ashby was alone and dependent on a small Social Security pension (his rent was usually paid by the McCartys). He died in 1980, soon after his health began to fail.

ARTISTIC BACKGROUND
According to his sister, Ashby had carved since he was quite young, but he started making what he called "fixing-ups" after he lost his wife and retired. These objects were never made for sale; to him, parting with one was like losing a companion.

Ashby told people that the images for his fixing-ups came to him in dreams: "I wake up with an idea that won't let me get back to sleep, so I wake up and make that idea," he stated. And, "I dreamed about it. I just had to do it."

SUBJECTS AND SOURCES
Ashby assembled a remarkable variety of objects that depicted with sly humor both the world he knew—the horse races at Upperville, farm activities, and farm animals—and the world he imagined—pinups from girlie magazines and iceboxes stuffed full of hams and other good things to eat.

The fixing-ups were very personal, and Ashby would dress many of his figures in cast-off clothing. In summer they hung from trees, moving in the wind, or stood guard over his garden; in winter he made smaller table objects, to be exhibited near hearth and bed. Some of his objects would appear to be erotic to some people, but not to Ashby—to him they were just plain real.

MATERIALS AND TECHNIQUES
Ashby's basic material was wood—plywood, used lumber, tree trunks or branches—trimmed with whatever he could find. Nuts from his hickory trees became breasts on his female figures; his old scythe became part of a self-portrait; a neighbor's lost earring would appear somewhere on a fixing-up. He would dress many of his figures in old clothes and sometimes even change their costumes. On occasion, he would glue cutouts from magazine illustrations—such as images of sports heroes and politicians—to his work.

Ashby often used model airplane paint, which he purchased in small jars at the Delaplane Store, to brighten up his pieces or to give them faces. He attached blades to some objects, which would catch the breeze and make parts of the piece move.

The fixing-ups range from a few inches in height to life-size figures of men and women. In all, Ashby made fewer than two hundred objects.

ARTISTIC RECOGNITION
Ashby's work has been widely exhibited and always draws attention. He was included in "Six Naives" at the Akron Art Institute in Ohio (1973); "American Folk Art from the

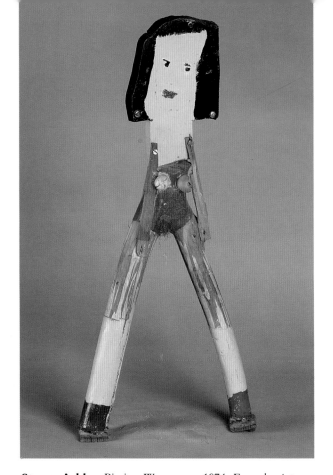

Steven Ashby, *Pissing Woman, c. 1974. Enamel paint on board with hair, hickory nuts, thumbtacks, and plastic, 22½ × 9 × 6 in. Chuck and Jan Rosenak. This buxom "fixing-up," one of many that the artist fashioned, was undoubtedly inspired by the men's magazines Ashby sometimes looked at.*

Traditional to the Naive" at the Cleveland Museum of Art (1978); the Abby Aldrich Rockefeller Folk Art Center, Williamsburg, Virginia (1980); the Milwaukee Art Museum (1981); "Black Folk Art in America 1930–1980" at the Corcoran Gallery of Art, Washington, D.C. (1982); the Smithsonian Institution's National Museum of American Art (1983); and "A Time To Reap," sponsored by Seton Hall University, South Orange, New Jersey, and the Museum of American Folk Art in New York City (1985). He is also in the permanent collections of the Museum of American Folk Art and the Smithsonian Institution's National Museum of American Art.

JOSEPH P. AULISIO—*"I always dreamed of becoming an artist and writer, but the early years were too busy earning a living, working in a dry-cleaning establishment. I paint because I love it."*

BIOGRAPHICAL DATA
Born November 15, 1910, Old Forge, Pennsylvania. Graduated from Penn State University, 1931. Married

Joseph P. Aulisio, Portrait of Frank Peters, *1965. Oil on Masonite, 28 × 20 in. Museum of American Folk Art, New York; Gift of Arnold B. Fuchs. Reminiscent of folk portraits of earlier centuries, this remarkable painting of a tailor who worked in the artist's dry-cleaning store is admired for its forthright style and strong characterization.*

Mary Hefferon, 1938; she died February 2, 1985. Five sons, one daughter. Died July 12, 1973, Old Forge, Pennsylvania.[1]

GENERAL BACKGROUND

Joseph Aulisio is best known for his sensitive portrayals of family and friends and for landscapes in and around the area of the Susquehanna River where he lived.

Aulisio loved to be outdoors. He had hoped to be a forester, obtaining a degree in that field, but graduated during the Depression, when such jobs were few and far between. He had worked as a tailor's apprentice while attending high school and used that training to open—and make a success of—Lease Cleaners in his hometown.

Aulisio satisfied his urge to be outdoors by building a cottage overlooking the Susquehanna River in Falls, Pennsylvania, and spending as much time there as possible. Later he would paint scenes of his beloved river and the surrounding area.

ARTISTIC BACKGROUND

Although Aulisio made a success of his dry-cleaning business, he was never fully reconciled to his career. Starting around 1952, he set up an easel in the basement of his store and began painting to escape from work.

He never sought publicity or buyers for his art, but when he entered some local art shows, people began to become interested in his work. In the 1960s Aulisio won first prize at the Lackawanna County Art Show, sponsored by the Everhart Museum in Scranton, with a picture of "his" river, entitled *The Narrows*. (That painting was purchased by W. W. Scranton, who later became governor of Pennsylvania.) Aulisio said that winning that prize encouraged him "to paint more." Sterling Strauser, an artist who befriended many folk artists, also encouraged Aulisio, and it was he who first bought the well-known *Portrait of Frank Peters, the Tailor* (Frank Peters was an employee of Aulisio's), which is now in the permanent collection of the Museum of American Folk Art in New York City.

SUBJECTS AND SOURCES

Aulisio painted what was most familiar to him—pictures of family affairs, scenes of the Susquehanna River, and portraits of friends, neighbors, coworkers, and family.

MATERIALS AND TECHNIQUES

Aulisio painted with oil paints on canvas. The pictures range in size from about 14 by 16 inches to 20 by 40 inches. Altogether, Aulisio painted fifty works. About thirty remain in the possession of his family.

ARTISTIC RECOGNITION

Aulisio was a master, and his works have both simplicity and, especially the portraits, strength of character. Although *Portrait of Frank Peters, the Tailor* has been widely exhibited and is widely known, few of his other works have been seen by the public because they were made for the enjoyment of the artist. He hung them in the back room of Lease Cleaners as they were finished, and most are still there today.

ANDREA BADAMI—*"I enjoy painting sometimes. Some day I will make a good painting—a masterpiece of work, some day before I die. It's gonna take time. Maybe this winter, before spring, maybe next year. I want to make something beautiful sometimes."*[1]

BIOGRAPHICAL DATA

Born October 27, 1913, Omaha, Nebraska. Some elementary education ("I had maybe five years in Corleone, Sicily"). Married Lena Badami (no relation), January 1939, Corleone, Sicily. Two sons, two daughters. Now resides Tucson, Arizona.

GENERAL BACKGROUND

Andrea Badami is a lively man who expresses his religious feelings and political opinions in allegorical and often complex works.

Born to parents who had immigrated to the United States from Italy, Badami remembers that when he was five years old, his father announced, "I better go back to Corleone [Sicily] to take care of Mama's property." And so the family returned to Italy.

Badami returned to Omaha when he was fifteen to earn his living, but, he says, "tell the truth, I only could make seven and a half a week picking sweet peppers and radishes on Charlie Sissman's farm." In 1931 he again traveled to Sicily. "There's no money here [Nebraska]. I go back there," he explains. "At least there I can sleep under an olive tree."

And there he lived and worked until 1940, one year after his marriage, when he was drafted into the Italian army

Andrea Badami, The Boss and His Wife, *c. 1973. Oil on canvas, 32 × 34⅛ in. Chuck and Jan Rosenak. Badami will not disclose the identity of this couple, whose depiction is characteristic of the artist's simpler, more accessible images.*

even though he was an American citizen. "Mussolini, he start trouble," Badami explains. "I gotta go to Africa. I was captured by the British." He spent almost six years as a British prisoner of war.

At the war's end Badami took his family and left Italy for good. He returned to Nebraska, where he worked for the Union Pacific Railroad in its Omaha repair shop from 1948 until he retired with his "golden spike" in 1978. Badami moved to Tucson, Arizona, after his retirement.

ARTISTIC BACKGROUND
Early in 1960 Badami saw some paintings in the Joselyn Museum in Omaha and shouted to himself, "Bunch of junk! I can do better." When his wife, Lena, came home that evening, she found that he had painted a mural on the dining room wall. She remembers crying out, "Don't spill on the rug!" "But next week," she says, "my draperies went."

In 1963 Badami began showing his work to Tom Bartek, a faculty member at Creighton University in Omaha. Bartek arranged for showings of Badami's work.

SUBJECTS AND SOURCES
Badami is full of stories to tell, experiences to pass on; he cannot express his pent-up emotions very well in English, so he paints them out—his view of life and people, his inner visions, his religious experiences, and his political commentaries. His work is touched by humor, love of family, love of God, and a recognition of the frailties of the world. Although Badami often draws upon popular imagery (public figures or events) as a resource, most of this material is only vaguely recognizable in his painting.

MATERIALS AND TECHNIQUES
Badami paints with oils on unstretched canvas. The paintings range in size from 2 feet square to 5 or even 6 feet long.

About one hundred paintings, which are owned by a few collectors, have survived (Badami burned about fifty canvases during the 1960s, perhaps because he felt that they did not measure up to his idea of a "good" painting). He is still painting today.

ARTISTIC RECOGNITION
It is difficult to fit Badami into any specific stylistic category, as his work tends to be idiosyncratic. Some of the stories told in Badami's paintings are very complex—especially those dealing with religious experiences. Even in those instances where the artist's specific intent may not be fully understood, however, the paintings hold up on their own. Many of his simpler images, besides being quite powerful and exciting, are more accessible to the viewer. A few of Badami's paintings—a series of cowboys, Indians, and stagecoaches painted shortly after he first moved to the West—are of only minor interest.

Badami's paintings are in the permanent collections of the Museum of American Folk Art in New York City and in the Smithsonian Institution's National Museum of American Art in Washington, D.C.

JOHN WILLARD BANKS

BIOGRAPHICAL DATA
Born November 7, 1912, Seguin (near San Antonio), Texas. Attended school through tenth grade, Hall High School, Seguin, Texas. Married Edna Mae Mitchell, c. 1928; divorced c. 1960. Married Earlie Smith, June 10, 1963. Three sons, two daughters by Mitchell. Died April 14, 1988, San Antonio, Texas.[1]

GENERAL BACKGROUND
John Willard Banks was a black artist whose drawings are a personal interpretation of religious themes, historic events, and the day-to-day life of black folk in Texas.

Banks lived the hand-to-mouth existence of many Texas blacks earlier in this century; he found work where he could, when he could—in the oil fields, on farms, driving trucks, pumping gas. Banks entered the service during World War II, becoming a sergeant and fighting on Okinawa. After his discharge in 1950, he worked as a custodian at Kelly Air Force Base, Fort Sam Houston, and then at Channel 5 in San Antonio, retiring about 1965.

Banks, a very religious man, sang in a Baptist gospel quartet.

ARTISTIC BACKGROUND
John Banks had drawn since he was a child, but his mature style developed late in life, around the time he married his second wife, Earlie. His production accelerated after a hospital stay in 1978. "I just loved them [the drawings],"

John Willard Banks, Aunt Molly's Hand Laundry, *1985. Colored pencil and felt-tip pen on poster board, 19 × 25 in. Leslie Muth Gallery, Houston, Texas. This drawing reveals many details—from the division of labor to popular products —about the life of black people in rural Texas in earlier years.*

Earlie said. "I took some to a laundromat and sold them [in 1978]." Banks's work eventually came to the attention of Dr. Joseph A. Pierce, Jr., a collector of black art, who became Banks's patron.

SUBJECTS AND SOURCES

Banks had visions, which formed the primary source for his drawings. He used to say, "My visions are like a veil crossing my eyes in the night. I have to draw them right away, or they'll be gone." Banks's visions often took the form of images such as the Second Coming of Christ; he also drew historic events like slave auctions and his remembrances of everyday black life in Texas—baptisms, hog killings, and household chores. He sometimes drew scenes of Africa as he envisioned they would look.

MATERIALS AND TECHNIQUES

Banks drew on paper and poster board with felt markers, watercolors, pencil, ballpoint pen, and crayon. The work is uniformly consistent, and the pictures are painted in bright colors. Sometimes he printed messages on his work to help the viewer identify the subject matter.

Although aware of perspective, Banks sometimes depicted his more important figures, or those he wished to focus on, in larger scale. He would greatly enlarge them in respect to the other figures in the piece, and draw their faces out of scale with their bodies.

His largest drawings are about 28 by 44 inches. In all, he did around 1,200 drawings, of which about one-third remain in his estate.

ARTISTIC RECOGNITION

Banks is quite well known in Texas, less so outside the state. During the 1980s he was widely exhibited in Texas museums, and his work is included in the permanent collection of the San Antonio Museum of Art.

LARRY BISSONNETTE

BIOGRAPHICAL DATA

Born June 24, 1957, Winooski, Vermont. Thought to be feeble-minded; received minimal formal education. Single. No children. Now resides Winooski, Vermont.[1]

GENERAL BACKGROUND

Larry Bissonnette creates compelling portraits that are part painting, part photograph.

Bissonnette was born with a learning disability and as a child was placed in the Brandon Training School in Brandon, Vermont, where he resided from 1965 to 1978. In 1978 he was transferred to the Vermont State Hospital at Waterbury. With the help of his parents and others, Bissonnette was released in 1988 and went to live with his family in Winooski. He now participates in a residential program for the developmentally disabled.

ARTISTIC BACKGROUND

Larry Bissonnette started drawing while he was in resi-

Larry Bissonnette, Lyn Torvach, *1988–1989. Mixed media on paper, 12 × 41 in. Webb & Parsons North, Burlington, Vermont. Bissonnette's portraits, like the one shown here, imprison his image of a face in a tight frame. He often overlays the face with a veil of plastic, creating a sense that the person portrayed is an onlooker rather than a participant in life.*

dence at the Brandon Training School in the 1970s. He began forcing his way into the sewing and carpentry shops late at night to make his art, and when the institution personnel and its inmates awoke in the morning, they would find his paintings and constructions displayed on the walls.

The artist has been shown locally and was given individual shows at the McCarthy Arts Center, St. Michael's College, in Colchester, Vermont, and at the University of Vermont. Bissonnette is included in "Ten Years of GRACE," an exhibit that is presently on a national tour. He is represented by Webb & Parsons North in Burlington, Vermont.

SUBJECTS AND SOURCES

Bissonnette has two themes that recur in his work: portraits of people who peer into space through a veil of plastic tape, and landscapes muted by a similar veil, with small faces visible in the windows of simple rural dwellings.

While all Bissonnette works are interesting, the portraits, which are based on Polaroid photographs taken by the artist, have a lasting impact on the viewer. The foreheads of the people in his portraits are cut by the frame,

and there is no body below the neck. Bissonnette's subjects often wear large plastic glasses and their lips appear to be rouged.

MATERIALS AND TECHNIQUES
The artist draws with crayon, pencil, and pen on paper. He attaches the paper to a constructed base made from old weathered lumber and box-crate wood that he crudely nails together. He then uses strips of rough wood, pieces of molding, and spliced plywood to form a frame for the work, and the frame itself becomes an important part of the overall construction. The veiled effect of his work is created by overlaying the drawing with sheet plastic and commercial tapes, some of which may be unstable.

Bissonnette has completed more than three hundred works. They vary widely in size; one piece is 20 feet long but only 6 inches wide.

ARTISTIC RECOGNITION
Larry Bissonnette is becoming known in the Northeast, although he is not yet widely recognized elsewhere. His images of faces peering through a veil, as though imprisoned, are powerful and moving, with a strong visual appeal. They are the artist's signature works.

CALVIN ("CAL") AND RUBY BLACK—*"Free to see Inside we have the most beautiful dolls U ever saw Hand carved Some can sing" (Sign outside shop at Possum Trot)*

BIOGRAPHICAL DATA
Born Calvin Anderson Black, September 21, 1903, in Tennessee; Ruby C. Ross, January 19, 1913, in Georgia.[1] It is doubtful whether either Black had much formal education. Married in 1933. No children. Calvin Black died March 2, 1972, Yermo, California; Ruby Black died July 26, 1980, also in Yermo, California.

GENERAL BACKGROUND
Calvin and Ruby Black were a husband-and-wife team whose unusual folk art environment on a desert highway entertained travelers for more than twenty-five years.

By the time he was thirteen, Cal Black was raising his siblings and caring for his mother. According to his wife, he taught himself to read and write. Black worked in carnivals and circuses, where he later helped to operate a puppet show and learned ventriloquism. Ruby was raised on a farm in Georgia, living there until she met and married Black.

The Blacks moved to California after their marriage, and during the Depression Calvin prospected for gold in northern California. In 1953 the Blacks bought land, sight unseen, near Yermo, California, intending to run a "mineral and rock shop" (a shop selling unusual rocks, pieces of mineral ore, and samples of semi-precious stones, still in an unpolished and crude state). Yermo is in the middle of the desert, adjacent to Highway 15 (running from Los Angeles to Las Vegas), and the shop drew little business.

ARTISTIC BACKGROUND
Cal began to carve dolls to put in front of the shop, hoping they would attract travelers and get them to stop in. The first dolls he made were a man and a woman and a dog representing a "rock hound"; soon the number of dolls expanded and Cal started to add movable dolls and merry-go-rounds. Eventually there were enough dolls for Cal to set up and operate the "Fantasy Doll Show," essentially a puppet theater with large animated dolls. (Black had built a windmill apparatus as a supplemental power source for the theater.) There Cal put his ventriloquist background (he could do nine different voices) to good use. The Blacks called their place Possum Trot (southern slang for the shortest distance between two points). As word of this unusual environment in the middle of the desert spread, Possum Trot became one of the most colorful tourist attractions and amusement stops around, with people going out of their way to pay a visit and see the show.

SUBJECTS AND SOURCES
Calvin Black used his experience as a puppeteer in creating Possum Trot. He was fascinated by Lillie Langtry, an actress at the turn of the century, and he made most of the female dolls to look as much like her as he could; others were made to look like friends and relatives.

Calvin made and operated the dolls, and Ruby costumed them. Cal played instruments and recorded his voice with accompaniments that could be heard on concealed speakers (some of the dolls had speakers in their heads) for the Fantasy Doll Show.

The dolls became almost real to the Blacks—perhaps a substitute for the family they never had. They would set cans near many of the dolls—those outside as well as those inside—so that customers could leave tips for their favorites. With the tips Black bought perfume and jewelry for the dolls.

MATERIALS AND TECHNIQUES
The dolls are simply carved and of jointed wood; their faces are painted and they are dressed with cloth. The Blacks used wigs, paint, amplifiers, all sorts of fabricated metal, old toys, and other found objects in creating their doll environment. The building housing the show was made of wood and tin.

There were fifty-seven dolls in all, ranging between 2 feet and 5 feet in height. Some dolls survived better than others—those outside suffered from the harsh desert winds that would rip and shred their clothes and roughen their paint with wind-blown sand.

ARTISTIC RECOGNITION
After Ruby's death in 1980, Possum Trot was dismantled and most of the dolls and furnishings were sold. The dolls are now in private or museum collections, but they have been exhibited in museums on both coasts, most recently at the Museum of American Folk Art in New York City (1989). Thus the simple and eloquent vision of Calvin and Ruby Black lives on in their "family" of dolls, which are

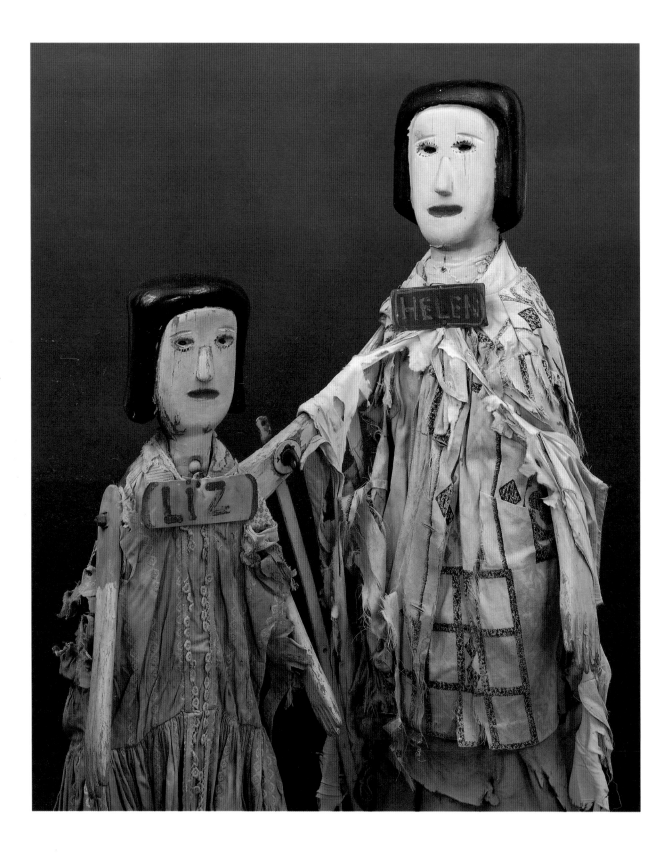

Calvin and Ruby Black, Possum Trot Figures: Helen and Liz, *c. 1955. Carved and painted redwood; Helen, 47 × 17 × 9 in.; Liz, 33 × 10 × 7 in. Museum of American Folk Art, New York; Gift of Elizabeth Ross Johnson. Although these representatives of the famous Possum Trot figures show the ravages of time and exposure, they still retain the simple and provocative charm endowed by their creators.*

now known to most people interested in environmental folk art, and through an excellent short documentary video, *Possum Trot.*[2]

MINNIE BLACK—*"I enjoy it. I like to please people and myself."*

BIOGRAPHICAL DATA
Born Minnie Lincks, February, 18, 1899, five miles north of London, Kentucky. Attended Annville Institute, Annville, Kentucky, for eight years; spent one year at Sue Bennett College (a training school for teachers), London, Kentucky. Married William Black, September 15, 1919; he died April 8, 1973. Three sons, one daughter. Now resides East Bernstadt, Kentucky.

GENERAL BACKGROUND
Minnie Black has made an art of turning ordinary gourds into unusual sculptures and musical instruments.

As a youngster, the eighth of twelve children, Minnie Black "always had plenty to eat and do" on the farm where her father raised the best grade of beef. Her education went as far as normal school but then she had "marryin' " on her mind.

"Being a teacher was the best job a girl could have," Black says of her early life. "I wanted to be a teacher but I married—so I couldn't." Black's husband, William, was a railway agent; he ran a depot for the Rockcastle Railroad, and when the depot closed, he opened a grocery store and gas station in East Bernstadt, Kentucky.

When William retired in the late 1960s, Minnie Black turned the white concrete-block grocery store into "Minnie Black's Gourd Craft Museum." She organized a senior citizens gourd band that plays gourd instruments of her making—mandolins, lutes, shakers, bells, drums, and kazoos. Her work was displayed at the World's Fair in Knoxville, Tennessee.

ARTISTIC BACKGROUND
Minnie Black claims that her work with gourds was strictly fortuitous: "In 1947 a stray gourd appeared alongside my driveway. I had a gourd garden," she says, "so I just started making things out of 'em."

Minnie Black's Gourd Craft Museum opened in the late 1960s and quickly attracted visitors interested in Appalachian crafts. Her art is also displayed at John Rice Irwin's Museum of Appalachia in Norris, Tennessee.

SUBJECTS AND SOURCES
Minnie Black turns her gourds into sculptures—people, dodo birds with chicken feet, prehistoric and fantastic animals, snakes, and occasionally the artist herself. "When I see a strange-looking animal in the papers or magazines, when I see a politician like Nixon, when I see TV characters, I can usually find that person or animal in the shape of a gourd and make it." She also uses *National Geographic* magazine as a source of ideas.

Minnie Black, Self-Portrait, *c. 1984. Ornamental gourds, paint, marbles, and wire, 16 in. high. Private collection. Only the hat and arms of this whimsical self-portrait suggest that it is made of home-grown gourds, the artist's unusual sculpting material.*

MATERIALS AND TECHNIQUES

Black picks her gourds from her garden, cuts them with a knife, and nails them together with fine nails. She then skins the gourd and dries it for months. She uses a commercial product, Sculptamold, to cover the joints and to add features.

Black keeps the natural color of the gourd, adding paint only to hide joints. She adds eyes that are used for stuffed animals and frozen chicken feet for her dodo birds. Her largest work stands 3 feet tall, but most are no higher than 15 inches. Black estimates that she has made about five hundred pieces.

The gourds are fragile, but Black advises that "if one is broken, it can be mended with glue and Sculptamold."

ARTISTIC RECOGNITION

Minnie Black's work straddles the thin line between craft and art. Her characterizations of people and her animals stand alone as artistic endeavors; her musical instruments are craft. She has sold very few of her works, preferring to keep her museum together. Although her work is well known among regional collectors, it has been included in only a few museum shows. Black, however, has gained some national attention—she has appeared on television on the Johnny Carson and the David Letterman shows.

"PROPHET" WILLIAM J. BLACKMON—*"God anointed me to be an artist so I could afford a place to sleep."*

BIOGRAPHICAL DATA

Born April 22, 1921, Albion (east of Battle Creek), Michigan. Attended school through eleventh grade, Albion High School. Married Betty Joe ("I can't remember her last name"), 1952; she died c. 1965. Married Bertha J. Jackson, c. 1968; separated c. 1976. One son, one daughter by Betty Joe; two sons, one daughter by Jackson. Now resides Milwaukee, Wisconsin.[1]

GENERAL BACKGROUND

William Blackmon is a black preacher who fills his lively and colorful paintings with spiritual messages about the difficulties encountered on the road to heaven.

In 1945 Blackmon said a prayer for a dying friend named Joel Jakes, and Jakes lived. Later he predicted that a man would find the thousand dollars he needed for a down payment on a house, and the man did. Thus the Reverend Blackmon became known as "Prophet" Blackmon to his friends and followers.

As a young man, Blackmon had served with the Eighty-fifth "Dump Truck" Battalion in New Guinea, Australia, and Japan during and immediately after the war (1943–1945). Mostly, he says, "I dug latrines." After his discharge, "I became a hitchhiking man of God," Blackmon explains. "For forty years I preached in Michigan, Illinois, and Indiana, sleeping on the streets."

Blackmon has lived off and on in Milwaukee, Wisconsin, since 1974. In that year he founded the "Revival Cen-

William J. Blackmon, Escape from Hell to Heaven No. 2, *1986. Paint on wood, 36 × 36 in. John and Diane Balsley. This colorful work exemplifies Blackmon's energetic paintings depicting the difficulties that may be encountered on the road to heaven.*

ter and Shoe Repair Shop," where he still lives, repairs shoes, preaches, and paints.

ARTISTIC BACKGROUND

"Prophet" Blackmon surrounded his Revival Center with printed signs advertising the nature of his ministry and his business of repairing shoes. One day in 1984, according to Blackmon, "a white lady stopped by and said 'they's beautiful, I want to buy some.' " This was all the encouragement Blackmon needed to begin painting seriously, and he soon began to move far beyond his signs. As his work became known locally, the Metropolitan Gallery in Milwaukee began to represent him.

SUBJECTS AND SOURCES

"All my painting is directed toward God and the spiritual," Blackmon declares. His paintings are highly charged pieces, filled with personal spiritual messages from the artist. Printed labels around the borders may announce "Escape from Hell to Heaven," and the work will often illustrate the dangers involved in following the difficult path between those two places.

Blackmon's colorful paintings have an animistic quality. They show bird's-eye views of people, as seen through houses, and the backgrounds often include barren trees, flowers of unrecognizable species, and colorful symbolic designs.

MATERIALS AND TECHNIQUES

Blackmon paints on any board he can find. Sometimes he cuts out leftover shoe leather and glues it to the board to cover imperfections. The artist also paints on Masonite when he can get it.

Blackmon has completed around one hundred major works and a fairly large number of printed signs. The paintings are usually about 20 by 30 inches in size, but one owned by the Milwaukee Art Museum is as large as 4 by 2½ feet.

ARTISTIC RECOGNITION

"Prophet" Blackmon's spiritual-message paintings are his best work, although the signs are also interesting. He is well known to folk art collectors in the Chicago-Milwaukee area, and his work is beginning to become known outside the Midwest. Blackmon's paintings were exhibited in 1988 at the Milwaukee Art Museum, where his paintings are also included in the permanent collection.

WILLIAM ALVIN BLAYNEY

BIOGRAPHICAL DATA

Born December 21, 1917, Claysville, Pennsylvania (near the West Virginia border). Attended school through eighth grade, Davidson School, New Field, Pennsylvania. Married Alice Bell, 1940; she died 1975. No children (Bell had a son by a prior marriage who lived with them). Died Thomas, Oklahoma, October 21, 1986.[1]

GENERAL BACKGROUND

William Blayney was a religious visionary who created colorful and dramatic paintings to convey his spiritual messages.

According to Blayney's brother, Charles, their father was very strict with the boys and brought them up as "proper Methodists," a rigid upbringing that undoubtedly influenced Blayney later in life. The family moved to Pittsburgh when Blayney was twelve years old. He left school after the eighth grade and began working in garages, becoming a very good auto mechanic.

During World War II, Blayney served in the armed forces and received a partial disability discharge after being

William Alvin Blayney, Revelation of the Holy Bible, *1960s. House paint on Masonite, 22 × 34 in. Chuck and Jan Rosenak. In this dramatic and vivid presentation of his religious visions, Blayney presents a complex biblical chronology as well as a copyright warning.*

wounded in Europe. After the war he and his wife returned to the Pittsburgh area and moved into a small house in Sandy Creek, sixteen miles east of the city. There they ran a garage and repair shop known as Blayney's Auto Repair.

In the late 1950s Blayney's strict religious background resurfaced. He became increasingly interested in studying the Bible and attended Bible meetings conducted by local TV evangelist Kathryn Kuhlman. (He painted at least one portrait of her.)

In 1966 Blayney had a quarrel with his wife, packed his tools into the trunk of his car, and drove to Thomas, Oklahoma, never to return to Pittsburgh and his family. In Oklahoma Blayney was ordained a Pentecostal minister and supported himself as a bulldozer operator. He maintained two small house trailers, living in one and using the other for a studio.

ARTISTIC BACKGROUND
Blayney suddenly started to paint in 1957, at the same time that he became immersed in the Bible. He felt he had a mission to preach and called upon the symbols of popular evangelism plus his imagination to tell his story, both verbally and through his painting.

Blayney never attempted to sell his art, but his work came to the attention of David T. Owsley, a curator at the Museum of Art, Carnegie Institute, Pittsburgh, who first saw one of Blayney's paintings at a flea market. Impressed by what he saw, Owsley wrote an article on Blayney for the *Carnegie Magazine* in 1980; he also arranged for a showing of the artist's work.[2]

When Blayney died in 1986, he left a trailer full of paintings—some finished, some unfinished—to his brother.

SUBJECTS AND SOURCES
Blayney's colorful and dramatic paintings express his concern with the spiritual and moral decay in the world. He had a simplistic view of the world and the Bible and typically used the scriptures, both the Old and the New Testaments, as well as popular imagery to support his Pentecostal teachings. In his paintings Blayney expressed his views with fervor and originality.[3]

The artist created a colorful and personalized vocabulary of symbols and cryptic messages to illustrate his apocalyptic visions. Heaven and hell, spiritual messages and worldly thoughts, angels and devils, as well as strange and fantastic multiheaded animals and tormented souls populate his paintings. In addition, Blayney often included puzzling phrases, numerical notations, or biblical quotes to help convey his message to the viewer.

MATERIALS AND TECHNIQUES
Blayney painted on canvas and Masonite with oil paints, using rich and exciting colors. Sometimes the painted area extends into frames that he attached to the paintings, as though he could not contain himself and his thoughts within the limits of the canvas. Blayney also occasionally mixed sand into his pigments so that he could build up the written messages that he used to augment his visual messages.

Most of his works are about 20 by 30 inches, some slightly larger. The artist probably finished fewer than one hundred paintings in all.

ARTISTIC RECOGNITION
Blayney's art can be characterized as the work of a religious visionary, and although it has not been seen by a wide audience, the reputation of the artist is growing. Blayney was first exhibited at the Museum of Art, Carnegie Institution, in Pittsburgh in 1980; since then his work has been included in a number of other shows, such as "Transmitters: The Isolate Artist in America" at the Philadelphia College of Art in 1981.

GEORGIA BLIZZARD—*"I feel the need to do it [make sculptures out of clay]. It's all I have left."*

BIOGRAPHICAL DATA
Born May 17, 1919, Saltville, Virginia. Attended school through eighth grade, Glade Springs School, Glade Springs, Virginia. Married Willard Michael, January 29, 1940; he died 1954. One daughter. Now resides outside Glade Springs, Virginia.[1]

GENERAL BACKGROUND
Georgia Blizzard, a folk potter of Apache heritage, makes expressive portrait pots that are sometimes self-portraits and sometimes people she knows.

During the Depression, Blizzard quit school at the age of sixteen to work for the National Youth Administration preparing hot lunches for underprivileged school children. During World War II, she had a job at a munitions factory in Bristol, Virginia. She finished her working career about 1965 in a plant operated by Burlington Mills at Chilhowie, Virginia.

ARTISTIC BACKGROUND
Georgia Blizzard works in clay. "Been doing it since I was eight," she says. "Didn't know it was art." As a child she and her older sister, May, played on the banks of Plum Creek making clay toys fired in the sun. When Blizzard was older, her father, an Arizona Apache Indian, taught her traditional Native American firing techniques. "I just never stopped playing with clay," she says.

When the Burlington Mill in which she was working closed, Blizzard started making and selling clay objects to earn extra money. Her daughter, Mary, opened a little concrete-block shop, only 12 feet by 12 feet, alongside Route 609 to show and sell the pieces, and soon tourists and collectors were detouring off the nearby major highway just to buy her pottery.

Judith Alexander, a folk art dealer in Atlanta, Georgia, recognized the quality and appeal of Blizzard's work and began to represent her. She also suggested that the potter use her maiden name on her work.

SUBJECTS AND SOURCES
Blizzard makes face pots (not to be confused with southern

grotesque face jugs) that are self-portraits or portraits of people she has known. She also models bas-relief plaques of animals and people, often with themes of good and evil or salvation and damnation. Blizzard prides herself on being able to "bring out the natural color of the clay," the browns and grays. She expresses her moods in clay: happiness or sorrow is shown in clay faces that weep or smile.

MATERIALS AND TECHNIQUES
The clay comes from a creek behind Blizzard's house. She forms it by hand into the desired shape, smoothes it with a piece of plastic, fires it in an electric kiln (the gift of Emory and Henry College), and refires it in her "coal kiln." "The electric kiln," she explains, "prevents breakage, the refiring brings out the color."

Blizzard has made more than a thousand works in clay. The tallest is about 17 inches high.

ARTISTIC RECOGNITION
Georgia Blizzard is one of the most innovative folk potters working on the East Coast today. Most folk potters do

Georgia Blizzard, Fading Harlot, 1986. Fired clay and slip, 12 × 7 × 5 in. The Tartt Collection, Washington, D.C. Blizzard's pottery often keenly expresses the artist's personal vision, here conveying a sensual message along with a feeling of desperation and pathos.

not attempt portraits in clay, but she has shown her ability to capture moods and express her personal vision through this medium.

Blizzard is becoming well known; one of her bas-relief plaques was recently purchased by the Chase Manhattan Bank in New York City, and her work is in the permanent collection of the High Museum of Art in Atlanta.

ANDREW BLOCK

BIOGRAPHICAL DATA
Born December 31, 1879, Aalborg, Denmark. Education unknown. Married Karen (last name unknown); marriage date and her death date unknown. One son, one daughter. Died December 2, 1969, Solvang (northwest of Santa Barbara), California.[1]

GENERAL BACKGROUND
Andrew Block, who became known for his vivid paintings of a broad range of themes, came to the United States in 1914, going first to Wisconsin but soon moving to Solvang, California, where there was a small community of Danish immigrants. Block had learned blacksmithing in Denmark and took up that trade in Solvang, working as a smithy until he retired in the 1940s.

Block had a "lovely home" in the central part of Solvang and an "extraordinary garden," but he was somewhat reclusive and was rarely seen on the streets of the town in his later years. On the few occasions when he did appear, he would always be in his best clothes, wearing a hat, and invariably had a cigar in his mouth. He was known to his few friends as "Old Man Block."

Block died three weeks short of his ninetieth birthday.

ARTISTIC BACKGROUND
Andrew Block started to paint around the age of seventy-five and painted with a passion, night and day, until shortly before his death. He was befriended by Marshall Thomas, a painter/gallery owner in Solvang, who encouraged the artist in his work and helped to arrange for exhibitions of his paintings.

SUBJECTS AND SOURCES
Block documented the life of the Danish community in Solvang and drew upon remembered scenes from Denmark in many of his works, but his interests were far-ranging and he did not limit himself to that which he himself had seen. Almost every subject appealed to the artist, and his work reflects this catholicism: he painted fanciful illustrations of biblical and literary subjects (Belshazzar's Feast and Johnny Appleseed), tackled historical personages (from Sam Houston to Garibaldi) and events (Valley Forge), and depicted ships plying the familiar waters off California. He even took some of his ideas from illustrations in National Geographic.

MATERIALS AND TECHNIQUES
Block had a vivid imagination and a strong sense of color

Andrew Block, Golden Gate Bridge, *c. 1960. Oil on cardboard, 14½ × 30 in. Marshall Thomas. As his colorful body of work suggests, almost every subject appealed to this somewhat reclusive artist, including ships and California's famous bridge.*

and design. He painted on corrugated cardboard, which he acquired from boxes or storage containers discarded by local merchants. He gessoed the cardboard, then painted on it with oil or house paints. He often painted on both sides of the cardboard, but the work was usually not related either in subject matter or date.

There are about five hundred known paintings by this artist; he painted rapidly, averaging almost a painting a week. They vary in size, the largest being about 25 by 45 inches.

ARTISTIC RECOGNITION
Andrew Block is considered to be among the most original of the West Coast folk artists and he is highly regarded for his major themes. His paintings have been exhibited in galleries and museums on both coasts, and in 1989 the Elverhoy Museum in Solvang, California, recognized his unique contribution to art and to the town itself in an individual show of his work.

PETER "CHARLIE" BOCHERO (BESHARO)—*"I always thought Besharo was ahead of his time." (Dr. H. C. Fraley, the artist's doctor)*

BIOGRAPHICAL DATA
Born Peter Attie Besharo, July 14, 1898, Syria, possibly Kafargzina. Little formal education. Single. No known children. Died June 5, 1960, Kittanning, Pennsylvania.[1]

GENERAL BACKGROUND
Peter "Charlie" Besharo, a painter of fanciful space odysseys that are mixed with personal religious symbolism, was recognized as an important folk painter only after his death. Although the artist's work has been known and written about under the name of "Peter Charlie Bochero,"[2] it has been recently discovered that the artist's last name is Besharo. More accurate information about his life has also been revealed.

Besharo immigrated to rural Pennsylvania from Syria early in the century.[3] There is little information available about his first years in America, but by 1913 he is known to have been peddling dry goods at mining camps within 50 miles of Leechburg, Pennsylvania, and by 1923 he was a full-time resident there. He rented a garage near a Chinese laundry in Diamond Alley and supported himself as a house and sign painter. A local resident remembers that his signs "always included misspelled words."

The artist lived in rented rooms at the Penn-Lee Hotel and frequented Tony's Lunch restaurant. Some residents recall that he spent evenings there, calculating on butcher paper the distance to the moon and the date that the world would run out of oxygen.

ARTISTIC BACKGROUND
Most local residents did not know that Besharo created extraordinary visionary paintings, nor is any information available on when he started to paint. It was not until after his death that his work was found. Approximately seventy paintings reached the Phyllis Kind Gallery in Chicago, and this gallery was responsible for exhibiting Besharo's amazing visionary paintings.

SUBJECTS AND SOURCES
In his unusual works the artist expressed his subconscious concerns about religion, alien invasion, and space travel. His paintings reflect a variety of sources of inspiration—

illustrations from *Buck Rogers*, traditional Far Eastern motifs, religious iconography, scenes from American history, and Egyptian mythology. Besharo also developed a system of signs, symbols, and words that he sometimes used in his paintings, and, unfortunately, they are not always understandable.

MATERIALS AND TECHNIQUES
Besharo painted with oil-base paints on canvas and poster board. Sometimes he mixed in sand to add texture to his work.

There appear to be fewer than one hundred works by Besharo extant. For the most part, the paintings are about 24 by 36 inches in size.

ARTISTIC RECOGNITION
Besharo's fantasy world, inhabited by space adventurers and mythological beings, is also replete with religious and mythical symbolism. He had a superb sense of color and design, and those elements combined with his visionary world, have long intrigued folk art audiences.

Under the name of "Bochero" this artist's work was

Peter Bochero (Besharo), Untitled, *1950s. House enamel on canvas, 31¼ × 25 in. Robert Bishop. Besharo often combined religious iconography with space-age elements, producing this mystical painting whose vitality is clear but whose meaning is obscure.*

included in "Transmitters: The Isolate Artist in America" at the Philadelphia College of Art in 1981, and in "Muffled Voices: Folk Artists in Contemporary America" at the Museum of American Folk Art in New York City in 1986. It is also in the collections of the Milwaukee Art Museum and the Smithsonian Institution's National Museum of American Art, as well as in many private collections.

REVEREND MACEPTAW ("REV. MAC") BOGUN—*"In the lonely hours, the angels speak through me."*

BIOGRAPHICAL DATA
Born October 26, 1917, New York City. Graduated from the High School of Commerce (no longer in existence), New York City. Married Rose Ruiz, June 12, 1950. One son. Now resides the Bronx, New York City.

GENERAL BACKGROUND
"Rev. Mac" Bogun is a self-taught painter whose work is guided by "the angels," as he likes to say.

The son of Polish immigrants, Bogun joined the army after he completed high school in 1941 and was sent to guard bauxite mines in South America. Upon his return to New York in 1945, he worked briefly on construction jobs. In 1950 he went to work for the New York City Transit Authority as a typist, later becoming a computer operator, and remained with the Transit Authority until his retirement in 1983.

Bogun was ordained as a minister in the Temple of Light Church in 1951 and later carried on his ministry in the Saint Andrews Spiritual Church. Neither church exists today.

ARTISTIC BACKGROUND
Bogun visited the first New York City Transit Authority Art Show in 1967 and said to himself, "They paint like Picasso. I can do better. 'God,' I said, 'send me an angel for guidance,' and the angel came." Thus, with the guidance of the angels, Bogun started painting in 1967.

About 1970 the New York collector Herbert Waide Hemphill, Jr., spied Bogun's work at the annual Transit Authority Art Show and immediately arranged to have it exhibited that same year at the Museum of American Folk Art in New York City.

Unfortunately, Bogun only paints when "the impulse is there," and at the present time the impulse lies dormant. He has not painted since 1986.

SUBJECTS AND SOURCES
Bogun paints self-portraits, landscapes, portraits of friends, and pictures of heroic Transit Authority police, sometimes using photographs for guidance. Bogun believes in heroes, and the heroes he chooses to depict are men of God who belong to obscure religious orders and wear medals and other insignia to show their rank and standing. The men in blue who guard the New York transit system also wear their badges proudly.

Reverend Maceptaw Bogun. OPPOSITE: Self Portrait, *c. 1972. Oil on canvas, 30 × 24 in. Museum of American Folk Art, New York; Gift of Herbert Waide Hemphill, Jr.* ABOVE: The Falls, *c. 1967. Oil on canvas, 23½ × 29½ in. National Museum of American Art, Smithsonian Institution, Washington, D.C.; Gift of Herbert Waide Hemphill, Jr., and Museum Purchase made possible by Ralph Cross Johnson. "Rev. Mac" Bogun refers to his work as "spiritual art" and says that when he paints the "angels guide my hand." His inspirations lead him to paint portraits—opposite, one of himself in clerical garb—as well as more delicate and contemplative landscapes (above).*

This artist has little concern for perspective, but he does want to get the details right. When he paints, "I use God power," he says, "God and the angels guide my hand." He refers to his work as spiritual art.

MATERIALS AND TECHNIQUES
Bogun draws on canvas with charcoal and then fills in with oil paints. Occasionally he has used luminous paint for a special effect. "When you turn out the lights," he says, "you see the moon."

Bogun has painted fifteen works; most are around 24 by 30 inches. He signs his paintings "Rev. Mac," usually with a date.

ARTISTIC RECOGNITION
Although Bogun's output has been small—of the fifteen paintings he has done, only five are in private or public hands—he is an important artist, well known through reproductions of his work. His portraits are forceful and intriguing; his somewhat allegorical landscapes less so. His work is included in the permanent collections of the Museum of American Folk Art in New York City and in the Smithsonian Institution's National Museum of American Art in Washington, D.C.

MILTON WALLACE BOND—
"Recognition and success—it should have happened forty years ago—but better late than never.
I am the last man who owned a commercial sailing boat on Long Island Sound."

BIOGRAPHICAL DATA
Born March 5, 1918, Bridgeport, Connecticut. Graduated from Harding High School, Bridgeport. Married Martha Doris Olsen, December 2, 1951. Two sons, one daughter. Now resides Stratford, Connecticut.

GENERAL BACKGROUND
Milton Wallace Bond is one of the few folk artists today working in the genre of reverse painting on glass. He is also one of a vanishing breed of proud New England seafarers. His famous ancestor, Sir William Bond, owned the shipyard that built the British flagship *Great Harry* in the 1500s.

Bond and his father owned a 40-foot oyster sailboat, the *Dorothy G,* and fished commercially until the father died in 1950 and the *Dorothy G* was sold. Bond then went to work as a tool grinder for Remington Arms Munitions in Bridgeport, Connecticut. He hated the work and took early retirement in 1968.

For many years Bond maintained a studio in Bridgeport, but he abandoned it because "the neighborhood got too tough." Today he works at his home in Stratford, relying on his small pension and the income he makes as an artist.

ARTISTIC BACKGROUND
At about the time of his retirement, Bond's sister, Mildred Foster, took an art course from Hazel Morrison in Bethel, Connecticut, which included reverse painting on glass. Her attempts intrigued Bond, who decided to try his hand at it.

Bond gave his first efforts to friends. Then, in April of 1976, he entered his paintings in the Dogwood Festival in Greenfield, Connecticut. A publisher of educational books, Maurice Thompson ordered 119 paintings from the artist to be given as favors at a Christmas party he was throwing for a well-known New York politician, and Bond's new career was under way.

SUBJECTS AND SOURCES
Bond portrays his love for the sea in many of his paintings; turn-of-the-century ships under sail, ships under steam power, and their ports of call are favorite topics, but he also paints nostalgic city scenes as well. He meticulously captures every detail, from the ropes and yardarms on the ships to the spokes of wagons on city streets. Bond augments his memories by referring to old prints, paintings, and photographs for their "historic value."

MATERIALS AND TECHNIQUES
Bond is one of the few American folk painters of this century who paints on the reverse side of glass. Although the art form was popular in this country in the first half of the nineteenth century, it is now more common in Europe

Milton Wallace Bond, Flat Iron Building 1910, *1985.*
Reverse painting on glass, 10 × 12 in. Jay Johnson
America's Folk Heritage Gallery, New York. Painting on
the reverse side of glass with meticulous detail, Bond often
depicts maritime subjects or, as in this example, charming
cityscapes of a bygone era.

(especially Yugoslavia) and has become almost a lost art in the United States.

Bond uses clear glass and oil paint. He sometimes glues small pieces of mother-of-pearl to the back of the glass so that the windows of his houses will shine in reflected light. His work started out very small, but recently he has been using a larger format "because the larger paintings sell better." Some of his works are as large as 30 by 40 inches.

Bond has finished more than one thousand reverse-glass paintings.

ARTISTIC RECOGNITION
Bond has perfected his technique. Because contemporary reverse painting on glass is rare in this country, there are few collectors specializing in the genre. There are, however, many people interested in marine subject matter, and Bond has gained a certain amount of attention for his topics.

For his work Bond has won a silver medal (in 1983) and a bronze medal (in 1984) at the Swiss International Folk Art Exhibition in Morges, Switzerland.

MARY BORKOWSKI—*"I was brought up*
Protestant, married Catholic, so I'm both. And the ideas keep
coming, I can't quit."

BIOGRAPHICAL DATA
Born Mary Catherine Porter, March 28, 1916, Sulphur Lick Springs (near Chillicothe), Ohio. Graduated from Stiver High School, Dayton, Ohio. Married Wallace Borkowski, June 23, 1936; he died 1958. No children. Now resides Dayton, Ohio.

GENERAL BACKGROUND
Mary Borkowski is a fiber artist who tells stories through her intricate "thread paintings," a technique that she developed.

When she was ten years old, Borkowski's family moved from the summer resort community of Sulphur Lick Springs to Dayton, Ohio. She married into a family who owned three bars in Polish Catholic neighborhoods in Dayton, and her husband insisted that she work as a waitress in one of them.

"I couldn't stand it," she says, "all that jiggling up and down, dancing the polka. And my mother-in-law counting her money in Polish every morning at 3 A.M. so I wouldn't know how much she took in." After the death of her husband in 1958, Borkowski retired.

ARTISTIC BACKGROUND
Mary Borkowski learned how to sew from her mother and

grandmother, but her creations in thread are all of her own design. In 1952 she entered a quilt in the Ohio State Fair and won the grand prize; she repeated her success in 1955, and from then on her quilts were hung in a special exhibition area at the fair and not entered in the competition.

In 1965 Borkowski realized that the center portion of her quilts, which usually told a story, could be lifted out and framed as a piece on its own. She then began to make what she called "thread paintings"—pieces that tell stories important to her.

In 1978, when her health was poor, Borkowski took up painting in acrylics. Although she threatens to quit sewing every few years, she still continues, despite arthritis and cataracts.

SUBJECTS AND SOURCES
"When my mother and grandmother taught me to sew in the early 1950s, I immediately rejected their patterns. My mind was full of stories, and I said to myself, 'I can do more than copy. I will tell stories with needle and thread.'" Borkowski's stories tell of her joys, her fears, and her personal tragedies, as well as those of others. She says that expressing some of these stories through her needle helps to relieve her of the excess of emotion she may have felt about certain events in her life.

MATERIALS AND TECHNIQUES
Mary Borkowski uses the finest materials available for her

Mary Borkowski, Trapped, *1968. Cotton and silk thread*
on polyester, 26¾ × 32½ in. Museum of American Folk
Art, New York; Gift of Jacqueline L. Fowler. In her
beautifully stitched thread paintings, Mary Borkowski tells
real-life stories, some tragic, some joyful, some with wry
commentary on human foibles.

work; often her "thread paintings" are composed of silk threads or yarns on silk fabric. These low-relief "paintings" are not embroidery but Borkowski's own technique. She builds up yarn from a bare canvas and then frames the pieces in shadow boxes. The quilting is done in the conventional way, on a stretcher. Borkowski works slowly, and everything she touches displays her care and mastery of her chosen craft.

Borkowski's paintings are done on canvas and Masonite with acrylics. To date, she has made about fifty quilts, one hundred thread paintings, and seventy-two acrylic paintings. These objects range in size from thread paintings that are about 30 inches high to a quilt covering large enough for a double bed.

ARTISTIC RECOGNITION

Although her acrylics are interesting, Mary Borkowski's real medium is cloth. Some of her quilts and thread paintings have a mysterious, almost surreal quality, and these may be her most important works. Borkowski is recognized as a major talent in thread and fiber art, and she has sold patterns to *McCall's* magazine and other magazines such as *Needle and Thread* and *Needlecraft*. The artist has been included in numerous exhibitions, such as the Museum of American Folk Art's "The Woman Folk Artist in America" in 1979 and "New Traditions/Non-Traditions: Contemporary Folk Art in Ohio," organized by the Columbus Museum of Art and the Ohio Arts Council in 1989.

Borkowski notes that, to celebrate President Nixon's election in 1968, she sent him a thread painting entitled *My Country*. "When Watergate hit the TV, I asked for it back," she says, "but they wouldn't return it—it's in the Nixon Library."

EMILE BRANCHARD—*"Any damn fool can do it—here are the paints and brushes."*[1]

BIOGRAPHICAL DATA

Born 1881, New York City. Educated by French nuns. Married five times; his fifth wife was called Bonnie, but nothing is known about the others. No known children. Died February, 1938.[2]

GENERAL BACKGROUND

Emile Branchard, a painter known for his stark and dramatic landscapes, was born to French parents and received some basic education from a group of French nuns in New York City. His mother ran a rooming house for artists known as the "House of Genius."

Branchard worked at odd jobs as he grew up—as a stevedore, as a truck driver, and, during World War I, as a policeman on the Home Defense Force. While patrolling the New York waterfront, Branchard contracted tuberculosis and was forced to resign from his job in 1918; the illness ended his formal working career.

ARTISTIC BACKGROUND

Although Branchard grew up in a family circle that included a great many artists, he never received any formal training. He started to paint only in 1918, during his confinement for tuberculosis, but quickly adopted art as a way of life.

Branchard was first exhibited by the Society of Independent Artists in New York in 1919. Subsequently, his work was shown regularly at Gallery Stephen Bourgeois.

SUBJECTS AND SOURCES

Branchard's best-known works are his landscapes. He painted stark, often snow-covered scenes in muted colors, with trees sharply silhouetted against the earth and sky, each branch and trunk painted in particular detail. This work is said to have come from the artist's memory of some time spent in Connecticut.

Although he seemed to prefer to paint nature, even at secondhand, Branchard also painted some portraits and family scenes; they tend to be quite somber in tone and mood.

MATERIALS AND TECHNIQUES

The artist painted with oils on canvas; he worked standing at an easel, perhaps emulating the style of the trained painters he had seen while growing up in the boarding house.

The paintings range from about 16 by 20 inches to 28 by 20 inches. Branchard's total output is unknown but thought to be small.

ARTISTIC RECOGNITION

Emile Branchard produced some of the most dramatic paintings of any untrained artist during the middle third of the century. He was included in the Museum of Modern Art's 1938 exhibition "Masters of Popular Painting," and his work is still highly regarded by scholars in the field of twentieth-century folk art.

BRUCE BRICE—*"Some people read. Some people write. I paint!"*

Emile Branchard, Trees and Rocks, *n.d. Oil on canvas, 20 × 28 in. Richard and Suzanne Barancik. This somber landscape (opposite), emphasizing stark and dramatic elements of nature, typifies the work of this artist.*

BIOGRAPHICAL DATA

Born May 4, 1942, New Orleans, Louisiana. Graduated 1960 from Joseph S. Clark High School, New Orleans, Louisiana. Married Mildred Mary Butler, 1961; divorced 1972. Married Jacqueline Sabie, 1976. Two daughters, one son by Butler; one son, two daughters by Sabie. Now resides New Orleans, Louisiana.

GENERAL BACKGROUND

Bruce Brice is a black artist whose colorful paintings emphasize the black experience and culture of his native city.

Brice started out, at the age of ten, as a puppeteer. He rented space from the housing project on the edge of the French Quarter where he lived, made the marionettes, sold cookies, and ran the shows. A few years later his act was appearing on a weekly TV show (Channel 6) in New Orleans.

After completing high school, Brice worked for the Blue Plate Coffee Company (1961–1963) the Bernard Lumber Yard (1964), and for a well-known New Orleans art dealer as a picture framer (1964–1969). It was during this last job that he decided to venture into the field of painting himself.

ARTISTIC BACKGROUND

Jackson Square in New Orleans's French Quarter is an ongoing outdoor art show and sale. Tourists, collectors, and art critics from all over the world circumnavigate the

Bruce Brice, Mardi Gras in New Orleans, *1978. Silkscreen, 16 × 20 in. Edward G. and Jacqueline M. Atkins. Brice's colorful Mardi Gras scene depicts the days when parades still twisted through the narrow streets of the French Quarter and flambeaux bearers (men who carried kerosene torches that are now outlawed) provided sparkling illumination.*

fence surrounding the square to see what the numerous artists who work there are doing and what new works are hanging on the fence. In 1969 Brice got a permit from the city to sell art in the square, and the bright and colorful New Orleans scenes that he started to exhibit were an immediate success. He has been able to support himself from his artistic efforts and now maintains a studio/gallery just outside the French Quarter.

SUBJECTS AND SOURCES

Bruce Brice believes that he was born to capture the spirit of the city of New Orleans in paint. "My theme," the artist says, "is New Orleans—its jazz funerals, Mardi Gras, architecture, street scenes." He has done a few paintings of other subjects, such as self-portraits and religious scenes, but he always returns to his favorite theme.

MATERIALS AND TECHNIQUES

Brice paints with acrylics on canvas or Masonite. "In this humid climate," he says, "acrylics dry faster." He also works in oil paints and occasionally in watercolor.

Brice has painted about 1,500 works, ranging in size from 8 by 10 inches to wall murals (four of them) that measure approximately 12 by 24 feet.

ARTISTIC RECOGNITION

Brice's bright and lively work is decorative as well as documentary, with an underlying sense of humor. He is well known to collectors, most of whom prefer his familiar New Orleans scenes, events, and personalities to his portraits or religious scenes. Brice's work was exhibited at the Museum of American Folk Art in New York City in 1973 along with the work of two other southern black folk artists, Sister Gertrude Morgan (see page 219) and Clementine Hunter (see page 160).

FRANK BRITO—*Corinne Brito says of her husband, "He almost cries every time a santo is sold."*

BIOGRAPHICAL DATA

Born January 10, 1922, Albuquerque, New Mexico. Attended school until fifth grade, St. Francis School, Santa Fe, New Mexico. Married Corinne Cortez, 1944. One son, one daughter. Now resides Santa Fe, New Mexico.

GENERAL BACKGROUND

Frank Brito, a well-known contemporary carver, is an excellent representative of the evolving *santero* tradition in the Southwest today.[1]

As a boy, Brito quit school to help his family by cutting grass, selling papers, and doing yard work. When he grew older, he worked as a laborer for McKee contractors, for the California Gas Company, for Escodero Construction as a plasterer, and finally for a plumbing company from 1950 until he retired in 1970.

Brito now receives Social Security payments, but he also makes a good living as a *santero*.

ARTISTIC BACKGROUND

"Carving *santos* is something I have to do," Frank Brito declares. He started to carve when he was only thirteen but did not really develop his technique until 1965, when he had to take a month off from his job because of surgery. His early work was given away.

In 1967 Brito began participating in Spanish Market,

Frank Brito, Saint Patrick, *c. 1976. Watercolor on cottonwood, 13½ × 4 × 4½ in. Chuck and Jan Rosenak. Not bound by long-standing conventions, this santero, known for his innovative style, often chooses to depict saints, like the Saint Patrick seen here, that are rarely found in New Mexico churches.*

held each year in July on the plaza in Santa Fe. "Galleries and collectors from all over started placing orders," Brito says, "From then on, I could sell everything I made." Since 1985 he has found himself too busy to exhibit in the Spanish Market.

Brito's son, Frank Brito, Jr., is also a *santero*.

SUBJECTS AND SOURCES

Brito carves the traditional *bultos* (carvings in the round of religious figures) of the Southwest, but he also makes saints that are not traditional, like Saint Patrick. Brito is innovative within the Hispanic tradition; he adds details to his carving from his own personal vision. Around the middle 1980s the artist moved beyond carving only religious figures and added animals—coyotes, rabbits, roosters, and cats—to his repertoire.

MATERIALS AND TECHNIQUES

Using aspen and pine and carving with a pocketknife, he coats the finished pieces with gesso made from a mixture of plaster, flour, and water and then paints them. Until 1985 the artist made his own paint from roots and berries, but now he buys watercolors and paint so he can "move along faster."

Brito estimates that he has made as many as 1,500 saints and animals, ranging in size from a few inches to 2 feet high.

ARTISTIC RECOGNITION

Frank Brito is among the most popular contemporary *santeros*. In 1987, when Pope John Paul visited Salinas, California, he was presented with a San Ysidro (a figure plowing with oxen) made by Brito.

Brito's early saints, painted with homemade paint (before about 1983), are his best and most innovative. His work appeared in "Ape to Zebra," sponsored by the Museum of American Folk Art in New York City in 1985, and that show spurred interest in his animal figures.

RICHARD BURNSIDE—*"I have seen many faces in my dreams, but now they seem to be coming out of the walls."*

BIOGRAPHICAL DATA

Born November 29, 1944, Baltimore, Maryland. Attended Sterling High School, Greenville, South Carolina (received GED while in the service). Married Maggie Holiday, November 26, 1966; divorced 1969. Married Mary Givens, 1974; divorced 1976. Two daughters by Holiday; one son, one daughter by Givens. Now resides Pendleton (southeast of Greenville), South Carolina.

GENERAL BACKGROUND

After years of working as a clerk in stores and as a chef, Richard Burnside today supports himself at doing what he likes best—painting.

For seven years Burnside worked at an S&H Green

Stamp store in Greenville, South Carolina. Then, in 1974 he enlisted in the army, but to his disappointment the army did not send him overseas.

After his discharge in 1978, Burnside got a job as a chef in a restaurant in Charlotte, North Carolina, and worked there until 1982. In 1983 he moved to Pendleton, South Carolina.

ARTISTIC BACKGROUND

Richard Burnside started painting around 1980, while he was employed as a chef, and quickly realized that he had found his métier. Others realized it too, and soon he was selling his work. He notes that he likes to take commissions: "An artist has to paint what people want," he explains.

Burnside is represented by the American Primitive Gallery in New York City and the Tartt Gallery in Washington, D.C.

SUBJECTS AND SOURCES

Sometimes Richard Burnside paints animals—usually lions and tigers—but he continually returns to a round, flat face, often with long white hair, as the major subject in his paintings. The face appears in many colors and against many different backgrounds; he surrounds his faces (there may be more than one in a picture) with personal symbols that he calls the "Roman Alphabet." The symbols appear in the form of snakes, spiders, and other small animals, reminiscent of figures seen in Navajo sand paintings. The faces surrounded by the Roman Alphabets are Burnside's trademark.

Burnside says he is painting stories of "ancient queens, kings, and Indians." These paintings are allegorical stories

Richard Burnside, King and His Two Wives, *1988. Oil on cardboard, 25 × 31 in. Tartt Gallery, Washington, D.C. This painting typifies Burnside's flat, billboardlike style, replete with personal symbols that may not be clear to the viewer.*

meant to illustrate the life experience in contemporary black culture.

MATERIALS AND TECHNIQUES
The artist has painted on gourds, cardboard, and scraps of metal, but his usual material is plywood. He gives the board two coats of enamel, then outlines his subject with a felt marker and fills in the lines with contrasting colors. The work is then left outside for a few days to give it a weathered look.

Burnside does most of his work outside on a table at his sister's home in Pendleton, South Carolina. The usual size of his paintings is 30 by 30 inches, but he has made larger commissioned works. The artist estimates that he has completed about three hundred paintings on plywood to date.

ARTISTIC RECOGNITION
Richard Burnside's work is the epitome of the "new breed" of southern black folk art. It is contemporary in feeling, colorful, and filled with symbolism that can arguably be called African or Afro-American. He was included in "Outside the Main Stream," an exhibit at the High Museum of Art, Atlanta, Georgia, in 1988, and he is beginning to be included in a number of private collections.

BRUCE BURRIS—*"I need to tell the story of the people living in the Tenderloin."*

BIOGRAPHICAL DATA
Born December 9, 1955, Wilmington, Delaware. Graduated from Alexis I. DuPont High School, Wilmington, Delaware, 1973. Single. No children. Now resides San Francisco, California.[1]

GENERAL BACKGROUND
Bruce Burris expresses his social consciousness through his vividly colored, graffitilike paintings.

When he graduated from high school, Burris tried a series of different jobs. He drove taxicabs, and worked in halfway houses and at the Delaware State Hospital. In 1976 he moved to San Francisco, California, where he has been working with Vietnamese children at the Phoenix Youth Project in the Tenderloin District of that city.

ARTISTIC BACKGROUND
Although he drew as a child, Bruce Burris thought that "adults didn't make art." He changed his mind while employed by the Delaware State Hospital in the 1970s. As he remembers, "A convicted murderer, ninety years old, was compulsively drawing three images every day—guns, whisky bottles, and knives—in different configurations. 'Wow,' I thought, 'this is art.'" Observing the work of this inmate inspired Burris to try his own hand at painting.

Janet Fleisher, the Philadelphia art gallery owner, discovered Burris and gave him one-person shows in her gallery from 1982 to 1984. His work has also been shown at the Braunstein/Quay Gallery in San Francisco (1985–1990).

SUBJECTS AND SOURCES
"My subjects," the artist says, "are people that nobody wants to know about, who have nothing and expect nothing." Bruce Burris expresses his social consciousness through a contemporary graffitilike style. He uses symbols of the underground drug culture—death heads, mermaids, and flowers—in repetition in his work. The paintings are flat, but unlike graffiti they are composed of fine lines and dots presented in extraordinary detail. His work may also contain printed messages.

Burris also enjoys making small objects such as people, cars, and trucks out of tin. He decorates these by punching holes in the material.

MATERIALS AND TECHNIQUES
At first Burris painted on old boards, but currently he is painting on canvas with acrylics "directly out of the tube." His cutouts are made from tin sheets and used tin cans.

The artist estimates that he has completed three hundred major pieces, ranging from as small as 6 by 12 inches to as large as 5 by 4 feet.

ARTISTIC RECOGNITION
Bruce Burris communicates his concerns about society

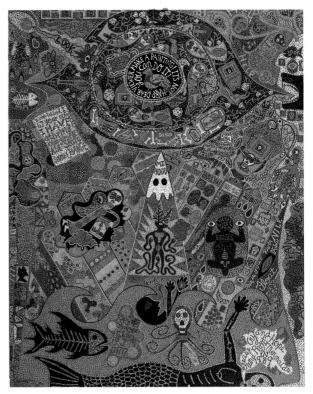

Bruce Burris, People Are Talking, *1989. Acrylic on canvas, 5 × 4 ft. Dr. and Mrs. Steven Lanster. Burris often conveys the grimmer aspects of street life and the drug culture through beguiling works, such as this one, that are metaphors for the harsh life-style of the underclass.*

through the use of colorful and imaginative designs and symbols. This artist has had exposure on both coasts and is emerging as a major contemporary folk artist.

VERNON BURWELL—*"Sometimes I don't have to look in a book. It's like a vision comes to me."*

BIOGRAPHICAL DATA
Born April 28, 1916, Rocky Mount, North Carolina. Attended Rocky Mount High School through eleventh grade. Married Cora Anderson, 1942. Three daughters, two sons. Now resides Rocky Mount, North Carolina.

GENERAL BACKGROUND
Vernon Burwell is a black sculptor who, as he puts it, makes "cement art" that is often inspired by the people around him as well as by known personalities.

At the age of nineteen, Burwell started working the farm he inherited from his father, near Rocky Mount, North Carolina. His cash crop was tobacco. Around 1943 he gave up full-time farming and went to work for the Seaboard Coastline Railroad, starting as a laborer and working his way up to mechanic and sheet metal worker in the repair shop. Burwell retired in 1976 after more than thirty years with the railroad.

The Burwell family currently resides in a small home in Rocky Mount with a basement and carport "good for making cement art."

ARTISTIC BACKGROUND
"Soon after my retirement in 1976," Burwell says, "I got a little sick [he has diabetes] and wanted to do something. I went down into the cellar and made a statue." Now, he boasts, "I can make almost anything out of concrete."

SUBJECTS AND SOURCES
Burwell's inspiration comes from all around him; he states that he makes "different people—friends, biblical characters, and people I sees in the daily papers." He also sculpts some animals, endowing them with anthropomorphic personality traits from his imagination.

MATERIALS AND TECHNIQUES
Burwell's basic mixture is lime, sand and gravel, water, and cement—the ingredients of concrete. He applies the concrete with a trowel to an armature of steel rods, clothes hangers, and pipes, then paints the finished work thickly with outdoor house paint. The surface texture in Burwell's chosen medium becomes a focal point and succeeds in adding interest.

Most of Burwell's work stands no higher than 3 feet, and many pieces are smaller. By working in segments, however, he has made one or two sculptures that are life-size. Burwell estimates that he has made about two hundred objects.

ARTISTIC RECOGNITION
Vernon Burwell is at his best when sculpting busts of his

Vernon Burwell, Bust of Black Man, *1984. Painted concrete, 21 × 10 in. Dr. and Mrs. Allen W. Huffman. The glossy paint on this bust does not detract from the texture of the underlying concrete and adds to the strong primitive appeal of Burwell's work.*

neighbors or heroes like Martin Luther King, Jr. His work is to be counted in the long list of emerging southern black folk artists.

Burwell's sculptures have been shown at North Carolina Wesleyan College, located in his hometown. In 1988 he was included in "Outside the Main Stream: Folk Art in Our Time" at the High Museum of Art in Atlanta, Georgia, and in 1989 in "Signs and Wonders: Outsider Art Inside North Carolina" at the North Carolina Museum of Art in Raleigh.

DAVID BUTLER

BIOGRAPHICAL DATA
Born October 2, 1898, Good Hope (near Patterson), Louisiana. Dropped out of school to take care of his siblings. Married Elnora, last name and marriage date unknown; she died c. 1968. No children. Now resides in a nursing home, Morgan City, Louisiana.[1]

GENERAL BACKGROUND
David Butler is an extraordinary sculptor who created a wonderful and whimsical environment in his own yard. A slim and wiry black man who is now a nonagenarian, But-

David Butler, Window Screen *(Nativity), 1984. Enamel paint on tin, 27½ × 43 in. Sylvia and Warren Lowe. David Butler's delightful tin cutouts of real and fantastic creatures turned his yard into a colorful, whimsical environment.*

ler held a long line of menial jobs throughout his working life: he cut grass, worked in the sugarcane fields, and drove a buggy, to mention just a few. In the early 1960s, while employed in a sawmill, he had an industrial accident that resulted in a partial disability and retirement.

Butler bought a small house in Patterson just about the time of his accident and almost immediately began decorating his yard with fanciful tin sculpture. He also rode proudly around town on a bicycle covered with moving tin objects.

ARTISTIC BACKGROUND
David Butler says that he followed directions he received from the Lord—to surround his Louisiana Gulf Coast home with color and beauty. This became his mission in life, and, shortly after he acquired his home, Butler started making sculptures that soon made his small yard a mélange of color, motion, and fantasy. Butler's work was discovered by William Fagaly, director of the New Orleans Museum of Art, in the 1970s, and he was given a one-person show at that museum in 1976.

Butler's best work was done before 1983. The artist has been in and out of nursing homes since 1984 and has been able to create very little since then. His house is still there, but the sculpture has been removed.

SUBJECTS AND SOURCES
Butler constructed brightly painted, complicated, and sometimes wind-driven assemblages and cutouts from roofing tin. His yard became a carnival of color encompassing all sorts of things—nativity scenes, roosters and chickens, fanciful creatures, and animals of all sorts—that were then surrounded with pattern pieces. The creations appeared realistic to the artist, but the images were, in fact, the stuff of which dreams are made, such as flying elephants and fire-spitting dragons.

There is a feeling of wonder and humor that runs through Butler's work, which is a delight to view. Although each of the tin constructions was conceived as part of the overall environment, each is a unique piece and can stand on its own as sculpture, outside its original setting.

MATERIALS AND TECHNIQUES
Butler worked with used tin roofing panels that he would place on the ground between his feet and hammer flat, then cut out shapes with a meat cleaver, hammer, and ax head. He wired the pieces together and decorated them with small plastic animals, toys, flags, and other found objects.

Butler painted his constructions with house paints in bright colors, often patriotic red, white, and blue. After about 1983 his nieces and nephews helped with the painting, although Butler continued to do all the cutting and shaping.

It is impossible to estimate how many art objects Butler made over the years he was decorating his yard. Some are very complicated, and a few are as large as 8 feet tall.

ARTISTIC RECOGNITION
David Butler is a one-of-a-kind sculptor, and his work offers humor, motion, and fantasy. He is well known to collectors of black folk art and to museums. In addition to the show at the New Orleans Museum of Art, Butler's work was included in "Black Folk Art in America: 1930–1980," sponsored by the Corcoran Gallery of Art in Washington, D.C. (1982) and "Baking in the Sun: Visionary Images from the South," sponsored by the University Art Museum, Lafayette, Louisiana (1987). He also has been exhibited at the Museum of American Folk Art in New York City and the High Museum of Art in Atlanta, among other museums.

MILES BURKHOLDER CARPENTER—*"I carve because it's relaxing and fascinating to me to bring forth and produce something that God put here [in the wood] for all of us."*

BIOGRAPHICAL DATA
Born May 12, 1889, Cedar Hill Farm, Brownstone (Lancaster County), Pennsylvania.[1] Educated through eighth grade (attended school both in Brownstone and in Waverly, Virginia). Married Mary Elizabeth Stahl, May 19,

Miles Burkholder Carpenter, Devil on a Root Monster, *1975. Painted wood with fur and leather, 22⅜ × 12 × 11½ in. Chuck and Jan Rosenak. The wood's natural shape influenced the form of this "root monster," and Carpenter's fertile and playful imagination created a cross-eyed devil as a rider.*

1915; she died November 5, 1966. One son. Died May 7, 1985, Waverly, Virginia.[2]

GENERAL BACKGROUND
Miles Carpenter, a well-known folk carver, learned about wood early in life. In 1901 his father sold the family's Pennsylvania farm and they moved to southwestern Virginia, near Waverly, where he built a sawmill. One of Carpenter's boyhood chores was operating the mill, which left him little time for school. By 1912 his father had backed him in a milling venture of his own, and later Carpenter would add an icehouse to his business operations. The businesses had their ups and downs, but Carpenter "cut the mustard," as he used to say, and did well enough to send his son to college. The Carpenters lived in a house on the mill property in Waverly.

Carpenter retired from the lumber business around 1955 but continued to operate the icehouse—by now selling soda and fruit as well. Known to local residents as an eccentric, he drove around town in a green 1952 Chevrolet pickup truck, the open back loaded with an ever-changing assortment of his large carvings—watermelons, monkeys, and Indians. He fixed a rope to the head of one of his Indians so that he could move the head from the driver's seat, which startled pedestrians.

ARTISTIC BACKGROUND
The mill business was slow during World War II, and Carpenter started carving (mostly small animals) to pass the time. When business picked up again after the war, he had no time to carve again until he shut down the lumber mill in 1955. When his wife died in 1966, he became melancholy and turned to carving for relief: "I was just about down and out from strain. . . . I really started carving and making real nice pieces of work."[3] One of the carvings he did at that time was a large watermelon, which he used as a trade sign (this well-known piece is in the permanent collection of the Abby Aldrich Rockefeller Folk Art Center, Williamsburg, Virginia).

Jeffrey Camp, a folk art dealer in Virginia, began to represent Carpenter in 1973 and was responsible for Carpenter's inclusion in a *Life* magazine cover story on folk art.[4] Camp was also instrumental in getting Carpenter his first one-person show in 1971 at the Anderson Gallery, Virginia Commonwealth University, in Richmond.

SUBJECTS AND SOURCES
Miles Carpenter sculpted to amuse himself and others; his subjects came from whatever struck his fancy. Many of his carvings made fun of politicians, friends, neighbors, Indians, and even religion (*The Devil and the Damned,* is an example). Sometimes he saw animals with twisted shapes in the wood, which he called "root monsters." "I see hidden objects," he noted, "and bring them almost to life."[5]

MATERIALS AND TECHNIQUES
Carpenter preferred yellow poplar for his figurative carving; the root monsters came out of almost any wood he could find, as long as he saw the right form in it. He worked with hand carving tools and painted many of his pieces with latex house paint in a variety of colors.

Carpenter carved about two hundred major pieces, ranging in size from about a foot high to larger-than-life Indians 7 feet tall. He also made many hundreds of small birds and animals.

ARTISTIC RECOGNITION
Miles Carpenter developed a lifelong philosophy of, as he put it, "cutting the mustard." What he is remembered for is cutting wood—he has done some of the most important folk sculpture of this century. Carpenter's work is so highly regarded that he was invited to the White House in 1981, where he presented President Reagan with a carving of an elephant cutting taxes. He also received a Virginia Heritage award in 1983.

Carpenter's son, Miles S. Carpenter, has given the family home and some sixty of his father's pieces to the Waverly Women's Club; these will be maintained as the Miles B. Carpenter Museum.

WILLIAM ("NED") CARTLEDGE—
"I say what I want to say—not cutesy things for folk art collectors."

BIOGRAPHICAL DATA
Born October 1, 1916, Canon, northeast Georgia. Graduated from Boys' High School, Atlanta, Georgia, 1935. Married Amy Adams, June 7, 1947. Four daughters, including two stepdaughters. Now resides Atlanta, Georgia.

GENERAL BACKGROUND
Ned Cartledge is a wood carver who finds inspiration for his satirical painted bas-reliefs in contemporary politics.

The fifth child in a family of six, Cartledge grew up in Austell and Atlanta, Georgia; his family left Canon after the failure of the bank in which his father had worked as a cashier. During part of his childhood, Cartledge's mother operated a boarding house in Atlanta. The family was not very well off, and Cartledge recalls he owned two pairs of pants: one on and one in the wash.

From 1936 to 1960 Cartledge worked as a "cotton classer" for Anderson Clayton and Company, taking a leave of absence during World War II to serve as an enlisted man and later as a first lieutenant in a mortar battalion that saw action in Europe. When he returned from the service, he became a self-employed cotton buyer, then manager of the Cotton States Arbitration Board, a position he left in 1973 when the board moved to Memphis. Cartledge then went to work as a salesman in the hardware department of a Sears Roebuck store in Atlanta until he retired in 1982.

ARTISTIC BACKGROUND
"I whittled as a child, using my mother's paring knife. I didn't own a pocketknife until I was twelve years old. When we moved to Atlanta in 1930, my carving practically stopped due to lack of motivation," Cartledge says. "But when I married," he jokingly comments, "my chain was

William Cartledge, Our Kind of Devil, *1981. Oil on carved wood, 19 × 17½ in. Collection of the artist.*

Cartledge is known for witty political and social commentary, exemplified here in a smiling "odd couple."

pretty tight, so I stayed home and took it up again. At the Cotton States Arbitration Board, I had days with nothing to do, so I carved." A gift set of X-Acto knives also helped to rekindle his love of carving. Later on, he says, "I was one of the 'old' people who opposed the Vietnam war and felt that I ought to speak out." Ned Cartledge's "speaking out" took the form of political commentary through sculpture.

In 1978 Atlanta folk art dealer Judith Alexander discovered Cartledge's work, and she has helped him gain a broader audience. In 1969 he was awarded second prize and in 1970 best of show at the Savannah Arts Festival; in 1971 he received a purchase award from the Arts Festival in Atlanta, Georgia.

SUBJECTS AND SOURCES
Cartledge carves bas-reliefs illustrating his strong political, religious, and social opinions—antiwar, anti-Reagan, and prohonesty at 1600 Pennsylvania Avenue—with a sense of humor. His primary subject matter is contemporary politics. He found "trickle-down economics" a revolting theory ("it's the poor who need help") and commented on this subject through several of his works; *One of the Leading Economic Indicators,* for example, shows a sleeping street person wrapped in the *Wall Street Journal.* Cartledge draws upon editorial comment, cartoons, and popular magazines for inspiration.

Not all of the artist's work is political or in the bas-relief format. He carves birds, cats, and fish, and one of the first works Cartledge ever sold was a three-dimensional watermelon slice. He also made carved boxes before he moved on to the bas-reliefs.

MATERIALS AND TECHNIQUES
Western pine, poplar, and basswood are Cartledge's favorite woods, but the type of wood he uses depends mostly on its availability. He now uses woodworking hand tools—gouges and chisels—to make his pieces and paints the finished carvings with oil or sometimes acrylic paints.

Cartledge has completed about three hundred works, but only about eighty are painted bas-reliefs. He produces only five or six of the latter a year and has long periods of inactivity.

The bas-reliefs measure about 18 by 28 inches; the other pieces vary in size.

ARTISTIC RECOGNITION
Ned Cartledge is best known for the biting political and social commentary in his satirical bas-reliefs. His highly regarded bas-relief work is now included in the permanent collections of the High Museum of Art in Atlanta, the Lyndon Johnson Library in Austin, Texas, the Museum of American Folk Art in New York City, and the Museum of International Folk Art in Santa Fe.

RUSSELL CHILDERS

BIOGRAPHICAL DATA
Born September 10, 1915, Wamic, Oregon. Received minimal education. Single. No children. Now resides Lebanon, Oregon.[1]

GENERAL BACKGROUND
Russell Childers is a remarkable West Coast wood carver who has pursued his craft despite many obstacles.

For most of his life Childers was thought to be retarded. He spent ten happy years at home, but in 1926, when his mother became too ill to care for him, he was committed to the Fairview State Home for the Feeble Minded in Salem, Oregon. At that time few institutions for the retarded showed progressive tendencies, so Childers, even though a child, was locked up and his shoes taken away as a safety precaution.

For many years it was thought that Childers was deaf and dumb; it was not until he was forty-nine years old that it was discovered that he could hear with the help of a hearing aid. Once he was equipped with a hearing aid, he learned to speak and write.

Childers stayed at Fairview until 1965, when his new abilities allowed him to move into a foster home in Lebanon, Oregon. Today he attends programs at the Willamette Valley Rehabilitation Center in Lebanon.

ARTISTIC BACKGROUND
In the 1940s, influenced by a picture story on a wood carver in *Life* magazine, Childers started to reproduce his childhood memories in wood sculpture. By 1964 his artistic skill had attracted the attention of local artists, as well as that of the hospital staff. After he moved into a foster home and began attending the rehabilitation center in Willamette, he had more time for developing his creative abilities—and more encouragement.

In 1977 the University of Oregon organized a traveling exhibition of Childers's work, and he was included in "Pioneers in Paradise: Folk and Outsider Artists of the West Coast," a traveling exhibition mounted by the Long Beach Museum of Art in 1984. Childers is currently represented by the Jamison-Thomas Gallery in Portland, Oregon.

SUBJECTS AND SOURCES
Russell Childers's major themes revolve around events recalled from the early years of his life—the neighborhood swimming hole, an aquarium visit, and even the loss of his freedom and his shoes. He painstakingly carves poignant and moving pieces that commemorate, in great detail, activities that to anyone else might seem commonplace. Many of Childers's pieces are self-portraits.

MATERIALS AND TECHNIQUES
Childers has always worked with wood. Before he was supplied with proper tools, he used sharpened metal scrapers for his work; now he can use the hand tools available at the rehabilitation center, and his work has benefited. The center supplies him with wood, and when he has a choice, his preference is for black walnut. Childers uses paint and other stains, including shoe polish, on his finished pieces, some of which are made out of more than one piece of wood.

Russell Childers, Dolphin Feeding, *n.d. Carved wood, 11 × 14 × 5 in. Jamison-Thomas Gallery, Portland, Oregon. Carved slowly and with great care, this detailed piece depicts a memorable visit to an aquarium, with an appreciative audience of awestruck children.*

The artist is able to complete only two or three sculptures in a year's time. They are not very large, about 10 by 8 by 6 inches.

ARTISTIC RECOGNITION
Russell Childers is one of a very small group of talented people who are compelled to create in spite of enormous handicaps. His carvings are crafted with great care, and his technical ability, as well as his ability to catch a fleeting moment in childhood, makes his work memorable. This artist has made a name for himself on the West Coast but has received little exposure elsewhere.

HENRY CHURCH

BIOGRAPHICAL DATA
Born May 20, 1836, Chagrin Falls (near Cleveland), Ohio. No formal schooling. Married Martha Prebble, September 18, 1859; her death date unknown. One son, one daughter. Died April 17, 1908.[1]

GENERAL BACKGROUND
A Victorian in spirit, Henry Church was a painter and rock carver whose work bridged the gap between the "dying days of the nineteenth century"[2] and the early years of the twentieth.

As a youth, Church was considered too frail to attend school and was taught at home by his mother. At the age of thirteen he was apprenticed to his father, a blacksmith. Although he had wanted to draw when he was young, his father strongly disapproved of this frivolous pursuit and punished him severely for drawing with charcoal on the walls of the smithy. Church opened his own blacksmith shop and built a home and studio after his marriage in 1859. He worked in the smithy until about 1886, when he retired.

Although known to have been a deeply religious and spiritual man, Church also enjoyed the more temporal things in life. Apparently he was gifted at music as well as art, and he played the cornet, banjo, alto horn, harp, and bass viola, making the latter two instruments himself.[3] He was also a thorough man. In addition to carving his own tombstone (he threatened to live forever unless the unusual design—a growling lion with green glass eyes—was approved by the cemetery trustees), Church organized his own last rites, which included a recorded gramophone message from him that ended with "Goodbye at present."[4] His family carried out his wishes for the service at his death.

ARTISTIC BACKGROUND
Although the young Church gave up the idea of art after his father's beatings, he retained the desire and, following his father's death in 1878, immediately began drawing again. He gave up the blacksmith shop when he was fifty years old in order to devote himself full-time to painting and making sculpture and rock carvings.

In 1888 Church set up a small museum by a popular picnic area where he could show his paintings. He charged ten cents admission but had little luck with sales.

Church's major rock work was done on the banks of a river near his home. The unusual carvings had a somewhat primitive look to the untrained eye, which is what led to the artist's discovery. In 1937 Sam Rosenberg, a New York writer and photographer, heard a rumor that there were prehistoric Indian rock carvings in the vicinity of Chagrin Falls; when he checked the rumor, he found that the carvings were Church's work. By then Church was dead, but Rosenberg, impressed by the pieces, took the opportunity to make his work known to the world.

SUBJECTS AND SOURCES
Henry Church painted still lifes of fruit set in Victorian interiors, yet they are not the expected static and traditional settings; they have a certain tongue-in-cheek quality and poke fun at Victorian conceits. His most famous painting,

Henry Church, The Monkey Picture, *c. 1895–1900. Oil on paper mounted on canvas, 28 × 44 in. Abby Aldrich Rockefeller Folk Art Center, Williamsburg, Virginia. In this* *well-executed painting, Church has taken a traditional Victorian conceit—the still life—and enlivened it with a modern sense of whimsy.*

The Monkey Picture, shows two monkeys tearing up a lavish festive arrangement of fruit on a table, with a policeman in hot pursuit in the background.

Church's carvings on the rock walls of the Chagrin River are quite different in feeling and subject from his paintings. There he created life-size animals and Indians—a mountain lion hanging by its tail, an eagle ready to swoop, an Indian maiden surrounded by a snake. He called these carvings *The Rape of the Indian Tribes by the White Man.*

MATERIALS AND TECHNIQUES

Church's paintings were done with oils on canvas or paper. He tended to use dark backgrounds that made his boldly colored foreground seem all the more vivid. The paintings are 20 by 30 inches to 28 by 44 inches.

The artist used standard hand tools for carving in rock. The rock carvings by the river are life-size; he also did some smaller stone carvings of unidentifiable or fantasy figures that he kept in his yard.

Church did about one hundred paintings in all. Mrs. Jessie Sargent, the artist's daughter, burned all but twenty or thirty (after caring for them for thirty years after her father's death) because she lacked room for them when she moved to a smaller house.[5] A number of Church's paintings and stone carvings remain in the family.

ARTISTIC RECOGNITION

Henry Church's still-life paintings and intriguing rock carvings are marvelously executed examples of turn-of-the century art. *The Monkey Picture* is generally acclaimed as the best work by this painter, but all of the surviving paintings are worthy of note. Church's work is known to virtually every student of American folk art, and it is included in some private collections.

HENRY RAY CLARK—*"Sometimes I don't know what to put on paper. I sleep on it and the ideas come." "As long as my mind can create something beautiful to look at, I am a free man, and I will live forever in my art."*

BIOGRAPHICAL DATA

Born October 12, 1936, Bartlett, Texas. Attended school for six years, Douglas Elementary School, Houston, Texas. Single. No children. Now resides Walls Prison, Huntsville, Texas.

GENERAL BACKGROUND

Henry Clark is a "three-time loser." In Texas that may mean many years in prison for this black artist who was given the street name of "the Magnificent Pretty Boy" in honor of his high-living style. He uses this name in his letters and paintings.

From the age of fifteen, Clark worked off and on for his father, who runs the Lee Clark Construction Company in Houston, Texas. He also worked as a plumber, plasterer, cement mixer, and carpenter, as well as in a Gulf Atlantic warehouse for a short period (1957–1958).

Henry Ray Clark, Birdbeam from the Planet Skybeam,
*1989. Marker and pen on paper, 14 × 11 in. Private
collection. This drawing displays Clark's unusual sense of
design and color and his compulsive, imaginative style. As
shown here, his pictures often include a space-age super-
woman and original hieroglyphs.*

Clark, however, did not fit easily into mainstream soci-
ety. In 1977-1978 he spent thirteen months in prison for
attempted murder; in 1982–1983, thirteen months for pos-
session of a controlled substance; and, in 1988 he was sen-
tenced to thirty years in the Walls Prison for possession of
narcotics.

ARTISTIC BACKGROUND
Henry Clark started to draw in 1977, during his first incar-
ceration. "I had a lot of time to work on it, so I started to
draw in prison," he says. "I also took a prison art course
run by Molly Campbell, but she didn't teach my kind of

art." Clark has never drawn except when he is in prison.

In May 1989 Murray Smither, an art dealer from Dal-
las, and Sandra York and Gail Siptak, Houston artists,
were asked to judge the 16th Texas Prison Art Show at
Huntsville. Clark's work was entered in the show; the
judges awarded him first prize. William Steen of The
Menil Collection in Houston was also present at that show
and has since helped the artist to become known.

SUBJECTS AND SOURCES
Clark fills his paper from edge to edge with his designs.
"If there's a bare spot," he says, "I just sit and wait until
an idea comes to me to fill it." He draws freehand designs
and is a compulsive geometric colorist, using mostly red,
black, yellow, and green.

Integrated into his design patterns are the figure and face
of a superwoman. "She's Robin, from another planet," the
artist explains. Her dark piercing eyes and scanty costumes
are a recognized trademark of the artist, and these draw-
ings are his most appealing.

MATERIALS AND TECHNIQUES

Clark has drawn on prison requisition forms, manila envelopes, and whatever else he can find. Now that he is selling most of his work, he can afford to send away to the Texas Art Supply Company for better materials. His drawings are done with ink, pen, pencil, and ballpoint pens; all are very colorful.

Clark has made fewer than one hundred drawings; less than fifty are known to have survived. They range in size from 9 by 12 inches to 18 by 30 inches.

ARTISTIC RECOGNITION

Henry Clark's work has much in common with the work of inmates confined in other types of institutions, especially mental hospitals. Such institutional art is better known in Europe than in America, but collectors in this country are aware of its importance. The Menil Collection has acquired a Henry Clark drawing, and others have been showing great interest in the artist's output.

SILAS CLAW

BIOGRAPHICAL DATA

Born December 15, 1913, to the *Lók'aa'dine'é* (Reed People clan),[1] near Cow Springs, the Navajo Nation, Arizona. Attended school for ten years, including Tuba City High

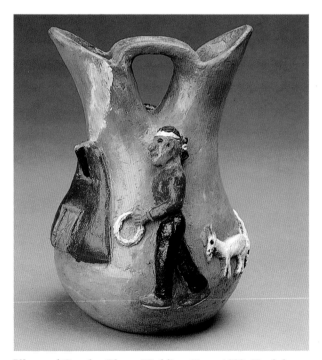

Silas and Bertha Claw, Wedding Vase, *1989. Fired clay, acrylic paint, and varnish, 6½ × 16 in. diameter. Tracy R. Cate. This double-spouted vessel is typical of the Claws' pottery, which is traditionally Navajo in form but not in subject matter, since people and animals are depicted.*

School, Arizona (but reads and speaks very little English). Married Bertha Little of the *T'ód'ich'i'i'nii* (Bitter Water clan), "about 1949." No children. Now resides Cow Springs (between the Grand Canyon and Monument Valley), the Navajo Nation, Arizona.

GENERAL BACKGROUND

Silas Claw is a Navajo potter known for his unusual vessels based on traditional forms. He and his wife, Bertha, live in a dwelling off a dirt track that climbs above a ridge overlooking the Cow Springs trading post. They also maintain a ceremonial hogan, now occasionally used as a pottery studio. The family does not speak much English, but sometimes a younger Navajo will be present to act as a translator.

The Claws follow the Navajo Way of life; they herd sheep, goats, and cattle, assisted by their dogs, which guard and help to herd the other animals. They are a proud family; guests are not allowed into their home until both husband and wife have changed into their best traditional velvet outfits and silver and turquoise jewelry.

ARTISTIC BACKGROUND

The Claws live about a half mile from Rose Williams, a traditional Navajo potter who became their teacher.[2] In 1968 Silas Claw began to work with clay and broke his first taboo—men do not pot among the Navajo. After that, he broke taboo after taboo in potting because of the innovative pots he makes and the nontraditional manner in which he decorates them.

Claw sold his pottery through Bill Beaver, who runs the Sacred Mountain Trading Post near Flagstaff, Arizona.[3]

SUBJECTS AND SOURCES

Bertha and Silas Claw both work on the pottery. He makes most of the pots and appliqués figures on them; she handles the sanding and painting. Silas Claw's style is influenced by the work of other contemporary Navajo potters as well as by the demand for his vessels.

The Claws make traditional single- and double-spouted ware, but because these are made for sale, they are smaller than those normally used by the Navajos for cooking. They break taboo by applying clay representations of horned toads,[4] bears, goats, Navajos, or cactus on their vessels. The Claws also make beaded clay necklaces with figures of birds and arrowheads; he occasionally makes decorated pipes and individual figurative depictions of Navajos as well.

MATERIALS AND TECHNIQUES

Claw uses traditional Navajo clay that is dug near Black Mesa; he purifies the material, forms it into coils, and winds the coils upward until he achieves the desired shape. He smoothes the vessel with a burnished corncob and then applies ornamentation.

The pots are fired in an open pit (the Claws' preferred fuel is cedar) and painted with acrylics (another taboo) when the firing is complete. Claw does not apply the piñon pitch traditionally used to seal Navajo pots because it will

cause the paint to run. He prefers to use shellac, which gives his vessel a lighter color than is normal in a Navajo pot.

The Claws' ware is small, usually not more than 8 inches high. They produce about fifty pots a year, along with assorted other objects.

ARTISTIC RECOGNITION
A Silas Claw pot is distinctive and recognizable, a wonderful example of a folk craft that has moved into the realm of art. Claw does not attend Indian Market in Santa Fe or other similar fairs and exhibitions. His work is known mostly from being shown and sold in galleries in the Southwest.

ALICE CLING—*"I wouldn't [use a wheel]—that's not the Navajo Way."*[1]

BIOGRAPHICAL DATA
Born Alice Williams, March 21, 1946, to the *Lók'aa'dine'é* (Reed People clan), Cow Springs, the Navajo Nation, Arizona. Graduated from Intermountain Indian School (no longer in existence), Brigham City, Utah. Married Jerry Cling, July 20, 1972. Two sons and two daughters, all of whom are learning pottery making. Now resides Cow Springs, the Navajo Nation, Arizona.

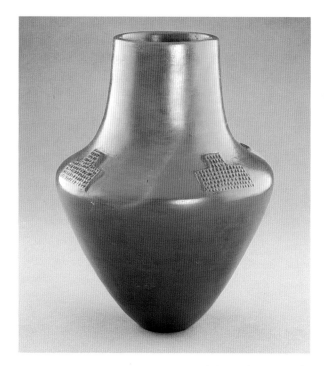

Alice Cling, Navajo Pot, *1987. Fired clay with piñon pitch, 10 × 29½ in. circumference. Robert and Dorothy Walker. With its understated decorative elements, this graceful pot is representative of Alice Cling's innovative work.*

GENERAL BACKGROUND
Alice Cling was born into the most famous clan of Navajo potters and has become a distinguished member of this renowned group. She grew up in her mother's hogan, where making pottery, along with herding sheep and goats, was a family business, even though it was a time when the demand for utilitarian ware was falling off and pottery for home use was being replaced by tin and plastic items sold at local trading posts.

Since 1969 Cling has held a position as a teacher's aide at the Shonto Boarding School for Indians; she still works there, as well as at her pottery. She and her family live in a house erected in 1988 by the Department of Housing and Urban Development; it is near the Page-Shonto junction of the road leading from the Grand Canyon to Kayenta and then on to Monument Valley.

ARTISTIC BACKGROUND
It has only been in the past ten or fifteen years that outside interest has helped to spur a revival of Navajo pottery making and inspired individual potters to find their own voices in clay. Rose Williams, Alice Cling's mother, taught Cling and a good many others of the new generation the traditional Navajo methods; they have added their own innovative touches.

In 1969 Cling took her work to Indian trader Bill Beaver, owner of the Sacred Mountain Trading Post near Flagstaff, Arizona, but her pots did not sell. One day in 1976 she looked at her pots; "I said to myself, 'Alice, they are ugly,' so I shaped and polished some up to make them beautiful." From then on, she had no trouble selling her work.

SUBJECTS AND SOURCES
Cling makes beautifully shaped, colored and polished non-utilitarian pots. She breaks with Navajo tradition by stylizing or eliminating the required *biyo'*, a beaded necklace just below the rim of a Navajo pot that is the one decorative element allowed.[2] Not following a taboo is supposed to bring bad luck to the maker. "I cannot bring myself," the artist says, "to add much decoration, because Grandmother said that would be bad."

MATERIALS AND TECHNIQUES
Cling makes her pots very much in the traditional manner of her people. She uses only clay dug from nearby Black Mesa; after the clay is mixed and purified, she forms coils from it that she then winds upward to produce the desired shape and size. She smoothes her vessels with a polished river stone or a Popsicle stick rather than the more traditional burnished corncob and applies a red slip (used by the Walapai Indians to decorate their faces).

After the pots have air-dried, Cling fires them in an open pit, using cedar for fuel. Where ash from the oxidized wood comes in contact with the clay, brownish gray discolorations called "fire clouds" appear. After the pot has cooled, she applies warm piñon pitch to make the pot waterproof.

Cling has made about four hundred pots. Many are quite small—only 1 to 2 inches high—but others may reach a height of 17½ inches.

ARTISTIC RECOGNITION

Although Alice Cling's graceful and highly polished pots represent a break with traditional style, they are among the most sought-after Navajo pottery. Her work has been exhibited at most of the museums in the Southwest, and she has won numerous awards for Native American pottery. In her first try at Indian Market in Santa Fe, New Mexico, in 1989, she took home a blue ribbon.

CLARK W. COE

BIOGRAPHICAL DATA

Born March 16, 1847, Killingworth (between Haddam and Clinton), Connecticut. It is doubtful that he had much

Clark W. Coe, Musician with Lute, *n.d. Wood figure, metal and wood lute, 30 in. high. Museum of American Folk Art, New York; Gift of Nina and Gordon Bunshaft. Coe's unique water-powered environment no longer exists, but its original power and scope are conveyed by the few pieces that remain.*

formal education. Married Harriet Sarnina Hull, October 4, 1877; she died March 26, 1916. One son, one daughter, five stepchildren. Died October 26, 1919, Killingworth, Connecticut.[1]

GENERAL BACKGROUND
Because of the animated environment that Clark Coe constructed, he has an established place in New England history. He was a farmer and a basketmaker by trade and supplemented his income by selling homemade ax handles in New Haven, Connecticut. However, it is the remarkable group of life-size, movable figures that he constructed on his land that makes him memorable and places him firmly among the folk art innovators of this century.

ARTISTIC BACKGROUND
Clark Coe started working on his figures around 1900. His motivation, as it is generally stated, was a desire to amuse a crippled nephew. According to local lore, however, the figures were intended to please his grandchildren. Whatever the truth of why he built this ingenious assemblage, the figures were a delight to all who saw them and by 1915 were well known to visitors to the area.

When Coe died in 1919, a man named Parmelee purchased the property and with donations kept the environment going for a time. By the end of the 1920s, he had ceased to keep it up, and, as a result, the remaining pieces were dispersed.

SUBJECTS AND SOURCES
Clark Coe developed a delightful environment, full of fantasy and motion, composed of articulated life-size figures of people and animals moved by water power; overall, they came to be known as the *Killingworth Images*. All were images that would appeal to children: there was a man riding a pig (this figure is sometimes referred to as *Girl on a Pig*), a man with a lute on a Ferris wheel, and a preacher/conductor, among others. The squeaks and squawks generated by the moving figures' motions could be heard by the neighbors day and night when the water wheel that ran them was in action.

MATERIALS AND TECHNIQUES
Coe created the life-size images out of barrel staves, slats, driftwood, and tree stumps, held together with metal and nails, and painted. Occasionally he shaped and carved the pieces of wood, and he dressed some of the figures in discarded clothing and bits of ribbon.

All the figures were powered by a water wheel that the artist had constructed. The water that turned the wheel had been diverted by a stone dam from a river that adjoined his property.

There were forty articulated figures that made up the total environment, but only seven of them are known to have survived.

ARTISTIC RECOGNITION
There were very few folk art environments known to have been created at the turn of the century, and Clark Coe's *Killingworth Images* were unequaled examples of the ingenuity of America's creative spirit at the time. Only one of his unique images remains in Killingworth (the Killingworth Historical Society owns the *Preacher/Conductor*), and a few of his other animated figures are included in private and public collections.

Those of Coe's figures that still exist are frequently illustrated, making his work known to a wide audience interested in folk art. They have also been exhibited at the Museum of American Folk Art and as part of the show "Folk Sculpture USA" at the Brooklyn Museum of Art in 1976.

RAYMOND COINS—*"I never knew a person who enjoyed himself working. But when I retired, I found that I do—because I can't sit still."*

BIOGRAPHICAL DATA
Born January 28, 1904, Stuart, Virginia. Some grade school education ("say, maybe fifth grade"). Married Ruby King, 1927. One son, two daughters. Now resides Westfield (near Pilot Mountain), North Carolina.

GENERAL BACKGROUND
Raymond Coins is a carver who is becoming known for his large wooden figures and small stone "doll babies."

Coins was born on a small farm in southern Virginia, the descendant of a long line of poor white subsistence mountain farmers. When he was ten years old, his father bought a farm in the Winston-Salem area and moved the family there. "I didn't like school," he recalls. "In fifth grade I couldn't write down them words—so I quit."

After Coins grew up, he did farm work for others until 1950, when he and his wife, Ruby, were able to purchase their own small farm and the frame house where they live today. Coins grew tobacco, corn, oats, wheat, and rye in summer and held a second job during the winter as a "floor man" at tobacco warehouses in the Winston-Salem area.

In 1968, when Coins was either sixty-four or sixty-five, he retired from the tobacco houses, quit farming his land, and began to collect modest Social Security checks.

ARTISTIC BACKGROUND
After retiring, Coins began to feel restless. He picked up a stone, started carving, and thus began his second career. He imitated Indian arrowheads and tomahawks at first, but before long he was working on his "doll babies" and bringing forth the animals and people that only he could see in his raw materials of local wood and stone.

"At first," Coins relates, "I'd give 'em away—didn't know they was worth anything." Then, in 1984, Terry Zug, a professor at the University of North Carolina at Chapel Hill who was doing research on the potter Burlon Craig (see page 86), saw Coins's work, and brought him to the attention of other teachers and collectors.

SUBJECTS AND SOURCES

"When I pick up a rock or piece of wood," Coins explains, "I turn it over until I see what's in there—I'm amazed sometimes at what comes out. Usually the faces look like me; bald on top." Coins carves what he calls "doll babies" —busts and angels with round, staring eyes and round, toothless mouths. He also carves stone bas-reliefs of religious themes, crucifixions, and Adam and Eve in the Garden of Eden. In addition, he has made a number of animal figures in both wood and stone.

MATERIALS AND TECHNIQUES

"I use three different kinds of rock," Coins says, "light white, speckled, and blue. I also like cedar [when he uses wood] because it's red and white." The rock is a soft river stone, found on a neighbor's farm. The artist uses chisels and knives for carving.

Coins's stonework ranges from only a few inches in height to about 30 inches tall. The wood carvings can be

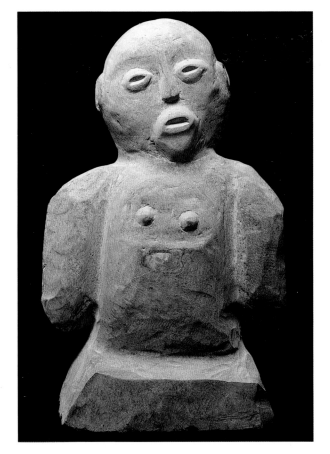

Raymond Coins, Stone Angel, *1988. River stone, 29½ × 18 × 6 in. American Primitive Gallery, New York. Made from the green river stone that Coins found on his farm property in North Carolina, this expressive carving is part self-portrait, part angel.*

almost life-size. He has made several hundred pieces.

ARTISTIC RECOGNITION

Raymond Coins is at his best when carving large wooden figures and his stone doll babies. The subject matter of his stone reliefs is not always as original or as interesting as his other work.

Coins is not as well known as some other southern folk artists, but his work is finding its way into museum shows and important private collections. In 1989 he was included in "Signs and Wonders: Outsider Art Inside North Carolina" at the North Carolina Museum of Art in Raleigh.

("SUH") JIM COLCLOUGH

BIOGRAPHICAL DATA

Born November 14, 1900, Fort Smith, Arkansas. Attended Sallisaw High School, Sallisaw, Oklahoma. Married Marian Peterson, December 23, 1923; she died May 4, 1961. Two daughters. Died June 2, 1986, Westport (north of Fort Bragg), California.[1]

GENERAL BACKGROUND

"Suh" Jim Colclough was an ingenious carver who created humorous, sometimes articulated, figures that often expressed his political and social views.

Colclough guessed wrong in business. He chose a Star Automobile dealership over General Motors, and the company folded in 1932. After this unfortunate foray into business, Colclough became a carnival man. He operated rides for children, traveling with small carnivals called "picnics," and designed and built two of the rides he operated: a baby automobile ride and a mule-powered ride somewhat like a merry-go-round. He abandoned his rides in 1942 but continued working carnivals until 1954.

When he left carnival life, Colclough and his family moved to San Simeon, California, but bad luck seemed to plague them, and their dream house was condemned for a freeway. The family then moved to Westport (almost a ghost town), where Colclough went into retirement and began making art.

ARTISTIC BACKGROUND

Jim Colclough said he always had the urge to make things but not the time to make them. After his wife died in 1961 and he retired, he felt that at last he had the time, and he began to produce a series of lively wooden pieces that poked fun at politics and society.

Colclough attracted attention and won ribbons when he exhibited his work at the California Art Festival in San Francisco. He was discovered in the 1960s by a prominent folk art collector, David L. Davies, who saw his work while visiting a small framing studio/gallery in Fort Bragg, California.

SUBJECTS AND SOURCES

Colclough had a dry sense of humor and a distrust of the government (especially after his house was condemned)

Jim Colclough, Duke and Duchess of Windsor on Their Wedding Day, *c. 1972. Paint on California redwood, 39 × 25 × 12 in. David L. Davies. The marriage of the Duke of Windsor to a commoner caught the attention of the world, and in one of his best carvings Colclough depicted the drama of the occasion.*

that he expressed without hesitation in his work. He carved the common man and political figures, making fun of them both—dogs chased mailmen; Harry Truman (to whom Colclough believed he was distantly related) appeared in a tight-fitting World War I uniform. Hardly anyone or anything was sacred.

The artist knew how to make objects move, which added charm and excitement to many of his pieces. For example, when a lever is pushed, the *Harry Truman* figure thumbs his nose at the world. Colclough devised ingenious systems of pulleys and cranks to obtain motion in his work. In another piece, *Creature in the Coffin,* a secret lever activates a flower that pops up from the creature's navel, never failing to startle the viewer.

MATERIALS AND TECHNIQUES

Colclough found redwood logs and assorted hardware on ocean beaches and made good use of these materials, occasionally adding other found objects. He applied various stains and finishes to his works but used paint sparingly.

Some of Colclough's figures are life-size, others smaller. The artist completed two to three hundred sculptures.

ARTISTIC RECOGNITION

An artist whose work is startling and original, Jim Colclough created some of the most dynamic pieces to be found in folk carving. His work is well known, especially on the West Coast, and almost everything he did is now in private or public collections. Colclough was included in every major exhibition of contemporary California folk art in the 1980s.

JESSIE F. AND RONALD E. COOPER—*Ronald Cooper: "I forget the pain [caused by the automobile accident] when I do folk art and teach the Bible to people."*

BIOGRAPHICAL DATA

Born Jessie Farris Dunaway, April 2, 1932, Muses Mill (near Flemingsburg), Kentucky, and Ronald Everett Cooper, April 14, 1931, Plummers Landing (near Flemingsburg), Kentucky. Jessie Cooper attended school through eighth grade, Muses Mills Elementary School; Ronald Cooper, through ninth grade, Flemingsburg High School. Married January 8, 1948. Now reside Flemingsburg, Kentucky.

GENERAL BACKGROUND

Jessie and Ronald Cooper are a gifted couple who collaborate on making folk art objects in the Appalachian Mountain tradition.

The Coopers married young. Ronald worked for the Doyle's Grocery Store in Flemingsburg, Kentucky, for the first few years of their marriage (1949–1952), then the couple opened their own store "till it went bad" (1968). After the failure of their store, the Coopers moved to Marion, Ohio, where Ronald worked on an assembly line for General Motors' Frigidaire Division and Jessie was a cashier in a Kroger's supermarket (1968–1983).

They remained in Marion until 1984, when Ronald was involved in a serious automobile accident that left him disabled. The Coopers decided to return to Flemingsburg, where they still live.

ARTISTIC BACKGROUND

The Coopers started making folk art after they returned to Kentucky in 1984. At first Ronald made whittled animals in the Kentucky mountain craft style, and Jessie, who had painted on and off for a number of years, decided to try her hand at sculpture as well. Then one day in 1984 Tom Sternal, chairman of the Art Department at Morehead State University, called and, as Ronald remembers it, said, "I think you folks are doing folk art."

Encouraged by Sternal, the Coopers began to make larger pieces. Jessie Cooper explains the family art as follows: "We each does our separate thing. But if I need something carved, he carves, and I sometimes paint on his."

Morehead University Gallery has been showing the work of the Coopers, and they were included in the show "Good and Evil," sponsored by the University, in 1988.

SUBJECTS AND SOURCES

"After my accident," Ronald says, "I had nightmares where walking snakes chased me. I carved the snakes and put them in hell, where I was living." Biblical scenes dominate the work of both Coopers, although Jessie's are more literal then Ronald's, and their message is the conflict between good and evil. Both artists paint on old furniture, and both print messages like "Listen to Mother" or "Do What Preacher Says" on their pieces.

Ronald carves devils and spooks and places them in drawers, so that a carved panoramic view of heaven or hell will pop out of a seemingly innocuous piece of painted furniture. Jessie often paints the boxes in which Ronald places his devils and spooks.

MATERIALS AND TECHNIQUES

The Coopers find old wood for their pieces and buy used furniture at flea markets and secondhand stores. They paint their pieces with house paint. Lately they have been looking for animal skulls, which they decorate liberally with biblical scenes.

The couple estimate that they have completed one hundred major objects, including a 7-foot-high cabinet.

ARTISTIC RECOGNITION

The work of the Coopers contains humorous elements as well as serious dissertations on good and evil. It is both

Jessie F. and Ronald E. Cooper, Home Sweet Home, *1989. Acrylic paint on antique trunk, 15 × 30½ × 15½ in. Arient Family Collection. Jessie's painting and Ronald's carving combined to produce this trunk with a message that reflects the Coopers' fundamentalist religious beliefs.*

Ronald E. Cooper, Devil and His Serpents, *1989. Acrylic paint on tree limb and found objects, 35½ × 10 × 9¾ in. Arient Family Collection. A devil and a "walking" snake are biblical subjects that Ronald Cooper often depicts.*

colorful and decorative. Collections of Appalachian folk art are beginning to include the work of this couple, and Morehead continues to give them museum exposure.

HELEN CORDERO

BIOGRAPHICAL DATA
Born Helen Quintano, a member of the Pumpkin group, Fox clan, June 17, 1915, Cochiti Pueblo (between Albuquerque and Santa Fe), New Mexico. Attended school through eighth grade at Saint Catherine Indian School, Santa Fe. Married Fernando (Fred) Cordero, December 13, 1932. Two sons, two daughters, nine grandchildren (two of her children and four of her grandchildren also make pottery). Now resides Cochiti Pueblo, New Mexico.

GENERAL BACKGROUND
Helen Cordero is one of the most respected pueblo figurative potters today. Although her income from pottery sales is considerably above the village average, there is no outward show of wealth. The extended Cordero family lives in a compound of adobe buildings and converses in Keres, their mother tongue. Cordero has led a full pueblo life, raising her family, preparing meals for ceremonial feast days, and participating fully in the social and religious life of Cochiti. For well over thirty years she has also made pottery in the traditional manner of her people.

Since 1984 Cordero has been ill and in and out of hospitals, but she still works on her pottery when she can.

ARTISTIC BACKGROUND
In the 1950s Cordero started making pottery. She was

Helen Cordero, Storyteller with Nine Children, *early to mid-1970s. Cochiti clay, Santo Domingo and Bandelier slip, and beeweed, 10¼ × 6 × 8 in. Dewey Galleries, Ltd., Santa Fe, New Mexico. Helen Cordero's storytellers—like the example shown here—have earned her a reputation as one of the most gifted figurative potters in the Southwest.*

strongly influenced by the figurative pottery tradition at Cochiti, but she did not do figurative work of her own until 1964. Since then, by drawing upon her imagination, Cordero has succeeded at creating a new art form while also reviving a dying tradition and revolutionizing the concept of figurative pottery.[1]

Cordero first showed her figurative pieces at a Santo Domingo feast day in 1964. They were an instant success, and folk art collector Alexander Girard, entranced by her "storyteller" figures, became her patron. Her work was awarded first, second, and third prizes at the New Mexico State Fair that year, and in 1965 one of her storytellers won first prize at Santa Fe's Indian Market. She has won ribbons at Indian Market almost yearly since then.

SUBJECTS AND SOURCES
In her pottery Cordero has immortalized and stylized remembrances of her grandfather, Santiago Quintano, a noted Cochiti storyteller who was always surrounded by enraptured small children. Pottery children—the more, the better—cling to and swarm over Cordero's very expressive storytellers. In describing her pieces, she says, "His eyes are closed because he's thinking; his mouth is open because he's singing."[2]

MATERIALS AND TECHNIQUES
Traditional Cochiti pottery is always made the same way, and Cordero follows tradition. The only materials she uses are the creamy brown Cochiti clay, which she first sifts to remove the impurities; white slip dug from the pueblo of Santo Domingo; red slip from Bandolier; and black coloring, which comes from beeweed that is gathered from the roadside and boiled down to become a greenish liquid (it is only after firing that it turns black).

First the clay is shaped and sanded, then the slip and beeweed applied. The painting is done with a yucca needle. The firing of the pieces takes place over an open cedar fire in Cordero's backyard; they are placed on a metal grate and covered with dry cow chips, which hold in the heat and send it down into the clay.

Cordero states that "it is bad luck to count," but she has probably made close to 1,600 objects, some very small, others more than 20 inches high.

ARTISTIC RECOGNITION
Cordero's storytellers are considered to be among the best of southwestern figurative pottery and are highly prized. Over the years Girard bought more than 650 of Cordero's figurative works, and he has now donated his collection, including Cordero's first storyteller piece, to the Museum of International Folk Art in Santa Fe, New Mexico.

CHESTER CORNETT

BIOGRAPHICAL DATA
Born September 4, 1913, Letcher County, Kentucky.[1] Little formal education but able to read and write. Married during World War II; separated or divorced. No known children. Died June 10, 1981, Fort Thomas, Kentucky.[2]

GENERAL BACKGROUND
A mountain man, Chester Cornett was a woodworker who lived a hermitlike existence in the back country near Dwarf (north of Hazard), Kentucky. Except for a period during World War II, when he was in the army and stationed in the Aleutian Islands, and a very brief sojourn in Cincinnati, Ohio, Cornett spent all his life in the Dwarf area of Kentucky.

When he was sixteen, Cornett worked with his grandfather, Cal Foutch, and his uncle, Linden Foutch, on Pine Mountain, learning chair-making, which became his trade.

Chester Cornett, Crucifix, *c. 1968. Polychromed wood and horsehair, 96 × 48 in. Museum of American Folk Art, New York; Gift of Pam and James Benedict. This crucifix was once attached to the prow of an ark Cornett built to escape an impending deluge. Although the ark was destroyed, the crucifix remains to reveal the artist's vision.*

In 1947, after his discharge from the service, he returned to Dwarf and chair-making; the only other employment Cornett ever knew was a short-lived job as a janitor in a bank in Hazard, Kentucky.

ARTISTIC BACKGROUND
In 1968 Chester Cornett had a dream/vision that eastern Kentucky was to be inundated by flood. In preparation for this event, he built a 20-foot-long ark with a cabin perched on top and a large crucifix mounted on the bow; he moored it in Troublesome Creek, near Dwarf, and moved onto the boat to await the flood.

When the flood did not occur, Cornett moved back into his house, subsequently removing the crucifix from the boat and taking it home with him. At a later date, the creek did flood, damaging the ark severely. Cornett salvaged the wood from the boat to make more of his unusual chairs, but the crucifix, a major piece of art, remained in his home.

SUBJECTS AND SOURCES
Chester Cornett's crucifix is a rare achievement and may be considered a classic example of contemporary backwoods art. The artist's vision of Christ's crucifixion combines the humor of the true mountain man with popular notions concerning the event. Cornett worked and reworked the crucifix over the years until it finally became a large-mouthed, round-eyed, grinning Christ.[3]

Many of Cornett's chairs are also works of art in a different way; they became the sculptural representations of his dreams. The chairs (the term is used loosely—they are often combined pieces of furniture) are large, crude, highly carved, and very atypical of the area and the styles he had been taught by his grandfather and uncle.[4] They frequently incorporate bookcases and tables, and serpents and other animals or objects are carved into the wood. Cornett also made an unusual three-legged rocking chair.

MATERIALS AND TECHNIQUES
Cornett worked in buckeye and white oak and carved with hand tools. The crucifix has some paint (applied with a spray gun), and Christ has a horsehair beard; at one point he wore a loin cloth.

The crucifix stands 8 feet tall. It is not known how many chairs Cornett produced.

ARTISTIC RECOGNITION
Chester Cornett and his work—particularly his crucifix (now in the collection of the Museum of American Folk Art in New York City)—have received a great deal of attention. The artist was the subject of a TV documentary, *Hand Carved*, in 1976.[5] His work was included in two local shows in Kentucky in 1976 and 1984; in "The Ties That Bind: Folk Art in Contemporary American Culture" at the Contemporary Arts Center, Cincinnati, in 1986; and in "Expressions of a New Spirit" at the Museum of American Folk Art in 1989.

CARLOS CORTEZ COYLE

BIOGRAPHICAL DATA
Born December 1, 1871, Bear Wallow (later called Dreyfus), Kentucky. Attended Berea Foundation School, a high school program (no longer in existence) run by Berea Col-

Carlos Cortez Coyle, The Transformation, *1934. Oil on canvas, 54 × 36 in. Berea College Art Gallery, Berea, Kentucky. This unusual garden of Eden probably depicts the artist with his former wife—who takes the form of a serpent coiled about his body.*

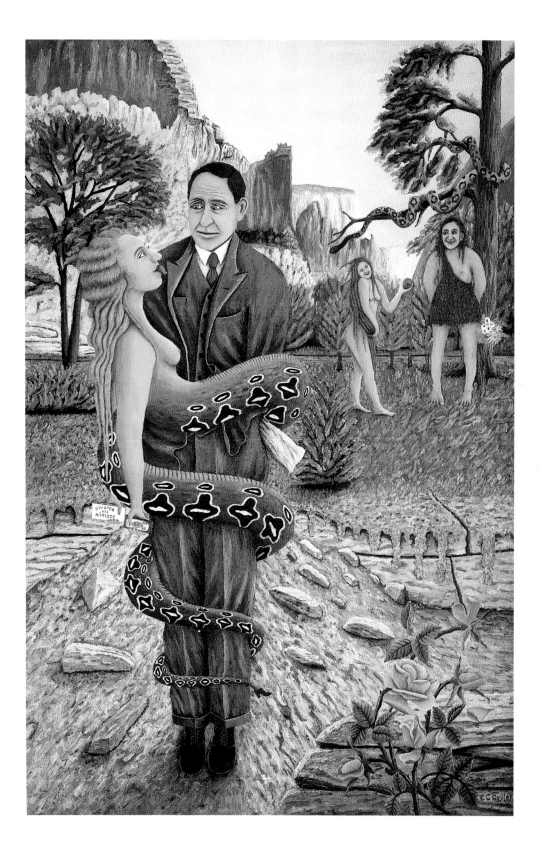

lege, Berea, Kentucky. Married Hattie Mae Bratcher, marriage and separation dates unknown. Two sons, one daughter. Died April 28, 1962, Leesburg, Florida.[1]

GENERAL BACKGROUND
Very little is known of Carlos Cortez Coyle. His legacy is an impressive series of surrealistic allegorical paintings and a diary that reveals much about his paintings but very little about his personal life.

It is known that, after leaving high school, Coyle moved from Kentucky north to Canada and then west to Seattle and San Francisco. He lived on the West Coast until approximately 1948, working in lumberyards and shipyards. After retiring, Coyle moved to Florida and settled in the Leesburg area, where he remained until his death.

ARTISTIC BACKGROUND
According to his diary, Carlos Coyle's artistic career seems to have commenced with the death of his beloved mother in 1929, while he was living in California. Nothing was known of Coyle and his work until December 1942, when Berea College in Kentucky received four crates containing forty-seven paintings, thirty-seven drawings, and a diary. The letter accompanying the gift, signed C. C. Coyle, explained that this was a gift "to the land of my birth."

Coyle's paintings remained in their crates and were not seriously examined until an art professor, Thomas Fern, discovered them in 1960 and recognized their importance. The accompanying diary meticulously recorded the data on each painting—when it was done, its size, cost, content, title, and so forth—and was invaluable in their documentation.

The *Courier Journal* magazine ran the first story about this amazing bequest on August 27, 1961. Coyle was subsequently located, living in Florida in relative obscurity and virtually blind from cataracts. Although an operation partially restored his sight, he died before he could paint again.

SUBJECTS AND SOURCES
Carlos Coyle's known work consists of landscapes, paintings of women, both clothed and unclothed, and celebrations of heroes and scientific progress. All record his unique personal philosophy—a mixture of patriotism, love of the countryside, and a complicated love/trust/hate relationship between himself and his mother and former wife—in an unusual surrealistic and semi-allegorical style.

Coyle's attitude toward women and motherhood can best be described as Victorian idealization, although there seems to have been some ambiguity in this outlook. He clearly idealized his mother, particularly after her death; the diary includes a studio photograph of his mother and several poems and essays in remembrance of her. These feelings just as clearly did not extend to his former wife; one of his most famous paintings, *The Transformation*, shows Eve (with his former wife's face) as a forked-tongued serpent holding a card marked "divorce and alimony" and wrapped around a well-dressed man (probably Coyle himself).

MATERIALS AND TECHNIQUES
Coyle made sketches and cartoons on paper in preparation for his paintings, which he then executed in oil paints on canvas.

The artist's diary describes a total of 170 works. It also states that he gave many away to friends; the location of these paintings is presently unknown, although one did turn up in a secondhand store in New York some years ago.

Coyle's work ranges from small sketches to massive paintings that measure 6½ by 5 feet. Apparently he was planning an even larger work, for a 6-by-8-foot canvas was found in his room after his death.

ARTISTIC RECOGNITION
It is generally believed that Carlos Coyle painted many of his greatest pieces between 1931 and 1938, and all of his paintings in the collection of Berea College are worthy of further exposure and study. After sending a good part of his early work to Berea, he continued to paint on and off for most of the rest of his life, but not much is known of these later works. Although the majority of Coyle's recognized works is to be found in the Berea collection, some are held in private collections as well.

BURLON ("B.B.") CRAIG—*"I don't make any specific people because some might not like seeing themselves that way."*

BIOGRAPHICAL DATA
Born April 21, 1914, Hickory (near Winston Salem), North Carolina. Attended school through eighth grade, Hickory, North Carolina. Married Irene Lindsay, September, 22, 1934. Three sons, two daughters ("they don't help in the pottery—always find somethin' else they gotta do"). Now resides Vale (southeast of Winston Salem), North Carolina.

GENERAL BACKGROUND
"I started pottery making 'long about 1929, helping gather clay," Burlon Craig remembers. At the same time that he was serving his apprenticeship to James Lyn, a local potter, Craig was also working for the Hickory Furniture Company (for nineteen years).

Craig was drafted into the navy in 1942 and served as a gunner on a troop ship in the South Pacific. After the war, with the help of the GI bill and money saved from his wife's defense plant earnings, Craig bought a farm and pottery near Vale, North Carolina. "I made churns, storage jars, and milk crocks," he explains. "That was about all you could sell in those days. People didn't have the money to collect pottery, like they have today."

In 1986 Craig had a heart attack that slowed him down somewhat, but the night sky around Vale is still often lit up by one of his firings.

ARTISTIC BACKGROUND
Although Craig learned his craft as a youngster in the

Burlon Craig, Grotesque Face Jug, 1978. Stoneware, 11 × 9½ × 9⅜ in. Museum of American Folk Art, New York; Gift of Roddy Moore. This "face jug," with its protruding eyes and large, porcelain teeth, is typical of Burlon Craig's well-known work.

1920s, his art did not develop until the late 1970s, when there was a resurgence of interest in hand-crafted pottery. As an experiment, Craig started making nonutilitarian sculpture in the form of face jugs, which quickly gained an enthusiastic audience.

SUBJECTS AND SOURCES
The artist still makes utilitarian pottery—the storage jars, milk crocks, and churns that are always useful and in demand—but he is best known for his large and unusual green, blue, and brown face vessels. These have exaggerated and fanciful faces, often with protruding white teeth.

MATERIALS AND TECHNIQUES
Craig gathers his clay locally, then purifies and mixes it in a pug mill of his own design that is powered by a tractor motor. He throws the jugs on a foot-powered "kick" wheel and finishes them with an ash glaze made of a mixture of ground glass, clay, wood ash, and water. "I dip 'em in a drum of glaze, let some run inside, and give 'em a roll," he says. Porcelain is used to make the teeth on his face vessels.

Craig's kiln is a long, narrow building with a firebox at one end. It is fueled by pine slabs that he purchases from a local lumber mill.

Craig has made many hundreds of face jugs since he turned to this mode of expression. They range anywhere from tiny—only 1½ inches high—to his famous large jugs that are 3 feet tall.

ARTISTIC RECOGNITION
Craig's best-known and most-admired works are his large face vessels; his miniatures are rare. His earliest pieces are signed "Burlon Craig Vale N.C."; the later ones, "B.B. Craig Vale, N.C." The earlier work is preferred.

JAMES CRANE

BIOGRAPHICAL DATA
Born February 2, 1877, Winter Harbor, Maine. Extent of education unknown. Married Jennie Maude Harris, Thanksgiving Day, 1917; she died 1934. No children. Died April 17, 1974.

GENERAL BACKGROUND
James Crane, a folk painter of maritime subjects who also had a fascination with air flight, was fourteen years old when his father, a New England fisherman, died in a storm at sea. Although Crane was also a fisherman, the loss of his father served to convince him that fishing was not the occupation he wished to pursue. He continued, however, to have a lifelong fascination with the sea and its disasters, which would later show up in his paintings.

Crane left home the year of his father's death and went to Bath, Maine, where he learned to be a mechanic at the Arthur Sewell Company. After leaving that company, he was employed by the Bath Iron Works and then the Hyde Windlass Company. By the time he was twenty-three, he had worked his way to Pittsburgh, Pennsylvania, where, in addition to his job as a mechanic and machinist, he began to work on an invention for a lock washer. While he was in Pittsburgh, a clairvoyant told him his invention would be a success, but he did not complete it until after his marriage in 1917. He then manufactured and sold the washer himself until the Great Depression forced him out of business.

In 1909, when Crane was back in Maine working for the Grand Trunk Company in Portland, he had a vision that would give him a goal for the rest of his life: he dreamed that a heavenly guide showed him an airship powered by "bird-motion flight," as he called the wing-flapping machine he would one day try to build. He wrote down a description of the machine and, from time to time over the following years, refined it so that he would have an accurate re-creation of his dream.

It was not until a great many years later that Crane had an opportunity to build his airship. When he was eighty-five, a wrecker put Crane in charge of his salvage yard, which gave him the space and materials to work on his dream machine, which he named the Eagle Airship, and eventually moved to his front yard. A flight was never tried, so the principle of bird-motion flight as designed by Crane remains untested.[1]

James Crane, The Titanic, *c. 1968. Oil on cloth with paper collage, 20 × 28 in. Museum of American Folk Art, New York; Gift of Robert Bishop. Specializing in maritime topics, Crane developed a technique for showing a subject from several perspectives at once, as exemplified by this scene of the top deck of the* Titanic.

ARTISTIC BACKGROUND

Although James Crane was known locally for his unusual airship, he is remembered in folk art for his maritime works. Apparently, quite late in his life he decided to paint, and although only a few of his works are known, they are fascinating glimpses of the maritime life from which he removed himself as a youth.

SUBJECTS AND SOURCES

Crane painted ship portraits and poetic, vital landscapes of New England coastal towns. The *Titanic* was a favorite subject, and he is known to have painted several versions of that ship; he also built a rough model of it that stood in his yard next to the *Eagle Airship*.

As with his airship, Crane seemed to have a special vision of the world that he applied to his painting. He recorded a subject from many perspectives at the same time —from above, below, and the side—allowing the viewer to see it all at once.

MATERIALS AND TECHNIQUES

The artist painted on a variety of materials—everything from discarded plywood to oilcloth to a piece of a bedsheet to the back wall of his house. He used oils or house paint as his medium.

The number of works he executed is unknown, but most likely it was quite small. The sizes of the known pieces vary considerably.

ARTISTIC RECOGNITION

James Crane remains an intriguing and somewhat mysterious figure in the history of folk art. No one knows for sure what turned him to painting—whether it was the delay in being able to work on his airship or the tragedies of the sea that had such a profound impact on him—but he produced some of the more creative and important maritime scenes of the century. His works are in both public and private collections.

ABRAHAM LINCOLN CRISS—*"I'm a dummy and a Negro, but I'm the most creative artist you ever seen."*

BIOGRAPHICAL DATA

Born February 20, 1914, Cumberland, Virginia. No formal education ("don't need no school if you serve the Lord"). Married and divorced but refuses to disclose names or dates. Two daughters. Now resides Cumberland, Virginia.[1]

GENERAL BACKGROUND

Abe Criss is a black sculptor whose life-size wood figures are lively, amusing characterizations of the human form.

After thirty years working for a New Jersey furniture company, first as a janitor and later as a furniture craftsman, Criss knew how to work with wood, and wood became a major part of his life. In the 1960s he left Essex County, New Jersey, where he had lived since the 1930s, and returned to Virginia. There he opened a furniture repair and antiques business in a group of self-erected shanties on a parcel of land bordering Route 60. He also started making sculpture. A trailer parked near the highway bears a sign: "ABELCRISS REDSABLE HANDCRAFT FOLKSART-1984 MUSEUM."[2]

ARTISTIC BACKGROUND

Since 1976 Abe Criss has been making his "masterpieces," as he calls his animal and human sculptures, in his front yard in rural Virginia. "I always made 'em," Criss remembers, "and put 'em in my yard. Then one day this lady [Ann Oppenhimer, around 1985] stops by and says, 'You make art. I'll put you in a museum.'" Oppenhimer, president of the Folk Art Society of America, kept her word. She has curated several museum shows in the Richmond area that included Criss.

SUBJECTS AND SOURCES

"Jesus told me," Criss avows, "to find trees that look like people and just add to them." He assembles his figures—almost life-size men and women—using local woods that he ages. The figures stand stiff, straight, and pop-eyed, solidly balanced on oversize feet. They are often nude and have hair on their heads and around their exposed genitalia. Criss's figures are eye-catching, and a group of them alongside the highway inevitably produces a car-stopping effect.

MATERIALS AND TECHNIQUES

Criss works with walnut and just about any other wood he can find that has the right shape. He uses a band saw and other tools from the furniture-making business to define his figures. His background in furniture making shows through in some of the sculptures, which have feet, legs, and arms that look as if they have been made from chair parts. In fact, a few of the pieces of this artist double as benches.

Criss sometimes adorns the bodies of his figures with colorful geometric designs. More recently he has relied on staining the wood, adding just a touch of color. Various finishes and the natural blemishes in the wood are incorporated into the designs, and Criss uses a mixture of sawdust and glue to shape features on the figures. Deer hooves, buttons, marbles, costume jewelry, and old wigs become further decoration.

Criss estimates that he has displayed more than a thousand objects for sale on his lawn. They range in size from a few inches to 7 feet tall.

ARTISTIC RECOGNITION

Abe Criss's observations on the human figure are instantly recognizable as coming from a one-of-a-kind sensibility. They are serious works of art while at the same time joyful creations, humorous characterizations of the human spirit. Criss is included in many major collections of contemporary folk art in Richmond, Virginia, and he is becoming known elsewhere in the country as well.

Abraham Lincoln Criss, Woman, *1986. Wood, marbles, paint, and acrylic hair, 31 × 7 × 7 in. William and Ann Oppenhimer. This lively, smiling lady, with her welcoming arms and large feet, is representative of the artist's work. Criss has used the grain of the wood and remnants of bark as decoration for the body.*

EARL CUNNINGHAM

BIOGRAPHICAL DATA
Born 1893, Edgecomb, Maine. Graduated from the Hamlin-Foster Company Academy of Automobile Engineering, 1912. Married Iva Moses, June 29, 1915; separated or divorced about 1929. No children. Died December 29, 1977, St. Augustine, Florida.

GENERAL BACKGROUND
Earl Cunningham painted seascapes and landscapes that combined elements from different times and places into brilliantly colored, idyllic fantasies.

Cunningham struck out on his own at the age of fourteen, leaving his parents' sawmill in Edgecomb, Maine, to make a living as a peddler and tinker. After his marriage to Iva Moses, he crewed on four- and five-masted sailing ships carrying coal and other cargo from Maine to Florida.

During World War II Cunningham gave up sailing and operated a chicken farm, selling his chickens to the army. In 1949 he gave up the farm and moved to St. Augustine, Florida, where he lived with his "patroness," Theresa Paffe, in a building (once a funeral parlor) she owned on historic St. George Street. He ran the Over-Fork Gallery (a better name, he thought, than Fork Over), a curio shop located downstairs from their living quarters. Cunningham was considered a testy "old salt," which earned him the nickname "Dragon of St. George Street."

Paffe sold her building in 1977 and bought a house on the outskirts of town, where she built Cunningham a studio. That same year rumor had it that Cunningham and Paffe were "fussing" and that he had gone out to rent a motel room but, when he discovered how much it cost to live on his own, he came back to the house. Shortly after that, Cunningham committed suicide by shooting himself.

ARTISTIC BACKGROUND
In 1909, to try to support himself, Cunningham did some paintings on old boards that had washed up from the sea. He sold them for fifty cents apiece. Forty years later, after he moved to St. Augustine, he returned to painting and produced a body of mature work. He refused, however, to sell his art at that time, stating that he wanted to keep the collection together.[1]

Marilyn Mennello, a collector, discovered his work at his curio shop in 1969. After his death she and her husband tracked down the dispersed paintings, had them restored, and devoted a good deal of time and effort to assuring Cunningham's reputation among twentieth-century folk artists.

SUBJECTS AND SOURCES
Cunningham painted "a peaceful idyllic world on canvas."[2] He was a romantic voyager on his own fantasy seascapes; his imagination carried him, in a dream houseboat, into a unique coastal world that never did nor ever could exist. American flags fly everywhere, Indians paddle canoes, boats of the last century and earlier mingle with cabin cruisers—he painted the east coast of America, but only he could tell you where or when.

MATERIALS AND TECHNIQUES
Cunningham painted with oils on canvas or canvas board, using a palette of rich, jewellike colors. His paintings range in size from approximately 11 by 22 inches up to 30 by 50 inches. His diary has an entry stating that he had completed 450 works; 350 of them are now in the Marilyn L. and Michael A. Mennello Collection.

Earl Cunningham, The Twenty-One, *c. 1970. Oil on Masonite, 23¼ × 47¼ in. Mr. and Mrs. Michael A. Mennello. Using a rich palette of colors and an active imagination, Cunningham portrayed an unlikely combination of boats and ships.*

ARTISTIC RECOGNITION

During the last decade few collectors of twentieth-century folk art have concentrated on landscape and marine painting. Accordingly, Cunningham's reputation is somewhat limited; he is, nevertheless, an important artist of this century.[3] His work is the subject of a recent traveling exhibition, "Earl Cunningham: The Marilyn L. and Michael A. Mennello Collection."

HENRY J. DARGER—*"Not until the final days of Darger's life did I become aware of the incredible world that [he] had created from within himself." (Nathan Lerner)*

BIOGRAPHICAL DATA

Born April 12, 1892, probably Chicago.[1] Received some education at the grade-school level through the Catholic Boys' Homes in Chicago. Never married. No children. Died April 13, 1973, Chicago, Illinois.[2]

GENERAL BACKGROUND

Henry Darger was a reclusive man who created an astounding world of fantasy in his ambitious illustrated books and journals.

No doubt his childhood experiences had a profound effect on his stories. At the age of eight, Darger was placed in a boys' home when his father became disabled and was unable to continue to care for him (nothing is known of Darger's mother). For the next few years the young Darger was shunted from orphanage to orphanage and school to school; somewhere along the way, because of occasional displays of antisocial behavior, he was adjudged feebleminded and placed in more restrictive institutional settings. By the time he reached adolescence, Darger had begun to run away from the asylums in which he was placed, sometimes returning voluntarily, sometimes not, and finally not returning at all.

In 1917 he was drafted into the army but discharged within a year because of poor eyesight. He then began a series of menial jobs, mostly in hospitals in Chicago, that lasted until 1963, when he retired because of ill health. For the next ten years Darger lived on Social Security payments, staying in the same small rented room on Chicago's North Side that he had occupied since 1932. He was regarded as a quiet, religious—almost saintly—man who

Henry J. Darger, Mt. Hendro Danno (Lava Flow), n.d. Carbon, pencil, pen, and watercolor with collage, 24 × 107 in. Janet Fleisher Gallery, Philadelphia. An illustration from Darger's voluminous manuscript, The Story of the Vivian Girls, depicts the girls having an adventure. Although his heroines always escape unscathed, Darger's drawings frequently have overtones of violence.

kept to himself and attended mass on a daily basis. No one who knew this reclusive man was aware of his secret world of fantasy, which was revealed in the journals and illustrated books found in Darger's room after his death in 1973 at a home run by the Little Sisters of the Poor.

ARTISTIC BACKGROUND

Throughout his adult life, starting sometime between 1920 and 1930, Darger worked on a manuscript he called *The Story of the Vivian Girls in What Is Known as the Realms of the Unreal or the Glandelinian War Storm or the Glandico-Abbienian Wars as Caused by the Child Slave Rebellion.* In Darger's manuscripts the Vivian Girls (seven very properly dressed little girls) and the warriorlike Child Slaves (usually naked and often hermaphroditic) represent good and are continually at odds with evil, represented by adult male soldiers. The children and the soldiers engage in violent and gory battles; the Vivian Girls always escape untouched, although the toll among the other combatants may be high. Darger also produced a 2,600-page autobiographical journal entitled *The History of My Life,* a blend of fact and fiction that presents a vision of Darger as one who leads the helpless out of chaos to salvation.

Darger died six months after completing his journal, but it is not known whether more volumes of the Vivian Girls material were planned. Darger's landlord, a photographer named Nathan Lerner, inherited the manuscripts and was so impressed with the material that he arranged for the work to be shown at the Hyde Park Art Center in Chicago, an exhibit that took place in 1977.

SUBJECTS AND SOURCES

No one knows what prompted Darger to embark upon a project of such gigantic proportions—the final manuscript is some 19,000 pages, in twelve hardbound volumes, illustrated by several hundred watercolors and drawings—but undoubtedly his institutional background, which tended

to isolate him from mainstream society, and his strong religious beliefs, which seemed to provide one very stable factor in his life, played their parts. In addition, according to his journal, Darger had witnessed the 1913 Easter Sunday tornado that devastated portions of the Midwest, including towns in the area of Brown County, Illinois, and this may have influenced the vision of chaos portrayed so vividly in his work.

MATERIALS AND TECHNIQUES
Darger cut out illustrations from comic books and magazines and used them to trace the outlines that formed the basis of his drawings. Sometimes he used the illustrations as they were; other times he would have them enlarged or reduced photographically to get the effect he wanted. He wrote and drew with pencil on paper and applied watercolors—mostly in a pastel palette—over his pencil outlines. Although some of his drawings are as large as 2 by 10 feet (achieved by gluing strips of paper together), most are considerably smaller, often around 20 by 48 inches or less.

ARTISTIC RECOGNITION
Darger's drawings are powerful and turbulent, possessed of a latent sexuality and a disturbing beauty. They are an excellent representation of one man's strong, individualistic inner vision that may not always be fully understandable by the viewer yet are, nevertheless, compelling.

PATRICK DAVIS—*"I make the hats first. The rest just comes to me."*

BIOGRAPHICAL DATA
Born March 29, 1943, Guyana, South America. Received a bachelor's degree from the University of Massachusetts, 1976. Married Joyce Cole, August 1970; separated 1984. One son, one daughter. Now resides Houston, Texas.

GENERAL BACKGROUND
Patrick Davis is a black folk artist known for his small carnivallike figures dressed in colorful and sometimes outrageous costumes.

After working as a factory laborer in his native Guyana, Davis emigrated to England in 1961. He took whatever work came along until he was drafted into the British army in 1966 for a three-year term.

Davis came to America on a visitor's visa in 1971 and decided to stay. He enrolled in the University of Massachusetts and earned a degree in comparative religions in 1976. By 1979 Davis had moved to Houston, Texas, where he settled in a three-room shanty-like house next to the railroad tracks. He delivered papers for the *Houston Post* until he was fired in 1984, when he turned to art.

ARTISTIC BACKGROUND
Around the time that he was fired from his paper route, Patrick Davis started assembling small figures that looked as though they were dressed to attend carnivals or, perhaps, voodoo ceremonies.

Davis was successful in seeking gallery representation in Houston, and several, including the Leslie Muth Gallery, began to show his work. He was given a show at the Lawndale Alternative Space Gallery at the University of Houston in 1984 and included in another show at that gallery in 1989.

SUBJECTS AND SOURCES
Davis makes small figures of black men and women decked out in gaily decorated, semi-realistic carnival-type outfits. Their hats and headdresses in outrageous designs are disproportionately large for their bodies. They also wear large collars, flowing tunics, and pantaloon trousers.

The artist creates a feeling of dance movement in his figures by balancing them on tiny, thin feet and extending their limbs and fingers so they are caught in exaggerated postures.

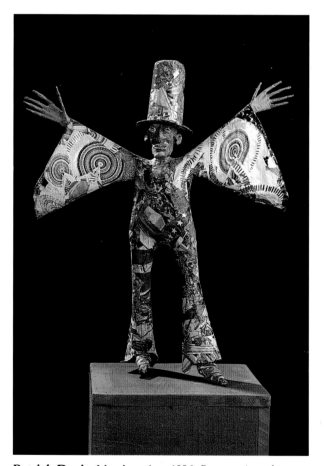

Patrick Davis, Mr. America, *1986. Paper, string, glue, and varnish, 20 × 18 × 2 in. Henri and Leslie Muth. Typical of the sculptures by Patrick Davis, this gaily decorated figure appears to be a reveler dressed in a carnival costume.*

Davis has made some animal figures, but these are not as popular as the dancing-people works.

MATERIALS AND TECHNIQUES
The bodies of the dancers are formed from heavy paper strips cut from computer punch cards and wound into tight cones. This armature is then covered with bits of paper cut from magazines like *Smithsonian* and *National Geographic* and coated with white glue mixed with water. The artist uses paint only for faces, hair, fingers, and shoes, letting the ink of the magazines provide other necessary color and design.

Davis has made several hundred of these lively figures. Most are about 12 inches high, but a few go up to 30 inches.

ARTISTIC RECOGNITION
The carnival figures of Patrick Davis are colorful, dramatic, and decorative. They are very popular in Houston, and collectors in New Orleans are interested in his work because they are evocative of the Mardi Gras. He has yet to receive recognition and exposure on a broader scale.

ULYSSES DAVIS—*"I visits with the Lord every day. . . . When I want to make something . . . the Lord will put it in my mind."*

BIOGRAPHICAL DATA
Born January 3, 1913, Fitzgerald, (in south central) Georgia. Attended Fitzgerald Elementary School ("promoted from fourth to fifth grade, but I didn't show up"). Married Walter ("she had her father's name") Willis, November 23, 1934; she died 1984. Six sons, three daughters. Now resides Savannah, Georgia.[1]

GENERAL BACKGROUND
Ulysses Davis, a black carver, is best known for his patriotic carvings and particularly for his remarkable series of busts of American presidents.

Davis was born in the small town of Fitzgerald, Georgia. "Instead of going to fifth grade," he says, "I worked for Mrs. Tower raising flowers for her garden store." When Davis was older, he cut ties for the now-defunct ABC Railroad, then worked for the Seaboard as a blacksmith's helper. He retired from the railroad in the early 1960s.

Davis moved to Savannah, Georgia, in 1942. In the 1950s he converted an outbuilding behind his house into a workshop and he rented it out for some years. In 1966, after his retirement, he turned this structure into a barber shop, now known as "Ulysses Barber Shop."

ARTISTIC BACKGROUND
Davis has been carving since he was ten years old, but his mature work, such as the busts of the presidents, did not start until the 1940s. The presidents and most of his other important sculptures are kept in the barber shop; Davis is not interested in selling them. "I'd like them to be together in a museum someday," he says.

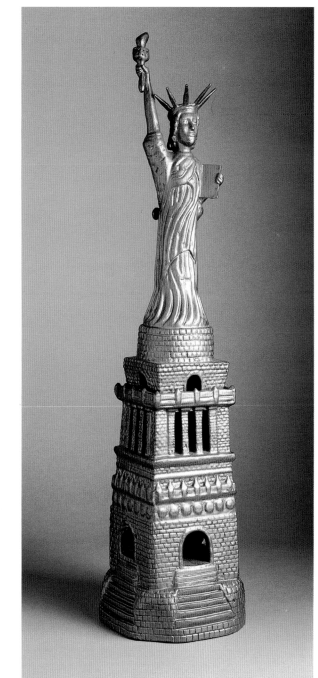

Ulysses Davis, Statue of Liberty, *c. 1939. Painted cypress, 25 × 5½ × 5½ in. High Museum of Art, Atlanta, Georgia; Purchased with funds from the Decorative Arts Acquisition Trust and the 20th Century Art Society. Well known for his patriotic works, Davis sculpted this Statue of Liberty early in his artistic career. Later he devoted much of his time to carving busts of the presidents.*

SUBJECTS AND SOURCES

"I'm an American," Davis explains, "so I carve the presidents. Whether you like them or not, they built the country." He has made a small bust of each president and is now working on George Bush ("can't get his glasses right"). He has also carved his version of the Statue of Liberty, some prehistoric monsters, several farm scenes, reliefs of religious subjects, and four crucifixes. As Davis says, "I carve wood to let the people know what I be thinkin'."

MATERIALS AND TECHNIQUES

The presidents are carved from mahogany, except for the bust of Buchanan, which is pecan. Davis also uses redwood and ebony for his other carvings. He applies paint sparingly—for example, only the black coats and white shirts of the presidents are painted—and on some pieces he will glue glitter and rhinestones, which he calls "twinklets," for decoration.

Davis carves with a pocketknife. His presidents are only 8 inches tall, but he has made a crucifix that stands 40½ inches high.

"I work with time," the artist declares. "I take my time and, in time, I'll finish two hundred pieces."

ARTISTIC RECOGNITION

Davis is well known to museum curators and collectors interested in black folk art but not to the public as a whole. The busts of the presidents are Davis's expression of his patriotic love of country. As a single unit they are exceptional, and many of his miscellaneous works pale by comparison. Davis's work was included in the 1982 exhibition, "Black Folk Art in America: 1930–1980," at the Corcoran Gallery of Art in Washington, D.C., and is in the collection of the High Museum of Art in Atlanta.

VESTIE DAVIS—*"I paint what people want, and they want what's familiar to them."*

BIOGRAPHICAL DATA

Born Edward Davis (name legally changed to Vestie Edward Davis, 1940), November 10, 1903, Hillsboro, Maryland. Received diploma from U.S. Naval Aviation Mechanics School, 1921, Great Lakes, Illinois. Married Sylvia (last name and marriage date unknown); divorced January 29, 1943; married Irma (last name and marriage date unknown); divorced May 19, 1948; married Edna Gray, 1948; she died in the 1980s. No children. Died November 14, 1978.[1]

Vestie Davis, Coney Island—Luna Park, *1970. Oil on canvas, 18 × 24 in. Joan and Darwin Bahm. Coney Island's sights, scenes, and people are often portrayed by this artist, as is shown by this detailed painting that captures the innocent enjoyment of a New York landmark.*

Vestie Davis, Coney Island Boardwalk*, 1969. Oil on canvas, 18 × 24 in. Joan and Darwin Bahm. Repetition of form and pose are typical of the cartoonlike figures that fill Davis's lively Coney Island scenes.*

GENERAL BACKGROUND

Vestie Davis, a painter recognized for his lighthearted scenes of New York City and its residents, was quite young when he left his home in Maryland to join the navy. From 1921 to 1928 he served in the navy, spending part of that time in China. Later he enjoyed surprising his friends by ordering in the language of the proprietor in Chinese restaurants.

Davis went to New York City in 1928, where he operated a newsstand, worked as a circus barker, and helped run a concession at Coney Island. In 1932, tiring of temporary jobs, he obtained an embalmer's license. "I've embalmed enough bodies," Davis once said, "to stretch from here to Philadelphia." He retired in 1960 but continued his avocation of playing the organ in Fisherman's Methodist Church in Brooklyn.

ARTISTIC BACKGROUND

Davis claims to have started painting "behind a corn shed" at the age of six. At some point, he also took a correspondence course in cartooning. But in 1947 Davis looked in the window of an art gallery in New York and decided to "do better"; he bought some materials and began to paint seriously.

By the 1950s Davis was exhibiting at the outdoor art show at Washington Square in New York's Greenwich Village. There he was discovered by Morris Weisenthal, owner of the Morris Gallery, who found Davis's work fresh and appealing and began to represent him.

SUBJECTS AND SOURCES

Davis painted the recognizable landmarks of New York City (and sometimes Atlantic City), particularly its parks and beaches. He soon discovered that he had to "add people" to scenes in order to create "human interest"—and seemed to think that the more people, the better. Davis populated his cityscapes with colorful and happy midget-like men, women, and children (these figures somewhat

resemble the cartoon characters he might have learned to draw from his correspondence course). Occasionally, if it suited the artist, his figures' joints might bend in the wrong direction or his buildings might appear with no structural support, but such incongruities only add to the lightness of the scene. The mood of the paintings is always gay; no clouds, garbage, fumes, or fights spoil the happy and lively scenes.

MATERIALS AND TECHNIQUES
Davis did not paint from memory. He would observe the life he painted firsthand and photograph scenes he liked; then he would paste the prints together until he had a panorama he wished to paint. The artist often sketched his ideas before starting to paint. He drew on paper with colored pencils and crayons and executed his paintings in oils on canvas. Many of his pieces are around 24 by 36 inches.

Davis worked slowly but continually for more than thirty years. It is estimated that at his death he left behind almost eight hundred works.

ARTISTIC RECOGNITION
Vestie Davis created colorful, pleasing paintings that reflect New York's changing cityscape. His highly populated New York scenes, especially those of Coney Island, are considered his best, and his paintings, perhaps because of the lively scenes they depict, draw considerable attention when they are exhibited. Davis's work was included in "Twentieth-Century American Folk Art and Artists" at the Museum of American Folk Art in New York City in 1970.

WILLIAM DAWSON—*"That man can sit there cutting and chomping on wood until he gets tired and falls over in bed. But I got to clean up the mess in the morning. That's our only misunderstanding!" (Osceola Dawson)*

BIOGRAPHICAL DATA
Born October 20, 1901, near Huntsville, Alabama. Attended school through fifth grade, Huntsville Rural District School. Married Osceola Harris, 1923; she died 1987. One daughter. Now resides Chicago, Illinois.[1]

GENERAL BACKGROUND
William Dawson is an accomplished carver who makes unusual wood figures and totemlike sculptures.

"Our family," Dawson proudly relates, "was what you'd consider top grade of blacks. We had a buggy and a team of white horses to pick us kids up at school or take Mama shopping in Huntsville, Alabama." Dawson lived on the 665-acre family farm when he was young. "We only went to school a month or two each year," he notes.

When Dawson married Osceola, the couple "ventured to Chicago," where he worked for three years as an elevator operator in the post office. "Even if I had gone to college," he says, "a black man couldn't do any better in those days." However, he notes, "My rich white friends went away to college, but I didn't have the learning."

In 1926 Dawson got a job in the South Water Street Market working for a produce vendor, Isadore Cohen and Company (later the E. A. Aron Distributors). He became the first black member of the Teamsters Union in Chicago. By the time he retired in 1967, he was the "boss man."[2] After retiring from his full-time job at the produce market, Dawson worked part-time as a security guard for IBM for several years before "retiring altogether."

ARTISTIC BACKGROUND
"I had always been good with my hands," Dawson says, "but when I retired altogether, I needed something to do, so I began whittling. I also went to a YMCA art class, but the instructor wanted me to make things his way—so I quit. By 1976 the apartment was full [of his carvings]. I took some pieces to the Lincoln Park Library, and the lady put them in a case. 'Gee whiz!' I said to myself, 'I'm an artist.'"

Susann Craig, who was teaching at Columbia College in Chicago, saw the display case and arranged a show for

William Dawson, Couple, *1982. Painted wood; man, 18¼ × 6¾ × 3 in.; woman, 17½ × 5½ × 3¼ in. Chuck and Jan Rosenak. This stalwart pair, with their flat faces and prominent eyes and mouths, is a familiar image in William Dawson's work.*

Dawson at her school in 1979. He has been included in a number of exhibitions since then, including the 1982 "Black Folk Art in America: 1930–1980" at the Corcoran Gallery of Art in Washington, D.C.

SUBJECTS AND SOURCES

Dawson carves what seems to be an obsessive personal image. His figures, both male and female, have blocklike bodies with large, primitive faces and prominently outlined facial features; the eyes and teeth dominate all other features. Sometimes the figures are based on TV characters, such as Chicken George, seen in Alex Haley's "Roots," or political despots like Idi Amin; other times Dawson draws his subjects from folktales, the Bible, or just plain folk.

The artist also arranges faces one on top of another to form totem poles. Occasionally the bases for these poles are carved likenesses of his birthplace in Alabama.

Dawson has created some drawings as well. They relate to the carvings and contain the same general themes. His primitive figures and faces appear in both.

MATERIALS AND TECHNIQUES

Dawson uses any wood available—purchased or rescued from streets or alleys. He has used oak chair legs, for instance, to make totem poles (the totems are carved in the round, from one long piece of wood). Most of his figures are carved in the round, often with movable arms held to the body with nails, but Dawson has been known to make a few pieces that are set against flat painted backgrounds.

Dawson outlines his figures with a coping saw and uses wood files and X-Acto knives for the detailing. When the carving is complete, he paints the wood with acrylics (making the teeth and eyes bright white so they stand out), then adds a varnish finish. He may attach found objects such as hair, glitter, bones, and stones to add realism or give his figures more character.

The carvings range in height from a few inches up to 4 feet. The drawings are notebook-size. Dawson has made approximately five hundred carvings and fewer than one hundred fifty drawings.

ARTISTIC RECOGNITION

William Dawson has a well-established reputation and is an important black folk artist. His carvings from 1971 to the early 1980s are his strongest. By the late 1980s Dawson was in poor health, and his more recent work may lack the vitality of the earlier pieces. A retrospective of his work, "The Artworks of William Dawson," organized by the Chicago Department of Cultural Affairs, opened in Chicago in January 1990.

MAMIE DESCHILLIE

BIOGRAPHICAL DATA

Born Mamie Bedon to the Red Bottom Clan, July 27, 1920, Burnham, the Navajo Nation, New Mexico. At-tended school through second grade, Toadlena, New Mexico (Deschillie speaks only a few words of English). Married 1937. Two daughters, one son. Now resides in the Fruitland area of the Navajo Nation, near Farmington, New Mexico.

GENERAL BACKGROUND

Mamie Deschillie, an innovative Navajo artist, has devised new and intriguing forms that are grounded in Navajo tradition.

Deschillie lives in a small trailer parked alongside the prefabricated home of her son and daughter-in-law, overlooking the San Juan River. A Navajo of the older generation, she has the easy, ground-covering walk of a person who has spent many years herding sheep and goats. She continues to dress in the traditional manner, in long velvet skirts and colorful velvet blouses, and is always bedecked in silver and turquoise, the wealth of the Navajos.

Deschillie is president of the Fruitland Senior Citizens Association and does volunteer work, such as accompanying children on school buses. She is also a well-known weaver and has demonstrated her work at the Flying "W" Ranch, a resort in Colorado.

ARTISTIC BACKGROUND

In 1981 or 1982 Indian trader Jack Beasley of Farmington, New Mexico, asked Mamie Deschillie if she could make something she remembered from her childhood. She returned to his trading post a few weeks later to show him her "mud toys." These toys came out of a tradition that, as far as was known, had died out.[1] Deschillie revived the tradition and added her personal vision to it. Her toys were much more than playthings—they had stories to tell.

In 1987 Deschillie began making unique and innovative "cutouts." Although the cutouts contain elements of the Navajo manner of dress and surroundings, her sense of humor and her way of looking at the Navajo environment are completely original and allow the cutouts to break new ground as an art form.

SUBJECTS AND SOURCES

Given her ties to her culture, it is not surprising that Deschillie's primary subjects are the Navajos or their animals; she also depicts circus animals, which she knows from illustrations in children's books. She expresses herself in two ways: through the mud toys that she covers with found objects, and through the cardboard cutouts that she similarly decorates.

MATERIALS AND TECHNIQUES

The mud toys are just that: mud air-dried on a table outdoors, then dressed with scraps of material, sequins, string, turquoise, paper, and other bits and pieces. The cutouts are made of cardboard and dressed and decorated with the same kinds of materials as the toys. Deschillie uses some paint to outline faces on the cutouts and is a master at capturing a fleeting gesture or expression. Some of the materials she uses are quite fragile; the mud toys in particular must be handled with extreme care.

Mamie Deschillie, Cow, *1985. Cardboard, paint, recycled clothing, and tape, 30 × 36 in. Chuck and Jan Rosenak. Cow is Mamie Deschillie's first "cutout"; its creation signifies the beginning of a new tradition.*

Deschillie has made many hundreds of toys and about three hundred cardboard cutouts. The toys are no more than 4½ inches tall; the cutouts can range from a few inches up to nearly 6 feet tall.

ARTISTIC RECOGNITION

Mamie Deschillie's work is highly imaginative, even unique. Although some of her work—particularly her toys—are founded in Navajo tradition, they evince the artist's very personal perspective and sense of creativity.

Deschillie's work has been shown at the Wheelwright Museum of the American Indian in Santa Fe (1983 and 1988) and the Museum of Northern Arizona in Flagstaff (1990).

JOHN WILLIAM ("UNCLE JACK") DEY

BIOGRAPHICAL DATA

Born November 11, 1912, Hampton, Virginia. Dropped out of Phoebus High School, Hampton, Virginia, 1930.

Married Margaret P. Cleveland, February 5, 1935. No children. Died October 10, 1978, Richmond, Virginia.[1]

GENERAL BACKGROUND

John William Dey was a painter whose storytelling ability and strong sense of design earned him widespread recognition.

Dey dropped out of high school before he could graduate and left Richmond to see what else the world offered. He settled in Maine around 1932 and stayed for the next two years, trapping and working for logging companies. The time he spent in Maine, though of short duration, had a strong influence on him, for when he started to paint years later, he often incorporated memories of Maine (snow scenes, moose, and bear) into his work.

Jack Dey returned to Richmond about 1934 and became a barber. Around 1942 he joined the Richmond City Police Force and spent the next thirteen years as a law enforcement officer, retiring in 1955. While he was on the force, Dey earned the affectionate moniker "Uncle Jack" from neighborhood children for fixing their toys and bikes.

ARTISTIC BACKGROUND

Shortly after leaving the police force, "Uncle Jack" Dey started to paint as a way to keep busy. Soon he was painting for the pleasure of it, giving many of his early works away.

Dey's doctor, Harold Nemuth (now deceased), was impressed with the artist's work and accepted pictures in lieu of fees for treatment. Dr. Nemuth also introduced Dey to Jeff Camp, a folk art dealer in Richmond, Virginia; Camp promoted Dey's work assiduously and sold examples to many collectors of contemporary folk art of the time. Dey's wife, however, made the decisions on which paintings were kept and which ones were sold.

SUBJECTS AND SOURCES

Dey's paintings told stories from his life but also showed imagined adventures and fanciful daydreams. Many of his story/paintings were full of friendly animals and people he admired, but Dey did not hesitate to punish people he did not like by portraying them stuck on the ends of pitchforks. Some of the paintings give a sense of impending danger, with black crows hovering over all. On the backs

John William Dey, *Accupuncture Pitchfork Style, c. 1974. Model airplane paint on board, frame painted by artist, 27⅜ × 40 in. Chuck and Jan Rosenak. Painted to fit the frame, this typical, colorful work may portray Dey's first dealer dangling at the end of a pitchfork.*

of many of his paintings, Dey affixed letters explaining the story he was telling.

The artist had a tongue-in-cheek sense of humor that is reflected in his work. (In one painting Eve is depicted as saying to Adam, "Please just try it. You will like it.") His paintings often contain strong patterns based on animals: birds (usually crows) flock across bright blue skies, forming a stark counterpoint to the fluffy white clouds; rabbits (which appear in almost every work) enhance the composition and, in Dey's words, "anchor the painting."

MATERIALS AND TECHNIQUES

"Uncle Jack" Dey believed that the frame made the picture. He collected old frames from secondhand stores and thrift shops, then painted the picture to fit the frame. Occasionally he would gild the frames. Unfortunately, some dealers have removed the frames from many paintings, thus destroying some of the intrinsic value of the works, as Dey created the pieces as a whole.

Dey painted on Masonite or board with brightly colored enamel model-airplane paint made by Testor. His small animal designs were traced from templates, giving them all a uniform quality from painting to painting. Dey was meticulous in his work, often going over a painting with a magnifying glass to make sure that nothing, to his eye, was "wrong."

It is believed that the artist completed about 650 paintings, ranging in size from a few inches square to 20 by 50 inches. Many of his earlier works were given away and may have been destroyed.

ARTISTIC RECOGNITION

"Uncle Jack" Dey's sense of design, his powerful images, his ability to tell satirical stories, and his eye for dramatic patterns have earned him a reputation as an outstanding and appealing folk painter. Today his paintings are in many museums, including the Museum of American Folk Art in New York City and the Museum of International Folk Art in Santa Fe, New Mexico, as well as in private collections.

THORNTON ("BUCK") DIAL, SR.

—"I make art about life—things people do, some that are true, and some that ain't."

BIOGRAPHICAL DATA

Born September 10, 1928, Emmel (near Livingston), Alabama. Attended school through fourth grade. Married Clara Mae Murrow, July 15, 1951. Three sons, two daughters. Now resides Bessemer, Alabama.

Thornton Dial, Sr., A Man's Mind Is Like a Basket, *1989. Oil on canvas, 36 × 48 in. Museum of American Folk Art, New York. As shown here, the work of the Dial family patriarch often features African-American and social themes, and it may be admired as much for its bold, expressionistic technique as for its colorful, poetic design.*

GENERAL BACKGROUND

Thorton Dial, Sr., patriarch of a clan of highly talented artists, is a painter and sculptor who has produced dramatic and colorful works of folk art.

Dial has always been a jack-of-all-trades: a carpenter, a house painter, a cement mixer, and an iron worker. For almost thirty years (1952–1980), he worked on and off for the Pullman Standard Company (known for its railroad cars) in Bessemer, Alabama; during periods of lay-off and when the company closed, he worked for the Bessemer Water Works fixing broken pipes under the streets.

Today Dial raises turkeys and is in business with his sons making wrought-iron lawn and patio furniture when he is not making art.

ARTISTIC BACKGROUND

"I was always making ideas," Dial says, "but the notion that they were art never occurred to me until I met Bill Arnett" in 1987. Arnett, a folk art collector and dealer from Atlanta, encouraged Dial and other members of his family, and arranged showings of their work at the High Museum of Art in Atlanta (1988) and at the INTAR Latin American Gallery in New York City (1989).

Two of Dial's sons, Thornton, Jr., and Richard, are folk artists, and his daughter Mattie occasionally makes pieces.[1] Other family members are also becoming recognized as folk artists.[2] Although the whole family congregates in Dial's backyard and shop, he says that they do not collaborate; each individual makes his or her own pieces.

SUBJECTS AND SOURCES

Thornton Dial has deep convictions concerning racial relationships in this country, as the artist's work expresses. His assemblages represent "what makes up the world" as he sees it: relationships between the races and between men and women; individuals in conflict and in harmony with nature and the community. One of his underlying and recurring themes is the struggle of blacks—both men and women—in society; God's concern for mankind is another. He deals with these themes as fables and relates them through the media of constructions or assemblages and paintings. Sometimes his fables are very complex and include animal symbols as well as human forms.

MATERIALS AND TECHNIQUES

Dial does not limit himself to one mode of expression; he paints and he sculpts. His paintings are done with oil-base and water-base paints in bold colors. His sculptures are made from materials that he collects—pieces of tin that he cuts into shapes, tree roots, wood, bottles, carpet, and plastic; he also often welds pieces of metal together. He sometimes attaches pieces of tin or other objects to his paintings to create dramatic assemblages.

The artist has made hundreds of objects, but about three hundred are considered major works. His pieces are usually large, measuring around 4 feet square to 4 by 6 feet.

ARTISTIC RECOGNITION

Black folk art, now a recognized genre, has been on the increase throughout the deep South, and "Buck" Dial's work presents a good example. His paintings can be enjoyed as much for their colorful, flat, poetic design as for their social commentary, and his large sculptural assemblages, which are a unique contribution to folk art, are as important for their messages as for their artistic value.

THORNTON ("LITTLE BUCK") DIAL, JR.—*"Man Can't Stop the Termite."*

BIOGRAPHICAL DATA

Born December 21, 1953, Bessemer, Alabama. Attended William A. Bell High School through eleventh grade, Bessemer, Alabama. Married Angela Campbell, April 1972; divorced 1981. Married Angela Jackson, April 11, 1986. One son, one daughter by Campbell; one son, one daughter, one stepdaughter by Jackson. Now resides Bessemer, Alabama.

GENERAL BACKGROUND

Thornton Dial, Jr., known within his family as "Little Buck"—his father, folk painter Thornton Dial, Sr., is called "Buck"[1]—is an artist who is developing his own potent style in the compelling painting/assemblages that he produces.

Dial grew up in Bessemer as part of a large and close-knit extended family. After leaving high school, he worked for seven or eight years for a construction company in the Bluff Park area of Birmingham, Alabama. He then returned to Bessemer, where he operated punch-and-shear machines for the Pullman Standard Company; he says that it was on this job that he learned to bend and shape iron, a skill that he put to good use when he turned to art.

Thornton Dial, Jr., King of Africa, *1989. Carpet, bondo, and enamel on incised wood, 48 × 72 in. Museum of American Folk Art, New York. This assemblage, with its strong lines and vibrant colors, is typical of Dial's style but includes less symbolism than many of his other works.*

ARTISTIC BACKGROUND
"Little Buck" Dial began his artistic activity about 1986, inspired by works of art in his father's backyard.

SUBJECTS AND SOURCES
The paintings, sculptures, and assemblages of Thornton Dial, Jr., almost always deal with social conditions and the relationships between blacks and whites or man and nature. His subject matter is often complex—a gorilla lending a helping hand to the United States and to the telephone company symbolizes the role of blacks in building the country—and he sometimes repeats images in series in order to make his point. For example, one of his series uses insects as symbols of the social conditions prevailing in the black world; a work in this group entitled *Role Model* shows a butterfly emerging from a cocoon.

MATERIALS AND TECHNIQUES
The artist expresses himself through bold lines and strong colors. His paintings are usually done with oil-based enamel house paints on board. Dial says he prefers basic materials to "artist's paint." His sculptures are most often made of cut-out sheet metal, although his work also includes some crucifixes made of iron. The assemblages are combinations of various materials, some found, some purchased.

Dial has made about 150 pieces to date. They range in size from about 4 feet square to 4 by 6 feet.

ARTISTIC RECOGNITION
The work of Thornton Dial, Jr., as well as that of other members of this artistically prolific family, provides a good illustration of where black folk art is today. His pieces are stimulating and thought-provoking, as much for their social statements as for their intrinsic artistic merit. He is receiving much-deserved attention from collectors, galleries, and museum personnel and was included, along with the work of other family members, in an exhibition at the High Museum of Art in Atlanta, Georgia, in 1988. One of his works is now in the permanent collection of the Museum of American Folk Art in New York City.

RICHARD DIAL

BIOGRAPHICAL DATA
Born January 26, 1955, Bessemer, Alabama. Graduated from Hueytown High School and attended Bessemer Technical School for two years, both in Bessemer, Alabama. Married Belinda Davis, August 27, 1976. Two sons. Now resides Bessemer, Alabama.

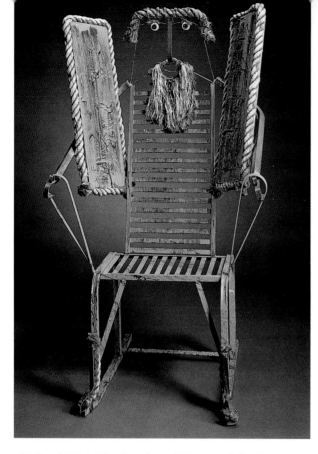

Richard Dial, The Comfort of Moses and the Ten Commandments, *1988. Steel, wood, bondo, hemp, and enamel, 56 × 33 × 31 in. Museum of American Folk Art, New York. With their whimsical titles, Dial's metaphorical chair sculptures that may or may not be used for sitting are the keystone of the artist's work.*

GENERAL BACKGROUND

Richard Dial follows in the artistic footsteps of his father, Thornton Dial, Sr., and his brother, Thornton Dial, Jr., but has chosen sculpture as his mode of expression.[1]

Dial learned how to handle basic machinery when he attended trade school, then worked for a few years in a small machine shop near his home. Like other men in his family, he spent part of his working life employed by the Pullman Standard Company in Bessemer. After Pullman closed down, he did maintenance work for the Mayfield Manufacturing Company but in 1984 became the driving force behind Dial Metal Patterns, a family-run business whose chief line—Shade Tree Comfort—is lawn and patio furniture.

ARTISTIC BACKGROUND

Inspired by the work of his father and older brother, Richard Dial carried the idea of the family lawn furniture business one step further—he began to create lawn chairs that not only were usable but were art pieces as well.

SUBJECTS AND SOURCES

Dial sends metaphorical messages and makes social commentaries through his unusual chairs. His sculptured furniture is sometimes whimsical and often has an accompanying philosophical narrative. The pieces may be given titles with an underlying sense of irony—for example, in one series of works, all titles include the word *comfort: The Comfort of Money* is a sly jibe at materialism, and *The Comfort of Moses and the Ten Commandments* is a comment on the need for law and order in a community.

MATERIALS AND TECHNIQUES

The artist uses the metal-working skills he learned in his earlier years to make his chairs, which are constructed of steel. He bends the metal to shape, welding pieces as necessary to present his message, then sometimes, but not always, Dial's younger brother, Dan, assists him in making the chairs.

The artist has made about forty sculptural chairs. They vary in size but are generally somewhat larger than regular patio-type chairs. Occasionally he has done other kinds of furniture.

ARTISTIC RECOGNITION

Richard Dial's unique chairs are filled with ideas and symbols and commentary on the world around the artist. His work has only recently begun to gain greater recognition; it was included, along with the work of other members of the Dial family, in an exhibition at the High Museum of Art in Atlanta, Georgia, in 1988. *The Comfort of Moses* is now in the permanent collection of the Museum of American Folk Art in New York City.

CHARLES DIETER—*"I couldn't teach the boys [Charlie Dieter and "Old Ironsides" Pry]. Those two boys had their own way of doing things." (Mary Brown Thompson)*

BIOGRAPHICAL DATA

Born January 30, 1922, Little Gap, Pennsylvania. Received some grade school education at the Little Gap School. Never married. No children. Died August 21, 1986, Weatherly, Pennsylvania.

GENERAL BACKGROUND

Charlie Dieter created delicate and childlike drawings of his own world, both real and imaginary.

Dieter devoted much of his life to taking care of his mother. When she died in 1969, he entered the Carbon County Home for the Aged (now called Weatherwood), even though he was only forty-seven years old.

Dieter had held a few jobs before his mother's death. For a short while he was a carpenter's helper and a caretaker, but apparently he had his own private sense of reality that prevented regular and ongoing employment. Once he moved to the home, Dieter would often stand on the lawn directing an imaginary band; he even drew several pictures of his band, naming each member in it.

ARTISTIC BACKGROUND

In 1969 Dieter joined an art class conducted by Mary Brown Thompson at the Weatherwood Home for the

Charles Dieter, Girls and Boys, *1984. Colored pen on paper, 18 × 24 in. Epstein/Powell Gallery, New York. Dieter loved to draw memories of his school days, and this picture brings to mind a school party and the charm of a first romance. In contrast to some of his other works, this drawing does not name the individuals depicted.*

Aged. His now-famous sidekick, "Old Ironsides" Pry, had no use for art class, although he was enrolled in it as well, but Dieter loved to sit and draw. Dieter went with Ironsides to a Carbon County Fair, where he was introduced to Sterling Strauser, an artist, friend, and promoter of many folk artists. "I draw art too!" Dieter proudly announced to him.

Dieter then became part of the "Strauser Circle," which included such artists as Justin McCarthy (see page 198), Old Ironsides Pry (see page 248), Jack Savitsky (see page 270), and Victor Joseph Gatto (see page 135). He was encouraged to enter his work in various shows, and soon began winning ribbons for his pictures at local fairs.

SUBJECTS AND SOURCES
Dieter drew his private world—the house he grew up in; his friends; the fields, woods, and animals familiar to him; his grade school class, with each classmate named; and his imaginary band. Dieter's subjects often stand stiff and straight, as though they were staring into a camera lens.

MATERIALS AND TECHNIQUES
Dieter drew on paper and paperboard with pen, ink, pencil, and crayon. His drawings range from 10 by 11 inches to 24 by 36 inches. In all, he made about two hundred drawings.

ARTISTIC RECOGNITION
Dieter's drawings are delicate, colorful, and have an unreal, somewhat intangible quality that is quite endearing. Without exception, the drawings are uniform in quality.

SAMUEL PERRY ("S. P.") DINSMOOR—*"[On Resurrection morn] if I have to go up, I have a cement angel outside, above the door, to take me up. If I have to go below, I'll grab my [two-gallon cement] jug and fill it with water on the way down. I think I am well prepared for the good old orthodox future."*[1]

BIOGRAPHICAL DATA
Born March 8, 1843, near Coolville, Ohio. Received some education. Married Frances Barlow, August 24, 1870, on

Samuel Perry Dinsmoor, Garden of Eden, *1907–1929. Cement and limestone environmental sculptures, Lucas, Kansas. Dinsmoor's original "Rock Log Cabin" in Lucas, Kansas, is surrounded by many of the massive concrete sculptures that comprise his spectacular environment.*

horseback; she died 1917. Married Emilie Brozek, 20 years old, 1924. Seven children; four sons, one daughter by Barlow; one son, one daughter by Brozek. Died July 21, 1932, Lucas, Kansas.

GENERAL BACKGROUND
Samuel Perry Dinsmoor was a folk sculptor whose massive "Garden of Eden" ranks among the most original of the environments of this century.

A veteran of the Civil War, Dinsmoor taught school in rural Illinois for five terms, farmed in Nebraska, and fi-

nally settled down on a farm near Lucas, Kansas, with his first wife, Frances, in the fall of 1891.[2] In 1905 Dinsmoor bought a half-acre corner lot in Lucas and embarked on the massive project that was to occupy him almost full-time for more than twenty years.

In the yard surrounding the eleven-room "Rock Log Cabin" home that Dinsmoor built of local limestone, he created a "Garden of Eden," complete with Adam and Eve, the serpent, Cain and Abel, the goddess of Liberty, flags, soldiers, Indians, animals, birds—150 pieces of sculpture in all. The Garden, completed in 1929, is the principal tourist attraction of the town of Lucas, population 500.

Dinsmoor had to abandon work on the Garden in the late 1920s because of blindness caused by cataracts. He died in 1932 at the age of eighty-nine and was buried next to his first wife in a concrete mausoleum and glass-covered concrete coffin that he had designed and built himself.

ARTISTIC BACKGROUND

Nothing in Samuel Dinsmoor's early life explains the creation of the Garden of Eden. It was while building his home, completed in 1907, that Dinsmoor first experimented with concrete, which he went on to use throughout his construction of the Garden. The permanence of the material seems to indicate that he expected the Garden to endure, as indeed it has.

Dinsmoor's Garden surrounds his house; the massive sculptures begin with *Adam and Eve* and end with the *Crucifixion of Labor* group (a clever and cynical depiction of labor being crucified by "grafters"—Dinsmoor's term—a lawyer, doctor, preacher, and banker). Among the many sculptures is a 4-by-7-foot concrete flag that turns on ball bearings.

Dinsmoor intended his Garden to be seen. He was an early user of electric lights, which not only illuminated the Garden at night but directed special attention to certain features. For example, a light bulb is at the center of *God's All-Seeing Eye,* a sculpture that overlooks the entire Garden, and a light behind the devil's eyes give the impression of a glowing stare.

SUBJECTS AND SOURCES

Dinsmoor's themes are primarily biblical, with the carved stone sign at the entrance leaving no doubt by proclaiming the site the "Garden of Eden." The artist used to say, "If the Garden of Eden is not right, Moses is to blame. He wrote it up and I built it."

Dinsmoor also had strong sentiments about the world he lived in, and the Garden was a forceful visual allegory of his political beliefs. For example, a scorpion representing monopolistic industries, or trusts, is shown protected by the American flag in one sequence, but in *The Liberty Tree,* Dinsmoor's goddess of Liberty is thrusting a spear through the head of the scorpion. The artist felt strongly that the trusts had grown too big and were too well protected by the government; he thought they should be done away with at the polls. He declared, "This is modern civilization as I see it."[3]

MATERIALS AND TECHNIQUES

Dinsmoor worked with native limestone, cement, and various woods. The house is made of limestone, and the large sculptures are concrete, molded wet over chicken wire. Almost all the pieces are substantially overbuilt, another indication of Dinsmoor's long-term intentions for his "Garden of Eden."

By the time he stopped work, Dinsmoor had used more than 113 tons, or about 2,273 sacks, of cement in the Garden of Eden.[4]

ARTISTIC RECOGNITION

Samuel Dinsmoor's Garden of Eden is included in the National Register of Historic Places. It is a massive and impressive monument to a man and his beliefs. After "Watts Tower,"[5] the Garden is probably the best-known surviving environment built in the twentieth century.

WILLIAM DORIANI

BIOGRAPHICAL DATA

Born January 27, 1891,[1] Ukraine. Studied music in Italy and Russia. Wife's name and date of marriage unknown. At least one son. Date of death unknown, probably New York City.[2]

GENERAL BACKGROUND

Although William Doriani was considered one of the best painters of his generation, little is known about him except that he was an opera singer before becoming an artist. He came to America as a child but returned to Europe as an adult to study music and pursue a career as an operatic tenor for thirteen years.

Doriani reportedly had a successful career in the opera in Europe. When he returned to this country, operatic work was difficult to obtain, and during the 1940s Doriani worked for the Federal Art Project of the WPA (Work Projects Administration).

ARTISTIC BACKGROUND

William Doriani seems to have been seized by a creative urge to paint in Europe. He painted his first work, *Toe Dancer,* in 1931 and continued painting into the early 1940s.

Doriani never showed his work while he was in Europe, but following his return to the States, he participated in the Washington Square Outdoor Art Mart in Greenwich Village in New York sometime in the 1930s. There he was discovered by Sidney Janis, an important art dealer. After that, Doriani was included in exhibitions at the Museum of Modern Art and represented by the Marie Harriman Gallery in New York. His first one-person show was in March 1939.

SUBJECTS AND SOURCES

William Doriani liked to depict dramatic moments in paint —ballet dancers on point, actors on stage. He often isolated individual performers in order to give greater emphasis to the central figure. In addition to theatrical scenes, he also painted domestic activities and politicians like Theodore Roosevelt.

It is said that Doriani returned from Europe to New York on Flag Day and was so overcome with emotion that he included the parade he saw that day in what was to become his most famous painting.

MATERIALS AND TECHNIQUES

Doriani worked in oils on canvas. Although the exact number is not known, he probably executed fewer than one hundred paintings in addition to some drawings. The works range in size up to about 13 by 39 inches.

ARTISTIC RECOGNITION

William Doriani is best known for his painting *Flag Day,* now part of the permanent collection of the Museum of Modern Art. His work has not been widely exhibited for many years because his rather theatrical style of painting

William Doriani, Flag Day, *1935. Oil on canvas, 12¼ ×*
38⅝ in. Museum of Modern Art, New York; Sidney and
Harriet Janis Collection. Doriani is best known for this
theatrical painting of a Flag Day parade he attended in New
York on the day he returned to the United States after
spending thirteen years in Europe.

has to some extent gone out of style. He is remembered
because he was considered one of the best painters of the
time by critics during the late 1930s and 1940s, and it is
important to place him in historical context.

SAM ("UNCLE SAM") DOYLE—

"Making pictures keeps me busy. When folks carries them
away, I got to replace them back."

BIOGRAPHICAL DATA
Born March 23, 1906, St. Helena Island (near Beaufort),
South Carolina. Attended Penn School, private vocational
school for blacks on St. Helena Island, through ninth
grade. Married Maude Thelma Brown, 1932; divorced,
early 1950s. Three children. Died September 24, 1985, St.
Helena Island.

GENERAL BACKGROUND
Sam Doyle was a black artist whose paintings reflect the
culture and traditions of St. Helena Island, off the coast of
South Carolina.

At the end of the Civil War, the plantations on St. Hel-
ena, an isolated island inhabited almost solely by blacks,
were divided up among the slaves who had worked them.
Sam Doyle's grandparents received 15 acres, and they and
their children continued to work the land and make the
island their home. Doyle, however, seemed to have had
mixed feelings about his heritage: "My father planted these
acres to raise nine of us," he said. "But today I just pays
the taxes and lets it grow."

Doyle attended school on the island, where his school-
mates gave him the nickname "Uncle Sam." An im-
properly treated foot injury left him with a life-long limp.
After leaving school, he worked off the island, first as a
clerk in Beaufort, South Carolina, then as a porter for the
McDowne Company, and later in the laundry at the Parris
Island Marine Base. In 1932 Doyle's "boss man" at Mc-
Downe introduced him to Maude Thelma Brown, who
was visiting Beaufort from New York City, and they were
married soon after. The isolated life of the island did not
agree with her, however, and she returned to New York

with their children around 1944. Doyle worked full-time until the 1960s, when he retired except for a part-time job as caretaker for the Chapel of Ease, the ruins of a church.

ARTISTIC BACKGROUND

When he was in school, Doyle was encouraged to draw by his teachers, but he did little artwork until the 1940s, when he took up drawing and painting again. After he retired, he began to paint more seriously and on a larger scale, hanging his work on a clothesline or leaning pieces against a tree for the world to see. Almost all of his paintings are simple, colorful representations of local or national personalities, with the figures prominent and the backgrounds almost nonexistent.

SUBJECTS AND SOURCES

St. Helena was virtually isolated from the mainland of South Carolina until the 1920s, when a bridge was built; this isolation helped to perpetuate a local dialect called Gullah (still spoken extensively on the island) and the practice of voodoo, which persists, at least among the older generation. These two cultural traditions, as well as other bits of island lore and island residents, are reflected in Sam Doyle's art. He painted the local root doctors (practitioners in the voodoo tradition), sports figures such as Larry Rivers and Joe Louis, members of his own family, historical figures such as the first black midwife on the island, and his island friends. He frequently labeled his work, using such descriptive names as *Le Bit* (for the smallest girl in town), *We We,* and *Try Me.* He drew inspiration from many local sources and once said, "My favorite painting is most anything that jump out of my head."

MATERIALS AND TECHNIQUES

Doyle's major works are on panels of used roofing tin or plywood—some as large as 6 by 10 feet—painted with enamel or latex house paint. He often glued objects to the panels for greater effect or to complement the figure shown; for example, in his painting of a local root doctor, Buz (for Buzzard), he glued a conch shell, as Buz gets his "cures" from a conch shell. Doyle also did some watercolors on paper, a few drawings on window shades, some small wooden animals that he covered with tar, and two or three painted voodoolike sculptures that are almost life size. In all, he made almost three hundred objects.

ARTISTIC RECOGNITION

Doyle's paintings from the 1970s and early 1980s form an

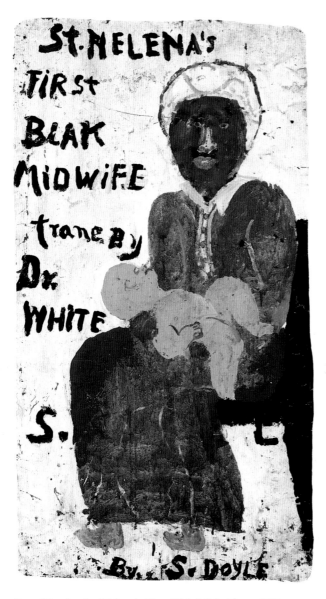

Sam Doyle, St. Helena's First Blak Midwife, c. 1980.
*House paint on used roofing panels, 50½ × 21⅜ in. Chuck
and Jan Rosenak. Doyle was proud that one of his grand-
mothers, pictured here, was the first black midwife on Saint
Helena Island, in South Carolina, and her achievement is a
theme in his paintings.*

PETER PAUL ("UNCLE PETE") DRGAC

BIOGRAPHICAL DATA
Born July 21, 1883, Nový Tabor, near Caldwell (100 miles
northwest of Houston), Texas. Educated through seventh
grade, Shady Grove School, Cook's Point, Texas. Married
Francis Mrnustik, December 26, 1905; she died 1962. No
children. Died November, 12, 1976, Caldwell, Texas.[1]

GENERAL BACKGROUND
"Uncle Pete" Drgac's highly stylized, unusually colored
works on paper have a quality reminiscent of prehistoric
cave paintings.

Drgac was born of Czech parents on a Texas farm. He
worked as a carpenter and house painter and built two
homes for himself over the years. In 1916 Drgac and his
wife began to operate a grocery/bakery in Caldwell,
Texas, later moving their business to Rosenberg, 100 miles
to the south. Although the couple had no children, they
had nieces and nephews who called Drgac "Uncle Pete," a
name by which he became generally known.

Peter Paul Drgac, Reindeer and Rider, *n.d. Enamel paint
on poster board, 25 × 23½ in. Butler and Lisa Hancock.
Drgac's highly stylized figures, reflecting his interest in
animals and people, have lively and appealing qualities.*

extraordinary body of work documenting the lore and cul-
ture of St. Helena. His later works, however, have some-
what less vitality; Doyle tended to repeat his more popular
themes and lost some spontaneity in the process. From
about 1982 on, Doyle's work began to be seen and appre-
ciated—and bought—by a wider audience, and his repu-
tation has continued to grow.

In 1955 the Drgacs retired and returned to Caldwell, where they lived for the remainder of their lives.

ARTISTIC BACKGROUND
After the death of his wife in 1962, Drgac was despondent. One day he decorated a flowerbox and found that it helped to take his mind off his bereavement. Soon he was painting everything; he decorated several rooms of his house, even the ceilings, then went on to other objects, as well as paper and board.

When Drgac died, his nephew Joseph J. Skrivanek, Jr., distributed the work to relatives. Some of the pieces found their way to the Leslie Muth Gallery in Houston, and Muth has been instrumental in getting Drgac's work known.

SUBJECTS AND SOURCES
Drgac's Czech heritage is evident in his work, but his art extends far beyond the traditions of decorated Easter eggs and designs on furniture. Uncle Pete's designs are composed of simple figures and brightly painted animals—cattle, birds, pigs, rabbits, and dogs—and he sometimes included out-of-scale people mounted on, or sitting among, the animals. Other themes include portraits of friends or relatives juxtaposed with objects from their homes.

MATERIALS AND TECHNIQUES
Although Drgac painted designs on objects (egg cartons, soda bottles, or used light bulbs, to name a few), his important work is on cardboard, paper, or poster board. He usually applied a light wash of white or gray to the paper and then painted over that with enamel paints. He liked to create patterns of contrasting colors in his work; for example, his horses are often red, his rabbits blue. Drgac's figures tend to be stylized and repetitive, forming colorful designs against the gray or white backgrounds.

There are tack holes in the corners of some of Drgac's work, because the artist hung them in this fashion on his walls. In all, Drgac executed more than two hundred paintings. The usual size of these works is about 11 by 17 inches.

ARTISTIC RECOGNITION
Drgac's unique and eccentric work has not yet been widely displayed. His early drawings, or the drawings with human figures, are rare. The artist's best and most prolific period occurred in 1975, the year before he died.

WILLIAM EDMONDSON—*"Can't nobody do these [sculptures] but me."*

BIOGRAPHICAL DATA
Born between 1865 and 1883, probably 1870 (the family Bible in which his birthdate was recorded was destroyed by fire, but family members have used 1870 as his birthdate), Davidson County, Tennessee (just outside Nash-

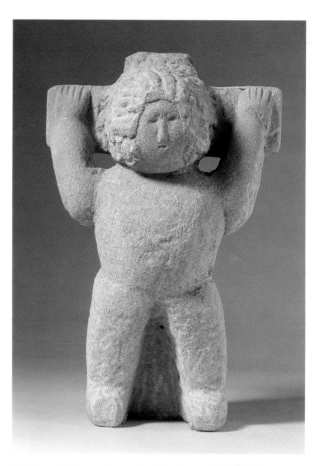

William Edmondson, Crucifixion, *c. 1932–1937. Limestone, 18 × 11⅞ × 6½ in. National Museum of American Art, Smithsonian Institution, Washington, D.C.; Gift of Elizabeth Gibbons-Hanson. Typical of William Edmondson's timeless work, this limestone carving is direct yet moving and has great visual and dramatic impact.*

ville). Received little formal education. Single. No children. Died February 8, 1951.

GENERAL BACKGROUND
The child of freed slaves, William Edmondson is among the most acclaimed of black folk sculptors of the century.

Like so many black men of his times, he was a menial laborer, working first as a farmhand and then in the yards of the Nashville, Chattanooga & St. Louis Railway. When a job-related accident caused him to leave the railyards in 1907, Edmondson went to work as a janitor in the Women's Hospital (later the Baptist Hospital) in Nashville, Tennessee, where he stayed from 1908 until the hospital closed in 1931.

It was shortly after the hospital closed that Edmondson was inspired to begin carving, and he worked on his sculpture until his death in 1951. For two brief periods, in 1939

and again in 1941, he was employed by the sculpture section of the WPA (Work Projects Administration); otherwise he supported himself by his carving and by selling vegetables from his garden.

ARTISTIC BACKGROUND
William Edmondson claimed to have had many visions, but none were so clear as the one around 1932 in which the Lord told him to take up tools and become a stone carver.[1] He followed the Lord's directions; his first carvings were memorials, often commissioned by members of his church (Edmondson was a devout member of the Primitive Baptist congregation), but soon he was carving other subjects. "God was telling me to cut figures," he said. "First He told me to make tombstones, then He told me to cut the figures."[2] The figures got larger and more complicated as the artist progressed.

Sidney Hirsch, a writer, scholar, and intellectual in Nashville who was associated with the 1920s Fugitive movement in poetry, was Edmondson's neighbor. He introduced the artist's work to other Nashville intellectuals and artists. Word of his superb work spread rapidly, and by 1937 Edmondson was honored by the first individual show ever given a black artist at the Museum of Modern Art in New York City.

SUBJECTS AND SOURCES
William Edmondson carved numerous memorials, tombstones, and small decorations for tombstones in the local black cemetery, but his masterpieces are the figurative sculptures—from cartoon characters like Orphan Annie to celebrities (a regal Eleanor Roosevelt) and from simple everyday people like a bride and groom and a preacher to such biblical subjects as Adam and Eve, Noah's Ark, and wonderfully serene angels.

Whatever the artist touched, his fundamental religious beliefs, his simple straightforward style, and his inner vision were added to the stone.

MATERIALS AND TECHNIQUES
Edmondson carved only in limestone, which was available locally and cheaply; it was delivered to his yard by wrecking companies. The sculptor fashioned some of his own tools—chisels from railroad spikes, for instance—and had different tools for rough carving and for the finer, more finished work. He smoothed his final product with a rasp.

Edmondson made several hundred limestone sculptures, ranging in size from small birds to pieces around 25 by 15 by 20 inches.

ARTISTIC RECOGNITION
Perhaps the most highly regarded and best-known black sculptor of this century, William Edmondson can be ranked among the best of any sculptors of international standing. His classic works are timeless, simple yet sophisticated, and beautiful. Most Edmondson sculptures are in museum collections, including those of the Abby Aldrich Rockefeller Folk Art Center in Williamsburg, Virginia; the Newark Museum in New Jersey; the Smithsonian Institution's Hirshhorn Museum and Sculpture Garden in Washington, D.C.; the University of Rochester Art Gallery, Rochester, New York; and the Museum of the University of Tennessee in Knoxville. When the state of Tennessee opened a new museum in 1981, it honored the work of this native artist with a special exhibition.

ROSE ERCEG

BIOGRAPHICAL DATA
Born Ruza Peric, December 20, 1898, Kamenmost (near Imotski), Yugoslavia. No formal education (taught herself to read and write both Serbo-Croatian and English). Married Matt Erceg, c. 1922; he died 1959. Seven daughters, two sons. Now resides Portland, Oregon.[1]

GENERAL BACKGROUND
Rose Erceg creates semi-abstract memory paintings that recall her native Yugoslavia.

Erceg was born in a small farming village in Yugoslavia, near the Adriatic Sea, and has never forgotten her homeland. She fondly remembers each and every building in the village, and can relate the details of doing her chores, which included taking care of the cows and growing tobacco. In 1922 Erceg immigrated with her husband to Clairton, Pennsylvania, where he became an industrial worker. She never worked outside of the home.

The Ercegs moved to Portland, Oregon, where she still lives, in 1925. She began to paint shortly after the death of her husband.

ARTISTIC BACKGROUND
In 1961 Erceg's son Joseph, a commercial artist, fulfilled his mother's request for watercolors and paper. "I did it," he said, "so she'd have a hobby. But, as it turned out, she had a great talent."

Even though her health is now failing, Erceg continues with her watercolor painting.

SUBJECTS AND SOURCES
Most of Erceg's paintings are of Kamenmost, the small village that is her birthplace; she paints the bright tile roofs, the crooked, narrow streets, and the hillside farms she remembers. On occasion she paints sailboats or a larger city.

Erceg may be considered a memory painter, but her work does not take the usual form of memory painting. Her scenes are more abstract, and she makes no attempt at precise detailing.

MATERIALS AND TECHNIQUES
Erceg works with broad, sure strokes of bright color, using watercolor pigments on paper. She creates perspective by building her subject matter up both vertically and horizontally. Although she relies mostly on her memory, Erceg also uses photographs as guides.

The artist has completed about three hundred watercolors, most of them around 10 by 12 inches in size.

Rose Erceg, Red Roofed Town, *1987. Watercolor on paper, 9 × 12 in. Jamison-Thomas Gallery, Portland, Oregon. A memory painter, Erceg often uses watercolor to portray the small Yugoslavian town in which she was born, as in the example shown here.*

ARTISTIC RECOGNITION

Rose Erceg's broad brushstrokes of color and her sensitive instinct for space and form, combined with the uniqueness of her subject matter, make for memory painting that is highly unusual. Her best work was done in the 1960s and 1970s, and her watercolor renditions of her native Yugoslavia are the most appreciated.

Erceg's work has not been widely exhibited, but it was included in "Pioneers in Paradise: Folk and Outsider Artists of the West Coast," a traveling exhibition that opened at the Long Beach Museum of Art, Long Beach, California, in 1984.

ANTONIO ESTEVES

BIOGRAPHICAL DATA

Born May 17, 1910, Rio de Janeiro, Brazil. Attended school through sixth grade. Married Marie Troise, c. 1930; she died November 28, 1974. Three sons, two daughters. Died July 2, 1983, Brooklyn, New York.

GENERAL BACKGROUND

Antonio Esteves was a self-taught artist who painted both religious and imaginary subjects in an original and expressionistic style.

Esteves did not have an easy childhood. His mother died soon after the family came to America, and his seafaring father was rarely around to take care of the young boy. Esteves was left to fare the best he could with relatives and friends, and occasionally he had to fend for himself on the streets of New York City.

Esteves spent most of his adult working life as a superintendent in various Brooklyn apartment buildings. Around 1970 he was seriously injured in an apartment building boiler explosion. He received a settlement of $500,000 from the accident, and with the money, he bought a building and opened the Eastern Pet Company and became an importer of exotic animals.

ARTISTIC BACKGROUND

After Antonio Esteves was injured in the explosion, his

Antonio Esteves, The Crucifixion, 1978. Acrylic on wood, 35½ in. diameter. Robert Bishop. In a vivid and intense Crucifixion scene, Esteves successfully presents his interpretation of this biblical event.

son, George, bought him a "paint by numbers" kit to help take his mind off the pain during his long period of recuperation. Esteves decided he did not like the numbers and threw the kit away; however, he did like the idea of painting and began to do it on his own, finding that it fulfilled a personal need for expression. He once referred to his painting as a "hobby got out of hand."

Esteves lived in a building directly opposite the Brooklyn Museum, which sponsors an annual outdoor art show; the artist entered the show one year and not only sold some of his works but won a prize as well. When the museum exhibited one of Esteves's paintings in 1976, it was seen by Stephen Gemberling, a gallery owner who then became his agent.

SUBJECTS AND SOURCES
Antonio Esteves's paintings are adventures of the mind, and his subject matter varies considerably, from the religious through the secular. He painted as though he had been present when Christ was crucified, when Noah built his ark, or when his own father fished for whales. Books discarded by apartment tenants helped to fuel his imagination for topics.

MATERIALS AND TECHNIQUES
Esteves expresses the colors of his dreams using inexpensive paints that he purchased or house paints left over from

the apartments in his building. He painted on abandoned furniture, tabletops, or boards that he precoated with white paint to give a base for the other colors. When a work was complete, he would varnish it.

Esteves completed about 150 paintings, in sizes up to about 35 by 45 inches.

ARTISTIC RECOGNITION
Antonio Esteves's religious journeys and fantasy adventures were created in an expressionistic style unusual for his time and place. Esteves's work is well known to collectors, and he is included in the collection of the Museum of American Folk Art in New York City.

MINNIE EVANS—*"No one has taught me about drawing. No one could because no one knows what to teach me. No one has taught me to paint. It came to me."*

BIOGRAPHICAL DATA
Born Minnie Jones, December 12, 1892, Long Creek (Pender County), North Carolina. Left school after promotion to sixth grade. Married Julius Evans, 1908; he died December 6, 1956. Three sons. Died December 17, 1987, Wilmington, North Carolina.[1]

GENERAL BACKGROUND
Minnie Evans created richly colored paintings with romantic and mystical overtones that have earned her well-deserved recognition.

Born into southern black poverty, Evans was brought as an infant to Wilmington, North Carolina, to live with her grandmother, Mary Croom Jones. Too poor to continue in school after she reached sixth grade (she loved studying history and reading about the gods, even though she disliked school in general), Evans went to work as a "sounder," a hawker of seafood from the Delaware Sound.

About 1918 she was employed as a domestic at Pembroke Park, an elegant estate that was the home of Mr. and Mrs. Pembroke Jones. She was awed by the lifestyle and the people and named her sons after the New York millionaires who came there to hunt. In 1948 Evans became the gatekeeper at Airlie Gardens, where she loved the profusion of flowers and color that surrounded her.

Evans's health failed around 1974, and she moved into the home of her son George in Wilmington. She died in a nursing home a few days after her ninety-fifth birthday.

ARTISTIC BACKGROUND
On Good Friday in 1935, Minnie Evans created her first two drawings (now in the collection of the Whitney Museum of American Art, New York City). She claimed that no one taught her to draw, that it just came to her: "In a dream it was shown to me what I have to do, of paintings. I never plan a drawing. They just happen."[2] However, she did not draw again until the 1940s, when she would sit in the gatehouse at Airlie House and draw, selling her finished work to tourists.

In 1962 Evans met Nina Howell Starr, a collector and

patron of the arts who recognized the intrinsic beauty and uniqueness of Evans's work. Starr purchased about five hundred of her drawings, helped Evans to sell her art, and arranged for showings of her work.

SUBJECTS AND SOURCES

In her art Evans combined her studies of the Bible and mythology with her love of the profusion of blooms that make up Airlie Gardens at its peak. Her days, her dreams, her fantasies were filled with floral beauty and heavenly and mythological subjects, which she captured in her colorful and romantic landscapes. She said, "We talk of heaven, we think everything is going to be white. But I believe that we're going to have the beautiful rainbow colors,"[3] and she managed to reflect this rainbow of rich and beautiful colors in her work.

Evans's paintings contain a recurring image of a full-lipped face that peers out from—often almost hidden among—the brilliant flowers and fantastic vegetation that overflow her canvases. Sometimes only the piercing eyes of the face are visible; sometimes multiple images of it will appear in one painting, but it is an outstanding characteristic of her work.

MATERIALS AND TECHNIQUES

Evans's drawings from the mid-1940s are done on the reverse side of U.S. Coast Guard stationery, but she soon shifted to canvas board or paper. Evans worked with ink, graphite, wax crayon, and, after 1950, oil paints.

After a trip to New York and a visit to the Metropolitan Museum of Art in 1966, Evans began making larger works. Sometimes, to get a larger format, she would cut several earlier drawings into pieces and recombine them by gluing the pieces onto composition board. Occasionally she would add new images to the collages. Most of her works,

Minnie Evans, Untitled, *1963. Oil on paper, 14½ × 20 in. Luise Ross Gallery, New York. Influenced by the gardens where she worked, Evans often featured lush gardens with imaginary flowers in her visionary paintings, as well as heavenly figures and, in this example, a mystical face.*

however, are relatively small, ranging from 4 by 6 inches to 20 by 23 inches.

Evans was quite prolific, producing about one thousand works during her lifetime. Many of her paintings are signed, although it is known that her granddaughter signed a number of those done during the late 1950s because Evans thought the granddaughter had a better handwriting than she had.

ARTISTIC RECOGNITION

Although Evans's paintings are preferred to her drawings, this artist has been consistent in her production. Both her paintings and drawings have beautiful and mysterious qualities and show a characteristic use of symmetry.

Minnie Evans's work is now in major museums, and she fills an important niche in the folk art history of the twentieth century.

EARL EYMAN

BIOGRAPHICAL DATA

Born Earl Fransler, March 17, 1891, Carthage (near Joplin), Missouri. Graduated from eighth grade, Pawnee, Oklahoma. Married Reba Helen West, March 22, 1914; she died c. 1984. Three sons, one daughter. Died August 21, 1971, Wagoner (east of Tulsa), Oklahoma.[1]

GENERAL BACKGROUND

Earl Eyman was a wood carver who became known for the exquisitely detailed miniature figures that he often assembled into complex tableaux.

Adopted at the age of two, Earl moved with his new family from Carthage, Missouri, to Pawnee, Oklahoma, where he attended school. After graduating from eighth grade, the young Eyman taught in a rural school in the same area.

In 1918 Eyman left teaching and went to work for the Sinclair-Prairie Oil Company in Drumright, Oklahoma. He bought a house for his growing family in Drumright and eventually added a room to it for himself. Called "Eyman's Playhouse," that room was where he carved the thousands of miniature figures that he sometimes assembled into complex tableaux.

Eyman retired from the oil fields in 1956 and moved with his wife to Wagoner, Oklahoma. After suffering a stroke in 1967, he carved only occasionally.

ARTISTIC BACKGROUND

Earl Eyman began carving in his spare time while he was working in the oil fields in the 1920s. After retirement he had more free time and devoted most of it to carving. The artist's work was always well known in the towns where he lived, and hundreds of visitors came to view his delightful compositions.

Eyman's work was included in "American Folk Art from the Ozarks to the Rockies," a show that originated at the Philbrook Art Center in Tulsa, Oklahoma, in 1975 and traveled extensively.

Earl Eyman, Carvings, c. 1930s. Carved and painted wood, approximately 4½ in. high. Private collections; Courtesy America Hurrah Antiques, New York. The depiction of these miniature figures reveals Eyman's mastery of minute detail, such as the rendering of the strings on the instruments.

SUBJECTS AND SOURCES

Earl Eyman carved miniature representations of gala events and activities he had witnessed; a marching band, school houses complete with the graduating class, parades, and circuses are among the more prosaic subjects brought to life in his work. But he also did some works based on illustrations he had seen; the flag raising at Iwo Jima and English tea gardens are among his more complicated tableaux.

One of Eyman's more ambitious and larger works was again based on personal experience; he created an oil field that included working mechanical oil rigs.

MATERIALS AND TECHNIQUES

The artist had an eye for color and detail that enabled him to execute miniature carvings with extreme accuracy. In the 1930s he probably reached the height of his ability to carve minute details, but all of his brightly colored and fanciful carvings are a joy to behold.

Eyman worked in wood, using small hand tools for his miniature works. He painted his pieces with enamel and also used cut and shaped metal decorations and trimmings.

The artist made as many as three thousand individual carvings, but some are part of large tableaux. The carved figures are generally only a few inches high, but the oil field composition has rigs that stand about 16 inches high.

ARTISTIC RECOGNITION

Earl Eyman was a master of miniaturization. He succeeded in capturing dramatic, colorful, and whimsical scenes in his tiny tableaux. In this specialized area the artist is unequaled. His work is well known in New York galleries and was shown at the Museum of American Folk Art in 1978.

JOSEPHUS FARMER—*Farmer explains why he used his guitar to carry his message into the streets: "The average people of my race don't know the value of sculpture. Their ancestors from way back wasn't taught sculpture—not in America. They know music, but not sculpture."*

BIOGRAPHICAL DATA

Born August 1, 1894, on the Cal Foster Farm, near Trenton, Tennessee. Attended some school, Mt. Sinai Methodist Grade School, Humboldt, Tennessee. Married Evelyn Griffin, 1922; she died 1984. One son. Since January 1987 resides Joliet, Illinois.

GENERAL BACKGROUND

Josephus Farmer is a black folk artist and former street preacher widely recognized for his relief wood carvings with religious and historical themes.

"You know," Farmer says, "my grandfather was a slave. My father was born a slave—freed by the Civil War." Farmer himself spent his youth in cotton and corn country, working on farms in the fertile bottomland near Humboldt, Tennessee. In 1917 he moved north, to East St. Louis, Illinois, and obtained a job with the Armour Packing Company, "cleaning up the pork side of the loading dock."

On May 14, 1922, Farmer heard the voice of God. "I received the Holy Ghost, speaking the tongues," he explains; "I was ordained a Pentecostal minister and took to the streets preaching." Farmer composed songs and taught himself to play the guitar, which he used to accompany himself while preaching the gospel. In 1947 he moved his family to Milwaukee, Wisconsin, where he opened a storefront church and obtained a job as a porter in the Randolph Hotel. He retired from that job in 1960.

After the death of his wife, Farmer, who was then in poor health, moved into his son's home in Joliet, Illinois.

ARTISTIC BACKGROUND

In addition to composing his songs, in the 1950s Farmer began to make colorful banners that he would take into the streets with him as preaching aids. After he retired, he began carving reliefs and dioramas; "It was the gift of God," he proclaims.

In the 1970s Farmer's work was exhibited at Milwaukee libraries and galleries. In 1981 he won first prize for sculpture at the Community Arts Festival. This brought his "gift" to the attention of Mr. and Mrs. Richard Flagg, art collectors, and Russell Bowman, the director of the Milwaukee Art Museum, and they helped him receive further exposure.

Farmer had an individual show, "The Gift of Josephus Farmer," at the University of Wisconsin in Milwaukee in 1982 and received the Wisconsin Governor's Heritage Award in 1984.

SUBJECTS AND SOURCES

Farmer's art is of three types: banners or painted canvases, carved wood reliefs, and dioramas. The painted canvases were his props for street preaching, the banner format deriving from "standard theological texts and charts," but they "maintain a system of relationships which only he can decode."[1] The relief wood carvings contain both biblical and historical subject matter—Farmer's version of popular biblical events and his depiction of such political heroes as Abraham Lincoln and John F. Kennedy—and the dioramas document his memories of Tennessee rural life.

Farmer owns the *American Heritage Illustrated History of the United States,* a sixteen-volume work from which he often takes his references and themes. His carvings, however, are uniquely transformed by his "gift."

MATERIALS AND TECHNIQUES

Farmer's banners are painted on unsized canvas. His earlier wood reliefs are made of redwood and mahogany, but after 1983 he preferred softer wood, mostly pine. The dioramas are assemblages of carvings and cloth, plastic, canvas, and other assorted objects. Farmer partially paints his wood with enamel and often attaches rhinestones or other objects to the work.

The banners are about 5 feet high, the wood reliefs about 20 by 35 inches, and the dioramas about 24 by 24 by 10

Josephus Farmer, John the Baptis (in the Wilderness of Judah), c. 1970. *Paint, glue, and rhinestones on redwood, 14 × 35 × 1½ in. Chuck and Jan Rosenak. As adjuncts to his ministry, Farmer created bas-reliefs and painted canvases. This carved panel showing the story of John the Baptist could have been intended as a teaching aid for his preaching.*

inches. Farmer has done fewer than ten banners, about two hundred carved reliefs, and twenty-five dioramas.

ARTISTIC RECOGNITION

The relief carvings that Farmer made from the late 1960s into the early 1980s were sculpted deep into the wood—at times, even through the wood—making the figures three-dimensional. These represent the artist's best work. Later, as he began to respond to orders from galleries and collectors, he spent less time on the individual works, and the pieces tend to lack definition.

Farmer's individual show in Milwaukee, which contained forty-two objects (three banners, thirty-one reliefs, and eight dioramas), included many of his best pieces. Most of these works are now owned by public institutions, such as the Milwaukee Art Museum and the Smithsonian Institution's National Museum of American Art.

RALPH FASANELLA—*"I show what's going on. I reflect the guy in the street."*

BIOGRAPHICAL DATA

Born September 10, 1914,[1] Greenwich Village, New York City. Received certificate for completing grade school at age sixteen. Married Tillie Weiss, 1940; divorced three months later. Married Eva Lazorek, July 29,1950. One daughter, one son by Lazorek. Now resides Ardsley, New York.[2]

GENERAL BACKGROUND

Ralph Fasanella[3] is a well-known contemporary folk painter who sees himself as "a working man with social ideas."

The son of Italian immigrant parents, Fasanella started working when he was seven years old, assisting his father with ice deliveries. "I didn't know you had to go to school, so I spent twenty-nine months [in blocks of nine months, fourteen months, and six months] in a Catholic protectory in the East Bronx for truancy."

Fasanella became a member of the Workers' Alliance when he was a young man and went to Spain in 1937 to fight with the Abraham Lincoln Brigade. "I met Hemingway," he boasts. "He gave the boys whisky." When he returned in 1938, Fasanella worked as a union organizer for the CIO (until 1944) and spent some time in politics as a supporter of the American Labor Party.

Fasanella notes that he was blacklisted during the McCarthy era. "It was tough," he says. "I had trouble finding a job." His brothers owned a gas station and helped him out, letting him work for them from 1944 to 1973, when he began to support himself through his art.

Ralph Fasanella, The Great Strike—Lawrence 1912, *1978. Oil on canvas, 65 × 118 in. Collection of the artist. Ralph Fasanella's large, complex paintings, of which this is an excellent example, often depict labor turmoil, the struggle of the working class, and social injustice. The artist sometimes reinforces his message with text, as he has done here by painting newspaper headlines on a building.*

ARTISTIC BACKGROUND
Ralph Fasanella started painting while his brothers helped to support him. His big break as an artist came in October 1972, when he was featured in a *New York* magazine cover story that stimulated strong interest in his work.

SUBJECTS AND SOURCES
The city is the inspiration for much of Fasanella's art. He portrays the everyday life and struggle of the working class in New York from the early years of the century until more recent times. Sweatshops, immigrants, different ethnic groups, politics, injustice, the good and the bad—all are subjects for his paintings. As he says, "I wanted to show that the city goes on anyway."[4]

Fasanella's paintings are stories shown in amazing detail; he manages to capture the oppressive side of a technological society in which the urban landscape crushes the working man. "I want to show what's going on," Fasanella says. "How the little guy is at odds with government and industry."

Sometimes the artist uses biblical references. For instance, in his famous painting *Joe the Ice Man,* the ice man (his father) is crucified in front of a tenement; he has referred to another painting, showing an Italian family at supper, as *The Last Supper.* Fasanella also uses historical references to strikes and other forms of labor unrest and to politics—not surprising, given his background.

MATERIALS AND TECHNIQUES
Fasanella makes preliminary studies for his works and then paints with oils on canvas. He applies clear varnish to a piece when it is finished.

The artist has completed around two hundred smaller works that average 30 by 40 inches, and about one hundred mural-size paintings, some as large as 5 by 9 feet.

ARTISTIC RECOGNITION
Ralph Fasanella has remained true to his style and technique throughout his painting career. His colorful and lively images, whether factual or allegorical, have captured the imagination of the general public.

Fasanella's work was included in "Fanciful Art of Plain Folk" (*Life* magazine, June 1980) and has been in various museum shows. Ron Carver, a union organizer, heads a group called Public Domain, which is dedicated to placing Ralph Fasanella's art in public institutions and museums.

ALBINA FELSKI

BIOGRAPHICAL DATA
Born Albina Kosiec, March 1, 1916, Fernie, British Columbia. Attended school through eighth grade in Canada. Married Joe Felski, 1953. No children. Now resides Chicago, Illinois.[1]

GENERAL BACKGROUND
Albina Felski paints large, action-filled canvases that are often devoted to scenes from her Canadian childhood.

Albina Felski, The Birthday Party, *c. early 1970s. Oil on canvas, 35½ × 48 in. Private collection. The artist draws upon her childhood memories to create vivid and exciting scenes that give the viewer the sense of being a participant rather than an onlooker, as she has done in this lushly detailed painting of children playing at a party.*

While growing up in British Columbia, Felski always knew she would go other places. She worked as a riveter in Canadian shipyards and later as a coffee shop waitress so that she would have the opportunity to travel. She arrived in Chicago on May 9, 1945, and took up permanent residence in the United States. For more than twenty-seven years, Felski worked for an electronics firm in Chicago, retiring in 1972.[2]

ARTISTIC BACKGROUND
Although Albina Felski began drawing when she was a schoolgirl in Canada, she did not begin painting seriously until after she had been living in Chicago for a number of years. Most of her paintings were undertaken after her retirement in 1972, and at present the artist is working on a few very large paintings.

Felski's work was exhibited at the Chicago and Vicinity shows sponsored by the Art Institute of Chicago in 1963, 1972, and 1979, and the Phyllis Kind Gallery in Chicago represented her for a period.

SUBJECTS AND SOURCES
Many of Felski's paintings are inspired by scenes remembered from her youth in Canada: loggers at work, coal miners, and what she calls "Beautiful Animal Scenes" that are based on recollections of photos her brothers took on hunting and fishing trips. She also paints events in her life or places she has visited, such as a birthday, a circus, or the Hawaiian islands.

The artist's large paintings are always brimming with

movement and activity; in *The Circus,* for example, even her spectators give the impression of being participants in the action-filled rings of performers, and in *The Birthday Party,* children are having a picnic amid a profusion of blooming flowers.

MATERIALS AND TECHNIQUES

Albina Felski paints with oils on canvas. She works on her dining room table, with the canvas pressed flat against the tabletop.

She paints with amazing detail, using small brushstrokes to achieve her fine lines. Her use of perspective is imprecise, however, so that the figures in her panoramic views tend to receive equal emphasis; all are aligned on a vertical plane and similar in size, whether they appear in the foreground or background.

Felski's work tends to be large, almost mural size—often at least 4 feet square. She has completed about twenty paintings, but only a few have been sold. The remainder are in her Chicago apartment and are not for sale.

ARTISTIC RECOGNITION

Albina Felski's use of color and detail, combined with eye-catching action, makes her work stand out in every museum show in which she has participated. Her work is in the collection of the Smithsonian Institution's National Museum of American Art in Washington, D.C., and a few private collections.

("CEDAR CREEK") CHARLIE FIELDS

BIOGRAPHICAL DATA

Born 1883, Lebanon, southwestern Virginia. No formal education (Fields could neither read nor write). Single. No children. Died December 21, 1966, Lebanon, Virginia.[1]

GENERAL BACKGROUND

Charlie Fields was born on the fifteen-acre farm next to Cedar Creek (source of his nickname) where he would later create one of the country's most interesting folk environments. He stayed home and cared for his mother, grew some tobacco, raised a few vegetables, and kept a cow. After his mother died, Fields began fixing up the old frame house on the homestead to suit his taste; soon his colorful decorations were spilling out of the house and onto the surrounding land. He was still working on the house when he died in 1966.

ARTISTIC BACKGROUND

Fields started decorating his home when he was forty-five or fifty years old and continued over the next thirty or more years. He painted everything—walls, floors, ceilings, both inside and out—with red, white, and blue polka dots, squiggles, wavy lines, and targets.

Fields obtained national recognition after his death, when his house was reproduced on the cover of a seminal book on folk art.[2]

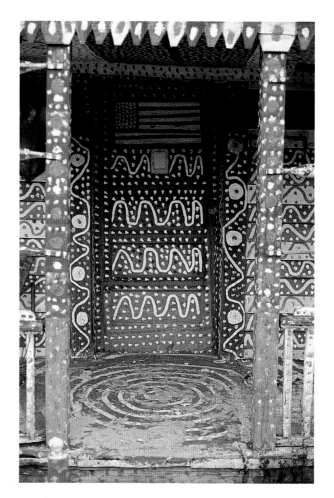

Charlie Fields, Detail of Front Porch and Door of House, *n.d. Paint on wood, Lebanon, Virginia. This detail of the front porch and door of Fields's house indicates the profusion of color and design that covered all indoor and outdoor surfaces.*

SUBJECTS AND SOURCES

Charlie Fields had two main sources of inspiration—the colors of patriotism and the form of polka dots—which were as divergent as they were prominent in his environment. Color and pattern were everywhere—he painted an American flag on his front door and covered most surfaces with red, white, and blue paint in various patterns (most often polka dots).

Fields reworked a crucifixion scene carved by a prison inmate, painted it with polka dots, then surrounded it with polka-dotted Christmas tree lights. He also dressed to fit his environment: he would greet visitors on Sundays in a polka-dotted suit. Fields further embellished his environment with model airplanes, suspended from the ceiling of the house, and three or four carved figures and a Ferris wheel that he had made. He even painted his beehives.

MATERIALS AND TECHNIQUES

Fields painted everything with house paint, preferably in red, white, and blue. Because friends brought him leftover paint, there were occasional browns and greens or other colors, but the dominant color scheme throughout was without doubt patriotic.

The assorted objects he made, such as the Ferris wheel and figures, were constructed from used wood. Probably only about ten objects from the whole environment survive, including the flag door and some of the figures.

ARTISTIC RECOGNITION

Charlie Fields was an eccentric with a compulsive desire to decorate his house and surroundings. Although his environment was not saved in its entirety—only polka-dotted remnants are left of the old frame house next to Cedar

Creek—he achieved a remarkable and documented success that few others have equaled. The door to Fields's house and three of his carved figures are now in the Smithsonian Institution's National Museum of American Art. There is also a permanent display of his clothing and other objects at the Museum of Appalachia in Norris, Tennessee.

HOWARD FINSTER—*"The Lord spoke and said:*

'Give up the repair of lawn mowers;
Give up the repair of bicycles;
Give up the preaching of sermons;
Paint my pictures.'
And that's what I done."

BIOGRAPHICAL DATA

Born December 2, 1916, Valley Head, Alabama.[1] Attended approximately six years of school, Violet Hill School, Valley Head, Alabama. Married Pauline Freeman, October 23, 1935. Four daughters, one son, fifteen grandchildren (at least one daughter and three grandchildren are making

Charlie Fields, Polka-Dotted Crucifixion, *c. 1960. Wood, leather, paint, electric lights, chips of glass, and nails, 14½ × 16 × 5 in. Private collection. This crucifix was covered with polka dots by the artist (the original light bulbs were also covered with polka dots) and displayed on his mantel.*

folk art). Now resides Pennville (just outside Summerville), Georgia.

GENERAL BACKGROUND

The Reverend Howard Finster has achieved "superstar" status for his exuberant paintings, or "sermon art," and his impressive *Paradise Garden* environment, an ongoing expression of his religious conviction.

"I preached about forty years. All the time I was preachin' . . . my mind was on building something. . . . Just something I told the Lord. Is there anything else you want me to do besides pastoring? Well, just show me."[2] So recalls Reverend Finster, an evangelical Baptist preacher who for more than forty years has preached the Lord's word at tent revival meetings and as minister of various churches throughout the rural South.

In 1965, after retiring as pastor of the Chelsea Baptist Church in Menlo, Georgia, Finster took up the avocation of repairing lawn mowers and bicycles in Pennville, Georgia. At about this time or slightly earlier, the preacher (who claims to have had religious visions since he was a child) says the Lord directed him to transform the two or so acres of swampland around his small repair shop into a *Paradise Garden*.

The *Garden,* in Finster's words, was constructed from "other people's junk."[3] He used a combination of materials, some donated and others rescued from local garbage dumps—broken dolls, tools, clocks—anything he could get his hands on. These objects were embedded in the concrete walls and paths that surround a tower 30 feet high

Howard Finster, No One Has to Cross Jordan Alone, *1976. Enamel paint on tin mirror, 24½ × 42½ in. Chuck and Jan Rosenak. This unnumbered painting originally hung in Finster's pump house at Paradise Garden. Its bright colors, prolific text, and moral sayings are typical of the artist's work.*

that Finster had built of bicycle parts, other startling buildings that he had composed of bottles and other cast-off objects, and Finster's own church, officially titled "The World's Folk Art Church, Inc.," which towers over the park and surrounding community. The church is crowned with a steeple and a dome intended someday to revolve in the wind.

ARTISTIC BACKGROUND

Finster is an eclectic artist, and his efforts did not stop with the creation of his concrete *Paradise Garden.* In 1976, in another one of his visions, he saw a tall man at his gate, following which the Lord directed him to begin painting "sermon art" because, as Finster says, "preaching don't do much good; no one listens—but a picture gets painted on a brain cell." Although he had created his first drawings (none of which exist today) many years earlier, he now began to create individual paintings that he considered crucial in passing on his spiritual messages to the world.

Nor was his *Garden* in any way forgotten after he began painting. In 1982 the National Endowment for the Arts awarded Finster a Visual Artist Fellowship in Sculpture, which he used to tie the whole garden together by improv-

ing his inlaid concrete walkways, and he has continued to enhance his environment in different ways.

The art world discovered Finster through a series of museum exhibitions, starting with "Missing Pieces: Georgia Folk Art 1770–1976," mounted by the Georgia Council for the Arts and Humanities in 1977. His paintings were brought to national attention in 1980 by *Life* magazine in an article that included him with a number of other leading folk artists,[4] and one of his drawings was used as a popular record cover.[5]

SUBJECTS AND SOURCES

Paradise Garden, born of a vision, is an ongoing project that clearly expresses Finster's deep-rooted religious convictions as well as his creativity. His paintings tend to embrace evangelical themes, many of them apocalyptic. He has frequently portrayed Jesus (who was also important in his sermons) and his own version of ultimate salvation. His images and messages come from his unique interpretation of the Bible, and he depicts angels and saints, as well as earthly characters, interspersed with printed quotations and original, often witty sayings, or "Finsterisms," as they have come to be known.

Sometimes Finster is influenced by the imagery on postcards or in popular magazines. A postcard showing a young Henry Ford, for example, has been re-created in many of Finster's works. Another commonly repeated theme is his self-portrait.

MATERIALS AND TECHNIQUES

Finster makes art out of anything at hand; in addition to painting on plywood and heavy canvas (which he gets from a local rug manufacturer), he has painted on nail heads, gourds, bottles, mirrors, plastic, a snow shovel, and even a Cadillac automobile. His paintings range in size from a few square inches to 8 or 9 feet in height. "I use the best bicycle paint available," he declares, but he also uses house paint, crayon, pencil, or wax, among other things. Finster does not concern himself with the lasting qualities of his art, only with its message, and some of his work—such as the paintings on gourds—is quite fragile. Some of the paintings are framed with wood that has designs burned in by a "machine" that Finster himself developed.

Finster's painting output is prodigious; in the latter part of 1976 or early in 1977 he began numbering his paintings, and, as of the early 1990s, he was over the 14,000 mark and still painting.[6] Generally, the earlier pieces (unnumbered or with low numbers) are the best; as his production increased, Finster sometimes took less care with his work and even began making multiples from stencils, although each one was still individually painted.

ARTISTIC RECOGNITION

Although preaching through art is not unique,[7] Howard Finster's personal inspiration and vision have resulted in unusually exciting work. His art is original, innovative, and expressive, sought after by museums and collectors

Howard Finster, Traveling Show, *1987–1988. Mixed media on board, 4 × 8 ft. Stephanie and Bob Tardell. This exciting personal collage includes snapshots of Finster and his church in addition to other images and many religious messages.*

OVERLEAF: **Howard Finster,** Sea Became as Blood, *c. 1977. Tractor enamel on board, 16½ × 28 in. Private collection. Finster's dramatic and bloody vision of the end of the world was painted in only three hours, as the artist noted in the lower right corner.*

alike. Finster himself has become a folk art "superstar" and celebrity. He now travels throughout the country giving seminars, demonstrations, and speeches at universities, museums, and galleries; he has even appeared on several television shows.

Finster's work has been included in shows at numerous museums, including the Museum of American Folk Art, New York City (1976), the Library of Congress, Washington, D.C. (1978), the Abby Aldrich Rockefeller Folk Art Center, Williamsburg, Virginia (1980), Milwaukee Art Museum (1981), the Smithsonian Institution's National Museum of American Art (1981), the New Museum of Contemporary Art, New York City (1983), and the High Museum of Art, Atlanta, Georgia (1988). Finster is included in the permanent collection of many of these museums (the Museum of American Folk Art, the High Museum of Art, National Museum of American Art, and the Library of Congress) as well as the Center for the Study of Southern Folk Art, Oxford, Mississippi. In addition, he has been given one-man shows by the Philadelphia Art Alliance (1984), the University of Richmond, Virginia (1984), and the Museum of American Folk Art (1989). Finster was also selected to represent the United States at the Venice Biennale in Italy in 1984.

Paradise Garden has become a symbol of its own, one that goes beyond Finster himself. Steps are being taken to ensure its preservation, and the Georgia Bureau of Tourism now counts it as one of the state's attractions.

WALTER ("CAPTAIN") FLAX—*About 1975 Flax bemoaned the fact that "my navy is slowly going down. Nobody can save it."*[1]

BIOGRAPHICAL DATA
Born 1896, Philadelphia, Pennsylvania. Received little or no education (Flax could neither read nor write). Single. No children. Died November 24, 1982, Newport News, Virginia.

GENERAL BACKGROUND
Walter Flax, a black man, created a remarkable naval environment near his home in the Virginia woods.

Flax was meant to be a man of the sea, although his life was spent on land. He was raised by his grandparents in Yorktown, Virginia, and later supported himself as a part-time dishwasher, yardman, and farmer; he also made and sold hickory brooms.

For most of his life Flax lived by himself in a small two-room frame dwelling deep in a piney woods infested with ticks and mosquitoes, near Yorktown. These woods not only housed Flax but were the site for his own personal "navy" as well.

ARTISTIC BACKGROUND
Near his home Flax created a "navy" of merchant ships, submarines, seagoing battle wagons, and all types of supporting craft. He made his first ship around 1915, as the United States was preparing for war, and continued to

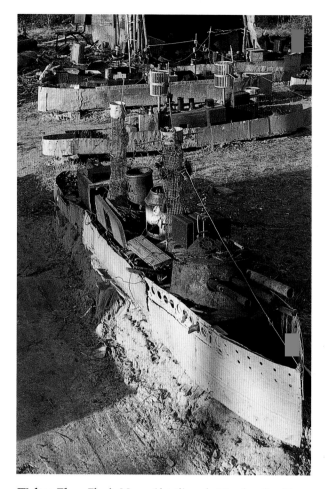

Walter Flax, Flax's Navy *(detail), n.d. Mixed media. Most of Flax's larger constructions, like this land-locked group of battleships, are known only through photographs.*

build, rebuild, and repair his fleet (cannibalizing one ship to fix another) until old age caught up with him in the late 1970s.

Flax became known to the local population as "Captain Flax" because he commanded the largest land-locked navy in Virginia. In 1978 the commander of the U.S.S. *Kennedy* heard about Flax's fleet and gave him a ride on the huge aircraft carrier.

SUBJECTS AND SOURCES
Flax took some of his ideas from magazine photos, but he was also undoubtedly influenced by the mighty military ships he saw ploughing the waters of the rivers and bays near his home. Building, caring for, and maintaining his many and varied ships became an important part of his life.

MATERIALS AND TECHNIQUES
The hulls of the ships were made of old roofing tin, the decks of wood, the guns of pipe. Flax also used old tele-

Walter Flax, Untitled (Ship), *c. 1974. Mixed media (scrap metal, wood, plastic, and pipe), 16 × 34 × 8 in. National Museum of American Art, Smithsonian Institution, Washington, D.C.; Gift of Chuck and Jan Rosenak. This small boat is one of the few examples of Captain Flax's landlocked navy that are still in existence.*

phones, toasters, stereopticon viewers, rusted clocks, toy cash registers, and lamp bulbs to add verisimilitude to the ships' fittings.

The fleet, which at one time comprised more than one hundred ships (ranging in size from tabletop models to some as long as 20 feet), was painted blue-gray, the color of U.S. naval ships. The ships were as realistic as Flax could make them, and he even kept an upside-down icebox full of rainwater near his home in order to test the seaworthiness of the smaller vessels.

ARTISTIC RECOGNITION

Today the fleet is overgrown, rusted, and beyond repair; only a few vessels have been salvaged. But in its heyday it was magnificent, and the occasional visitor can sense the drama of the warships under the pines, headed by their admiral and creator, Captain Flax. The full vision of Flax's navy has been preserved mainly through the black-and-white photographs of Joshua Horwitz.[2]

JOSEPH FRACAROSSI

BIOGRAPHICAL DATA

Born July 2, 1886, Trieste, Austrian-Hungarian Empire, now Italy. Attended school through "seven terms," Trieste. Married Anna Erlach, 1915; she died 1956. Two sons, one daughter. Died April 12, 1970, Coventry, Rhode Island.[1]

GENERAL BACKGROUND

Joseph Fracarossi, a folk painter remembered for his detailed cityscapes of New York, worked in a photorealistic style.

Fracarossi served in the Austrian army from 1906–1910, then joined the Austrian merchant marine as a baker. At the outbreak of World War I in 1914, he found himself interned in New York Harbor on the naval ship *Martha Washington* and remained there until 1917. While on the ship, he lost the use of one eye through an accident.

Fracarossi was allowed to stay in the United States at the

Joseph Fracarossi, Central Park Boat House, 1957. Oil on canvas, 16 × 20 in. Patricia L. Coblentz. Fracarossi loved to paint colorful and romantic scenes of New York City and its people, and this idyllic picture of Central Park on a sunlit day is representative of his photorealistic style.

end of the war. For many years he lived in the Ridgewood section of Brooklyn and worked in the garment industry as a stamper and designer of fancy embroidery and sequined dresses. Fracarossi became a devotee of the city; he loved to walk the streets of New York and go to the museums.

In the late 1950s or early 1960s he retired from the garment industry and eventually, because of poor health, had to leave New York to live with his son, Richard, in Rhode Island. The slower pace of a small-town life-style did not suit him, however, and he once wrote, "I feel to be alive in a grave."

ARTISTIC BACKGROUND

Joseph Fracarossi's family has a few early sketches that he made while he served in the Austrian army, but he did not start to paint until the 1950s, when he was inspired by visits to the outdoor art show held every year at Washington Square in Greenwich Village.

In the late 1950s and early 1960s Fracarossi began exhibiting at the shows in Washington Square. There he was discovered by Morris Weisenthal of the Morris Gallery in New York City, who then began to represent the artist.

Fracarossi continued to paint until shortly before his death in 1970.

SUBJECTS AND SOURCES

Fracarossi loved New York—its streets, vistas, buildings, people, and amusement parks. He was an artist ahead of his time, painting in a style similar to what would later be called photorealism. In his paintings the signs on billboards

and buildings are faithfully reproduced, but trash, litter, and grime do not exist, and the people obviously enjoy themselves on the artist's always-sunny days.

The artist sometimes copied his own paintings and the work of others. When he did this, he signed those paintings with his initials instead of his full name.

MATERIALS AND TECHNIQUES
To create his highly realistic pictures, Joseph Fracarossi took photographs and glued them together. Using a perforating machine, he would make pin pricks in the photographs that could be traced with chalk onto canvas or board.[2] This gave him a basic outline, which he then filled in with oil paints.

The artist completed about fifty original paintings and an unknown (though believed to be small) number of copies. The paintings range in size from about 18 by 24 inches to around 20 by 40 inches.

ARTISTIC RECOGNITION
Joseph Fracarossi had a love affair with New York, and his paintings reflect it. His bright, romantic, detailed urban cityscapes of the 1950s and 1960s capture the city at its best. He is widely known through reproductions of his work, much of which is held in private collections.

JOHN ORNE JOHNSON ("J.O.J.") FROST
—". . . think of me at 71 years a doing something that I did not know I could do now I love it it is hard to let the brush alone." (From a letter to his sister, Lily Marguerite Frost, December 18, 1923)[1]

BIOGRAPHICAL DATA
Born January 2, 1852, Marblehead, Massachusetts. Received elementary school education. Married Amy Anna ("Annie") Lillibridge, March 5, 1873; she committed suicide after a long illness, November 1919. One son, Frank, survived to adulthood. Died November 3, 1928, Marblehead, Massachusetts.[2]

GENERAL BACKGROUND
J.O.J. Frost brought the memories and adventures of his

John Orne Johnson Frost, Marblehead Harbor, *c. 1925. Oil on wallboard, 48 × 74 in. Marblehead Historical Society, Marblehead, Massachusetts. This is one of a series of the artist's paintings that documents the history of Marblehead, Massachusetts. Rendered in great detail, this painting shows the harbor and its commerce, which for so long depended on sailing vessels.*

youth in the mid-nineteenth century to the paintings he did as an elderly man in the first quarter of this century.

Born during the heyday of the New England fishing industry, Frost left home in 1868 at the age of sixteen to go to sea aboard the *Josephine,* a Grand Banks fishing schooner. Always at home whether on the water or next to it, Frost nevertheless quit the sea in 1870, not, as he said, through fear of danger, but because he wished to get into a better-paying business so he could marry his "sweetheart." He went into the restaurant business, first with his wife's family and later on his own; his restaurant was known for its high-quality food and low prices. When illness forced him to retire as a restaurateur in 1895, he worked with the Marblehead Parks Commission and helped his wife in her nursery business until her death in 1919.

Within a year or two after Annie's death, Frost began to write articles about the history of Marblehead and to paint pictures of it. In fact, he devoted most of his time to preserving and chronicling the heritage. In 1924 he built a small museum in back of his house to house his paintings and "relics of Marblehead." Although local response was poor (the townspeople ridiculed him), he received some attention from the Boston and Salem media, and people from around the country wrote to him to learn about Marblehead's history.

ARTISTIC BACKGROUND
Frost first began to paint in the summer of 1922, and there is more than one story about why he started. He once said that he "felt the first impulse" as he stood at his wife's grave, but at another time he said that people were always asking him about Marblehead and the fishing business and so that "started me to try." His son said that a summer visitor had asked Frost to draw a Grand Banks schooner and was so pleased with the result that he encouraged the old man to do more. Whichever story is true, there is no doubt that the desire to preserve the history of Marblehead for future generations played a large part in Frost's dedication to his work.

SUBJECTS AND SOURCES
The largest group of Frost's paintings deals with life at sea —the schooners and clippers of his youth, day-to-day fishing experiences, and storms at sea. Few of these have captions or labels. Another dominant theme is the history of Marblehead; Frost painted the early settlers, Indians, scenes from the Revolutionary and Civil wars, and the local marine and sailing industries. These paintings often have detailed labels, not only stating the subject and what action was taking place, but also indicating the names of the various parts of the town.

Frost also made sculptural objects, including carved fish and ship models. Most of these were intended as educational pieces for his museum.

MATERIALS AND TECHNIQUES
Frost painted with watercolors or oil-base paints (primarily house paints) on wallboard, chipboard, or Masonite. He would outline his work in pencil, then fill in with color, often preserving the outlines. Details, such as eyes and buttons, were often drawn in with pencil as well, and he always used white or black paint for the written labels on his works.

Frost is known for his extraordinary ability to use color to portray action and adventure on both land and sea (deep greens and blues and contrasting oranges, yellows, and whites). He also included a great many details so that his work would appear realistic. If a regiment of men took part in a battle, every soldier would be included in his painting.

The paintings range in size from about 7 by 12 inches to 22 by 28 inches. Although most of the sculptures are small, Frost once carved a 6-foot-long codfish. In all, he made about 130 paintings and 40 sculptures.

ARTISTIC RECOGNITION
Frost received little public recognition during his lifetime. After his death his son gave eighty paintings to the Marblehead Historical Society, but they remained virtually unappreciated and unshown until 1940, when they were included as part of a "Marbleheadiana" retrospective; they received so much popular attention that the society subsequently provided a room for their permanent display. Since then Frost's work has been shown in a number of museums and galleries. In 1952, when more than thirty paintings were discovered nailed in the walls of his former house, critical acclaim for his work was extensive.

Today Frost's marine paintings are appreciated as unique and exciting works that help to document a bygone era. His simple yet dramatic portrayals of schooners and clippers under sail are unequaled in this century, and his pictures of historical and local events have a charm that goes far beyond his documentary intentions.

JOSEPH ENDICOTT FUREY—*"I was just trying to make the place [his apartment] look nice. I did it to kill time, grieving for my wife."*

BIOGRAPHICAL DATA
Born January 3, 1906, Camden, New Jersey. Attended four years of elementary school, Boston, Massachusetts; received high school equivalency degree in the navy. Married Lillian Fleming, February 12, 1933; she died September 28, 1981. Three daughters, two sons. Now resides Chester, New York.[1]

GENERAL BACKGROUND
Joseph Furey, a retired steelworker, created an extraordinary painted and decorated environment in his Brooklyn apartment.

At the age of thirteen, Furey, who had been living with his father in Boston, left home to travel the United States; he made his way by picking fruit and doing odd jobs. Furey enlisted in the navy when he was seventeen and served for four years, becoming the light heavyweight champion of the Atlantic Fleet in 1926.

Joseph Endicott Furey, Apartment Assemblage, *1980s. Mixed-media environment (bow ties, paint, shells, plaster chickens, lima beans, and other objects), Brooklyn, New York. Furey turned his apartment into a spectacular personalized environment without realizing that he had created one of the most important conceptual sculptures of our time.*

After his discharge from the service, Furey became a structural steelworker. Although he now had a wife and growing family, he continued his somewhat itinerant lifestyle. He worked on dangerous projects, such as the maintenance of cables on the Golden Gate Bridge (1936) and the George Washington Bridge (1950–51), and from 1948 to 1950 he worked for an oil refinery in Las Piedras, Venezuela.

In 1938 the Fureys rented an apartment in Brooklyn that was home for the next fifty years. Furey continued to live there after his wife's death and his own retirement in 1981, moving out only when he went to live with his son Joseph in 1988.

ARTISTIC BACKGROUND
Joseph Furey began to make appliquéd picture frames while he was working in Venezuela, but otherwise he had never shown any artistic interests before he began to decorate his five-room apartment in the Park Slope area of Brooklyn. Furey started decorating the bathroom and kitchen while his wife was still alive, but after she died, he

began working night and day on his project. "I wanted to mix it up so it looked good," he says. "And I had to honor an engineer at one of the companies where I worked, Bow-Tie George."

When Furey moved out of the apartment, his landlord was confronted with an extraordinary environmental work. He called the associate curator of painting and sculpture at the Brooklyn Museum, who brought the apartment to the attention of the Museum of American Folk Art in New York City.

SUBJECTS AND SOURCES
Furey developed an abstract series of mosaics, tied together with a bow-tie motif, in the decoration of his apartment. He covered virtually every inch of the walls, ceilings, and much of the furniture with geometric patterns. The entire apartment became one single, shimmering, balanced, and symmetrical work of art.

MATERIALS AND TECHNIQUES
Furey's decorations are many and varied, with some 70,000 items making up the whole. Shells are everywhere; some Furey had collected while in Venezuela, others came from a nearby deli, and mussel shells he collected locally. He cut out bow ties and hearts from cardboard; he added dried lima beans and plaster chickens; and he did not hesitate to add paint where it seemed necessary.

Furey glued and nailed the thousands of pieces of decoupage, as well as found objects (beads and spools in addition to the shells), to all the walls, ceilings, doors, and moldings of his apartment. The entire construction is covered with a coat of polyurethane clear varnish.

Joseph Endicott Furey, Apartment Assemblage, *1980s. Mixed-media environment, Brooklyn, New York. A collage of shells, beans, cutouts, and other small objects decorates all the surfaces of Furey's former apartment.*

Romano Gabriel, Wooden Sculpture Garden, c. 1976.
*Mixed-media environment (fruit crates, wood, paint, and
found objects), Eureka, California. Romano Gabriel's
fantastic and exuberant wooden flower garden surrounded his
home and filled his small yard. Although the garden is no
longer on its original site (as shown here), it has been
preserved in Eureka, California.*

ARTISTIC RECOGNITION

Furey's apartment is a monumental achievement, an un-
usual environmental work that once was hidden and pri-
vate, unlike anything else. Since Furey has vacated the
apartment he spent so much time and effort decorating, its
future is uncertain. While some people argue that it should
be preserved and made available for public viewing, this
proposal presents problems. First, because of the nature of
the many objects that went into the construction of the
environment, its preservation poses a serious problem; sec-
ond, and not least, is the fact that the landlord holds all
legal right to the disposal of the apartment as well as to its
contents.[2]

Joseph Furey and his environment were featured in a *Life*
magazine article (June 1989) and in a *New York Times* arti-
cle (July 13, 1989).

ROMANO GABRIEL—*"My idea was just to make these things. I just wanted to make something different. I just made up pictures out of wood."*[1]

BIOGRAPHICAL DATA
Born February 15, 1896, Mura, Italy. Received little edu-
cation. Single. No children. Died February 23, 1977, Eu-
reka, California.

GENERAL BACKGROUND

Romano Gabriel is regarded as one of the foremost envi-
ronmental artists of recent years. This simple carpenter and
gardener created a fantastic wooden garden from discarded
fruit crates in Eureka, California. "I used to be a gardener
here in Eureka," he said. "Eureka is a bad place for flow-
ers, the salty air and no sun. So I just make this garden."[2]

Gabriel came to the United States from Italy in 1913.
After serving in World War I, he moved to Eureka, where
he built houses and worked in lumberyards and as a gar-
dener. After building his own home, Gabriel began to
build his garden, working on it over a period of thirty
years. He finally quit during the last four or five years of
his life, partly due to lack of room, but mostly because, as
he explained, "No more boxes. Now all the boxes, they
come in paper, no wood."[3]

ARTISTIC BACKGROUND
Little is known of the reasons why Gabriel began his garden or why he chose to make it of wood rather than of living things. Perhaps he missed the bright flowers and colors of his childhood, or perhaps, as he indicated, flowers simply do not do well in Eureka.

Many of his neighbors claimed not to be aware of the house with the wooden garden,[4] but word got around and gradually people from other places made their way to Gabriel's house, which had virtually disappeared behind the blossoming of wooden figures.

SUBJECTS AND SOURCES
Wooden flowers, trees, animals (many of which moved in the wind or with the help of ropes and motors), and faces of people—all these grew in abundance in Gabriel's garden. The figures were based on memory, imagination, and people and places he saw in *National Geographic* magazine, to which he was a long-time subscriber.

MATERIALS AND TECHNIQUES
Gabriel declared that he did not buy materials. The pieces that made up his garden generally came from the ends and sides of wooden fruit crates, which he cut to the right shape with a handsaw and later a small power saw. The figures were gaily painted, and most years he repainted them to keep them bright and in good shape.

ARTISTIC RECOGNITION
Romano Gabriel is considered to be one of the most important environmental artists working in this country during the latter half of the twentieth century. He has been included in various books on environmental art and fantastic architecture,[5] which have undoubtedly increased his

reputation as an artist who created a major environment.

On the day Gabriel died in 1977, the California State Arts Council designated his garden a folk art environment. It has been preserved (although not in situ) in the town of Eureka, where the pieces are on display as *Romano Gabriel's Wooden Sculpture Garden.*

CARLTON ELONZO GARRETT—
"What I love to do is make something somebody else don't make."[1]

BIOGRAPHICAL DATA
Born May 22, 1900, Gwinnett County (near Atlanta), Georgia. Received two years of schooling. Married Bertie Catherine Clark, October 8, 1927. Two daughters. Now resides Flowery Branch (northeast of Atlanta), Georgia.

GENERAL BACKGROUND
Carlton Garrett is a wood carver who has achieved recognition for a series of elaborate and colorful machine-driven scenes he constructed.

"If I had the time to go over, my love would be machinery," Garrett reminisced recently, but he had very little time to learn about anything but hard work. He was born on a farm rented by his father, and when he was old

Carlton Elonzo Garrett, The Car Parade, *c. 1965.
Painted wood, metal, and string, 46¾ × 48 × 48 in. High Museum of Art, Atlanta, Georgia; Gift of Judith Alexander. This colorful motorized diorama of a small-town parade is an excellent example of the innovative genius of Carlton Garrett, whose love of machinery was channeled in his art.*

enough to carry a hoe, he hoed—cotton, potatoes, and corn.

Garrett moved to Flowery Branch, Georgia, when he was twenty-four years old. There he sawed, planed, glued, and nailed for two Flowery Branch furniture companies—Chattahoochie Furniture (from 1924 to 1943) and Mooney Furniture (from 1957 until he retired in 1962). In the period between these two jobs, he ran the town waterworks.

In 1941 Garrett spent his hard-earned savings ($805, to be exact) to buy the house he lives in today; an Oddfellows insignia is proudly nailed to its porch. Out back is a shed Garrett calls his "playhouse," and that is where he goes to have a private place to work on his art.

A religious man, Garrett was also ordained a Baptist minister in 1931. He preached in the Flowery Branch Baptist Church until 1962.

ARTISTIC BACKGROUND

Carlton Garrett started carving in 1940 by making dolls for his daughters. After 1942 he started to make machine-driven scenes—a parade complete with audience, for example, a church complete with choir and minister, and a hospital with moving nurses, doctors, and patients. In these scenes electric motors whir, pulleys and wheels turn, and appropriate sounds and songs are played on old phonographs ("When the Saints Go Marching In" is sung by the church choir, for instance). Sometimes, he says, "I'd go to bed at night and wonder how I was going to do a certain thing. In the morning I'd know."

When Garrett retired in 1962, he stopped making the machine-driven constructions. He did not seek publicity, but Judith Alexander, a folk art dealer in Atlanta, discovered him in the late 1970s, and she began to promote his carvings.

In 1984 Garrett suffered a stroke that left him unable to work.

SUBJECTS AND SOURCES

In the beginning, Garrett made dolls representing people, animals, and wagons for his daughters to play with. When he moved on to his more serious work—the machine-driven pieces—he started to create more fanciful scenes.

MATERIALS AND TECHNIQUES

Garrett carved from various kinds of wood and painted his sculptures in bright colors. He used only a drill press, band saw, and pocketknife to make his sculptures and painted the dolls with paint purchased from a local hardware store. "But," he says, "I was up a tree for power, so I used abandoned washing machine and icebox motors."

Carlton Garrett has made hundreds of dolls but only eight machine-driven scenes. The scenes measure about 45 by 35 by 30 inches. Both the dolls that were made as part of these scenes and the dolls made for play are only about 8 inches tall.

ARTISTIC RECOGNITION

Carlton Garrett's wooden dolls are quite ordinary, just good examples of country whittling, but his eight machine-driven scenes are unique. The mechanical invention, the brilliant use of color, and the organization of these large works mark Garrett as a true artist. Judith Alexander placed most of them in museum collections, and she retains the rest.

Garrett had an individual show of his pieces at Atlanta's High Museum of Art in 1981, and he has appeared on television to talk about his work.

HAROLD GARRISON—*"My twenty-acre farm don't make no money, but I can sit in the middle of it—whittle—and don't nobody bother me."*

BIOGRAPHICAL DATA

Born February 27, 1923, Weatherville, North Carolina. Graduated from Flat Creek High School, Weatherville, North Carolina. Single. No children. Now resides Weatherville, North Carolina.

GENERAL BACKGROUND

Harold Garrison is a mountain wood carver who makes clever, satirical figures that are animated by a unique trigger mechanism.

"I was born on my Daddy's farm [20 mountainous acres]," Garrison remembers, "and I farmed. But I also took second jobs to make ends meet." He worked on construction jobs and for American Enka operating machines for many years.

Harold Garrison, The Beaver, *c. 1975. Wood, paint, cloth, rubber band, and wire, 13 × 10 × 1½ in. Chuck and Jan Rosenak. This movable sculpture, a self-portrait of the artist walking his dog, is in the form of a rubber band–powered gun. When the trigger is pulled, the man's legs move and the dog turns its tail toward the fire hydrant.*

"In 1967," Garrison says, "Daddy broke down [he lost both legs and died]. It was then that I started whittlin' and making artificial flowers for a living."

At 6 feet 10 inches tall and thin as a rail, this mountain man is nothing if not noticeable. He walks about town wearing a black stovepipe hat and a flowing green velvet cape.

ARTISTIC BACKGROUND
In explaining how he moved from artificial flowers to sculpture, Garrison says, "After Daddy broke down, I used to sit there in his room watching Watergate. So I started foolin' around with a knife."

His "foolin' around" led to an extraordinary collection of political and social characterizations in a gunlike format (the carvings have triggers that animate the parts) that quickly drew attention. "I didn't consider myself anything special, but they chose *Watergate Gun Number Four* to exhibit at the World's Fair [Knoxville, 1982]."

SUBJECTS AND SOURCES
Garrison makes artificial wood flowers for decorators and florists and small flying ducks and animals for tourists, but for himself he makes the "gun" carvings with triggers operated by rubber bands. This is his real art as well as a means of social commentary.

Some of his guns, such as the *Watergate* series, depict with motion his characterization of that event. Others, like his portrait of a tall man walking a dog, may poke fun at himself or others (when the trigger is pressed, the dog turns toward a fire hydrant).

MATERIALS AND TECHNIQUES
Garrison carves pine, cherry, buckeye, and walnut. He does not use paint, preferring to apply commercial dyes for color; sometimes he makes his own stain with pokeberries. Garrison also prints messages on his guns with ballpoint pens and uses bits of cloth to add realism.

The guns measure about 14 by 17 inches; his other carvings are of various sizes.

Garrison has made 15,000 to 20,000 artificial flowers, 600 ducks, 50 different animals, and 12 guns, of which 4 are *Watergate* guns.

ARTISTIC RECOGNITION
Garrison's artificial flowers set him apart as one of the most prolific mountain whittlers of all time, but his twelve guns, with their biting and ironic commentary, their format, and their unusual animation, are truly original examples of twentieth-century folk sculpture.

VICTOR JOSEPH GATTO

BIOGRAPHICAL DATA
Born July 23, 1893, New York City. Attended school through fifth grade. Single. No children. Died May 25, 1965, Miami, Florida.[1]

Victor Joseph Gatto, Eve and the Serpent, *mid-1940s. Oil on canvas, 36 × 48 in. Epstein/Powell Gallery, New York. Painting slowly and deliberately, Gatto was inclined to create series of works. This vibrant piece is part of a group based loosely on biblical stories that are more imaginary than literal (Adam does not appear here).*

GENERAL BACKGROUND
Victor Joseph Gatto was a painter whose colorful and often complex works of fantasy and personal insight established him as a major folk art figure.

Gatto was born in a tenement in the bustling and colorful section of New York City known as Little Italy. After his mother died, he spent several years in a Catholic orphanage and school, and his artistic talent was apparent even at this early period. Teddy Roosevelt is said to have visited Gatto's classroom and pronounced the eight-year-old boy "the best drawer in the school."[2] Although Gatto loved to draw, it was many years before he followed up on this encomium.

Once he left school, Joe Gatto (as he was then known) tried his hand at different kinds of work, including plumbing and steamfitting; at one point (1913–1918) he was even a professional featherweight boxer, "taking the count" only once. Gatto entered the navy during World War I but was dishonorably discharged; he subsequently served time in Dannemora Prison in upstate New York (from 1920

until 1930). From that time onward, he held only menial jobs and never seemed to be able to break what was to be a lifelong cycle of being broke, in spite of his artistic success.

ARTISTIC BACKGROUND

In 1938 Gatto visited a Greenwich Village outdoor art show. When he learned that it was possible to receive $600 for a single painting, he decided to start a new career; thus Joe Gatto became Victor Joseph Gatto, the artist. By 1943 Gatto had had a one-person show at the Charles Barzansky Gallery in New York, for which he received outstanding reviews in newspapers and magazines, and his work was purchased by a number of collectors.[3]

As Gatto's paintings gained attention, so did the artist himself. He had a brash, arrogant personality; for example, in 1940 he told Sidney Janis, a major New York art dealer, that all the artists Janis represented were bums and that he, Gatto, was great.[4] Another story comes from Dorothy and Sterling Strauser, artists and folk art collectors, who recall the summers Gatto spent with them in the 1940s in East Stroudsburg, Pennsylvania. "He would call us bums," Strauser remembers, "and then ask for ten dollars to buy paint. He'd winter in Florida's cheap hotels and write us for ten dollars to bet at the dog races."

SUBJECTS AND SOURCES

Gatto had to paint; he was obssessed with it once he started at the age of forty-eight. Art gave him a means of letting out years of pent-up anger and feelings of repression. Although he thought himself great, he did not really care whether anyone bought his work or liked his art; it had become a necessity for him.

For subject matter Gatto observed the world and delved into his imagination. He tended to paint in series—reli-gious paintings, horse and dog races, landscapes (including some jungle scenes), portraits of friends and enemies—and executed all his paintings with the same degree of intensity.

MATERIALS AND TECHNIQUES

Although Gatto did some pencil drawings and water-colors, his true medium was oil paints on canvas and Masonite. He did not always stretch his canvas, which left some works out of plumb and difficult to frame.

Gatto's paintings are filled with vibrant color and complex detail, created with brushes in which he often left only a few hairs. He worked slowly, spending a great deal of time on each piece, and frequently painted for hours at a stretch without pause, ignoring his doctor's advice when his eyesight began to fail and resorting to a magnifying glass to help him.

In spite of the time spent on each painting, Gatto made many hundreds of works. They range in size from tiny paintings done on calling cards to others as big as 3 by 4 feet.

ARTISTIC RECOGNITION

Victor Joseph Gatto painted with passion and a flair for color. His flights of fantasy and personal insight create a sense of wonder and excitement. His work has now received general acceptance in the art world and has been exhibited at the Abby Aldrich Rockefeller Folk Art Center in Williamsburg, Virginia; the Whitney Museum of American Art and the Museum of American Folk Art in New York City; and the Museum of the City of New York, as well as private collections.

EZEKIEL GIBBS—*"I've painted just about everything I ever did or ever saw. . . . Sometimes, when I think I'm just about played out, I sit down and rest awhile. Then I just go to it again."*

BIOGRAPHICAL DATA

Born April 15, 1889, Houston, Texas. No formal education. Married Josephine Johnson, c. 1910; she died 1972. Nine children. Now resides Houston, Texas.[1]

GENERAL BACKGROUND

Ezekiel Gibbs paints to set the record straight, to tell the world how he lived. His has been a long life of hard farm work on the Texas Gulf Coast. The child of freed slaves, Gibbs was orphaned at a young age and "adopted" by a white farming family, who required him to assist in farm chores.

When Gibbs went out on his own, he farmed 300 acres of land near Katy, Texas. He once remarked he had grown just about everything that would grow. He raised cattle as well, using the brand EG 2, which later would become the signature on his paintings.

After his wife died, Gibbs bought a small frame house in Houston, Texas, where he lives today. His surviving children, all of whom live in Houston, visit their father frequently.

Ezekiel Gibbs, Untitled, *n.d. Pastel and pencil on paper, 12 × 18 in. Butler and Lisa Hancock. Gibbs developed a colorful pointillistic style, as shown here, to illustrate his memories of scenes, people, and events from his youth in east Texas.*

ARTISTIC BACKGROUND

At the age of eighty-seven, Ezekiel Gibbs, feeling rather lonely and depressed after the death of his wife, showed up for painting lessons at the Houston Museum of Fine Arts Outreach Program for Older Americans (Glassell School of Art). Once started, Gibbs began to paint his life's story on any piece of paper available; he considered art as his second career.

SUBJECTS AND SOURCES

Ezekiel Gibbs's paintings focus on his life experiences and important activities—farming, family, and church. He is recording his entire family history—and then some—in his work. "I want people to know how I lived my life," he says.

MATERIALS AND TECHNIQUES

Gibbs's subjects are often done with strokes of bold color and his backgounds are filled with bursts of small colorful dots, in a style reminiscent of the pointillists. He outlines his subjects with pencil on paper, then fills in with pastels, tempera, and various paints.

His paintings and drawings, which number about six hundred, measure about 20 by 26 inches.

ARTISTIC RECOGNITION

Ezekiel Gibbs, who still paints at the age of one hundred one, is well known in Houston art circles and by those interested in black folk art. He was included in "Black History/ Black Vision: The Visionary Image in Texas," a 1989 traveling exhibition organized by the Archer M. Huntington Art Gallery, University of Texas at Austin. Gibbs was also included in a show organized by the Museum of African-American Life and Culture in Dallas and has been exhibited in Houston.

SYBIL GIBSON—*"I lost more priceless art to the dump than any other artist ever did. My very personal collection. . . the most appealing creations that I just couldn't let go at any price went to the dump. When I learned of it, I was made very ill." "Good art paper turns me off, while something out of a trash pile turns me on." (Entry from Gibson's autobiography, dated June 10, 1984.)*

BIOGRAPHICAL DATA

Born Sybil Aaron, February 18, 1908, Dora, Alabama. Graduated with a degree in biology from Jacksonville State College, Alabama. Married Hugh Gibson,[1] 1929; divorce date unknown. Married David de Yarmon, whom she described as "the Frenchman," around 1950; his death date unknown. One daughter. Now resides near Jasper, Alabama.[2]

GENERAL BACKGROUND

Sybil Gibson, a reclusive folk artist who often disappears for months at a time, is known for the delicate and ethereal images that she painted on brown paper bags.

Although Gibson's father was a prosperous Alabama

Sybil Gibson, Look at Their Eyes, *1970. Paint on brown shopping bag, 14¼ × 18 in. Didi and David Barrett. Gibson's paintings on brown paper bags have a soft, ethereal quality that results in dreamlike images, such as this scene of pretty, starry-eyed girls.*

coal mine operator (he owned the Sulphur Springs Coal Company and a farm the family visited regularly), she has spent most of her adult life in poverty.

Gibson taught elementary school in Cordova, Alabama, until the mid-1940s, when she moved to Florida. She acquired a small rental property there, but after being beset with health and financial problems, she sold it in the 1960s. Shortly before the opening of her first art exhibition at the Miami Museum of Modern Art (May 1971), Gibson disappeared, leaving drawings strewn about her yard. When rediscovered, she was living in a trailer in Gainesville, Florida, but she also left there.

In 1983 Gibson turned up at Delaware House, a project for the elderly in Jasper, Alabama, but she left there suddenly in 1988. For a period her whereabouts were unknown, but she was found again recently, living in a nursing home not far from Delaware House.

ARTISTIC BACKGROUND

Sybil Gibson began drawing on Thanksgiving Day 1963, with the intention of making her own Christmas wrapping paper out of brown paper grocery bags. Through the 1960s Gibson's work appeared in small galleries in Miami, and

Robert E. Gilkerson, Blue Plate Special, *1986. Painted metal and wood, 28 × 28 × 8 in. Jamison-Thomas Gallery, Portland, Oregon. This artist assembles other people's junk into witty satirical sculptures like this piece, which pokes fun at roadside restaurants.*

in May 1971 she was given a show at the Miami Museum of Modern Art. She became known as the "Bag Lady" because most of her paintings are done on used paper bags.

Gibson is no longer painting. She has been ill and is now legally blind.

SUBJECTS AND SOURCES

Gibson created dreamlike drawings in pastel shades that mirror a sweet unreality. The faces of her subjects, which are mostly female, are masklike images that appear to be hiding from the real world. Although Gibson is known for her "girls" in frilly dresses, she also painted a few male faces, multiple portraits, and some animals.

MATERIALS AND TECHNIQUES

Gibson worked on old guitar cases, mirrors, and newsprint in addition to used brown paper bags. Her paper bag paintings, however, are the most common. Gibson would make a pad out of old paper bags all cut to a certain size, then soak the pad in water, smooth the "pages" out, and allow them to dry. She painted on the pads with tempera and house paint.

The paintings range in size from 9 by 12 inches to about 15 by 20 inches. It should be noted that the paper she uses is unstable.

Many of Gibson's works were destroyed by the elements when she abandoned her home in 1971, but there are believed to be about three hundred extant.

ARTISTIC RECOGNITION

Sybil Gibson's flowery, childlike women have a lyrical quality that is quite appealing. She portrays a very harsh—even cruel—world, and the sweetness is superficial and deceiving.

Because of her tendency to disappear, Gibson has not been shown a great deal, even though she is a very deserving painter. Recently, however, her work has been appearing at Alabama and Louisiana galleries that specialize in folk art.

ROBERT E. GILKERSON—*"I make things that people might buy. If they don't, I make them anyway."*

BIOGRAPHICAL DATA

Born September 28, 1922, Oakland, California. Attended Freemont High School (did not graduate) and Victor Blaney Trade School, Oakland, California; also attended College of the Redwoods, Federal Job Retraining Program, 1979–83. Married Marie Willis, 1956; she died 1985. No children. Now resides Arcata (just north of Eureka), California.

GENERAL BACKGROUND

Robert Gilkerson is a prolific metal sculptor whose intriguing, often animated, works are likely to show a wry sense of humor about life.

Gilkerson has held many jobs in the past; among others, he has worked for International Harvester, Del Monte, and California Lumber, and from 1968 to 1978, he maintained service stations. At night he would make imitation antique lamps that he sold as the real thing at flea markets.

In 1978 Gilkerson was injured in an industrial accident, and with the $23,000 award from the accident he bought his present house in Arcata, California. The federal government paid for job retraining for him following the accident, but Gilkerson likes to say that "they told me there were too many artists in northern California, so I had to learn plumbing."

Today Gilkerson lives in Arcata and works as an artist.

ARTISTIC BACKGROUND

Gilkerson was sent to College of the Redwoods in 1979 to learn plumbing, and while he was there he took an elective course in jewelry making. "My teacher, John Rotter, said I was no good," Gilkerson explains, "but he found me some old oil cans, and I began making sculpture."

Gilkerson was given a one-person show at College of the Redwoods in 1983 and was selected for inclusion in "Pioneers in Paradise: Folk and Outsider Artists of the West Coast" at the Long Beach Museum of Art, Long Beach, California, in 1984.

SUBJECTS AND SOURCES

Gilkerson displays black humor in his sculpture, touching on everything from fast food to politics to consumerism. "I make fun of everything," the artist says, "even if it's controversial."

MATERIALS AND TECHNIQUES

Gilkerson works mostly with metal; he will use various metals but seems to prefer tin. He solders with brass (brazing). Sometimes he incorporates wood—pine, fir, and driftwood—into his sculptures. The works are painted with Kemp enamels, which Gilkerson likes because they come in a variety of unusual colors.

The artist has animated two hundred of his works—some of which are life-size—by using electric motors.

As of June 1989 Gilkerson, an extremely prolific artist, had made 1,653 objects, including the 200 motorized ones.

ARTISTIC RECOGNITION

Robert Gilkerson's animated cartoonlike sculptures are a notable achievement. He has become well known in the Bay Area of California, where he has been exhibited.

LEE GODIE—*"Once, in the early 1970s, I took my paintings to Frumkin [a well-known Chicago gallery] and the gallery wouldn't buy them—but their employees did, and I knew I was an artist."*

BIOGRAPHICAL DATA

Birthdate unknown (Godie refuses to tell her age because "Mrs. Baker Eddy said that's not a true record"). As to place of birth, the artist states, "I was born in Mudtown, Illinois." Education consisted of "some piano lessons as a child." No known marriage. No known children. Now resides Chicago, Illinois.

GENERAL BACKGROUND

Lee Godie[1] is a homeless "bag lady" who is also a remarkable artist. Godie lives on the streets of Chicago; she sleeps

on grates, in parking garages, and sometimes, when the weather is too severe, in cheap hotel rooms. She has been arrested for vagrancy, even sent for mental examination, but this is her life by choice.

Godie will not tell anyone about her background. "If she were 65 years younger, she could have represented one of those tattered, orphaned waifs that soulfully stare out at you from missionary pamphlets soliciting donations. . . . She was a homeless old lady, bundled in layers of dirty, raglike clothing, with a huge safety pin clasping the front of her coat. . . . I looked at her with mixed emotions: repulsion at her filthiness and compassion at her totally indigent state."[2]

ARTISTIC BACKGROUND

Lee Godie is homeless, and no one knows where or how she paints; only the finished products give evidence to her industry. A self-proclaimed French Impressionist, Godie appeared from nowhere in the 1960s, took up a position in front of the Art Institute of Chicago, and began to sell her paintings. "Someone told me," she explains, "If you want to sell, stand where the most people go back and forth."

For close to twenty years, Godie sold her paintings on the steps of the Art Institute; then, when a callous curator tried to explain to her that she was not really a French Impressionist, she moved to the north side of the city—up Michigan Avenue—where she has been for the last ten years.

SUBJECTS AND SOURCES

Godie recently stated: "I read in a book by Renoir's son that his father cashed in when he started to paint beauty; so I do, too. My favorite subject is Prince Charming, a friend of Picasso's." Godie claims to have been influenced by paintings she has seen in books and at the Art Institute, but in reality she has created her own vision of a world occupied by her "Prince Charming"—not Picasso's—and her version of "beauty."

Godie paints Prince Charming, a tight-lipped youth with yellow hair; vegetable and fruit still lifes; and self-portraits, which often have recognizable Chicago landmarks such as the Hancock Building in the background. Her portraits are preferred, and if there are multiple portraits on a single canvas, she has been known to cut them apart to bring down the purchase price.

MATERIALS AND TECHNIQUES

Lee Godie's paintings are done with oils, watercolors, felt markers, colored pencils, and crayons on canvas—usually old window shades. She uses material that is unsized, un-

Lee Godie, Mona Lisa, *1979. Oil on canvas, 17 × 27½ in. Arient Family Collection. Calling herself a French impressionist, Godie says she paints "beauty," which is represented here in her version of the* Mona Lisa, *who appears to be a woman of modern times wearing a swimsuit.*

stretched, and irregular. Sometimes she pins objects, such as cheap cameos and photo arcade self-portraits, to her paintings, and she irons wax over the finished picture. Because of the materials, some of her work fades easily in direct sunlight.

A few of Godie's earliest works were painted with oils and contain more detail than her later paintings. Her largest works are about 4 feet high, and she is thought to have completed hundreds of paintings, perhaps as many as a thousand.

ARTISTIC RECOGNITION

Lee Godie's reputation has spread mostly by word of mouth; generations of students from the Art Institute have purchased her paintings and been influenced by her work. Godie's paintings were included in "Outsider Art in Chicago" at the Museum of Contemporary Art in Chicago in 1979. Although her reputation is strongest in Chicago, she has gained broader attention through articles in various national newspapers and magazines.[3]

DENZIL GOODPASTER—*"People wants 'em different—so I thought them up different—and makes 'em different."*

BIOGRAPHICAL DATA

Born May 28, 1908, Deniston, Kentucky. Attended school through fifth grade, Tom Branch School, Kentucky. Married Lexie Barker, 1929. One daughter. Now resides Ezel, Kentucky.

GENERAL BACKGROUND

Denzil Goodpaster is a carver who has turned the craft of cane carving into a highly prized art form.

Goodpaster's grandparents came to the rolling Kentucky hills from Russia more than one hundred years ago. A misspelling of *pasture* gave the family its English name. The farm his grandfather cleared belongs to Goodpaster now, and through hard work and thrift, he has added 200 acres to the original plot.

When he was a child, Goodpaster found that the nearest grade school was "a little too long a walk." Since then, he reminisces, "I done nothing but raise tobacco every year of my life. I lived in this here home since just after I been born." The pale green house that is his home has a wide front porch—perfect for whittling and dreaming—that looks out over fields of tobacco spotted with white tobacco barns.

Goodpaster retired from farming in 1968 and leased out his tobacco operation. Today he spends his time making canes and fanciful carvings.

ARTISTIC BACKGROUND

In 1970, two years after Goodpaster retired, a neighbor showed him a carved-snake walking stick. "Gol darn!" Goodpaster swore to himself, "I believe I can beat the man!" and he set out to do so.

Denzil Goodpaster, Canes: Dolly Parton, *1982. Painted wood with rhinestones and wire, 33½ × 7½ in.;* Lady in Yellow Bikini, *1981. Painted wood with rhinestones, 36½ × 7½ in. Arient Family Collection. These two pieces are early examples of Goodpaster's highly imaginative canes, one of which represents Dolly Parton and the other his famous "twice-eaten" lady.*

By the early 1970s Goodpaster's canes were good enough to take to the county fair at Liberty, Kentucky. In earlier years he had won blue ribbons for his tobacco; soon he was winning blue ribbons for his art.

In 1985 the Kentucky Arts Council awarded Goodpaster an Al Smith Fellowship for his work.

SUBJECTS AND SOURCES
One of Goodpaster's favorite topics to carve on a cane is a "twice-eaten" young woman—sometimes clothed in a bikini, sometimes not—who is simultaneously being devoured by a leopard that forms the handle of the cane and a hungry alligator that crawls up from below. Goodpaster will also entwine his canes with as many as ten multicolored snakes. Others he makes in the form of portraits of both men and women. His busty carvings of Dolly Parton in particular are much sought after.

MATERIALS AND TECHNIQUES
Goodpaster whittles with a pocketknife on cedar staves or black walnut and paints his finished canes with shiny bright enamel. He uses white plastic bleach bottles to make snake teeth and sometimes adds sequins for decorative effect.

The canes and walking sticks are 30 to 40 inches in height. Goodpaster makes other smaller carvings as well, estimating that he makes about one hundred objects per year.

ARTISTIC RECOGNITION
Goodpaster is a master carver, sought out by craft collectors as well as folk art collectors interested in humor and whimsy. His earlier canes—especially the portrait pieces and the "twice-eaten" girl—are preferred. Repetition has caused some of the sense of spontaneity to be lost in the later canes.

THEODORE GORDON—*"The human face is a microcosm of the total universe, containing both good and evil. If I could, I'd get right into the eye. I'd go in with a microscope and fill in each little detail until it would be infinite."*

BIOGRAPHICAL DATA
Born June 23, 1924, Louisville, Kentucky. Graduated from Eastern District High School, Brooklyn, New York, 1942; graduated from San Francisco State College (now San Francisco State University), 1958. Married Zona Chern, June 19, 1954. No children. Now resides Laguna Hills, California.

GENERAL BACKGROUND
Ted Gordon's intricate and vividly colored line drawings of the human face have brought him increasing attention in recent years.

In his early years Gordon gave no hint that he would draw compulsively. He grew up in a strict Jewish home in Louisville, Kentucky, over the Goodwear Overall Manu-

Theodore Gordon, Jovial Fan, *1989. Marker on paper, 12½ x 11 in. Braunstein/Quay Gallery, San Francisco. This brilliantly colored face is typical of the compulsive singular image—said to be a self-portrait—that this artist produces.*

facturing Company that his grandparents owned. When the business failed in 1938, his grandparents took him to live in Brooklyn, New York. After graduating from high school, Gordon became a member of the Bricklayers, Masons and Plasterers International Union. Gradually he worked his way west, arriving in San Francisco in 1951, where he attended San Francisco State College and obtained a degree.

In 1961 Gordon obtained a job as a file clerk in the Radiology Laboratory of the Wadsworth Veterans Administration Hospital. When he retired from government service in December 1985, he was a receptionist at the Letterman Army Medical Center.

Gordon and his wife moved to a retirement community in Laguna Hills, California, in 1986, where he continues to work as an artist.

ARTISTIC BACKGROUND
Ted Gordon did not study art when he was in college, but that is when he started to make what he called "doodles," compulsive line drawings that would later bring him recognition in the art world. Gordon doodled for almost thirty years before he realized that his work was part of a recognized genre. In early 1981 he found two art books in the library of the hospital where he was working and became convinced that his doodles bore some relation to what was included in those books.[1] He sent some of his drawings to the two authors, Roger Cardinal (who teaches

at the University of Kent, Canterbury, England) and Michel Thevoz (curator of the Collection de l'Art Brut, Lausanne, Switzerland). Cardinal wrote back, "There is a streak of *brut* in you that must be developed and preserved."[2] Thevoz accepted Gordon's drawings into the permanent Collection de l' Art Brut.

In 1981 the Braunstein/Quay Gallery in San Francisco began to represent Gordon. He was included in the show "Pioneers in Paradise: Folk and Outsider Artists of the West Coast" at the Long Beach Museum of Art in California in 1984, and in a 1989 show at the New Jersey State Museum in Trenton.

SUBJECTS AND SOURCES

Gordon fills his paper or poster board with compulsive line drawings and spirals. The lines usually resolve themselves into a human face—his—and this endless self-portrait has become his trademark. "When I draw something," he states, "I am that person, fish, or bird." Although Gordon has done some drawings of animals that are of interest, his best work is the human face; the variety that he can produce without repetition is quite amazing.

MATERIALS AND TECHNIQUES

Gordon began drawing his doodles on 3-by-5-inch notepaper in 1954. In the 1960s he started cutting the cardboard posters used to advertise the San Francisco opera into quarters; he felt that the white side was good for drawing. Currently he uses sheets of high-quality paper and poster board.

Gordon draws with felt markers, colored pencils, and pens. His drawings, which are composed of thousands of small lines and details, are vividly and often unrealistically colored—faces can be red or green. He sometimes attaches commercial office products—plastic stickers or even the white dots that fall from a paper punch—to the surface.

Gordon has made about four hundred drawings, ranging in size from his early 3-by-5 inch pieces up to 3 feet square. Some of his early materials and those done with felt marker may not be stable.

ARTISTIC RECOGNITION

Ted Gordon is known for his compulsive style and for his singular theme of the human face in infinite variety. The artist, who is highly regarded among collectors of visionary folk art, has been exhibited on both coasts, including a 1989 show at the New Jersey State Museum in Trenton entitled "A Density of Passions," and is represented in American and European collections.

RALPH GRIFFIN—*"Being a folk artist is the only way a black guy can get to talk to doctors and all from the big cities. They come to me out in the country."*

BIOGRAPHICAL DATA

Born September 22, 1925, Girard, southeast Georgia. Attended school through ninth grade, Girard Elementary School. Married Loretta Gordon, January 13, 1947. Five daughters, one son. Now resides Girard, Georgia.

GENERAL BACKGROUND

Ralph Griffin, a black folk artist, uses roots and driftwood to assemble compelling sculptures that depict biblical characters as black.

Of his early life, Griffin claims that "the boll weevils did all the work" on his family's cotton farm and that he went "bankrupt" because of them. So he quit farming when he was thirty and started to travel, taking construction jobs.

"I had to work to bring up kids," he explains. "But I ended up right back in Girard, Georgia, as a janitor for Murray Biscuit Company." Griffin worked for that company for twenty-three years. When he retired in September 1989, he said he intended to "get me Social Security and work full-time on art."

ARTISTIC BACKGROUND

Griffin began making sculpture about 1980. He worked in his front yard, which faced a county road. Tom Wells, a collector and dealer, spotted the artist's work in 1981 and began to show and sell it to dealers in major cities.

SUBJECTS AND SOURCES

Griffin finds figures and animals in wood, then works to bring them out. "You can see somethin' in just about any

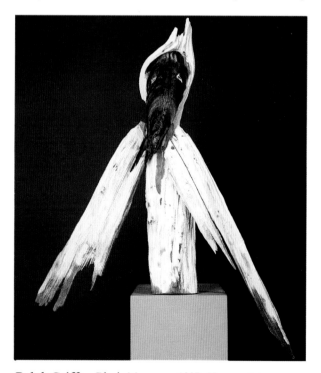

Ralph Griffin, Black Moses, *c. 1987. House paint on driftwood, 36 × 31 × 8 in. Tartt Gallery, Washington, D.C. This artist assembles pieces of driftwood into biblical characterizations in order to deliver his spiritual messages—in this case a black Moses.*

piece of wood," Griffin says. "I paints the faces black because black is more noticeable." Perhaps that explains Griffin's carvings of a black Jesus and his black half-animal, half-human figures that look as though they were rooted in the ground yet ready to take flight.

MATERIALS AND TECHNIQUES
Griffin uses driftwood (both logs and roots) that he finds along Poplar Creek, a nearby fast-running stream. He assembles the wood into the desired shape with nails and applies spray paint—usually black—from a can; he also uses red and white paint occasionally. The artist has completed more than one hundred assemblages, ranging in size from 5 inches high to 5½ feet high. Generally, the larger the piece, the stronger the statement it makes, but the more difficult it is to display.

ARTISTIC RECOGNITION
Ralph Griffin is one of a group of rapidly emerging southern black talents who show great promise. His work has been exhibited in the South, in New York City, and in Washington, D.C. Along with Bessie Harvey (see page 152), he is one of the best of the root/branch sculptors.

Griffin's work was brought to the attention of the general public when he was included in "Outside the Main Stream: Folk Art in Our Time" at the High Museum of Art, Atlanta, Georgia, in 1988.

HENRY THOMAS GULICK—*When asked why he painted so industriously, Gulick replied, "To keep from rocking and rocking and blowing away."*

BIOGRAPHICAL DATA
Born August 1, 1872, Manalapan, New Jersey. Graduated from Chattle High School, New Jersey. Married Charlotte Emily Wikoff Field, October 30, 1901; she died 1949. Two daughters, two sons. Died August 3, 1964, Middletown, New Jersey.

Henry Thomas Gulick, The Corner Cupboard, *1952. Oil on Masonite, 14 × 20 in. Barbara and Tracy R. Cate. Gulick, who was a farmer in New Jersey, portrayed in detail the rural life he experienced and observed, from local landscapes to familiar interiors like this dining room nook.*

GENERAL BACKGROUND

Henry Thomas Gulick became known for his paintings of interiors and farm scenes of New Jersey, his home state.

Gulick spent his life on a hundred-acre farm in central New Jersey. He rarely traveled, and when he did, it was only for short distances. This God-fearing man believed in hard work and love of family, and he was also a good farmer. He retired from farming in 1946.

ARTISTIC BACKGROUND

After an active life as a farmer, Gulick found that he was restless. One of his children gave him a paint box, and soon he had discovered an excellent outlet for his energy. Gulick started painting when he was seventy-five and continued to paint until the year of his death.

Marshal Simpson, an artist living in Gulick's hometown of Middletown, New Jersey, soon recognized his talent. He helped Gulick to participate in more than sixty group shows and arranged nine individual exhibitions, including a show in 1985, "A Time to Reap," at Seton Hall University, a show cosponsored by the Museum of American Folk Art in New York City.

SUBJECTS AND SOURCES

Henry Gulick painted what was around him and what he knew well—the interiors of farmhouses and barns, farm animals, and farm landscapes. He did not paint from memory; he preferred to set up an easel and work on site. He removed or rearranged disturbing elements like telephone poles, but otherwise the paintings are factual. Gulick was accomplished at capturing perspective and using realistic, but not dramatic, colors. Occasionally he did still-lifes, but these works are not as successful as his other paintings. Gulick's work has sometimes been referred to as primitive; the artist took exception to this label because he said it made him feel like a savage.

MATERIALS AND TECHNIQUES

Gulick painted with oils on Masonite and canvas. He completed about 165 paintings, which are, for the most part, around 20 to 36 inches in width. On the front of each painting the artist wrote "Henry T. Gulick" and on the back, his initials, the month, and year.

ARTISTIC RECOGNITION

Henry Gulick is one of the best-known folk painters of New Jersey and is represented in many of the major museums of that state. Because he produced a limited number of paintings, his work is rarely seen in the marketplace.

THEORA HAMBLETT

BIOGRAPHICAL DATA

Born January 15, 1895, Paris (near Old Ford), Mississippi. Graduated from Lafayette County Agricultural High School, College Hill, Mississippi, 1915; attended Mississippi Normal College for several summers. Single. No children. Died March 5, 1977, Oxford, Mississippi.

Theora Hamblett, The Angel's Request, *1954. Oil on Masonite, 18 × 24 in. University Museums, University of Mississippi. The artist frequently painted her memories of life in Mississippi, but her "visionary" paintings, such as this one, constitute a unique body of work and are highly regarded.*

GENERAL BACKGROUND

Theora Hamblett painted a wide range of subjects, but her unusual "dream" paintings brought her special renown.

Hamblett taught at several "one- and two-teacher" rural schools from 1915 until 1936, taking time out to care for her sick mother, who died in 1935. Finally she quit teaching, admitting to "daydreaming" so much so that she really could not concentrate on teaching school. She would dream of her childhood and of the 300-acre farm on which she was raised.

After leaving teaching, Hamblett made an unsuccessful attempt at raising chickens. In 1939 she bought a stately home in Oxford, Mississippi, and took in sewing and rented out apartments to make a living. Once she started painting, however, she began to move the tenants out, filling the house with her art arranged according to subject matter. She put a sign in front of the house: "Theora Hamblett Paintings."

When Hamblett died in 1977, she willed the contents of her home, including all the artwork, to the University of Mississippi, Oxford.

ARTISTIC BACKGROUND

Theora Hamblett once said that she had a lifelong desire to paint, but that financial problems had prevented her from doing so.[1] In 1950, when she was fifty-five years old, the University of Mississippi added an art department and she enrolled in a basic course in oil painting. The school was teaching abstract art, which did not interest her; she wanted to paint her own dreams and visions, and so she did.

Hamblett's first dream painting (bought by Betty Parsons, a New York art dealer) is now in the Museum of Modern Art in New York. She later regretted selling the pictures of her "dreams" and "visions" and began to keep them for herself. These paintings, part of her estate, are currently in the museum of the University of Mississippi.

SUBJECTS AND SOURCES

Hamblett developed four types of work: memory paintings, landscapes, children's games, and dreams and visions. Her paintings sometimes tell sequential stories based on her visions; for example, *Heaven's Descent to Earth,* a triple triptych (three painted panels, each panel composed of three scenes), shows a group of children sitting with an adult (perhaps Hamblett) and watching the arrival of heavenly chariots and their celestial occupants, who leave the chariots in a flow of light to bring greetings to the earthly group watching them.

MATERIALS AND TECHNIQUES

Hamblett painted approximately six hundred works with oil paints on Masonite, developing a wonderful palette of subtle colors in rainbow hues. She would use small brushstrokes and dots of color to make her figures stand out from the background.

Her paintings range in size from 20 by 36 inches to 36 by 40 inches. Some of her triptych panels are as long as 54 inches.

ARTISTIC RECOGNITION

Hamblett's surrealistic dream and vision paintings are unique; indeed, they are among some of the most unusual of this century. The memory paintings, landscapes, and pictures of children's games are important for their illustrative value and as fine examples of southern genre painting —colorful and romantic. Her work may be found in many major collections today.

ESTHER HAMERMAN

BIOGRAPHICAL DATA
Born Esther Wachsmann, 1886, Wieliczka (near Krakow), Poland. Received the equivalent of schooling through eighth grade while in Poland. Married Baruch Hamerman, 1906; he died 1948. Four daughters. Died April 1977, New York City.[1]

GENERAL BACKGROUND
Esther Hamerman[2] was a memory painter whose varied works show the bad as well as the good times in her life.

Hamerman and her husband managed to stay one step ahead of Europe's anti-Jewish pogroms, which occurred on the brink of both world wars. In 1912 they left Poland for Vienna, where Baruch Hamerman ran a business making unblocked straw and felt hats. In 1939 the family fled to Port-of-Spain, Trinidad, where they were interned by the British.

The Hamermans arrived in New York in 1944. In 1950, shortly after the death of her husband, Esther Hamerman moved to San Francisco to join her daughter Helen Breger. She returned to New York City in 1963 and remained there until her death in 1977.

ARTISTIC BACKGROUND
Hamerman started drawing around 1946, when she was living in New York. She was encouraged by her daughter Helen, and after she moved to San Francisco to live with her, Hamerman started painting seriously. "I remember," Breger recalls, that "Mother used to paint in the kitchen and discuss her work with us in the evenings."

SUBJECTS AND SOURCES
Hamerman was a memory painter, remembering the bad along with the good. She painted as close to reality as possible, showing Jewish life in Poland and Austria as war approached, depicting the family's internment in Trinidad, and painting remembrances of her life in New York and California.

MATERIALS AND TECHNIQUES
The artist did a few drawings and watercolors on paper, but her best work was done in oils on canvas. She had a rare sense of color, and although she lacked the ability to use perspective properly, her paintings have a strong feeling of reality. None of her work is fussy or contrived.

Hamerman completed about seventy-five oil paintings and drawings. The oils range in size from about 14 by 18 inches to about 38 by 46 inches.

Esther Hamerman, Passover, c. 1957. Mixed media on paper, 8½ × 6¾ in. Ames Gallery of American Folk Art, Berkeley, California. Hamerman painted her remembrances of a long life, which included hard times as well as good ones. As in this work, she often was inspired by her Jewish religious convictions.

ARTISTIC RECOGNITION
Esther Hamerman is one of the best-known folk artists who have lived and worked in San Francisco. The paintings she did in the thirteen years she lived there are considered to be among her best. Hamerman has been shown at many of the major museums in the Bay Area and is represented by the Ames Gallery in Berkeley, California.

JAMES HAMPTON

BIOGRAPHICAL DATA
Born April 8, 1909, Elloree, South Carolina. Attended school through tenth grade. Single. No children. Died November 4, 1964, Washington, D.C.[1]

GENERAL BACKGROUND
Little is known of the early years of this black folk artist who was to create one of the most extraordinary visionary pieces of the time.

James Hampton's father was a gospel singer and preacher. At the age of nineteen Hampton moved to Washington, D.C., to live with an older brother. From 1939 to 1942 he worked as a short-order cook, then as a government laborer, until he was drafted. He served with the 385th Aviation Squadron in Texas, Seattle, and various bases in the South Pacific. After his discharge in 1945, Hampton returned to Washington, D.C., and a year later went to work for the General Services Administration as a janitor, a job he would hold until his death in 1964.

About 1950 Hampton rented an unheated and poorly illuminated garage not far from the rooming house where he lived; he told the owner only that he was working on a project that needed a large space. This small, slight, and unassuming man then began to spend long hours at the garage when his daily job was over, but few of his neighbors had the curiosity to see what he was working on so diligently. He had a reputation for being somewhat reclusive, and this was a neighborhood where few explanations were required or desired. Thus Hampton spent the years until his death building his environment dedicated to the Lord in almost complete isolation.

ARTISTIC BACKGROUND
James Hampton claimed that he had had "visions" throughout his life, the first occurring when he was twenty-two. He believed that God, the Virgin Mary, and the prophets visited him and gave him inspiration and direction, and he documented his visions on tags, some of which were later attached to pieces of his work. Inspired by these visions, and following what he believed were God's instructions, Hampton set to work in his garage creating the assemblage that he called The Throne of the Third Heaven of the Nations Millenium General Assembly.[2]

Hampton may have started his construction before moving into the garage in 1950, as one small piece is marked "Made on Guam, April 14, 1945," but no other evidence of earlier work exists. Hampton compulsively worked on the Throne for fourteen years, and few people knew of its

existence until after he died and his sister came north to claim his body.

SUBJECT AND SOURCES

Hampton's *The Throne of the Third Heaven of the Nations Millenium General Assembly* is dominated by a glittering and elaborately decorated central throne, on either side of which are symmetrically arranged pulpits, chairs, tables, vases, and stands (on the viewer's left, the New Testament; on the right, the Old Testament); twenty-five individual crowns are placed throughout the entire assemblage.

Hampton left no explanation of the symbolism in the *Throne,* but it is thought that he derived many of the ideas from the Book of Revelation—pertinent references are found inscribed on some of the pieces. He also developed an undeciphered script that he claimed God had given him, and he filled a small notebook with the graceful characters of this unknown language.

It has been said that "the Throne . . . create[s] a vehicle for religious renewal and teaching,"[3] but whether that is what Hampton meant it to be is largely a matter of conjecture, because he shared his visions with no one else. It is known that he used it himself for solitary religious services on Sundays, and perhaps he did intend it ultimately to have a broader religious and educational use, as some have said.

MATERIALS AND TECHNIQUES

Hampton "applied his imagination to the transformation of discarded materials."[4] Drawers turned upside down, old furniture, glass vases, jelly glasses, light bulbs—the flotsam and jetsam of Washington's alleys became transcendent when given new life as part of the *Throne.* All these found objects—thousands of which are part of the *Throne*—Hampton carefully covered with different grades of gold and aluminum foil, changing the tawdry and mundane into a mystical masterpiece.

The artist often scoured the streets to find the right materials for his construction, but he also had local street

James Hampton, Throne of the Third Heaven of the Nations Millenium General Assembly *(middle section), c. 1950–1964. Gold and silver foil over furniture, 177 pieces of various sizes. National Museum of American Art, Smithsonian Institution, Washington, D.C.; Gift of anonymous donor. Created from cast-off furniture and used gold and silver foil and inspired by divine "visions," James Hampton's* Throne*, of which a major portion is shown here, is a spectacular and awe-inspiring achievement.*

people search for discarded pieces of foil. Tacks, small nails, and pins help to hold the work together, and occasional touches of color—from a green desk blotter or an old red velvet armchair—relieve the glow of silver and gold.

One hundred eighty separate pieces make up the *Throne.* It is not known for sure if the construction was complete at Hampton's death, but the general consensus is that, had he lived, Hampton would have added still more objects to it. Although the overall size of the *Throne* partly depends on the method of display or the space available, the assemblage is approximately 32 feet long and 9 feet high.

ARTISTIC RECOGNITION

The Throne of the Third Heaven of the Nations Millenium General Assembly is on permanent display in the Smithsonian Institution's National Museum of American Art. It can be viewed as a small church and altar, as a puzzle whose meaning is yet to be deciphered, or simply as a thing of beauty, a true work of art. It is inspiring yet humbling, a never-to-be-forgotten masterpiece and an enduring monument to its quiet creator.

JOSEPH HARDIN—*"When collectors come here —they empty my walls. Then I gotta start over. But I need the money."*

BIOGRAPHICAL DATA
Born April 19, 1921, Raymond, Alabama. Attended school for three grades at Martin School, Birmingham, Alabama. Single. No children. Died December 25, 1989, Birmingham, Alabama.

GENERAL BACKGROUND
When disease limited his world, the artist Joseph Hardin found a way to express his emotions through highly original works on paper.

"I have rheumatoid arthritis," Hardin lamented, "everywhere but my eyes. I am crippled over and crippled up. When children see my hands, they break into tears." Hardin had been afflicted with this disease since he was seven years old. He was confined to a wheel chair, and it was impossible for him to hold down a job.

Before moving into his apartment in a federally sponsored project in Birmingham, Alabama, Hardin lived with a nephew in Albany, Georgia (from 1969 to 1975). He missed the "frog wallpaper" in his nephew's home after he moved and decided to wallpaper his new home with "my own pictures." Hardin was found dead in his apartment on Christmas Day, 1989.

ARTISTIC BACKGROUND
Hardin started making drawings to "wallpaper" his apartment in 1975 or 1976. A Meals-on-Wheels volunteer who was interested in his work introduced Hardin to watercolor artist Virginia Martin, who helped to supply him with materials. She also arranged for an exhibition of his drawings at the Birmingham Museum of Art in 1987.

SUBJECTS AND SOURCES
With anguish and repressed sexuality, Hardin drew the world in which he could not participate. His most frequent subjects were men and women; the women are often nude, with foreshortened limbs, and appear as objects of sexual desire. He also drew very haunting faces of women, as well as gentler scenes of animals, flowers, and birds.

MATERIALS AND TECHNIQUES
Hardin worked on paper. He started out drawing on corrugated cardboard and wastepaper, but in recent years the Birmingham Art Association supplied him with high-quality materials.

Hardin drew with crayon and pencil; he also used acrylics because "they are easy to wash off my hands." His colors are symbolic rather than realistic; often faces are green and yellow or other unusual combinations. Hardin gave some of his work a slightly three-dimensional effect by melting crayons and using the colored wax to build up breasts or the pupils of eyes.

Hardin completed about two hundred drawings. They are approximately 16 by 13 inches; he could not work on larger paper because it had to fit on his lap.

Some of his early work is on unstable material, and the drawings that he used as wallpaper may have thumbtack holes in the corners or marks where cellophane tape was applied.

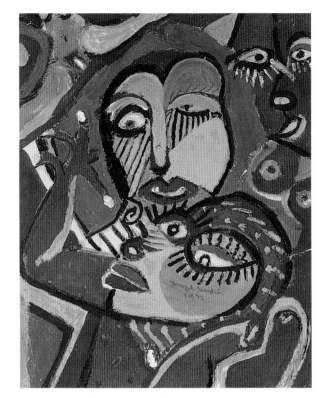

Joseph Hardin, Untitled, *1971. Mixed media on paper, 17 × 13¾ in. Tartt Gallery, Washington, D.C. Joseph Hardin used his art to express his anxiety and sexual frustration, and the result was striking abstract images like the one shown here.*

ARTISTIC RECOGNITION
Hardin's early drawings are among his best. They represent the individualistic expression of an artist who, when disease prevented him from enjoying the "normal" world, created a world of his own.

The artist was included in a two-person exhibition at the Birmingham Museum of Art in 1987. After his work was exhibited, Hardin began making pictures that he felt were expected of him—nudes in landscapes and colorful flowers—and these are perhaps not as original as his earlier work. In his most recent work, however, the artist was again expressing his own vision, and his drawings are very powerful.

STEVE HARLEY

BIOGRAPHICAL DATA
Born December 19, 1863, Fremont, Ohio. Family soon moved to Scottsville, Michigan. Extent of education unknown. Single. No children. Died November 24, 1947, Scottsville, Michigan.[1]

GENERAL BACKGROUND

Steve Harley was a naturalist whose magnificent landscape paintings show extraordinary attention to detail and color.

Very few details of Harley's life are known, but it is clear that he was an avid observer of nature, a man who preferred hunting and trail riding to farming. When the family farm he had inherited failed in the 1920s, he took the opportunity to leave Michigan and travel extensively in California, Washington, and Alaska. Overwhelmed by the grandeur of the frontier landscape of the Northwest, Harley tried to capture its beauty and majesty in photographs but found that he could not match the reality.

In the 1930s, broke and in poor health, Harley returned to Scottsville, Michigan, where he found a shack in which to live. His only source of income was relief payments from the Michigan Bureau of Old Age Assistance.

ARTISTIC BACKGROUND

Steve Harley's only background in art was a course in taxidermy and a correspondence course in drawing. He taught himself photography, but it did not seem to measure up to his expectations. Apparently he became dissatisfied with photographs because of the lack of color (color photography in the 1920s was not yet widespread at the amateur level), and the photos, to him, did not mirror reality. He turned to painting to capture the qualities in the landscape that photography could not, and in 1927 and 1928 produced three spectacular paintings that he kept with him for the rest of his life. No other works are known.

SUBJECTS AND SOURCES

Harley was a naturalist; he captured the "essence of the primeval Northwest with greater strength than perhaps any other naive painter."[2] The artist had an uncanny ability to use color, and his knowledge of taxidermy, together with his close observance of nature, made it possible for him to portray animals with great accuracy. A gliding eagle, a deer, and a bear become the focal points of interest in his works. Nature reigns supreme; there are no people in his paintings to mar the awesome serenity.

MATERIALS AND TECHNIQUES

Harley painted with oils on canvas. He was so concerned with capturing every minute detail of the scenes he wished to portray that he worked with a tiny brush and a magnifying glass; no blade of grass was too unimportant to be overlooked.

There are only three known paintings by Harley: *South End of Hood River,* 20 by 33½ inches, done in 1927; *Upper Reaches of Wind River,* 20¼ by 33⅜ inches, also done in 1927; and *Wallowa Lake,* 24¹¹⁄₁₆ by 36¼ inches, painted in

Steve Harley, Wallowa Lake, *1927–1928. Oil on canvas, 24¹¹⁄₁₆ × 36¼ in. Abby Aldrich Rockefeller Folk Art Center, Williamsburg, Virginia. One of Harley's three known paintings, this spectacular wilderness scene is considered to be one of the finest examples of the romantic naturalist style.*

1927–1928. He signed the back of at least one of his paintings "S. W. Harley 'the Invincible.' "

ARTISTIC RECOGNITION
Steve Harley painted in the style of a nineteenth-century romantic naturalist and bridged the gap between the centuries. His body of work, although small, is known to scholars and students of folk art and is highly respected. All three of his paintings are in the collection of the Abby Aldrich Rockefeller Folk Art Center in Williamsburg, Virginia.

BESSIE HARVEY—*"I have a feeling for Africa. I see African people in the trees and in the roots."*

BIOGRAPHICAL DATA
Born Bessie Ruth White, October 11, 1929, Dallas, Georgia.[1] Educated through fourth grade, Dallas, Georgia. Married Charles Harvey, 1944; divorced 1968. Married

Bessie Harvey, Jezebel, *1988. Wood, paint, and found objects, 50 × 47 × 24 in. Arnett Collection. Harvey envisions "souls in the branches and roots" that she carves, and she adds found objects and a bit of paint to the wood, creating intriguing, sometimes grotesque figurative characterizations, such as the glitter-dusted* Jezebel *shown here.*

Carl Henry, February 14, 1989. Four sons, seven daughters. Now resides Alcoa, Tennessee.

GENERAL BACKGROUND
Bessie Harvey is a black folk sculptor who creates powerful, sometimes grotesque figures from tree branches and roots.

Harvey began working in the homes of others when she was twenty-one. "I ran away from my husband," she explains; then she "went to work for the Metcalf family in Knoxville, Tennessee [about 1960]." Although Harvey was reunited with her family briefly in Alcoa, Tennessee, she and Charles Harvey were finally divorced in 1968.

From the late 1960s until 1983, when she retired, Harvey worked as a housekeeper's aide at the Block Memorial Hospital in Alcoa. Now she devotes her time to the creation of her sculpture.

ARTISTIC BACKGROUND
"I have a vision. I have a gift. I can close my eyes and see things others can't," Bessie Harvey proclaims. Her "gift" led her to start making sculptures out of tree roots and branches around 1974. At the time, she was working at the Block Memorial Hospital, which has an annual art show that she entered in 1978. The show brought her work to the attention of doctors on the staff, one of whom introduced her to a New York gallery that represented her for a few years. Presently, however, Harvey prefers to sell her pieces from her front porch, where she likes to display them.

SUBJECTS AND SOURCES
"I talk to the trees," Harvey says. "There's souls in the branches and roots. I frees them." From the wood she brings out faces, people, and shapes that she believes are already there. She makes very simple "dolls" (as she often refers to her sculptures) as well as quite complex figures. Some of her work is sexually suggestive; some is rather gruesome and even difficult to view.

MATERIALS AND TECHNIQUES
Harvey uses tree branches, logs, and roots to make her sculptures. She nails and glues pieces together, altering them only slightly. She adds putty, beads for teeth, glitter, hanks of her own hair, and other objects. The work is mostly painted black. "Evil is beautiful because the devil would disguise himself as good. I paint 'em black for evil."

Harvey's sculptures can be as small as 10 inches high or as large as 6 feet. She is a prolific worker: "I don't do nothing much to the wood, so I can make a porch full in an afternoon."

ARTISTIC RECOGNITION
Bessie Harvey's sculpture is powerful and mysterious. Her work was shown at the High Museum in Atlanta, Georgia, in 1988, and since then she has had gallery showings in New York City and San Francisco. She has reached what could be considered "star" status with collectors interested in black folk art.

GERALD HAWKES—"*I don't draw it—He does.*"

BIOGRAPHICAL DATA
Born April 16, 1943, Baltimore, Maryland. Graduated from Carver Vocational Technical High School, Baltimore, Maryland. Married Luella Lee, 1965; divorced 1975. Married Helen Baskerville, 1981; divorced 1983. Married Diane Thompson, 1984; divorced 1986. No children. Now resides Baltimore, Maryland.[1]

GENERAL BACKGROUND
Gerald Hawkes is a black folk artist who builds fantastic sculptures from matchsticks to convey messages from God.

Hawkes is a printer by training. After high school, he worked as an assistant teacher in printing at the Mergenthaler Vocational High School in Baltimore. From 1963 through 1965 he was in the army and was trained as a medical specialist, but upon his discharge he returned to Baltimore and to printing, working as a compositor for the Moran Printing Company and other printing houses.

A religious man, Hawkes was ordained as a deacon in the Shiloh Baptist Church in 1981, a position he still holds.

In 1984 Hawkes was mugged by pipe-wielding thugs and was so disabled from the encounter that he was unable to work for three years; he also lost most of his senses of taste and smell. Although he has now generally recovered, rather than return to printing, he is devoting himself full-time to his art.

ARTISTIC BACKGROUND
In 1973 Gerald Hawkes spent six months in New York City, where he started to make what he calls his "matchworks"—sculptural pieces composed only of matches and furniture decorated with thousands of matchsticks. He has continued ever since, except for the period when he was disabled by the mugging.

Hawkes's work was discovered by George Ciscle, a private dealer in Baltimore. Ciscle arranged for several local showings and for Hawkes's inclusion in exhibitions at the Baltimore Museum of Art in 1980 and 1989.

SUBJECTS AND SOURCES
God speaks to this artist through a mole in the center of his forehead. "The triangle formed by the mole and my two eyes," he says, "is the holy trinity." Following God's instructions, Hawkes creates his matchstick artwork, using symbols to convey God's directives about religion, family, and the condition of the world. Somewhere on each piece his black mole and two eyes (the trinity) are always present in the form of a triangle. The artist says he likes working with numbers and geometric shapes, and matches have become the mathematical units—nineteen make a square —through which he can best communicate his philosophy and God's directives.

Hawkes can create endless variations in texture and color through the placement of the matches on furniture. He also uses the matches to build up ingenious free-standing sculp-

Gerald Hawkes, Beck-ee My Woman of the Year, *1988. Matchstick sculpture, 11 × 6 × 8 in. LeRoy and Rebecca Hoffberger. Hawkes uses his personal medium—dyed matchsticks—to create mysterious sculptural objects, as in this example, that convey his mystical beliefs.*

tural forms, such as heads, chests, and cubes. Sometimes the sculptures have secret drawers and can be assembled like puzzles. The sculptural heads appear to be his most interesting work to date.

MATERIALS AND TECHNIQUES
The artist rescues assorted old furniture and boards and attaches matches to their surfaces with ordinary household glue. He has glued more than four million matchsticks to used furniture in the course of making his art.

Hawkes buys Diamond and Ohio brand matches and soaks them in warm water to remove the sulfur. Then he colors them with dyes made from berry juices, herbs, and coffee grounds that he mixes with water, vinegar, and alcohol. He finishes his works with a clear protective coat of oil, wax, or polyethylene.

The artist has completed 150 pieces, some of which are as large as 3 by 4 feet.

ARTISTIC RECOGNITION
Gerald Hawkes has developed a unique medium for expressing himself;[2] his matchworks are geometrically designed, colorful, and fascinating. He is well known in Baltimore through his inclusion in gallery and museum shows.

WILLIAM LAWRENCE HAWKINS

BIOGRAPHICAL DATA

Born July 27, 1895, Union City (near Lexington), Kentucky. Attended school for three years, Four Mile School, Four Mile, Kentucky. Married Ruth Cousin, January 16, 1916; divorced 1923. Married Chaney Martin, 1925; she died 1940s. Three children by Cousin. Died January 23, 1990; Columbus, Ohio.[1]

GENERAL BACKGROUND

William Lawrence Hawkins painted dramatic expressionistic works that placed him among the best known and most widely exhibited of the contemporary black folk painters.

A "romantic problem" motivated Hawkins to move north from Kentucky to Ohio in 1916. Before that, he farmed, shucked corn, and broke horses around the area where he grew up. Hawkins found work in Ohio driving trucks and working on construction projects. From April 1918 to December 1919 he served in the army, working burial details in France.

In the early 1920s Hawkins worked for the Buckeye Steel Casting Company in Columbus; he was particularly proud of that job because he was one of the few blacks that the company hired. An energetic man, Hawkins often worked several jobs at a time—driving trucks, doing demolition (he was a one-man wrecking crew), and running numbers.

After retiring, Hawkins spent his excess energies working on his art.

William Lawrence Hawkins, Willard Hotel, *1987. Enamel on Masonite, 48 × 60 in. Private collection. Late in his life, the artist displayed a bold and expressionistic technique he had perfected to create dramatic and colorful architectural portraits of buildings that caught his fancy.*

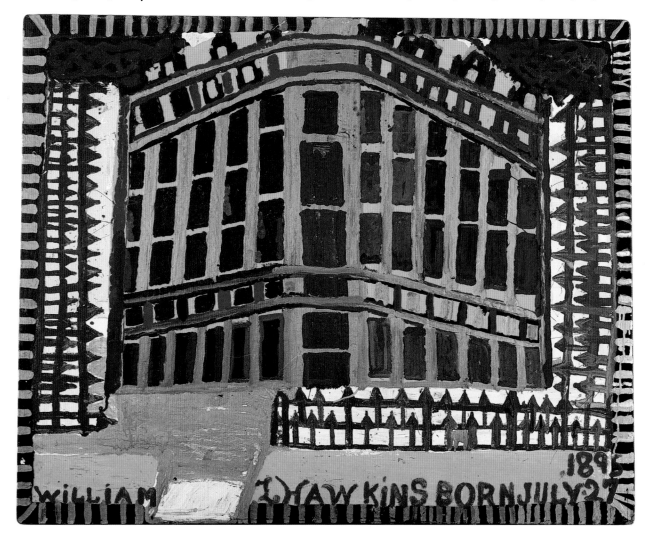

ARTISTIC BACKGROUND

William Hawkins started painting in the 1930s, but his mature work, for which he became known, began to appear about 1979. That was when Lee Garrett, an artist who lived across the street from Hawkins, started to notice the artistic activity of his neighbor and introduced him to Roger Ricco, a New York city dealer, writer, and gallery owner. Since then Hawkins's work has been promoted and exhibited extensively; age daunted neither the spirit nor the ability of this artist.

SUBJECTS AND SOURCES

Hawkins worked from black-and-white photographs of cityscapes and animals that he took himself. He endowed his subjects with his personal sense of reality, with no particular concern for perspective or detail. His art is dramatic: the cityscapes and houses seem to have a life of their own, the animals possess human qualities, and there is a great sense of motion in the paintings. The artist had begun to include the human figure in his art only recently.

MATERIALS AND TECHNIQUES

Hawkins painted on used, sometimes torn and irregular Masonite and plywood and sometimes attached found objects to the board. He used semi-gloss enamel paint, working with only one brush and wiping it as he went along. He mixed stark colors (mostly whites and reds) directly on the base material with broad, sure brushstokes.

Hawkins's paintings are large, reaching up to 5 or even 7 feet in length. His early works are unaccounted for, but 450 completed paintings would be a conservative estimate of his known output.

ARTISTIC RECOGNITION

Because of his bold and expressionistic style, William Hawkins, prior to his death, had become one of the most widely exhibited and sought-after folk artists. His work is in a number of public collections, including the Museum of American Folk Art in New York City and the Akron and Columbus museums in Ohio.

REVEREND HERMAN LEE HAYES

—"When I can pick up an old piece of scrap wood and turn it into something that makes people happy, I call that art." "If you are going to carve, you are going to cut your fingers. I have more then thirty-five scars on my hands to prove it."

BIOGRAPHICAL DATA

Born September 23, 1923, Elkview (near Charleston), West Virginia. Graduated from Elkview High School; attended West Virginian Wesleyan, Buckhannon, West Virginia, and Morse Harvey College, Charleston, West Virginia; courses in sociology and religion. Married Ladena Rooper, September 6, 1953. One son. Now resides Hurricane (between Charleston and Huntington), West Virginia.[1]

Reverend Herman Lee Hayes, *Three Figures, c. 1986. Carved wood, 9 in. high. Liz Blackman/Outside-in, Los Angeles. Hayes started his carving career by making tiny thimbles that he sold to benefit his ministry. By the mid-1980s he was carving unadorned but complex totemlike figures, such as those illustrated here.*

GENERAL BACKGROUND

The Reverend Herman Lee Hayes has a sly sense of humor that is immediately apparent in the whimsical carvings that have made him well known among the Appalachian carvers today.

Hayes was a successful middleweight boxer in high school and college—forty wins in forty-eight bouts—but he did not choose to pursue boxing as a profession. In 1942 he joined the marines and saw action in the invasion of Okinawa. After his discharge in 1945, he sold vacuum cleaners in Charleston, West Virginia, then traveled through thirty-five states selling magazines (1947-1948).

"Then," he says, "I felt my calling and went back to school." Hayes started preaching but was not ordained a Methodist minister until 1962. For the next twenty-plus years he rode a circuit of six churches in Logan County, West Virginia, and pastored two churches on Huff Creek before retiring in 1986.

ARTISTIC BACKGROUND

Hayes started to carve about 1954, before his ordination. He made thimbles that he advertised for sale in women's sewing magazines. "I did it to benefit Reverend Hayes," he says. As time went by, his carving became larger and more complicated, moving from the functional to the sculptural. He calls these later pieces "what-nots."

In 1979 Hayes's work was shown at the Smithsonian Institution's Renwick Gallery, bringing him national attention. He also won the West Virginia Governor's Award in the Arts in 1979 and 1989.

SUBJECTS AND SOURCES

"Look at my pieces," Hayes beckons. "All of a sudden it will hit you and you'll start laughing. Sometimes I laugh myself." Whimsy has always been present in the craft of the Appalachian whittler in such forms as pecking chickens and dancing men, but Hayes has taken this craft one step further by carving imaginary personalities. He puts them in cages and builds them up in totem-structures. His usual central character is a round-faced little man who continually gets trapped within the confines of the wooden cages. Only the most experienced whittler can create this type of what-not fantasy.

MATERIALS AND TECHNIQUES

The artist uses local woods—pine, buckeye, poplar, walnut, and bass. He carves with a pocketknife, X-Acto knives, and chisels. He does not use paint on his work.

Hayes has made many thousands of objects, a number of which are the half-inch-high thimbles for mail-order sales. His major pieces, which number one hundred or more, range from about 6 inches in height to a man with a rake that is 6 feet tall.

ARTISTIC RECOGNITION

The Reverend Herman Lee Hayes has produced some of the best and most complex Appalachian carving of the time. His style and humor set him apart from the ordinary whittler, and he is well known to collectors of this type of art.

MORRIS HIRSHFIELD

BIOGRAPHICAL DATA

Born 1872, near the German border of Russian Poland (Lithuania). Education unknown. Married Henrietta Overstein; marriage date unknown. Two daughters, one son. Died July 26, 1946, New York City.[1]

GENERAL BACKGROUND

Morris Hirshfield's imaginative and distinctive style placed him as a vanguard painter in the 1940s, and his work remains highly appreciated today.

Hirshfield immigrated to New York City with his family when he was eighteen years old. He soon found employment as a worker in a women's coat factory, and within a few years he and his brother had founded Hirshfield Brothers, a company that made women's coats and suits. Twelve years later he opened the E. Z. Walk Manufacturing Company, specializing in women's slippers; it is reputed to be the largest slipper-making company in New York at the time.

A long and serious illness left Hirshfield in poor health, and he retired from business in 1937.

ARTISTIC BACKGROUND

Morris Hirshfield had shown an aptitude for art from childhood; he began carving when he was twelve, and by the time he was sixteen he had made a massive carved and gilded prayer stand for his synagogue in Poland. However, he did not begin to paint until after his retirement in 1937.

Hirshfield's initial efforts were a disappointment to him. "It seems my mind knew well what I wanted to portray," he once said, "but my hands were unable to produce what my mind demanded." Nor was his family very supportive of his work. Nevertheless, he persevered in his determination to paint and was rewarded in 1939 when Sidney Janis, the New York art dealer, discovered him.

Janis was curating "Contemporary Unknown American Painters" at the Museum of Modern Art in New York in 1939 and invited Hirshfield to be in that exhibition. He also organized an individual show for the artist at the museum in 1943. Over the years Janis himself bought a number of Hirshfield's paintings and regularly exhibited the artist's work in his gallery. Hirshfield, however, was not always appreciative of Janis's efforts, often feeling that he did not get what the paintings were worth. "It was just heartbreaking pay for the work I put in," he commented once. "The time, effort, strain, and hours of tedious labor with no compensation is very discouraging."[2]

SUBJECTS AND SOURCES

Women and animals were Hirshfield's favorite subjects, and he frequently included both in the same painting. His women are sometimes nude, often set off by rich fabrics.

The artist also portrayed domestic cats and dogs, as well as lions, tigers, and zebras. His animals have an appealing Rousseau-like quality, and *The Tiger* is one of the best.

Hirshfield's religious background is evident in some of his paintings. The Star of David sometimes appears in stylized form, or a blue-and-white motif, the color of Zion's flag, is used; candleholders resemble the seven-stemmed Jewish menorah. Because of his long years in the garment business, texture and design were also important to this artist. Hirshfield painted vibrant fabriclike backgrounds and floral designs that appear to be reminiscent of his former occupation.

MATERIALS AND TECHNIQUES

Hirshfield made large preliminary drawings, which he then traced onto his canvas, filling in the outline with oil paints. He worked compulsively on his paintings, sometimes ten or eleven hours a day, and would often rework them—over a period of years, if need be—until he was satisfied with the result.

The artist never painted from models. "Can I have a tiger pose for me?" he once commented. "And I couldn't very well bring a nude woman in and paint her. It wouldn't look right." He did use reference photographs, however, especially of animals.

Morris Hirshfield, Nude with Hairbrush, *1942. Oil on canvas, 48 × 40 in. Private collection. This sensual nude— displaying the artist's distinctive style—is complemented by his use of intricately designed and detailed fabrics, inspired most likely by the many years Hirshfield spent in the garment business.*

The artist completed seventy-seven canvases, some as large as 60 by 40 inches.

ARTISTIC RECOGNITION

Morris Hirshfield "painted with realism, not the realism of actual appearance but that of the inner life of the artist."[3] The art world of the 1940s recognized him as a "vanguard" painter, even though he never studied art; he remains an important folk artist, well known to museum-goers. His work is included in both public and private collections.

LONNIE ("SANDMAN") HOLLEY

—"I try to get white people to love the spirit of the black man."

BIOGRAPHICAL DATA

Born February 10, 1950, Birmingham, Alabama. Attended school through seventh grade, Princeton Elementary School, Birmingham, Alabama. Married Carolyn Rose Robinson, January 17, 1981. Three sons, two daughters. Now resides Birmingham, Alabama.

GENERAL BACKGROUND

Lonnie Holley is a black folk artist who is becoming known especially for his dramatic sandstone carvings.

"I was given away to foster homes," Holley remembers of his childhood in Birmingham. "They was rough years, full of drinkin' and beatin's. I ran away to Louisiana when I was fourteen."

Holley worked as a short-order cook in restaurants in Louisiana, Florida, and Ohio, then returned to Birmingham in 1972 and worked in restaurants in that city. When Holley's sister lost two children in a house fire in 1979, he became so depressed that he tried suicide. When his attempt failed, he decided to try to do something constructive with his grief; he made tombstones for the children because the family could not afford to buy any.

ARTISTIC BACKGROUND

The two tombstones for his nieces were Lonnie Holley's first venture into art. He says that at the time of his suicide attempt he asked the Lord, "Take me to the top," and the Lord replied, "Make art!" After the tombstones Holley went on to create an environment of sculptures and carvings out of a variety of materials that he assembled in his backyard.

Eventually Richard Murray, director of the Birmingham Museum of Art, discovered Holley's backyard environment. Murray contacted the Smithsonian Institution, and as a result Holley's work was included in "More Than Land and Sky," a traveling exhibition that originated in 1981 at the Smithsonian Institution's National Museum of American Art in Washington, D.C.

Holley is now working full-time as an artist.

SUBJECTS AND SOURCES

Holley has created a unique and unusual environment composed of sandstone carvings and sculptured assemblages made of steel, wire, and board. His work, he says, "takes me to the top after I sunk so low." In it he is preaching a message against the "cruel and the bad."

His sandstone carvings show embryolike figures or masklike faces embossed into the stone; his assemblages and paintings tell stories to illustrate the philosophy the artist has developed concerning racial and social issues.

MATERIALS AND TECHNIQUES

For his sandstone carvings Holley rescues the inner core liners (core sand) that are discarded by foundries and reuses them. He applies a sealer of Elmer's glue to the finished works. The sculptured assemblages are made out of found objects—anything from musical instruments to chair legs to clothing to wire.

Holley has made about 1,500 sandstone carvings, which range from a few inches high to 3 by 5 feet. He has done a number of paintings and wire assemblages, some of which are as tall as 5 feet.

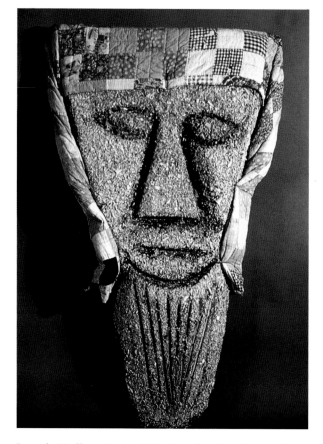

Lonnie Holley, Spirit of My Grandmother Wrapped in the Blanket of Time, *1987. Wood covered with sawdust and found quilt, 45½ in. high. Arnett Collection. Known for his dramatic sandstone sculptures, Lonnie Holley also carved various other materials that he assembled in his backyard, including wood, which he used in this tribute to his grandmother.*

ARTISTIC RECOGNITION

To date, the sandstone carvings are Lonnie Holley's most original work, although his environment, considered as a whole, is significant. He is part of a group of emerging southern black artists whose work is becoming increasingly appreciated.

JESSE HOWARD—"FREE THOUGHT FREE SPEECH AND JESSE HOWARD IS MY NAME."

"SOME PEOPLE'S MIND IS SET IN CONCRETE, AND PERMELY MIXED. I DEAL WITH PEOPLE LIKE THAT MOST EVERY DAY. JESSE—THE—SIGN PAINTER."

"WHOT A WONDERFUL DAY. BIRDS CHIRPING. FROGS CROAKING! IF THE PEOPLE WERE AS NICE AS THIS DAY IS! THIS WOULD BE A WONDERFUL WORLD TO LIVE IN!"

(Taken from Jesse Howard's signs)

BIOGRAPHICAL DATA

Born June 4, 1885, Shamrock, Missouri.[1] Attended school through sixth grade, Pugh School, Shamrock, Missouri.

Jessie Howard, Cross: The Saw and the Scroll, *c. 1976. Paint on canvas, two-man saw, 39½ × 19¼ in. Chuck and Jan Rosenak. Howard's bold roadside signs advertised his views and beliefs, and many have strong biblical overtones. This sign, which incorporates a two-handed saw, was once displayed in his yard; it also includes his name on each element.*

Married Maude Linton, July 23, 1916. Three daughters, two sons. Died November 1983, "Sorehead Hill" (near Fulton), Missouri.[2]

GENERAL BACKGROUND

Jesse Howard was a unique man whose obsession with sign making resulted in an amazing environment.

With fourteen dollars in his pocket and an education based on a few months a year over six years in a rural one-room schoolhouse, Howard chose to leave his Missouri home in 1903 and see what the world had to offer. He took the hobo's route to California, seeing Illinois, North Dakota, Montana, and Yellowstone Park along the way and working at odd jobs. Two years later he returned to Missouri, where eventually he married and raised a family.

Howard worked hard on the farms that and he and his wife, Maude, bought and fixed up. They sold several at a profit and in 1944 purchased 20 acres in Fulton, Missouri, that would become their final home. Howard began to refer to this property as "Sorehead Hill."

While Maude Howard worked in a shoe factory, her husband took on a new job. He fenced in their land with signs, sheds, and other objects and over the next nearly forty years created a totally unique environment, laced with pathways through the many signs and structures that embellished the landscape. It was a project that he would work on until his death.

ARTISTIC BACKGROUND

Jesse Howard started making signs soon after he moved into his home on Sorehead Hill. He was probably influ-

enced by the advertising signs that he had seen while criss-crossing America or by the overblown hyperbole of the outdoor advertisements for a popular farm machinery show in Missouri a number of years earlier.

Once started, however, sign making became an obsession with Howard, but not an obssession that everyone appreciated. In 1952 some of the townspeople in Fulton circulated a petition to have him committed to a state mental institution, and on May 12, 1954, Howard took a bus to Washington, D.C., to complain to his state representatives about vandalism and to ask for protection. It was a standoff. Neither side won, but Howard retaliated with yet another sign: "SOME OF THESE FULTONITES HAD BETTER TAKE A COURSE IN CIVILATION [sic]."

A 1968 article in *Art in America* brought Howard's art to the attention of the public.[3] Now he had supporters for his work outside the neighboring community, as well as many visitors, but he felt no less bitter for the lack of appreciation he found at home.

SUBJECTS AND SOURCES
Howard's roadside signs, painted in bold and simple block letters, served a multitude of purposes. He used them to preach texts from the Bible, to comment on current events, and to denounce politicians, taxes, regulations, and his neighbors. Nailed almost end-to-end, they made a formidable barrier between his workshops, a small hand-built chapel, and his house across the road.

MATERIALS AND TECHNIQUES
Howard raided demolition sites and junkyards to find used lumber, house siding, window shades, and pieces of canvas. If he found a large saw or other implement that sparked his imagination (a corn planter, for example), he would take it home, attach used toys or other objects, and paint messages on it too.

Howard's signs are painted mostly with black and white household paint, but he had no inhibitions about throwing on an occasional splash of color for emphasis. The signs range from about 12 by 30 inches up to 6 feet in height. They were nailed to his outbuildings, to fence posts, to various implements set around the yard, or affixed to poles.

The total number of signs that Howard made is unknown. Some were vandalized and some were sold, but a few hundred have probably survived.

ARTISTIC RECOGNITION
If art serves to convey messages, then Jesse Howard was a successful communicator. The environment he created was a notable achievement, and it is unfortunate that it no longer exists.

The surviving signs exemplify an art form akin to calligraphy that is becoming increasingly recognized in this country. Trained and untrained artists are trying their hand at incorporating words in art, but Jesse Howard was a master of the craft.[4] His neighbors may have thought him crazy, but today his work is in the collections of many museums, including the Museum of American Folk Art in New York City and the Kansas City Art Institute in Kansas City, Missouri.

CLEMENTINE HUNTER—*"God puts these pictures in my head and I just puts them on canvas, like he wants me to."*[1]

BIOGRAPHICAL DATA
Born Clementine or Clemence Reuben, December 1886 or early January 1887, Hidden Hill Plantation (near Cloutierville), Louisiana.[2] No formal schooling (although illiterate, Hunter learned to write her initials). Common-law marriage with Charlie Dupree, dates unknown. Married Emanuel Hunter, January 1924; he died 1944. Three daughters, two sons (two children by Dupree; three children by Hunter).[3] Died January 1, 1988, near Melrose Plantation, northwestern Louisiana.

GENERAL BACKGROUND
Clementine Hunter is recognized as one of the most important black folk artists of the twentieth century.

The descendant of slaves, Hunter was born at Hidden Hill—the infamous Louisiana plantation that, according to local legend, inspired Harriet Beecher Stowe to write *Uncle Tom's Cabin*. Hunter moved to nearby Melrose Plantation at the age of fourteen or fifteen and spent most of the remainder of her life there, working first in the fields and later in the Big House.

When the plantation was sold in 1970, Hunter continued to live near the Big House in a rented cabin. Decorating her door was a sign that read "Clementine Hunter, Artist, 50 cents to look." In 1978, at the age of ninety-one, she moved to a trailer in a rural area about fifteen miles from Natchitoches, Louisiana—it had electricity and running water, conveniences her cabin had lacked. Her cabin was later moved onto the grounds behind the Big House at Melrose and is now a part of that historic landmark.

ARTISTIC BACKGROUND
Melrose Plantation was owned by a patron of the arts and by the 1940s had become a center for visiting artists. Whether it was this ambience or her own need for expression that encouraged Clementine Hunter to begin to paint is unclear, but sometime in about 1940 she created her first work.

Hunter showed her painting to Francois Mignon, a writer and more or less permanent guest at the plantation (later he would become its curator). Mignon, in turn, consulted with another frequent guest, James Register, who taught at the University of Oklahoma. From the very first, both men were supportive of Hunter: they purchased almost all of her paintings, they encouraged her to continue, they documented her artistic activities, and they supplied her with materials. They also arranged for her first public showing, which took place in 1946 at Millspaugh's Drug Store in Natchitoches, Louisiana. After that, the artist became increasingly well known; she had small shows in Brownwood and Waco, Texas, and was in a major arts

Clementine Hunter, Washing Day, *1971. Acrylic on board, 24 × 16 in. Museum of American Folk Art, New York. Typical of the artist's paintings, this charming scene shows various elements of life at Melrose Plantation in Louisiana, where Hunter lived and worked for most of her adult life.*

Clementine Hunter, Gourd Harvest, *1955. Oil on wood panel, 70½ × 48 in. Kurt A. Gitter and Alice Yelen. This delightful mural was painted on a wall at Melrose Plantation.*

and crafts show in New Orleans, Louisiana, in 1949. In 1955 the Delgado Museum (now the New Orleans Museum of Art) gave her a one-person show—the first for a black artist at that museum.

Hunter received a number of awards during her lifetime as the world grew more aware of the extraordinary work this former field hand was creating. Among them were a Julius Rosenwald Foundation grant in 1945 and an honorary Doctor of Arts degree from Northeastern State University of Louisiana in 1986. In 1987 Louisiana Governor Edwin Edwards made her an honorary colonel and aide-de-camp.

SUBJECTS AND SOURCES

Clementine Hunter was inspired by her plantation life, portraying the plantation hands at work, at church, and at play in her paintings. With humor, simplicity, and a marvelous sense of color, she recorded a bygone era of American life:

> She was one of those women picking cotton and wearing a red hat to shade her from the summer sun. She was one of those women who boiled clothes in the black iron pot for the plantation owner. She was there on Saturday night at the honky-tonk, down the road from the plantation. And she was there on Sunday morning when the plantation folk were baptized in the Cane River.[4]

She also painted floral still lifes, an occasional picture of domestic animals, a series of portraits, and some masklike images.[5]

MATERIALS AND TECHNIQUES

Hunter's earliest pieces were done on scraps of paper, cardboard, window shades, paper bags—in other words, on anything she could find—often with house paint. Later Mignon and Register, her patrons, were supplying better materials and she was painting on canvas board and canvas, with oil paints and watercolors as well as house paint. Hunter tended to repeat her most popular subjects, although she might vary the composition or colors slightly.

The artist did not sign her paintings in the early 1940s, but she did begin to do so later. Her signature, which changed over the years from "Clemence" to "C H" to "CH" to " ƆH" to a backward *C* superimposed over *H,* provides a fairly reliable method of dating her paintings.

Hunter painted a few mural-size works for Melrose Plantation, but the majority of her works are no larger than 20 by 30 inches. She was an extremely prolific worker and, in all, painted several thousand works.[6]

Hunter also made a very few, but spectacular, appliquéd quilts.

ARTISTIC RECOGNITION

Today Clementine Hunter is one of the best-known twentieth-century American folk artists. Although her work is somewhat uneven, many critics contend that her earliest pieces will stand the test of time.[7]

Hunter's work has been shown in exhibitions at a number of museums. Her paintings are part of various public and private collections, including Melrose Plantation, now a historical site.

KATHERINE ANN JAKOBSEN—*"I try to create something that will give people a good feeling—that'll make 'em say, 'Oh! Wow!' "*

BIOGRAPHICAL DATA

Born October 8, 1952, Wyandotte, Michigan. Graduated from Crestwood High School, Dearborn, Michigan. Married Keith Hallquist, 1985. One daughter, one son. Now resides Clearwater, Florida, in the winter, various places (such as Michigan or Minnesota) in the summer.

GENERAL BACKGROUND

Kathy Jakobsen[1] paints elegantly detailed nostalgic city scenes and rural landscapes.

Jakobsen grew up in Michigan, where she enjoyed a lively tomboy childhood with two rambunctious brothers (they nicknamed her "Queen of the Jungle"). After graduating from high school, Jakobsen drove a Good Humor truck in the Detroit area for five years, then worked in a factory making bumper stickers and later as a dye cutter. She also painted at night.

In 1978 Jakobsen moved to New York City to pursue her art career. There she met a fellow folk artist named Mattie Lou O'Kelley (see page 228), who turned her apartment over to Jakobsen. In 1985 Jakobsen married a computer operator and began a gypsy life: "I haven't lived anywhere more than six months since my marriage," she says, "and I like it that way."

ARTISTIC BACKGROUND

Kathy Jakobsen notes that when she was young she decided she would be a boy, an artist, or a horse trainer when she grew up.[2] She finally gave up on the first and the last but held to the second of her goals. She started painting as a part-time hobby in the mid-1970s and took some of her watercolors to the Henry Ford Museum Shop in Dearborn, Michigan, where she met Robert Bishop (current director of the Museum of American Folk Art in New York City), who was then associated with that museum. Bishop encouraged Jakobsen to move to New York and introduced her to the gallery that now represents her.

SUBJECTS AND SOURCES

Jakobsen carefully and charmingly depicts all the details of a scene, from the many bricks in a wall to a lamp in a house window. Her paintings, which are full of color, capture the romance of a past moment in time.

Katherine Ann Jakobsen, The Woolworth Building, *1988. Oil on canvas, 32 × 52 in. Private collection. Jakobsen's exuberant style captures the excitement of New York City in this detailed painting, which was undoubtedly inspired by the years she lived in the city.*

Jakobsen takes photographs of city streets and then paints the scene in thorough detail, although she may change the era. Sometimes she paints her scenes in the present; sometimes they reflect the past. Some of her work reflects her Michigan background, particularly her landscapes. Jakobsen has also painted "dream fantasies," scenes that are totally imaginary.

The artist has retained her youthful love of horses and tries to work them into her paintings whenever possible.

MATERIALS AND TECHNIQUES
Jakobsen's early works were delicate frakturlike watercolors on paper. Since 1978 she has worked in oils on canvas.

The artist has painted about three hundred canvases. Most are 18 by 24 inches, but some are as large as 30 by 80 inches.

ARTISTIC RECOGNITION
Kathy Jakobsen is regarded as one of the best landscape folk painters of the century, and some of her fraktur work is without parallel among contemporary folk artists. She has developed a strong following and is currently working mainly on commission—painting portraits and, for example, patrons' farms.

JAMES HAROLD JENNINGS
—"*TUFGH GIRLS RAID THE WOODCHOPPERS, NO BULLY WHIPS SIS AND BAD GIRLS GOS TO HELL AND BEATS HELL OUT OF DEVIL.*"

BIOGRAPHICAL DATA
Born April 20, 1931, Pinnacle (northeast of Winston-Salem), North Carolina. Attended school through fifth grade, King, North Carolina. Single. No children. Now resides near Pinnacle, North Carolina.[1]

GENERAL BACKGROUND
James Jennings expresses his personal philosophy through bold and colorful billboard art that presents his messages in a dramatic manner.

Although Jennings dropped out of school at an early age, he did not stop his education. His mother, a grammar school teacher, educated him at home; he also read encyclopedias, various texts, and *Popular Mechanics*. He learned to love words and became interested in such esoteric subjects as astral projection and metempsychosis, sciences he claims to practice and live by.

Jennings worked occasionally on the small family tobacco farm until 1950. For the next eight years he worked as a night watchman, then in 1959 became a projectionist at the King Drive-In Theatre, which was owned by his stepfather. Drinking in the projection booth and watching "adult" movies made his nerves "go bust," as he says, so in 1968 he returned to the farm and took care of his mother until she died in 1974.

James Harold Jennings, Art World, *1988. Paint on wood, 54 × 29 × 4 in. Kurt A. Gitter and Alice Yelen. Jennings has created colorful billboard art that expresses his personal and religious views. This lively collage presents a collection of animals and other forms in a shooting gallery format.*

ARTISTIC BACKGROUND

Jennings's art career began when his mother died. He inherited the farm and began to erect a series of small houses, whirligigs, windmills, signs, and painted figures on the property, transforming the yard into the environment it is today.

Jennings's work was discovered by folk art collector Randy Sewell in 1976. When Jennings began to sell his art, he bought a beat-up Blue Bird bus from a local church for $500, parked it in his yard, and filled it with his books and objects for sale.

SUBJECTS AND SOURCES

Jennings's work has several themes: motion and color, represented by windmills mounted on poles; the domination of men by large-breasted "Amazons"; and his personal philosophical and religious beliefs, which he expresses through astrological symbols and other colorfully labeled displays that can be considered billboard art. Flat and signlike, they are complete with printed slogans intended to educate and color meant to be seen over a great distance.

MATERIALS AND TECHNIQUES

Jennings uses scrap wood, plywood, metal, and some leather and plastic in his pieces. He paints with flat enamel and Day Glo latex outdoor paint, with reds, blues, and greens dominating.

The artist's work ranges from about 12 inches high to 7 feet, and the windmills, mounted on poles, are even higher. It is estimated that he has made several hundred objects.

ARTISTIC RECOGNITION

Roadside messages proliferate in the South, but James Jennings's signlike art is unusual. It represents a personal vision and philosophy combined with a marvelous sense of color and dramatic presentation. His work is beginning to attract a larger and larger audience.

Jennings's cutouts were first shown in "Southern Visionary Folk Artists" in Winston-Salem, North Carolina, in 1985. He was also included in "Baking in the Sun: Visionary Images from the South," a 1987 traveling exhibition organized by the University Art Museum, Lafayette, Louisiana, and in "Signs and Wonders: Outsider Art Inside North Carolina," a 1989 exhibition organized by the North Carolina Museum of Art in Raleigh.

FRANK ALBERT JONES—*"I draw what I feel."*

BIOGRAPHICAL DATA

Born 1900, Clarksville, Texas. No formal education. Married Audrey Bess Culberson, 1945. Two stepsons. Died February 15, 1969, Huntsville, Texas.[1]

GENERAL BACKGROUND

Frank Jones, a visionary artist who spent much of his adult life in prison, created highly controlled line drawings fea-

Frank Albert Jones, Untitled #6, *c. 1968–1970. Colored pencil on paper, 25½ × 30½ in. Janet Fleisher Gallery, Philadelphia. Through their enticing and friendly smiles, the many creatures the artist called "haints," which occupy every room in this drawing, can lure the unwary into committing evil deeds.*

turing ghostlike figures that smile to "make you come closer and do bad things."

The son of a black man and an Indian woman, Jones was abandoned by his mother in 1906 and raised by Willie Dean Baker and her neighbor, Della Gray, in Clarksville, Texas. Jones had been born with a veil or caul (part of the fetal membrane) over one eye. In many ethnic groups such infants are believed to have "second sight," the ability to see visions. Jones believed he saw ghosts, or "haints," especially at night, and these are the spirits that appear in his art.

Jones held a series of low-paying jobs throughout his life. He was a dishwasher in the employees' cafeteria for the Red River Railroad, did yard work, and "hoboed." In 1935 he found an "abandoned" seven-year old girl and brought her home to live with him. The girl's mother appeared in 1941 and Jones was sent to prison for rape and kidnapping. He was released in 1943.

Willie Baker died in 1944 and left her house, located across the street from the Clarksville courthouse/jail, to Jones. (It was called a shotgun house because all the rooms were built in a straight line, with all their doors lined up, so that a shot fired from the front door could exit at the back door without hitting any obstacles.) In 1945 Jones married and acquired two stepsons.

In 1949 these two stepsons, Charlie and James Earl, killed Jones's "Aunt" Della Gray and may have framed Jones. In any case, all three men were convicted of murder. Jones spent most of the rest of his life in the Huntsville prison for this crime, where he died in the prison hospital in 1969.

ARTISTIC BACKGROUND

Jones started drawing at the age of nine or ten, and the surviving examples of his earlier work are surprisingly similar to his later prison drawings. Jones drew regularly while he was in prison, but whether he did it to pass the time or as a means of expression is not clear.

In 1964 Murray Smither, a Dallas art dealer, was asked to judge an inmate art show at the Huntsville prison. He awarded Jones first prize and then began to represent the artist.

SUBJECTS AND SOURCES

Jones's drawings, composed of a series of compulsively drawn lines, show buildings that vaguely resemble the courthouse/jail across the street from his home. He divided the drawings into linear segments occupied by winged "haints," "winged devils," "grand daddy," and "humpty-dumpty devils." There is danger behind the smiling devils in the drawings. Jones saw them as frightening but felt that by capturing them in his "houses" he could render them harmless.[2]

MATERIALS AND TECHNIQUES

Jones drew with pencil on paper, combining contrasting colors—preferably red and blue—when available. He first used scrap paper salvaged from the prison trash but later was provided with better-quality materials. Jones usually signed his drawings with his prison number, 114591, rather than a signature.

It is estimated that he did 1,500 to 2,000 drawings, ranging in size from 4 by 6 inches to 25 by 30 inches.

ARTISTIC RECOGNITION

Frank Jones was a single-theme artist. His drawings are haunting and beautiful but not always easy to view. This style of compulsive art is rare in this country, although it is becoming a recognized genre. Jones was recently featured in "Black History/Black Visions: The Visionary Image in Texas," a 1989 traveling exhibition organized by the University of Texas at Austin.

SHIELDS LANDON ("S. L.") JONES—*"I guess I'm famous. I get calls from people I don't know. They have seen my work. But I would have done the carving whether or not I got famous. A person has to have some work to do."*

BIOGRAPHICAL DATA

Born October 17, 1901, Indian Mills, West Virginia. Attended school for eight years, Fairview School, Summers County, West Virginia. Married Hazel Boyer, 1923; she died 1969. Married Madeline Miller, November, 1972. Two sons, two daughters by Boyer. Now resides Pine Hill (near Hinton), West Virginia.

GENERAL BACKGROUND

S. L. Jones, an accomplished mountain fiddler as well as a carver, is known for his single-image portraits in wood.

Jones lives in West Virginia, a mile or so south of the statue on Route 12 commemorating John Henry, the legendary "steel-driving man" who worked on the Chesapeake and Ohio's railroad tunnel that runs under these hills. Jones, too, worked for the "Chessie," as the railroad was known. By lying about his age, he was able to start

Shields Landon Jones, Portrait of Standing Woman, *c. 1978. Carved and painted yellow poplar, 30 × 13 × 12½ in. Chuck and Jan Rosenak. The carvings of S. L. Jones are clearly recognizable. His figures stand stiff and proud and their eyes look straight ahead, yet each one has its own distinct personality, as evinced by this obviously strong-minded* Standing Woman.

Shields Landon Jones, Three Musicians, *1975–1978.*
Carved and painted yellow poplar, 43 × 20, 34 × 20, and
28 × 20 in. Chuck and Jan Rosenak. The faces of this
typical group of country musicians bear a similarity to all of
Jones's images.

work as a laborer in 1918. By the time he retired in 1967, Jones was a shop foreman.

Hazel, his first wife, died in 1969, two years after his retirement. "I had just taken my pension," he laments, "and I lost my first wife. So I turned to my boyhood hobbies of carving and playing the fiddle." In 1972 he married again, and the couple moved into their present home. It has a small workshed in back that Jones uses for carving and fiddle playing.

Jones is an accomplished fiddle player. He won his first fiddle contest when he was only ten years old and has appeared with country bands since then. "I could really do some fiddling when I was young," he declares.

ARTISTIC BACKGROUND
S. L. Jones started to carve after the death of his first wife. In the early 1970s he began taking some of his small carvings of rabbits, dogs, and horses to county fairs; the many ribbons he has won are pinned to a bulletin board in his shed studio.

By early 1975 Jones had started to make larger carvings, as well as heads. These were displayed for sale at the gift shop at Pipestem, a nearby state park, and gradually found their way farther afield to galleries and museums.

In the last few years, Jones has been ill and has not carved very much.

SUBJECTS AND SOURCES
Jones has been described as a single-image artist.[1] His figures, whether carved or drawn, male or female, are depictions of a familiar single personage, generally smiling. "The heads look like I feel," he says, "happy or sad—they aren't of anyone in particular but they come from me."

Jones's drawings of heads relate to his sculptures. He also carves small animals for exhibition at county fairs, but his faces, frozen in time, and his stiff, full figures are especially memorable.

MATERIALS AND TECHNIQUES
Jones chisels and whittles his carvings from yellow poplar, black walnut, and maple and highlights them with paint that he purchases in small jars from a local store. His drawings are done in pencil and crayon on paper.

Jones estimates that he has made 150 large heads and figures, 250 small animals, and about 300 drawings. The carvings range from a few inches in height to 4 feet. Most of his drawings are about 9 by 11 inches, but some are slightly larger.

ARTISTIC RECOGNITION

The carved heads and standing figures of S. L. Jones, considered one of the region's most important artists, have been shown in many major museum and gallery exhibitions, including a survey of contemporary American folk sculpture in 1975 at the Phyllis Kind Gallery in Chicago; the Museum of American Folk Art, New York City, in 1977 and 1989; the Abby Aldrich Rockefeller Folk Art Center, Williamsburg, Virginia, in 1980; and "O, Appalachia: Artists of the Southern Mountains," sponsored by the Huntington Museum of Art, West Virginia, in 1989.

ANDY KANE—*"I believe God wants me to do art to make a more beautiful world."*

BIOGRAPHICAL DATA

Born Andrew Mark Kagan, April 16, 1956, New York City. Attended school through eleventh grade, West Hill High School, Stamford, Connecticut. Single. No children. Now resides Philadelphia, Pennsylvania.

GENERAL BACKGROUND

Andrew Mark Kagan changed his name to Andy Kane because, he says, "that's a name people will remember," and this young protest artist is someone who wants to be remembered.

Kane spent his early childhood in Long Beach, on New

Andy Kane, Positive Thinking, *1977. Acrylic on canvas, 30 × 36 in. Museum of American Folk Art, New York; Promised Gift of Robert Bishop. Through his colorful cityscapes, Kane protests urban society's oppressive treatment of the common man. His paintings depict faceless individuals and incorporate graffiti messages.*

York's Long Island, then moved with his family to Connecticut, where he attended high school for a few years. After dropping out of school, Kane left home and went to New York, where he stayed from 1973 through 1974, supporting himself by making sandwiches in a New York restaurant, working as a shipping clerk, and peddling goods on the streets. From 1975 until 1980 he traveled the United States and Canada, returning to New York periodically, and working at whatever jobs he could find, including the racetrack in Saratoga, New York.

By 1980 Kane was in Chicago, selling T-shirts on the steps of the Art Institute. "I did very well," he proclaims. After a few more years of wandering, he settled in Philadelphia, where he now works at temporary jobs.

ARTISTIC BACKGROUND
Kane claims that he has always painted, no matter what his job; painting was something he "wanted and had to do." Between 1976 and 1977 he tried classes at New York's Art Students League and the National Academy of Design, but, he says, "I didn't fit into life drawing classes. I lasted only a few months at each place."

That did not discourage Kane from painting, however, and in 1976 Robert Bishop of the Museum of American Folk Art discovered the artist selling his paintings on the street near the Museum of Modern Art. He introduced Kane to the gallery system, but the young man's wanderlust was not yet satisfied and he left New York before he could become established as an artist.

SUBJECTS AND SOURCES
Kane paints as a means of social protest. As he explains it, he paints "the clash between people and a highly organized society that tends to be oppressive." His colorful cityscapes depict the daily struggle for survival; the inhabitants of his cities are faceless, sticklike figures that are painted flat against the graffiti-covered walls of unwelcoming buildings.

MATERIALS AND TECHNIQUES
Kane paints with acrylics, alkyd, or oils on canvas and Masonite. His works average around 20 by 30 inches, although some are as large as 40 by 60 inches.

Kane has executed only about fifty major paintings.

ARTISTIC RECOGNITION
Social protest painting is a relatively new direction in folk art and is attracting an increasing audience. Andy Kane continues to develop in this area, and his work has been shown at galleries in New York, Philadelphia, and Connecticut.

JOHN KANE

BIOGRAPHICAL DATA
Born John Cain,[1] August 19, 1860, West Calder (later called Glasgow Bank), Scotland. Attended first three grades in school and some later night courses. Married Maggie Halloran, March 2, 1897. Two daughters, one son (who lived only two days). Died August 10, 1934, Pittsburgh, Pennsylvania.[2]

GENERAL BACKGROUND
John Kane, a self-taught artist who started his working life at the age of nine in the shale mines of Scotland, is known for his paintings that capture the industrial development of Pittsburgh and its environs in the 1920s and 1930s.

Kane worked in the Scottish shale mines until he was nineteen; then he immigrated to Braddock, Pennsylvania, to join other members of his family who had already come to the United States. He spent most of his life as an unskilled manual laborer, working in steel mills, laying railroad beds, mining coke, digging coal, doing carpentry, and paving streets in such diverse areas as Alabama, Kentucky, Tennessee, and Pennsylvania. As he said, "I did almost every kind of work that a man can do."[3] He also earned the title "Jack the Giant Killer" by fighting bare knuckles with the soon-to-be world boxing champion, Jim Corbett.

In 1891 a railroad locomotive running without lights struck Kane, and he lost his left leg. No longer able to do heavy manual labor, he became crossing watchman for the Baltimore and Ohio Railroad Company and later a house and boxcar painter; he also took up enlarging and coloring photographs and selling paintings on a door-to-door basis when painting work slacked off.

In 1904 Kane was devastated by his infant son's death and began drinking heavily—"I was no longer ambitious," he said—and his wife and daughters eventually left him. He then became an itinerant worker, his travels over the next fifteen years taking him to Ohio, West Virginia, and back to Pennsylvania. Finally he settled in an industrial area of Pittsburgh known as "the Strip" and, during the last years of his life, painted the pictures upon which his reputation rests.

Kane was reunited with his family in his later years; after he began to gain some fame and recognition as a painter, his wife saw an article about him in the New York Times and reestablished contact. Although happy for the reunion, Kane was by then so inured to poverty and disappointment that he was not much moved by success: "I have lived too long the life of the poor to attach undue importance to the honors of the world or to any honors that come from man and not God."

Kane died of tuberculosis on August 10, 1934.

ARTISTIC BACKGROUND
John Kane drew "on the sly" as a child in Scotland, sketched throughout most of his life, and started painting with colors around 1910. He tried to attend art school in Cleveland, Charleston, West Virginia, and Pittsburgh but never succeeded, the tuition being "too dear" or his migratory life-style too interfering. Kane claimed, however, that he learned how to use color by painting boxcars; he would paint scenes on the cars during his lunch break, then paint over them with "the monotonous paint of a railroad car."

He made his living for a period by enlarging and coloring photographs (using pastels, crayon, and oil) for a small fee; he also sold paintings door to door, selling his first in Pittsburgh around 1915.[4] His first popular recognition as a painter came in 1927, when he was sixty-seven years old, and the major part of his art that is known today was created in the last seven years of his life.

In 1927 Kane's *Scene in the Scottish Highlands* was accepted for the juried Carnegie Institute International, and that set the stage for his recognition as an artist.[5] Andrew Dasburg, an artist who was one of the jurors, bought the painting and helped gain him some attention, and the

John Kane, Across the Strip, *1929. Oil on canvas, 32¼ × 34¼ in. Phillips Collection, Washington, D.C. With the romantic eye of a believer in industrialism, John Kane portrayed the drab living conditions of a working-class area in Pittsburgh known as "the Strip."*

newspapers picked up on the "house painter" whose work hung with the "'art school' men."

Kane appeared in numerous exhibitions after that show and in 1938 was accepted for inclusion in the landmark survey "Masters of Popular Painting" at the Museum of Modern Art in New York City.

SUBJECTS AND SOURCES

Kane painted pictures of Scots in costume, portraits of himself and his family, and national heroes, but his crowning achievement was immortalizing the industrial landscape of Pittsburgh in the glory days of its development. Kane found beauty everywhere; industrial smoke, steel mills, puffing trains, dark bridges—all appeared romantic to him and symbolized progress. "I have found inspiration in every conceivable thing," he once said.

MATERIALS AND TECHNIQUES

Kane painted on a great many materials—bromide paper (a photographic paper), poster board, oilcloth, cardboard, wood, paper—but his favorite medium was oil on canvas. The artist used lead-base paints, similar to house paint, and mixed varnish into the pigment, giving it a gritty quality. He often made preliminary pencil sketches of his paintings, and he constructed his own frames.

Only 156 oils and a few sketches have been documented. The oils are around 27 by 37 inches to 37 by 47 inches. The artist once said he liked to use pastels, but none are known.

ARTISTIC RECOGNITION

John Kane's paintings of Pittsburgh are the heart and soul of his work. Also justifiably famous is his 1929 self-portrait, which now hangs in the Museum of Modern Art in New York. Kane was perhaps the best of his genre, and his body of work has been deemed worthy of inclusion in the most important collections of the time.

LAVERN KELLEY—*"I never intended or thought of my carvings as art when I was doing them over the first forty-five years. . . . The beauty of the whole thing is making it."*[1]

BIOGRAPHICAL DATA

Born April 27, 1928, Oneonta (between Binghamton and Albany), New York. Graduated from high school, Oneonta, New York. Single. No children. Now resides Oneonta, New York.[2]

GENERAL BACKGROUND

Lavern Kelley is an artist whose realistic, close-to-scale wood carvings of people and of farm vehicles are widely appreciated.

Kelley was the child of a farming family in upstate New York. When his father died in 1946, he managed to run the family's 300-acre farm and still graduate from high school, receiving the school's Pendleton Award for "completing high school in the face of the greatest difficulties."

Kelley maintained the farm after graduation, supplementing his income by working as a logger and at the local sawmill or by helping out at the cemetery. A logging accident in 1978 cost him his right eye and crushed his leg; these injuries precipitated a heart attack and left him with physical limitations.

In spite of these setbacks, Kelley returned to his farm, where he and his brother still live in the house where they grew up. "The cows get milked," he says, "although I have had to slow down a bit."

ARTISTIC BACKGROUND

Lavern Kelley started carving at the age of seven, when he was given a penknife while recuperating from an appendectomy. When he was eight, he and his brother Roger starting carving a miniature farm community that they constructed on a creek bank near their house. Kelley took art classes through eighth grade and remembers that his teachers always encouraged him—although his father did not.

Except for the time he spent in the hospital immediately following his accident, when he tried his hand at painting, Kelley has continued to carve, even though the disabilities resulting from the accident and heart attack required him to make some adjustments in his technique. For a number of years he carved mostly for himself or friends, occasionally doing a commissioned carving of a neighbor's truck or car, but around 1975 several local antique dealers became interested in Kelley's work and began showing it to a wider audience.

The artist gained greater public attention after his work was included in a group show at Gallery 53, a nonprofit gallery in Cooperstown, New York, in 1985, and he was appointed artist-in-residence at that gallery in 1986, under a grant from the New York State Council on the Arts.

SUBJECTS AND SOURCES

Lavern Kelley is inspired by what he sees around him. He carves whole farmyard environments; models of trucks, tractors, or other farm equipment; and people he knows— "real farmers and friends." He also uses books, catalogs, and magazines as source material.

MATERIALS AND TECHNIQUES

Kelley painted twenty canvases while he was in the hospital recuperating from his logging accident, but the bulk of his work comprises carvings made from white pine and occasionally basswood or elm.

His trucks, tractors, and other vehicles are often embellished with wire, sheet tin, twine, or clear plastic (taken from food wrappers and used for windshields); his figures, with satin bows or other materials. Kelley paints his carvings with Rustoleum enamel, either flat or glossy.

Kelley initially worked only with hand tools, but as he progressed in his ability and his desire to create realism, he started using power tools. "At first," he says, "the wheels [on his trucks] came out flat, but I bought power machinery and they are round now. I try to make everything as real as possible and close to scale."

Kelley believes that he has made as many as 1,500 objects. The model vehicles are small, but some of his figures are as much as 3 feet tall.

ARTISTIC RECOGNITION

The work Kelley is currently doing is more refined than his earlier pieces, but all of them are colorful, whimsical, and collectible. He is especially well regarded in the North-

Lavern Kelley, Six Figures, *1986–1988. Carved and painted wood. Various sizes, 16 to 34 in. high. Private collections. Kelley's figurative carvings often feature light-hearted, semirealistic portrayals of his friends and neighbors.*

east and has had individual shows at Gallery 53 in Cooperstown (1987) and at Hamilton College, Clinton, New York (1989).

CHARLES KINNEY—*"Teacher said: 'It's no use you drawing pictures, 'cause you might sell one, and then you'd have to be able to count your money.' " "The 'haint' sounds like he is throwing tin cans down on you."*

BIOGRAPHICAL DATA
Born May 30, 1906, Vanceburg (near Salt Lick), Kentucky. Attended school through third grade, Brewer School, Salt Lick, Kentucky. Single. No children. Now resides Vanceburg, Kentucky.

GENERAL BACKGROUND
Charles Kinney, known as Charley, is a storyteller, both verbally and through his drawings. His favorite stories are about a "chain-rattling haint" (ghost) that haunts his two-room log cabin. "I was hatched here in the cabin," he says, "and grew up with the 'haint.'" Luckily for Kinney, the "haint" stays in the attic most of the time.

Charley and Noah Kinney inherited their father's tobacco farm in 1950, but since the middle 1970s they have "let it go."[1] The brothers have always been close, and both are country music fans. Charley plays the fiddle; his brother, the guitar. When they were young, they would team up with a banjo and perform "old time" music at country and school dances. When Charley tells his stories, he accompanies himself on the fiddle.

ARTISTIC BACKGROUND
Charley Kinney has been painting as a hobby since first grade, but after the farm was "let go wild," he had more time and began to pursue his hobby with greater vigor.

Kinney lives near Morehead College, which has exhibited his work. That exposure encouraged collectors of Appalachian art to begin to take an interest in the artist's paintings.

SUBJECTS AND SOURCES
The stories Kinney tells through his art include devil stories, religious stories, and "haint" stories. The haint in his pictures often appears as a dominant dark-colored and grotesquely shaped mass.

Kinney has also painted a few pictures of animals, and he has created some painted concrete sculptures that are placed in front of his log cabin.

MATERIALS AND TECHNIQUES
Kinney is best known for his storytelling pictures painted with watercolors on poster board. He has made a few concrete sculptures, but they are not of the same sensibility as his paintings.

Charles Kinney, Hantd Hous, *1988. Tempera and charcoal on paper, 22 × 28 in. William and Ann Oppenhimer. Kinney believes he shares his log cabin home with a scary creature he calls a "haint," and this painting captures on paper that invisible yet ferocious monster.*

To date, Kinney has made several hundred paintings, some as large as 30 by 30 inches.

ARTISTIC RECOGNITION
Collectors of the lore of the Kentucky hills are interested in the haint stories of this isolated artist, and he is beginning to be represented in private collections. Kinney has been included in several shows of Kentucky folk art, including "Folk Art of Kentucky," at the Kentucky Fine Arts Gallery in Lexington, Kentucky, in 1975; "God, Man, and the Devil: Religion in Recent Kentucky Folk Art," a 1984 exhibition sponsored by the Mint Museum in Charlotte, North Carolina; "God and the Devil," organized by Morehead State University, Kentucky, in 1989; and "O, Appalachia: Artists of the Southern Mountains" at the Huntington Museum of Art, West Virginia, also in 1989.

NOAH KINNEY—*"I hope I'm famous. . . . I don't consider myself that way."*

BIOGRAPHICAL DATA
Born December 28, 1912, Vanceburg (near Salt Lick), Kentucky. Attended school through eighth grade, Brewer School, "a mile down the creek in Salt Lick." Married Hazel Bateman, December 27, 1960. No children. Now resides Vanceburg, Kentucky.

GENERAL BACKGROUND
Noah Kinney is a mountain carver who speaks with the twangy short sentences of the Kentucky hills. He has lived

Noah Kinney, Raccoon, 1988. Painted wood, 13 × 20 × 8 in. William and Ann Oppenhimer. This Appalachian carver sometimes makes versions of animals seen in zoos, but he is at his best when depicting the animals, such as this wide-eyed raccoon, that inhabit the Kentucky hills where he lives.

his life on a small family farm in Vanceburg, staying on to help his parents after he grew up. When his father died in 1950, he continued to grow tobacco and corn until the mid-1970s.

In his younger days Noah Kinney and his brother, Charley, played in country bands—Noah on the guitar, Charley on the fiddle.[1] They still perform "up at the house" to amuse themselves.

Kinney had a heart attack fourteen years ago and is no longer able to do farm work. Nowadays he "lets the farm go wild" and spends his days carving.

ARTISTIC BACKGROUND
Noah Kinney started painting and drawing as long as forty years ago, but after he discontinued the farming operation around 1975, he took up carving. That is when he began to make the animals that gave him his present reputation.

Kentucky is proud of its mountain artisans, and Kinney reflects the true Appalachian carving tradition in his work. After being exhibited locally, he says, "Friends began to come by and take my stuff all over the country, to museums and such."

SUBJECTS AND SOURCES
"I saw the Cincinnati zoo some years ago," Kinney explains, and "I started carving them lions and tigers. But I also does raccoons, opossums, skunks, and snakes."

When Kinney painted, he usually depicted religious scenes, like the church at Bethlehem. He rarely paints today; his brother, Charley, has taken over that medium.

MATERIALS AND TECHNIQUES
Kinney used to paint on paper with "just any old paint." Now he carves his animals out of yellow poplar and white pine with a pocketknife and paints the finished animals.

Noah Kinney has completed many hundreds of carvings, some as large as 2 feet in height.

ARTISTIC RECOGNITION
Noah Kinney's animals are exemplary representations of Kentucky mountain carving, a vanishing art. Noah, along with his brother Charley, was included in "Folk Art of Kentucky" at the Kentucky Fine Arts Gallery in Lexington in 1975 and in "O, Appalachia: Artists of the Southern Mountains" at the Huntington Museum of Art, West Virginia, in 1989.

TELLA KITCHEN

BIOGRAPHICAL DATA
Born Tella Gwendolyn Denehue, February 14, 1902, Londonderry (near McArthur), Ohio. Attended school through eighth grade, Independence, Indiana. Married Noland Dwight Kitchen, November 16, 1920; he died December 1963. Three sons, one daughter. Died June 6, 1988, Adelphi, Ohio.[1]

GENERAL BACKGROUND
Tella Kitchen, an important memory painter, had strong ties to rural life. She was born in the farm country of Ohio and brought up on a farm near Independence, Indiana. After her marriage in 1920, she and her husband, Noland, returned to Ohio, settling in the small town of Adelphi. There the Kitchens farmed, but they also engaged in many business activities as well. They ran a service station, sold used automobiles, and for a period operated a commercial greenhouse.

The Kitchens were well-respected members of the Adelphi community, which Noland served as mayor. After his death in 1963, Tella Kitchen was elected mayor for two years; she was the first woman in the county to serve in that position. Kitchen was also a member for more than fifty years of the Order of Eastern Star (part of the Freemason organization).

ARTISTIC BACKGROUND
Tella Kitchen came late to painting. After she lost her husband, her son Denny gave her a paint set for Christmas to help keep her busy. "She sat and looked at it for three years," he recalls. "Then one day a picture of a covered bridge appeared." Kitchen had tried art lessons, but one was enough; "I was too old to paint new-fangled things and I just began to paint the simple things I loved," she once said.[2]

Denny Kitchen eventually showed one of his mother's paintings to Robert Bishop (current director of the Museum of American Folk Art in New York City), who was then associated with the Henry Ford Museum in Dearborn, Michigan. In December 1974, Bishop visited the

Tella Kitchen, The Day My Father Died and Our Neighbors' House Burned, *1980. Oil on canvas, 23 × 19½ in. Museum of American Folk Art, New York; Gift of the artist. Kitchen's lively memory paintings are always full of action and often drama. This painting carries dual memories as the artist recalls her neighbors' tragedy on the day of her own misfortune—her father's death.*

Kitchen home in Adelphi, liked her "homespun style," and included the artist in a book he was writing on American folk painters.[3]

About 1987 Kitchen became too ill to continue painting. After her death in 1988, her family decided not to sell any more of her paintings.

SUBJECTS AND SOURCES
Kitchen's paintings are a diary of the happy or exciting memories of her life and a chronicle of the day-to-day events in a small rural community. According to her son, she could "remember back to age two with remarkable clarity."

The majority of her paintings are landscapes or town scenes, and the human figure is always an important element in the design. The scenes are rarely static views of the countryside; there is always a sense of life and action. Smoke drifts lazily from chimneys; people move to board a train while the engine bellows black smoke; townspeople rush to rescue furniture from a burning house.

MATERIALS AND TECHNIQUES
Tella Kitchen painted on canvas with oils. She is known for her use of bright colors and small brushstrokes, which allowed her to capture every detail of her memories. The artist worked in a relaxed manner, sometimes while sitting on a porch swing.

Kitchen painted about two hundred works. She put a lot of effort into her paintings, which are all of uniformly high quality. Some of her paintings are very small—about 2 inches square—and were given as gifts to family members. Her more usual size was about 30 by 40 inches.

ARTISTIC RECOGNITION
Tella Kitchen's vividly colored documentation of the Midwest in the first half of this century evidenced a remarkable ability to recall details and to put them together in appealing yet forceful compositions. She is one of the century's important memory painters, and her work is included in both museum and private collections.

O. W. ("PAPPY") KITCHENS

BIOGRAPHICAL DATA
Born December 17, 1901, between Hazelhurst and Crystal Springs, Mississippi. Attended school through eighth grade, Hazelhurst, Mississippi. Married Ruby McCoy, date unknown; she died December 25, 1985. One daughter. Died October 30, 1986, Jackson, Mississippi.[1]

GENERAL BACKGROUND
"Pappy" Kitchens was an old-fashioned Southerner, a "good old boy," and a natural southern storyteller to boot. His drawings spin yarns of his youth—they tell of a young man who left home to go hoboing, to ride the rails, to find work when and where he could.

In the 1940s, however, Kitchens gave up his roving life and settled in Jackson, Mississippi. He eventually owned a construction company and house-moving business and liked to brag about building a slab for a Frank Lloyd Wright home. He retired from the business in 1970, complaining that "bad investments done him in." For the next sixteen years, until his death, Kitchens devoted himself to painting.

ARTISTIC BACKGROUND
Shortly before his retirement, Kitchens observed his son-in-law, William Dunlop, who is a trained artist, at work and decided that he could do better. After making the decision to become an artist, he grew a white beard, started calling himself "Pappy," and began to act like Ernest Hemingway. Dunlop showed Kitchens's work to John Bullard, director of the New Orleans Museum of Art. As a result, Kitchens was selected for the Award of Merit in the Sixty-first Biennial of the New Orleans Museum of Art in 1975.

In 1983, the artist developed Parkinson's disease and his hand became less steady. Although he did not totally give up his art, he executed very few works in the following years.

O. W. Kitchens, The Young and the Old, *c. 1978.*
Acrylic on mounted paper, 18½ × 30¾ in. Private collection. Kitchens frequently included himself in his work as an omnipresent observer and narrator of the activities, which in this case is a family gathering.

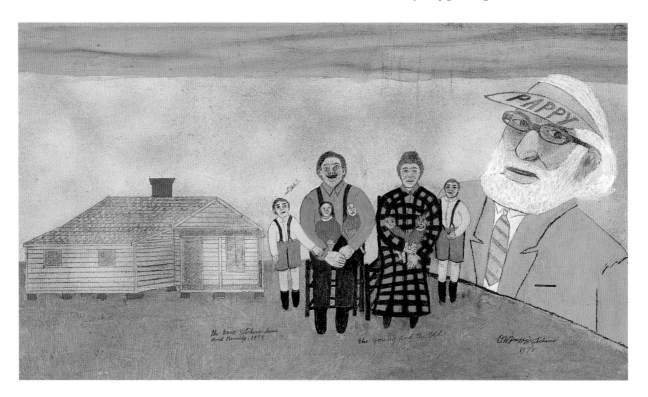

SUBJECTS AND SOURCES

Kitchens's drawings tell stories about himself, his family, and his political views. He often invented fables to paint; his opus is an allegorical work, *The Saga of Red Eye the Rooster,* about a rooster who took on Colonel Sanders of Kentucky Fried Chicken fame, among others. The fable follows from foundling to funeral the saga of an extraordinary rooster named Red Eye who exhibits quasi-human behavior throughout. The artist frequently added printed materials to help his viewer understand his stories and sometimes would include himself as narrator in the form of a self-portrait.

The artist's son-in-law says that Kitchens would sometimes use a crystal ball as a source of inspiration, claiming that he could see "angels and things."

MATERIALS AND TECHNIQUES

Pappy Kitchens drew on paper and canvas. According to William Dunlop, he mixed oils and acrylics to form washes for his work.

Kitchens made about five hundred drawings in all, most around 11 by 13 inches; there are a few as large as 30 by 50 inches. And then there is the *Red Eye* fable; it consisted of sixty drawings, each 15 by 15 inches, arranged in three chapters of twenty drawings each.

ARTISTIC RECOGNITION

Pappy Kitchens had an instinct for design and composition that enabled him to throw out one-liners in his work with the best of storytellers. His work was included in the prestigious Biennial Exhibition of Contemporary American Painting at the Corcoran Gallery of Art in Washington, D.C., in 1977, and he is becoming well known to collectors in this field.

GUSTAV KLUMPP

BIOGRAPHICAL DATA

Born January 5, 1902, Baiersbronn (in the Black Forest region), Germany (now West Germany). Apprenticed as a compositor in the printing industry in Germany. Single. No children. Died 1980, Brooklyn, New York.[1]

GENERAL BACKGROUND

Gustav Klumpp, a painter with a keen sense of humor, delighted in painting the female nude.

Klumpp came to New York City in 1923, living at first in the sleeping quarters of a Jewish temple where his uncle worked as a janitor. He quickly found employment in the printing industry as a compositor and linotype operator, a trade for which he had been trained as a youth in Germany.

In 1964, after a forty-year career in the printing industry, Klumpp retired. He lived in the Red Hook Housing Project in Brooklyn, New York, and his only source of income was what he received from Social Security.

ARTISTIC BACKGROUND

Two years after he retired, Gustav Klumpp started visiting

Gustav Klumpp, Reclining Nude, *c. 1970. Oil on canvas, 14 × 20 in. Robert Bishop. Klumpp based his colorful paintings on his fantasies of "beautiful girls," and he quite definitely preferred to portray them nude.*

the senior citizens center in the housing project where he lived, and the personnel there encouraged him to try his hand at painting. Once started, Klumpp realized he had found his métier and moved rapidly to develop his own style.

In 1970 Henry Ghent, curator of a show entitled "Art of the Elders of Brooklyn" at the Community Gallery of the Brooklyn Museum, chose Klumpp's work for inclusion. When John Canaday reviewed the exhibition in the *New York Times,* he made specific mention of Klumpp's paintings. That brought the artist to the attention of the public and to that of Mrs. William Leffler, the wife of a trustee of the Museum of American Folk Art in New York City, who befriended the artist.

Klumpp's total output was done over a period of five years. He stopped painting in December 1971, stating simply that he did not feel well.

SUBJECTS AND SOURCES

Gustav Klumpp called his paintings "fantasies," saying that the ideas came to him during daydreams. His fantasies had basically one theme—the nude, particularly, the female nude. Klumpp had a keen sense of humor and delighted in painting "beautiful girls," as he called them, in the nude or semi-nude in what he referred to as "fictitious surroundings." The surroundings might be as diverse as a nudist camp, as simple as a lounge chair in the backyard, or as complex as an art gallery, and his sly sense of humor always formed a counterpoint to his subject. The artist had an excellent sense of composition and color, although he tended to exaggerate the attributes of the female figure, whatever the setting.

Klumpp did an occasional landscape, although he once said "I am not fond of dull paintings of landscapes or oth-

Gustav Klumpp, Virgin's Dream of Babies, *c. 1971. Oil on canvas, 19⅝ × 29¾ in. Chuck and Jan Rosenak. This intriguing pastoral scene is somewhat of a departure for Klumpp, but the flat perspective used for the central female figure is typical.*

erwise." No one, however, could accuse him of "dull" paintings.

MATERIALS AND TECHNIQUES
Klumpp painted on canvas with acrylics and oils. It is estimated that he did about fifty works before he gave up painting. The paintings range in size from around 14 by 18 inches to 20 by 30 inches.

ARTISTIC RECOGNITION
The paintings by Gustav Klumpp are lively, colorful examples of fantasy at its very best. He is undoubtedly one of the better-known folk painters of the latter half of the century, as his work has been included in almost every major book on contemporary folk art. Klumpp's paintings are included in private collections and in the permanent collections of the Museum of American Folk Art in New York City and the Museum of International Folk Art in Santa Fe, New Mexico, among others.

KAROL KOZLOWSKI

BIOGRAPHICAL DATA
Born March 13, 1885, District of Stopnica (between Krakow and Warsaw), Poland. Attended school for two weeks in Poland. Single. No children. Died December 4, 1969, Nyack, New York.[1]

GENERAL BACKGROUND
Karol Kozlowski was a shy Polish immigrant remembered for his vivid paintings of idealized urban and rural scenes.

Kozlowski was conscripted into the Russian army and served in Siberia from 1907 through 1910; little else is known of his life before he immigrated to the United States at the age of twenty-eight. Like many Poles unhappy with the oppressive life-style of the working class and the ongoing threat of military conscription, Kozlowski left his homeland to search for a better life. Kozlowski arrived in America in 1913 and settled in the Greenpoint area of Brooklyn, New York, a bustling industrial area that was already a home to many immigrants, including Edward Gronet, a fellow Pole with whom Kozlowski had served in the army. In 1918 he moved in with the Gronet family; they treated this shy, retiring, and religious man as a family member and he continued to live

with them for the rest of his life. After Gronet's death, his daughter, Irene Gronet Urban, continued to house and care for Kozlowski. In the 1960s the Urbans bought a vacation home in Congers, a country area just north of New York; they moved there in 1965 and took Kozlowski with them.

During his first years in this country Kozlowski held several jobs as an unskilled laborer. Then in 1923 he went to work for the Astoria Light, Heat, and Power Company, one of the largest power plants in the world (in 1936, it became affiliated with Consolidated Edison), and remained in his job as a fire cleaner until his retirement April 15, 1950.

Although his days were filled with arduous work at menial tasks, Kozlowski had his art to bring meaning to his life and a small collection of exotic tropical birds on which to lavish attention. He always had six to ten birds, for which he crafted beautiful and elaborate cages.

ARTISTIC BACKGROUND
Although he was welcomed into a close and generous family, Kozlowski remained essentially a loner, living a quiet and restricted life (he never became very fluent in English). He started painting about 1920, probably motivated by a desire to expand his life beyond its limited everyday horizons. He painted in a tiny space—only 9 by 9 feet—in a small shed behind the Gronet house, a space he also shared with his tropical birds.

Kozlowski did not seem to be interested in profiting from his work and gave away many of his paintings to friends, including the Gronets. He also gave a major paint-ing of the Astoria plant where he had worked for so many years to the power company shortly after he retired, and it was displayed in the company offices for a period. In 1962 Abril Lamarque, the art director for the employee magazine produced by Consolidated Edison, saw the painting (which the power company eventually gave to him) and arranged to meet the artist. Lamarque was so excited by the work he found rolled up in the corners of Kozlowski's shed that he purchased nineteen of the paintings. He was instrumental in bringing Kozlowski's work to the attention of the Abby Aldrich Rockefeller Folk Art Center in Williamsburg, Virginia, in 1980.

SUBJECTS AND SOURCES
Kozlowski painted familiar urban landscapes—some probably inspired by trips to Prospect Park and Coney Island —that were filled with affluent and formally dressed people and detailed city skylines (one, a view of lower Manhattan, was done on a window shade). He painted the power company in which he worked and scenes from rural areas (Kozlowski's rural countrysides and mountain scenes were possibly influenced by his life in Congers). He also painted fanciful views of Paris, Switzerland, and India that

Karol Kozlowski, The Estate, *1960–1962. Oil on canvas, 32¼ × 54⅛ in. Abby Aldrich Rockefeller Folk Art Center, Williamsburg, Virginia. This dreamlike painting, one of Kozlowski's best in terms of execution, composition, and subject matter, was most likely inspired by his visits to rural Congers, New York.*

were probably based on photographs or illustrations, since he had never been to those places.

The artist's paintings, whether of city or country, frequently showed abundant animal life—especially large flocks of birds.

MATERIALS AND TECHNIQUES

Kozlowski usually made a few preliminary sketches of his pictures. He did his earliest paintings on slats of wood taken from fruit crates; these became colorful backdrops for his bird cages. He soon moved on to painting with oils on large pieces of canvas, but because of his confined work space in the shed, he had to roll the canvas over a worktable, so that only a small portion could be painted at a time. He created his gay and colorful landscapes while standing up at his table and trimmed his brushes to a small stub, which he preferred for work in close quarters.

Although words appear on some of Kozlowski's paintings, the artist was essentially illiterate in Polish and knew only a few words of English; the words were written for him by someone else—usually one of the Gronets—and he would painstakingly copy their form onto his pictures. Because he could not write, his canvases are unsigned.

Kozlowski was not a prolific painter. He worked carefully over a long period and often spent a year on one work. His total output consists of six colorful backgrounds for his bird cages and fewer than thirty large canvases. His largest painting is the 4-by-12-foot picture of the Astoria plant.

ARTISTIC RECOGNITION

The painting of the Astoria plant may represent Karol Kozlowski's greatest achievement. In it he reflected an era of romantic industrialization and idealized landscapes. His style is highly original, and he had an extraordinary ability to combine color and design into a complex and coherent whole. His work is even more impressive when it is remembered that he worked on only a small segment of a painting at a time and was unable to step back and view the whole as he progressed.

Kozlowski's work was shown at a one-person exhibition at the Abby Aldrich Rockefeller Folk Art Center, Williamsburg, Virginia, in 1984. The center has some of the artist's work in its permanent collection; many pieces are still held by Lamarque and Urban.

OLOF KRANS

BIOGRAPHICAL DATA

Born Olof Olsson, November 2, 1838, Salja, Sweden.[1] Received some elementary education in Sweden and English lessons at Bishop Hill, Illinois. Married Christine (Matilda Christine Charlotta) Aspequist, December 28, 1868; she died April 17, 1920. Three sons, one daughter. Died January 4, 1916, Altona, Illinois.[2]

GENERAL BACKGROUND

Olof Krans was a Swedish-American artist whose portraits and genre paintings of the Swedish community that settled at Bishop Hill, Illinois, bridge the nineteenth and twentieth centuries.

Krans, then named Olsson, came to this country with his parents in 1850 on the sailing ship *Condor*. The family went to the Bishop Hill Colony in northern Illinois, a utopian communal settlement started by Swedish religious dissidents called Devotionalists. Although Krans had shown a talent for painting from an early age, at Bishop Hill his early responsibilities were in the blacksmith shop, which produced wagons and carriages. Residents at Bishop Hill were named by the type of work they performed, however, and as Krans bloomed in his painting career, he became known to the colonists as "Painter Krans, the Wizard with the Brush."

In September 1861, Krans enlisted in the Union Army as a private and rose to the rank of sergeant. Illness cut short his military career, however, and he was discharged in June of the following year. Eventually he received a veteran's pension and often proudly wore his G.A.R. badge.

Following his discharge, Krans moved first to Galesburg, Illinois, and then to Galva, Illinois, a community with close ties to Bishop Hill, where he lived from 1869 to 1903. There he worked first in a photographer's studio and later as a painter—of houses, signs, theater curtains, or whatever else needed to be painted. He opened his own business, "O. Krans Home and Sign Painters and Artistic Paper Hangers," in 1870 and ran it successfully for a number of years.

ARTISTIC BACKGROUND

Olof Krans had painted from time to time since childhood. When he was in his mid-twenties he did some painting at Bishop Hill, although most was of a utilitarian nature—house painting or decorative work.

By 1875 Krans had demonstrated his talent within his community, but it was not until a decade or so later that he turned seriously to portrait and landscape painting. At that time a crippling accident curtailed his activities and limited him to more sedentary pursuits such as painting; an anniversary celebration of the founding of Bishop Hill encouraged him to celebrate the event in pictures. He painted a number of works in honor of this event and gave almost all of them to the community there.

National recognition came slowly, but the state of Illinois has preserved much of Bishop Hill Colony, and the paintings he gave to the community are on display there.

SUBJECTS AND SOURCES

Olof Krans's memories of Bishop Hill provided the main inspiration for his work. He did portrait and genre paintings of the community, painting the residents at work and the landscape, documenting the farm work and the activities of Bishop Hill through his pictures; and he painted portraits of the colonists, working from photographs, his memories, and life. He also did a memorable self-portrait and some miscellaneous scenes, portraits, and animal paintings, none of which were related to Bishop Hill.

MATERIALS AND TECHNIQUES

A few of Krans's wooden trade signs and boxes still exist, but his major works—the paintings—are oils on canvas. He used a broad palette of color, not limiting himself in any way.

In the Bishop Hill landscapes all the men and women are more or less the same size and look alike, emphasizing the spirit of equality that was prevalent among the colonists. The paintings were done in a wide range of sizes, although many of the landscapes are around 30 by 48 inches. Most of Krans's portraits are approximately 25 by 30 inches, and some of the other oils are very large, including a theater curtain measuring 15½ by 10 feet depicting the 1855 skyline of Bishop Hill.

Krans did about two hundred canvases in all, of which sixty-nine are portraits in the Krans Collection at Bishop Hill.

ARTISTIC RECOGNITION

The work of Olof Krans bridges the centuries. His documentation of Bishop Hill and his great flowing landscapes depicting farm work are among the best of their kind. His mature work began around the turn of the century, and his greatest landscapes and portraits date from around 1900 to shortly before his death in 1916.

In addition to the collection at Bishop Hill, Krans's work is held by other institutions in Illinois and in some private collections.

Olof Krans, Peter Johnson, Brother of Erik Jansson, *c. 1900. Oil on canvas, 18 × 24 in. Bishop Hill State Historic Site, Illinois. Another of Krans's memorable portraits clearly reflects his nineteenth-century roots, although the painting may be dated early in this century.*

Olof Krans, Rev. Jonas Olson, *c. 1900. Oil on canvas, 18 × 24 in. Bishop Hill State Historic Site, Illinois. "Painter Krans" was known for his portrayals of the life and citizens at the Bishop Hill Colony in northern Illinois, a commune of Swedish religious dissidents. This painting, showing one of the elders of the colony, is typical of his portraiture.*

ELIZABETH ("GRANDMA") LAYTON—*"Art makes life worth living. One must do what one can to make the world better."*

BIOGRAPHICAL DATA
Born Elizabeth Converse, October 27, 1909, Wellsville, Kansas. Graduated from Wellsville High School; attended college for two years, Ottawa University, Ottawa, Kansas. Married Clyde Nichols, July 16, 1929; separated, 1942 (divorced later). Married Glenn F. Layton, March 31, 1957. Two sons, three daughters by Nichols. Now resides Wellsville, Kansas.

GENERAL BACKGROUND
Elizabeth Layton turns unflattering self-portraits into sharp political and social commentaries.

Layton grew up and went to school in small communities in Kansas. After her first marriage, she and her husband moved to Denver, Colorado, where he worked as a milk deliveryman. They began to raise a family, although, as Layton says, "All my life I felt depressed."

Elizabeth Layton, Censored, *1989. Crayon and colored pencil on paper, 22 × 30 in. Collection of the artist. Grandma Layton uses her own image as the starting point for her vigorously drawn social comments. In this rendition she shows herself as a symbol of the oppression of censorship.*

In 1942 Layton faced many upheavals in her life. She separated from her husband, and her father died. She decided to return to Kansas to run the family's small newspaper and left Colorado with custody of her five children. She ran the paper successfully on her own for the next fifteen years, finally selling it in 1957 in order to retire. She also in 1957 remarried.

In 1976 tragedy struck again when her youngest son died after a long and difficult illness.

ARTISTIC BACKGROUND
"When my son died, I was suicidal," Layton recalls. "Drawing ended my depression." At the suggestion of her sister, Layton audited a course in "contour drawing" at nearby Ottawa University.[1] She then found her mission in life: the drawing of mirror images of her own face. "I came home and practiced by looking into a mirror," she says.

Layton was discovered by Don Lambert, a newspaper reporter in Ottawa, who still acts as her agent. In 1980 the Wichita Art Museum and the Kansas Arts Commission organized an exhibition entitled "Through the Looking Glass, Drawings by Elizabeth Layton," which has been toured by the Mid-America Arts Alliance to many major cities.

SUBJECTS AND SOURCES
Layton "holds a mirror, as it were, to life"—she draws self-portraits from her reflection in a small hand-held mirror. After drawing her face, she surrounds herself with symbols of her life, from teacups and flowers to pictures of her husband.

Layton does not beautify her appearance. She is blind in one eye and has wrinkles, and these features, if anything, are exaggerated in her drawings. Through her mirror images Layton speaks out for what she feels is right; her pieces have taken stands against censorship in the arts, racism, and nuclear war, to name just a few topics. She also draws her present husband, Glenn, both as himself and as mythological or fantasy figures such as Apollo or Aladdin.

MATERIALS AND TECHNIQUES
"I can't use brushes," the artist explains. "I draw with colored pencils and crayons on paper."

Layton has made close to one thousand drawings, ranging from around 22 by 31 inches to 34 by 45 inches.

ARTISTIC RECOGNITION
Elizabeth Layton's "simple self-portraits are distinguished by a complex sophisticated wit."[2] She does not sell her drawings but does give some to institutions that she supports, and she has lent pieces for shows, so her work has been seen and appreciated by museum audiences the country over.

PAUL ("P") LE BATARD

BIOGRAPHICAL DATA
Born June 9, 1886, New Orleans, Louisiana. Attended

school through sixth grade, New Orleans, Louisiana. Married Georgia Edna Thomas, c. 1911; she died April 1976. Three sons, two daughters. Died June 13, 1986, Gautier (near Pasagoula), Mississippi.[1]

GENERAL BACKGROUND
Paul Le Batard was a Cajun artist who captured a bit of history in his colorful and appealing whirligigs and wind toys.

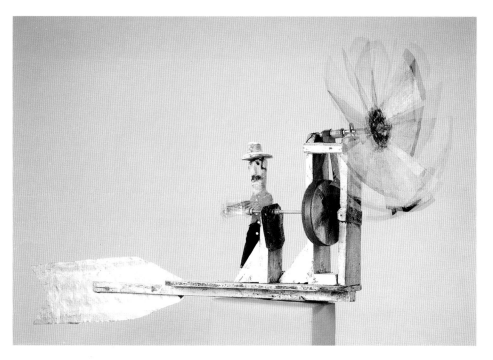

Paul Le Batard, Turning the Winch, *c. 1975. Pine board, tin, cloth, aluminum paint, and house paint, 16½ × 38½ × 9 in. Private collection. This delightful whirligig, once powered by the breezes off the Gulf of Mexico, may be intended to represent the artist as a young man at work on an oyster boat.*

Le Batard spent almost all his working life as a carpenter and fisherman, working the flat-bottomed sailboats known in the region as oyster and shrimp dredges, which harvested the bounty of the Gulf of Mexico.

For more than fifty years, Le Batard lived in a one-story cottage with a view of the water. After retiring from active seafaring in 1951, he began to devote his time to surrounding his house and filling his small garden with whirligigs mounted on poles. When he was over ninety, Le Batard was still mending fishnets for a living and working on his whirligigs. He died shortly after his one hundredth birthday.

ARTISTIC BACKGROUND
No one is sure why Paul Le Batard started making whirligigs after he retired from fishing; he may have had a desire to fill his time, a craving to see action on his doorstep, or simply a need to carry out interesting and amusing ideas to delight himself and passersby alike.

He sold a few of his wind toys through Richard Gasperi, the New Orleans folk art dealer, but for the most part his handiwork was meant for himself and his neighbors to enjoy.

SUBJECTS AND SOURCES
Le Batard made two styles of whirligigs. There are whimsical mustachioed men in pantaloons (there is some speculation that these were self-portraits), one to a pole, who turn winches similar to those used on oyster dredges for raising and lowering nets; his men and winches are powered by the whirligig blades as they catch the wind. And there are groupings of rigged, flat-bottomed sailboats on crossbars that revolve in the wind. This latter group is of particular interest because very few wind toys have been done in the form of rigged ships.

MATERIALS AND TECHNIQUES
The boats, platforms, poles, and figures are all made of wood, while the realistic white sails are made from old bedsheets rigged on string halyards. The whirligig men are dressed in colorful outfits made from scraps of cloth, and the blades that catch the wind are of cut tin. Le Batard painted his pieces with aluminum paint.

Paul Le Batard constructed about one hundred whirligigs and wind toys. Many have been destroyed, but a few are still owned by neighbors who lovingly keep them in repair; of those still in existence, the mustachioed man is probably more commonly seen, as the boats are far more fragile. Le Batard's work is unsigned.

The boats are about 6 inches long from bow to stern and the masts about 8 inches high. The men measure about 9 inches high and the blades that power them about 25 inches in circumference.

ARTISTIC RECOGNITION
There are few existing reminders of the flat-bottomed dredges that were once used to gather shrimp and oysters off the Gulf Coast, and Paul Le Batard captured a bit of history in his appealing pieces.

LAWRENCE LEBDUSKA

BIOGRAPHICAL DATA
Born 1894, Baltimore, Maryland. Educated at a technical school run by Fleider and Schneider, Leipzig, Czechoslovakia. Wife's name and date of marriage unknown; divorced. Children unknown. Died 1966, New York City.[1]

GENERAL BACKGROUND
Lawrence Lebduska, whose fantasy and pastoral paintings brought him some renown in the 1930s and early 1940s, painted to please himself.

Lebduska was born in Baltimore, Maryland, of Bohemian parents, and was trained to be a craft artisan. When his family returned to Czechoslovakia, his father, a stained-glass maker, sent Lebduska to be trained in that profession and in decorating.

Lawrence Lebduska, Nude in Paradise, *1963. Oil on canvas, 60 × 40 in. Michael D. Abrams. Lebduska's colorful pastoral scenes always contain an element of fantasy, as though the scene portrayed is not quite of this world, as in this provocative rendition.*

Lawrence Lebduska, Two Monkeys, *1945. Oil on canvas, 27 × 31 in. Private collection. A lushly imaginative environment serves as the background for a group of animals that in reality are not likely to dwell together.*

When he was eighteen, Lebduska and his family returned to New York. He went to work for Elsie de Wolfe doing decorative murals and three years later opened his own decorating business. Later, probably in the 1940s, Lebduska worked for the WPA Federal Art Project in New York City, but little else is known about his life.

ARTISTIC BACKGROUND
Lawrence Lebduska started painting fantasies and fables in his spare time around 1912, on his return to this country, but for the first few years he painted mostly for his own pleasure or for friends. He came to prominence in the 1920s, when his work was discovered in a New York gallery show by violinist Louis Kaufman, who purchased many of his oils.

The artist was widely exhibited and quite popular in the 1930s and through the early 1940s, after which he disappeared from the art scene for almost twenty years. There has been speculation that he became ill and spent time in institutions during this period, and it is not known if he continued painting. In 1960 he was located by Eva Lee, a Long Island dealer, who encouraged him to resume painting and drawing. He did so, continuing until his death in 1966, but never fully regained his earlier popularity.

Lawrence Lebduska, Panicky Horses, *1957. Oil on canvas, 29½ × 39½ in. Private collection. Many of Lebduska's paintings include horses, his favorite animal; dramatic rural scenes, as shown in this tempestuous work, are not unusual.*

SUBJECTS AND SOURCES

Lebduska painted pastorals and fantasies based on childhood recollections, fairy tales, Czech folklore, biblical scenes, and personal observation. On his canvases animals, often horses and occasionally unicorns, frolic under bucolic conditions, and people are surrounded by colorful, almost surreal reminders of nature. He also did a few portraits, usually of people to whom he felt close or who had helped him.

The artist had a fondness for horses, which appear in many of his works. At one point in his life he had lived with an uncle in Maryland who bred horses, where he had the opportunity to observe the animals firsthand and develop an appreciation for them.

MATERIALS AND TECHNIQUES

Lebduska's drawings were done on paper with ink and crayon, his paintings on canvas with oils. He drew with a sure hand that showed an interest in both anatomy and perspective. His colors are bold and realistic.

Lebduska's drawings are small, generally 11 by 12 inches, and the paintings average about 30 inches square, although size and shape vary according to the subject. The number of works he completed is not known, but his output is not thought to be large.

ARTISTIC RECOGNITION

Lawrence Lebduska's eye for fantasy and his love of animal fables, combined with his exceptional ability to draw and use color, make him one of the more important folk artists of the century. His work hangs in the Metropolitan Museum and the Museum of Modern Art in New York City, the Abby Aldrich Rockefeller Folk Art Center (his talent was a motivating factor in Abby Aldrich Rockefeller's development of a major collection of folk art) in Williamsburg, Virginia, and in other public collections.

EDWARD LEEDSKALNIN

BIOGRAPHICAL DATA

Born 1887, Stramereens Pogosta (a village near Riga), Latvia. Received minimal education in Latvia. Single. No children. Died December 7, 1951, Homestead, Florida.[1]

GENERAL BACKGROUND

Edward Leedskalnin created an elaborate, castlelike environment, built from coral, in a small Florida town.

Leedskalnin grew up in Latvia, where he was trained as a clerk and later as a stonemason. In 1912 he became engaged to a sixteen-year-old girl named Agnes, who jilted him the night before they were to be married. Brokenhearted, Leedskalnin left his homeland to try to find a new life.

After traveling through western Europe, Canada, and the state of Washington (where he worked as a logger), Leedskalnin developed lung problems and was advised to

Edward Leedskalnin, Saturn and the Moons at Coral Castle, *1936–1951. Sculpted coral environment, 10 acres, Homestead, Florida. Leedskalnin created a number of structures as part of his coral environment; this detail of the garden area includes massive, oversize chairs in addition to crescent moons and Saturn.*

seek a warmer climate. Eventually he settled in Florida City, Florida, in 1918, purchasing an acre of land there. In 1936 he decided that Florida City was too populated and moved to ten acres near Homestead, Florida.

ARTISTIC BACKGROUND

Edward Leedskalnin was never able to forget his Agnes, who was always "sweet sixteen" in his memories, and he secretly began to carve coral pieces as a monument to her after he settled in Florida City. When he moved to Homestead, Leedskalnin moved hundreds of tons of rock by himself at night in a homemade trailer so that he could continue his tribute to Agnes.

The remainder of his life was devoted to a sad fantasy—building a castle where his beloved could live with him. The castle and its grounds included a tower room, throne room, bedroom, children's playground, wall, 9-ton gate, and many additional structures. The environment was a remarkable accomplishment for this slight man, who was only 5 feet tall and considered frail in his youth, but Leedskalnin considered his life a failure because Agnes never came to live in his Coral Castle.

SUBJECTS AND SOURCES

Edward Leedskalnin created a coral environment to house himself, his love, and any children they might have. The

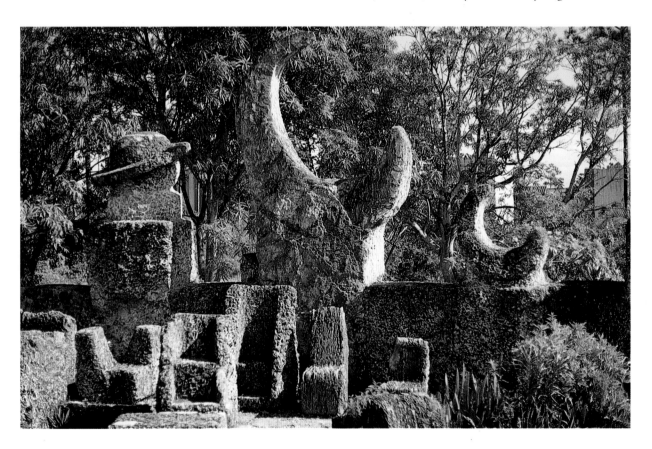

main tower was to be their living quarters; next to the bed for his would-be wife he sculptured a rocking cradle that weighs 155 pounds. Coral chairs and tables, a barbecue and sundial, a moon fountain and pond were all part of the many pieces that made up the unique environment within the wall surrounding the castle.

MATERIALS AND TECHNIQUES
All the pieces in Leedskalnin's *Coral Castle* were made of coral rock, which is extremely porous and hard to work with, and the artist used only simple handmade tools on this difficult material. About 1,000 tons of coral went into the construction of the walls and the tower, and another 100 tons were used for the furniture and other objects in the parklike grounds around the tower.

The construction of *Coral Castle* has long baffled engineers and scientists alike. The 9-ton gate alone is perfectly mounted and balanced so that even a child can open it. Working alone, moving and lifting the huge blocks of coral with only simple block tackles and crude winches, Leedskalnin completed what seems an almost impossible task, and his methods remain obscure.

ARTISTIC RECOGNITION
Coral Castle is one man's monument. It has been featured in hundreds of newspaper and magazine articles, and in 1984 it was placed on the National Register of Historic Places.

ABRAHAM LEVIN

BIOGRAPHICAL DATA
Born 1880, near Vilna, Lithuania. Minimal schooling in Lithuania. Married Sophie Bookman, date unknown; her death date unknown. Two daughters, one son. Died November 29, 1957, Bronx, New York.[1]

GENERAL BACKGROUND
Abraham Levin came to this country in 1903 looking for a home and a better way of life. "I found a home in my art," he is quoted as saying; ". . . I paint my little town [in Lithuania], my people, my own life from my youth to this moment."[2]

Levin found work, along with thousands of other immigrants, in the sweatshops of the garment industry. A member of the tenement society on New York's Lower East Side, he wanted to better the lives of the working class. He became a union man and political activist, serving on the executive board of Local 19, Amalgamated Clothing Workers of America. When he had his first show in 1941, he was working as a tailor for the Royal Knee Pants Company, and his union supported his artistic efforts.

ARTISTIC BACKGROUND
Abraham Levin started painting in 1937, when he was fifty-seven years old. His first works were drawings, copies of pictures from newspapers. By 1941 he was working with oils on canvas and Masonite, and his work had gained

enough recognition that he was given an individual show at the prestigious Uptown Gallery in New York City. When the union officials with whom he worked heard about Levin's painting and the attention his work had received, they decided to pay him a regular stipend for several years so that he could paint full-time.

SUBJECTS AND SOURCES
Levin painted landscapes, portraits, and still lifes—often recollections of ghetto and rural life in Lithuania. He also dramatically portrayed the darker aspects of immigrant existence in New York City during the first half of this century. His are not light or happy paintings; rather, they convey a powerful impression of a difficult and dreary way of life.

MATERIALS AND TECHNIQUES
Levin's early drawings were done with pen and ink on paper, but most of his work was created with oil paints on canvas or Masonite. His somber palette of blacks and blues, highlighted by areas of vivid oranges and reds, gives his work a feeling of quiet melancholy.

The paintings range from 22 by 28 inches to 30 by 36 inches. It is not known how many paintings the artist did, but two hundred or more would probably be a reasonable estimate. Levin's work during the 1940s, particularly his portraits, are undoubtedly his finest.

ARTISTIC RECOGNITION
Abraham Levin had a series of exhibitions in the 1940s, including several shows at the Galerie St. Etienne in New

Abraham Levin, Man with Still Life of Fruits, *1940s.*
Oil on canvas, 30 × 36 in. Private collection. This somber, brooding figure, counterpoised against a lavish still life, is typical of the melancholy mood of many of Levin's paintings.

York, and his work received very favorable reviews. There were a number of years, however, when little was heard of the artist. Inclusion of his work in "Transmitters: The Isolate Artist in America" at the Philadelphia College of Art in 1981 caused some resurgence of interest, and his work is now included in many collections and has been shown in both the United States and Europe.

Levin's brooding and melancholy paintings are generally thought to be among the best folk art produced in the middle years of the century. They often express a sense of oppression and despair, setting a mood that can have a strong impact on the viewer.

HARRY LIEBERMAN

BIOGRAPHICAL DATA

Born Naftulo Hertzke Liebhaber, November 15, 1876, Gniewoszow (a village outside of Warsaw, sometimes spelled phonetically as Gnieveschev), Poland.[1] Studied the Torah from the age of nine until his death. Married Sophie Korman, 1911; she died 1967. Two daughters. Died June 3, 1983, Great Neck, New York.

GENERAL BACKGROUND

Harry Lieberman was a painter known for his portrayal of Jewish folk life.

Born near Warsaw, Poland, in the last quarter of the nineteenth century, Lieberman was raised as a Hasid, required by tradition to spend his life studying the Torah. He was preparing to be a rabbi when, in 1906, he decided to immigrate to the United States. His first job in his adopted country was as a clothing cutter in a sweatshop on New York's Lower East Side.

Lieberman decided he was not going to spend his life in the dark and crowded shops of the garment district. Shortly after getting married, he and his wife borrowed two hundred dollars from a "rich cousin, who had four hundred dollars"[2] and founded a confectionery distributing company, on Ludlow Street, also on the Lower East Side.

Their wholesale business flourished and around 1921 Lieberman felt that he was ready to retire. In 1932, however, he found he did not like having idle time on his hands and he bought back his company.

By 1951 Lieberman was ready to retire again. This time "he moved his family to Great Neck, New York, and devoted himself to playing chess at the Great Neck senior citizens center." From 1979 through 1982 (only a year before his death at the age of 106) Lieberman regularly left Great Neck to visit his daughter in a suburb of Los Angeles, California. "He would appear just after Yom Kippur [in the fall] and leave before Easter—he acted as artist-in-residence at the Fairfax High School."

ARTISTIC BACKGROUND

One day in 1956 Harry Lieberman's chess partner at the Great Neck senior citizens center did not show up and Lieberman was "roped into a painting class. Once started,

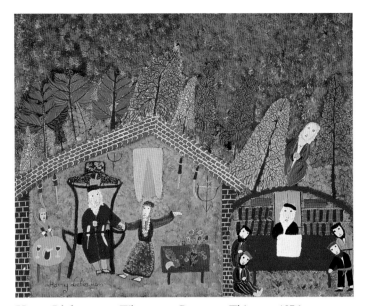

Harry Lieberman, Whosoever Reports a Thing, *c. 1976. Acrylic on canvas, 24 × 30 in. Museum of American Folk Art, New York; Gift of a Friend of the Museum. Lieberman's vivid style of memory painting is evident in this work, which depicts a biblical story as told by a rabbi to his students.*

he threw all his energy into painting." Later that year Lieberman attended an adult education class at the Great Neck High School, which the now well-known painter Larry Rivers was teaching. Rivers offered him no advice during the classes, and when Lieberman inquired why, Rivers replied, "I can't teach you anything." Lieberman by then had already developed his own distinctive style.

SUBJECTS AND SOURCES

Although his earliest works were floral, Lieberman is best known for his scenes of Jewish folk life and his memories of his early days in Poland. He also painted his recollections of religious experiences and of his family. Lieberman always insisted that his paintings came from ideas original to him; "he kept a file index of memories he planned to paint someday." Biblical figures and themes frequently appear in his work.

MATERIALS AND TECHNIQUES

Lieberman painted with oils on canvas or paper. After the late 1960s he used acrylics exclusively because he "liked the fact that they shined." His paintings reflect a combination of complexity and delicacy that is quite appealing.

In 1960 Lieberman spent two weeks at St. Andrew's Priory in Valyermo, California, where he made a series of ceramic sculptures. "He didn't have the patience to fire them, so he worked in self-hardening clay." Following this experiment in the medium, he continued to make sculpture occasionally upon returning to Great Neck.

According to his daughter, Lieberman created 1,500 oil

paintings and only a few drawings. She notes that "in the last year of his life, his hand became a little unsteady, but not his vision." His paintings range in size from about 14 by 18 inches up to about 40 inches square.

ARTISTIC RECOGNITION
Harry Lieberman's work is of historic importance because it documents the integration into America of immigrants from an Eastern European religious tradition. His paintings may be found in the Seattle Museum of Art in Seattle, Washington, the Hirshhorn Museum and Sculpture Garden in Washington, D.C., and in many important collections of Jewish ethnic and religious folk art.

JOE LOUIS LIGHT—*"Life ain't much use if you use other people's ideas."*

BIOGRAPHICAL DATA
Born J. L. Light, September 5, 1934, Dyersburg, Tennessee.[1] Attended school through eighth grade, Brewer High School, Dyersburg, Tennessee. Married Rosie Lee Cotton, September 1, 1968. Five sons, five daughters. Now resides Memphis, Tennessee.

GENERAL BACKGROUND
Joe Light is a leading member of a group of contemporary black folk artists who makes political art.

Light worked on a farm throughout his youth and then enlisted in the army in March 1951. However, in August he was discharged because, as he says, "I found out they was going to send me to Korea, so I hurt my arm."

For a decade or more after leaving the service, Light lived on the wrong side of the law, and not always successfully. He spent 1954 to 1955 in the Dyersburg jail for armed robbery of a grocery store, and from 1960 to 1968 he was in the Nashville penitentiary. There, according to the artist, he changed his ways and converted to Judaism. "I believe in the Old Testament," Light explains. "I'm not African, I'm an American Jew." Upon release from jail, he began selling housewares at flea markets and got married.

ARTISTIC BACKGROUND
Around 1975 Joe Light started making driftwood sculptures and signs to express his views. In 1984 or 1985 he met Bill Arnett, an Atlanta folk art collector and dealer, who helped Light support himself by making folk art. Arnett also encouraged him when Light decided to try his hand at painting.

Light was included in "Outside the Main Stream: Folk Art in Our Time," an exhibition at the High Museum of Art in Atlanta in 1988, which brought him to the attention of a larger folk art audience.

SUBJECTS AND SOURCES
Joe Light has the fervor of a convert; he believes that he has the answers to the problems of the world. He erects signs with appropriate messages in his yard in order to educate those who pass by, and he speaks out on current events and racial issues through his lively paintings. Some scholars believe that Light's work is inspired by photographs and African themes, but the artist denies this.

MATERIALS AND TECHNIQUES
Light uses driftwood that he finds along the Mississippi River, old TV sets, hubcaps, and other found objects to make collage assemblages and as bases for his paintings. He uses simple house paint for his bright, semi-abstract paintings on both wood and found objects. Light has made about twenty-five sculptures, fifty signs, and three hundred paintings in all sizes, some as large as 4 by 7 feet.

Joe Louis Light, Hard to Beat*, c. 1988. Oil on canvas, 35 × 89 in. Arnett Collection. Light's bold and colorful semiabstract style is well exemplified in this seemingly simple painting of a surreal landscape.*

ARTISTIC RECOGNITION

Joe Light is a leader in a newly emerging school of black, mostly southern artists who create political art. Many of these artists know one another.

Light's sculptures and paintings have attracted a lot of attention from scholars who are trying to find African roots in his work and that of other contemporary black artists. There will undoubtedly continue to be ongoing research and controversy over the origins of this type of art.

RONALD LOCKETT—*"I have a belief in myself. That's my dream."*

BIOGRAPHICAL DATA

Born May 20, 1965, Bessemer, Alabama. Graduated from Hueytown High School, Bessemer, Alabama. Single. Now resides Bessemer, Alabama.

GENERAL BACKGROUND

Ronald Lockett, a young artist who creates uncommon paintings and assemblages of social commentary, is a member of the extended Dial family, an exceptionally creative clan living in Bessemer, Alabama.[1]

Lockett is a relative of the Dials; his father and Thornton

Ronald Lockett, Traps, *1989. Wood, wire fence, tin, plastic, oil, and enamel on wood, 53½ × 48 × 3¾ in. Museum of American Folk Art, New York. In this assemblage, Lockett has effectively used wire fencing and metal pipes to dramatically express the feeling of entrapment.*

Dial, Sr., were raised by Sarah Dial Lockett, a relative who still maintains close ties with all the family. After high school graduation, Lockett continued to live with Sarah Lockett and the Dials; he did not immediately find work but occasionally helped out in the family business of manufacturing lawn furniture until he began to work on his own art.

ARTISTIC BACKGROUND

"I always drew and painted," says Lockett, recalling how he was best in art in grade school and always took the subject, "but I was going to give it up because I thought art was for white folks." However, others in the family encouraged the young man and told him to "get serious." Lockett took their advice and, spurred by the creative activity of the Dials around him, began to develop his own distinctive technique and style. He says that being able to create art every day is "like a dream."

SUBJECTS AND SOURCES

Ronald Lockett creates poignant social statements disguised as pastoral scenes. He often uses animals as symbols of such diverse aspects of American culture as family relationships, man's abuse of nature, and the plight of the Native American. He has also developed pieces based on the Holocaust, Hiroshima, and the Ku Klux Klan.

MATERIALS AND TECHNIQUES

Lockett is primarily a painter, but he has no hesitation in adding various found materials—such as fencing, chicken wire, pieces of metal, wood, or sticks—to his assemblages if they seem appropriate. Almost all of his work is on plywood, but he is known to have painted on Masonite, old boards, chipboard, and sometimes even canvas. He uses artist's oil paints as well as oil-base enamel house paints, although, like others in the Dial family, he has a preference for the latter. His palette tends to be dark, and he frequently uses only two or three colors to create his images.

Lockett says that he is not a fast worker but he does work on his art every day. Altogether he has made about one hundred paintings and assemblages, most of them measuring around 4 feet square in size.

ARTISTIC RECOGNITION

The strong social statements that form the core of Ronald Lockett's work are garnering more and more interest from collectors and museums, and his work has been included, along with that of other members of the Dial family, at the Ricco-Maresca Gallery in New York City. One of his pieces is now in the permanent collection of the Museum of American Folk Art, also in New York City.

FELIX A. LOPEZ—*"It is a great honor to be called* santero *and produce sacred images."*

BIOGRAPHICAL DATA

Born June 8, 1942, Gilman (south of Vail), Colorado. Re-

ceived a master's degree in Spanish, 1965, University of New Mexico, Albuquerque. Married Louise Romero, December 28, 1968. One son, one daughter. Now resides La Mesilla (near Espanola), New Mexico.

GENERAL BACKGROUND

Félix Lopez[1] is one of the leading carvers in the *santero* tradition of northern New Mexico.[2]

After graduating from college, Lopez moved to California and taught Spanish in two high schools from 1965 through 1966. He then returned to the "fresh air" of New Mexico and his roots. He is currently teaching at his old alma mater, Espanola Valley High School. "I teach," he says, "Spanish-speaking kids to improve their vocabularies and read in their language."

ARTISTIC BACKGROUND

"I lost touch with my Hispanic roots while in college," Félix Lopez explains. "Being a *santero* helps me understand my heritage." It was his father's death in 1975 that inspired him to take up the traditional carving.

"We held a funeral service in the *morada* [chapel] at Santa Cruz," the artist remembers. "*Alabados* [religious songs] were sung, and the coffin was surrounded by familiar saints. I was overcome."[3] Lopez first tried working in clay from 1976 to 1977, but then, he says, "The saints surrounding my father's coffin appeared to me, and I became a *santero*."

Lopez started exhibiting his carvings at Spanish Market, an annual event in Santa Fe, New Mexico, in the early 1980s. His work gained a great deal of exposure in 1987 when he was included in the traveling exhibition "Hispanic Art in the United States: Thirty Contemporary Painters and Sculptors," organized by the Museum of Fine Arts in Houston, Texas.

SUBJECTS AND SOURCES

Félix Lopez carves the traditional saints of Hispanic northern New Mexico, but he also believes in innovation. "I reposition the saints," he says, "and change their expressions and gestures." His colors are vibrant, subtle, and, although some may complain, not necessarily the colors used on the *santos* from Spanish colonial times.

MATERIALS AND TECHNIQUES

Lopez carves aspen, cottonwood, and pine using only simple hand tools, then covers the wood with a homemade gesso of rabbit glue mixed with gypsum and water. The artist also makes his own pigments from minerals, clay, berries, walnut husks, and sometimes his own blood.

Lopez has control over his media, but he is not overly concerned with proportion. The limbs of his saints may be foreshortened or their fingers elongated, but this in no way detracts from their overall appeal.

The *santero* has carved slightly more than one hundred objects. They range in height from a few inches to 5 feet.

ARTISTIC RECOGNITION

Félix Lopez is becoming well known and is no longer able to keep up with the demand for his work. He received a Visual Artists Fellowship from the National Endowment for the Arts in 1984.

Félix A. Lopez, San Augustin Obispo, *1986. Painted wood, 32 × 12¼ in. Museum of International Folk Art, a unit of the Museum of New Mexico, Santa Fe; International Folk Art Foundation Collection. Although Félix Lopez is a carver in the* santero *tradition, the innovative poses and subtle use of color give his* santos *a contemporary feeling, as can be seen in this fine example.*

JOSE DOLORES LOPEZ

BIOGRAPHICAL DATA

Born April 1, 1868, Cordova, northern New Mexico. Received little, if any, formal education. Married Candelaria Trujillo, November 21, 1893; she died 1912. Married Demetra Romero, June 9, 1913. Six sons, one daughter by Trujillo. Died May 17, 1937.[1]

José Dolores Lopez, The Virgin of Guadalupe, c. 1930. Wood, 13½ × 13 in. Museum of International Folk Art, a unit of the Museum of New Mexico, Santa Fe. A major artist of the santero tradition that uses chip carving as a technique, Lopez carved simple santos like this outstanding example from the 1930s.

GENERAL BACKGROUND

José Dolores Lopez[2] was one of the master carvers in the santero tradition of New Mexico.[3]

During Lopez's youth, the town of Cordova, New Mexico, was a tiny mountain agricultural village connected to the outside world only by footpaths.[4] The villagers depended primarily on herding and on small mountain farms for their livelihood, although a few craftsmen made a living among them.

Lopez was a carpenter; his furniture was the forerunner of today's Santa Fe style. He made beautiful chip-carved chairs, tables, beds, and other household furnishings, including doors. He also held the position of sacristan for the church at Cordova, where one of his tasks was repairing and making objects for the church.

Like many of the Hispanic men of his time and place, Lopez was a member of the Brothers of Jesus of Nazareth (known throughout the Southwest as the Brotherhood of the Penitentes[5]), serving as the hermano mayor, or "elder brother," of the group in Cordova for a period.

ARTISTIC BACKGROUND

José Dolores Lopez was strongly influenced by the great northern New Mexico santeros (carvers of saints) who came before him, including José Rafael Aragon, who died in 1862 and whose work was in many churches. When Lopez became a santero, however, he revolutionized the style; although his subjects were traditional, he created an entirely original approach with chip-carved animals, saints, and tableaux that were unique for his time.

The transition to a more contemporary form of sculp-

ture occurred when his oldest son, Nicudemos, was drafted for World War I. Convinced his son would never return, Lopez began to whittle and chip-carve small sculptures at night to pass the time. When Nicudemos returned home safely in 1919, his father was firmly set on a new woodworking path.

By 1921 Lopez was carving bultos (in-the-round figures of saints) and had a wide local following; he produced his first objects for sale in about 1929. Several of Lopez's saints were purchased by the WPA Federal Art Project in the 1930s.

SUBJECTS AND SOURCES

Lopez carved his figures for the adobe churches and simple home altars of the region. His plain, unpainted saints, unadorned by rich clothing or other embellishment, broke with the more elaborate style of Spain, but their religious message and look were right for the very different lifestyle to be found in the hills of New Mexico. Their very simplicity made them the embodiment of a sense of spiritual power and presence.

The artist's other religious carvings—of Adam and Eve Before a Tree of Life, of Michael the Archangel Slaying the Dragon, and of his version of the Expulsion from Paradise—are as well known as his carvings of saints.

MATERIALS AND TECHNIQUES

A highly skilled craftsman, Lopez used only simple hand tools for his carpentry and carving. His preferred wood was aspen, but he also carved pine, willow, and juniper. He used paint sparingly, if at all, and allowed the skill of his knife and the pale tones of the wood to speak to the viewer.

Because he was not trained in the arts, Lopez did not concern himself with proportion. If an arm had to be extraordinarily long to embrace the baby Jesus, then it would be; it was the overall impression and the message that were important rather than absolute accuracy.

His symmetrical carvings range in size from small animals and crosses to works about 40 inches high.

ARTISTIC RECOGNITION

José Dolores Lopez's saints, religious tableaux, and furniture place him among the great folk carvers of this century; he brought innovation and revival to a declining santero tradition in northern New Mexico. Most of Lopez's pieces are now in museums in the Southwest.

Many of Lopez's descendants have followed in his creative footsteps.[6]

GEORGE T. LOPEZ

BIOGRAPHICAL DATA

Born April 23, 1900, Cordova (south of Taos), New Mexico. Attended grade school for several years (Lopez speaks Spanish and a little English). Married Silvianita Trujillo, November 18, 1925. No children. Now resides Cordova, New Mexico.[1]

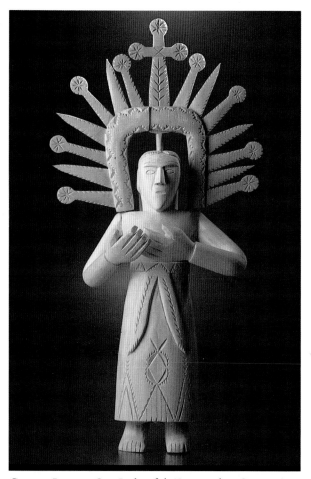

George Lopez, Our Lady of the Immaculate Conception (Nuestra Señora de la Purísima Concepción), *c. 1960. Wood, 21¾ × 10½ in. Museum of International Folk Art, a unit of the Museum of New Mexico, Santa Fe; Girard Foundation Collection. This* santo *displays Lopez's use of chip carving rather than color to adorn the figure.*

GENERAL BACKGROUND

George T. Lopez,[2] the son of a *santero* and a *santero* himself, achieves a sense of color in his work by a combination of different woods rather than by use of paint.[3]

When the small family farms that supported the family of José Dolores Lopez,[4] George's father, could no longer support the community, the young Lopez, at fifteen, began working in the sheep camps and with road section gangs; seasonally he harvested crops in Colorado. In the 1940s he worked on the Los Alamos road leading from Santa Fe to that strategic community.

Lopez is a Roman Catholic and, like his father before him, was initiated into the Brothers of Jesus of Nazareth (sometimes known as the Brotherhood of the Penitentes), but he has not participated in their secret ceremonies for many years.

ARTISTIC BACKGROUND

Because he was away from home so much while he was working at road building and other jobs, George Lopez had very little time to carve. However, after his father, a well-known *santero,* died in 1937, Lopez began to devote more and more of his time to the art and slowly took over the duties his father had shouldered as a *santero.* By 1952 carving was his principal occupation and he had gained a reputation of his own for his work.

Lopez was invited to participate in the annual Festival of American Folklife sponsored by the Smithsonian Institution in 1978 and was awarded a National Heritage Fellowship for his work in 1982.

SUBJECTS AND SOURCES

Lopez makes the traditional saints of the New Mexico church, as well as religious tableaux, animals, crosses, and the "death carts" used in Good Friday services. The carvings have a quiet dignity and seem to glow with an inner spirituality.

The artist does not copy the more traditional carving of the Spanish colonial period, nor does he copy the work of his father; he has developed his own style. He uses different woods to get tones of color in his work and often adds decorative elements, such as small birds or other animals, to his pieces.

MATERIALS AND TECHNIQUES

Lopez continues the tradition of chip carving that was founded by his father. The main wood that he uses is aspen, but, to get variations in tone, he will also carve with pine, cedar, willow, juniper, and cottonwood.[5] The works have the innate simplicity and beauty of the wood; Lopez never applies paint to them.

The carvings, which are done with a well-worn pocketknife, range from a few inches in height to the height of the death carts, where the figure of Doña Sebastiana, the skeleton-saint that rides the carts, may be life-size. As in the work of all *santeros,* popular themes are often repeated.

In spite of his age and failing eyesight, George Lopez still carves occasionally. It is impossible, however, to estimate with any accuracy the number of carvings that Lopez himself makes, although it is known to be a large number.

ARTISTIC RECOGNITION

George Lopez, one in a line of generations of *santeros,* has a reputation that equals, if not surpasses, that of his father. His works appear in public and private collections as well as in the churches and on the home altars for which they were often made.

GEORGE EDWIN LOTHROP

BIOGRAPHICAL DATA

Born December 15, 1867, Dighton, Massachusetts. Attended some high school. Probably single. No known children. Died March 9, 1939, Boston, Massachusetts.[1]

George Edwin Lothrop, Buttercup, *c. 1915. Oil on canvas, 20¾ × 16¼ in. Museum of American Folk Art, New York; Gift of Elias Getz. Despite the pastoral setting, it can easily be imagined that these attractive figures—perhaps intended to represent a mother and daughter—were participants in an imaginary theatrical performance.*

GENERAL BACKGROUND

George Edwin Lothrop created a series of flamboyant paintings of an unreal theatrical world.

Lothrop studied piano polishing and carving under his father, a piano polisher in Boston, Massachusetts. He became a skilled piano case carver, but does not seem to have followed that trade for long. During World War I he worked as a machinist in a naval yard and subsequently as a doorman or watchman.

Lothrop fancied himself a poet, songwriter, playwright, and inventor. He was the author of two books of verse, a self-claimed forty songs, and fifteen plays, all of which he published himself. He also claimed to have invented a machine that could "revolutionize" the motion picture business, but no one was interested in it.

George Lothrop called himself the "Poet King," and it appears that most of the time he lived in a dream world in which he was surrounded by bathing beauties, lovely revelers, and female performers. His dream world came to an end on March 9, 1939, when, after not working for many years, he was found dead on the streets of Boston.

ARTISTIC BACKGROUND

George Lothrop is thought to have painted from about 1917 to around 1930. The exact dates are unknown, but one painting is dated as late as 1929.

The artist exhibited with the Society of Independent Artists in New York City from 1917 through 1920, but it is not known whether he sold any of his works during his lifetime. After his death his paintings were found in storage; several years later they were removed from storage and given to a charity thrift shop. There they were discovered by Peter Hunt, a collector from Provincetown, Massachusetts, who hoped to gain recognition for the work.

SUBJECTS AND SOURCES

George Lothrop's paintings often depicted imaginary theatrical performances. The scenes are sometimes very elaborate, almost bacchanalian, involving numerous figures of women who are nude or semi-draped. The women wear elegant jeweled costumes and gowns reminiscent of the 1920s and are posed like flappers. Occasionally the artist would include recognizable stage personalities—Pavlova, for example—among the performers depicted in his canvases. Those paintings that are not of performances retain a stage-set quality and also often feature beautiful women.

MATERIALS AND TECHNIQUES

Lothrop painted with oils on canvas, sometimes embellishing his work by collaging costume jewelry to the figures. He used the piano-carving skills that he had learned as a youth to make his own frames. Most of his paintings are around 20 by 23 inches in size.

Twenty-one Lothrop paintings were auctioned at the Parke-Bernet Galleries in New York on April 8, 1971. How many others exist is not known, but the number is thought to be small.

ARTISTIC RECOGNITION

Today George Edwin Lothrop's body of work is known primarily to scholars in the field. Although he has been exhibited from time to time, the general public has had little opportunity to examine his paintings because they are held mostly in private collections. His work is, however, in the collection of the Museum of American Folk Art in New York City.

CHARLIE LUCAS—*Lucas's prayer: " God give me the vision. Let me come out of this shell and recycle myself."*

BIOGRAPHICAL DATA

Born October 12, 1951, Birmingham, Alabama. Attended school through fourth grade, Elmo County, Alabama. Married Annie Marie Lykes, April 26, 1971. Four sons, two daughters (some of whom help him create his art). Now resides Prattville (near Montgomery), Alabama.

GENERAL BACKGROUND

Charlie Lucas is a black folk sculptor and painter looking

for meaning in his life. He calls it "recycling himself."

Lucas left home when he was fourteen and went "out on the streets," cutting grass and repairing cars. By the age of seventeen, he had made his way to Florida and was operating a machine "breading shrimp." At twenty he returned to Alabama and built a house in Prattville, where he supported himself as a mechanic. In 1984 Lucas had an accident that-left him bedridden for a long period. During this

Charlie Lucas, Old Wheel Don't Roll Anymore, *1988. Assemblage (metal, wheels), 60 × 18 × 18 in. Arnett Collection. Made from rusted metal and machine parts, this assemblage appears to portray a message about the frustrations of aging.*

recuperation he prayed for a new meaning in life and found art.

ARTISTIC BACKGROUND

When Charlie Lucas was a child, he made toys for other children. After recovering from his accident in 1984, he started making sculptures that he continued to call "toys."

Mark Kennedy, owner of the Sweetgum Gallery in Montgomery, Alabama, discovered the artist's work in 1986. In 1989 Lucas was included in "Another Face of the Diamond," organized by the INTAR Latin American Gallery in New York City.

SUBJECTS AND SOURCES

Lucas claims to "make toys for me to play with." His toys are complex metal assemblages that resemble larger-than-life animals and people. Lucas hopes that his heritage, compassion for mankind, and desire for "social unity" are apparent in the work.

The artist attempts to convey similar messages through his large, colorful, semi-abstract paintings. His paintings tell stories, and his titles hint at their meaning, for example, *Bad Old Twins,* or *Shade Tree Mechanic.* The pictures may, however, simply be enjoyed as abstract art, with or without a message.

MATERIALS AND TECHNIQUES

Lucas paints with house paint on canvas and used boards, but it is his large sculptures, or toys, of welded metal bands of rusted steel and wire that have attracted the most attention. The bands have space between them, giving the work a light and airy appearance.

Lucas has made about one hundred paintings and approximately sixty sculptures. The sculpture can be as large as 8 feet tall.

ARTISTIC RECOGNITION

Charlie Lucas is one of a group of southern black folk artists who are consciously trying to make a place for themselves in the art world. He has attracted a large following who believe this style of art indicates the direction folk art will take in the coming years. His sculptures are his most successful work, although there is a growing interest in his almost-abstract paintings.

EMILY LUNDE—*"I don't like to sell to big shots in New York. I like to keep my prices down so that local folk can own my paintings."*

BIOGRAPHICAL DATA

Born Emily Dufke, April 30, 1914, Newfolden (near the Canadian border), Minnesota. Attended school through eighth grade, Argyle, Minnesota. Married Leonard Lunde, January 18, 1936; he died February 6, 1983. Two sons, two daughters. Now resides Grand Forks, North Dakota.

GENERAL BACKGROUND

"You have to have something to do here in winter," Emily

Emily Lunde, Cottage Meeting, 1914, *1976. Oil on board, 18 × 24 in. Museum of American Folk Art, New York; Gift of the artist. Lunde's memory paintings, recording events such as this religious gathering, preserve the daily life of immigrants at the turn of the century.*

Lunde says of the long and bitterly cold period that characterizes the winters in North Dakota. "I paint scenes of my childhood spent with Swedish immigrant grandparents." She is certainly familiar with the isolation of the north country in winter, having grown up in the immigrant Scandinavian community in northern Minnesota where her grandparents lived.

After her marriage Lunde moved to North Dakota with her husband, Leonard, who was a carpenter. He traveled to construction projects in various midwestern cities, leaving her at home to care for their children; he was away from home so often that Lunde felt she could not work outside the home until her children were grown. Once they were old enough to be on their own, she obtained a job at a photographic studio, Sillmore Studio, in Grand Forks, North Dakota, in 1963 and stayed there for three years. From there she went on to work as a nurse's aide at Deaconess Hospital in Grand Forks until she retired in 1974 and began to devote more time to her art.

ARTISTIC BACKGROUND

Emily Lunde had painted on and off for a number of years, depending on the demands of her home life, but she became more dedicated to her art around the time of her retirement. In 1974, as a tribute to her grandparents, Lunde published a book called *Uff Da* that she illustrated with cartoonlike drawings of scenes remembered from her youth.[1] After that, she kept right on painting. "There were so many stories to illustrate," she said. "Choosing one was like finding your gum after you dropped it in a chicken coop."

Shortly after her book came out, the artist was discovered by Lauren Monda, then a student at the University of North Dakota. The university exhibited the artist's work in 1975 and again in 1987.

SUBJECTS AND SOURCES

Lunde preserves in paint the simple life-style of her Swedish grandparents and others in the small Minnesota immigrant community in the early years of the century. "It's like I'm a candid camera," she says; her characters, however, are generic and not necessarily recognizable.

The stories the artist tells in her paintings are realistic depictions of life as she recalls it—of important family events such as weddings and christenings, of neighborhood gatherings, of Sunday meetings, and of the everyday activities that reflect the culture and customs of the community.

MATERIALS AND TECHNIQUES

Lunde paints with oils and acrylics in swirls of bright, romantic colors on canvas and Masonite. Her favorite size is 24 by 30 inches.

The artist estimates that she has completed almost one thousand paintings.

ARTISTIC RECOGNITION

Emily Lunde is known for her use of color and her ability to capture the mood of the culture in which her grandparents lived. She has exhibited in New York but does not attempt to seek a national market. She is well known to collectors of memory paintings, and her work is included in the collection of the New York State Historical Society at Cooperstown.

JUSTIN McCARTHY

BIOGRAPHICAL DATA

Born May 13, 1892,[1] Weatherly, Pennsylvania. Attended the University of Pennsylvania Law School. Single. No children. Died July 14, 1977, Tucson, Arizona.[2]

GENERAL BACKGROUND

Justin McCarthy is considered one of the most important

yet enigmatic folk artists of the mid-twentieth century.

McCarthy's father, John, was a newspaper publisher, gentleman farmer, and, at one time, the richest man in town. The family lived a lavish life, but soon after the turn of the century suffered a major reversal of fortune. In 1907 his younger brother, whom his father had favored, died. The family went to Europe to forget their grief and, soon after their return in 1908, John McCarthy died, leaving the family finances in ruin. McCarthy went to law school, but he failed the final exams in his second year and could not return. Shortly thereafter he had a nervous breakdown and was hospitalized.

From 1915 to 1920 McCarthy was in the Rittersville (Pennsylvania) State Home for the Insane. He returned home after his release from the hospital and, during the 1920s and 1930s, lived with his mother in the family mansion, selling fruit and vegetables that they grew on the grounds.

After his mother's death in 1940, McCarthy continued to live in the old family mansion and took menial jobs to support himself. In the 1940s and 1950s he worked for Penn Dixie Cement, Just Born Candy Company, Bethlehem Steel, and Allentown State Memorial Hospital. Although a recluse to a certain extent, McCarthy loved to attend movies, sporting events, and the Ice Capades.

His health failing, McCarthy left his family home to spend time in Tucson, Arizona, where he died in 1977.

ARTISTIC BACKGROUND
The legend of Justin McCarthy—the recluse who lived in a decaying mansion next door to Tweedle Park in Weatherly, Pennsylvania, and painted his way into the Museum

Justin McCarthy, West Pointettes Ice Capades, *1962– 1963. Oil on Masonite, 16½ × 47 in. Chuck and Jan Rosenak. McCarthy loved the Ice Capades and clearly expressed his enthusiasm in this jaunty painting of a chorus line of skaters.*

of Modern Art—is a matter of history. McCarthy started drawing around 1920 while he was hospitalized, signing his early work with names like "Prince Dashing." He drew continually throughout the following years but did not start to use oils until the late 1940s, during the period when he was working for the Bethlehem Steel Company.

McCarthy sold his work from his mansion and at local fairs, but it remained largely ignored until 1960, when Dorothy Strauser, wife of the artist and collector Sterling Strauser, discovered him at an outdoor show in Stroudsburg, Pennsylvania. McCarthy soon joined the "Strauser Circle," which included such other folk artists as Jack Savitsky (see page 270), Victor Joseph Gatto (see page 135), "Old Ironsides" Pry (see page 248), and Charlie Dieter (see page 104). Strauser subsidized McCarthy and arranged for him to be included in a 1966–1967 traveling show, "Seventeen Naive Painters," organized by the Museum of Modern Art in New York City.

SUBJECTS AND SOURCES

McCarthy was eclectic in his choice of subjects; he would paint anything if it interested him—pretty girls, movie stars, high fashion, politicians, sporting events, personal heroes, flowers, vegetables, animals, or historical events. He looked at the world with a singular eye, a quiet sense of humor, and, in spite of his personal problems and insecurities, the artistic confidence to solve any problem of composition.

Through his work, the artist commented on the way the people of his time lived. He portrayed popular figures without glamour or glitter, and, characteristically, he depicted motion by elongating and exaggerating individuals.

MATERIALS AND TECHNIQUES

The artist was as eclectic in his choice of materials as in his choice of subject matter. He drew and painted on anything he had at hand—old file folders, cardboard, Masonite, or canvas—and tried everything from oils, acrylics, and watercolors to crayons, pencils, and pens. In the 1950s and 1960s oils became McCarthy's principal medium, and he began to use acrylics in the early 1970s. His style also varies tremendously, from the highly detailed to the very abstract, making it difficult to place him in any one or two categories. His work, however, is always intense, with bold lines and strong colors.

The size of McCarthy's drawings and paintings is as varied as the work itself. Some pieces are as small as 8 by 11 inches, while others (particularly the acrylics) may be as large as 30 by 60 inches. McCarthy completed many thousands of works over a career that spanned more than thirty years, and no accurate inventory exists.

ARTISTIC RECOGNITION

Justin McCarthy's work has appeared at the Brooklyn Museum, the Museum of Modern Art, and the Museum of American Folk Art, all in New York City, as well as in numerous gallery shows. McCarthy is recognized as a major folk artist of his time, with a reputation that continues to grow.

J. T. ("JAKE") McCORD—*"I likes to paint a picture at night—dream about it and go outside in the morning and see it again."*

BIOGRAPHICAL DATA

Born December 28, 1945, Thomson (35 miles from Augusta), Georgia. Educated "off and on," Pleasant School, Thomson, Georgia. Single. No children. Now resides Thomson, Georgia.

GENERAL BACKGROUND

J. T. McCord is a southern black artist who paints bold, naive images on large sheets of plywood.

"I picked cotton, corn, and peas on Daddy's farm, so I didn't learn to spell so good," McCord says. He worked on the family farm until 1976, than cut grass for the city in summer and drove a truck in winter.

About 1984 McCord bought a 10-by-15-foot concrete-block building on Railroad Street in Thomson to live in. It had been a café, and the sign Scott's Café still stands in front of McCord's house.

ARTISTIC BACKGROUND

J. T. McCord relates that he observed "some white ladies taking painting lessons at the Hawes Paint Store" around 1984 and decided to try his hand at it. His first subject was an alligator. "I just finished that old 'gator," he says, "and kept right on goin'." McCord paints on large sheets of plywood in his front yard; he leans the finished product against the building to, as he says, "showcase" his house.

Tom Wells, a Georgia collector and dealer, discovered McCord's work in 1984, shortly after the artist began working, and helped him to become known to other dealers and collectors.

J.T. McCord, Untitled, *1988. Paint on board, 35¾ × 48 in. Edward and Barbara Okun. This young painter's simple, flat, and colorful renditions of people and houses were originally used to decorate the outside of his small block home.*

SUBJECTS AND SOURCES

McCord's paintings show houses or other buildings, flat, round-faced men and women with white flowing hair, and animals against colorful solid backgrounds. Because the artist does not attempt to include much detail, his work carries well from a great distance and accomplishes his purpose of "showcasing" the house.

MATERIALS AND TECHNIQUES

McCord usually paints on plywood with acrylic house paints purchased at a local lumberyard. He always outlines his flat figures—human, animal, or structural—against solid fields of bold primary colors. He also paints a strip of solid color around the edge of each piece to act as a frame.

The plywood sheets on which McCord works are often as large as 4 by 6 feet. The artist has completed more than two hundred works since he began painting.

ARTISTIC RECOGNITION

J. T. McCord's brightly outlined figures and architectural subjects are eye-catching and have a naive appeal. He had a successful individual show at the Tartt Gallery in Washington, D.C., in July 1989, and his work is of particular interest to collectors of southern folk art.

MARJORIE McDONALD—*"My life would be empty without my talent to create."*

BIOGRAPHICAL DATA

Born Marjorie Campbell, April 17, 1898, Akron (near South Bend), Indiana. Graduated from the University of Oregon, majoring in English and Latin. Married John McDonald, June 25, 1925; he died 1943. No children. Now resides Corvallis, Oregon.

GENERAL BACKGROUND

Marjorie McDonald creates luminous, colorful collages of dyed rice paper that cover a wide range of subjects.

McDonald spent forty years—from 1923 through 1963—teaching in the public school system of Portland, Oregon. The first twenty years she taught commercial subjects at Washington High School. During World War II, however, she became fascinated with Russian and achieved fluency in that language. McDonald then established and taught what was reported to be the nation's first Russian language course at the high school level.

After this energetic woman retired in 1963, she began to look for other outlets to keep her busy. She took a few art lessons, "but nothing worked right for me," she says, "until I tried collage."

ARTISTIC BACKGROUND

"When I was seventy-two years old," McDonald explains, "and had just started making collages, an old friend, Ernest Smith, gave me a book on [James] Ensor, and I said to myself, 'If he could do it, I can too.'" The book on Ensor was a watershed for McDonald; she somehow knew that she had found her métier and has continued to work in the medium of collage ever since.

Marjorie McDonald, Visitors from Outer Space, *1986. Dyed rice paper collage, 11½ × 15 in. Jamison-Thomas Gallery, Portland, Oregon. McDonald has developed a unique collage technique that results in translucent images of mysterious figures.*

Marjorie McDonald, Where Have the Dinosaurs Gone?, *1986. Dyed rice paper collage, 11½ × 15 in. Jamison-Thomas Gallery, Portland, Oregon. Some critics believe the artist's best work is her unusual renditions of fanciful animals from prehistoric times.*

In the early 1980s McDonald's work began to gain some public recognition and the Jamison-Thomas Gallery in Portland, Oregon, began to represent her and include her in a number of local shows. McDonald often still attends openings of her shows, although she is now over ninety.

SUBJECTS AND SOURCES

McDonald's collage technique, layering paper upon paper so that the work has a luminous quality, is the most important aspect of her art. Her subject matter covers a broad spectrum—prehistoric animals, science fiction, animals, flowers, and portraits, for instance—and some of her col-

lages are semi-abstract, yet her technique overshadows her subject matter. The surrealistic landscapes with fantastic animals and figures tend to be the most impressive.

MATERIALS AND TECHNIQUES
McDonald dyes high-quality rice paper in a mixture of oil paint and turpentine and dries the wet paper in her oven at 200 degrees. "I used to keep it hotter," she says, "but one day the door blew off in my face." She then tears the paper into the desired shapes and glues it, layer by layer, onto wallboard.

The artist works on a card table that cannot accommodate large-scale work. The collages are usually no more than 8 by 12 inches or 12 by 15 inches.

McDonald has completed about seven hundred works to date. She has shortened her work hours because of arthritis but continues to make collages.

ARTISTIC RECOGNITION
Marjorie McDonald has developed a style of collage that sets her apart from other artists. It is exciting and colorful and enables her to achieve great variety. Although her work is not yet well known outside the Pacific Northwest, she has recently acquired gallery representation in other areas of the country.

CHRISTINE McHORSE—*"Applying piñon pitch in the Navajo Way gives me another dimension. Fire clouds are a natural thing—better than paint or dye, I think."*

BIOGRAPHICAL DATA
Born Christine Nofchissey as a member of the *T'od'ich'i'i'nii* (Bitter Water) clan, December 21, 1948, Morenci, just outside the Navajo Nation, Arizona. Educated at the Institute of American Indian Arts (a high school that currently offers some college-level courses), Santa Fe, New Mexico. Married Joel McHorse, October 27, 1969. Two sons. Now resides Santa Fe, New Mexico.

GENERAL BACKGROUND
Christine McHorse is a modern Navajo potter in a changing world. She has lived outside the reservation all her life, but family traditions run deep. In 1969 she married Joel McHorse, a silversmith from the Pueblo of Taos, New Mexico. "Joel's father was Irish," according to Christine, "and therefore was given the good old Irish name McHorse by the Taos Indians."

After their marriage the McHorses lived in the Taos Pueblo until 1980, when they moved to Santa Fe, New Mexico. The family currently lives and works in a trailer while they await completion of the house and studio they are building. The McHorses support themselves by making pottery and jewelry, and both of their sons help their father with his silver work.

McHorse is very much aware of the fact that her work breaks both Navajo taboo and tradition,[1] but states, "I feel as Navajo as anyone else—I can make my own taboos and traditions."

Christine McHorse, Wolves Courting at the Full Moon, *1988. Fired micaceous clay with piñon pitch, 12½ × 14½ in. diameter (24 in. circumference). Chuck and Jan Rosenak. Simplicity of form and purity of design characterize Chris McHorse's graceful vessels.*

ARTISTIC BACKGROUND
The McHorses began making silver jewelry in 1973. Soon thereafter, Christine learned to pot from her husband's grandmother, Lena Archuleta, who ran a curio shop inside the Taos Pueblo. Archuleta potted in the traditional Taos manner, which is the style that McHorse learned.

In 1984 McHorse was admitted to the Indian Market in Santa Fe, where entry is governed by strict rules and a jury that decides on artistic merit. "In that year I got a blue ribbon," she explains, "and I have received ribbons every year since, except 1988, when I didn't enter the judging."

SUBJECTS AND SOURCES
McHorse is interested in the beauty and purity of form and the endless possibilities to be achieved from micaceous kiln-fired vessels. She reveres the almost religious depth of spirit that comes out of the accidental interaction of earth and fire—the essential elements of Navajo pottery.

McHorse breaks with Navajo tradition in many ways, but her strength of design and craft is clearly a factor of her inheritance.

MATERIALS AND TECHNIQUES
McHorse uses micaceous clay from the Taos Pueblo. She forms her vessels with coils of the purified clay and smoothes them with river stone instead of the traditional burnished corncob.

Sometimes McHorse fires in an outside pit in the traditional Navajo Way, using cottonwood bark for fuel. How-

ever, she prefers an electric kiln. "Firing in a kiln," she states, "gives me better control and allows thinner walls, but the Navajo Way is my way too." She coats some of her finished pots with piñon pitch in the traditional Navajo manner.

McHorse's pots range in size from only several inches high to 25 inches. She makes about thirty pots a year.

ARTISTIC RECOGNITION
McHorse's pottery does not have the same folk sensibility as that of the more traditional Navajo potters, but it is beautifully conceived and graceful in design. Galleries in the Southwest may prefer her kiln-fired work because it is perfect in coloration and form and because the walls are extremely thin. Some, however, prefer her pots fired in the Navajo manner because they have a more natural look.

McHorse's high-quality work is widely appreciated, and the artist finds it difficult to keep up with the demand.

CARL McKENZIE—*"I carve to forget about working in the coal mines—I had ten years doing that."*

BIOGRAPHICAL DATA
Born June 4, 1905, near Campton, Kentucky. No formal education. Married Elva Pitts, July 1927; divorced. Married Edna Spurlock, May 1938; she died January 17, 1989. One daughter by Pitts. Now resides Nada (near Natural Bridge State Park), Kentucky.[1]

GENERAL BACKGROUND
Carl McKenzie, a well-known Kentucky wood carver, has always been a hard worker. He started out as a farmhand in Ohio; worked for Armco Steel and Middletown Iron and Coal in Middletown, Ohio; spent ten years working in the coal mines for Harvey Coal Company in Hazard, Kentucky; and worked in the steel-rolling mills in Newport, Kentucky. His last job, which lasted seventeen years, was driving a lumber truck, from which he retired in the late 1950s.

Now carving is McKenzie's full-time occupation. On nice days he sits on a stump in front of his mostly unpainted mountain cabin near Natural Bridge State Park in Kentucky and whittles.

ARTISTIC BACKGROUND
At the age of ten McKenzie learned to whittle from his grandfather. On and off throughout his working life, he continued to whittle for fun, but after he retired he began carving for income as well as pleasure.

McKenzie brought his early work to the Daniel Boone Trading Post, a tourist stop near Natural Bridge State Park, and soon it was selling so well that he could not keep up with demand. The artist has received an Al Smith Fellowship Award from the Kentucky Arts Council (1985), as well as a Southern Arts Award.

SUBJECTS AND SOURCES
Carl McKenzie carves whatever his fancy dictates, from

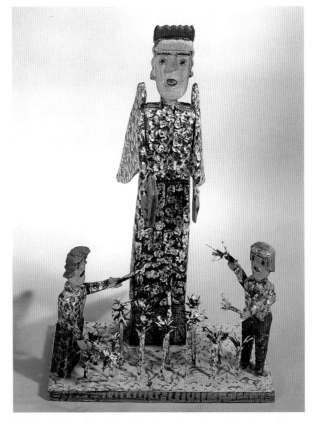

Carl McKenzie, Guardian Angel, *1985. Painted wood, 20½ × 13 × 11 in. Arient Family Collection. An imaginative whittler, McKenzie here has featured a guardian angel watching over two mischievous children playing with firecrackers.*

the Statue of Liberty, waitresses, and barnyard animals to biblical scenes and families of devils. Although he has repeated many of these themes, he has done some one-of-a-kind carvings as well.

MATERIALS AND TECHNIQUES
McKenzie prefers white pine or birch for carving. He decorates his pieces with graphite, colored pencil, felt marker, and acrylic house paint and often adds touches of metal, twigs, plastic, or other found objects.

McKenzie favors color. He makes his own brushes from split twigs, then covers his carvings with thick layers of bright paint applied in polka dots or splotches of red, green, yellow, and black. The result is often quite startling.

McKenzie's pieces usually range from 6 to 24 inches in height. He says that he has made "two semi-truck loads" of carvings to date.

ARTISTIC RECOGNITION
Carl McKenzie is a well-known and prolific Kentucky carver, and his work is much sought after. His version of

the Statue of Liberty, which has a striated surface and holds a Bible and a matchsticklike torch, is one of his most popular pieces, followed by his gardens of Eden and his devil families. His polka-dotted animals are very decorative and have a real "country" look.

Although all McKenzie's work is good technically, his earlier carvings are among his best. When he started repeating his themes and supplying carvings to order, some of the spontaneity of the originals was lost.

EDGAR ALEXANDER McKILLOP

BIOGRAPHICAL DATA
Born June 8, 1879,[1] Balfour, North Carolina. Education unknown. Married Lular Moore, December 16, 1906; she died October 15, 1938. Two daughters. Died August 4, 1950, Balfour, North Carolina.[2]

GENERAL BACKGROUND
Edgar McKillop was an eccentric carver whose body of work, although small, is outstanding and unusual.

Of Scottish descent, McKillop spent most, if not all, of his life in the vicinity of Balfour, North Carolina. Although usually described as a blacksmith, he may also have been a farmer and furniture maker. According to his daughter Luler, "Edgar Alexander McKillop was a tal-

Edgar Alexander McKillop, Hippoceros, *1928–1929. Carved walnut, hinged lid, leather, ivory, and Victrola works, 58¼ in. long. Abby Aldrich Rockefeller Folk Art Center, Williamsburg, Virginia.* Hippoceros *is a wonderfully inventive carving by an eccentric genius who created few known works.*

ented man. He could cook and sew and make rustic and fancy furniture. He could make anything from wood or any kind of metal. He was an inventor. We don't know of any kind of work that he could not do."[3] McKillop is said to have invented a machine for cleaning bobbins, which he sold to the Balfour Textile Mills.

ARTISTIC BACKGROUND
Edgar McKillop was an eccentric carver who worked to satisfy his own personal need to create. When he started carving is not known, but most of his pieces appear to have been made in the late 1920s. After his fellow inventor, Henry Ford, established Greenfield Village in 1929, McKillop presented him with a carving of a man, an eagle, and two frogs.

This highly imaginative and skilled artist did not receive the recognition he deserved during his lifetime.

SUBJECTS AND SOURCES
McKillop carved animals and people, placing them in unusual configurations, as he did with the *Man, an Eagle, and Two Frogs.* He invented animal forms as well, his most famous being the *Hippoceros,* a large, fantastic creature that has a phonograph hidden within its back and that wags its tongue as the phonograph plays. The artist also made clock cases that are elaborately carved and topped by small animals.

MATERIALS AND TECHNIQUES
McKillop worked in wood and, from the few pieces known, his favorite appears to have been black walnut.

The *Hippoceros* is made of walnut, with teeth that resemble piano keys. It has glass eyes, originally had rhinestones in its nostrils, and a tongue made from a leather boxing glove. The tongue is rigged to move in and out as the turntable of the phonograph in its back revolves. McKillop used commercial clock works in his carved clock cases, usually bought from Sears, Roebuck and Company.

McKillop produced very few pieces. Four major carvings are in museum collections, and only several others, including some carved clock cases, are known. The *Hippoceros* is 58¼ inches long.

ARTISTIC RECOGNITION
This highly inventive artist had great technical skill, a sense of humor, and the ability to transmit his vision, even though he left behind only a small body of work. The *Hippoceros,* now in the permanent collection of the Abby Aldrich Rockefeller Folk Art Center in Williamsburg, Virginia, is considered one of the great masterpieces of folk art sculpture of his time.

ALEXANDER A. MALDONADO—
"They use to call me a left-hook artist. Now they call me an artist." "I paint the impossible."[1]

BIOGRAPHICAL DATA
Born December 17, 1901, Mazatlan, Sinaloa, Mexico. At-

tended school for two years in Mexico and for a few years at the elementary level in San Francisco. Single. No children. Died February 10, 1989, San Francisco, California.[2]

GENERAL BACKGROUND

Alex Maldonado, a fan of popular science and astronomy, painted brightly colored futuristic images that won him attention on both the East and West coasts.

Between 1917 and 1922 Maldonado was a colorful and prominent San Francisco personality, fighting as a professional featherweight boxer under the ring name "Frankie Baker," and San Francisco's mayor, Jim Rolph, liked to escort him to ringside at Garibaldi Hall. He fought forty or fifty bouts and never lost.

After his career in the ring, Maldonado, who spoke only Spanish when he came to this country from Mexico in 1911, went to work for the Western Can Company as a production worker, retiring from that company at the age of sixty. Shortly after his retirement, he had eye problems that were partially cured by laser surgery in 1983. For many years he lived with his sister, Carmen, until she died in 1985.

ARTISTIC BACKGROUND

Carmen Maldonado persuaded her brother to take up painting as a hobby when he approached retirement. Maldonado's first efforts were sketches and watercolors, but he soon graduated to oils. He painted in the basement of his sister's house, which was his studio/domain.

Maldonado started to receive widespread attention in 1973, when KQED-TV in San Francisco did a half-hour documentary featuring the artist. The San Francisco Museum of Art included his work in "Art Naif" the following year, and Bonnie Grossman, director of the Ames Gallery in Berkeley, California, who helped prepare the TV documentary, became Maldonado's agent.

SUBJECTS AND SOURCES

As a boy Maldonado had seen Halley's Comet and viewed Mars through a telescope; he continued to follow popular science and astronomy in magazines. His paintings, which show a bright, futuristic world of extraterrestrial cityscapes and modernistic buildings of his own design, were clearly influenced by these interests and events. In addition, Maldonado was a vegetarian and pacifist who believed that people should live with their minds in the future.

MATERIALS AND TECHNIQUES

Except for a few early pieces, all of Maldonado's work is oil on canvas. He bought cheap frames at the dime store and sometimes painted his pictures onto the frames. His strongest work was done from 1965 to 1980.

Maldonado's body of work includes about 250 oil paintings, 10 or 12 watercolors, and 6 sketches. The works range from 6 by 8 inches up to 24 by 36 inches.

ARTISTIC RECOGNITION

Alex Maldonado is an important California artist whose work is equally well known on both coasts, and his rendi-

Alexander A. Maldonado, Out of Space Planet, *1973.*
Oil on canvas (frame painted on back only), 16 × 20 in.
Ames Gallery of American Folk Art, Berkeley, California.
Maldonado was fascinated by astronomy and science fiction and painted dramatic landscapes such as this solar system.

tions of colorful, almost utopian, futuristic cities are his most popular works with both collectors and exhibition-goers. Maldonado's paintings were included in more than twenty-seven shows between 1973 and 1989.

BETTY MANYGOATS

BIOGRAPHICAL DATA

Born Betty Barlow to the *Táchii'nii* (Red Running into the Water) clan, January 30, 1945, the Shonto/Cow Springs area, the Navajo Nation, Arizona. Education unknown. Married William Manygoats August 8, 1963. One son, nine daughters (many of her children are potters). Now resides Cow Springs (between Grand Canyon and Monument Valley), the Navajo Nation, Arizona.

GENERAL BACKGROUND

On a sheep-nibbled plain, the Manygoats extended family lives in a cluster of prefabricated houses interspersed with hogans and corrals.[1] Unemployment is high among the Navajos, and the family lives off the land and its animals —sheep and goats—as well as what is earned by making pottery.

Since the 1870s the women of the clans who live in this remote area have made utilitarian Navajo pottery for cooking and storage. However, by the 1960s the sale of cheap tin and plastic utensils at the trading posts had virtually wiped out local commerce in these items. Bill Beaver, an Indian trader who owns the Sacred Mountain Trading Post near Flagstaff, Arizona, helped to revive pottery making

Betty Manygoats, Horned Toad Pot, *1988. Fired clay with piñon pitch, 28 × 16 in. diameter. Edward and Barbara Okun. This impressive example of Manygoats's work—a double-spouted jug decorated with her favorite horned toads—is one of the largest pieces this artist has produced.*

in this area. He started collecting Navajo pottery in the 1950s (when other traders were uninterested in it because it lacked decoration) and encouraged innovation among the potters.[2]

ARTISTIC BACKGROUND

Betty Manygoats's mother, Zonie Barlow, and other members of her family taught her how to pot. According to Bill Beaver, "I first saw Betty's pots in mid-1975, but they were undistinguished. I sent her home and told her to try something different. In 1978 she brought me one encrusted with horny toads. Now I had something great!"

Manygoats soon began winning awards for her work at the annual Navajo exhibitions held at the Museum of

Northern Arizona in Flagstaff, and at the Inter-Tribal Indian Ceremony in Gallup, New Mexico. She never, however, personally appears at this type of event.

Manygoats's husband, William, also makes pots (even though it is a Navajo taboo for men to pot), but his are of a different type, usually with painted designs.

SUBJECTS AND SOURCES

Manygoats makes Navajo pottery in the traditional way, just as it has been made for more then one hundred years, but she exaggerates the shapes and modernizes the styling. Some pieces are small and some are greatly enlarged.

Although her pots are made in the Navajo Way, Manygoats disregards Navajo taboos on design (in traditional Navajo pottery, only one decorative element—a *biyo',* or small beaded necklace just below the rim—is allowed). She puts one or more horned toads, for instance, on almost everything she makes, from the smallest to the largest pieces.[3] Occasionally her pieces include a painted design—also a taboo in the Navajo pottery tradition.

Manygoats also makes small animals—buffalo, horses, sheep, and goats—that are similar to the clay toys that the Navajo used to make for their children.

MATERIALS AND TECHNIQUES

Manygoats uses Navajo clay from Black Mesa, forming it into coils that wind upward. She starts her coils in various-sized bowls and pie tins, which determine the eventual circumference of the piece. Then she smoothes the coiled clay and adds the decorations. (Manygoats makes her horned toad scales with a bobby pin.)

After the piece has dried in the sun, it is placed in an open-pit kiln and covered with cow dung. Cedar is the preferred fuel for the kiln. Where the wood ash comes in contact with the clay, brownish gray discolorations called "fire clouds" appear. After firing, warm piñon pitch is applied to the piece, inside and out. Once coated with pitch, the pot is watertight.

Manygoats's ware can be as small as 3 inches high, but some of her pots are very large—close to 3 feet. Her wedding vases, often measuring over 2 feet high, are famous.

Manygoats is a prolific worker. If the weather is good, she will make as many as thirty pots in a month.

ARTISTIC RECOGNITION

The new Navajo pottery is finding its way into the important collections of Native American art and pottery. It is featured in galleries and museums surrounding the Navajo Nation—those in Phoenix and Tucson, Arizona, and in Gallup, Farmington, and Santa Fe, New Mexico. Manygoats is one of the most innovative of the Navajo potters working today. Her work was featured in a 1988 exhibition at the Wheelwright Museum of the American Indian in Santa Fe and a 1990 exhibition at the Museum of Northern Arizona in Flagstaff.

ROBERT J. MARINO—*"My world is full of a number of things—we all should be as happy as kings."*

BIOGRAPHICAL DATA
Born 1893, Blacksher, Alabama. Attended elementary school, Daphne (south of Mobile), Alabama. First wife's name and marriage and death dates unknown. Married Vivian Quinney, date unknown; she died 1985. One daughter by first wife. Died May 1973, Daphne, Alabama.[1]

GENERAL BACKGROUND
Robert Marino was a black artist whose satirical carvings often used public figures as subjects.

A recluse, Marino lived in a secluded house on a small farm east of Daphne, Alabama, on the Tiawasee Creek,

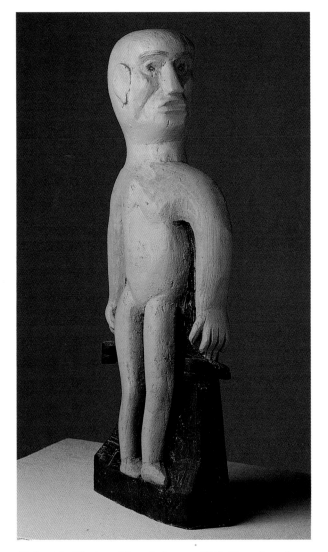

Robert J. Marino, Khrushchev, c. 1963. Carved wood with paint, 25 × 9 × 4 in. Fine Arts Museum of the South, Mobile, Alabama. In this carving, Marino has created his own starkly simple version of a well-known political figure.

which flows into Mobile Bay. He moved into his modest home in 1908 and grew some corn and other vegetables on the accompanying 20 acres. Although he took odd jobs over the years as a carpenter and handyman, the town remained unaware of his artistic talent until 1971.

ARTISTIC BACKGROUND
The local legend is that Marino started to carve in the 1960s when a large camphor tree in his yard was killed by frost. Rather than cut it down and remove it, he turned the tree into a carved grouping of Indians (Marino's mother was a Creek Indian; he claimed to have Portuguese ancestors as well), then went on to do more and more carvings that he placed in and about his front yard.

A local resident, Doris Allegri, stumbled on Marino's hideaway while on an outing. She called the town newspaper, which ran a story on Marino and his sculpture on August 19, 1971.

When Marino died in 1973, the Fine Arts Museum of the South in Mobile, Alabama, bought thirty of his works; the rest were more or less left outside his house to face whatever would happen to them.

SUBJECTS AND SOURCES
Marino carved rough likenesses of people, concentrating on political figures such as John F. Kennedy and Nikita Khrushchev, television personalities like Merv Griffith, and neighbors and relatives. The characterizations developed from his imagination, aided by the shape of the wood, and often have the added depth of social, political, or personal commentary.

Marino clothed some of his figures, like the one of his neighbor, entitled *Mary Ellen,* which is shown in a ball gown carrying a parasol. At the other extreme, his nephew is depicted standing behind a bush without a stitch of clothing on.

MATERIALS AND TECHNIQUES
The artist used indigenous woods in his carving—pine, cedar, mimosa, cypress, and camphor—and worked with hand tools. He painted the pieces sparingly with house paint and dressed some of the figures in discarded cloth that he crudely sewed into garments. *Mary Ellen* was decorated with Mardi Gras beads.

Marino is believed to have made about one hundred objects, but probably fewer than fifty have survived. The majority are about 3 feet high, but one Indian is 8 feet tall.

ARTISTIC RECOGNITION
Robert Marino's best works are his political characterizations; Khrushchev, for instance, stands unclothed, shoes in hand, ready to face the United Nations. Although reclusive, Marino nevertheless had an insight into the affairs of the world that enabled him to complete a rare grouping of satirical carvings. This artist is becoming well known in the South, and he was included in the 1987 "Enisled Visions: The Southern Non-Traditional Folk Artist," an exhibition at the Fine Arts Museum of the South in Mobile, Alabama.

EDDIE OWENS MARTIN ("ST. EOM")

BIOGRAPHICAL DATA
Born Eddie Owens Martin, July 4, 1908, Glen Alta (near Buena Vista), west central Georgia. Attended school until the age of fourteen, Glen Alta, Georgia. Single. No children. Died April 16, 1986, Buena Vista, Georgia.[1]

GENERAL BACKGROUND
Eddie Owens Martin was a religious eccentric who, as "St. EOM," built an unusual environment of brightly colored temples and pagodas.

Martin worked with his sharecropping family until he was fourteen years old, then left school and family and "took off for New York City." Once there, Martin generally made his living in what could be considered shady ways; he was a street hustler, gambler, and small-time dealer in marijuana.

On May 28, 1935, Martin's life took a different direction when an inner voice told him, "You're gonna be the start of somethin' new, and you'll call yourself 'Saint EOM,' and you'll be a Pasaquoyan—the first in the world." Martin took the voice seriously and let his hair grow long, donned flowing African and Indian robes, and became St. EOM, formulator of the Pasaquoyan religion. He told for-tunes and read tea leaves, operating from places like the Wishing Cup Tearoom. St. EOM continued some of his old practices, however, and between 1942 and 1943 spent nine months in a federal prison in Lexington, Kentucky, for possession of marijuana. He returned to New York and his old life as fortune-teller when he was released.

On his mother's death in 1950, Martin inherited a small farmhouse on 4 acres a few miles outside Buena Vista, Georgia. In 1957 he moved there to begin the process of turning the land into Pasaquan, the temple of the Pasa-quoyan (the name, he once said, meant "the place where the past and the present and the future and everything else comes together"[2]). He continued in the fortune-telling business to support himself.

In 1982 Martin had heart surgery and thereafter was plagued by various health problems. Overwhelmed by the fear of becoming an invalid and dependent on others, the

Eddie Owens Martin, The Land of Pasaquan, *1957–1986. Mixed-media environment (aluminum, concrete, paint, roofing shingles, plaster, and beads), 4 acres, Buena Vista, Georgia. Pasaquan, the temple of Martin's Pasaquoyan religion, includes an environment with many fantastically decorated structures like the one shown here.*

Eddie Owens Martin, The Land of Pasaquan *(details).*
These details give some sense of the colorful and complex designs that cover the structures at Pasaquan. Some have masklike designs, while others incorporate plants and other images.

Pasaquoyan committed suicide on April 16, 1986, by shooting himself in the head.

ARTISTIC BACKGROUND
In the 1940s and 1950s, St. EOM had tried his hand at painting and exhibited in New York, with little success. But in 1957, when he started building Pasaquan, the unusual, almost tribal-looking structures that he erected attracted attention almost immediately.

St. EOM and Pasaquan were included in "Missing Pieces: Georgia Folk Art 1770–1976," sponsored by the Georgia Council for the Arts and Humanities. In 1978 he was invited to the Library of Congress to meet President Carter's family; he came dressed in African gowns and beads, beating a drum, and let out a "shaman yell" from the second-floor balcony that considerably enlivened the proceedings.

SUBJECTS AND SOURCES
On his property St. EOM built temples, pagodas, and shrines for use in the practice of the Pasaquoyan religion; all were surrounded by an elaborately decorated wall. He borrowed themes and styles from Egyptian, Mayan, Native American, Chinese, and Japanese art and architecture.

St. EOM intended to attract attention to himself by his dress and in his art, both of which were flamboyant and colorful. At Pasaquan, huge eyes emblazoned on the walls and statues and figures of larger-than-life-size male nudes greet visitors, as well as totemlike pillars, clownlike heads, and floral-patterned walls.

MATERIALS AND TECHNIQUES
St. EOM produced some oils and some drawings, but the artist is known primarily for the Pasaquan environment. He built it mainly of concrete and painted it with the brightest colors that any paint company could produce.

The environment sprawls over the 4-acre site, and the temples and pagodas rise two stories above the ground. St. EOM did much of the work himself, although a few novice laborers assisted him at least some of the time.

ARTISTIC RECOGNITION
Pasaquan is the crowning jewel of St. EOM's work, a unique and colorful environment of one man's special vision and voice, and efforts are being undertaken to see that it is preserved. The property is being maintained by the Marion County Historic Society, which is presently raising funds for preservation and plans to open Pasaquan to the public in 1990.

MARIA MARTINEZ

BIOGRAPHICAL DATA
Born Maria Montoya, April 5, 1887,[1] San Ildefonso Pueblo (northwest of Santa Fe), New Mexico. Attended grade school, San Ildefonso, and two years at St. Catherine Indian School, Santa Fe. Married Julian Martinez, 1904; he died 1943. Four sons (a daughter died in infancy). Died June 20, 1980, San Ildefonso.[2]

GENERAL BACKGROUND
Maria Martinez grew up in the Tewa-speaking pueblo of San Ildefonso. As a child and young woman, she had made pottery for utilitarian purposes. Encouraged by the School of American Research and local traders, she began to pot in earnest when she was in her twenties although, except for a few pieces, she never decorated the pottery herself. It was decorated first by her sister Maxmiliana (known as Anna) and later by her husband, Julian. The matte black-on-black style for which the Martinez family is famous was actually worked out by Julian about 1919.

The Martinez family first received recognition at the St. Louis World's Fair in 1904, where they appeared as part of

Maria and Julian Martinez, Untitled, *c. 1942. Fired clay storage jar with matte decoration (geometric patterns, clouds, and leaf and bird motifs), 18¾ × 22½ in. diameter. Laboratory of Anthropology/Museum of Indian Arts and Culture, Santa Fe, New Mexico. Martinez notes that this pot, one of the first black-on-black pieces that she made, was sold for forty dollars and three shawls.*

a Native American group that was dancing and demonstrating pottery making. Later they participated in the San Diego World's Fair (1914), the Chicago World's Fair Century of Progress (1934), and the San Francisco World's Fair (1939).

After her husband's death in 1943, Maria began working with her daughter-in-law Santana, and in 1956 she began a partnership with her son Popovi Da. She continued to work steadily until 1970, after which she made only an occasional piece.

Martinez consistently won top awards at the annual Indian Market in Santa Fe and the Inter-Tribal Indian Ceremony in Gallup, New Mexico, and was the recipient of numerous other awards, including the Craftmanship Medal from the American Institute of Architects in 1954. She also received an honorary doctorate of fine arts from New Mexico State University in 1971 and an honorary doctorate from Columbia University in New York in 1977, and she was invited to the White House four times.

ARTISTIC BACKGROUND
In 1907 the School of American Research in Santa Fe, under the guidance of Edgar L. Hewett, began excavation of prehistoric pueblo sites on the Pajarito Plateau and hired local Indians, including Julian Martinez, as diggers. Maria Martinez was excited by the pottery shards uncovered at the excavation site, and Dr. Hewett encouraged her to try to reproduce this pottery.

By the next season she and and her husband had produced pottery—not reproductions, but exciting and unique pieces. Dr. Hewett purchased the work and ordered more; thus Martinez and her husband had begun the revival of Pueblo pottery.

SUBJECTS AND SOURCES
Some of the early Martinez pots were undecorated. Then, prior to the development of their black-on-black work, the couple worked in the traditional polychrome style of San Ildefonso.

Feather, floral, and geometric motifs appear on the pots as well as stylized skunk and animal motifs. Other pots contain *avanyu* (plumed serpent) designs.

MATERIALS AND TECHNIQUES
Martinez used local clay and applied Cochiti slip on the polychrome wares; then she smoothed the pottery with a polishing stone or sandpaper. For the famous black-on-black ware, the design was painted before firing with red clay slip (to create a matte design) on a polished vessel; the pot was then smoked until it turned black. Julian Martinez painted with yucca brushes, using a hard yellow rock ground to powder and mixed with guaco for paint.[3]

Many of the vessels Martinez made are around 9 by 10 inches. However, some of the pots are as large as 15 by 21 inches. The artist made thousands of pots—the precise number is not known.

ARTISTIC RECOGNITION
Maria Martinez began to sign her pots around 1923. She used various signatures over the years: Pohveka, Marie, Marie & Julian, Marie & Santana, Maria & Santana, Maria Poveka, and Maria/Popovi. Pots with a fired-in signature are rare, and sometimes, in order not to disappoint visitors, Martinez would sign a pot with a felt-tip pen even if it were not hers.

Until the advent of Maria and Julian Martinez, pueblo pottery making was in a period of decline. Maria Martinez revived pottery making not only in San Ildefonso but in all the Rio Grande pueblos because she shared her skills and knowledge with other potters. Today pottery making is the single most important source of income at these pueblos.

Maria Martinez would seem to justly deserve the title of the "most famous Indian artist of all time."[4]

GREGORIO MARZAN

BIOGRAPHICAL DATA
Born May 9, 1906, Vega Baja, Puerto Rico. Attended first grade, Puerto Rico.[1] Married Louisa Valintin, date unknown; she died 1938. Two sons, three daughters. Now resides New York City.

GENERAL BACKGROUND
Gregorio Marzan is a Hispanic artist who creates colorful

and imaginative sculptures from a wide range of found objects.

The children of Marzan's village in Puerto Rico were required to work in the sweltering sugarcane fields as soon as they reached six or seven years of age, and he was no exception. Escape to a better life was almost impossible, but in his teens Marzan found employment as a carpenter making wooden frames for suitcases and began saving

Gregorio Marzan, Statue of Liberty, 1989. *Mixed media (plaster, fabric, tape, glue, light bulb, Elmer's Glue caps, and wig), 64½ × 30 × 7 in. Chuck and Jan Rosenak.*
Although the artist lives in New York City, he claims he has never seen the Statue of Liberty; his inspiration came from a poster depicting this famous landmark that hangs on his wall.

money toward the day when he could leave the island.

In 1937 he became part of the tide of Puerto Ricans moving to New York. His wife remained in Puerto Rico with their children, and after her death in 1938 Marzan continued to save his money, eventually bringing his children to New York so that he could raise them.

During the war Marzan was disqualified for defense factory work because he was almost deaf (and had been so for many years). Instead, he found a job stuffing dolls and animals for Novelty Toys. When the company switched to machine stuffing, he operated the machines until he retired in 1971.

Marzan has since lost the sight in one eye from glaucoma, but, although half blind and mostly deaf, he still walks the streets of New York gathering material for his sculpture.

ARTISTIC BACKGROUND

Marzan started creating sculpture out of bits and pieces of found objects before his retirement, but since then he has devoted much more time to his art. The first pieces he made were miniature houses, typical of those seen in Puerto Rico; then he began to do the figures of birds and animals for which he is known.

El Museo del Barrio in Manhattan is located near the housing project in Spanish Harlem where Marzan lives, and the directors of this museum took an interest in the artist, encouraged him, and began collecting and exhibiting his work.

SUBJECTS AND SOURCES

The artist makes fanciful and glittering animals—chickens, dogs, butterflies, and more. Sometimes his figures are a recognizable species, but other times the artist gives them human heads, making it difficult to tell just what animal the body represents. Marzan also makes large renditions of buildings and monuments such as the Statue of Liberty.

MATERIALS AND TECHNIQUES

Gregorio Marzan buys or finds what is "surplus"—clothes hangers for the armatures of his figures, plaster, fabric, tape, Contact paper, hair, glass, caps from glue bottles. He wraps the metal armatures with tape and trims them with the other objects. Marzan does not paint his figures; the color comes from the material he uses and may be discordant. He makes no attempt at realism; his chickens may be red, blue, gray, or any other color.

Marzan has made about 250 objects. The majority of his animals are 24 to 30 inches tall, but he has made a few pieces as large as 5 or 5½ feet tall.

ARTISTIC RECOGNITION

Marzan's fanciful creatures are unique examples of a creative spirit that seeks escape from the barrio. His work is beginning to appear in collections of Hispanic and fanciful folk art, and he was included in "Hispanic Art in the United States: Thirty Contemporary Painters & Sculptors," a traveling show that originated at the Museum of Fine Arts in Houston, Texas, in 1987.

WILLIE MASSEY—*"It's all I can do now."*

BIOGRAPHICAL INFORMATION
Born March 10, 1910,[1] Brown (near Bowling Green), Kentucky. Attended Brown High School, Brown, Kentucky. Married Eva Taylor, c. 1935; she died 1955. No children. Died January 13, 1990, Bowling Green, Kentucky.[2]

GENERAL BACKGROUND
Willie Massey, a black folk artist, made wonderful birdhouses inhabited by wingless birds, as well as fanciful paintings of animals.

Massey worked on the farm owned by Willie Bohanon for nearly seventy years, from the age of eighteen until old age caught up with him in 1985. "He gave me a house—a little ol' bungalow—for my life. I milked his cows and helped with the hogs and cattle," Massey said.

"I got a handicap and stay home making my things. It's all I can do now," explained this proud old man, who suffered from severe rheumatism. "People buyin' my art keeps me from going to the nursing home." Massey died of complications from pneumonia as he was recovering from injuries sustained during a December 1989 fire in his home. The fire destroyed all the artwork in his house at the time.

ARTISTIC BACKGROUND
Willie Massey started making folk art shortly after his wife died in 1955. First it was a way to keep busy; then it became a way of life. After his rheumatism worsened in 1984 he gave up farm work as well as most of his social activity and increased his artistic activity.

Massey's work was first discovered by a local dealer and eventually found its way to the American Primitive Gallery in New York City, which now represents the artist's work.

SUBJECTS AND SOURCES
Massey worked in wood and paint. He constructed whimsical and delightful birdhouses occupied by small wingless birds, and he painted animals that closely resemble alligators, monkeys, and lions but that have human or otherworldly characteristics that give them a surreal appearance. The paintings of animals bear a resemblance to heraldic plaques, but the backgrounds that Massey added have a moonscape quality.

MATERIALS AND TECHNIQUES
Massey's birdhouses are colorful multistory structures made out of old boards, mostly pine, and painted in shiny bright enamels. They have the appearance of crudely made dollhouses and sometimes have a small airplane mounted on top. Perched on and about the houses are tiny birds made of painted aluminum foil or wood.

For his paintings Massey bought prestretched canvas and painted on the verso side. The stretcher thus became a frame that the artist painted colorfully. He collaged aluminum foil and buttons onto the canvases.

Willie Massie, Birdhouse, *1989. Wood, paint, foil, and tape, 23 × 15 × 12 in. Kurt A. Gitter and Alice Yelen. Willie Massie's delightful and colorful surrealistic birdhouses are usually occupied by such fanciful wingless birds as the one perched on the roof here.*

Willie Massey did not know how many objects he had made. "I have a house full," he said. Some of the birdhouses are 3 feet tall, some smaller; the paintings measure about 15 by 20 inches.

ARTISTIC RECOGNITION
Willie Massey's work illustrates the need of the human soul to create, especially when the person is almost totally isolated from social contact. Massey's work is known and collected in Kentucky, and now that it is represented in New York City his reputation is likely to grow.

QUILLIAN LANIER MEADERS—*"If folks want them [the jugs], they're here; if they don't, they're still here. People used to need them; now they don't. I guess the pottery will die when I do; nobody else left to carry it on."*

BIOGRAPHICAL DATA
Born October 4, 1917, Mossy Creek (near Cleveland), Georgia. Attended school through about tenth grade.[1] Married Betty Jean Lewis, September 10, 1988. No children. Now resides Mossy Creek (near Cleveland), Georgia.

GENERAL BACKGROUND

Lanier Meaders has tried to leave the family pottery (founded in the winter of 1892 by his grandfather, John M. Meaders), but clay is now so much a part of him that escape from Mossy Creek is impossible.

During World War II Meaders served with the airborne infantry in France, but at the war's end he returned home to help his father and mother, Cheever and Arie, in the family pottery. He tried to find a place for himself outside the family business and worked in various jobs—outfitting trailers in a Gainesville, Georgia, sheet-metal factory and working in a textile mill.

Meaders's fate, however, was decided in 1967 when a film crew from the Smithsonian Institution came to Mossy Creek to film the pottery operation. His father was sick, so Meaders filled in. The Smithsonian also ordered some face jugs to sell at its first summer Festival of the Arts, and

Quillian Lanier Meaders, Grotesque Face Jug, 1981.
Pottery with ash glaze, 10¾ × 7½ in. Dr. and Mrs. Allen W. Huffman. Lanier Meaders uses clay from the banks of Mossy Creek, Georgia, for his grotesque face jugs, which are part of a pottery tradition that dates from the time of slavery.

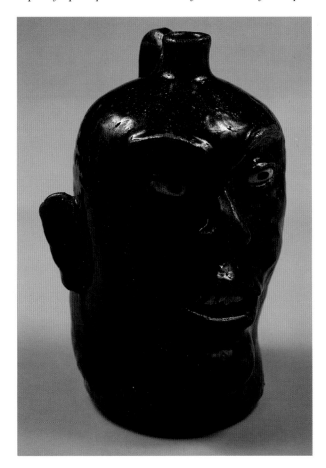

Meaders was the one who made the pots to fill the order.

The bottom clay along the banks of Mossy Creek has supported many potteries; today only the Meaders establishment is still in existence. It survives because Meaders stopped depending on utilitarian ware, such as candle holders, jugs, and plates, and started making art objects.

ARTISTIC BACKGROUND

Lanier Meaders inherited his craft from his father and mother, but the art is uniquely his. Demand for and interest in Meaders's artwork increased after his exposure at the Smithsonian Institution's Festival of American Folklife in 1967, and he received a National Heritage Fellowship in 1983.

SUBJECTS AND SOURCES

Meaders's pots are sculptural heads—commonly known as face jugs or grotesque jugs.[2] Some, called "dillies," are portraits of popular figures and political leaders, and Meaders's favorites include Richard Nixon, Bert Lance, and Idi Amin. He has also thrown "congressmen and senators" jugs, which have a face on each side. The artist still makes some utilitarian pottery, but the quantity is limited.

MATERIALS AND TECHNIQUES

Meaders purifies the local stoneware clay and turns it on a wheel, using a foot pedal for power. He uses porcelain for the white teeth and the whites of eyes, and his glazes are green to brown, depending on the heat of the fire.

Meaders refers to the glaze he uses as "ash glaze"; it is a combination of firebox ash, ground-up glass, red silt ("setlin's"), and water. The clay is fired in a long oblong hand-built kiln, fueled with end pieces and scraps of pine from a nearby lumber mill.

The jugs are approximately the size of standard 1-gallon ware. They run 8 to 12 inches in height.

Meaders will make thirty to fifty jugs at a time, but then he may not work again for months. There is no record of his total output.

ARTISTIC RECOGNITION

Lanier Meaders's work is popular among collectors of southern folk pottery. His dillies, his early work (done before 1980), the one-of-a-kind jugs that happen by accident (the white of the eyes runs down onto the cheeks, for instance), and his unusual jugs that are combined with snakes or candle holders are special examples of folk art.

ANNA MILLER

BIOGRAPHICAL DATA

Born Anna Louisa Flath, January 12, 1906, Glenbeulah, Wisconsin. Attended public schools in Wisconsin. Married Lynn Miller, date unknown; he died July 21, 1970. No children. Now resides in Eau Claire, Wisconsin.[1]

GENERAL BACKGROUND

Anna Miller's boldly colored memory paintings of rural

Anna Miller, No More Gravy, *1950. Oil on Masonite, 16 × 12 in. Viterbo College, La Crosse, Wisconsin. This painting is replete with personal symbolism and typifies the artist's dream paintings. In the upper panel, she has portrayed herself swinging among the stars while a blimplike UFO floats below.*

life in Wisconsin are well regarded although not widely known.

A reclusive person, Miller has had few close friends. She gardened, tended to a variety of pets, and painted late into the evening while her husband, Lynn, worked as a night watchman in Milwaukee, Wisconsin.

Aside from the time she spent in Milwaukee, Miller has always lived in rural areas. She was known for being somewhat eccentric because of her numerous pets—which included chickens and goats—and because she dressed somewhat like a homeless street person.

In 1971, shortly after the death of her husband, Miller started to worry that her paintings might be "thrown out on a rubbish heap." In order to save them, she wrote a letter addressed to the "Catholic University, La Crosse" (Viterbo College), in which she donated some thirty objects (including twenty-five major oil paintings) to the school.

At about that time Miller also began to have a difficult time living on her own on her rather isolated farm. Her

neighbors did what they could, but the state intervened in 1976, and she now lives in a nursing home.

ARTISTIC BACKGROUND
Anna Miller started painting about 1940 to keep busy at night while her husband was at work. She stopped painting when he died in 1970 and has done only a few insignificant drawings, more like doodles, since then.

Her work was exhibited at the Milwaukee Art Museum in 1951 and included in a circulating exhibition, "Grass Roots Art: Wisconsin," in 1978 and 1979.

SUBJECTS AND SOURCES
Miller painted portraits of her husband, memory images of her younger days in rural Wisconsin, and a few mystical fantasy dream sequences. She would outline the features she wished to emphasize in bold color and then fill in the outlines with contrasting shades. Her landscapes are characterized by the use of both vertical and horizontal lines, which helped her to make up for her inability to achieve perspective.

MATERIALS AND TECHNIQUES
Miller painted some pictures on note cards, but most of her work, including the best examples, is painted on canvas board or Masonite. The paintings are no larger than about 48 by 24 inches.

Viterbo College has the thirty works donated by Miller in the 1970s; it is uncertain how many others exist.

ARTISTIC RECOGNITION
Anna Miller's bold and eccentric work preserves for future generations a picture of important aspects of life in rural Wisconsin. Within Wisconsin Miller is well regarded, but outside the state she is known only to folk art scholars. Her work is in the permanent collection of the Milwaukee Art Museum as well as on permanent display at Viterbo College.

PETER MINCHELL

BIOGRAPHICAL DATA
Born October 11, 1889, Treves, Germany. Attended a German trade school for two and a half years. Information on marriage and children unknown. Date of death unknown; probably died in Florida.[1]

GENERAL BACKGROUND
Little is known of the personal life of this man who created a series of highly imaginative drawings well after his retirement. In 1906, at the age of seventeen, Peter Minchell emigrated from Germany to the United States and settled in New Orleans, Louisiana. After a few years there, he moved to Florida in 1911 and went to work in the building trade, his profession until he retired in the late 1950s.

ARTISTIC BACKGROUND
Peter Minchell is thought to have begun drawing around

Peter Minchell, Avery Island, *n.d. Watercolor and ink on paper, 19 × 28 in. Private collection. While Minchell based his drawings on actual locations along the Gulf Coast, he interpreted them as fantastic and sometimes frightening places.*

1960 and to have continued into the mid-1970s. His first works are unusual floral and arboreal representations that often bear little resemblence to reality. His *Geological Phenomena* series, which include illustrations of natural disasters such as tornadoes and hurricanes, was done around 1972 and was the work that brought him to the attention of various museum people, including Robert Bishop, director of the Museum of American Folk Art, who recognized Minchell's unique talent and included the artist in his book *Folk Painters of America.*[2]

SUBJECTS AND SOURCES

Minchell is well known for his mysterious watercolors of the waters, flora, and fauna of the Gulf Coast. He populated these waters with larger-than-life birds and reptiles, and Spanish moss often drips from the branches of strange and imaginary trees with twisted trunks and branches. The artist also made several groups of serial drawings, of which *Geological Phenomena* was the first; others deal with the end of the earth and alien visitors.

At the bottom margin of some of the drawings, in a small and meticulous script, the artist wrote comments and explained the story that is depicted in the work. He used pale and quiet colors, with greens or soft yellows predominating, but his subject matter is often unsettling and gives a sense of ominous action and movement.

MATERIALS AND TECHNIQUES

The artist worked with watercolors on a heavy paper. Pencil sketch marks are evident on many of his works, indicating that he sketched out his design before doing the final painting.

The drawings are about 20 by 25 inches. How many exist is not known.

ARTISTIC RECOGNITION

Peter Minchell had a highly personal vision that grew out

of his introspective nature. His use of pale colors to set mood and the mysterious quality that is characteristic of his sometimes sensuous work have made him known to many collectors. Minchell's drawings have frequently been reproduced in books on folk art and are included in the permanent collection of the Smithsonian Institution's National Museum of American Art in Washington, D.C.

ETHEL WRIGHT ("BIG BAMMA") MOHAMED—*When asked why she always shows such happy scenes in her work, Ethel Mohamed replies, "Who wants to put down a toothache? Who wants to put down a sore throat? Not me!"*

BIOGRAPHICAL DATA
Born Ethel Lee Wright, October 13, 1906, Eupora, Mississippi. Attended school through tenth grade, Cumberland High School, Eupora, Mississippi. Married Hassan Mohamed April 21, 1924; he died March 23, 1965. Five daughters, three sons. Now resides Belzoni, Mississippi.

GENERAL BACKGROUND
Ethel Mohamed is a fiber artist whose gaily stitched pictures of her happiest memories cover her walls as daily reminders of those times.

Mohamed lived on her family's cotton farm until she married Hassan Mohamed, a "peddler from Lebanon." They opened a general store in Shaw, Mississippi, and in 1929 moved it to Belzoni. "I loved that store," she remem-

Ethel Wright Mohamed, Me at the Renwick, *1978. Embroidery floss on fabric, 23¾ × 15⅞ in. National Museum of American Art, Smithsonian Institution, Washington, D.C.; Gift of Ethel W. Mohamed. Mohamed stitch-paints her happy memories on cloth for her own and her family's enjoyment. Here she recalls a show that included her work at the Renwick Gallery in Washington, D.C.*

bers. "My grandson runs it now. I worked there every day of my life, even after my husband died." In 1984 Mohamed retired.

ARTISTIC BACKGROUND
After her husband died, Mohamed started making stitched pictures of the past to keep herself occupied and to reflect on happy times. She remembers saying to herself, "I don't want to be one of those old ladies who sit alone waiting for the children to call."

Ethel Mohamed has always refused to sell her stitchings, which she refers to as her "dreams"; instead, she puts them up on the walls of her house, where she can look at them and remember. "I call my house 'Big Bamma's Dream World,'" she relates with a chuckle ("Big Bamma" is her own nickname for herself). "My memories are on the walls where they belong."

SUBJECTS AND SOURCES
Mohamed immortalizes her happy memories in stitched pictures on fabric. "They are," she says, "like a family album. I keep scrapbooks, love letters, report cards, and all those things in the attic. The family calls it 'Big Bamma's Treasure House.' I draw on these small things from which happy dreams come."

MATERIALS AND TECHNIQUES
Mohamed's pictures are composed of embroidery stitches on linen. "I use simple stitches," she explains, "crewel stitch, chain stitch, running stitch, and such." She buys her supplies in Jackson, Mississippi, and prefers wool thread, but mainly it is color that governs her choice. Mohamed "draws off" the picture with a pencil before stitching because mistakes in yarn cannot be erased.

The artist has stitched 150 pictures. They range in size from only a few square inches to 3 by 5 feet.

ARTISTIC RECOGNITION
Mohamed's *Dream World* is unique, brightly colored, gay, and full of romantic images. Although she has always refused to sell her pieces, every year she does give one to each of three charities (the Heart Association, Children with Cancer, and the Diabetes Association) for their annual auctions. The stitchings draw quite high bids as competition for them is fierce.

Mohamed was invited to participate in the Smithsonian Institution's Festival of American Folklife in 1974. A poster advertising the event reproduced one of her stitchings. She has given two of her pieces to the Smithsonian's Renwick Gallery.

LOUIS MONZA

BIOGRAPHICAL DATA
Born August 23, 1897, Turate, Italy. Attended grade school and apprenticed as a furniture carver, Turate, Italy. Married Heidi Gloor, August 23, 1947. No children. Died June 22, 1984, Redondo Beach, California.[1]

Louis Monza, The Corneaters at a Reunion, *1944. Oil on board, 20 × 24 in. Didi and David Barrett. In this early work, the thin ears of corn suggest economically hard times, one of Monza's frequent subjects.*

GENERAL BACKGROUND

Louis Monza was a prolific artist who painted a wide range of subjects but who is best known for his allegorical works.

Anticipating war in Europe, Monza immigrated to the United States in 1913 and set out to see this country, working his way as a railroad hand. In 1917 he joined the army and was stationed in Panama during the war. He settled in New York City at the war's end and took up employment as a house painter, but in 1938 he fell from a scaffold and suffered a permanent injury to his spine.

Monza moved to Redondo Beach, California, in 1946 and married the next year. He painted and his wife went to work to provide support for them both.

ARTISTIC BACKGROUND

Monza started painting shortly after his fall from the scaffold in 1938 and within a few years received some recognition for his work; the Artists' Gallery in New York City gave him showings in both 1941 and 1943. Although he continued painting until his death, he received little additional recognition until shortly before his death in 1984.

SUBJECTS AND SOURCES

Monza painted a wide range of subject matter. He became a pacifist and socialist as he grew older and is best known for his allegorical depictions of the horror of fascism and the carnage of Europe during the two world wars. He predicted Mussolini's downfall and painted an allegory of his death. His paintings are colorful and often full of gruesome detail—the slaughter of people and animals and the destruction of cities by soldiers who are represented as robots.

The Monzas traveled extensively in Mexico, and the colors, people, and architecture of that country greatly

influenced Monza's later work. The artist's palette brightened considerably after his move to California, when he began to include local subjects.

MATERIALS AND TECHNIQUES

Monza is known for his oils on canvas, but he also made bronzes, large terra-cotta sculptures (fired at a nearby high school), and lithographs.

The artist painted for many years, and his output was prodigious. He created more than a thousand pieces in different media—oil paintings, acrylics, bronzes, terra-cotta works, and numerous drawings and lithographs. Monza's paintings range from 9 by 11 inches to 55 by 70 inches.

ARTISTIC RECOGNITION

Louis Monza's allegorical work produced in the 1930s through the 1960s was probably his best. In it he combined themes from his Italian origins, his Mexican travels, and his adopted homeland. His use of color, allegory, and dramatic presentation sets him apart from most other folk painters of the middle part of this century. There has been a resurgence of interest in this artist in recent years, and he was included in "Pioneers in Paradise: Folk and Outsider Artists of the West Coast," a traveling exhibition that opened at the Long Beach Museum of Art in California in 1984, and in "Muffled Voices: Folk Artists in Contemporary America," a 1986 exhibition sponsored by the Museum of American Folk Art in New York City.

IKE MORGAN—*"The art keeps the voices to the back of my head. I need water, food, and art."*

BIOGRAPHICAL DATA

Born October 4, 1958, Rockdale (near Austin), Texas. Quit school in eleventh grade, Johnston High School, Austin, Texas. Single. No children. Now resides Austin, Texas.

GENERAL BACKGROUND

Ike Morgan, a black artist who is mentally ill, is gaining wide recognition for his vibrant paintings and pastels.

On April 11, 1977, Morgan was picked up by the police and charged with murdering his grandmother, Margarite Morgan, with a butcher knife. Diagnosed as suffering from chronic schizophrenia, he was found incompetent to stand trial and, as a result, was hospitalized in the Austin State Hospital.

Virtually nothing is known about Morgan's early years; he himself is unable to remember much about his life prior to his hospitalization. What he does remember is that he was born in the rural farming area of Rockdale, Texas, near Austin, and that he was reared by his grandmother, "who worked very hard as a maid." Morgan believes that his family brought him to Austin when he was about ten years old. "In school," he states, "I liked to play football and run track. I did try to do art, but I didn't do no good."

Morgan recalls that he had a job for a short time (from

about 1975 to 1977) painting fire hydrants for the Austin Safety Department. Since the death of his grandmother, he has been institutionalized in the state hospital in Austin.

ARTISTIC BACKGROUND

After Ike Morgan was hospitalized, the social workers encouraged him to attend art classes, but he states, "I didn't like no class—I am my own class!" He went off by himself and quietly began to draw. "That is my job," he says.

In 1987 Jim Pirtle, an orderly at the state hospital, took some of Ike Morgan's drawings to Leslie Muth, a folk art gallery owner in Houston. Muth liked the work and began showing the drawings to influential collectors who were interested in black folk art, southern folk art, and the works of the mentally ill.

SUBJECTS AND SOURCES

Morgan says that he hears voices in the back of his head that dictate his subjects to him, and that his paintings are his own personal vision. He draws the dark side of life, such as the patients in the hospital, and also black men and black women in general. Sometimes these latter subjects are well-known actors like Bill Cosby, but often they are

Ike Morgan, Untitled, *1987. Pastel on paper, 24 × 18 in. Henri and Leslie Muth. Morgan's portraits are based on people he has observed or illustrations he has seen in magazines; they often convey strength and power through bold colors and direct composition.*

the black women pictured in *Playboy* magazine. Morgan does not emphasize the sexuality of the women but rather the awkwardness of the poses.

Morgan also paints animals with strange, haunting eyes and birds that swoop and threaten. Occasionally rather odd characters, transformed from illustrations in Dr. Seuss books, crop up in his work.

MATERIALS AND TECHNIQUES

The artist has experimented with various types of paint and commercial papers, but he prefers the texture of cardboard and found objects, like discarded window blinds. He also likes pastels because "they feel good when you rub them on with your fingers." Morgan's pastels may need conservation work, as the hospital does not allow him to keep the fixative that has to be applied to pastels. The lasting quality of his cardboard work is also a concern.

Morgan claims to have finished more than one thousand works. Hospital orderlies charged with cleaning responsibilities have disposed of some. The drawings range in size from small pieces up to an 8-foot-high venetian blind.

ARTISTIC RECOGNITION

Ike Morgan's paintings and pastels are all strong and vibrant and his reputation is beginning to grow. He was included in "Narrative Images: Folk and Folk Related" at the Art Museum of South Texas in Corpus Christi in 1987.

SISTER GERTRUDE MORGAN—

"God moves my hand. Do you think I would ever know how to do a picture like this myself?"

BIOGRAPHICAL DATA

Born April 7, 1900, Lafayette, Alabama. Little formal education. Single (Morgan believed she was married to the "lamb," Jesus Christ). No children. Died July 8, 1980, New Orleans, Louisiana.[1]

GENERAL BACKGROUND

Sister Gertrude Morgan was among the most important of the black visionary painters of the century, and her work conveys spiritual messages.

From her youth, when she was an active member of the Baptist church, she showed strong religious convictions, but when she was thirty-seven, she found her true vocation. As she told it, a voice spoke to her and said, "Go and preach, tell it to the world"; she followed the command and became a street evangelist for a fundamentalist sect, preaching in Columbus, Georgia, and Montgomery, Alabama, and accompanying her deep and throaty singing voice with tambourine, guitar, and piano. By 1939 she had settled in New Orleans, Louisiana, where she continued her street preaching and, with two other women, founded a small orphanage and built a chapel and child care center in the Gentilly section of the city.

In 1957 Morgan was the recipient of another divine order; this time the voice told her, "You are married to the lamb, Christ." She shed the black habit traditional for her

Sister Gertrude Morgan, New Jerusalem, *c. 1970. Acrylic and tempera on cardboard, 12 × 19 in. Museum of American Folk Art, New York; Gift of Sanford and Patricia Smith. Morgan's paintings of her religious experiences and biblical stories convey her spiritual messages. She often included a self-portrait as well as a narrative to reinforce her ideas.*

sect and began to dress only in white; soon she had converted her entire environment—house, furniture, any objects she used—to white as well.

In 1965 Hurricane Betsy destroyed Morgan's orphanage but not her religious fervor. She simply turned it in another direction. By the late 1960s Sister Gertrude had rented a small building from E. Lorenz Borenstein, a local art gallery owner, and named the building the Everlasting Gospel Mission. It was painted white, of course, and the front lawn was planted in what she claimed was "four-leaf" clover.

ARTISTIC BACKGROUND

Sister Gertrude Morgan began her painting activity around 1956, but after the destruction of the orphanage she turned to her art with a much greater intensity. At one point, she said, "the Lord commanded" her to begin to teach the gospel in a different manner; she gave up street preaching to concentrate on passing on the Lord's word through her paintings. Morgan illustrated sermons and used the money she received from their sale to pay the rent on the mission.

Morgan sold her work through Borenstein's gallery; he kept the paintings in piles labeled $10, $20, and $25 in his gallery, depending on their size. By 1970 Sister Gertrude's work was receiving attention that went beyond its religious import and it was included in many exhibitions. She remained, however, an evangelist first and foremost; when the Museum of American Folk Art in New York City featured her in a three-person show in 1973, she was too busy preaching to attend the opening.

Toward the end of her life, Morgan lost some motor control, but her spirit and vision remained constant. The Lord commanded her to stop painting about 1978, and she died in 1980.

SUBJECTS AND SOURCES

Sister Gertrude's paintings show a colorful, often apocalyptic, vision of biblical events and of heaven and hell. Her pictures are occupied by religious figures, angels, and children, many of whom resemble the artist. Morgan frequently portrayed herself as the bride of Christ, and some of her biblical characters and angels are shown as black.

Morgan covered her paintings with personal and biblical messages, written in a childlike script, that are meant as tools to expand the meaning of the illustrations. Without being conscious of it, she was a calligrapher, and her text is an integral part of the work.

MATERIALS AND TECHNIQUES

Morgan painted on anything that was handy—paper, board, the cardboard in toilet paper rolls, her guitar case, window shades, funeral parlor fans, or tambourine covers. She outlined her subjects with pencil and pen, filling in with acrylic paints, watercolors, pastels, crayons, or tempera—again, whatever was available at the moment of inspiration. Her paintings are colorful, full of the vigor and belief that she herself always projected so strongly.

Morgan made many hundreds of paintings; no accurate count was ever taken. There are a few large works, but most are smaller than 12 by 20 inches.

ARTISTIC RECOGNITION

There is not a collector or museum interested in black folk art that is unfamiliar with the paintings of Sister Gertrude Morgan. Her work has been widely shown in numerous galleries, museums, and other institutions, and she has earned a well-deserved position among the folk artists of this century.

ANNA MARY ROBERTSON "GRANDMA" MOSES

BIOGRAPHICAL DATA

Born Anna Mary Robertson, September 7, 1860, Greenwich, New York. Sporadically attended a rural school. Married Thomas Salmon Moses, November 9, 1887; he died January 15, 1927. Ten children; five died in infancy. Died December 13, 1961, Hoosick Falls, New York.[1]

GENERAL BACKGROUND

Anna Mary Robertson Moses—better known as Grandma Moses—was the originator of a style of art now called memory painting. As a child she had loved painting, and her brother said she called her work "lamb scapes." How fitting that term is to describe the soft and glowing scenes of times remembered, as done by this artist whose work caught the imagination of a nation.

Moses grew up in rural New York State and lived all her life there and in Virginia, where she moved for a period after her marriage. She and her husband settled on a dairy farm near Staunton, Virginia, where they raised their family. Painting was soon forgotten amid the daily demands of a growing family and a business that required time and energy.

In 1905 they returned to Eagle Bridge, New York, a rural area where Moses, a traditional farm wife, became well known for her household arts and began winning ribbons at county fairs for her jellies, pies, and canned goods. Through it all she was storing up the memories that one day would be expressed in paint and make her name almost a household word.

ARTISTIC BACKGROUND

Moses had not painted since childhood and was well into her seventies when she started painting again at the suggestion of one of her daughters. She began with her now-famous landscapes, and soon her work—displayed in the window of a drugstore—was discovered by Louis J. Caldor, a New York engineer and art collector who was charmed by the images.

Caldor brought her work to the attention of Otto Kallir and others, and by 1939 Moses was included in "Contemporary Unknown American Painters," an exhibition at the Museum of Modern Art in New York City. She had her first individual show the next year, and then there was no turning back. Her work has been represented by Kallir's Galerie St. Etienne in New York City for many years.

SUBJECTS AND SOURCES

Grandma Moses portrayed the rural landscapes of her youth, showing an idyllic countryside at the turn of the century—prosperous farms and villages, verdant in summer, covered by clean snow in winter—where unhappiness and heartache play no part. Her scenes are populated by happy, active, smiling men, women, and children, busy at work and at play, all in harmony with one another and with nature. Her people, however, are always subordinate to the bountiful and beautiful rural landscape.

Sometimes Moses used magazine and newspaper clippings (of which she had several thousand on file) and, occasionally, postcards for guidance in her paintings. Turn-of-the-century prints, such as those of Currier & Ives, also initially influenced her work. These sources provided inspiration for such details as buildings, people, and animals, but the landscape elements were always observed directly from nature.

MATERIALS AND TECHNIQUES

As a child, Moses drew her "lamb scapes" on paper, coloring them with grape juice or berries. When she returned to art many years later, she worked in oils on Masonite, hard board, or cardboard, covering the base material with three coats of flat white paint before colors were applied. Moses preferred to work on an antique "tip-up" table.

Grandma Moses painted about 1,500 works in all, ranging in size from about 8 by 10 inches up to 36 by 48 inches.

ARTISTIC RECOGNITION

There are two schools of thought concerning memory painting—a term that provides an apt description of Moses's work—in general and Grandma Moses in partic-

Anna Mary Robertson Moses, We Are Resting, *1951.*
Oil on canvas, 24 × 30 in. Galerie St. Etienne, New York.
Perhaps the best-known American folk artist, Grandma
Moses painted her memories of an idyllic past, when country
life seemed to offer harmony and contentment.

ular. Some critics think that her paintings lack reality and
that her work is merely decorative, without great artistic
merit. Others think that Moses managed to capture the
true American spirit, that her art is the best and most rep-
resentative of the folk art produced in this century. Which-
ever school of thought is espoused, there is no doubt that
Grandma Moses has gained a reputation bigger than life;
she served as a trailblazer for those who would follow and
she set a standard that has yet to be matched.

Moses's paintings are included in the permanent collec-
tions of many American museums, including the Metro-
politan Museum of Art and the Museum of American Folk

Art in New York City and the Phillips Collection in Wash-
ington, D.C.

ED ("MR. EDDY") MUMMA—*"But a painting has to be painted on both sides—to be complete."*

BIOGRAPHICAL DATA
Born 1908 ("he was a Cancer, so it had to be July"[1]),
Milton (near Cleveland), Ohio. Attended school through
eighth grade, Milton, Ohio. Married Thelma Heubner,
1936; she died 1953. One daughter. Died October 7, 1986,
Gainesville, Florida.

GENERAL BACKGROUND
Eddy Mumma, who liked to call himself "Mr. Eddy," was
an artist who compulsively painted a single image. He was
a self-sufficient man, proud and uncomplaining in the face
of adversity. "Even when he lacked funds for necessities

Ed Mumma, Untitled, *c. 1980. Oil on board, 17¼ ×
14¼ in. Luise Ross Gallery, New York. An artist who
compulsively painted one subject, "Mr. Eddy" decorated his
walls with round-faced images probably meant to be self-
portraits.*

and was sick and immobile, he'd always say, 'I have
enough.'"

After finishing eighth grade, Mumma "rode the rails."
He became a hobo, traveling the country and picking up
whatever jobs a particular locality had to offer. When he
married in 1936, he and his wife settled on a small farm
near Springfield, Ohio, and raised vegetables.

Mumma continued farming for a while after his wife's
death, but by 1966 he had sold the farm and moved to
Gainesville, Florida, to be near his daughter. He bought
two small houses there, living in one and renting out the
other.

Eddy Mumma suffered from diabetes. His left leg was
amputated just above the knee in 1970, and his right leg
followed in 1984.

ARTISTIC BACKGROUND
In 1969 Mumma's daughter, Carroll, suggested to her fa-
ther that he "get out of the house and take an art lesson."
The class did not work out because the "instructor accused
his pupil of being artistically sloppy," but from that day
on, Mumma painted feverishly, filling every wall of his
small home with his work. He sold very few paintings
during his lifetime, even though he needed money desper-
ately. "They belong here, where I can see them," he re-
peatedly declared.

Lenny Kesl, a Gainesville artist, discovered Mumma,
befriended him, and supplied him with materials. "I of-
fered to show his work at the college where I taught," he
says, "but Mr. Eddy wouldn't take [his paintings] down
off his walls." On the day Mumma died, a folk art collec-
tor happened to see the family gathering and, after inquir-
ing into the circumstances, arranged on the spot to buy
between six hundred and eight hundred of the artist's
works. The family considered Mumma an eccentric and
had no use for his paintings.

SUBJECTS AND SOURCES
Mumma repeatedly painted an abstract version of the bust
of a round-faced man with his hands held against his chest,
possibly a self-portrait. The face always looks straight
ahead, without expression. It is a compulsive image,
painted flat on a colorful background, and is both intrigu-
ing and compelling. The artist also did some landscapes
and some animals, but he always returned to his full-faced
man, often painting images on both sides of the board.

MATERIALS AND TECHNIQUES
Mumma painted on plywood or Masonite with acrylics.
He was a colorist and did not hesitate to experiment with
different shades of the same color in his paintings. He made
some of his own frames from scraps of wood and plastic.

Mumma completed close to one thousand paintings.
Most are around 12 by 15 inches, but a few are larger,
about 40 by 60 inches.

ARTISTIC RECOGNITION
Eddy Mumma's work is owned by a very small number
of collectors and is not well known to the general viewing
public. He has been included in some shows, one of the
first of which was "A Separate Reality: Florida Eccentrics"
at the Museum of Art, Fort Lauderdale, Florida, in 1987.
He has also been shown at Rutgers University, New
Brunswick, New Jersey (1987), and the Santa Fe Com-
munity College, Gainesville, Florida (1988).

JOHN ("J. B.") MURRY

BIOGRAPHICAL DATA
Born March 5, 1908, near Sandersville, Georgia. Attended
school for one month, Warren County schools, Georgia.
Married Cleo Kitchens in 1929 (Murry refused to talk
about his marriage; he and Kitchens were separated in the
1950s or 1960s). Eleven children. Died September 18,
1988, near Sandersville, Georgia.[1]

GENERAL BACKGROUND
J. B. Murry was a mystic who created beautiful drawings
and writings filled with spiritual messages.

A product of rural black Georgia at the turn of the cen-
tury, Murry was tied to the land by his lack of education.
He was strongly influenced by primitive religious practices
and by a Bible he could not read. From the age of six until
the late 1970s, when illness caught up with him, Murry

worked on Georgia farms when he needed money. When he became ill, he lived on small Social Security checks, with no other income. Murry died in 1988.

ARTISTIC BACKGROUND
In the 1970s J. B. Murry had a religious experience that he wanted to share, and his writings and drawings were his media. He created beautiful "spirit drawings" and complex abstract paintings that served as aids to meditation and divination.

Murry was befriended by William Rawlings, Jr., who met him in 1979. "He was living in a shack," Dr. Rawlings explains. "The electricity had been turned off, but the outside well worked. Murry was continuously ripping down

John Murry, Faces, n.d. Tempera on paper, 27 × 19 in. Museum of American Folk Art, New York; Gift of Elizabeth Ross Johnson. Murry painted in spiritual languages that only he could decipher by looking through a glass of "holy water." These colorful markings can be considered a sort of wonderful, abstract, figurative calligraphy.

walls and redesigning his shelter, perhaps attempting to manipulate his environment. He brought me drawings because he believed we had a spiritual affinity and that I could read them." Rawlings arranged for exhibitions of Murry's drawings and writings.

SUBJECTS AND SOURCES
Murry wrote in tongues, spiritual messages that only he could read by looking at his script through a bottle of "holy" water held over the work like a magnifying glass. Chants or prayers would often accompany his readings, which might be done with visitors present: "Oh, Lord, show me the way through your water." Murry believed the Lord directed his writing and drawing, which depicted both the spiritual side and evil forces.

MATERIALS AND TECHNIQUES
At first Murry wrote on adding machine tape; later Dr. Rawlings supplied him with high-quality paper. Using pencil, pen, paint—anything he could find—he wrote like a computer printer—left to right, right to left. Both writings and drawings are mostly black and red. Murry made about 1,500 writings, some as large as 20 by 18 inches. There may be conservation problems involved with some of the early work.

ARTISTIC RECOGNITION
J. B. Murry's art can be examined on two levels: as abstract drawing and as a written attempt to communicate an indecipherable religious message. He is considered to have been an outstanding artist in mystical figurative work.

Murry's work is becoming well known to museum audiences. He was included in the prestigious Corcoran Gallery of Art's Biennial Show in Washington, D.C. in 1989.

NAMPEYO

BIOGRAPHICAL DATA
Born c. 1860, Hano, First Mesa, Arizona. No formal education. Married Kwivioya, 1879.[1] Married Lesou Nampeyo, 1881; he died May 7, 1930 (name recorded as Lesso on death certificate). Three daughters (all potters), one son by Nampeyo. Died July 20, 1942.[2]

GENERAL BACKGROUND
The daughter of a Hopi from Walpi and a Tewa mother, Nampeyo learned pottery making at a young age from her paternal grandmother, one of the few remaining potters at Walpi. By the time she was in her twenties, Nampeyo was considered one of the best of the Hopi potters.

Pottery making had been in a decline since 1875, when trader Thomas Keams brought commercial wares to the Hopi, who lost interest in using clay pots. Nampeyo, however, revived the tradition through innovative design and gained wide recognition as an artist. She and other family members demonstrated pottery making at the Grand Canyon in 1905 and 1907 and in Chicago in 1910.

Nampeyo established a tradition of artistic excellence

Nampeyo, Untitled, *n.d. Fired clay jar (black and red bird design on white), 11 × 17 × 6¼ in. Museum of Northern Arizona Collections, Flagstaff. In 1895 Nampeyo saw pottery shards from the ruins of the Hopi village of Sikyatki and, basing her designs upon these ancient fragments, revived the pottery tradition among the Hopis.*

that has continued through the suceeding five generations of her descendants.

ARTISTIC BACKGROUND

Nampeyo's great artistic achievement began in 1895. In that year her husband, Lesou, accompanied J. Walter Fewkes as a digger on his excavation of the ruin of Sikyatki. Lesou brought home shards of Sikyatki pottery, which inspired Nampeyo to begin to make free replicas of the prehistoric vessels, with variations of traditional designs.

These pots were an immediate success within and outside Nampeyo's culture and inspired other Hopi potters to begin to pot again. Thus a dying art took on new life.

After Nampeyo's sight failed about 1920, her daughters and husband decorated many of her pots.

SUBJECTS AND SOURCES

Nampeyo experimented with shape and design; she was particularly interested in experimenting with the older design forms. Although her motifs contained some traditional Hopi elements, the compositions were entirely Nampeyo's creation.

Nampeyo (and later her family) continued to utilize several design patterns that she developed around the turn of the century. These include the migration pattern, a series of interlocking diagonal hatchings with three-pronged spikes (sometimes said to represent a bear claw or bird wing) that usually appear on the shoulder of low jars; the eagle or feather pattern, often used by Nampeyo to decorate the mouth of jars; and an asymmetrical bird and feather design that she used on shallow bowls.

MATERIALS AND TECHNIQUES

The artist made her pots in the traditional Hopi manner, hand-coiling them to the desired shape. She used yellow firing clay from the old Sikyatki clay beds and etched her designs with yucca brushes chewed to a fine point.

Nampeyo rejected crude modeling and sloppy painting. Her pots were always thin walled and beautifully shaped.

ARTISTIC RECOGNITION

Nampeyo was the greatest Hopi potter known. She produced superb works and inspired the revival of Hopi pottery. Most of her work is in museums today, but family members have continued the tradition she started, handing it down from one generation to the next.

The work of one of Nampeyo's daughters, Fannie Polacca Nampeyo, who died recently, is still available. Other well-known Nampeyo potters include granddaughters Tonita Hamilton and Iris Youvella; grandson Thomas Polacca; great-grandchildren James Garcia, Rayvin Garcia, Priscilla Namingha, and Dextra Quotskuyva; and great-great-grandchildren Jean and Rachel Sahmie.

LOUIS NARANJO—*"When you look at my work, pray for us—that we'll have good health. And spirit to keep it up."*

BIOGRAPHICAL DATA
Born August 17, 1932, as a member of the Pumpkin Group of the *Hapah-nee*[1] (Oak) clan, Cochiti Pueblo (between Santa Fe and Albuquerque), New Mexico. Graduated from St. Catherine Indian School, Santa Fe, New Mexico. Married Virginia Arquero, July 22, 1961. One son, two daughters. Now resides Cochiti Pueblo, New Mexico.

Louis Naranjo, Cochiti Drummer-Storyteller, *1987– 1988. Fired clay, slip, and beeweed, 9½ × 6 × 7 in. Bob and Marianne Kapoun. Naranjo's figurine depicts a drummer telling stories to children wearing pueblo dance costumes.*

GENERAL BACKGROUND

The pueblo of Cochiti has a figurative folk pottery tradition dating from the 1870s, and Louis Naranjo is the current standardbearer for that proud tradition.[2] Cochiti is a small village of adobe houses surrounding an adobe Catholic church that is more than one hundred years old; the church faces a plaza used for feast-day dances. The pueblo also has two kivas, sacred traditional structures that outsiders are forbidden to enter.[3]

From 1958 to 1960 Naranjo served in the army. "They sent me to Hawaii," he says, "but the girls there would have nothing to do with Native Americans." After he returned to Cochiti, he married Virginia, who had grown up with him in the same pueblo.

Naranjo was called back into the service in 1961 and 1962 because of the Berlin crisis. He then had a short-lived job as a night watchman at Cochiti Dam, but soon returned to become part of the family's artistic industry. "Making pottery is the way of our people" Naranjo boasts, "and I want to keep it up."

The Naranjos live in a comfortable two-bedroom house built by HUD in the 1970s. "We are supposed to keep our payments up," the potter explains, with a smile. Naranjo is now a respected elder of the pueblo and participates in all its important dances and religious ceremonies.

ARTISTIC BACKGROUND

Louis Naranjo's wife, Virginia, made pottery first; she had begun at the age of six, making pots under the watchful eye of an aunt. By 1962 she was making small animal figures. Shortly after their marriage Naranjo started as a drum maker;[4] he learned pottery making by observing his mother, the well-known figurative potter Frances Suina.

In 1976 Virginia Naranjo took a large clay turtle that she had made to Indian Market in Santa Fe, and won a blue ribbon. From then on, however, Louis took over. He won at least one blue ribbon at the market each year from 1977 through 1988. (Winning a blue ribbon at this prestigious event assures an artist's reputation and almost guarantees a demand for sales.)

Virginia Naranjo continued to do some potting, but in 1980 she had a stroke that left one arm partially paralyzed. She still helps with the sanding and firing.

SUBJECTS AND SOURCES

"I saw that everyone was making storytellers," Naranjo says of Cochiti's figurative potters. "So I decided to portray everyday life—tableta, dancers, drummers, hunters."[5] The artist has also developed a series of bear characters that romp with their cubs, which are based on his observations while hunting.

"I sing to the clay, and the clay sings back—telling me what to make," Naranjo declares.

MATERIALS AND TECHNIQUES

The materials used in making Cochiti pottery have not changed in the last one hundred years. The light brown clay comes from Cochiti, the white slip from the pueblo of Santo Domingo, the reddish brown slip from Bandolier, and the black coloring is beeweed.[6] No other colors are used.

After the ware is shaped, it is sanded, and the slip and beeweed applied. The object is placed on a metal grate and covered with dried cow chips to hold the heat in and force it down into the clay. The wood used for firing is cedar.

Naranjo's work ranges from about 1½ inches to about 20 inches in height. The artist works slowly, making fewer than fifty objects a year. Some pieces are lost in the firing.

ARTISTIC RECOGNITION

Louis Naranjo is among the best of the figurative artists working in clay. About half of his output is made for tourists; although these pieces are exquisitely made, they are small and contain themes that are often repeated. The remainder of his work consists of unique objects that are intended as art pieces, and these have found their way into many southwestern museums as well as into major private collections.

SATURNINO PORTUONDO ("PUCHO") ODIO

BIOGRAPHICAL DATA

Born May 15, 1928, Santiago de Cuba. Attended school through sixth grade in Cuba (Odio does not speak English). Married Angelica Garcia, 1971. One stepdaughter. Now resides New York City.[1]

GENERAL BACKGROUND

Saturnino Portuondo Odio is a talented wood carver known especially for his lively caricatures of his fellow Cuban Americans.

Odio lived in Cuba, working as a carpenter, a barber, and a member of the merchant marine, until he was thirty-five years old, then moved to New York City by way of Canada in 1963. He returned to barbering after he settled in New York but by 1974 he was able to give it up in favor of full-time work as a carver.

ARTISTIC BACKGROUND

Pucho Odio started to carve sometime after he came to the United States, probably in the late 1960s. His previous professions—particularly his years as a carpenter—had helped to hone the skills he needed for this new venture, and his imagination did the rest. Odio works in a basement studio on the upper West Side of New York City.

Jay Johnson, owner of America's Folk Heritage Gallery, first discovered Odio's carvings in a small antiques shop on Eighth Avenue and tracked the artist down in order to include him in his gallery and give him broader exposure in the art world.

SUBJECTS AND SOURCES

Odio carves caricatures of members of the Cuban community in New York and is well known for his depictions of dancers, street people, and everyday folk. The artist also portrays animals—cats, birds, snakes, and dogs—endow-

Saturnino Portuondo Odio, Peacock, 1982. *Carved and painted wood, 45 × 53 × 12 in. Private collection. Odio's well-known, almost life-size peacock sparkles with color and is endowed with a special charm like his other portrayals of animals.*

ing them with a sort of lovable charm. There is a certain amount of street humor in his work, partially a result of the crudeness of the carving, but his topics often lend their own whimsey, as in his carving of a woman eating a watermelon, which he entitled *Hmm, It's Good.*

MATERIALS AND TECHNIQUES
Odio uses "downed" wood that he finds in the public parks or pieces of wood that he finds in the streets for his carving; he is not fussy about the kind of wood as long as it fits his purpose. He carves with hand tools and uses latex house paint on the finished pieces.

The artist has completed between two hundred and three hundred major works. They vary widely in size, with some pieces reaching 3 feet in height; his rather well-known *Peacock* carving stands 45 inches high with a tail spread reaching a magnificent 53 inches.

ARTISTIC RECOGNITION
Pucho Odio's depictions of Cuban Americans, especially his renditions of dancers, represent his best work. The animals are appealing but do not have the whimsical qualities of his human figures.

Odio is one of the few Cuban American folk artists

working in this country. His work is well known to collectors and has been exhibited widely. It is included in the permanent collections of the Museum of American Folk Art in New York City and the John Judkyn Memorial in Bath, England, among others.

MATTIE LOU O'KELLEY—

"I made no friends, I had no beaus,
I stayed at home.
I piddled at this and that,
I did not roam.

Now my one room house has only me,
I never roam,
No lessons have I, But I paint
And paint
And stay at home."
(From a poem written by Mattie Lou O'Kelley[1])

BIOGRAPHICAL DATA
Born March 30, 1908,[2] Maysville (between Athens and Cleveland), Georgia. Attended school through ninth grade, Homer High School, Homer, Georgia. Single. No children. Now resides Decatur, Georgia.

GENERAL BACKGROUND
Mattie Lou O'Kelley is a popular memory painter whose idyllic landscapes depict her early life in Georgia.

O'Kelley remembers her time growing up on one hundred acres of corn and cotton land in northwest Georgia as days of happiness. Perhaps she thought of those days as happy, but she had to leave school in ninth grade because the family could not afford her room and board in town and the seven-mile walk was too much for the young girl.

O'Kelley remained with her parents on the farm until her father died in 1943 and the land was sold. She then moved into the small town of Maysville, Georgia, where she held a series of jobs. She sewed work clothes, worked as a cook and waitress in the Maysville County School cafeteria, and worked for a mill making mop yarn. In 1968, at the age of sixty, she retired.

Mattie Lou O'Kelley, Yard Sale, *1979. Oil on canvas, 28 × 40 in. Stephanie and Robert Tardell. O'Kelley's much-admired memory paintings convey a wealth of detail and reflect her nostalgic vision of rural life in Georgia as it once was.*

ARTISTIC BACKGROUND

Mattie Lou O'Kelley usually gives 1968, the year of her retirement, as the date she started to paint.[3] "I had always wanted to paint," she recently stated; "now I had the time."

In 1974 O'Kelley showed some of her paintings to the High Museum of Art in Atlanta. They were displayed in the museum shop, where Robert Bishop, director of the Museum of American Folk Art in New York City, saw them. He encouraged the work of the artist and helped her to obtain gallery representation in New York City, where she became almost an overnight success.

Once she became a known painter, O'Kelley made an attempt to break out of her small-town mold and in the late 1970s, with Bishop's help, moved from Maysville first to New York City and later to West Palm Beach, Florida. The hectic aspects of city life did not seem to suit her, however, and in 1983 she returned to her roots in Georgia, taking up residence in Decatur, where she lives and works today.

SUBJECTS AND SOURCES

O'Kelley is a memory painter; she romanticizes the rural landscapes of her youth. She portrays small, happy figures —both people and animals—frolicking through a colorful and bucolic Georgia countryside in the earlier years of the century. Her landscapes are in harmony with nature; fruit trees bloom on round-domed hills, gardens overflow with flowers and vegetables, and cows graze in lush pastures— the barren, red, eroded clay of Georgia never appears in these verdant scenes.

MATERIALS AND TECHNIQUES

O'Kelley uses an appealing and charming pointillistic technique to depict her extremely detailed scenes. Working in oils on canvas, she often paints her canvases flat on a table rather than on an easel.

O'Kelley's canvases may be as large as 3 by 4 feet. The artist has painted so many works that she is unable to estimate the number of paintings she has completed.

ARTISTIC RECOGNITION

Mattie Lou O'Kelley's early paintings reflect her vision of life as it was. As her market developed, she painted to meet the demand for decorative landscapes, and she became extremely accomplished at producing idyllic memory paintings.

O'Kelley has written two books and illustrated a third,[4] and her painting of a yellow cat was featured on the cover of *Life* magazine in 1980.[5] Her work is included in the collections of many major museums and corporations.

GEORGIANNA ORR—*"Mother read me the Bible each night and I dreamed about the verses in color. I can still close my eyes and paint those dreams."*

BIOGRAPHICAL DATA

Born Georgianna Rose Mary Lewis, September 23, 1945,

Georgiana Orr, To God Be The Glory, Rev. 18:1–24, *1981. Acrylic on canvas, painted frame, 27 × 33 in. Jamison-Thomas Gallery, Portland, Oregon. To illustrate passages of the Bible, Orr uses a simple, direct, and colorful style. One of her hand-painted frames encloses this work.*

Gridley, California. Attended three years of high school, Gridley High School, California. Married Steven Harlan Webb, September, 29, 1962; divorced August 26, 1971. Married David Nicholas Orr, September 10, 1971. Two sons, one daughter by Webb; one son, two daughters by Orr; one stepson. Now resides Gilchrist, Oregon.

GENERAL BACKGROUND

Georgianna Orr is a painter who has dedicated herself to illustrating stories and themes from the Bible.

After leaving high school, Orr worked as a waitress in several California locations, picked fruit and tomatoes, and raised a growing family. In 1976 she moved to Gilchrist, Oregon, where she and her husband, Nicholas, a former highway patrol officer, bought a grocery store/service station/laundry. When the venture failed in 1979, Nicholas went to work in a lumber mill, and Orr took up painting.

ARTISTIC BACKGROUND

"I have a mission," Georgianna Orr declares, "to illustrate and simplify the Bible so it can be taught." When the grocery business failed, she began to carry out her mission.

Orr was discovered by the Jamison-Thomas Gallery in Portland, Oregon, about 1982. This gallery has been instrumental in bringing her work to the attention of collectors on both coasts.

SUBJECTS AND SOURCES

"The Lord gave me a talent," Orr says, "so I tithe by illustrating the Bible for Him." She paints in series, illus-

trating events or sections from the Bible. She has done a series based on the book of Revelation that includes thirty illustrations, one on the Creation with fourteen illustrations, Psalms with seven, the Song of Solomon with two, and Noah's Ark with three. Orr is currently working on a text of Revelation that will have one hundred illustrations.

Orr's paintings are simplified versions of biblical events. She is a serious student of the Bible, and it is her intention to interest everyone in the stories and not to frighten them with apocalyptic views. Her angels look modern, her animals childlike. She also adds written material to the paintings to help explain and label the story.

MATERIALS AND TECHNIQUES
Orr paints with oils on canvas and acrylics on paper. Her work is always vividly colored. High school students make frames for her in their shop classes, and she paints over their mistakes with squiggly marks.

Her paintings range in size from 9 by 11 inches to 24 by 30 inches. The artist has completed fewer than one hundred works.

ARTISTIC RECOGNITION
Georgianna Orr is the best-known folk artist in Oregon, and her colorful biblical messages have earned her a large following. She participated in the 1984 "Pioneers in Paradise: Folk and Outsider Artists of the West Coast," sponsored by the Long Beach Museum of Art in California.

WILLIAM ("W.C.") OWENS—*"I don't think I'll start up again—you gotta be in the mood for things like that."*

BIOGRAPHICAL DATA
Born December 20, 1908, Poplar Branch (near Nags Head), North Carolina. Attended school for five or six years, Bertha School, Poplar Branch, North Carolina. Married Icey Simpson, June 15, 1941. Three daughters, two sons. Now resides Poplar Branch, North Carolina.

GENERAL BACKGROUND
William Owens is a black artist whose appealing cutout figures painted in bright colors proved to be traffic-stoppers when he put them in his front yard.

Owens grew up on the family farm, helping out in the corn and soybean fields. In the late 1930s he worked for the WPA (Work Projects Administration) on road projects, and from the 1950s until 1964 he drove a tractor for a local farmer.

Owens retired about 1964 to live in a wood-sided house near the tourist beaches of North Carolina's Outer Banks. The Owens's front yard, which faces Route 158, is a neatly tended family cemetery. Items intended for sale are placed among the graves.

ARTISTIC BACKGROUND
"About fifteen years ago," Owens explains, "my wife said, 'W. C. you gotta put somethin' out by the highway

William Owens, Bathing Beauty, *c. 1980. Pine board with enamel paint, 23½ × 6 × 3 in. Private collection. Owens uses his striking carvings, like this curvaceous, brightly painted "bathing beauty," to attract tourists to his home near the highway leading to North Carolina's Outer Banks.*

to sell,' and I started making things." The first thing he made after Icey Owens's suggestion (about 1974) was a large Uncle Sam figure to hold his mailbox, which had his name, W. C. Owens, emblazoned on it. Soon tourists were demanding his Uncle Sams, and he was in business.

Russell Bowman, director of the Milwaukee Art Museum, was vacationing in the area in the late 1970s when he discovered Owens's work. Since then he has helped Owens present his work to a broader group of people through galleries and museums.

Owens has been ill and has not worked on his art since 1985.

SUBJECTS AND SOURCES
Owens assembled angular bathing beauties, Uncle Sams, Nativity scenes that include Noah's Ark and Jonah and the whale, animals, and other figures. He is obviously influenced by illustrations that he sees in the media and by popular culture.

MATERIALS AND TECHNIQUES

Owens sketched on pine boards, then cut out his figures with an electric jigsaw. He used nails and glue on the extremities and bases and painted his pieces with colorful enamel house paint.

Owens's women are large, big bosomed, long legged, and painted bright pink—he clearly intended for them to be spotted from the highway. His Uncle Sams are sometimes painted pink on one side, black on the other. The figures are made from boards and are therefore two-dimensional.

The figures start at about 6 inches high and go up to nearly life-size. Owens believes that he has made and sold about three hundred objects.

ARTISTIC RECOGNITION

William Owens is well known to collectors of the folk art of the Southeast; his work invariably brings forth a pleasurable response from museum audiences. The bathing beauties, Uncle Sams, and Nativity scenes are probably the best examples of this artist's work.

Owens was included in "Southern Visionary Folk Artists" at the R. J. Reynolds Gallery in Winston-Salem, North Carolina, in 1985, and in 1989 he participated in "Signs and Wonders: Outsider Art Inside North Carolina" at the North Carolina Museum of Art in Raleigh.

ANGELA PALLADINO—*" I paint for myself and to feel free."*

BIOGRAPHICAL DATA

Born Angela Sodale, December 4, 1929, Trapani, Sicily. Educated at the Liceo Classico, Rome, Italy. Married Anthony Palladino, 1959. Two daughters. Now resides New York City.

GENERAL BACKGROUND

Angela Palladino's intriguing paintings and unusual ceramic masks reveal a masterful sense of color.

Palladino's father was an American citizen. "He kept telling me about freedom," she says. "In a small Sicilian town I could never feel free." Palladino came to the United States in 1958 and settled in New York. She worked for a year as a secretary for an insurance company, then married Tony Palladino, an advertising agency art director, and became a housewife and mother. She and her family lived in London for a period and are now back in New York.

Angela Palladino, Goodbye Filomena, *1967. Acrylic on wood, 40 × 26 in. Collection of the artist. At times Palladino has been interested in telling a story by portraying a female nude against a contrasting background; this is one of her favorites.*

ARTISTIC BACKGROUND

In 1964, while living in London, Angela Palladino was hospitalized for surgery. During her recovery she began sketching to relieve her boredom. Her husband, noting her interest in the pastime, bought her some painting materials. "I supplied Angela with materials," he says, "but she is a single-minded individual and does things her way no matter what any one else says."

Around 1972 Palladino began to make clay masks in addition to painting. That same year, she had an individual show at the Merridin Gallery in London.

SUBJECTS AND SOURCES

Palladino has a favorite expression: "We all hang out together, so we should get along." Some of her paintings illustrate her philosophy; one, for example, shows John F. Kennedy and Benito Mussolini talking things over in their caskets. Many of her paintings are of women, but she is not a feminist painter; she seems to be saying "here are mature women—this is really what women are all about." More recently Palladino has been painting nudes, again as a way of expressing the essence of women rather than simply their sexuality. She also does vibrant and strong "story" pictures.

Palladino's ceramic masks seem to have grown out of a very different sensibility. The faces are asexual, almost ritualized in concept.

MATERIALS AND TECHNIQUES

The artist paints with acrylics on canvas and plywood, often using large areas of solid background color to make her main subject more prominent. Her masklike sculptures are of clay glazed with bright colors.

Palladino has completed fifty oil paintings ranging in size from 9 by 12 inches to 3 by 5 feet, one hundred drawings and watercolors, and twenty ceramic masks.

ARTISTIC RECOGNITION

Angela Palladino is an accomplished painter and colorist. She has been exhibited at galleries in New York and London and in museums in New York, Ohio, Georgia, and Tennessee. Her small body of work, however, is known to a wider audience largely through reproductions in books.

EARNEST PATTON—*"I get it pictured in my mind. I enjoy figurin' somethin' out and makin' it my way."*

BIOGRAPHICAL DATA

Born April 1, 1935, Holly Creek (near Campton), Kentucky. Attended school through second grade, Hollyville School, Kentucky. Married Betty Ruth Brewer, 1963. Four daughters, one son. Now resides on a 30-acre farm outside Campton, Kentucky.

GENERAL BACKGROUND

Earnest Patton[1] is one of the leading Kentucky wood carvers of the Campton School.

Earnest Patton, Booger Man, *c. 1987. Carved and painted wood, 17 × 5 in. Le Raye Bunn. In the mountains of Kentucky, the "booger man" is an imaginary person used to frighten children and adults alike, and Patton depicts this figure in an original and straightforward style.*

"I ain't no mean man," Patton proudly proclaims. "I cares for what I do and I do right. I had to do right by Daddy because he had no job, so I quit school to work tobacco. I do right by my family, but I've had to work like a mule." He has only one regret: "I sure wish I learned to read and write."

After Patton married, he became a sharecropper for Russell Tence, a tobacco farmer. "It's worrisome. You have to worry about the crop, and whether come fall you'll get any wages at all." Patton also drives a school bus and works as a mechanic to make ends meet.

Since 1987 he has been disabled by arthritis in his back and hands and has slowed down both in his farming and in his carving.

ARTISTIC BACKGROUND

Dr. Paul Maddox, who runs a clinic in Campton, Kentucky, treated folk artist Edgar Tolson (see page 304) for many years. The doctor maintains a display case of Tolson's work in his waiting room, and Earnest Patton and several other Campton carvers have been influenced by the display. "I been whittling for twenty or twenty-five years," Patton declares. "When I seen the Tolson carvings at Doc Maddox's, I felt I could do it, too, went home, and carved an ox." Patton started carving seriously about 1970.

A generation of Kentucky carvers (sometimes called the Campton School) have been influenced by the Tolson display. Larry Hackley, a dealer in North Middletown, Kentucky, represents these carvers and has shown their work widely throughout the South and on the East Coast.

SUBJECTS AND SOURCES

Like Tolson, Patton carves devils and religious scenes such as the *Garden of Eden* or the *Nativity* (Patton's, however, are more prosaic than Tolson's—Mary carries a lantern in her hand and Joseph carries a coffeepot). Occasionally he will branch out on his own and carve a piece of exotic sculpture based on mythology or his imagination.

"Mother had an old Bible with pictures in it," Patton says. "I keep it in my mind."

MATERIALS AND TECHNIQUES

Patton carves with a pocketknife, using poplar, some pine, and various other woods. He paints his pieces sparingly with enamel tractor paint.

He has carved between 100 and 130 pieces. They range from a few inches in height to about 20 inches tall.

ARTISTIC RECOGNITION

Earnest Patton's finest work is original and not at all derivative of Edgar Tolson. His carving ability is outstanding, and when he combines that with his originality of expression, he is capable of producing some of the best work of the region. Patton is one of the leaders of the Campton School.

LESLIE J. ("OLD AIRPLANE") PAYNE

BIOGRAPHICAL DATA

Born September 20, 1907,[1] Lillian (in an area on the Chesapeake Bay known as the Northern Neck), Virginia. Attended school through fourth grade. Married Dorothy Hannah Bens, date unknown; date of her death unknown. Five children. Died June 10, 1981, Kilmarnock, Virginia.

GENERAL BACKGROUND

Leslie J. Payne, called "Old Airplane" or "Old Airplane Builder" by residents of the sparsely populated fishing towns along the Eastern Shore of Virginia where he lived, was a black folk artist remembered especially for his large, brightly painted models of early airplanes and his airfield environment.

As a boy, Payne had attended a county air show in the spring of 1918, and that was what started him dreaming about flight. The dream became an obsession and a major theme of his later life.

Payne was also influenced by the sea. He worked for a time on coastal fishing vessels, crewing for Captain Walter Beddlecomb on his boat *Dudley,* and for the McNeal-Dodson Company on boats like the *G. H. McNeal* (models of this boat would later appear in his work). They fished for menhaden, or "bunkers," little fish used for oil, animal feed, and fertilizer.

In the 1940s, after spending some time in other areas along the East Coast, Payne returned to the Northern Neck for good. He supported himself and his family by taking odd jobs and started building a series of sheds on a neatly tended plot of land near Greenfield, Virginia. The

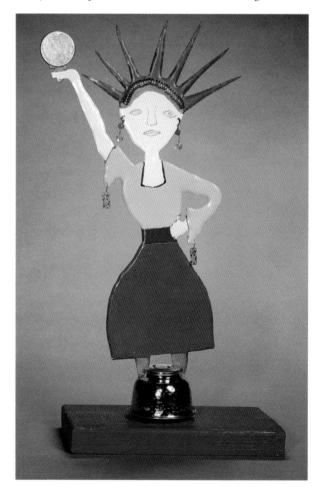

Leslie J. Payne, New York Lady, *c. 1970. Painted tin, copper, costume jewelry, and reflector, 26¾ × 13¾ × 7⅜ in. Chuck and Jan Rosenak. In addition to airplanes, "Old Airplane" Payne made various other models and images. After a trip to New York City, he was so taken with the Statue of Liberty that he made his own bejeweled version.*

sheds he built contained shops for airplane building. Painted on the front of one was a hand-scrawled sign: Air Plane Machine Shop. Safety First/Tak No Chance. And so Payne began to build replicas of the planes he had seen as a child.

The fact that his planes could not fly did not seem to bother Payne; an imaginary flight was just as good, and he made many of them, keeping a logbook of his travels and actually preparing his planes for takeoff. A solo "flight" to Paris was described in a newspaper article:

> He flung that plane up the tree with a block-and-fall. Then he loaded it with all kinds of provisions. He had a car engine hooked to it so it would run. He had a propeller. Put it in gear to turn the prop. Then he reached out and cut the ropes. You can imagine what happened—he crash landed.[2]

Payne was a large, powerful, flamboyant man. He had rhinestones embedded in his front teeth and dressed in his version of a World War II aviator's outfit. He enlisted a group of young women—he called them "The Colored Girls"—who would dress up in white and join him on his imaginary journeys in his model planes.

Payne worked on his airplanes until he was admitted to the Lancashire Nursing Home in Kilmarnock, Virginia, in 1977.

ARTISTIC BACKGROUND
Leslie Payne, who never stepped into an airplane (his only major trip was taken by bus to New York), had been obsessed with planes since he was a child, and he satisfied this fascination by building model planes. His heroes were the heroes of flight—Charles Lindbergh, for example—and the planes after which he built his models were those of the pioneer era of flight, such as *The Spirit of St. Louis* and World War I biplanes.

Patricia Brincefield, a writer who grew up near Payne's "airfield," documented his work. She also introduced him to a dealer, Jeff Camp, and curated a retrospective show on Payne at Virginia Commonwealth University in 1987.

SUBJECTS AND SOURCES
Payne built an airfield environment to match his dreams, and central to it were his World War I biplane models. The airfield, to him, was the real thing. A secondary theme encompassed boats and fishing. Payne constructed several elaborate models of the boats he had worked on and also made some large sculptures of fish.

In addition to his planes and boats, the artist made other sculptures. He created images to preach a patriotic message; he saw Adolph Hitler as "evil," Lindbergh as "good," and the *New York Lady* (his version of the Statue of Liberty) as a symbol of freedom. Other works include a whirligig and a model of an early car.

MATERIALS AND TECHNIQUES
Payne made sketches in preparation for building his planes and sculptures, and some of these drawings still exist. He used whatever he could find to make his pieces—a refrigerator shelf became an airplane grill; a copper oil can, the base for his collaged assemblage *New York Lady*. He referred to books and photographs—of *The Spirit of St. Louis,* of Hitler, and of soldiers from the two world wars—to develop plans for his pieces and to make them realistic. He painted the works in bright enamel house paint.

The airplanes were large—12 to 16 feet long—and at least one of them was actually equipped with an engine. Payne also made some smaller plane models; one is mounted on a pole as part of his sculpture *Sunrise, Sunset.* His boats and fish are 3 to 4 feet in length and of varying widths and heights.

Payne is known to have made twenty pieces of sculpture and six airplanes. One plane is still rusting in the field where he left it.

ARTISTIC RECOGNITION
Few of Leslie Payne's works have survived, and those that have are now held mostly by private collectors. His airplanes are known primarily through photographs. His work was included in "Black Folk Art in America, 1930–1980" at the Corcoran Gallery of Art, Washington, D.C., in 1982.

JOHN W. PERATES

BIOGRAPHICAL DATA
Born February 10, 1895, Amphikleia, Delphi, Greece. No formal schooling. Married Catherine Keenan, date unknown; date of her death unknown. Two sons. Died February 20, 1970, Portland, Maine.[1]

GENERAL BACKGROUND
A gifted wood carver, John Perates created memorable icons, combining subjects related to the Greek Orthodox church with his personal view.

Perates was born into a family with a five-generation tradition of wood carving and learned the skill from his grandfather in Greece. In 1912 he immigrated to the United States and settled in Portland, where he went to work for the J. F. Crockett Company, a manufacturer of handmade furniture. About 1930 Perates founded his own establishment, the J. H. Pratt Company.[2] Perates was a member of the Greek Orthodox church, and when business was slow, he read the Bible and carved.

ARTISTIC BACKGROUND
John Perates had learned basic carpentry skills as a boy. He started carving icons or, as he said, "furniture for the House of the Lord," in the fall of 1938, when his cabinet-making business was slow and he had idle time on his hands. Although he intended the pieces for his local church, they were stored in the basement and never put on display because the church administrators considered them too unusual as well as too large.

The importance of Perates's body of work was only recognized after his death in 1970. Exhibitions of his impressive carvings were held at the Cincinnati Art Museum

John W. Perates, Saint Matthew, *c. 1930. Carved, polychromed, and varnished wood, 49 × 27⅜ × 6 in. Museum of American Folk Art, New York; Promised Gift of Robert Bishop. John Perates created stunning iconographic panels with Byzantine subjects and themes that he intended for installation in the local Greek Orthodox church, of which he was a member.*

in Ohio in 1974 and later at the Museum of American Folk Art in New York City.

SUBJECTS AND SOURCES
Over nearly a forty-year period, Perates carved massive painted icons, a pulpit, and an altar screen intended to grace his church. He took Byzantine subjects and themes that he remembered from his native Greece or that he had seen illustrated in books and added his personal vision to create powerful iconographic panels.

Although a skilled carver, Perates was academically untrained, and his work has unmistakable folk origins. His saints and madonnas stare straight out at the viewer, and their flat, elongated features only enhance their seemingly innate religious power and beauty.

MATERIALS AND TECHNIQUES
Perates used hand tools to carve deeply into well-aged walnut, South American ironwood, cherry, and pumpkin pine. He painted his work, surrounding his central figures with elaborately decorated frames carved from the same piece of wood.

The artist worked slowly on his massive pieces, and it took him many years to complete the 16½-foot altar. Besides the altar, he made a bishop's throne (now in use in the church), twenty individual icons, and several other carvings. The panels range from about 2½ to 6 feet in height, with a width of 20 to 49 inches and a depth of around 5 inches.

ARTISTIC RECOGNITION
John Perates combined the art of the iconographic wood carver with a strong faith, a sure hand, and a unique personal vision. His work has been widely exhibited in the United States and abroad and is included in the permanent collection of the Museum of American Folk Art.

REVEREND BENJAMIN ("B. F.") PERKINS—*"When I was on my way down, I took up painting to have something to do."*

BIOGRAPHICAL DATA
Born February 6, 1904, Vernon, Alabama. Took some courses at Albert Brewer Junior College, Fayette, Alabama. Married Marlene Lowery, December 16, 1936; divorced 1960. Two daughters. Now resides Bankston (east of Fayette), Alabama.

GENERAL BACKGROUND
The Reverend Benjamin Perkins is a southern artist who paints colorful patriotic and biblical themes on gourds as well as traditional surfaces.

"I went to the top," states Perkins, a longtime man of God. "I was a bishop in the Church of God, but now I'm over eighty and on my way down."

In addition to being a preacher, Perkins likes to think of himself as a staunch patriot. He served in the Marine Corps from 1921 through 1925 and claims that during his service he was sent on secret missions to Latin America and other places. Perkins also says that he worked for the Federal Aviation Administration in Washington, D.C., "on and off" for forty years, from 1926 to 1966. "I've a pension to prove it," he declares.

In 1929 Perkins became a minister in the Assembly of God, and in 1940 he joined the Church of God, rising to the rank of bishop within that church. Presently he is the

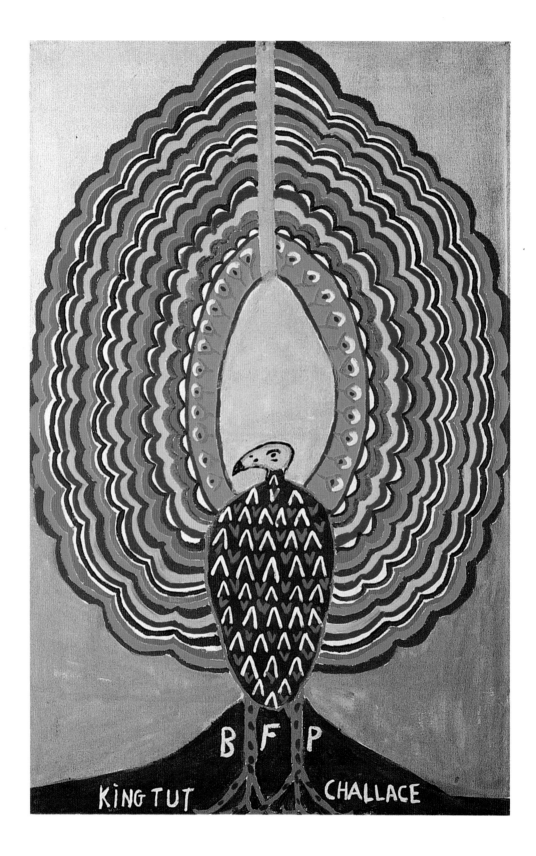

Reverend Benjamin Perkins, King Tut Challace, *1988.*
Oil on canvas, 34½ × 22½ in. Tartt Gallery, Washington,
D.C. Perkins was fascinated with the objects from King
Tut's tomb, which were widely illustrated in magazines, and
he painted a series of colorful works based on them.

pastor of a small congregation of about twenty souls in
Bankston, Alabama.

ARTISTIC BACKGROUND
When B. F. Perkins began planning for his retirement in
1979, he decided that art would be an appropriate activity.
He took an art course at the Albert Brewer Junior College
in Fayette, where, he says, "They let you pick your own
style." He began to paint both on gourds and on canvas.

A 1987 newspaper article about the artist and his unusual
work brought Perkins to the attention of Joe Tartt, owner
of the Tartt Gallery in Washington, D.C., who began to
represent him.[1]

SUBJECTS AND SOURCES
Perkins deals with three main themes in his colorful work.
He paints patriotic scenes, frequently including the American flag and the Statue of Liberty and adding antidrug and
patriotic slogans such as "Life, liberty, and the pursuit of
happiness." He illustrates stories from the Bible, and he
depicts the objects found in King Tut's tomb. "King Tut's
treasures are important," the artist says, "because they illuminate the way to come for all history." He is partly
inspired by popular illustrations.

MATERIALS AND TECHNIQUES
Perkins buys gourds, some as large as 20 inches, affixes
wire to one end so they can be hung, and paints them with
acrylics. The artist also paints on canvas with watercolors
and acrylics. "The small ones [about 20 by 14 inches] sell
best," he says. He has made paintings as large as 4 by 7
feet.

Perkins has painted about three hundred gourds and one
hundred canvases.

ARTISTIC RECOGNITION
The work of the Reverend Benjamin Perkins provides the
kind of colorful whimsy that can brighten up any collection. Collectors, especially those interested in the South,
are paying more attention to his work, which is represented in the permanent collection of the Montgomery Art
Museum in Montgomery, Alabama.

OSCAR WILLIAM ("PELEE") PETERSON

BIOGRAPHICAL DATA
Born November 14, 1887, Grayling (100 miles north of
Grand Rapids), Michigan. Received a grade school education, perhaps some high school. Single. No children. Died
October 7, 1951, Cadillac, Michigan.[1]

GENERAL BACKGROUND
Oscar Peterson is considered by many to be the master
among the numerous carvers of fish decoys.[2]

The son of Swedish immigrants, Peterson lived in Michigan all his life. For a period he had a landscaping business
with his brother, but mostly he worked outdoors as a common laborer or served as a hunting guide.

Fishing and hunting around lakes Cadillac and Mitchell
in northern Michigan were Peterson's real loves, and his
carvings of fish and other wildlife native to the area reflect
this strong interest.

ARTISTIC BACKGROUND
"Pelee" Peterson[3] started to carve decoys when he was a
young man. He carved brook trout, rainbow trout, suckers, perch, pike, and muskie—all decoys that would interest the sport fisherman. At that time, the decoys sold in
bait shops for 75 cents to $2.50. He also carved plaques
and other ornamental pieces so that he would have sales
year-round. He sold the fish decoys in the fall and the
plaques and other tourist items in the summer.

SUBJECTS AND SOURCES
Peterson carved fish for use as decoys in spear fishing, a
major winter sport in northern Michigan, Wisconsin, and
Minnesota. Some of his decoys were functional, while others were both functional and decorative. (The action of a
Peterson decoy in the water is said to be superior.) He also
carved assorted plaques, usually bas-reliefs of fish, birds,
and other animals, as well as bowls and three-dimensional
animals to sell to tourists. In addition, Peterson made trade
signs for bait shops (often large flat carvings of fish), and
he carved special items—fish vases, frogs, a pincushion
canoe—primarily as gifts for relatives and neighbors.

MATERIALS AND TECHNIQUES
Peterson's style of carving is unique and instantly recognizable. His fish are carefully crafted, often with protruding jaws, curved and slender bodies, detailed carving
around the eyes, and an elegant paint job. He used well-seasoned woods, such as white pine, oak, walnut, and
birch, and only a handful of tools: a hatchet, a drawknife,
files, chisels, a pocketknife, sandpaper, and paintbrushes.

Once the carving was complete, if the decoy was intended for underwater working use, he would pour molten
lead into a cavity he had hollowed out in the belly of the
fish, then cover the hole with wood filler before painting.
Not all his decoys were weighted, however; some were
used as "floaters."

Peterson painted his decoys with realistic colors and
coated them with varnish. He carved and painted eyes on
some pieces, but he also used glass eyes or tacks on others.
He was known for highlighting the eyes of his fish with a
fine, thin line of white, red, or yellow paint. He used
copper and metal fittings for fasteners and fins.

His decoys are mostly small, from about 2½ to 14 inches
long, but a few are as long as 50 inches.

It is believed that as many as three thousand Peterson
decoys may have survived. Some are still in use, and many

Oscar William Peterson, *Fish Decoy, c. 1940s. Carved and painted wood with tin, lead, and tacks, 7¼ × 1½ × 1 in. Art Kimball. Known for its unsurpassed "action" in the water, this decoy typifies those from the best period of the artist, who is considered a master carver of fish decoys.*

are in museum or private collections. The unique pieces—standing figures, vases, cats, and frogs—are rare.

ARTISTIC RECOGNITION
Oscar Peterson's fish are considered the ultimate in fish decoys. His early ones—those done before 1935—are his best; many of the ones from the late 1940s have almost a mass-produced quality and are much less refined. The artist's work is well known, and almost all major collections of folk art that include fish decoys try to include a Peterson work.

JOSEPH PICKETT

BIOGRAPHICAL DATA
Born 1848, New Hope, Pennsylvania. No formal education; learned trade skills from his father. Married Emily (last name unknown), c. 1893; her date of death unknown. No children. Died December 12, 1918, New Hope, Pennsylvania.[1]

GENERAL BACKGROUND
Joseph Pickett lived during years of great change in this country; he witnessed and documented in his paintings the

gradual disappearance of the rural life-style in the area where he was born.

Pickett passed by the traditional crafts of shipbuilding and carpentry that he had learned from his father, choosing instead to work small carnivals and fairs, sometimes running concessions such as knife boards and shooting galleries. This roving life-style, which lasted until he was in his forties, gave him an ideal opportunity to observe the changes overtaking America as it moved into the twentieth century.

Pickett apparently retained a close attachment to the place of his birth, always returning to New Hope when the carnival season was over, and when he married at the age of forty-five, he chose to settle there. He and his wife ran a small store called Pickett, and in June 1912 he bought a larger store and built on an addition where he could both live and paint.

ARTISTIC BACKGROUND
It is believed that Joseph Pickett started painting in the late 1890s and continued until shortly before his death in 1918. He worked in the back room of his store.

Pickett's work was ignored for many years, until it came to the attention of the distinguished curator/writer Holger Cahill and was shown in a series of museum exhibitions, including "American Primitives" at the Newark Museum in New Jersey in 1930 and "Masters of Popular Painting" at the Museum of Modern Art in New York City in 1938, among others. After that, the artist gained the recognition he well deserved.

SUBJECTS AND SOURCES
Pickett documented rural Pennsylvania as he knew and

saw it, before the industrial revolution had taken full effect. Flags fly jauntily from courthouses; smoke billows from railroad trains passing through idyllic small towns; the country is on the threshold of change, waiting for commerce and wealth to appear.

Although Pickett had a bright palette that was balanced, he sometimes omitted precise detail and shadow. He also painted historical legends without concern for accuracy.

MATERIALS AND TECHNIQUES

At first Pickett used house paint, but he soon turned to oils and better-quality artist's materials. He layered his paint heavily on the canvas, often mixing it with sand, shells, and other gritty substances to give it varying textures. This use of texture is one of the most striking characteristics of his paintings.

Pickett worked slowly, sometimes spending years on a single painting. Although only four of his paintings are known to have survived, he is thought to have painted many others; he is also known to have painted backdrops for his carnival concessions, but none are believed extant.

The paintings measure from about 37 by 48 inches to 45 by 60 inches.

ARTISTIC RECOGNITION

Joseph Pickett was one of the small cadre of important self-taught artists who helped to bridge the centuries. He documented a bygone era and stands with John Kane (see page 169) as one of the best known and most popular of their generation. His works are held in, among others, the collections of the Whitney Museum of Art in New York City and the Newark Museum, Newark, New Jersey.

Joseph Pickett, Coryell's Ferry, 1776, *1914–1918. Oil on canvas, 37½ × 48¼ in. Whitney Museum of American Art, New York. Pickett's charming pastoral scene includes a portrait of George Washington looking through a spyglass from a vantage point on the hill while his famous white horse waits below.*

ELIJAH PIERCE

BIOGRAPHICAL DATA
Born March 5, 1892, Baldwyn, Mississippi. Attended grammar school, Baldwyn, Mississippi. Pierce had three wives: married Zetta (last name unknown) about 1916; she died a year or so later. Married Cordelia (last name unknown), 1924; she died, early 1950s. Married Estelle Green, 1954; she now lives in Elkin, North Carolina. Two sons. Died May 8, 1984.[1]

GENERAL BACKGROUND
Elijah Pierce was a black wood carver who is regarded as one of the folk masters of bas-relief carving.

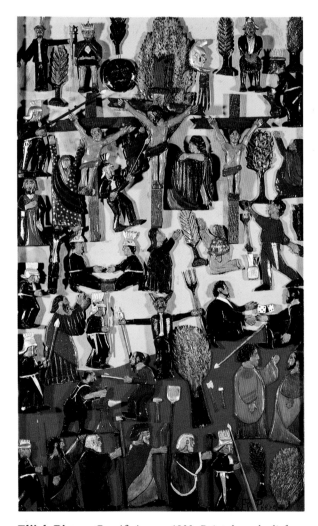

Elijah Pierce, Crucifixion, c. 1933. Painted wood relief, 47½ × 30½ in. Columbus Museum of Art, Columbus, Ohio. Elijah Pierce's stirring version of the Crucifixion, with its many symbolic messages, is representative of the visionary carvings and religious themes of this artist.

Pierce was born in a log cabin on a farm that his father, a former slave, owned in Mississippi. His family was intensely religious, which had a profound influence on him throughout his life. His father was a church deacon, and Pierce himself was ordained at the Mt. Zion Baptist Church in Baldwyn, Mississippi, around 1920.

Pierce decided early that farming was not the life for him and began a career as a barber in Baldwyn at the age of sixteen. After his first wife died (about 1917), he took to the road, taking jobs wherever he could find them. He claimed to have left one town in Mississippi just ahead of a lynch mob.

After a period of roaming, Pierce became a barber in Danville, Illinois, then in 1924 moved to Columbus, Ohio, the home of his second wife's family. There he worked in the barber shops of John Dickson and others until he built his own shop on Long Street around 1954. His shop had two rooms—one for barbering, the other for carving. By the late 1970s Pierce had more or less retired from barbering and was carving full-time.

ARTISTIC BACKGROUND
Elijah Pierce had whittled when he was a boy, but his first serious carving was an elephant he made for his second wife. She liked it so much that he carved every animal he could think of, then he moved on to other kinds of figures and religious carvings. In the late 1920s and 1930s Pierce and his wife traveled about in summer selling his carvings at churches and fairs, where the artist loved to explain the sermon or story behind each one to anyone who would listen. After he had his own barber shop, he would carve between customers and occasionally sell pieces out of his gallery cum barber shop.

Pierce gave much of his early work to fellow parishioners before he was discovered in 1971 by Boris Gruenwald, then a student in sculpture at Ohio University. Gruenwald began to arrange public exhibitions for Pierce, the first of which was at the Krannert Art Museum of the University of Illinois at Urbana-Champaign in late 1971. By mid-1972 Pierce had his first show in New York at the Danenberg Gallery.

From then on, the carver was widely exhibited and participated in many shows, including the Corcoran Gallery's 1982 traveling show, "Black Folk Art in America: 1930–1980." In 1980 Pierce was given an honorary doctorate in fine arts by Franklin University in Columbus, Ohio, and in 1982 he received a National Heritage Fellowship.

SUBJECTS AND SOURCES
Elijah Pierce preached sermons in wood, but he was also a sculptural storyteller, documenting his personal adventures and experiences. Although the religious carvings were the most important to him, he also carved wooden reliefs of sports heroes like Joe Louis, allegorical or social commentary pieces, and assorted animals and other free-standing figures.

One of Pierce's best-known carvings, which he did in 1932, was entitled the Book of Wood. The Book contained thirty-three large wood reliefs mounted on cardboard and

bound together with string. Each page illustrated a year in the life of Jesus, who is depicted as black.[2]

MATERIALS AND TECHNIQUES
Pierce carved bas-reliefs, animals, and figures, mostly from pine, with a simple pocketknife. He painted his carvings and sometimes applied glitter to the finished piece.

The pieces range in size from a few inches square to 30 by 50 inches. Pierce probably made two to three hundred major carvings, but he also made a great many smaller animals and figures.

ARTISTIC RECOGNITION
Elijah Pierce was an acknowledged master carver whose work is respected and admired by a wide audience. Over one hundred of his sculptures, including the *Book of Wood* (1931) and the *Crucifixion* (1940), a similar group of sequential story carvings, were purchased by the Columbus Museum of Art in 1985, and his pieces are included in numerous other museum and private collections.

HORACE PIPPIN—*"The war [World War I] brought out all the art in me."*

BIOGRAPHICAL DATA
Born February 2, 1888, West Chester, Pennsylvania. Dropped out of high school, 1903. Married Jennie Ora Featherstone Wade, 1920. One stepson. Died July 4, 1946, West Chester, Pennsylvania.[1]

GENERAL BACKGROUND
Horace Pippin, one of the most famous black painters of this century, started life in poverty. He left high school in 1903 to help support his widowed mother, who was a domestic, and went to work at the St. Elmo Hotel in Goshen, New York. After his mother died in 1911, Pippin moved to Paterson, New Jersey, to work first at the Fidelity Storage House crating pictures and then at the American Brakeshoe Company from 1912 to 1916.

During World War I Pippin served in the armed forces and saw action in France, where he was wounded; he never fully regained complete use of his right arm. Pippin showed outstanding bravery in battle and received the French Croix de Guerre; subsequently, in 1945, he was also awarded the Purple Heart for his service in World War I.

After the war Pippin returned to West Chester, where he married and began painting; he often spent seventeen-hour days working on his canvases. His wife, Jennie, took in laundry to help make money, and Pippin helped with the deliveries. He also received a disability pension of $22.50 a month.

ARTISTIC BACKGROUND
Horace Pippin started drawing around the age of ten, while he was still in school; he once illustrated the words on a spelling test, and he drew in a diary during his war service. After he was wounded, he learned to support his arm so that he could continue drawing and, eventually, painting.

By the late 1920s Pippin had started to paint seriously. He studied briefly at the Barnes Foundation in Philadelphia, where he saw the work of Renoir, but decided that he wanted to go his own way rather than follow the academic tradition. In 1937 Pippin entered two paintings in the West Chester County Art Association's annual invitational show, and his work was so well received that this led to an individual show. By 1938 he was included in "Masters of Popular Painting" at the Museum of Modern Art in New York, and Robert Carlen Galleries in Philadelphia became his art dealer in 1939, sponsoring numerous exhibitions and one-person shows.

When Pippin died on July 4, 1946, at the age of fifty-eight, he had achieved a considerable and well-deserved artistic reputation.

SUBJECTS AND SOURCES
Horace Pippin was the first black folk painter to express his concerns about war and social and political injustices in his art, and his compositions on those themes are forceful and striking. His landscapes, biblical subjects, and interiors, often showing the turn-of-the-century black lifestyle, are also painted with a masterful hand.

Pippin was a superb colorist, offsetting blocks of somber colors such as blacks and grays with contrasting whites and reds. Each color had its own function in setting the mood and helping to structure his bold renditions of a scene.

MATERIALS AND TECHNIQUES
Between 1920 and 1930 Pippin used a white-hot poker to etch lines into wood (a technique called pyrography), sometimes adding paint afterward, but his preferred medium was oils on canvas. He also did a few sketches on paper.

Pippin's paintings are generally of moderate size, around 16 to 24 inches by about 30 inches, although several are larger—one oil is 36 by 48 inches. The artist worked slowly and did not leave behind a large body of paintings.

ARTISTIC RECOGNITION
Horace Pippin became the most celebrated black artist of his time, painting more than twenty recognized masterpieces. The sheer virtuosity of the *John Brown* series, his war pictures, the *Holy Mountain* paintings, and the *Domino Players* makes it difficult to label any one better or more important than another. His work is included in museum collections as well as important private collections.

OVERLEAF: **Horace Pippin,** Domino Players, *1943. Oil on composition board, 12¾ × 22 in. Phillips Collection, Washington, D.C. Skilled in his use of color, Pippin not only captures the commonplace activities recalled from his youth but also depicts the settings realistically, here revealing the familiar living conditions of a room with peeling paint and cracked plaster.*

ROSEMARY PITTMAN—*"I went to an art show downtown. One painting was just colored squares. I said to myself, 'It needs faces.'"*

BIOGRAPHICAL DATA

Born Jeanne Forsythe, April 29, 1916, Cordova (150 miles southwest of Chicago), Illinois. Received an M.S. in nursing, University of Chicago, Chicago, Illinois. Married Marvin Summers Pittman, August 1947; he died 1948. One daughter. Now resides Seattle, Washington.

Rosemary Pittman, A la Recherche du Temps Perdu *(triptych), 1989. Watercolor on Masonite, 42 × 48 in. Courtesy of the artist and MIA Gallery, Seattle, Washington. A memory painter, this artist uses panels, filling each segment with portraits of friends and relatives and personal symbols that commemorate their lives.*

GENERAL BACKGROUND

Rosemary Pittman is a memory painter whose segmented artworks are a highly unusual and original method of conveying her memories.

Pittman was born on a 360-acre farm in rural Illinois. "I had my choice," she says; "teach or farm. I taught all eight grades in a one-room schoolhouse [1935–1937] and then went back to school to learn nursing."

Pittman used her nurse's training well, serving from 1942 through 1946 as an army nurse in the South Pacific. Upon discharge, she married and then took graduate training at the University of Chicago. Her husband, an anthropologist, was killed by headhunters in the Philippines in 1948, and Pittman was left with a child to support.

After the tragedy of her husband's death, Pittman worked in public health nursing and taught at the University of Washington in Seattle. She later became director of nursing practitioners for the Public Health Department of

A LA RECHERCHE DU TEMPS PERDU

Clark County, Washington. She retired in 1981 but continued to work part-time until 1984.

ARTISTIC BACKGROUND
Rosemary Pittman began to paint as a hobby about 1948. She took some sketching courses but was not satisfied by the styles of painting being taught; she continued to try to develop her own style and in 1988, at the age of seventy-two, felt that she had found herself.

The artist's work was discovered by Mia McEldowney, the owner of the MIA Gallery in Seattle.

SUBJECTS AND SOURCES
Pittman has painted interiors and landscapes but her best work is an attempt, as she says, to "live over the important events that have happened in my life."

Pittman divides her picture plane into multisegmented panels composed of squares that she paints in contrasting pastel colors. She fills each square with a portrait of a relative or friend and reminders of that person, such as their pets. She also uses symbols—copies of death masks, for instance—to express her feelings about the subject and may print labels in one or more segments to identify the portraits or events.

MATERIALS AND TECHNIQUES
The artist has experimented with watercolors, oils, and acrylics and is currently working with acrylics on Masonite and canvas; the colors she uses are soft ones. Her paintings may be as large as 30 by 40 inches.

Pittman believes that she may have completed several hundred works, but the whereabouts of most of them are unknown.

ARTISTIC RECOGNITION
The segmented paintings of the last few years are the best work that Rosemary Pittman has created to date and serve as extraordinary examples of contemporary folk art. Her work has been exhibited in Seattle and in 1989 was included in the exhibit "Famous and Infamous Women of the West" in that city.

NAOMI ("MRS. N. H.") POLK

BIOGRAPHICAL DATA
Born Naomi Howard, July 2, 1892, Houston, Texas. Attended school through about sixth grade, Old Colored School (now called Booker T. Washington School), Houston, Texas. Married Bill Myers, c. 1920; he died c. 1925. Married Robert Polk, c. 1925; he died 1933. Married Reverend James, 1961; divorced a few months later. Two sons, one daughter. Died May 1, 1984, Houston, Texas.[1]

GENERAL BACKGROUND
Naomi Polk was a black folk artist remembered for her moving paintings of religious subjects.

Polk's grandmother, a freed slave, was given a plot of land in Houston's Fourth Ward, a section called Freed-

Naomi Polk, Triple Crucifixion, *n.d. Crayon and watercolor on paper, 30 × 40 in. Butler and Lisa Hancock. Naomi Polk developed her own individual style, often expressing her religious convictions through dramatically simple paintings.*

man's Town, about 1865. Polk was born in and spent most of her life in this community. She did not attend school regularly because, as the youngest of ten children, she had the responsibility of caring for the children of her siblings. She believed in education and always regretted her minimal schooling. The lack of education, however, did not stop her from writing poetry and essays.

In 1933 Polk's second husband, Robert, was shot and killed by a policeman while walking through a white neighborhood as he returned from a construction job. She was left to care for her three children on $36 a month, which she received from Aid to Dependent Children. She supplemented her income by selling cosmetics and a secret formula roach powder of her invention.

Polk's home was destroyed by fire in 1961. All of the paintings, essays, and poetry she had created up to that time went up in smoke, but the fire did not defeat this strong woman.

ARTISTIC BACKGROUND
Naomi Polk probably started drawing in the 1920s and 1930s and by 1961 had completed close to one hundred works. When they were all destroyed by fire, she simply resolved to "repaint" them and began work immediately.

After Polk's death in 1984, her daughter, Rosalie Taylor, became dedicated to promoting her mother's work and was successful in gaining recognition for it. Polk was included in the show "Black History/ Black Vision" at the Archer M. Huntington Art Gallery, University of Texas at Austin, which traveled extensively in Texas in 1989.

SUBJECTS AND SOURCES
Polk was a lifelong Baptist, and the central theme in her

paintings is an expression of her spiritual experiences. She painted church scenes, baptisms, and crucifixions. An especially interesting series, done in bright, contrasting colors, centers around a small stick doll that her mother, Josephine, had made for her as a play toy and which she depicted as the crucified Christ.

Many of Polk's subjects have round eyes with enlarged pupils. Sometimes they appear to be pleading for divine intervention in worldly injustices. Toward the end of her life, the artist did a series of watercolors that she called *Lonesome Road,* in which an empty road lined with flowers stretches across the paper and no people are in view. These are not considered her best work.

MATERIALS AND TECHNIQUES
Polk painted on old cloth, window shades, and ceiling tiles, but her major work is on cheap paper and cardboard. She painted with oil-base paints, enamel paint thinned with kerosene or turpentine, watercolors, crayon, and felt markers. Polk's paintings and watercolors are mostly somber in tone, but occasionally, as in the stick-doll series, she used bright contrasting colors.

After the fire Polk "repainted" only about seventy pieces. Most are small, around 8 by 12 inches to about 23 by 28 inches. One piece, however, is 4 feet square. With the exception of a few minor pieces, Polk's work is of uniformly high quality.

ARTISTIC RECOGNITION
Naomi Polk had a keen eye that enabled her to record dramatic moments in religious events from the perspective of her cultural environment, and her paintings have received a positive response. The art of Texas black folk artists is less commonly known than the work of those from the Southeast and not well known outside the state.

DANIEL PRESSLEY—*"I have never studied art of any kind but I call my art the 'lost art'—folk art." "Anyone's life is a look up, look down process."*

BIOGRAPHICAL DATA
Born January 22, 1918, Wasamasaw, South Carolina. Had "limited Grama school learning."[1] Married and divorced; name of wife and dates unknown. Two daughters. Died February 17, 1971, Brooklyn, New York.[2]

GENERAL BACKGROUND
Very little is known about the early life of this important black carver, other than the fact that his mother was a "washerwoman" and his father was killed by "rednecks."

Daniel Pressley, After Hour Shower, *n.d. Wood panel relief, 60 × 19 in. Cavin-Morris Gallery, New York. Although he is known for his exquisitely carved bas-reliefs of events from the black experience, Pressley has also depicted such mundane scenes as this modest lady in a shower.*

Daniel Pressley noted in his diary, which he kept through-out his life, that "Mom loved reading old newspapers white folks finished with. That is how I learned there were others in the world besides the ones my poor old Negro teacher had us read about."

As a young man, Pressley moved north to Ohio, where he married and had a family, then moved to New York City around 1943. According to some accounts, he worked as a plumber or in a plumbing supply firm for some years. About 1962 he had a prolonged and serious illness that prevented him from taking on regular employment.

ARTISTIC BACKGROUND
"I began to draw at age 5," the artist wrote in his diary. "At age 6, I modeled clay from the ditches into human and animal figures. At age 7, I began to whittle wood like my grandfather whom I had never seen."

After his illness, when he realized that he could not re-turn to work, Daniel Pressley turned to painting and sculp-ture as his full-time occupation. It is clear from his diary and from his conversations with other artists who be-friended him that he took his art seriously and was eager to earn a reputation.

In the 1960s Pressley exhibited at the outdoor art shows held in New York's Greenwich Village and thus gained his early recognition and reputation. When he was included in a 1969 exhibition at the Brooklyn Museum in New York, a newspaper review named him one of the three strongest artists in the show.[3]

SUBJECTS AND SOURCES
Pressley's art is highly imaginative; he drew and carved memories of the rural "Jim Crow" South of his youth and also of the street life and people that he observed in the black communities of New York City. He had a very spe-cial concern for the life around him, and a great need and desire to record and document his emotional responses for future generations.

The artist's work often contains a certain sense of irony, and women are frequently portrayed as prostitutes or as angels.

MATERIALS AND TECHNIQUES
Pressley practiced what he called "the art of woodcarving" and is best known for his bas-reliefs. He carved in pine, working with chisels and other hand tools, and used paint sparingly, often applying wax or shellac as a finish.

The artist also painted and drew in addition to carving. He continued to keep his diary, which he profusely illus-trated with pencil sketches, and his commentary on life as he saw it is invaluable.

Pressley made about seventy-five bas-reliefs and the same number of paintings. The wood plaques are fairly large, about 40 by 20 inches, and are considered to be his major works.

ARTISTIC RECOGNITION
Pressley's pieces are highly regarded today by museums and private collectors alike. He was most recently included in "Black Art—Ancestral Legacy: The African Impulse in African-American Art," a traveling show that opened at the Dallas Museum of Art, Dallas, Texas, in December 1989.

TRESSA ("GRANDMA") PRISBREY

BIOGRAPHICAL DATA
Born Thresie (pronounced Tressa) Schafer (sometimes spelled Shafer or Schaeffer), February 1, 1896 (although she celebrated her birthday on January 19), Easton (near Wells), Minnesota. Attended elementary school, Easton, Minnesota. Married Theodore Grinolds, 1912; separated, late 1920s; he died 1931. Married Al Prisbrey, 1954 or 1955; he died February 9, 1968. Four sons, three daugh-ters; six predeceased their mother. Died October 5, 1988.[1]

GENERAL BACKGROUND
In her girlhood, Tressa Prisbrey gave no hint of the incred-ible environment she would one day create.

The youngest of eight children, she was born in a small farming community in Minnesota. In 1908 the family moved to a homestead near Minot, North Dakota, and against the wishes of her father, the fifteen-year-old Pris-brey insisted on marrying a much older man. They later separated, and Prisbrey returned to Minot, where she worked as a waitress, played the piano, and started a life-long hobby collecting pencils.

During World War II Prisbrey worked for Boeing Cor-poration in Seattle; in 1950 she moved to California, where she later married Al Prisbrey. They purchased a third of an acre in Simi Valley (then called Santa Susana), financed by the sale of a cement-block house the two had earlier built near her sister Hattie's property in Santa Susana.

The Prisbreys lived in a trailer home (from which she had removed the wheels so they "would stay put") on their property in Santa Susana until—between babysitting grandchildren and collecting more and more pencils—Prisbrey began to feel the need for more space. And thus she began her *Bottle Village*. After completing a glass wall and the *Pencil House* for her collection, Prisbrey kept right on building "because," she said, "I enjoyed it. I never thought of it as work; I was just having a good time."

After the death of her husband in an automobile acci-dent, Prisbrey sold her property and moved to the North-west for a short time. She quickly became bored, however, and the new owner of the *Village* (who was intent on pre-serving it) let her return to again take up residence in her trailer. There she remained until ill health forced her to move to a convalescent hospital.

ARTISTIC BACKGROUND
Bottle Village, comprising fifteen buildings and a number of other sculptures fashioned largely of bottles and con-crete and gleaming in the light of Simi Valley, was Pris-brey's monumental creation. She worked on the *Village*

Tressa Prisbrey, Bottle Village *(detail), c. 1956–1961.*
Mixed-media environment, ⅓ acre, Simi Valley, California.
"Grandma" Prisbrey's Bottle Village *is one of the few well-*
known ambitious environmental works produced by a woman.
Her creation, a detail of which is shown, contains a lifetime of
mementos and dreams.

from 1955 until about 1970, stopping only because she ran
out of room to put any more structures on her third of an
acre.

The initial inspiration for the *Village* came from Pris-
brey's pencil collection, which she had started back in her
days in Minot, when she received several commemorative
pencils from North Dakota governors, and kept collecting
through the years. She built the *Village* to house her collec-
tion, to earn income from tours, and, not the least, for her
own enjoyment. As she gradually built new bottle struc-
tures, she also added to her collection.

As the fame of the *Village* grew, more and more visitors
stopped by to see "Grandma" and her unique setting. She
enjoyed the attention, calling the *Village* her "monument
to show biz."

SUBJECTS AND SOURCES
In one form or another, the *Village* is crammed with me-
mentos of Prisbrey's life. Each building has its own inte-
rior theme and special meaning for her: there is the *Pencil
House,* the *Rumpus Room,* the *School House,* the *Shell House,*
the *Bottle House,* the *Round House, Cleopatra's Bedroom,* the

Doll House, the *Little Chapel,* the *Meditation Room,* the *Shot
House,* and the *Little Hut.* There is also a variety of other
sculptures: two wishing wells, a horseshoe shrine, a tele-
vision picture tube fence, the sanctuary wall, the *Leaning
Tower of Bottle Village,* a fluorescent fountain, the pyramid
planter, and a doll's head planter.[2]

MATERIALS AND TECHNIQUES
With the exception of roofing and major excavating, Pris-
brey did all the work on *Bottle Village* herself. She planned,
designed, constructed, and decorated it. She embedded
thousands of industrial and household discards in concrete,
creating an environment of great beauty.

Prisbrey collected virtually all of the objects and mate-
rials used to construct *Bottle Village.* Her only purchases
were sand, cement, roofing paper, and 2-by-4s. She mixed
and poured the concrete for her buildings and embellished
them with found objects. Colorful mosaic walkways, in-
laid with tiles, ceramics, costume jewelry, and other ob-
jects, wind between and around the buildings. Each
building also has a mosaic floor, except the *Shell House.*

Bottles are a major element of the *Village,* and there are
reportedly over one million making up the various struc-
tures.[3] In addition, there are dolls, car headlights, gourds,
medical supplies, eyeglass frames—anything available at
the city dump, which Prisbrey visited almost daily. Visi-
tors also brought her "treasures," which she used in her
creations.

ARTISTIC RECOGNITION
Bottle Village is one of the few environmental works in
America produced by a woman. In 1986 it was acquired
by the Preserve Bottle Village Committee of Simi Valley
to prevent it from being destroyed. The *Village* is tempo-
rarily closed while funds are being sought for restoration
and reopening.

Bottle Village has earned a landmark designation from
the state of California, Ventura County, and the city of
Simi Valley.

LAMONT ALFRED ("OLD IRONSIDES") PRY—
"I can see it all in my mind.
I want an elephant.
I draw an elephant.
He needs a man on top of him.
I give Susy a trapeze to swing on.
I get it all drawn out just right,
Then I color it in."

BIOGRAPHICAL DATA
Born February 12, 1921, Mauch Chunk (now Jim Thorpe),
Pennsylvania. Attended Asa Packer Grade School for nine
years, Mauch Chunk, Pennsylvania. Married Virginia
Logan, 1941 or 1942; divorced, date unknown. Married
Myrtle Binder, 1947; she died 1952. Two daughters, one
son by Logan. Died November 28, 1987, Weatherly,
Pennsylvania.

GENERAL BACKGROUND

Lamont Alfred Pry produced lively and imaginative paintings that reflected his sense of adventure and the love of his life—the circus.

Pry's father "took off" as a youth and joined up with the Sells and Downs-Floto Circus. But "when he returned to Mauch Chunk," Pry recalls, "he married Mom and she made him go into the mines." Still, his father's tales of the nomadic circus life fueled the imagination of the young Pry, who left home in his late teens to see what it was like for himself. According to Pry, he worked as a clown at events such as the Fireman's Carnival, but, he said, "I couldn't make it to the Big Top."[1] Although Pry tried many jobs, including one for the National Youth Administration, the circus always remained his first love.

In 1941, at the start of the war, Pry enlisted in the U.S. Army Air Corps. He was seriously injured when the B-25 he was in crashed on a routine reconnaissance flight but made an amazing recovery. It is believed that one of the nurses at the Bolling military hospital, where he was sent for recuperation, christened him "Old Ironsides." In any case, Pry liked the nickname and proceeded to use it throughout the rest of his life.[2]

After discharge from the service in 1943, Pry returned to Mauch Chunk to take care of his ailing mother. He joined the civil service and was employed at the Annie M. Warner Hospital in Gettysburg, Pennsylvania, as an orderly. It was at that hospital that he claimed to have met the great love of his life, Susan Maury, who, according to Pry, was the head nurse and whom he referred to in some of his paintings as "Mrs. Susan Pry."[3] "I used to prowl around with Susan Maury," the artist claimed, "but I never married her because she didn't like circuses—so I put her in my circus scenes anyway."

By 1968 Pry was ill enough to keep him from working any longer. In January he was admitted to the Carbon County Home for the Aged, where he continued to use the radio skills he had learned in the service, broadcasting as a ham under the call name "Porky Pine." When the Carbon County Home was torn down in 1974, he was

Lamont Alfred Pry, The First Circus in the United States of America, *1978. Acrylic on cardboard, 21½ × 35½ in. Chuck and Jan Rosenak. Pry's rendition of the motion, excitement, and color of the circus in a flat, expressionistic style is characteristic of his work.*

moved to the newly constructed Weatherwood Home for the Aged, where he lived until his death in 1987.

ARTISTIC BACKGROUND
In 1974, when the wrecker's ball threatened the boiler room of the Carbon County Home for the Aged, its custodian, Peter Pfeiffer, called Sterling Strauser, a painter and folk art collector in nearby East Stroudsburg, Pennsylvania, and asked him to look at the paintings that were nailed to the boiler room wall. These paintings turned out to be the work of "Old Ironsides" Pry. The artist had started painting around the time that he entered the home but had made no attempt to promote or show his work before Strauser was called.

Strauser rescued Pry's work and began to help him exhibit at local fairs and flea markets. Pry was quite successful, his paintings striking sympathetic chords among a broad spectrum of people, and from 1975 until 1982 he won at least one blue ribbon a year at the Carbon County Fair. He also became part of the "Strauser Circle," a group of artists whom Strauser encouraged that included Victor Joseph Gatto (see page 135), Justin McCarthy (see page 198), and others.

SUBJECTS AND SOURCES
Pry had three loves, all of which appear as major themes in his work: circuses, aircraft (especially those of World War I vintage), and Susan, who may have been real or imaginary. Often he combined these themes, showing Susan on a trapeze in the circus or on the wing of a biplane and in illustrations of imaginary adventures. He also painted other subjects, often of things he had seen. All his works are bright and boisterous and show an uninhibited use of color. Some contain written comments that tell the viewer in detail exactly what is going on and who the players are.

Pry sometimes relied on magazine illustrations, pictures of airplanes, or circus posters as sources of ideas for his work, but most of his pictures drew inspiration from his own zest for life and adventure and his love of circuses and carnivals.

MATERIALS AND TECHNIQUES
Pry painted with house paint, poster paint, enamel, metallic radiator paint, or anything that might be available in the art room at the nursing home. He would get cardboard from the home's loading dock, a material he preferred to the paper given out in art class.

The paintings range in size from fairly small (about 10 inches square) to about 21 by 53 inches.

Pry created about 150 paintings. Before entering the Carbon County Home, he had also made a few sculptures, including carvings of circus wagons and wooden airplanes.

ARTISTIC RECOGNITION
The early paintings are generally considered "Old Ironsides" Pry's best. By the late 1970s the artist was often not well, and the medicine he was receiving seemed to sap him of vitality; his output decreased and the quality of the work diminished.

Pry has been receiving greater recognition as his highly imaginative and brightly colored art becomes better known. He is included in a number of private collections, and his work has been exhibited at the Abby Aldrich Rockefeller Folk Art Center in Williamsburg, Virginia, among other places.

LORANZO DOW PUGH

BIOGRAPHICAL DATA
Born August 12, 1906, Monterey, Tennessee. Attended school through eighth grade, Monterey, Tennessee. Married Lela McKensies, 1927; she died 1950. Married Mary Elizabeth Milligan, 1980; she died 1983. One son (deceased) by McKensies. Now resides Monterey, Tennessee.[1]

GENERAL BACKGROUND
Loranzo Dow Pugh, known as Dow, is an Appalachian wood carver recognized especially for his fanciful representations of his neighbors and of political figures.

The Pugh family owns just about the whole town of Monterey, Tennessee—the saw mill, the hardware company, the grocery store—but Dow Pugh is and has always been a loner; he does not participate in the family business.

Pugh left Monterey during World War II to work in defense plants in Battle Creek, Michigan, but tragedy soon touched his life when his young son died as a result of a tricycle accident. Later his first wife died, but he remained in Michigan, working as a meter reader until he retired at the age of sixty-two.

About 1970 Pugh returned to Monterey, where he moved into a one-room cabin in the hills above the town. He filled his cabin with his wood carvings and with found objects: old hats were hung from the rafters, stuffed fish and game animals were mounted on the walls, and there was a collection of Indian relics found in the nearby woods. Under Pugh's mattress was the skeleton of an "Indian princess."

In 1980 Pugh married Mary Elizabeth Milligan, a widow who owned a neat frame house near the center of town. He gave up carving when he moved into her house, but he brought the princess's skull with him and kept it on display in the toolshed.

After the death of his second wife, Pugh began to carve again and to fill their home with objects.

ARTISTIC BACKGROUND
When Pugh moved into his mountain cabin in 1970, he picked up a piece of firewood and started carving just for fun. Soon he had a cabin full of carvings, in addition to his many found objects.

In the late 1970s John Rice Irwin, owner of the Museum of Appalachia in Norris, Tennessee, saw Pugh's work. He was so impressed that he installed a permanent display of the carvings in the museum.

SUBJECTS AND SOURCES

Pugh carves and paints whatever strikes his fancy—political cartoons, portraits of mountain men and women, Indians, comic faces on gourds, boot scrapers, or busts of Hitler. He has also made a few large painted concrete sculptures, one of which is a self-portrait.

MATERIALS AND TECHNIQUES

Pugh carves local woods—buckeye, hickory, and pine—and also paints on gourds and canvas board. He adorns some of his pieces with found objects, such as beads, trinkets, hats, and assorted clothing. Because he carves only for his own pleasure, he makes no attempt at consistency within his work.

Pugh has made two or three hundred objects, ranging from a few inches high to larger than life-size.

ARTISTIC RECOGNITION

Dow Pugh's serious art—such as the early work in the Museum of Appalachia in Norris, Tennessee, his portraits, and his heads—is simple, direct, honest, and very strong. Only about one hundred of his pieces can be considered

Loranzo Dow Pugh, Bikini Girl, *c. 1975. Carved pine, pinecone, and paint, 12 × 6½ × 3 in. Private collection.* Bikini Girl, *with a wood burl forming her elaborate hairdo, exemplifies Pugh's virtuosity and sense of humor.*

Loranzo Dow Pugh, Hitler Head, *c. 1974. Carved and painted wood, 14⅜ × 7½ × 6 in. Chuck and Jan Rosenak. The subjects of Dow Pugh, a reclusive Appalachian wood carver, range far beyond the borders of his native Tennessee, as this bust of Hitler illustrates.*

major, however, and such items as windmills, boot scrapers, and painted gourds cannot be classed among his best work.

Pugh is best known by collectors of Appalachian art, but the importance of this artist will be recognized by anyone who views the exhibition of his work at the Museum of Appalachia.

MATTEO RADOSLOVICH

BIOGRAPHICAL DATA
Born May 3, 1882, Lussinpiccolo, Lussin (a small island in the Adriatic Sea), now part of Yugoslavia. Received basic elementary education, Lussin. Married Mary Anne Radoslovich (also her maiden name), date unknown; she died November 1982. Two daughters. Died December 21, 1972, West New York, New Jersey.

GENERAL BACKGROUND
Matteo Radoslovich, a Yugoslav immigrant, created an enchanting, circuslike miniature environment in his backyard in New Jersey.

The economies of the Adriatic islands have long been tied to seafaring and shipbuilding, and the small island where Radoslovich was born was no exception. True to tradition, Radoslovich learned ship carpentry from his uncle, who ran a boatyard and built sailboats.

Around 1914, as Europe went to war, Radoslovich immigrated to the United States, where his skills were in demand. He became "first carpenter" at the Todd Shipyards in Hoboken, New Jersey, retiring after thirty years in 1947.

ARTISTIC BACKGROUND
When Radoslovich retired, he began a twenty-five-year labor of love creating a magical, circuslike environment in the small backyard (20 by 40 feet) of his home in West New York, New Jersey. His earliest pieces were typcial whirligigs, such as a man chopping wood, but as he progressed, he began to innovate and create a number of entirely original pieces.

On his seventy-fifth and eighty-sixth birthdays, Radoslovich called a local newspaper to tell them about his work, and small articles were written about him. For the most part, however, his wondrous backyard went undiscovered. After his death his family found that they had no use for his creations and sold everything to a picker for ten dollars; the picker, in turn, sold his purchase to a New York City folk art dealer. Eventually Leo and Dorothy Rabkin, two important folk art collectors, bought thirty-eight objects from Radoslovich's environment and donated them to the Museum of American Folk Art in New York City.

SUBJECTS AND SOURCES
Matteo Radoslovich's backyard was a spellbinding environment, a mass of color and motion. "The total effect was of a miniature carnival, complete with clowns, birds,

Matteo Radoslovich, Pumpkin-Head Figure, *n.d. Painted metal and wood, 26 × 11 × 12 in. Museum of American Folk Art, New York; Gift of Dorothy and Leo Rabkin. Radoslovich created a delightful environment in his small backyard in New Jersey, which he filled with colorful and whimsical pieces like the one illustrated here.*

boats, dancing girls, soldiers with rifles and a man riding a pig," all twisting and turning in the wind.[1]

MATERIALS AND TECHNIQUES
Radoslovich built his environment from almost any material that was at hand, including wood, glass, tin, cloth, and various metals. As the years went by, he built and rebuilt, painted and repainted, to keep the environment in good shape.

His pieces are not large but were made to scale in his yard. When he died, there were thirty-nine surviving objects in the garden.

ARTISTIC RECOGNITION
Matteo Radoslovich has been recognized as a master for his unique work. Unlike the work of some other environmentalists,[2] the individual objects in Radoslovich's envi-

ronment can stand on their own as sculpture, even though the garden was created to be viewed as a whole.

MARTIN RAMIREZ

BIOGRAPHICAL DATA
Born March 31, 1895, Jalisco, Mexico. Education unknown. Married Ana Maria Navarro in Mexico, date unknown. No known children. Died February 17, 1963, Auburn, California.[1]

GENERAL BACKGROUND
Martin Ramirez, who was Mexican-born, created mysterious, symbolic drawings while suffering from severe mental illness.

Little is known about Ramirez's life. The only biographical material available (other than state records) is contained in the notes of Dr. Tarmo Pasto, a Finnish-born psychologist who befriended Ramirez in the late 1940s. He wrote:

Martin Ramirez, Untitled, *c. 1950s. Pencil, tempera, and crayon on paper collage, 34 × 23 in. Gladys Nilsson and Jim Nutt. The bandito pictured here appears in many of the works of Martin Ramirez, a Mexican-born artist who created hundreds of symbolic drawings while suffering from schizophrenia.*

Martin Ramirez, Madonna, *1953. Colored pencil and crayon on paper, 26¼ × 25½ in. John and Ann Ollman. Termed an "outsider" artist, Martin Ramirez is known for compelling visionary works depicted in a personal iconographic style, as illustrated by this remarkable drawing.*

Martin Ramirez was born in Jalisco, Mexico. . . . He worked as a laundryman. Being half-starved, he crossed the border into the U.S.A. in the hope of finding employment that would pay him so he could eat and send money back home. He was a frail man, weighing about a hundred pounds, and being about five feet, two inches tall.

He soon found that in America his life was so different from his life in Mexico that he became bewildered. The cultural shock was too much for him. He became disoriented, delusional, and had hallucinations, exhibiting all the characteristics of a schizophrenic. He was working on the railroad as a section hand, but the work became too demanding on his physical energies. He was picked up by the Los Angeles authorities in Pershing Square. He was placed in an institution in the Los Angeles area, where he was classified as catatonic.[2]

Ramirez was institutionalized in Los Angeles in 1930 and transferred to the De Witt State Hospital in Auburn after seven months. He was mute by then, and his condition continued to deteriorate. At De Witt, Ramirez was diagnosed as "paranoid schizophrenia, deteriorated." He remained in the state hospital until his death.

ARTISTIC BACKGROUND
In 1948 Ramirez produced a roll of drawings from under

his shirt and showed them to Dr. Pasto, who encouraged him to continue drawing, both as art and as therapy.

Three hundred drawings ended up in Dr. Pasto's possession. In the fall of 1968 the Chicago artist Jim Nutt, who was teaching at Sacramento State College in California, met Pasto and saw the drawings; Nutt and his Chicago dealer, Phyllis Kind, bought and began to restore them. With Pasto's help, Nutt mounted a Ramirez exhibition at Sacramento State College in 1969.

SUBJECTS AND SOURCES
Ramirez developed highly personalized symbols and expressive designs that are instantly recognizable but not decodeable. His "imagery [is] alternately primitive and Catholic, Mexican and American. . . . Foremost are his signatory Mexican bandito . . . and this character's counterpart, the impressive pre-Columbian Madonna—Miss Liberty."[3]

MATERIALS AND TECHNIQUES
Ramirez made a paste of potatoes or bread and his own spit that he used to glue together pieces of paper to give himself a big enough surface to draw on. In the beginning he used almost anything he could get—"flattened paper cups, hospital supply forms, laundry slips, as well as large pieces of kraft . . . [he drew on these with] pencil, ink, chalk, and crayon."[4] Later Dr. Pasto supplied him with better paper. Ramirez sometimes glued magazine illustrations onto his drawings, but for the most part drew, covering his sheets with intricate patterns and figures.

Three hundred drawings have survived, ranging in size from small scraps to scrolls 10 feet long. Ramirez's work, particularly the earlier pieces, is extremely fragile due to the nature of his materials, and restoration is often necessary to preserve it.

ARTISTIC RECOGNITION
Ramirez's mental and social isolation from the everyday world has placed his work in the category of "outsider" art, but his art transcends labels. His work, although delicate with a haunting, formal beauty, is complex; the iconography is not always evident, which gives a certain sense of mystery to the works.

The artist was given a major retrospective at the Moore College of Art in Philadelphia in 1985.

ERNEST ("POPEYE") REED—*"Hard times, nothing to do, kid about fourteen years old, broke, barefooted, lived in a damn place that wasn't fit for a dog to live, that's what started me carving."*

BIOGRAPHICAL DATA
Born February 2, 1919, Jackson, Ohio. Attended school through eighth grade, Married Ina Johnson, 1950; divorced 1964; she died April 21, 1984. Two daughters, one son. Died May 21, 1985, Fort Jackson, South Carolina.[1]

Ernest Reed, Woman with Two Children and Cat, *c. 1968. Carved stone, 60 × 12 × 15 in. Museum of American Folk Art, New York; Gift of Dorothy and Leo Rabkin. Adept at working in stone, Reed carved simple, striking images that also have a mythic look, such as this woman with children and a cat.*

GENERAL BACKGROUND
"Popeye" Reed was one of the rare carvers who was as expert in carving stone as he was in wood.

According to his son, Stephen, "Dad had a brother called 'White Eye,' and he was 'Popeye' since their school days." Reed, who was part Native American, left home and school at the age of fourteen and began working with wood. He became a cabinetmaker and worked in a saw mill; he also made "moonshine" whisky as a sideline.

For a number of years Reed lived in a 150-year-old log cabin. After his divorce he moved into a tepee alongside Highway 35 for about a year and then into an old trailer, which he remodeled. According to his son, it was full of "secret compartments," and Reed made all his furniture. "Dad didn't want anything you could buy," Stephen Reed recalls.

In the later part of his life, Reed made his living by taking odd jobs as a carpenter and by selling Indian items, fake Indian arrowheads, and his own carvings. About 1968 he was able to stop taking other jobs and became an artist full-time.

ARTISTIC BACKGROUND

Popeye Reed had carved wood since he was fourteen. About 1964 he started making tourist items to sell at the roadside, and the story is often told that he made a bowl, put Daniel Boone's initials on it, and sold it as genuine.

By 1968 or somewhat earlier, Reed had progressed from carving wood to working in stone as well; at that point his work moved from the realm of craft to that of art. Reed began to appear at various state fairs, exhibiting his work and sometimes demonstrating his carving techniques, and in 1980 he was featured in "Folk Art from Ohio Collections" at the Ohio State Fair.

SUBJECTS AND SOURCES

The world according to Popeye Reed is presented in the artist's major carvings of individual mythological and biblical figures; of special interest are his Indian carvings. The artist studied encyclopedias, illustrated magazines, and books on Greek mythology for inspiration. Greek mythology had been a long-standing interest, and Reed once hinted that he might have left school early because "the teachers did not know enough Greek mythology to teach me anything."

In addition to stone, Reed continued to carve in wood —making small animals, pipes for tourists, life-size Indian figures, and motorized hula girls for his own pleasure.

MATERIALS AND TECHNIQUES

Reed preferred to use local sandstone and limestone for his stone carving and walnut for wood carving. In addition to pocketknives, chisels, and mallets, he often improvised or designed his own tools—he had a drill made of old motor parts, and he used a stag horn to make fine lines in the stone. His carved wooden Indians are dressed in leather clothing and wear handmade necklaces of elk horn and flint.

Reed may have made as many as three thousand carvings, but these include arrowheads, pipes, and small animals for tourist sales; he made no more than two hundred major works. Most of the artist's carvings are small, often less than a foot high, although some are as large as 4 feet in height. The departure from this norm is the life-size wooden Indians; the stone ones are smaller.

ARTISTIC RECOGNITION

There are not many carvers who work in stone, and Popeye Reed is one who had great skill. His work is held in high esteem by collectors of folk art in the Northeast and Midwest, but he is lesser known on the West Coast. His work appears in both public and private collections.

ENRIQUE RENDON—*"My saints have an honest good look—not artificial, like some in the churches."*

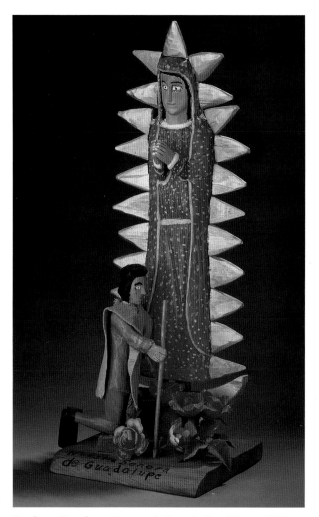

Enrique Rendon, Nuestra Señora de Guadalupe, *1978. Carved and painted wood, cloth, and plastic flowers, 19¾ × 7 × 7 in. Sallie R. Wagner. Rendon's* santos *are imaginative and innovative within the* santero *tradition. The large "pop" eyes of his saints are characteristic of his style.*

BIOGRAPHICAL DATA

Born October 2, 1923, Monero, New Mexico. Left school in eighth grade, Monero, New Mexico. Married Carmen Gutierrez, 1948; divorced 1955. Married Sara Martinez, 1965; she died 1972. Married Margaret Gutierrez (not related to first wife), 1980. No children. Died April 16, 1987, Velarde (north of Santa Fe), New Mexico.[1]

GENERAL BACKGROUND

Enrique Rendon was a *santero* whose imaginative works conform to his own unique vision of what a saint should look like.

Born in northern New Mexico, Rendon started working at the age of seventeen in coal mines in that state, in Utah, and in Colorado. He also worked in Los Alamos, New Mexico, from 1952 to 1955 and for the Union Pacific Railroad from 1958 to 1962. In 1962 he became custodian for the grade school at Velarde, New Mexico, and worked there until he retired after an illness in 1974.

Rendon was the *hermano mayor* of the Brotherhood of the Penitentes (the Brothers of Jesus of Nazareth, a secret religious group that is important to Hispanics in the Southwest) in Lyden, New Mexico, during most of the years between 1962 and 1987.[2]

ARTISTIC BACKGROUND

While pruning a tree in his family's apple orchard one day in 1962, Enrique Rendon decided that he would start to carve. He became a *santero* (an artist who makes religious images, or *santos*) and most of his work was done following his retirement.

At first, Rendon gave away most of his saints. Later many were sold locally or through the Potrero Trading Post at Chimayo, New Mexico, and it was not too long before Rendon's work gained the attention of both collectors and museums.

SUBJECTS AND SOURCES

Rendon's carvings of the traditional saints of New Mexico were influenced by old carvings he had seen in New Mexico churches as well as by contemporary plastic saints. He had a unique vision of what a saint should look like, and his carvings conform to this image: their faces have eyes that are round and pop-eyed with long lashes and they are brightly colored.

MATERIALS AND TECHNIQUES

Rendon carved aspen, cedar, and cottonwood, using only a pocketknife. He coated his saints with gesso made from flour, plaster, and water, then painted them with watercolors and acrylics. Religious medals, plastic trinkets, and artificial flowers were often added for decoration.

In addition to his saints, Rendon also made some small animals. It is estimated that his total production was fewer than four hundred pieces. His works range from about 4 inches in height to about 20 inches.

ARTISTIC RECOGNITION

Enrique Rendon was an imaginative artist. His saints are among the most innovative within the contemporary Hispanic *santero* tradition. The artist's work is well known to collectors in the Southwest and has been exhibited in Chicago and on both coasts—at the Craft and Folk Art Museum of Los Angeles in 1988 and as part of the exhibition "A Time to Reap" at Seton Hall University in New Jersey (co-sponsored by the Museum of American Folk Art in New York City) in 1985.

MORTON RIDDLE—*"I got arthritis. Carving is good therapy."*

BIOGRAPHICAL DATA

Born December 9, 1909, Peastick, Kentucky. Attended school through fourth grade, Mount Serling, Kentucky. Married Evelyn Spencer, 1933; divorced 1946 (Riddle says he "threw her out the door"). Married Florence Ethel Fisher, 1963. One son, one daughter by Spencer; one stepdaughter by Fisher. Now resides Whittier, California.

GENERAL BACKGROUND

Morton Riddle is a retired watchmaker who carves articulated dolls, as well as other objects.

"My fourth-grade teacher said, 'If you so good at art, go to art school.' Couldn't find no art school, so I quit altogether," Riddle recalls.

Born on a farm in a small mining town near Owingsville, Kentucky, Riddle lived and worked on farms in Kentucky, Illinois, and Indiana until 1955 or 1956. Then he took a correspondence course from the Chicago School of Master Watch Making and opened a repair shop in Marion, Indiana.

He moved to Alhambra, California, in 1964, then to San Gabriel, and finally to Whittier. He operated watch repair shops in all three cities, finally retiring in 1988 because of poor health.

ARTISTIC BACKGROUND

When he was a child, Morton Riddle learned how to carve from Kentucky whittlers who made traditional folk craft pieces such as pecking chickens and dancing men. When he had his watch repair business, he carved elaborate clock cases to order. In the 1960s Riddle took the Famous Artists School correspondence course and then started to carve other objects.

Riddle's earliest pieces were given away, and their whereabouts are now unknown. He was discovered in the late 1970s by Liz Blackman, owner of an art gallery in Hollywood, California.

SUBJECTS AND SOURCES

After Riddle began his serious carving, his major theme became a hairless, sexless, doll-like figure. These articulated figures look estranged from society—their eyes bulge, their extremities are too large for their bodies, and they are unclothed—yet they have an appealing ageless quality. Sometimes Riddle makes furniture, signs, or boxlike cages to accompany the dolls.

Morton Riddle, Doll, *c. 1986. Carved wood, 16½ × 7½ in. Liz Blackman/Outside-in, Los Angeles. This sexless articulated doll is typical of the artist's unusual style of carving.*

The artist continues to make clock cases to order and other small carved objects in addition to his dolls.

MATERIALS AND TECHNIQUES
Riddle's favorite woods are linden and yellow poplar. He works with small watchmaker tools and does not use paint on his pieces.

The artist has made many clock cases and a number of small animals and other objects but only seven of the articulated dolls. The dolls are between 12 and 20 inches in height.

ARTISTIC RECOGNITION
Morton Riddle's dolls are poignant and expressive examples of articulated woodcarving. The artist was included in two major museum showings of twentieth-century California and West Coast folk art—"Pioneers in Paradise" at the Long Beach Museum in 1984 and "Cat and a Ball on a Waterfall" at the Oakland Museum in 1986—but he is not as yet well known to the rest of the country.

"PROPHET" ROYAL ROBERTSON
—*"God Holy Angle Saith to Prophet Lord Royal Beware of Harlots and Whores" (sign by Robertson in his yard)*

BIOGRAPHICAL DATA
Born October 21, 1936,[1] Baldwin, Louisiana. Attended school through eighth grade, G. W. Hamilton School, Baldwin, Louisiana. Married Adell Brent, October 1955; separated 1975. Possibly twelve children.[2] Now resides Baldwin, Louisiana.[3]

GENERAL BACKGROUND
"Prophet" Royal Robertson's energetic style and misogynistic images have attracted widespread attention.[4]

A self-proclaimed prophet, Robertson lives in a small

Royal Robertson, Mrs. Doroted, *1985. Mixed media on paper, 17 × 14 in. Sylvia and Warren Lowe. An eccentric visionary, Robertson often depicts cartoonlike women using an obsessive and bold style.*

house surrounded by large signs warning female visitors, especially "whores" and "vipers," to keep out. Inside the the tin-roofed shack is a shrine to his mother and a profusion of drawings, calendars, and portraits denouncing his former wife, Adell.

Details of the earlier life of this artist are somewhat fuzzy, but he is known to have spent some time in institutions. He once worked as a sign painter and talks about painting large billboards and working as a field hand, although when or where is unclear.

ARTISTIC BACKGROUND

Royal Robertson states that he started to draw on the "command of the Lord to denounce the evil ways of women," but when he started is unknown.

He was discovered by Warren and Sylvia Lowe, collectors of contemporary folk art in Lafayette, Louisiana, who included his drawings in "Baking in the Sun: Visionary Images from the South," a traveling exhibition that originated at the University Art Museum of the University of Southwestern Louisiana, Lafayette, in 1987.

SUBJECTS AND SOURCES

Robertson has developed three dominant themes in his work: calendar drawings and drawings chronicling his unhappy marriage; portraits of his former wife and Amazon-like women and children who are labeled as "bad, adulterous, and vipers"; and fantasy paintings of futuristic cities and space travel among the planets. His subjects are usually set against contrasting colors and heavily outlined so that they stand out. To make sure the viewer understands the intended messages in his pieces, the artist includes printed material, sometimes in cartoonlike balloons.

The depictions of "bad women" and futuristic space cities are probably the most interesting of this artist's work. His art shows the clear influence of his well-worn Bible, "girlie" magazines, comic strips, and science fiction.

MATERIALS AND TECHNIQUES

Robertson draws on poster paper with conté crayons, felt markers, and enamel paint. He paints in a colorful, billboardlike style and sometimes glues glitter to the paper for additional effect.

The work is mostly around 28 by 22 inches. Robertson often works on both sides of his paper, and it is believed that he has done several hundred images.

ARTISTIC RECOGNITION

The entire body of Royal Robertson's art is colorful and charged with energy; it is the work of a visionary eccentric who has many messages to preach. His bold style and obsessive images have attracted a great deal of attention among collectors, and his work is receiving some public recognition through exhibitions.

SIMON ("SAM") RODIA—*"I had it in my mind to do something big and I did."*[1]

BIOGRAPHICAL DATA

Born April 15, 1875, Italy (probably a village near Naples). Little formal education. Married 1900; divorced about 1913 (wife's name unknown). No known children. Died July 17, 1965, Martinez, California.[2]

GENERAL BACKGROUND

Simon Rodia was the creator of *Watts Towers,* the most famous folk art environment in the country.

When he was ten or eleven years old, Rodia's parents sent him to America to join an older brother in Pennsylvania. He received little education, but tried to teach himself by reading the *Encyclopedia Britannica.* After his brother was killed in an accident, Rodia began to travel and work at such jobs as a laborer in logging and mining camps and a tile setter.

By 1919 he had settled in Long Beach, California, but in 1921 moved to 107th Street in Watts, an area in south central Los Angeles not far from the International Airport. Watts was then a largely Spanish-speaking neighborhood, and Rodia was known variously as Sam Rodia, Sam Rodilla, or sometimes "El Italiano." Although he held construction jobs on and off, his principal occupation soon became working on the soaring towers that began to rise on his land. Rodia averaged eight hours every day working on his structures, an obsession that continued until 1954, when he closed his door, deeded the property to a neighbor for the price of a bus ticket to Martinez, California, where he had some family, and left, telling the neighbor that he was going away to die.

Rodia was not heard of again until 1959, when he was discovered living in Martinez, about 500 miles from his towers. Rodia refused to explain his actions, either the building of the *Towers* or his departure, and died in 1965 with many questions still unanswered.[3]

ARTISTIC BACKGROUND

Single-handed, without assistance, with imagination and unbelievable perseverance, Simon Rodia created the most famous folk art site in the country: the *Watts Towers.* Although he had built some much smaller decorated concrete structures when he lived in Long Beach, the *Towers* was clearly an inspired and significant construction. He began work on it shortly after moving to the Watts area in 1921.

Initially, the *Watts Towers* attracted little attention, but in 1951 Jules Langsner, an art critic, discovered and wrote about it. The following year William Hale, a student of filmmaking at the University of California, recorded Rodia at work. After Rodia left Watts, the *Towers* was not cared for, and in 1959 the city of Los Angeles suggested demolition. When located and informed of the demolition threat, Rodia said, "I don't want to have anymore to do with them."[4]

Simon Rodia, Watts Towers, *1921–1954. Mixed-media environment (cement, bottles, dishes, seashells, mirrors, and steel rods), as high as 99½ ft., Los Angeles. A major tourist attraction, Simon Rodia's soaring towers contain mosaic inlays of various materials.*

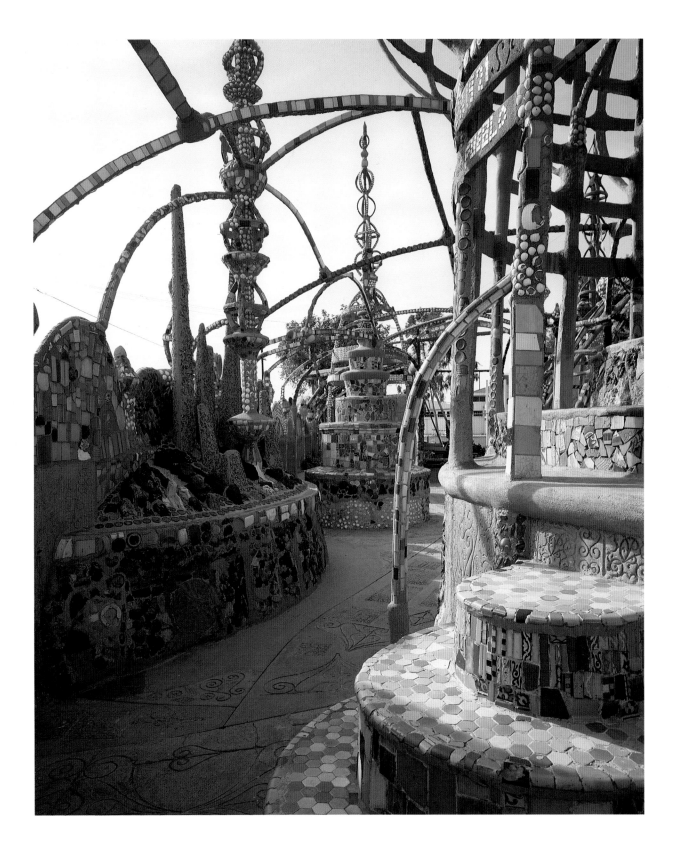

Public resistance, however, proved to be strong, and the controversy over whether or not to destroy the *Watts Towers* brought ever-increasing recognition to the site. A dedicated group that was formed to preserve the magnificent structures administered the *Towers* for a number of years, and the site is now the property of the state of California, which leases it to the city of Los Angeles.

SUBJECTS AND SOURCES
Surrounding the *Towers,* a scalloped mosaic wall faces the street. Inside, on a triangular lot, there are three large towers and four smaller towers, plus a series of fountains, birdbaths, decorated walkways, a ship model, and a gazebo. On the outside of the gate and repeated three or four times on the tallest tower is etched "*Nuestro Pueblo*" ("Our Town" or "Our People").

Although Rodia never said so, there is reason to believe that the inspiration for the *Towers* may have been *giglios,* elaborate towerlike structures that are used as part of some religious celebrations in Italian communities. It is possible that Rodia had seen *giglios* during his childhood in Italy.[5]

MATERIALS AND TECHNIQUES
The 99½-foot-high tower and the smaller towers are constructed of steel reinforcing rods and wire mesh covered with cement. Everything in the garden—the towers, fountains, birdbaths—is a multicolored mosaic, the surfaces embedded with thousands of fragmented and whole bottles, broken dishes, mirrors, more than 72,000 seashells, impressions of tools, hands, and corncobs. Except for the steel and cement, the materials were all discards, some brought to Rodia by children in the neighborhood. Not a single bolt, weld, or rivet holds the *Towers* together.[6]

ARTISTIC RECOGNITION
The *Watts Towers* complex is a major tourist attraction and is listed in the National Register of Historic Places. Art historians have called it "the paramount achievement of folk art in the United States." A curator of the Los Angeles County Museum of Art has said, "The towers are Los Angeles's only art monument; we usually suggest that visitors go there, because they are really [our] Parthenon."[7]

JOHN ROEDER

BIOGRAPHICAL DATA
Born July 7, 1877, Bollendorfebrück, Luxembourg. Left school in Luxembourg at the age of twelve. Married Amelia Becker, 1903; she died 1958. Two sons, one daughter. Died July 31, 1964, Richmond, California.[1]

GENERAL BACKGROUND
John Roeder, a West Coast artist, was best known for the unusual paintings he did during his "blind man" period.

Roeder farmed and worked in steel mills in France before bringing his family to Richmond, California, in 1909. In California he worked as a pipe fitter for the Standard

John Roeder, Fire of Love, *1960. Oil on cardboard, 26¾ × 46 in. Museum of American Folk Art, New York; Gift of Chuck and Jan Rosenak. This imaginative Crucifixion, which conveys the power of the artist's personal mystical beliefs, was created during the years when Roeder was nearly blind.*

Oil Refinery until 1915, when he bought a small farm in Sonoma, California.

The Roeder family gave up the farm in 1928 and returned to Richmond, where Roeder became gardener for the Richmond Union High School, a job he remained in for almost twenty years, retiring in 1947.

ARTISTIC BACKGROUND
John Roeder was a gardener, painter, and sculptor. Over the years he created a garden around his house that actually became a miniature village, complete with chapel, concrete figures, and animals on which children could play. Roeder began construction of the garden when he returned to Richmond in 1928 and also began to paint at about the same time.

The artist concentrated more heavily on his painting after he retired, but in 1952 his eyesight became impaired. A staunch Catholic, Roeder attributed his weakened sight to a vision he had had of the Virgin Mary.[2] From 1952 until 1958 he discontinued painting, and when he started again, he signed his work "John Roeder the Blind Man." These later paintings tend to be larger and the subject matter is heavily outlined.

Roeder was discovered by Henry Schaefer-Simmern, who taught at the University of California at Berkeley. In 1962 Roeder was given an individual show at the Richmond Art Center in his hometown, and since then his work has been widely exhibited on the West Coast.

SUBJECTS AND SOURCES
Roeder painted landscapes, some of which were imaginary, but most of which were of gardens and buildings that he knew and that were important to him. He also

painted religious scenes, pictures of family outings, and portraits. Roeder often incorporated stories and poetry into his paintings, and when he told stories about his family, he worked in a linear manner, from left to right, enlarging central figures out of proportion for the sake of emphasis.

The artist's sculpture consisted of concrete outdoor figures, some of them larger than life, intended as garden decorations, and a series of smaller whimsical pieces, mostly animals, created for the entertainment of children. The small chapel that he built was decorated with his sculptures and paintings on glass.

MATERIALS AND TECHNIQUES

The sculptures were made of concrete poured over an armature of window screening, pipes, and plumbing fixtures and painted with house paint. Roeder did some reverse-glass paintings, but most of his paintings were done on mirrors, paper, and Masonite. Sometimes the artist mixed sand into his paint to create texture.

Roeder painted about two hundred pictures, ranging from about 1 to 2 feet square. There were approximately fifty sculptures in the garden.

ARTISTIC RECOGNITION

The work that John Roeder did during his "blind man" period is undoubtedly some of the most unusual folk art of recent years. His narrative style, his use of color, and his persistence in the face of adversity have earned him a significant position among the best of the California folk artists. His garden survives only in photographs; most of his paintings are now in private collections, and the sculpture that was saved is now in the Richmond Art Museum in California.

JUANITA ROGERS—*"No, m'am; I'm not an artist—just an artist worker. An artist makes things perfect. An artist worker makes them sloppy like."*[1]

BIOGRAPHICAL DATA

Born May 12, 1934, probably North Montgomery, Alabama. Attended Nazareth Catholic Mission, Billingsley School, and Booker T. Washington School, Montgomery, Alabama, through ninth grade. Married Sol Huffman, 1966, by common law; he died 1981. No children. Died January 26, 1985, Montgomery, Alabama.

GENERAL BACKGROUND

Juanita Rogers, a black artist, created unusual small sculptures that she called "funny bricks" and watercolor drawings filled with popular icons.

Rogers spent much of her life in a black neighborhood of North Montgomery known as Tin Top. She insisted, however, that she was born in a place called Indian and came to Montgomery via a carnival freight train at the age of five.

Rogers had several short periods of employment as a waitress/dishwasher, which included working at the well-

Juanita Rogers, Girl with Fish, *c. 1982. Mixed media on paper, 17¾ × 31 in. Anton Haardt Studio/Gallery, Montgomery, Alabama. This whimsical drawing indicates the artist's innate skill and sense of humor.*

known Montgomery restaurant, The Sahara. Like most other members of her immediate family, she also worked for Mr. and Mrs. Spears Rhodes, a prominent Montgomery family, as a domestic.[2] Mr. Rhodes owned a brickyard, which may have given rise to the term "funny brick" that Rogers later used to describe her sculpture.

When Rogers was in her twenties, she had a self-administered abortion. As a result, a tumor formed that steadily increased in size, giving her the physical appearance of being pregnant. She refused medical treatment and, as the tumor developed, became more and more reclusive.

In the late 1970s Rogers and her common-law husband moved to the country, where they lived in a small shack in the middle of a cow pasture. They had only one light fixture and no running water, and they cooked in their fireplace. Their only luxuries were an old portable stereo, a tape recorder, and a black-and-white TV set.

After Huffman died in 1981, Rogers refused to work, stating that she had a job making funny bricks. "During her last years, Rogers began to speak in a poetic way—like she was in another world—a world dominated by TV images."

ARTISTIC BACKGROUND

Juanita Rogers had a compulsive urge to create; she treated her mud works—her funny bricks—with a sense of mission. Television images, which often appear in her drawings, were her principal contact with the outside world, especially toward the end of her life.

"A welfare worker came to me," remembers Anton Haardt, a Montgomery artist who discovered and promoted Rogers's work. "It was in 1981. She knew of my interest in folk art, because I had befriended Mose Tolliver [see page 302] and asked me to help. Juanita was telling everyone that she had a job making funny brick, and employment disqualified her from welfare.

"I brought Juanita paper and did what I could. Then, in

January of 1982, I attended the opening of 'Black Folk Art in America' at the Corcoran Gallery of Art [in Washington, D.C.] and brought Juanita's drawings with me. I sold them all to important collectors and to Janet Fleisher, who runs a gallery in Philadelphia. I knew I had a hit on my hands."

SUBJECTS AND SOURCES

Juanita Rogers made a series of drawings based on television programs; characters like Miss Piggy, the Coneheads, Fat Albert, and others appear in her work. She also depicted black men and women at play. Toward the end of her life, she did a series of drawings of a spaceship. "Rogers believed that the ship had visited her home," Haardt recalls. A giant sun appears in some of her drawings.

The funny-brick sculptures that the artist claimed were her "job" were of animals and mythical creatures, among them goat men and mermaids.

MATERIALS AND TECHNIQUES

Rogers's drawings are on paper (sometimes colored) and drawing board. She used watercolor, pencil, and occasionally acrylics. The funny bricks are a combination of mud and fossil shells mixed with mule and cow bones. The mud is fragile, and the pieces disintegrate easily if moved. Haardt devised a method of preserving the mud by spraying and saturating the sculptures with glue and water, then coating them with polyurethane.

The watercolors of Juanita Rogers range in size from 6 by 12 inches up to about 17 by 31 inches. She made about three hundred watercolors and forty funny bricks.

ARTISTIC RECOGNITION

Juanita Rogers's drawings constitute a body of high-quality work. The funny-brick sculptures are quite different. They are eccentric—nothing like them exists anywhere else—and transporting them is a major problem. Virtually all of the funny bricks are in Anton Haardt's studio. The drawings, however, have been widely disseminated and shown in various galleries. In 1986 the rock group R.E.M. selected one for one of its album covers.

Collectors of folk art once feared that television would bring about a decline in the art form, but Rogers's work shows that this media, enhanced by personal vision, can add a new dimension. Her drawings have been exhibited at a number of museums, including the Anderson Gallery, Virginia Commonwealth University, in Richmond, in 1982.

SULTAN ROGERS—*"I dream about somethin'. I wake up and think about it. I draw an outline and go back to sleep. I remember it when I get up."*

BIOGRAPHICAL INFORMATION

Born May 22, 1922, near Oxford, Mississippi. Attended school for "a few grades," Oxford, Mississippi. Married Ruth Ivory, c. 1941; separated c. 1953. Five sons, five daughters. Now resides Syracuse, New York.[1]

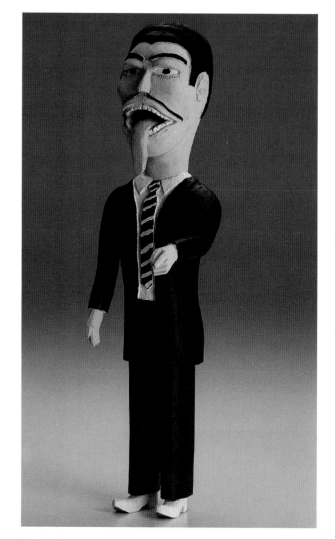

Sultan Rogers, Man in Striped Necktie, *1988. Painted wood, 15 × 4¼ × 5½ in. University Museums, University of Mississippi. An accomplished carpenter, Rogers turned to carving satirical forms for his own amusement. This witty example is representative of the artist's recent work.*

GENERAL BACKGROUND

Sultan Rogers, a black artist who was reared in the South, is gaining a reputation for his humorous, sometimes satirical carvings.

Rogers learned the trade of carpentry from his father and then, in his words, "took off for the North. I could always get a job, so I didn't stay in one place long—Memphis, St. Louis, Chicago, Ohio, and New York." During the war years he spent some time in the army (from 1943 through 1944), stationed in Texas.

Rogers finally settled in Syracuse, New York, in 1952 to work as a carpenter. In 1970 he went to work for Allied

Chemical, overseeing equipment that monitored the processing of soda ash. He retired in 1984.

Oxford, Mississippi, still holds a firm place in Rogers's affections. He often returns to visit his family and is thinking of returning there to live.

ARTISTIC BACKGROUND

As a small boy, Sultan Rogers learned how to carve small likenesses of rabbits, dogs, and horses from his father, who was a skilled whittler as well as a carpenter. While working for Allied Chemical in Syracuse, he often had time to carve on the job, as long as the machinery was operating properly. "I did it to keep from sleeping," he explains.

Rogers's work was discovered by William Ferris, director of the Center for the Study of Southern Culture at the University of Mississippi. "I brings my things to Oxford," the artist says, "and Mr. Ferris buys 'em for the museum."

SUBJECTS AND SOURCES

In his dreams Rogers sees "futures," which is what he calls the images of what he plans to make, and then, upon awaking, "I carves them out," he says. "I can make most anything I can imagine a future of," Rogers boasts.

The artist has made carvings of men and women he knows, animals, snakes with vicious-looking fangs, and vampires. He sometimes puts a man in a coffin; when the figure is lifted out, there is a space for hiding valuables underneath. "People's afraid of the dead," he says. "They won't take noth'n out of a coffin."

In addition to carving, Rogers paints, usually portraits that have exaggerated expressions that give them a cartoonlike quality. His sculptures of people he knows often have dramatic expressions and are amusing caricatures.

MATERIALS AND TECHNIQUES

Rogers prefers to carve soft woods like sugar pine or gum. He uses paint sparingly, favoring natural finishes such as varnish for his work. He will often incorporate other materials into his pieces for effect, such as glass diamonds for snake eyes and wire for the teeth and fangs.

The number of works produced by this artist is unknown but estimated to be quite large. While many of the pieces are small, he is carving a *Statue of Liberty* for the city of Oxford that will be 4 feet tall. Rogers hopes someday to sculpt a version of the *Last Supper* in which a black Jesus and his disciples will be joined by Martin Luther King, Jr., and presidents John F. Kennedy and Lyndon B. Johnson.

ARTISTIC RECOGNITION

Sultan Rogers is not yet well known, but his satirical carvings, his clever depictions of animals, and his caricatures of people mark him as an important new artist. His work, which is included in the collection of the University of Mississippi Art Museum and in the State Historical Museum, was also featured in "Black Art—Ancestral Legacy: The African Impulse in African-American Art," a traveling exhibition that opened at the Dallas Museum of Art in Texas in 1989.

BILL ROSEMAN—

> " *When somebody needs a lift,*
> *Don't send him adrift;*
> *When Nations face each other,*
> *Brother against brother;*
> *When bombs will tear them apart,*
> *Destroy the bombs;*
> *Have a heart.*"
> *(Lyrics by Bill Roseman)*

BIOGRAPHICAL DATA

Born December 16, 1891, New York City. Graduated from Hebrew Technical Institute, New York City. Married Frances Schnapper August 12, 1916; she died 1949 (Roseman adds, "I married four more times—one or two good—some not so good, but none of your business"). Two sons by Schnapper. Now resides Brooklyn, New York.

GENERAL BACKGROUND

Bill Roseman's paintings are inspired by a number of sources, from family evenings at home to biblical events.

After graduation from Hebrew Technical Institute, a vocational training school in New York City, Bill Roseman

Bill Roseman, The Champion, *1964. Oil on canvas, 30 × 36 in. Epstein/Powell Gallery, New York. This domestic scene reflects one interest of the artist's; his works often convey a sense of violence ready to erupt.*

worked for seventeen years in various industrial plants, at one point becoming a foreman for American Machine and Foundry's Brooklyn division. In October 1924 he became a teacher of industrial and applied arts in the New York City school system. He taught at five high schools, retiring in 1957 from Midwood High School.

Roseman took adult education courses at the Brooklyn Museum's Art School and at various senior citizens centers between 1940 and 1974. "Thank God, they left me alone," he says. "I went there when I was lonely—more for the company than for the learning." He is a songwriter ("I have fifty songs copyrighted," he boasts, "but none sung, except privately") as well as an artist. Both his sons are artists and teachers.

ARTISTIC BACKGROUND

Roseman started painting in the 1940s, but he progressed very slowly and made no attempt to sell his work. In the late 1970s, he relates, "I was alone and feeling lonely, so I went to a senior citizens center in Brooklyn to paint. Gene [Gene Epstein, a private dealer in folk art] called the center and said, 'Hey, you got any good painters over there?' That's how he discovered me."

At the age of ninety-eight, Roseman still paints daily at his home in Brooklyn. His hand may not be as steady as it was in the 1950s, but his imagination is as vivid as ever.

SUBJECTS AND SOURCES

"My subjects are universal," Roseman says. He preaches against war, for religion, and for the family in his paintings: "I paint God—not male, not female. If you don't follow God's word, the world will blow up, and I show that."

Popular illustrations, especially of biblical events, find their way into Roseman's work, although his antiwar paintings are his most powerful. Sometimes his paintings also depict cozy family scenes, celebrations, musical gatherings, and religious observances.

MATERIALS AND TECHNIQUES

Roseman paints with oils or acrylics on canvas or canvas board. He estimates that he has painted three hundred pictures, some in sizes as large as 38 by 44 inches.

ARTISTIC RECOGNITION

Roseman is not yet widely known, but his work has found its way into books on twentieth-century folk art and his reputation is steadily growing.

NELLIE MAE ROWE—*"They weren't real drawings, 'til people come and take them away." "On good days I feel close to God on this terrace. Call him up—ask Him what he wants—He'll hear you."*

BIOGRAPHICAL DATA

Born Nellie Mae Williams, July 4, 1900, Fayetteville, Georgia.[1] Attended school through fourth grade ("I never got beyond the fourth grade—had to work in Father's fields"). Married Ben Wheat, 1916; he died 1936. Married Henry Rowe, 1936; he died 1948. No children. Died October 18, 1982, Vinings, Georgia, on the Chattahoochee River.

GENERAL BACKGROUND

From early childhood Nellie Mae Rowe, a black artist known for her vibrant, colorful work, used art to escape from the drudgery of everyday life.

"My daddy lived in slavery time," Rowe explained, when talking about her background. "They used to feed people in troughs, like the hogs." She used to help her father on his farm but never liked the work. "I married at seventeen," she said, "and found out that I was still a field hand. Married again at thirty-six, and I was still at it."

In 1930 Rowe and Ben Wheat, her first husband, moved to a small farm in Vinings, now a suburb of Atlanta, Georgia, and she worked as a domestic for a neighbor across the road. In 1936, after the death of her husband, she married Henry Rowe and they built the basic two-room house in which Nellie Mae would live for the remainder of her life. She had two small electric organs, one in each room, for the playing of gospel music. "I spend more time at home singing hymns, playing the organ," she said, "than in church. Here I can call Him up and ask Him what He wants."

The home had a pleasant entranceway terrace with a nice shade tree where Rowe would sit, draw, and sew. When she was again widowed in 1948, she began to decorate her terrace and yard. She hung "Real Lemon and Lime" plastic containers from the shade tree and placed artificial flowers and found objects, including old dolls, on the walls.

ARTISTIC BACKGROUND

Rowe began to draw when she was a child; she remembered sometimes escaping (in her mind) from the drudgery of daily life by lying on her stomach and drawing. She learned how to sew from her mother, who taught her how to make quilts and dolls as well.

After her husband, Henry, died, Rowe began to spend more of her time drawing and decorating her house. A house decorated in her fashion in the growing suburbs of Atlanta, however, was bound to attract attention. "At first," she said, "they threw rocks." Then people came to visit and take photographs, and then they came to see the artist's other work—her drawings and her sculpture.

Rowe's work was included in "Black Folk Art in America: 1930–1980" at the Corcoran Gallery of Art in Washington, D.C., in 1982; she was too ill to attend the opening, where she had been invited to meet President and Mrs. Reagan.

SUBJECTS AND SOURCES

Rowe explained, "I just draw things the way I sees them. I see people crippled and I draw them to ask the Lord to help. . . . The pictures I am proud that I have made are of my hand. . . . When I am gone they can see my hand . . . and say 'that is Nellie Mae's hand.'"[2] Many of her drawings are of images born of her imagination; others present

remembered scenes or common things—such as a pig or other farm animals—in an innovative and intriguing way.

Rowe told stories about the people around her—friends and family. She never forgot the Lord, and she painted for His pleasure and to ask Him for divine intervention to help those she cared for.

MATERIALS AND TECHNIQUES

Rowe's earliest drawings were done on scraps of paper, Styrofoam meat containers, cardboard boxes, whatever she could find. By the 1980s friends and an Atlanta dealer, Judith Alexander, were supplying Rowe with high-quality drawing paper for her work. She liked her drawings to be colorful; first she outlined her subject matter with pencil and "then I use my color. I don't care if the color is ink, watercolor, crayon, or pencil."[3] She also used felt markers, which are unstable in sunlight, and occasionally acrylics.

Rowe's drawings range in size from 5 by 8 inches up to 18 by 30 inches. It is estimated there may be as many as three hundred of them.

Rowe made sculptures as well—pieces of wood painted with acrylics that reflect some of the same bright characteristics of her drawings and sculptures made of chewing gum. A doctor once told Rowe to chew gum to make her less nervous. She saved the gum and then made sculptures of it—usually animals or fantastic (and not always beautiful) heads. She would decorate these sculptures with found objects and paint them in vibrant watercolors.

To keep her company after her husband's death, Rowe assembled marvelous doll personages that were stuffed with rags and adorned with wigs and eyeglasses. She also made a few colorful appliqué quilts.

Nellie Mae Rowe, Fish on Spools, *1980. Acrylic on wood, 7½ × 25 × 1½ in. High Museum of Art, Atlanta, Georgia; Purchased with funds donated by Georgia Designer Craftsmen. The artist's sculptures reflect the same highly imaginative and vivid style that characterizes her paintings. This fish is a favorite example of her work.*

Nellie Mae Rowe, Woman Warning Black Dog Not to Eat Too Many Mulberries, *1978. Wax crayon on paper, 19 × 24 in. Museum of American Folk Art, New York; Gift of Judith Alexander. Rowe chronicled memories of everyday activities in a colorful and original style, as in this amusing depiction of a woman scolding her dog.*

Preservation of some of Rowe's earlier work is difficult, and very few of her dolls, gum sculptures, and quilts have survived.

ARTISTIC RECOGNITION

Nellie Mae Rowe expressed her creativity and imagination through several media. Her dolls, quilts, and gum sculptures are very rare, so her lively and colorful drawings and paintings must be considered as her legacy to the world.

In addition to the Corcoran show, Rowe's work has been included in major exhibitions in Georgia and at the Library of Congress in Washington, D.C., and she has had solo exhibitions at galleries in Atlanta and New York.

IDA SAHMIE—*"My relatives believe that when I burn the Yei images on my pots, I burn the gods themselves. I'm unsure—so I had a 'Blessing Way' conducted to protect my work and myself. So far, no harm has come to me."*

BIOGRAPHICAL DATA

Born Ida Nobell, May 27, 1960, near Pine Springs, the Navajo Nation, Arizona. Graduated from Ganado High School, Ganado, the Navajo Nation, Arizona, in 1978. Married Andrew ("Louie") Sahmie, July 24, 1986. One son, one daughter. Now resides just south of the Hopi village of Polacca, Arizona.

GENERAL BACKGROUND

Ida Sahmie is a Native American potter who combines Hopi and Navajo elements with her own designs in her graceful vessels.

The Navajos have been feuding with their Pueblo neighbors—the Hopis—for more than a century, but Ida Sahmie, a Navajo from a family of weavers, decided to marry a Hopi man. Her husband, Louie, is a well-known kachina carver and a member of the most famous family of Hopi potters in the Southwest. Her mother-in-law, Priscilla Namingha, is the great-granddaughter of Nampeyo (see page 223), the woman who revitalized Hopi pottery making at the turn of the century.

For a short time the Sahmies lived with Ida's relatives in Pine Springs, Arizona. They presently live and work in a trailer south of the Hopi village of Polacca.

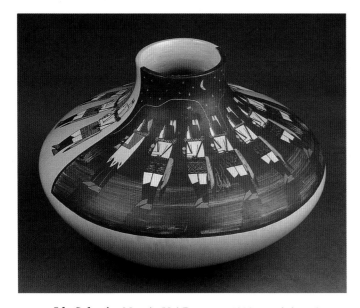

Ida Sahmie, Navajo Yei Dancers, *1989. Fired clay, clay slip, and beeweed, 6⅛ × 9 in. diameter. Robert and Dorothy Walker. Sahmie, a Navajo, makes thin-walled, beautifully shaped vessels in the classic Hopi way but decorates her pots with nontraditional Navajo designs, such as the yei dancers in this example.*

ARTISTIC BACKGROUND

Sahmie started potting in 1984 after visiting her future mother-in-law. "I wanted something to do with my hands," she said; "I had been watching Priscilla and thought I should try too."

Sahmie learned to pot in the traditional Hopi manner. Some of her Hopi in-laws, however, have been displeased by Sahmie's pottery making, and she is not allowed to repeat their traditional designs. A feud with her sisters-in-law (two of the best-known Hopi potters of the present younger generation of Nampeyos) during 1987 pushed their rivalry over pots into the Navajo Tribal Court in Window Rock, Arizona.

Sahmie's pots, reflecting the excellence of Hopi craft and her own unusual designs, are outstanding. When she started, she took her work to the Keams Canyon Trading Post in Arizona, which immediately agreed to handle her work. Sahmie does not exhibit at fairs or markets.

SUBJECTS AND SOURCES

Sahmie has developed thin-walled, beautifully shaped vessels; in fact, they are so thin that many break in the firing process. Because Sahmie cannot use the Hopi designs, and design other than very restricted decoration is taboo on Navajo pots, she has developed a unique and very nontraditional style of her own.[1] Her inspiration is from Navajo ceremonies, and she is probably the only potter who depicts night scenes—the night sky, bonfires, and dancers—using only traditional materials.

Sahmie breaks Navajo taboo by depicting *Yeis* on her pottery.[2] But because she is a traditional Navajo in many ways, she had a sing conducted—"The Blessing Way," a nine-day ceremony that is both curative and preventative—both to protect herself from the ramifications of a broken taboo and to keep her relatives happy.

MATERIALS AND TECHNIQUES

Ida Sahmie uses Hopi clay for her pots. She forms her clay into coils that she winds into shapes, then polishes the pot with a river stone that has been worn smooth.

Sahmie has developed subtle slips of soft yellow and tan from clays that she discovered herself (she will not reveal the sources). Besides the slips, she uses beeweed for color.[3] She applies the slips and beeweed to the pots with yucca needles, creating lines as thin and delicate as any found in the works of potters using more contemporary tools.

Sahmie fires the clay in her backyard and her husband helps with the firing. The pots, which rest on a metal grate so that they do not come in contact with the wood ash, are fired with cedar in an open pit.

The diameter of Sahmie's pots range from only 5 inches to about 20 inches. She says that she breaks so many pots in the firing process that only about twenty a year survive.

ARTISTIC RECOGNITION

Ida Sahmie has not made enough pots to be well known outside a small circle of collectors of southwestern Native American pottery, but her reputation is fast-growing. Her *Yei* scenes, especially the night scenes, are unparalleled in

other modern southwestern pottery. The artist was featured in an exhibition at the Museum of Northern Arizona in 1990.

ANTHONY JOSEPH ("TONY JOE") SALVATORE—*"My work is about the relationship with the Lord."*

BIOGRAPHICAL DATA
Born March 20, 1938, Youngstown, Ohio. Attended school through tenth grade, Youngstown, Ohio; took correspondence courses through W. B. Grant Bible College, Dallas, Texas. Single. No children. Now resides Youngstown, Ohio.[1]

GENERAL BACKGROUND
The only "steady job" Tony Joe Salvatore has ever had is, as he says, "painting in the service of the Lord." According to this religious folk artist, various people have always supported his endeavors, and from 1975 through 1981 a prominent businessman furnished him with financial aid so that he could devote himself to study of the Bible through correspondence courses. He became an ordained Pentecostal minister while supporting himself for three-and-a-half years working in the laundry of the Seminary School Society of the Mission of the Sacred Heart in Chicago, Illinois.

Salvatore has suffered from a variety of serious illnesses throughout his life. He also had to undergo a series of spinal operations as a result of an automobile accident in 1973.

ARTISTIC BACKGROUND
Tony Joe Salvatore claims he has been painting all his life,

Anthony Joseph Salvatore, Untitled, *1983. Craypas, acrylic, oil, and hairspray on canvas, 52 × 72 in. Estelle E. Friedman. Salvatore's semiabstract mystical images have a subtle beauty, but the precise message of the artist is not always easy to decipher.*

but his creative activity is known to have increased substantially after his automobile accident in 1973.

David Colts, a dealer from Youngstown, Ohio, discovered Salvatore in the late 1970s, befriended him, and now acts as his agent. The artist was included in "Muffled Voices: Folk Artists in Contemporary America" at the Museum of American Folk Art in New York City in 1986 and was given a one-person show by the Akron Art Museum in Ohio in 1989.

SUBJECTS AND SOURCES
"I paint what Christ directs me to paint," Salvatore explains. "I have been directed by the Lord to illustrate all sixty-six books of the Bible." He works from the Lamsa Bible, an English translation of the Peshitta (Aramaic or Syriac) Bible. According to Salvatore, the color and composition of his paintings are strict (albeit abstract) translations of his visions and the biblical text.

The artist uses a vivid palette with many greens and blues. He layers wax and paint in order to build up the surface of the work so that it appears almost translucent; light seems to come from within. His messages are abstracted from their source and diffused through the mind and hand of the artist, making them not always easily accessible to the viewer. On another level, however, the work can be appreciated for its beautiful, serene, and mystical passages.

MATERIALS AND TECHNIQUES
The artist is known for his paintings on fine linen canvas, which are primed with a layer of gesso. He sketches the subject onto the canvas with pencil and then paints with acrylics and Craypas. He adds wax encaustic and sometimes builds the paint to a depth of fifteen layers. When finished, he covers the work with hair spray to fix the paint.

Salvatore states that he has completed ten thousand canvases, although no verified count is available. Most are about 18 by 24 inches, but a few are very large—up to 36 feet long.

ARTISTIC RECOGNITION
Tony Joe Salvatore's mystical religious and biblical illustrations are an important contribution to contemporary folk art. His quiet messages contrast with other biblical artists of this century, and his technical proficiency sets him apart as a skilled colorist and illustrator.

The paintings of Salvatore have found an interested audience among discriminating scholars in the field. His work is included in the permanent collections of the Museum of American Folk Art and the Akron Museum.

MARIO SANCHEZ—*"Se que mi modesto arte no es bueno, pero gusta." ("I know that my modest art is not good, but it pleases.")*[1]

BIOGRAPHICAL DATA
Born October 7, 1908, Gato's Village, Key West, Florida.

Educated at the Otto L. Schultz Business Institute, Key West, Florida. Married Rosa de Armas, June 5, 1929. No children. Now resides Key West (winters) and Tampa, Florida (summers).[2]

GENERAL BACKGROUND

Mario Sanchez, an important Cuban-American folk artist, carves detailed bas-reliefs depicting life in the Key West town where he was born and grew up. Gato's Village no

Mario Sanchez, Hemingway House, *c. late 1970s. Painted wood relief, 19½ × 39 in. Key West Art and Historical Society, Key West, Florida. Sanchez enlivens this house, now a well-known tourist site in Key West, with a street scene of earlier times and with characteristic dreamlike images among the clouds.*

longer exists, but in the nineteenth and early twentieth centuries it supported a Cuban community and flourished as a headquarters for as many as 116 cigar factories.

After leaving business school, Sanchez worked for the Meltzer Navarro Real Estate Company in 1925 and then as a court reporter and translator for a lawyer at the Monroe County courthouse in Key West. He was not interested in steady employment, however, and in the 1930s he wrote skits and directed plays in Spanish at the San Carlos Theatre, pitched for the Key West Pirates, and generally lived as he chose. Later Sanchez became a janitor at the Key West Museum, but by 1970 he was supporting himself through the sale of his art.

ARTISTIC BACKGROUND

Sanchez started carving in the 1930s and sold his first work

in 1946. He soon developed a large local following; the Key West Art and Historical Society bought fifty of his carvings and fifteen other objects, many of which are on permanent display at the East Martello Gallery and Museum in Key West.

SUBJECTS AND SOURCES

Sanchez documents the sights and sounds of old Key West —the streets, the houses, and the stores—in the form of bas-relief carvings. He sits outside and carves on a table in the middle of what used to be Gato's Village, remembering how it looked in his youth. Black funeral processions dressed in early-twentieth-century finery, delivery wagons and streetcars, colorful Conch homes, and Cubans dressed in the costumes of Key West, celebrating in the city—all are subjects for his skill.

MATERIALS AND TECHNIQUES

Sanchez makes preliminary sketches on brown paper bags and traces them onto the wood (he often keeps his sketch and the carving together). He works with white pine, cypress, or cedar, carving deeply into the wood with chisels, broken glass, and razor blades, and he paints the finished carvings with oil-base paints thinned with castor oil.

The artist also adds other materials to give a more realistic sense to his carvings. Clear glue may be used for windowpanes, egg yolks for fruit (it dries to look like bananas), coffee grounds or cat litter for street surfaces, and glitter for dazzle.

Sanchez has carved around 450 bas-reliefs, plus a number of other objects, such as fishes and pelicans. The bas-reliefs range from about 10 by 20 inches to 20 by 40 inches.

ARTISTIC RECOGNITION

Mario Sanchez is considered the best Cuban-American folk artist of this century. His memory carvings are both decorative and historically significant, documenting as they do the life of the Cuban community in Key West at the turn of the century. His earlier works, done before about 1970, are more muted in tone (they contain less glitter) and are of greater interest. Sanchez has been widely exhibited in Florida and was included in the traveling show "A Separate Reality: Florida Eccentrics," organized by the Museum of Art in Fort Lauderdale in 1987. The artist is the subject of a film, *Mario Sanchez, Painter of Memories,* by Bowling Green Films, and he was featured in a 1970 ABC *Discovery* film about Key West.

ALEJANDRO ("ALEX") SANDOVAL—*"I'm so thankful that the Lord finally gave me a gift."*

BIOGRAPHICAL DATA

Born May 22, 1896, Cañoncito (between Santa Fe and Pecos), New Mexico. Attended school through fourth grade, Pecos, New Mexico. Married Josefita Garcia, 1920; she died December 16, 1968. Married Isabel Garcia (not related), 1974. Four daughters, two sons by Josefita Garcia. Died March 2, 1989, El Paso, Texas.

GENERAL BACKGROUND

Alex Sandoval was seventy-nine years old when he first began to make his lively and often whimsical wood carvings.

Sandoval was born on his grandfather's farm in Cañoncito, New Mexico; his mother died when he was an infant, so he lived among various relatives while he was young. When grown, Sandoval went to work in the coal mines in Silver City, New Mexico, and then in iron mines in Arizona. He served in the army during World War I and later worked at the army officers' club in El Paso, Texas, retiring in 1971.

In 1974 Sandoval married for the second time and moved into a trailer on the west side of Santa Fe, New Mexico. He played the fiddle and danced with a group

Alejandro Sandoval, Conquistador, *c. 1984. Wood, nails, brass tacks, leather, and house paint, 16½ × 3 × 16¾ in. Private collection. While Sandoval's carvings are influenced by the* santero *tradition, his subjects are original, as evidenced by this formidable cavalryman ready for battle.*

called the Colonials, who were dedicated to preserving Hispanic customs at the annual Fiesta. In 1986, when he became seriously ill, Sandoval moved to El Paso, Texas, where his daughter Ida Revera could take care of him; his wife's health was too poor to allow her to care for him. Before his death he moved into a nursing home in El Paso.

ARTISTIC BACKGROUND
Alex Sandoval's neighbor was the *santero* Frank Brito (see page 62). Around 1975 Brito persuaded his friend to try his hand at carving, and, to his surprise, Sandoval discovered that the Lord had selected him to be an artist. Sandoval and Brito took the carvings to galleries on Santa Fe's Canyon Road and were successful in selling them.

SUBJECTS AND SOURCES
Sandoval was not a carver of *santos,* although his work

shows the strong influence of that Hispanic tradition. He carved animals, religious figures such as Christ walking on water, and conquistadors on charging steeds, applying his unique vision and sense of humor to his imaginative works.

MATERIALS AND TECHNIQUES
Sandoval carved aspen and pine with simple hand tools. He did not paint his pieces himself. According to Isabel Sandoval, his second wife, "He was color blind, so I painted them with watercolor and house paint. The colors were my idea, so they'd look right."

Sandoval made about two hundred carvings, ranging in size from 2 inches to about 20 inches in height.

ARTISTIC RECOGNITION
As Alex Sandoval aged, his carvings began to lack definition but gained in charm and whimsy. His work was exhibited at the Museum of American Folk Art in New York City in 1985 and is included in the museum's collection.

JOHN ("JACK") SAVITSKY—

*"Worked in the coal mines 30 years,
and 5 years as a coal breaker.
I went to school.
I went to church.
I went to work.
And on pay day, I went out and got drunk."
(Written on the back of a 1975 self-portrait)*

BIOGRAPHICAL DATA
Born January 24, 1910, New Philadelphia, Pennsylvania. Attended school through sixth grade, Sacred Heart School, New Philadelphia, Pennsylvania. Married Mae Spack, August 1932. One son. Now resides Lansford, Pennsylvania.

GENERAL BACKGROUND
Jack Savitsky ("Coal Miner Jack") documented the life and hardships of the Pennsylvania coal miner through his sharp and colorful paintings.[1]

After finishing sixth grade, Savitsky, like his father before him, went underground to work. He was only twelve years old when he landed full-time employment as a slate picker at the Kaska Colliery, near Pottsville, Pennsylvania.

During his later youth Savitsky also worked for a sign painter in his spare time and painted barroom murals and mirrors in exchange for whisky. In the early 1940s he became a contract miner (that is, he ran a crew that was paid by the number of cars full of coal that the crew brought out of a mine) at No. 9 Colliery, in Coaldale, Pennsylvania. The work was long, arduous, dirty, and dangerous, but it allowed the Savitskys to buy a red-brick coal-town row house in Lansford, where they still reside today.

When the No. 9 Colliery closed in 1959, Savitsky was already suffering from black lung disease and could not get another job; coal mining was all he knew. He retired on Social Security. Today, his coal-mining legacy includes emphysema as well as black lung, and he also has cataracts.

John Savitsky, Train in Coal Town, *c. 1975. Oil on board, 33 × 25 in. Museum of American Folk Art, New York; Gift of Mr. and Mrs. Gary Stass. Through such colorful paintings as this, Savitsky documented the hard life of the Pennsylvania coal miner and his environs. The painting's bright colors and cartoonlike figures contrast sharply with the dangers and difficulties the miners faced each day.*

ARTISTIC BACKGROUND

When the mine closed in 1959 and Jack Savitsky was out of work, his son Jack Savitt, a newspaperman, suggested that his father take up painting. Savitsky thought, "What the hell, why not?" and so he did, thinking of it at first as recreation but soon realizing that there was more to it.

By 1961 Savitsky had joined the cadre of artists painting with Sterling Strauser, a neighbor in East Stroudsburg, Pennsylvania.[2] Strauser, an accomplished artist himself and a collector, helped folk artists whom he had befriended to exhibit at local fairs and flea markets. He also bought any work they cared to sell and showed it to interested collectors and museum curators.

SUBJECTS AND SOURCES

Jack Savitsky paints the Pennsylvania coal country—its mines, its miners, and the surrounding landscape. He is the only folk artist who has illustrated the miner's workplace. His paintings are stunning in their impact, getting to the core of the drudgery and difficulties of the miners' daily life, and the flatness of his images only seems to emphasize the hazards of their work.

Savitsky has also painted a series of religiously motivated pictures: peaceable kingdoms and studies of Adam and Eve. Some of this work was influenced by postcards and illustrations.

MATERIALS AND TECHNIQUES

The artist paints on canvas board and Masonite with oils and acrylics; he draws on paper with watercolor, colored pencils, pens, and pastels.

His work ranges from only a few square inches up to 3 by 4 feet. Savitsky has completed about eight hundred oils and three thousand drawings since he took up his new occupation.

ARTISTIC RECOGNITION

Jack Savitsky's early paintings, especially his portraits of miners, show great sensitivity and a subtle use of color. They document a vanishing way of life and are as important for that aspect as for their artistic value.

By 1979 the artist was repeating himself. "He was influenced by the demands of collectors. He spent less time on his work and began making more and more flat, cartoon-like figures in colorful landscapes. It was a natural progression."[3] The desire for material gain may also have played a part in Savitsky's style change. His later work, however, is still sought after for its decorative quality.

Savitsky's paintings are in a number of museum collections, including that of the Museum of American Folk Art.

CLARENCE SCHMIDT—*"Look! Look! Look! Look! God Almighty, has anyone living or dead done anything like this? Would you believe that I done all this?"*[1]

BIOGRAPHICAL DATA

Born September 11, 1897, Astoria, Queens, New York. Attended Bryant High School, Astoria, but did not graduate. Married Grace Schmidt, by 1928; separated a few years later. One son. Died November 5, 1978, Catskill, New York.[2]

GENERAL BACKGROUND

Clarence Schmidt created an extraordinary complex environment of tar-coated, foil-trimmed buildings in the Catskill Mountains of New York.

Schmidt claimed he went to high school with singer-actress Ethel Merman, but he did not graduate. His father trained him to be a plasterer and a mason, but he worked at his trade professionally for only a brief time.

When he was thirty-one, Schmidt acquired a 5-acre plot of land on Ohayo Mountain, facing the Ashokan Reservoir near Woodstock, New York, from a relative. He started spending summers there, building a cabin out of railroad ties. In the 1930s, when it was finished, he covered it with tar to preserve it and threw broken glass at it to make it sparkle. (Schmidt is said to have sung "My Old Kentucky Home" while he decorated his cabin.) This house, called "Journey's End," was the first of a series of structures that Schmidt would build; by 1940 he was a year-round resident and his permanent occupation was working on his folk art environment.

By the end of 1971, two separate fires had destroyed much of his environment, and Schmidt, by now in poor health, gave up rebuilding and moved off the mountain. He began sleeping in doorways or wherever he could find temporary quarters and was finally sent to a state hospital, where he was found to be suffering from diabetes. After spending five years in a nursing home in Kingston, New York, Schmidt was transferred to a nursing home in Catskill, New York, where he died in 1978.

ARTISTIC BACKGROUND

Clarence Schmidt sold his first house, Journey's End, and then built another one-room cabin on nearby property. In the late 1940s he began adding to the new cabin, which eventually became a topsy-turvy affair that meandered in all directions, its shape dictated by the topography of the land. By 1967 the structure, covered with tar and aluminum foil, portraits, and masked objects, was an awe-inspiring seven stories high and was known as the "House of Mirrors." Schmidt proclaimed, "It's going to make history." Unfortunately, fire broke out in the house in January 1968. Because of the large amounts of tar Schmidt had used in its construction and the numerous containers of tar he had on the premises, the fire burned for days, completely destroying the house.

Shortly after the fire, Schmidt started anew and built a second house, the "Mark II," on a platform set on top of a Studebaker station wagon. He developed a new area

Clarence Schmidt, House of Clarence Schmidt, *n.d. Mixed-media environment (found and cast-off objects, assembled and painted), 5 acres, Woodstock, New York. Unusual sculptures such as this mysterious head inset with shining fragments were found throughout Schmidt's Catskill environment.*

around this structure, known as the "Silver Forest" because of the aluminum paint he had brushed on the surrounding saplings; he had also impaled doll heads and dolls on the trees. In December 1971, the Mark II also caught fire; this time Schmidt barely escaped alive and left his mountain aerie for good.

Schmidt's son, Michael, a sculptor, built some pieces on the property and for a time attempted to integrate his sculpture into the little that was left of his father's creations, but he soon gave up as well.

SUBJECTS AND SOURCES
Clarence Schmidt intended to build for posterity, to leave a legacy. He believed his house would benefit society, but he also viewed it as his child, claiming that it talked to him every morning.

The House of Mirrors was surrounded by walkways, shrines, and grottoes, some of which had titles like "Cinderella," "The Four-Headed Indian," or "The Red Cross (Hope)." Schmidt devoted almost as much time to the grounds as to the structures themselves and was constantly remaking and improving these smaller structures just as he reworked the facade of the house itself. A few of the shrines and walkways survived the fires, but they have now, for the most part, disappeared.

MATERIALS AND TECHNIQUES
A large tree was the central feature of the House of Mirrors; Schmidt intended to bring the garden inside. The exterior was made of wood and window frames and covered with bark, tar, mirrors, and sheets of aluminum foil. (Tar was used as a preservative, not as a decorative element.) Each of the seven stories had walkways, balconies, and ramps. On the inside, walls and ceilings were covered with paint, foil, plastic flowers, and mirrors. Christmas tree lights were everywhere.

The Mark II was also made of wood, and Schmidt covered it with so many foil-wrapped tree branches that it was difficult to see the structure itself. Objects such as dolls and plastic beads were strung down the sides of the Mark II.

Schmidt himself did all the work on the structures within his environment, and his earlier training as a mason proved helpful in building the dry walls that were the supports for his work. He built most of his site with found materials or with things that people would give him or leave on his property. He did purchase some items—the tar, for example, and a series of rubber face masks that were incorporated into one of his alleyways.

ARTISTIC RECOGNITION
The environment created by Clarence Schmidt is now known primarily through photographs. Because of the fires, only ruins remain of his work, and time has left only fragments of the shrines and the stone terraces. Yet the incredibly complex series of buildings, grottoes, and shrines with which he intended to "startle the world" have become part of the lore of the Catskills and have earned Schmidt a permanent niche in the history of folk art environmentalists.

JOHN SCHOLL

BIOGRAPHICAL DATA
Born July 8, 1827, Kingdom of Württemberg, now West Germany. Trained as a carpenter. Married Augusta Kuhlsmahl, 1853. Three sons, two daughters. Died February 26, 1916, Germania, Pennsylvania.[1]

GENERAL BACKGROUND
John Scholl was a German immigrant who created wonderfully intricate wood sculptures that combined Germanic folk art elements and American Victorian motifs.

John Scholl, Sunburst, c. 1900. Wood, paint, and metal wire, 71 × 38 × 24½ in. Museum of American Folk Art, New York; Gift of Cordelia Hamilton. Scholl's intricate sculpture combines the art of the whittler and the imagination of the artist as well as architectural and design elements from two cultures. Unfortunately, the meaning of his personal symbolism was never recorded.

Scholl came to this country with his fiancée in 1853. After marrying in New York City, the couple settled in Schuylkill County, Pennsylvania, then the center of the anthracite coal industry, where he worked as a carpenter and house builder, probably for one of the mining companies. Scholl became a citizen in 1860.

By 1870 Scholl had purchased a farmstead in Germania, Pennsylvania, a German community that retained a strong ethnic character well into the twentieth century. The farm prospered and Scholl added to it over the years so that it eventually encompassed more than 158 acres.

Scholl was fascinated by the ornate woodwork of the era, and the large house he built on his land was in the Victorian style, heavily ornamented with gingerbread trim, including snowflakes, garlands, and sculptural elements incorporating doves. As a carpenter, he had access to a large number of architectual pattern books, and he seems to have made full use of them. The house was demolished in the 1960s, but photographs showing its ornamentation still exist.

ARTISTIC BACKGROUND

John Scholl's grandchildren claim that he had whittled for years as a pastime, making chains carved from single pieces of wood, balls in cages, and other such small objects. Around 1907, when he was in his eighties, he started carving larger and more ambitious pieces.

Scholl never sold or gave away any of his carvings but displayed them in his parlor, adding new ones as he finished them. The artist was well known in the area, and soon had so many visitors (neighbors and curiosity seekers alike) who came to see his sculptures that he instituted formal visiting hours and provided personal guided tours in which he explained the meaning of the pieces. His son continued the tours for about fifteen years after Scholl's death, but the parlor was closed to the public in the 1930s.

In 1967 an antiques picker purchased the sculpture collection from the Scholl family and sold it to Adele Earnest, a gallery owner in Stony Point, New York. She arranged for an exhibition of Scholl's work at a gallery in New York City, bringing it to the attention of a wider audience.

SUBJECTS AND SOURCES

Scholl took architectural elements of Germanic folk art, combined them with American Victorian conceits, and made some of the most whimsically romantic sculpture of this century. His style is easily recognizable, and his work can be divided into four principal types: small whittler's puzzles called "finials," flat constructions that he intended to represent idealized "snowflakes," mechanized toys,[2] and large, freestanding sculptures that he called "celebrations."

Many of Scholl's design motifs seem to have come from his German heritage—doves, tulips, German crosses, and star-crossed circles, to name a few—while others are composed of personal, patriotic, or religious symbols that had meaning for him. He would explain the symbolic content of his work to visitors, but unfortunately no attempt was made to document his explanations and the meanings are lost today.

MATERIALS AND TECHNIQUES

A pocketknife was Scholl's favorite tool, but he also used a number of other hand tools in his work; he may have used a lathe or band saw to rough out forms. His basic material was scrap wood that he glued, screwed, and wired together, and it is quite likely that he used templates for some of his repetitive patterns, such as tulips, arrows, or stars. He used casein (milk-base) paint on the objects, painting them in a variety of soft colors—gold and white, blues, greens, reds, and occasionally mustard yellow.[3]

Scholl's toys often had movable parts, and some were activated by wheel pulleys and cranks, perhaps inspired by the famous cuckoo clocks of his homeland. He also constructed elaborate stands for many of his pieces, decorating them heavily with carved balls, bobbins, and Victorian fretwork.

There are forty known surviving Scholl sculptures, ranging in height from only a few inches to his elegant swan carving, which reaches almost 7 feet. None of Scholl's work is dated, and Edward Scholl, Jr., is thought to have later repainted, repaired, and even reconstructed some of his grandfather's sculpture.

ARTISTIC RECOGNITION

John Scholl's carvings have the whimsical, inventive combination of the art of the whittler in concert with the creativity of the artist. Today his work is found in the Whitney Museum of American Art and the Museum of American Folk Art in New York City, and the Abby Aldrich Rockefeller Folk Art Center in Williamsburg, Virginia, as well as in private collections.

ANTOINETTE SCHWOB—*"I did everything to please my husband."*

BIOGRAPHICAL DATA

Born Antoinette Branchard, September 26, 1906, Cavalier (near the Canadian border), North Dakota. Attended St. Joseph's Boarding School for twelve years, St. Boniface (near Winnepeg), Canada. Married André Schwob, 1944; he died 1977. No children. Now resides New York City.

GENERAL BACKGROUND

Antoinette Schwob is a painter known for her bold use of contrasting colors and her stark compositions.

When she was young, Schwob explains that, "I had to choose between teaching and nursing. I taught in a little country school in Tembiana, North Dakota, for two years and then [in 1928] I entered nurse's training at St. Mary's Hospital in Minneapolis, Minnesota and earned an RN."

Schwob moved to New York City in 1931 and went to work for the state psychiatric institute. "At first," she says, "you got ninety dollars a month and room and board." She worked for the institute until her retirement in 1974 and remained in New York afterward.

ARTISTIC BACKGROUND

Antoinette Schwob started her painting career in the 1950s

Antoinette Schwob, Grand Forks, *1978. Oil on canvas, 36 × 48 in. Private collection. Schwob's strong, spare memory paintings of life in rural North Dakota reflect a nostalgia for an earlier, simpler life that is poignantly captured in this scene of a father waving good-bye as his son moves on toward new adventures.*

almost by accident. When her husband, who was an artist, saw her arrangement of some pie dough figures, he thought that she had the potential to be an artist and told her, "Don't be afraid—try to paint." He bought her an easel and Schwob set to work, proving her husband to be correct in his assessment of her abilities.

Sometime in the late 1960s André Schwob showed his wife's paintings to art galleries in New York City, and America's Folk Heritage Gallery began to represent her. In about 1988 Schwob decided to retire from painting.

SUBJECTS AND SOURCES
"I make up little stories," the artist says, "and paint them." The stories are based on memories—both real and imagined—of her early life in North Dakota and Canada. She also paints self-portraits and portraits of her husband and others, as well as imaginary pictures of life in turn-of-the-century France.

Schwob works in bold blocks of contrasting colors, and her figures and subjects stand out starkly against her backgrounds. The compositions are precise and balanced; each element is sharply outlined, as though drawn with a ruler's edge. In most cases, the subject matter—whether buildings, cars, or people—dominates nature.

MATERIALS AND TECHNIQUES
Schwob paints on canvas with oils. She makes preliminary sketches, but makes changes as she works rather than adhering strictly to her sketch. In her portraits Schwob sets off her subject with strong, solid backgrounds of red, black, and yellow.

The artist has completed about ninety works. Most are 30 by 40 inches, although a few are larger.

ARTISTIC RECOGNITION
Antoinette Schwob has been widely exhibited and shown in New York City for more then twenty years. Her work is in the collections of the Museum of American Folk Art in New York City and the Museum of International Folk Art in Santa Fe, New Mexico.

JAMES ("J. P.") SCOTT—*"The shrimp is mostly gone now, but the boats is still in my head."*

BIOGRAPHICAL DATA
Born November 16, 1922, Orina, Plaquemines Parish (south of New Orleans), Louisiana. Attended Orina Church School through sixth grade. Married Evelina Jackson, October 24, 1946; separated 1962. Three daughters, one son. Now resides Lafitte (south of New Orleans), Louisiana.

GENERAL BACKGROUND
J. P. Scott is a black artist who builds models of the boats that ply the Mississippi and its bayous.

From New Orleans south to the Gulf of Mexico, only a long, snaking line of levees keeps the Mississippi River from overwhelming the surrounding land, which is below sea level. Water is a way of life here, and boats of all types dance on the horizon, their hulls visible from the road. This is the world of J. P. Scott, a man who knows the delta bayou country and its boats; it is in his blood.

Scott worked on construction jobs in New Orleans, married, and separated because his wife would not return to live in a home he had inherited in the delta country in

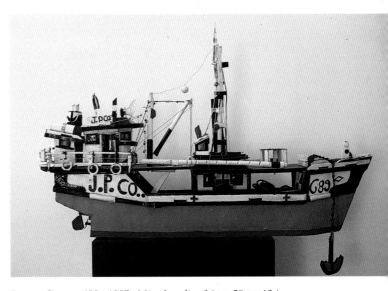

James Scott, 689, *1987. Mixed media, 36 × 58 × 12 in. Gasperi Folk Art Gallery, New Orleans, Louisiana. Scott's carefully crafted boats are romantic versions of the many types of vessels that may be viewed on the Mississippi River and the Gulf waters south of New Orleans.*

1962. When Scott took up residence there, he made his living working on commercial fishing boats and hunting muskrats. He was also a "clean-up" at the Lafitte Canning Company from 1975 to 1984.

ARTISTIC BACKGROUND

"I started rigging up in 1962," Scott says; that is when he returned to the bayou country from New Orleans and began to make his model boats.

Scott never intended to sell his boats, and some still weather in his yard, but his work is now represented by the Gasperi Folk Art Gallery in New Orleans, Louisiana. He was brought to the attention of serious collectors when one of his boats was exhibited in "Rambling on My Mind: Black Folk Art of the Southwest," a traveling show that originated in 1987 at the Museum of African-American Life and Culture in Dallas, Texas.

SUBJECTS AND SOURCES

"I just go on side the bayou and watch the boats," the artist explains. "Then I find some cypress and scrap paint and make me a boat." Scott's boats are not scale models; they are romantic versions of the originals, whether houseboats, shrimpers, or oil-servicing rigs, and some bear the name of the maker. Scott tries to rig his boats realistically, with nets and other devices.

MATERIALS AND TECHNIQUES

Scott makes his boats out of cypress, using simple hand tools to give them shape. He works outside, in his backyard, and the boats take a great deal of time to build. They are decorated with found objects, including Mardi Gras beads, dried fruits, seashells, parade flags, bits of plastic, and sometimes the boats are crewed by plastic toys. Scott paints the boats with house paint and shows a distinct preference for orange and red.

The boats are quite large, some as big as 3 by 5 by 2 feet. The artist has made about twenty models to date.

ARTISTIC RECOGNITION

J. P. Scott's boats are one-of-a-kind depictions, reminders of the swampland below New Orleans as well as the importance of the boat culture in that area. His work is included in many important southern collections but is not generally known outside the region.

JON SERL—*"I paint. Painting is life. I have to empty my head."*

BIOGRAPHICAL DATA

Born Joseph Searles (also known as Joe Seals, Ned Palmer, and Jerry Palmer), November 7, 1894, Olean, New York. Educated through sixth grade, Maple Street School, Salamander, New York. May have attended Texas Christian University for a short period. Married Janet Davidson (Serl does not remember date of marriage); she died, date unknown. No children. Now resides Lake Elsinore, California.[1]

GENERAL BACKGROUND

This lively artist lives under the name Jerry Palmer and paints under the signature Jon Serl, but neither name is his by birth. Serl had become a vaudeville song and dance man by the age of ten: "The family shipped me from town to town with a tag on my coat," he remembers. "I was playing Fort Worth about 1930 or 1940 when the Fox Studio signed me up under the name Palmer. Everybody was Ned or Jerry, so I was too." He did a little "voice-over" work and had some walk-on parts in films over the next few years.

In the 1960s Serl lived in a historic adobe house near the old mission in San Juan Capistrano, California, and it was here that the former vaudevillian turned artist. He moved to Lake Elsinore about 1970, where he intended to renovate an old hotel, but it did not work out. He now lives on the main street of town in a rambling, makeshift house that is overgrown with tropical vegetation.

Serl has added small trap doors to his house so that pet chickens can come and go freely. A chicken nest, complete with eggs, resides in the center of the artist's bed. He gets up each morning and starts to paint long before his cocks begin to crow.

ARTISTIC BACKGROUND

Serl's home in San Juan Capistrano was at the end of a bus line that a number of art students used. One day he decided to show a thing or two to some students waiting for the

Jon Serl, The Pregnant Virgin, *1982. Oil on board, 60 × 60 in. Museum of American Folk Art, New York; Gift of Jon Serl. Serl paints simple yet dramatic images that often reflect personal relationships, but they may be presented in a highly theatrical manner, as in this wedding ceremony.*

bus: "I went out one day," he says, "and painted 'em a picture with black, red, and white shoe polish." Once he started painting, Serl worked day and night.

Serl is a nonagenarian and is still vigorous.

SUBJECTS AND SOURCES
Serl's theme is the human condition—personal relationships, human foibles, and the perverseness of life. He paints men, women, and animals that often appear to be acting, singularly or in groups, in unidentified roles. The powdered and rouged players look as though they are lighted by old-fashioned spotlights covered with gelatins.

MATERIALS AND TECHNIQUES
Serl finds old paintings, frames and all, in junk piles. He covers them with gesso and paints over them with oil paints. He also paints on old boards, Masonite, and miscellaneous other materials.

Serl's work starts small, at about 5 by 8 inches, but can be as large as 5 by 7 feet. The artist has painted more than one thousand works.

ARTISTIC RECOGNITION
Serl has been called an expressionist. His figurative style easily catches the attention of museum-goers: "You've got to give 'em a little theater," he says. His early work is a bit flat and not as dramatic as his later pieces.

Serl's early paintings were exhibited at a gallery in Laguna Beach, California, and he had his first individual show at the San Pedro Municipal Art Gallery in 1971. His first major showing was at the Newport Harbor Art Museum, Newport Beach, California, in 1982, and he was included in the 1984 show "Pioneers in Paradise: Folk and Outsider Artists of the West Coast," mounted by the Long Beach Museum of Art. Recently. Serl has also made two television appearances on the "Tonight" show.

MARY SHELLEY—*"I want to make pictures that look nice and aren't terrifying."*

BIOGRAPHICAL DATA
Born February 19, 1950, Doylestown, Pennsylvania. Received a bachelor of arts in English, 1972, from Cornell University, Ithaca, New York. Single. One son, one daughter. Now resides Ithaca, New York.

GENERAL BACKGROUND
Mary Shelley may be the only female folk carver representative of this century. Unlike most folk artists, she is also a graduate of an Ivy League college.

After graduation from college, Shelley worked as a house painter and carpenter. She learned carpentry working for two years for a contractor who was renovating the Clinton House, an old hotel in Ithaca, New York. She then opened a studio in a two-car garage in Ithaca and became a free-lance sign carver and painter. She still continues to practice her profession as a sign maker.

Mary Shelley, Barn Scene, 1979. *Painted wood relief, 15¼ × 22 in. Museum of American Folk Art, New York; Anonymous gift. This bas-relief carving is from Shelley's barnyard/cow series and is representative of her skill in subtly combining social comment with everyday activities.*

ARTISTIC BACKGROUND
"My father brought home a carving by Mario Sanchez [see page 267], which he purchased on a trip to Key West, Florida," Shelley remembers, and the work inspired her. "In 1974 I began carving in the style of Sanchez." Shelley's subject matter, however, bears no relationship to the work of Sanchez, as she has developed her own interests and style.

Shelley was discovered by Jay Johnson, director of the America's Folk Heritage Gallery in New York City. She presently has a grant from the New York State Council on the Arts to carve bas-reliefs of upstate New York diners.

SUBJECTS AND SOURCES
Shelley works in topical series. Her current topic is diners, and she recently completed a series of "cow" carvings. Her work frequently contains social commentary; in her last series, for example, "I compare the cows with women," she explains. "Women are OK as long as they stay in the barn and give milk."

MATERIALS AND TECHNIQUES
Shelley carves bas-reliefs from pine boards or basswood. She traces the outlines of her carving onto the wood with a router, then uses chisels and mallets. She carves deep into the wood, leaving the outside edge intact to form a frame. Shelley paints her reliefs with acrylics.

The artist has made three hundred bas-reliefs; the largest is 43 by 36 inches, but most are smaller.

ARTISTIC RECOGNITION
Some say that Mary Shelley's education disqualifies her as a folk artist, but she did not study art and has always been included under a broad definition of folk art. Her work is

unique as well as decorative, and the quality of her pieces is consistent.

VOLLIS SIMPSON—*"After I'm dead—I guess someone will have a big yard sale."*

BIOGRAPHICAL DATA
Born January 17, 1919, Lucama, North Carolina. Attended school through eleventh grade, Lucama, North Carolina. Married Jean Barnes, January 20, 1947. Two sons, one daughter. Now resides Lucama, North Carolina.

GENERAL BACKGROUND
Vollis Simpson, the inventor of a wind-powered sculptural environment, worked the family farm in North Carolina until he was drafted into the Army Air Corps in 1941. He spent some of his service years in the South Pacific, and when he was discharged in 1945, he opened a repair shop for trucks and tractors—Simpson's Repairs—near Williams, North Carolina.

ARTISTIC BACKGROUND
"I built a big windmill on Saipan [while in the Army Air Corps]. It picked up dirty clothes in baskets—slushed 'em through soapy water," Simpson explains. "That's how I got started." That experience and a surfeit of discarded materials from his repair shop provided the impetus Simp-

son needed to begin a create an unusual outdoor environment that centers around machinelike sculptural assemblages powered by the wind. "I never threw nothin' away," Simpson says. "All that junk just lay out there in the field. So I decided to build a windmill 40 feet high." About 1969 he started constructing that windmill—his first major creation—in the field across the street from his repair shop.

The artist continues to improve and repaint some of the older structures and cannibalizes others to make new ones. He works nights, weekends, every spare moment that he can, to make this collection of wind-driven objects exceptional.

SUBJECTS AND SOURCES
Simpson has moved far beyond the original windmill that he planned for his environment. He has filled an entire acre of pasture with constant motion and color. Some of his eye-catching pieces are mounted as high as 10 feet in the air. A horse-drawn buggy, a man riding a bicycle, a six-

Vollis Simpson, Wind-Powered Sculptural Environment, *1969–present. Mixed media (repair shop parts, paint, aluminum reflectors, and other objects), approximately 1 acre, near Williams, North Carolina. Simpson constructed a huge wind-powered fantasy with leftover parts from his automobile repair shop.*

Vollis Simpson, Windmill *(detail), 1985. Mixed media (repair shop parts, paint, and other objects), 25 ft. high. Simpson modeled this windmill after the bombers he saw during his service in World War II and painted it in patriotic red, white, and blue.*

engine airplane, and smaller aircraft surround the huge windmill and compete for the viewer's attention.

His wind-powered display is covered with many aluminum reflectors. "People can come here at night," the artist says, "turn on their car lights, and the whole thing lights up."

MATERIALS AND TECHNIQUES

In addition to cast-off steel and iron parts from his repair shop, Simpson uses some plywood and aluminum in constructing the various parts making up the environment. The individual objects are painted with tractor enamel, usually in patriotic red, white, and blue.

The windmill does indeed go up 40 feet. The individual components can be as large as 20 feet, and they are 7 to 10 feet off the ground. The dozen large objects and the many smaller ones that make up Simpson's special environment are all powered by the windmill through an ingenious system of pulleys and belts.

ARTISTIC RECOGNITION

Vollis Simpson makes some small airplanes to sell to tourists, but he is known for his big pieces, which are moved by the wind. To date, only one of those pieces is thought to have been sold, a bicycle rider that is mounted in the cathedral ceiling of the house of Allen Huffman, a former president of the Folk Art Society of North Carolina. Once seen, Simpson's massive mechanical sculptures are not easily forgotten.

Individual constructions from Simpson's environment were exhibited at the High Museum of Art in Atlanta, Georgia, in 1988 and at the North Carolina Museum of Art in Raleigh in 1989.

HERBERT SINGLETON—*"I would reach in [muddy clay] and pull out a snake [shape], just like that. I'd let it dry in the sun, but it would fall apart. That's when I decided to work with wood." "When the river was low, I would find a plank of wood to carve. I would look at it and wonder if someone's house and life fell apart."*

BIOGRAPHICAL DATA

Born May 31, 1945, New Orleans, Louisiana. Attended school through seventh grade, New Orleans, Louisiana. Single. No children. Now resides Algiers (a suburb of New Orleans), Louisiana.[1]

GENERAL BACKGROUND

Herbert Singleton is a black folk artist who started carving walking sticks out of ax handles about 1975. The buggy drivers in the French Quarter were his clients, buying up the canes he made. One night a buggy driver used a Singleton stick on the head of a would-be robber and the carvings were christened "Killer Sticks."

Herbert Singleton, Come Out of Here, *1989. Painted wood relief, 39 × 11 in. Barrister's Gallery, New Orleans, Louisiana. A powerful carving with strong images, this work also reflects the artist's concern with symbols of life and death.*

Singleton is a member of an urban subculture that is often involved with drugs. Between 1967 and 1986 he spent thirteen years in Angola State Prison, Angola, Louisiana, for various narcotic offenses.

Today Singleton carves for a living, picking up occasional jobs on construction sites to supplement his income. Like many blacks, he is interested in finding roots in his African heritage.

ARTISTIC BACKGROUND
Herbert Singleton started carving walking sticks in the 1970s with the intention of trading his work to drug pushers in exchange for crack and cocaine. He also carved staffs for use in voodoo ceremonies and Mardi Gras parades. His carvings were discovered by Sainte-James Boudreaux, the owner of the Barrister's Gallery in New Orleans.

SUBJECTS AND SOURCES
Singleton's carvings now encompass more than walking sticks, although he has not given up making them. His subject matter is African-American, and the artist may have been influenced to some extent by the African objects that are sold in the French Quarter in New Orleans. His African format includes masks, totem poles, drums, and staffs. Voodoolike symbols—skulls, bones, and crosses—are also present, as are images that are reminders of life in the drug culture. Many of his carved figures are dressed in contemporary American outfits; others reflect a concern with political and social events or groups, such as the Ku Klux Klan.

MATERIALS AND TECHNIQUES
The artist buys ax handles to carve and also looks for usable driftwood on the levees of the Mississippi River. Sometimes he splits driftwood logs and carves bas-reliefs. Singleton paints his carvings with oil-base enamel house paints, choosing bright, shiny colors such as reds, blacks, blues, greens, and whites.

It is estimated that Singleton has made around two hundred works, but there is no accurate count of the early pieces. Some of his carvings are more than 7 feet tall.

ARTISTIC RECOGNITION
Herbert Singleton's work presents images that are powerful, symbols that are intense. It is not always art that is easy to live with, but it makes a dramatic visual statement. Singleton's carvings are recognized as important by a specialized group of collectors interested in black folk art.

In addition to Barrister's Gallery, Singleton's work was shown at the Icons Gallery in Houston, Texas, in 1990.

DROSSOS P. SKYLLAS

BIOGRAPHICAL DATA
Born 1912, Kalymnos, Greece. Little formal education. Married Iola, last name and dates unknown. Children unknown. Died 1973, Chicago, Illinois.[1]

GENERAL BACKGROUND
Drossos Skyllas was a self-taught painter who combined the skill of the trained artist with the naïveté of the folk artist.

Skyllas was born on an island in the Aegean Sea and worked for many years as an accountant for a tobacco business owned by his father. At the end of World War II he and his wife came to this country and settled in Chicago, Illinois.

The artist never sought employment in America; his ambition was to become a professional painter, and he devoted all his time to achieving this goal. He was strongly encouraged by his wife, who worked to support the two of them and the caged exotic birds that shared their small apartment.

ABOVE AND OPPOSITE: **Drossos P. Skyllas,** Greek Bishop, *c. 1967. Oil on canvas, 65 × 41½ in. Private collection. This radiant rendering of a Greek bishop as a holy man illustrates the artist's gifted technique and religious and mystical symbolism.*

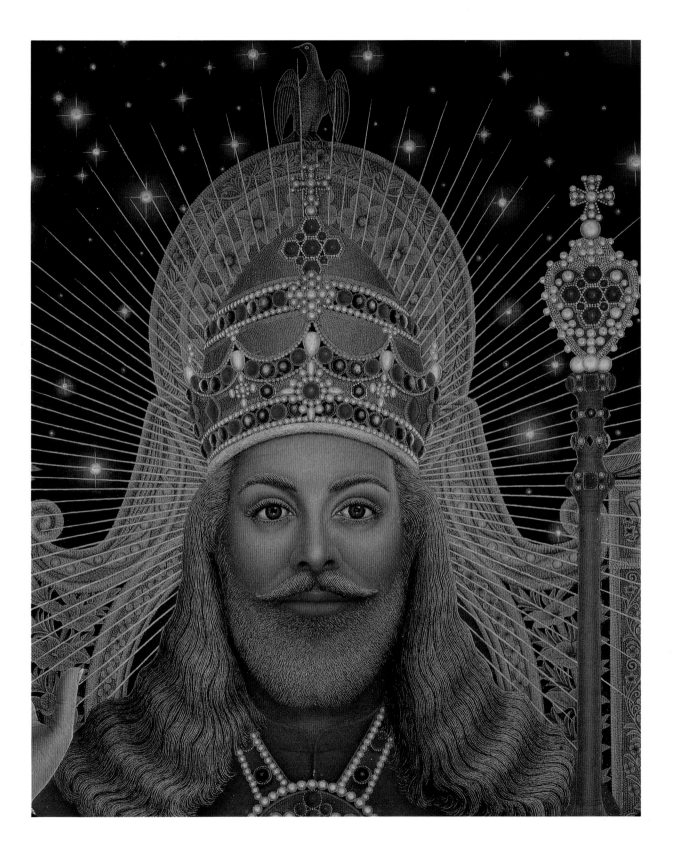

ARTISTIC BACKGROUND

Drossos Skyllas had wanted to be a painter from the time he was quite young, but his father disapproved, so he did not have the chance to carry out his dream until he came to America, away from his father's influence. He started painting as soon as he arrived in Chicago and continued until his death in 1973. Although he was exhibited at the Chicago and Vicinity Show in 1967, 1969, and 1973, he priced his work so high that he was never able to sell a painting during his lifetime. He is said to have sought commissions to paint portraits, but with fees starting at $25,000 he did not find any takers.[2]

In 1974 William Bengston of the Phyllis Kind Gallery in Chicago went to a police station to claim a lost wallet. When he showed a gallery card for identification, a policeman said, "Hey, I got a painter friend who died by the name of Skyllas." Once Bengston met Iola Skyllas and viewed the artist's work, he took it to sell through the gallery.

Skyllas's paintings were included in "Transmitters: The Isolate Artist in America" at the Philadelphia College of Art in 1981.

SUBJECTS AND SOURCES

Skyllas was fond of saying, "My sweetest dream in life is to do a large painting of the Last Supper for the American people."[3] He made at least two sketches of his proposed Last Supper but died before he could paint it.

The body of work he did leave behind was substantial, however, and included many religious subjects as well as the Greek Orthodox pantheon, surreal landscapes, still lifes, and nudes. Skyllas seems to have used a good deal of symbolism in his work, but not all of it is well understood.

Although untrained, Skyllas developed a technical mastery of his medium and the ability to add purposeful small details that created frozen, dramatic moments in time. The artist's skillful use of color and light adds both realism and a sense of mystery to the work.

MATERIALS AND TECHNIQUES

The artist's favorite medium was oil on canvas; his sketches for the *Last Supper* were done with pencil.

There are thirty-five known paintings by Skyllas, which range from about 24 by 30 inches to 42 by 50 inches. His *Last Supper* sketches are quite different and meant to be panoramic—8 feet by 12 inches and 16 feet by 32 inches.

ARTISTIC RECOGNITION

Skyllas had the technical ability of the trained artist and the naive vision of the folk artist, a rare combination. His work is now included in sophisticated private collections of twentieth-century art, as well as in public collections.

FRED SMITH

BIOGRAPHICAL DATA

Born September 20, 1886, Price County, Wisconsin. No education. Married Alta May, June 1915; she died 1970.

Four daughters, one son. Died February 21, 1976, Phillips, Wisconsin.[1]

GENERAL BACKGROUND

Fred Smith created a stunning concrete environment filled with more than two hundred oversize sculptures of animals and people.

Fred Smith, Concrete Park *(detail), 1950–1968. Mixed-media environment (glass-covered concrete images, tin), over 16 acres; tallest figure, 13 ft. high, Phillips, Wisconsin. Smith created an extensive environment comprising several hundred large concrete figures, all of which are embellished with glass and mirrors. The sculpture shown here is an angel.*

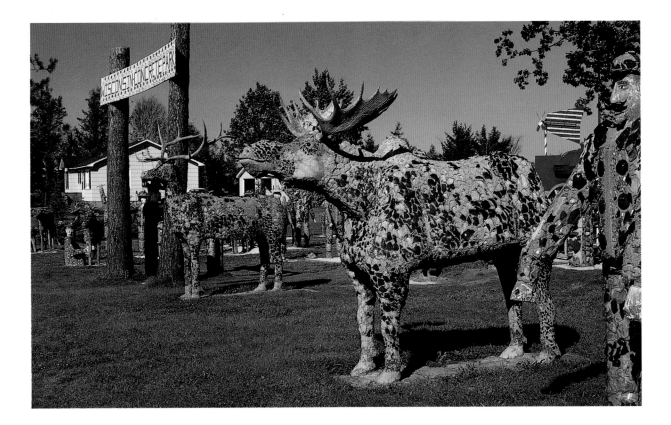

Fred Smith, Concrete Park *(detail). This 7-ton moose is approximately life-size and has real antlers. In other figures Smith used horse heads obtained from a butcher to give his pieces a realistic shape.*

A man of strong opinions, Smith had no education and believed that he was "better off without it."[2] He worked as a logger for most of his life, beginning as a child in logging camps in Wisconsin and continuing until 1949, when he retired because of arthritis.

Between jobs as a lumberjack, Smith homesteaded 120 acres in Phillips, Wisconsin, where in the 1930s he built a tavern, the Rock Garden. When he retired, he ran the bar, serving only Rhinelander beer.

ARTISTIC BACKGROUND
Once Fred Smith returned to Phillips for good, he started to work "around 1950" on a unique environment that he called *Concrete Park.* For more than fifteen years he spent from "daylight to dark" creating the *Park,* which ultimately encompassed sixty-four groups of sculpture containing more than two hundred figures that he built. In fact, Smith did little else but work on the *Park* until he was stopped by a stroke in late 1968.

The first piece that Smith made was a buck jumping over a log. He recalled that a neighbor had come by with his little boy, who had on a sweater showing a big buck jumping over a log. Inspired by the picture, Smith borrowed the sweater and started work. The piece took all summer, but when it was completed, the boy's family thought it a pretty good likeness. From then on, Smith worked on his *Park* whenever the weather permitted. He was not certain just why he started, but "it's gotta be in ya to do it."

SUBJECTS AND SOURCES
Animals (from the buck to lions to a 7-ton moose), people, even the Statue of Liberty—Smith considered almost anything that came to mind as appropriate for the *Park.* He particularly liked to sculpt horses and larger-than-life-size people—one figure is a 13-foot-tall Paul Bunyan. All of his people have long legs; "otherwise they're too small," he said. "I would have made them 100 feet tall if I could."

MATERIALS AND TECHNIQUES
Smith's figures are concrete, made of three parts cement to one part sand. They are embellished with stained glass, beer bottles, Hilex bottles (amber-colored bleach bottles), telephone pole insulators, mirrors, anything that would give the work color. "It shines . . . you can see yourself in them—beautiful." The empty beer bottles came from his tavern.

Every one of the more than two hundred statues has its own concrete footing. Smith said he built them just like a house, with "foundation and cement on a wooden frame."

He put real horse heads (obtained from a butcher) underneath the cement to help give those pieces a realistic shape.

ARTISTIC RECOGNITION
Fred Smith created an outstanding environment in the little town of Phillips, Wisconsin; it was and is a popular spot for visitors of all ages. Although the lions and the Paul Bunyan figure are the favorites of many, it is the concept of *Concrete Park* that gives its creator his fame.

Smith never charged admission to his *Park* and never sold off pieces, though he had many offers; he said he wanted his work to be "for the American people." During his lifetime, however, he gave little thought to maintenance of the *Park* after his death. Fortunately, through the efforts of Price County and with some help from the Kohler Foundation, Smith's masterpiece has been preserved.

MARY T. SMITH

BIOGRAPHICAL DATA
Born Mary Tillman, November 4, 1904, Brookhaven, Mississippi. Received some education at primary school level at the Pleasantville Church School, Pleasantville, Mississippi. Married Gus Williams, 1922; divorce and death dates unknown. Married John Smith, 1930s. One son by Williams. Now resides Hazelhurst, Mississippi.

GENERAL BACKGROUND
Mary Smith has made her yard into an environment filled with bright paintings done on corrugated tin.

The daughter of poor black Mississippi sharecroppers, Smith grew up with only a minimal church school education. At an early age, however, she learned how to do hard field work—picking strawberries and potatoes and hoeing weeds—under a spirit-breaking sun.

For a time after her marriage to Smith in the early 1930s, the couple sharecropped at the Dixie Garden Farm in Martinsville, Mississippi. But as her son, Sherdie Major, relates, "She was run off in 1938 because she could do accounts and figured out that she was not fairly treated."

Smith moved to Hazelhurst, Mississippi, where she did housework, gardening, and babysitting. By 1975 she had retired.

ARTISTIC BACKGROUND
In 1980 Mary Smith's son, Sherdie, took a trip to South Carolina. On his return he found his mother's yard fenced in by tin panels that he had intended to use for a shed, and tin paintings were sprouting on the lawn. "I did it," she says, "to brighten the place up, and please the Lord." Not only did she brighten up the yard, but she also attracted widespread attention—Smith's small green wooden house is on one of the main streets leading through Hazelhurst.

In 1985 Smith's ability to write and her power of speech suffered when she had a serious stroke, but her compulsive desire to "fix up" her hillside yard with bright paintings and her mental energy remain lively and vigorous.

Mary T. Smith, Three Figures, *1988. Oil on board, 24 × 48 in. Kurt Gitter and Alice Yelen. This work is a very fine example of the artist's paintings, many of which she created to fix up her yard along the highway.*

SUBJECTS AND SOURCES

Smith's home is her castle, a fenced-in environment proclaiming her belief in the Lord and the wisdom of following His commandments, along with a colorful display of portraits of neighbors, heroes, and friends. The artist is influenced by television images, popular illustrations, and religious sayings and usually paints her subjects flat, without detail.

Smith's paintings often carry lettered messages, such as "In God We Trust," or names like "Mr. Big" on the heads and torsos of figures.

MATERIALS AND TECHNIQUES

The artist prefers corrugated tin roofing panels, which she paints with broad brushstrokes of house paint in primary colors. She also paints on plywood panels, and in recent years collectors and dealers have brought or sent plywood panels to her and commissioned her to paint for them.

Smith has completed several hundred paintings that range in size from a foot or two to life-size.

ARTISTIC RECOGNITION

Mary Smith's early paintings on tin roofing panels are her best work. The more recent made-to-order works on plywood (sometimes made while the buyer waits) lack the conviction of the art made specifically for her environment. The artist's work was included in "Baking in the Sun: Visionary Images from the South" at the University Art Museum, Lafayette, Louisiana, in 1987 and "Outside the Main Stream: Folk Art in Our Time," sponsored by the High Museum of Art, Atlanta, Georgia, in 1988.

ROBERT E. SMITH—*"Folk art can help you to lead a halfway decent life."*

BIOGRAPHICAL DATA

Born October 14, 1927, St. Louis, Missouri. Claims to have obtained a high school diploma in later life and to have attended courses at five different colleges without success. Married Catherine Straep, March 1969; marriage annulled September 1969. No children. Now resides Springfield, Missouri.

GENERAL BACKGROUND

Robert Smith is emerging as an important artist whose drawings have an unusual storytelling style.

In his younger years Smith moved around a great deal from place to place and from job to job. He did his roving mostly in the Ozark Mountain area of Missouri, although he did live with an uncle in Dallas, Texas, from 1936 to 1939.

"Something always comes up to stop me," Smith proclaims, "I just can't make the grade." He joined the army in 1948 but was given a medical discharge after six months. Soon after, in 1950, he had a "nervous breakdown" and was committed to the Farmington State Hospital, near St. Louis, until 1968. (He escaped on at least one occasion.) After release from the hospital, Smith worked in a menial

Robert E. Smith, A Funny Christmas Night, *1989. Acrylic, oil, pen, and marker on paper, 30¼ × 20 in. Dan Prince/Prince Art Consultants. Smith's colorful paintings often tell complex, action-filled stories and may be accompanied by audio tapes or written text.*

capacity for the Mid-Missouri Mental Health Services at various hospitals from 1974 through 1979 and as a "hawker" at Busch Stadium, St. Louis, and in Kansas City and Houston.

ARTISTIC BACKGROUND

Smith began to draw about 1964, while he was at Farmington State Hospital, but he was hampered in doing his artwork by the administration of drugs. "In the hospital," he explains, "I started to draw. And I saved up stories for later."

Smith first gained recognition when he exhibited at the Missouri State Fair in 1976; in 1988 he won first prize at the fair.

SUBJECTS AND SOURCES

Smith is, first and foremost, a storyteller. He tells stories about major political events or familiar happenings, such as attending class, art show openings, and family gatherings. He writes or records his stories on tape, then draws them; the tapes and written stories sometimes accompany the paintings.

Although some of his topics may indicate it, Smith is not a memory painter. He is a preacher and a philosopher —he opposes nuclear energy and the preaching of false gospel—as demonstrated by many of his works.

MATERIALS AND TECHNIQUES

Smith draws on posterboard and paper with acrylics, crayon, and watercolors and also paints scenes on used furniture. He uses a wide palette of colors in his work, but his favorites are red, black, and green.

There is always a lot of action in Smith's drawings, and his stories can be quite complicated. The drawings are flat and segmented like cartoon strips and sometimes incorporate printed messages.

Smith's paper pieces are about 18 by 24 inches. He states he has completed 1,200 works.

ARTISTIC RECOGNITION

Although some may see Smith as somewhat eccentric or may prefer his simpler, less complex messages, he is emerging as an important new talent. He has a colorful and lyrical storytelling style that is gaining more and more attention from museums.

SIMON SPARROW—*"Everything of mine comes from the Spirit."*

BIOGRAPHICAL DATA

Born October 16, 1925, West Africa. Attended school for three years in New Bern, North Carolina. Married Johnnie Roper, 1942; divorced 1946. Married Jocelyn Reed, 1968. Four daughters, two sons by Roper; one daughter, one son by Reed. Now resides Madison, Wisconsin.

Simon Sparrow, Untitled, *1989. Assemblage (beads, chains, shells, tree ornaments, and other objects on plywood), 44 × 32 in. Carl Hammer Gallery, Chicago. This shimmering collage, typical of Sparrow's work, is filled with personal symbols that only the artist can translate.*

Simon Sparrow, Untitled, *1989. Assemblage (beads, chains, shells, buttons, and other objects on plywood), 37 × 53 in. Carl Hammer Gallery, Chicago. Faces appear throughout Sparrow's assemblages, as in this example, as well as his pastel drawings. He says that the images come to him in "small visions."*

GENERAL BACKGROUND

Simon Sparrow is especially recognized for his large, complicated, collaged assemblages that sparkle with color, beads, and trinkets.

"I am the missing link between African and Afro-American art," Sparrow proclaims. "I was born in Africa. My father was African, but my mother was a Cherokee." Sparrow's parents moved from Africa to North Carolina to become sharecroppers when he was two years old. At the age of twelve, he ran away to Philadelphia, where he was "adopted by a Jewish family."

In 1942 Sparrow lied about his age and enlisted in the army, serving for the next two years. He became a welterweight fighter while in the army and had twenty-seven fights. After his discharge, Sparrow became a house painter in New York City and began to create art until a fire destroyed much of his work in 1958.

Sparrow left New York to settle in Madison, Wisconsin,

in 1969. He preaches in the streets as a Pentecostal minister, paints houses, and continues his art career.

ARTISTIC BACKGROUND
Simon Sparrow started to draw when he was seven years old, but his mature work, consisting mostly of pastel drawings, was started while he lived in New York City from 1944 to 1968. Unfortunately, much of the work he did during the earlier part of this period was lost; "I had an art place," he says, "but it burned down with all my paintings in 1958." The artist also creates large, collaged assemblages, some of which he uses to aid his Pentecostal street preaching.

Carl Hammer of the Hammer Gallery in Chicago discovered Sparrow's work in 1984 and began representing the artist.

SUBJECTS AND SOURCES
"I get small visions—fleeting pictures," Sparrow says, "and I paint them." Both his pastel drawings and his large assemblages contain images that are barely recognizable as human faces. He incorporates an iconography of personal symbols in his pieces that he claims "come from spiritual sources." The literal meaning of the work can only be understood, he says, "by the Lord."

MATERIALS AND TECHNIQUES
Sparrow's drawings are done with pastels on poster board or paper. The assemblages on plywood are composed of thousands of small objects: plastic beads, buttons, trinkets, and cheap souvenirs of all types that the artist finds at garage sales and secondhand stores in Chicago. Sparrow works outside while creating the assemblages, supporting them on sawhorses.

Perspective does not concern Sparrow; his faces, surrounded by symbols, designs, and fields of color, are flat. He uses color freely both in his pastels and in the assemblages.

The pastel drawings are approximately 30 by 24 inches; the assemblages are large, often 3 by 4 feet. Since the fire in which Sparrow lost an unknown number of pieces, he has made several hundred pastel drawings and about thirty large assemblages.

ARTISTIC RECOGNITION
Although Simon Sparrow's pastels are quite interesting, the large, complicated, heavy collaged assemblages are the artist's crowning achievement. The work is highly original and presents the type of spiritual expression that is often found in the work of folk artists.

The artist has been exhibited in Madison, Wisconsin, and at the Milwaukee Art Museum.

FANNIE LOU SPELCE—*"To me it is delightful memories that I am eager to share with others."*

BIOGRAPHICAL DATA
Born Fannie Lou Bennett, June 19, 1908, Dyer, Arkansas. Completed nurse's training, 1929, Sparks Memorial Hospital, Fort Smith, Arkansas; one year of postgraduate study, Beth Moses Jewish Charity Hospital, New York City. Married Neal Leslie Spelce, December 23, 1930; divorced 1954. Two sons. Now resides Austin, Texas.[1]

GENERAL BACKGROUND
Fannie Lou Spelce paints extremely detailed, cheerful scenes of old-fashioned social events.

Spelce's philosophy has always been to work hard and remember only "happy things," and she seems to have followed this maxim well, particularly when she turned to painting later in life. Spelce grew up on a farm in the Ozarks, attended school, studied hard, and eventually became a registered nurse, a career that she found rewarding.

After several successful nursing assignments in various places, Spelce was selected to serve with Dr. Michael DeBakey during the early days of open-heart surgery in Houston, Texas, from 1955 through 1959. She finally left hospital nursing but continued her career at St. Stephens Episcopal School in Austin, Texas, in the position of resident school nurse. She retired in 1972.

ARTISTIC BACKGROUND
Long summer vacations are one of the benefits of being a school nurse, and Fannie Lou Spelce decided to use this time to learn something new. In the summer of 1966 she showed up for art lessons at the Laguna Gloria Art Museum in Austin. Once the teacher saw her work, however, he said that she was a primitive; he also said that he could not teach her and advised her to discontinue the lessons and work on her own. "I may be old, but I'm not primitive," Spelce pertly told the teacher.[2] She did decide to take his advice, though, and continued painting on her own and in her own way.

By 1970 Spelce had amassed a reasonable body of work, and her son Bennett, an Austin advertising executive, took some of her paintings to show to galleries in New York City. The prestigious Kennedy Galleries offered to represent her, and her art quickly drew a favorable and interested audience.

SUBJECTS AND SOURCES
Spelce paints what she calls her "treasured memories"—band concerts, camp meetings, quilting bees, daily events in small towns—in other words, the sociable, neighborly activities that made up the "good old-fashioned life." In keeping with her philosophy of remembering only "happy things," her memory improves on reality, discarding the drab or the ugly.

The artist does not overlook even the tiniest details in her paintings. The patterns on the wallpaper, lace curtains at a window, individual floorboards, the words on a newspaper, the design of a quilt block, each row of vegetables in a garden—all are carefully and lovingly shown.

MATERIALS AND TECHNIQUES
Spelce paints with oils on canvas, using the smallest, finest brushes she can find in order to produce the minuscule

Fannie Lou Spelce, Arkansas Peach Season, *1968. Oil on canvas, 24 × 30 in. Collection of the artist. Fannie Lou Spelce captures minute details in her "treasured memories," and this small-town celebration is a delightful and representative example.*

details in her work. The paintings range up to about 30 by 40 inches.

She has painted 478 canvases. One painting remained unfinished in 1989 and may never be completed because of her failing eyesight.

ARTISTIC RECOGNITION

To many, Fannie Lou Spelce's paintings are the epitome of memory painting in the last twenty years. They are highly decorative, happy renditions of days gone by, even though not everyone may agree with the rose-colored view that the artist presents.

Spelce's work has been featured in magazines and newspapers both nationally and locally. It has been shown at museums in New York and Texas and appears in many major private folk art collections.

HENRY SPELLER

BIOGRAPHICAL DATA

Born January 6, 1900, Rolling Fork, Mississippi. Attended school through sixth grade. Married Mary Davis, 1941; separated, date unknown. Married Georgia Verges, date unknown; she died 1987. No known children. Now resides Memphis, Tennessee.[1]

GENERAL BACKGROUND

Henry Speller is a black folk artist whose inventive, colorful renderings of round-faced, long-legged figures that he identifies as "characters from 'Dallas'" have brought him recognition.

Born to a family of Mississippi sharecroppers, Speller spent much of his early life working in the cotton fields. His first wife was from Memphis, and they moved there in 1941. The couple moved from place to place in the big city and Speller went from job to job. He was a "junky" (one who collects scrap metal) for a period and later a grounds keeper for the the city parks commission, retiring in the middle 1960s.

Today the artist lives in a housing project far removed from the Memphis that tourists visit. He spends his days sitting on a tubular steel chair in front of a turned-on TV set and sketching.

ARTISTIC BACKGROUND

Henry Speller started drawing when he moved to Memphis in 1941. After he retired, he devoted much more time to his art. Speller's eyesight is now failing, and soon he may no longer be able to draw.

Speller was discovered and documented by folklorist Ray Allen in the early 1980s. Allen arranged for a showing

Henry Speller, Untitled, *1982. Mixed media on paper, 18¾ × 23¾ in. Luise Ross Gallery, New York. Speller says that his round-faced images, some of which have exaggerated sexual features—like the lady in this drawing—represent "characters from 'Dallas.'"*

of his work by the Center for Southern Folklore in Memphis, Tennessee, and for representation of the artist by the Luise Ross gallery in New York City.

SUBJECTS AND SOURCES
Speller draws scenes from his own life experience: houses, cars, riverboats, animals, and human figures. He is best known for his repetitive renderings of round-faced, long-legged men and women who wear patterned clothing,

sometimes with exposed breasts and genitalia. Speller calls them "characters from 'Dallas.'" He costumes his *Dallas* personages in bizarre, vaguely western attire decorated with multicolored patterns.

MATERIALS AND TECHNIQUES
Speller draws on large sheets of paper (19 by 20 inches), outlining his subjects with a graphite pencil and filling in with crayon and colored pencils. Except for his single-figure drawings, Speller fills all available space on the paper, often by use of patterns.

Because of Speller's many moves within the city of Memphis, some of his drawings have been lost. However, it is believed that several hundred have survived.

ARTISTIC RECOGNITION
Henry Speller's art is tough and direct but does not appeal to everyone. His *Dallas* characterizations from the late 1970s and early 1980s are his most sought-after work.

HUGO SPERGER—*"I just reads the Bible and illustrates the psalms."*

BIOGRAPHICAL DATA
Born February 20, 1922, Mirano, Italy. Attended Groton

Hugo Sperger, Sorrow and Hope, *1985. Oil on Masonite, 16⅜ × 31⅜ in. Folk Art Collection at Morehead State University, Morehead, Kentucky. Sperger's fanciful landscapes often deliver religious messages, as does this lively rendering in which good and evil are symbolized in many ways under the aegis of God's all-seeing eye.*

High School for three years, Groton, New York. Married Faye Reed, June 20, 1948. Two sons. Now resides Salyersville (100 miles east of Lexington), Kentucky.[1]

GENERAL BACKGROUND

Hugo Sperger is becoming well known for his dramatic painted landscapes that often deal with death and salvation.

The son of German parents, Sperger was born in Italy and has been running from an "industrial environment" for most of his life. He was brought by his parents to live in upstate New York when he was seven years old, and in 1940, before he finished high school, he enlisted in the army. He served in New Guinea and remained in the army until 1948.

On his return to his home in New York, Sperger found that he didn't fit into an "industrial environment." He moved from plant to plant in low-paying jobs in New York, Michigan, Indiana, and Kentucky.

Sperger is presently in poor health—he is nearly deaf and suffers from cancer. He now lives in a rural area of Kentucky and continues to paint.

ARTISTIC BACKGROUND

Hugo Sperger has been painting on and off, as time permitted, for forty years. The work that he is presently known for was started after his health began to fail and he required surgery in the early 1970s.

Sperger's work was included in "Good and Evil," a 1988 exhibition organized by Morehead State University, Morehead, Kentucky. He is also included in *O, Appalachia,* a major survey of Appalachian art.[2]

SUBJECTS AND SOURCES

Hugo Sperger paints fanciful, often biblical, landscapes. Figures, both animal and human, fly and float through unreal environments. The artist uses the paintings to convey his feelings about the human condition to the viewer and, to help in this regard, attaches angels and devils who carry balloonlike labels that read, for example, "life," "faith," and "folly."

Some of Sperger's subject matter, painted during periods of severe illness, can be considered gruesome, but usually lighter passages are injected to offset the pessimistic outlook of the work. Now that the artist's cancer is in remission, the paintings, although still quite intense, seem less heavy, more lighthearted and optimistic.

MATERIALS AND TECHNIQUES

Sperger has made some drawings with watercolors on paper, but he currently works with oils on Masonite.

Most of the paintings are 24 by 16 inches, but there are also a few large panels, about 4 by 8 feet. Sperger has done around one hundred major paintings.

ARTISTIC RECOGNITION

Hugo Sperger's biblical scenes, with their intense preoccupation with death and salvation, draw the most attention. He is well known to collectors of Appalachian folk art and is beginning to be recognized by a wider audience.

LAWRENCE STINSON—*"Whittling is making wood get smaller. When you finish, you have a bunch of shavings. When you carve, you got something left that's beautiful."*

BIOGRAPHICAL DATA

Born December 25, 1906, Bentonville (near Front Royal), Virginia. Attended school through ninth grade, Bentonville, Virginia. Married Sinie Roberts, 1938; she died April 4, 1987. One son. Now resides Cashmere, Washington.

GENERAL BACKGROUND

Larry Stinson is a wood carver who grew up in the Shenandoah Valley, where he was exposed to Appalachian craft traditions that have been handed down for generations. In 1927 he moved from Bentonville, Virginia, to the District of Columbia, where he was a "houseman" at the Georgetown Prep School. On March 29, 1929, he became an engineer/custodian for the National Cathedral and worked there until he retired in 1979.

Stinson moved to Charlottesville, Virginia, in the 1980s. After his wife died, he joined his son in Cashmere, Washington, where, he says, "I can walk along the river or through the woods and identify every tree."

ARTISTIC BACKGROUND

Larry Stinson has been whittling since he was six. "I saw John Lentz [a local whittler] carving chains when I was six," Stinson says. "I practiced, cutting myself in the process, until I made a chain with a swivel. I had him beat!"

Stinson began to make religious carvings while he was employed at the National Cathedral, and the works were exhibited in the nave of the church from 1976 through 1979. Stinson eventually withdrew them because some animals from his *Noah's Ark* disappeared.

In recent years arthritis has slowed this artist down, but he still carves. In fact, he won a number of blue ribbons at the fair in Waterville, Washington, in 1988.

SUBJECTS AND SOURCES

Stinson whittles traditional Appalachian chains and dancing men, but his art carving concentrates on religious figures and tableaux—Adam and Eve, Noah and the Ark, and crucifixes. "Well, I think a lot of it is in the wood," he says, "but then you got to form the picture."

MATERIALS AND TECHNIQUES

Stinson makes his carvings from pieces of driftwood or from hardwoods that he finds in the woods. He sometimes adds bits of plastic or other decorative objects, such as artificial flowers, to the pieces. He uses very little paint, preferring to let the texture and natural graining of the wood become part of the design of his work, such as the stripes on a zebra or the spots on a giraffe.

His carvings are small, usually not more than 6 inches high, but his tableaux often include many of these small figures and measure around 20 by 40 by 30 inches. Stinson has made fewer than one hundred objects and has shown no interest in selling them.

Lawrence Stinson, Garden of Eden, *c. 1975. Plywood, driftwood, plastic flowers, and paint, 9½ × 13 × 14 in. Chuck and Jan Rosenak. Stinson says he sold this profusely decorated rendition of the Garden of Eden because his wife was embarrassed, thinking Eve looked too much like her.*

ARTISTIC RECOGNITION

The Appalachian Mountains and the Shenandoah Valley have produced generations of craftspeople and artisans—whittlers, basket makers, furniture makers, and quilters—but only a very few artists. Larry Stinson is one of the few. His dancing men and chains represent some of the best of Appalachian craft objects, but his religious carvings stand out as beautiful, simple, direct expressions of faith, totally unlike other carvings of this type.

Stinson has yet to be widely recognized. His work is not known to museum audiences; since he lost figures at the National Cathedral, he will not lend out his work. He has only sold one major tableau.

"QUEENA" STOVALL

BIOGRAPHICAL DATA

Born Emma Serena Dillard, December 21, 1887, Lynchburg, Virginia. Left school in her senior year, Lynchburg High School, Lynchburg, Virginia. Married Jonathan Breckenridge ("Brack") Stovall, September 24, 1908; he died December 25, 1953. Five sons, four daughters. Died June 27, 1980, Elon, Virginia.[1]

GENERAL BACKGROUND

"Queena" Stovall (the nickname came from her childhood attempts to pronounce Serena) was a southern artist whose

"Queena" Stovall, Comp'ny Comin', *c. 1975. Oil on canvas, 20 × 24 in. David H. Stovall. A southern memory painter, Stovall sympathetically portrays her black neighbors and documents their everyday lives in the rural Virginia of her youth.*

memory paintings, especially those of her black neighbors, are well known.

Stovall grew up in a southern home where ladies of the middle class were expected to cook, keep house, do farm chores, raise large families, and not concern themselves with other matters. She did what was expected of her until she was a great-grandmother, when, at the age of sixty-two, she suddenly discovered that she had a "gift" to paint.

The Stovall family lived in various homes in the Lynchburg, Virginia, area, but the one the artist loved the best was a farmhouse she called the "Wigwam." She died at her favorite home in 1980.

ARTISTIC BACKGROUND
At the urging of David Hugh, her brother, Queena Stovall enrolled in an art course at Randolph-Macon Woman's College in Lynchburg in 1949, and her talent was immediately evident. Her teacher, Pierre Daura, realized that he could not improve on the artist's technique, and he included her first painting, *Hog Killing,* in an exhibition at the college. By 1952 she was given an individual exhibition at the Lynchburg Art Center.

In 1968 Stovall painted her last work. Her eyesight was failing, and she felt that the life she knew and represented so well in her work was disappearing. "I can't draw all this big machinery that's in the fields now," she declared.

SUBJECTS AND SOURCES
Stovall was an acute observer of a vanished southern existence. She painted the rural Virginia that she had known, the life she had led and observed and showed the day-to-day facets of life—farm chores, household chores, family gatherings, funerals, and holidays. She also documented the lives of her neighbors with great understanding and compassion.

MATERIALS AND TECHNIQUES
Stovall painted on canvas with oil paints. Sometimes she made preliminary sketches on paper and traced them onto the canvas. "If I'm going to put a figure down," she stated, "I put his feet where I want him to stand and then bring him up."[2]

Stovall worked slowly. She spent months on each painting, and one took her two years to complete. She painted forty-seven works in all, ranging in size from about 16 by 12 inches to 32 by 44 inches.

ARTISTIC RECOGNITION
Perhaps the most important accomplishment of this southern artist was documenting the lives of rural black families. Reproductions of her work have been widely sold, but because there are so few original Stovall paintings, only a relatively small audience has actually seen them. She was, however, exhibited at the Abby Aldrich Rockefeller Folk Art Center in Williamsburg, Virginia, in 1975 and at the Museum of American Folk Art, New York City, in 1978, and in December 1981 a film on the artist's life was aired on public television.

CLARENCE STRINGFIELD

BIOGRAPHICAL DATA
Born January 28, 1903, Erin, Tennessee. Attended school through tenth grade, Erin, Tennessee. Married Mary Emma Pack, May 29, 1926; she died 1944. Six daughters, two sons. Died June 6, 1976, Nashville, Tennessee.[1]

GENERAL BACKGROUND
Clarence Stringfield was a talented wood carver known for his humorous style and clever caricatures—and especially for his "bathing beauties."

In his youth Stringfield had been an active man—a farmer and a cabinetmaker—but in 1934, when he was working for DuPont in Nashville, Tennessee, he became bedridden with tuberculosis and remained ill for the next three years. It was during this period that he began to carve.

By 1940 Stringfield's health had improved enough for him to return to work, and he found employment operating a spindle-carving machine for Murray's Chair Company in Nashville. He remained there for twenty-two years, leaving in 1962 to work for the Lyzon Gallery, also in Nashville, making picture frames. He remained with the gallery until his death in 1976.

In addition to his other interests and activities, Stringfield was a skilled country fiddler. He played a fiddle he made himself, and his favorite tune was the "Over the Waves Waltz."

ARTISTIC BACKGROUND
Clarence Stringfield began carving for amusement while he was bedridden in the 1930s and found the hobby so satisfying that he continued to carve even after he returned to work. He started by "drawing off" fish that friends would bring him and made "fish tales" out of them by carving them larger than life.

For many years Stringfield carved only for his own pleasure and the entertainment of friends, but eventually his work was discovered by his employer, Myron King, the owner of the Lyzon Gallery. King had helped many other folk artists and also helped Stringfield to become known.

SUBJECTS AND SOURCES
Besides fish, Stringfield carved a series of "bathing beauties," country musicians, and politicians, some in the form of wall plaques. His work includes forty or fifty plaques of Grand Ole Opry figures—both the luminaries and the little-known "pickers" and singers.

MATERIALS AND TECHNIQUES
Stringfield carved softwoods with a pocketknife and a few simple hand tools. He painted his bathing beauties and some of the other figures with bright colors and dyes, including Mercurochrome and iodine, and finished most with lacquer or wax.

Stringfield's bathing beauties all seem to have been modeled after the same woman. They are amply proportioned, with large pointed noses, angular faces, and thin lips that

Clarence Stringfield, Bathing Beauty, *c. 1950. Painted wood, 26 × 6 in. Chuck and Jan Rosenak. This sensuous "bathing beauty" of ample proportions is a repeated image in this artist's work. His bathing beauties—all of whom wear brown loafers—appear to have been modeled after the same unknown woman.*

turn down at the corners; they are dressed in 1940s- or 1950s-style swimsuits; and wear brown loafers. Although some of Stringfield's figures appear stiff and uncomfortable, he had complete control of his medium. He also had a wry sense of humor, and some of his carvings are clever caricatures.

Stringfield made several hundred carvings, ranging in size from a few inches high to a life-size bathing beauty.

ARTISTIC RECOGNITION
Clarence Stringfield is generally considered one of the better folk carvers of this century. Although his bathing beauties are the most popular, all of his works are of interest. His work is included in both private and public collections.

JIMMY LEE SUDDUTH—*"I'm gonna be fay-mous, fay-mous! I didn't learn much in school—Just learned to write my name—Jim. But I believe I'd rather be famous, than rich or smart." "I leave the drips so people know it is mine."*

BIOGRAPHICAL DATA
Born March 10, 1910, Caines Ridge, Alabama. Some education at the grade school level. Married Ethel Palmore, 1940s. No children, although the Sudduths had a close relationship with Rance Maddov, a young folk artist who may have been a nephew; he died in an accidental drowning some years ago.[1] Now resides Fayette, Alabama.

GENERAL BACKGROUND
Jimmy Lee Sudduth[2] is a black artist who has achieved recognition for his colorful mud paintings of Alabama architecture and life.

The Sudduths live alongside the tracks of the Southern Railroad, "out back" of the white community of big Victorian houses facing the road. Their two-room concrete-block house has partial wooden siding and a wraparound screen porch where the family can escape the oppressive heat of Alabama's summers. Sudduth likes to point to one of the big houses and say, "The white folks up there willed this [his little house] to me—cost $1,500 to build."

Sudduth grew up in the South before it faced the upheaval of the 1960s. Like many southern blacks of those earlier years, he had little formal education, and his teachers claimed he would rather draw than learn formal subjects.[3] Jan McWater, the wife of Sudduth's pastor, sums up the artist's relationship with the community:

The schools may not be segregated now, but this is still the deep South and there is a line down the town.

Blacks and whites keep to themselves. But everyone loves Jimmy Lee. He does the best he can and we are real proud of him. I have a painting of his in my house, and most my friends do too.[4]

Sudduth spent many years working hard; he was employed at several nearby farms and at a grist mill, and then he and his wife, Ethel, worked on the Lumpkin White farm for twenty-five years. They moved into town in 1950, where Sudduth does odd jobs, mostly as a gardener.

In addition to being known for his painting, Sudduth has quite a reputation for his blues renditions on the harmonica. He has played in local groups and in 1976 per-

Jimmy Lee Sudduth. ABOVE LEFT: Self-Portrait of Jim, *1988. Clay, mud, and molasses, 23¾ × 48 in. Kurt A. Gitter and Alice Yelen. This farmhand is characteristic of Sudduth's earth-toned mud paintings.* ABOVE RIGHT: Self-Portrait with Guitar, *1986. Dirt, natural pigments, and house paint on plywood, 48 × 24 in. Chuck and Jan Rosenak. The artist has been experimenting with paint in addition to dirt and natural pigments, with bold results.*

formed at the Smithsonian Institution's bicentennial Festival of American Folklife.

ARTISTIC BACKGROUND

Jimmy Lee Sudduth makes mud paintings, which he claims he has been doing since he was three years old. In the late 1960s he started appearing at county fairs with his harmonica and his mud paintings, and that is when others began to learn of his work.

Sudduth's paintings were exhibited at the Fayette Art Museum in 1971, and in 1976 the Smithsonian Institution invited him to Washington, D.C., to participate in its bicentennial Festival of American Folklife.

SUBJECTS AND SOURCES

Sudduth is best known for his fanciful mud renditions of the residents and buildings of turn-of-the-century Fayette. He has depicted its churches, houses, and public buildings, including the jail house.

Sudduth also paints animals and other objects. He has shown turtles, cats, and snakes, and he did a series of paintings of Ford automobiles and another of log cabins. Lately he has done some self-portraits, usually depicting himself playing a banjo.

MATERIALS AND TECHNIQUES

Sudduth uses locally manufactured plywood as the bases for his paintings: "They got a big factory, biggest in the world," he proclaims, "they makes the board, and I go get it."

First the artist blocks in the design of a painting and heavily outlines it with what he calls a "dye rock." Dye rocks are soft stones that Sudduth claims were first used by Indians to paint their faces; after they are dipped in water, they will leave a heavy earthy line when pressed against a hard surface.

Sudduth keeps a galvanized washtub at hand in which he stores mud mixed with sugar water. The sweetened water, he explains, makes the mud permanent. "After it's down," Sudduth says, "you can step on it, kick it, anything you like, and it won't come off the board." He fills in his outlines with the mud mixture, letting the dye-rock lines show through.

After the mud surface has dried, Sudduth gathers various weeds and other vegetable matter and rubs them over the painting's surface to obtain his colors. He manages to get amazing variations from these natural colorants, from greens to yellows and browns. "Sometimes I use pork berries," he states; "pork salad—it's red."[5] In recent years, at the urging of collectors and dealers, who are sometimes fearful that there may be preservation problems with the mud works, the artist has started to experiment with house paint, which he rubs onto his baseboards with his bare hands.

Sudduth has produced hundreds of paintings and is still at work.

ARTISTIC RECOGNITION

Jimmy Lee Sudduth keeps experimenting with new materials, but his subject matter has remained pretty much the same over the years. He gained some national attention after an appearance on the "Today" show in 1980, but he is still known mostly to those interested in black folk art. His work appears in the Fayette Art Museum collection and in a number of private collections.

PATRICK SULLIVAN

BIOGRAPHICAL DATA

Born March 17, 1894, Braddock, Pennsylvania. Received little formal education. Married Martha Ritter, March 13, 1920; date of her death unknown. Two daughters, one son (who died only an hour after birth). Died August 31, 1967, West Virginia.[1]

GENERAL BACKGROUND

Patrick Sullivan was a "Naive Symbolist" painter known for his complex allegorical images.

Sullivan's father died when he was only two, and his mother, too ill to care for her son, placed him in an orphanage where he remained until he was fifteen. He left the orphanage to work in a sheet-iron mill in McKeesport, Pennsylvania, and later in the mills of West Virginia.

Sullivan became a house painter for a period before serving in the army during World War I, from 1916 to 1919. When he left the service, he returned to Wheeling, West Virginia, to work as a house painter, then became a playground manager. Throughout the remainder of his life, Sullivan continued to have a series of low-paying jobs—selling washing machines, working for Wheeling Steel

Patrick Sullivan, The Fourth Dimension, *1938. Oil on canvas, 24¼ × 30¼ in. Museum of Modern Art, New York; Sidney and Harriet Janis Collection. As depicted in this striking allegorical painting, the artist believed that man is chained to a three-dimensional planet and, when he dies, the chain is broken and the spirit departs.*

Corporation, and working as a night watchman and at a waterworks. He died in 1967 of emphysema.

ARTISTIC BACKGROUND
Although Patrick Sullivan started drawing while he was still in the orphanage, he did not seriously pursue his interest in painting until after the war. His major works were painted between 1936 and 1941.

In 1937 Sidney Janis, a New York art dealer, discovered Sullivan when his work was included in an exhibition held by the Society of Independent Artists in New York. Janis began to represent him at that time. Although Sullivan gained recognition and was included in a series of exhibitions at the Museum of Modern Art in New York City, he was unable to support himself through the sale of his art.

SUBJECTS AND SOURCES
Sullivan expressed his religious beliefs, love of mankind, opposition to violence, and hatred of fascism in his paintings. He developed a series of complex symbols that he mixed with representations of such world leaders as Hitler, Roosevelt, Mussolini, and Chamberlain. His symbols included an hourglass for time, a dove and two men for the Trinity, and a club, ax, and knife for courage, will power, and intellect. His are very complex, almost surreal paintings that are highly allegorical.

MATERIALS AND TECHNIQUES
Some of Sullivan's early work was done on a window blind and a tea towel, but later he painted with oils on canvas, using a newspaper as a palette. He also painted with house paint in paste form, sometimes building up heavy layers of pigment and adding egg yolk to linseed oil in order to thin the paint. His colors are mostly earth tones—warm browns and greens—and jewellike blues. Sullivan's clouds are quite distinctive; they are long and horizontal, ranging from mere wisps to stripes running across the canvas.

Sullivan was a slow and careful painter, sometimes taking as long as a year to complete a piece. He rarely produced more than three paintings a year, and his total output was not great. Only nineteen paintings (of which eleven are considered major works) and a crucifixion mural in the apse of the Sacred Heart Church in Wheeling, West Virginia, are known to have survived. The paintings are mostly around 20 by 30 inches; the church mural is 26½ feet in height.

ARTISTIC RECOGNITION
Patrick Sullivan's crucifixion mural and his allegorical paintings that are now in Oglebay Institute's Mansion Museum in Wheeling, West Virginia, stand as testament to his talent. His mysticism, his ability to handle paint, and the surreal quality of his art continue to draw the respect and interest of collectors and scholars alike. His work is included in the Museum of Modern Art in New York City and in the Smithsonian Institution's National Museum of American Art, Washington, D.C.

REVEREND JOHNNIE SWEARINGEN—*"I hear the Lord. He tells me to do His bidding and that's what I do."*

BIOGRAPHICAL DATA
Born August 27, 1908, Campground Church near Chappell Hill (near Brenham), Texas. Attended school through eighth grade, Petersville (near Brenham), Texas. Married Lora Ann Williams, c. 1926; divorced; she died c. 1948. Married Murray Lee Williams (not related to Lora Ann), 1949. Two stepsons, two stepdaughters. Now resides Brenham, Texas.[1]

GENERAL BACKGROUND
The Reverend Johnnie Swearingen is a black preacher who paints religious scenes and impressions of life in rural Texas.

Swearingen claims that he was only seven years old when he first heard the word of the Lord. "But," he says, "I went through periods when I fell away [from about 1947 through 1962]. I had worldly deals—girlfriends."

Swearingen left his home in Texas when he was a young man and worked his way west to California, hitching rides on freight trains, "chopping" cotton (hoeing between the cotton rows), and picking grapes. When he reached San Pedro, he went to work as a longshoreman.

In 1948 Swearingen returned to Texas and took up farming; that was also the period when he had a lapse from the Lord's call. But "In 1962 God called to me again," he states; "I will never give up preaching and painting."

ARTISTIC BACKGROUND
Johnnie Swearingen claims he started painting at an early age but turned to it more seriously when he returned to Texas about 1948. By 1962, when he started preaching again, he was painting as much as possible.

Reverend Johnnie Swearingen, 4 Horsemen of the Apocalypse, *1985. Oil on board, 24 × 31½ in. Butler and Lisa Hancock. This version of a popular biblical story is a strong and vibrant statement by this rural black preacher.*

The artist was introduced to the public in an exhibition entitled "The Eyes of Texas: An Exhibition of Living Texas Folk Artists," held at the University of Houston in Houston, Texas, in 1980.

SUBJECTS AND SOURCES
Swearingen paints biblical scenes, fables, and memories of his life in Texas and the people he knows. His paintings show a vivid and quirky imagination: cars bend as they turn corners, the devil appears at the open door of a church, death rides in a horserace. The artist lets his work preach in quiet tones about the everyday realities of the rural black culture.

MATERIALS AND TECHNIQUES
Swearingen made some early drawings with shoe polish on paper, but his medium has mostly been oil paints on Masonite. He generally signs his paintings "J.S.S.," and he sometimes repeats his topics.

The paintings are usually around 24 by 26 inches in size, although he has done a large painting of Noah's Ark that is 4 by 8 feet. When questioned, Swearingen would not say how many works he had completed, only that he had eight for sale at the moment.

ARTISTIC RECOGNITION
The Reverend John Swearingen is well known in parts of the Southwest but less known elsewhere in the country. He has been widely exhibited in Texas, and his work is included in The Menil Collection in Houston.

LUIS TAPIA—*"I think that what I am doing is very traditional—in line with what my ancestors did two hundred years ago. It is religious; it is made of wood; and it is covered with gesso and paint."*

BIOGRAPHICAL DATA
Born July 6, 1950, Santa Fe, New Mexico. Graduated from St. Michael's High School, Santa Fe; spent one year at New Mexico State University, Las Cruces. Married Star Rodriguez (she uses the name Tapia and is an artist), 1969;

Luis Tapia, Christ Calming the Sea, *c. 1988. Painted wood, 20 × 21 × 9 in. Jorge Luis and Barbara Cervera. In this lyrical representation of Christ calming the sea, Tapia breaks with the* santero *tradition and carves his own interpretation of a biblical story.*

divorced 1980. One son, one daughter. Now resides Santa Fe, New Mexico.

GENERAL BACKGROUND

Luis Tapia is a contemporary *santero* whose work combines traditional and nontraditional elements.[1]

"In the late 1960s," Tapia explains, "the Brown Berets started shouting 'Viva La Raza' and I realized that I knew very little about my Hispanic origins. I started listening to music and looking at old *santos* in museums and churches."

Tapia started work in 1969 as a stock boy for Cooper's Western Wear in Santa Fe; when he left in 1974, he was store manager. By that time, however, he was able to support himself by restoring old southwestern furniture and by selling *santos*. Tapia also does restoration work for museums.

ARTISTIC BACKGROUND

After studying the work of the *santeros* in museums, Tapia began to carve his own saints in 1971. "At first," he says, "I gave them away to older people. And then more and more people came to my house, so I started selling."

In the early 1970s Tapia exhibited his work at the Spanish Market (held each July in Santa Fe).[2] However, he had a falling out with the Spanish Colonial Arts Society that runs the market: "They said I couldn't exhibit unless I copied old *santos*—I wanted to advance the tradition, so I said no."

SUBJECTS AND SOURCES

Luis Tapia is a contemporary *santero*. He carves the traditional saints of the Hispanic culture, but he also carves nontraditional ones, such as Saint Veronica, who is not usually found in New Mexico churches, or puts his figures in unusual groupings. He has modernized the styling of his saints, sometimes making them angular or almost cubistic. The figure of *La Muerte* and "death carts" also appear in the religious carvings done by the artist.[3]

Tapia does some secular carving (mostly guitar players and nudes) as well as some very abstract sculpture.

MATERIALS AND TECHNIQUES

Tapia carves in many kinds of wood. He covers his carvings with gesso and paints them with acrylics and watercolors.

His saints and other sculptures range from quite small—about 8 inches—to 7 feet tall. He has also carved *retablos* or *reredos* for church altars that are as large as 20 by 40 feet. Tapia believes that he has made hundreds of pieces.

ARTISTIC RECOGNITION

Luis Tapia has become one of the best known of the modern southwestern *santeros*. His stylized death carts exemplify the artist's effort to make religious innovations by modernizing a traditional form.

Tapia has been shown at the Museum of International Folk Art in Santa Fe, New Mexico, and, in 1980 he was awarded a grant for his work from the National Endowment for the Arts. His sculpture is in the permanent collections of the Smithsonian Institution's National Museum of American Art in Washington, D.C., and in the Los Angeles Craft and Folk Art Museum in California.

SARAH MARY TAYLOR—*"The quilts mean a lot to me. They looks pretty! Sure do! They warm me up. They pay for the doctor."*

BIOGRAPHICAL DATA

Born Sarah Mary Johnson, August 12, 1916, Anding (near Jackson), Mississippi. No formal schooling. Married six times (all by common law): Sam Hankin, 1931; Otis Anderson, 1934; Jeff Jefferson, 1939; Simon Heard, c. 1951; Willie C. Fletcher, 1958; and O. C. Taylor, 1961; widowed 1970. One son by Hankin. Now resides Yazoo City, Mississippi.

GENERAL BACKGROUND

Sarah Mary Taylor, a southern black woman, creates innovative quilt designs that reflect various influences in her life.

Taylor's mother, Pearlie Posey, worked the fields and plantations of the Mississippi Delta and quilted to provide warm bed coverings for her family. Her daughter sat by

Sarah Mary Taylor, Sarah Mary Quilt, *1981. Appliquéd quilt, 92 × 69 in. Maude and James Wahlman. Taylor's sense of color and design and her spirited, imaginative style have elevated her to the top rank of southern quilters, as this remarkable example verifies.*

her side and learned how to quilt, and that was her education.[1] "I didn't get no learnin'," she remembers. "My mother had a friend who could read, and he'd write it out for me to copy. What I learned, I taught myself."

Taylor went into the fields when she was tall enough and strong enough to hold a hoe. "I hoed cotton, corn, and beans. When I was lucky, I could get a job in a white folks' kitchen, or taking care of their children. I started out making 75 cents a day—my last year working I made $14.95 a day."

Taylor bought her present home for herself and her husband in 1964. "I promised to pay $1,200," she says, "at $30 a month, from the money I made cooking in a white woman's kitchen." Her home is a wood frame southern-style shotgun house (a long narrow dwelling with one room opening into the next) set on wood pilings. The house is distinguished from its neighbors because Taylor decorated the trim in a gay bright orange, "to bring out the gray," she explains.

In 1971 Taylor fell sick while hoeing cotton; she had heart trouble. She was forced to retire, even though she was not eligible for Social Security. Today she also suffers from arthritis.

ARTISTIC BACKGROUND
"Mother and Grandmother taught me to make quilts. At first, I made 'nine-patch' quilts [nine large patches in three rows, the materials cut from discarded clothing], but one morning in 1970, I got up and made a cutout of my hand and started making my own style."

Taylor's aunt, Pecolia Warner, also a quilter, took some of Sarah's quilts to sell in 1971 or 1972. "She sold them for $100 each," Taylor says, "and kept $5 for herself. I didn't like that, so I started sewing my name and number into the quilts—pretty soon I didn't need her no more." After Taylor retired, quilting became her sole source of income. She continues to sew, even though she has arthritis. Recently she has also started to make drawings (she calls them "books") for sale.

SUBJECTS AND SOURCES
Taylor's quilts are not narratives; she is interested in design. "I tries to make 'em beautiful," she says. She makes a template of a frog, for instance, and that will be her theme of the day. Her designs are lively, and she surrounds her subjects with joyous bursts of random color.[2]

MATERIALS AND TECHNIQUES
"The Black and White store in Yazoo City, where I shop, is the only one that sells dry goods," says the artist, and that is where she buys the fabrics for her quilts. The fabric quality varies, and the colors are not always fast.

Taylor makes templates out of paper, then uses them to cut out her materials. She appliqués the cutout fabric onto larger pieces (the patches) and joins those together, with strips in between, to form the quilt top. Then she sews the top to batting and backing in the traditional manner, adding a border strip. Many of Taylor's quilts are still based on the nine-patch format that she learned in her youth. Her stitches are coarse, and she often uses white thread.

Taylor's drawings are done with felt marker and pencils on poster board and paper, using templates similar to those for her quilts, to form bright patterns of color.

Her quilts range in size from crib quilts to full bed-size coverings; her drawings are about 20 by 30 inches. Taylor has created several hundred quilts and about the same number of drawings.

ARTISTIC RECOGNITION
Sarah Mary Taylor's quilts make a strong folk art statement apart from the quilting tradition, and her work has been acquired by many serious folk art collectors.[3]

JAMES HENRY ("SON FORD") THOMAS—*Thomas's speech is punctuated by blues lyrics: "Goin' to get up in the morning—believe I dust my blues" (Get out and make some art).*

BIOGRAPHICAL DATA
Born October 14, 1926, Eden (near Yazoo), Mississippi. Attended school through fifth grade, Morning Star Baptist Church School, Eden, Mississippi. Married Hattie Green, 1948; now separated. Five sons, five daughters. Now resides Leland, Mississippi.

GENERAL BACKGROUND
"Son Ford" Thomas is a southern black man who was first a sharecropper and then became a blues musician and noted clay sculptor. "You can't play the blues, drink whisky,

James Henry Thomas, Skull with Corn Teeth and Foil Eyes, *1971. Unfired local clay ("gumbo" or "buckshot"), corn kernels, foil, paint, and wax, 6½ × 9½ × 5½ in. University Museums, University of Mississippi. Thomas's unfired clay skulls, with their shining eyes and realistic-looking teeth, are dramatic reminders of the mortality of man.*

and be a Baptist," he says, " 'cause you doin' wrong." Thomas had natural talents for music and art but did not fully develop them until he was nearly fifty.

Thomas got his nickname, "Son Ford," while still in school, because he was always modeling Ford tractors out of clay or wood. After he left school, he worked alongside his father sharecropping. "You borrow to put seeds in the ground—pay for the seeds and end in the hole. I done it till 1961." After he gave up sharecropping, Thomas dug graves for "white people" at the Stoveville Cemetery until 1971. By then he had found that he could support himself composing and playing the blues (Thomas sings and accompanies himself on the harmonica, piano, and guitar), and making clay sculptures.

ARTISTIC BACKGROUND

Thomas recalls making things with clay or wood from his early years: "At age ten, I made a skull," he says, "to frighten Grandfather." The skull was successful (his grandfather ordered him to remove it from the house) and has remained a favorite theme of his mature work.

In 1971 Thomas gave up digging graves and started performing as a blues musician and making art full-time. Within a few years William Ferris, a folklorist and director of the Center for the Study of Southern Culture at the University of Mississippi in nearby Oxford, discovered Thomas and has since spent time documenting both his sculptures and his music. Ferris has also donated many of Thomas's early works to the university.

SUBJECTS AND SOURCES

Dreams are the basis for many of Thomas's ideas for both his sculpture and his blues lyrics. His sculpture—clay animals, heads, and, of course, the skulls—conveys a message of doom, but it is intended to be beautiful, in the sense that "bad" is "good."

MATERIALS AND TECHNIQUES

Thomas uses "black gumbo" clay, which appears gray. Sometimes he mixes a little wax with the clay and puts hair grease on it to smooth it. He air-dries the clay in direct sunlight, which leaves it quite fragile. The artist embellishes his skulls and heads with wigs, sunglasses, glass eyes, ribbons, and other objects. His skulls often have vacant or aluminum foil–lined eyes, and the animals are frequently covered with tar. Recently, Thomas's son Raymond has been making skulls, and they may be difficult to distinguish from his father's work.

His earlier pieces are the simplest; the later works are more highly decorated. In the beginning the skulls had teeth of corn. In the last few years Jim Arient, a Chicago dentist and collector, has been supplying the artist with denture teeth. "I traded for skulls," Arient says.

Thomas has completed about four hundred objects. His skulls and heads are usually less than a foot high, his animals about a foot long.

ARTISTIC RECOGNITION

"Son Ford" Thomas's skulls are his most significant con-

tribution to folk art, and his work has appeared in galleries all over the country. As life in the Mississippi Delta changes, documenting the fragile and fugitive work of artists like Thomas is increasingly important.

Thomas's work was included in "Black Folk Art in America: 1930–1980" at the Corcoran Gallery of Art, Washington, D.C., in 1982. Not only were his sculptures exhibited, but Thomas also entertained guests at the opening with his blues music.

MOSE TOLLIVER—*"At first [after his accident], everyone took care of me and I got lazy. When I took up painting, I got started again." "I run a painting out with a black stripe—that's better than a frame."*

BIOGRAPHICAL DATA

Born July 4, 1919,[1] Pike Road Community (southeast of Montgomery), Alabama. Received little formal education, Macedonia, Alabama. Married Willie Mae Thomas, early

Mose Tolliver, Self-Portrait, *1980. House paint on Masonite, white-washed wood panel, 19 × 14⅝ in. Museum of American Folk Art, New York; Gift of Elizabeth Ross Johnson. Tolliver's flat and fantastic images have a posterlike quality that reflects an appealing sense of humor.*

1940s. Fourteen children; seven sons, four daughters still living. Now resides Montgomery, Alabama.

GENERAL BACKGROUND
Mose Tolliver, who paints simple and colorful posterlike images, is one of the best-known black folk artists in the South.

A sharecropper's son and one of a dozen siblings, Tolliver might never have become a famous artist if a load of marble hadn't crushed his legs in the late 1960s. "It almost kilt me," he says.

Tolliver spent many years as a tenant farmer and gardener in and around Montgomery, Alabama. He worked as a laborer in Georgia for a while, then returned to Montgomery. Eventually he left gardening and found employment in the shipping department of the McLendon Furniture Company, which is where the accident occurred. Since then he has had to depend on crutches and is unable to work.

ARTISTIC BACKGROUND
Mose Tolliver began to paint in 1970 or 1971, at the encouragement of a former employer. Prior to that time he had done a few root sculptures and carvings, but nothing sparked his interest the way painting did.

One of the first to discover Tolliver was artist Anton Haardt, who bought a number of his paintings. In 1978 he also came to the attention of Mitchell D. Kahan, a curator at the Montgomery Museum of Fine Arts (the artist lives near the museum), and Kahan curated a one-person show for Tolliver at the museum in 1981. The artist was also included in "Black Folk Art in America: 1930–1980," a traveling exhibition that opened at the Corcoran Gallery of Art in Washington, D.C., in 1982.

SUBJECTS AND SOURCES
Tolliver lives out fantasies in his paintings. He paints purple birds, green-faced people, and strange, sometimes anthropomorphic, animals. At times he turns to sexual images (in what he calls his "nasty" paintings)—women with legs spread and resting on pointed objects that Tolliver refers to as "scooters" or "exercising bicycles." At other times he paints self-portraits or vegetables and flowers.

Tolliver's work is flat, simple, and opaque, almost childlike in its execution yet dramatic in its impact. All of his paintings consist of flat central figures surrounded by a contrasting field of color. Sometimes the artist finishes off a painting by painting a stripe of black around the picture to act as a frame and tacking a beer can pull tab on the back so that it can be hung.

MATERIALS AND TECHNIQUES
Because of his injury, Tolliver cannot stand at an easel, and so he works on relatively small boards that can be rested on his legs or placed flat on the floor below his chair. His family used to "scrounge up" used wood and leftover paint in alleyways, but now he can afford to buy plywood and house paint for his artwork. His work ranges from about

10 by 12 inches to 25 by 36 inches. Tolliver signs his work "MOSET," with a backward S.

Tolliver works quickly. "If it took me more than an hour to finish a picture," he says, "I wouldn't paint." He has produced as many as ten paintings in a day. Because the artist is so very prolific, his output is in the low thousands. His wife and other family members also paint.

ARTISTIC RECOGNITION
Generally, Mose Tolliver's early work is considered his best. After the Corcoran show he began working on commission and repeating subjects, but the work is still of high quality, and occasionally the artist will come up with a new idea that removes the work from the ordinary.

Tolliver's imagination knows no bounds. His sense of color is superb, his sense of humor pleasing, and few black folk artists in the South are better known. His paintings are included in many collections, and he has been widely exhibited.

EDGAR TOLSON—*"Talk about fire and brimstone. . . . I saw my father preach with a .38 caliber revolver in one hand and a pint of whisky in the other." (From a conversation in May 1989 with Bill Tolson, son of Hulda Tolson and stepson of Edgar Tolson)*

BIOGRAPHICAL DATA
Born June 24, 1904, Lee City (near Hazel Green), Kentucky. Attended school for six or eight grades, Edgar

Edgar Tolson, Sodom and Gomorrah, *c. 1980. Model airplane paint and bronze radiator paint on wood with small stones, 14¼ × 8⅛ × 11⅛ in. Chuck and Jan Rosenak. In this biblical group Lot's wife turns into a pillar of salt as she looks back on the home they are leaving. Tolson's carvings reflect the essence rather than the details of his message.*

Johnson Fork Elementary School. Married Lily Smith, 1921; divorced 1940. Married Hulda Patton, 1942. Three sons, three daughters by Smith; eight sons, three daughters by Patton. Died September 7, 1984, Campton, Kentucky.

GENERAL BACKGROUND

Edgar Tolson was the most important Kentucky carver of the century. Like many of the Kentucky mountain people, he was a descendant of seventeenth-century settlers from England. He worked at various jobs—as farmer, laborer, chair maker, and preacher—but for many years before his death he was first and foremost a wood carver.

Tolson began preaching as a "called preacher" in 1921 and eventually became pastor of the Holly, Kentucky, Baptist church. Yet he was troubled by what he saw in the world, and one Sunday in 1935 or 1936 he put a stick of dynamite under his church and blew it off its foundation (no one was hurt). "Bunch of hypocrites," he is said to have yelled, "they can't live it [the word of the Lord]." Nevertheless, he continued preaching for another twenty-five years.

On September 23, 1957, Tolson suffered a stroke. He sold the small tobacco farm that he owned and moved into two house trailers on the side of a hill overlooking Campton, Kentucky; the larger one was for his wife and the children, the smaller one for himself. In 1961 Tolson announced to his congregation that he, too, "couldn't live it," and stepped down from the pulpit.

ARTISTIC BACKGROUND

Edgar Tolson made some whittlings and Appalachian toys as early as 1912 or 1916. However, his mature carving career did not begin until after his stroke in 1957, when he started to devote much more time to his art.

In the middle 1960s Carl Fox, director of the Smithsonian Institution's Museum Shop, took a group of Tolson's work on consignment. The carvings proved to be quite popular, and Tolson was invited to participate in the Smithsonian Institution's Festival of American Folklife in 1968 and 1973. In 1968 Michael Hall, at that time assistant professor of sculpture at the University of Kentucky in Lexington, saw Tolson's work and became his dealer.

SUBJECTS AND SOURCES

Through a technique of reduction, Tolson portrayed men and women and the relationships between them. He reduced his subject matter in size; stripped away the nonessential, and in the process captured the fleeting glance or moment of truth.

Tolson used biblical characters as well as temporal figures, but he was not necessarily preaching God's word—he was simply telling people some eternal truths through his work. His eight-part *Fall of Man* series, from *Paradise* through *Cain Goes into the World,* may almost be viewed as allegorical as well as a simple presentation of biblical stories.

MATERIALS AND TECHNIQUES

Tolson did a few carvings in soft stone, but his preferred medium was poplar, which he carved with a pocketknife and sparsely painted. He also went through periods when he hardly used paint at all.

Tolson carved at least one thousand objects. Some are small animals not more than 2 to 4 inches high, but even his major pieces (with a few exceptions) are no larger than 24 inches high.

ARTISTIC RECOGNITION

All of Edgar Tolson's carvings, even his smallest animals, are of museum quality, despite the fact that he repeated many themes. In 1973 Tolson was exhibited at the Whitney Museum's "Biennial of American Art"; he is the only folk artist who was ever invited to participate in this prestigious event. His work is included in many collections.

DONALD LEE TOLSON—*"Since Dad died, it gets on my nerves to sit around and carve, but I do it anyway."*

BIOGRAPHICAL DATA

Born December 1, 1958, Campton, Kentucky. Attended school through seventh grade, Campton, Kentucky. Single. No children. Now resides Campton, Kentucky.

GENERAL BACKGROUND

Donny Tolson was closer to his father, Edgar Tolson (see page 303), than any of his numerous brothers and sisters because he was the only child who whittled. The Tolson family lived in two trailers parked on the side of a mountain above Campton, Kentucky; the larger trailer, where Donny grew up, was for Hulda Tolson and the children; the other was for Edgar Tolson.

Tolson was not overly interested in school; "I flunked seventh grade and wouldn't go back," he says. After leaving school, he held various odd jobs and in the early 1970s lived for a time in Indiana, moving furniture and driving a truck, but he liked none of it. About 1980 he returned to Campton and his family in the two trailers. When Edgar Tolson died in 1984, Donny Tolson left the family compound and moved into town.

Tolson still lives in Campton; he spends his time carving and driving and repairing trucks.

ARTISTIC BACKGROUND

"I watched Dad," Donny Tolson relates, "but I was never happy. I ran with wild women, gambled, and drank. Then in 1980 I started making some carvings out of poplar. There was plenty of people come by the trailer—they bought from Dad and they bought all I could make too." Tolson learned his skills from his father and sold to some of the same market as well.

SUBJECTS AND SOURCES

"He taught me what the Garden of Eden looks like, and he showed me how to make it," Donny Tolson says. Like his father, Tolson carves biblical characters and scenes such as David and Goliath, Adam and Eve, or the Garden of

Donald Lee Tolson, Preacher, *c. 1980s. Carved birch, 15 × 5 × 10 in. Timothy Egert. Tolson's skillful and spare wood carvings capture essential elements of the activities of his subjects, as shown by this preacher emphasizing a point during a Bible reading.*

Eden, but he is also developing his own particular body of work—preachers, rock-and-rollers, guitar players, and sports heroes.

MATERIALS AND TECHNIQUES

Like his father, Donny Tolson also prefers poplar for carving. He whittles with a pocketknife and applies paint sparingly to his figures.

Tolson has made fewer than two hundred carvings. They range in size from small animals only 4 inches high to figures about 15 inches high.

ARTISTIC RECOGNITION

Donny Tolson is still in the process of developing his own style. Those who have collected the father's work feel that the son is too derivative, but others are delighted with Donny Tolson's carvings, which show a singular skill.

BILL TRAYLOR

BIOGRAPHICAL DATA

Born 1854, George Traylor Plantation, near Benton (between Salem and Montgomery), Alabama. Probably no formal education. According to Traylor, he had married and his wife died in the 1930s. Approximately twenty children; some were known to have lived in Detroit, Washington, D.C., and Montgomery, Alabama. Died 1947, Montgomery, Alabama.[1]

GENERAL BACKGROUND

Bill Traylor, born into slavery, became an extraordinary artist whose starkly simple drawings depict individual facets of the black experience in the South.

After the Civil War, Traylor chose to stay on the plantation where he grew up. He took the name of the plantation owner, worked as a field hand, and lived on the plantation until he was eighty-four years old. By then, he said, "they're all gone" (meaning his wife and the family that had owned the plantation), so he moved to Montgomery, Alabama, in 1938.

In Montgomery, Traylor worked briefly in a shoe factory; when illness and rheumatism prevented him from working any longer, he received welfare. He did not need much money because he had a free place to sleep, in the back room of the Ross-Clayton Funeral Home, and in the daytime he sat in front of a pool hall or near the Montgomery fruit and vegetable market.

During World War II Traylor lived with his children in Detroit and Washington.[2] He lost a leg to gangrene at some point during this period, but he chose to return to Montgomery in 1946. Traylor went back to sitting in front of the pool hall or near the market, now spending his nights in a shoe repair shop. In 1947 he went to live briefly with a daughter in Montgomery, then went into a nursing home until he died.

ARTISTIC BACKGROUND

Bill Traylor started drawing in 1938. "Art came from

Bill Traylor, Untitled, c. 1939–1942. Show-card color on cardboard, 9 × 6 in. Luise Ross Gallery, New York. The overall effect of this lively drawing of acrobatic figures is complex, although Traylor's imaginative use of space and composition is straightforward.

Traylor like water from a spring," says Montgomery artist Charles Shannon, who met the eighty-five-year-old artist sitting on a wooden box and drawing by the curb on Monroe Street in downtown Montgomery, in the summer of 1939.

Shannon immediately befriended Traylor, brought him materials to work with, and helped to promote his art. Traylor's first individual exhibition was at the New South Art Center in Montgomery in 1940. "In 1941 or 1942," Shannon remembers, "I left twenty-five of Traylor's drawings with a staff member of the Museum of Modern Art in New York. They sent me a check for $25, and sale had not even been discussed. When the drawings were eventually returned, I found out that the museum thought it had purchased two and Alfred Barr, its director, one."

When Traylor returned to Montgomery after the war, he resumed drawing for a short period before his death. After his death Shannon continued to try to promote interest in Traylor's work, but it took him forty years before these wonderful drawings were appreciated by a wide public audience.

SUBJECTS AND SOURCES
In his stark and simple drawings, Traylor spun yarns about plantation life, street life, and the black experience in the South. He also drew familiar farm and domestic animals. His forms are devoid of ornamentation and flat—he could not draw three-dimensionally, so he developed devices, such as a two-eyed profile that he sometimes used to give the sense of depth.

Traylor's subject matter stands out from the background in stark and contrasting colors. He did not care if a face was blue or a pig red; the overall effect was what counted. He was also a master in his use of space; his sense of line and color is unparalleled.

MATERIALS AND TECHNIQUES
Traylor drew on whatever material he could find in the streets—cardboard shirt boxes, for instance. Any irregularities in the material became part of the composition. He used stubs of pencils to outline his forms, then painted with whatever color or type of paint he had on hand.

Charles Shannon began to bring Traylor paper and poster paints soon after meeting the artist. Despite the uncertainties of the earlier materials, Shannon says, "I have owned Traylors for fifty years and have not observed deterioration."

Traylor's works number about 1,500 in total, a huge output for one who started painting at such a late date and age as did this artist. The works range in size up to 24 by 30 inches.

ARTISTIC RECOGNITION
Bill Traylor's imaginative and narrative drawings are significant contributions to the folk art of this century. His work has been widely exhibited, and it appears in many museum and private collections, including that of the Museum of American Folk Art in New York City.

FAYE TSO—"If the clay doesn't like you, you will never be able to make a good pot."

BIOGRAPHICAL DATA
Born Faye Bilagody, as a member of the Naakaii Dine'e (Mexican clan), 1933, Tuba City, the Navajo Nation, Arizona. Attended Tuba City public schools for two years (when her mother died, she had to leave school to take care of two sisters). Married Emmett Tso, date unknown. Four sons, four daughters. Now resides Tuba City, the Navajo Nation, Arizona.

GENERAL BACKGROUND
Faye Tso is a leader among the innovative Navajo potters

who have broken with tradition. The Tsos, however, are a traditional family, and their loyalty to the Navajo Nation is reflected in everything they do. They are herders of sheep and goats but also much more. Faye Tso is an herbalist and weaver, as well as a potter. Her husband, Emmett, is a former Navajo councilman, a current adviser to the Navajo Nation, and a potter; he and one of their sons are medicine men. At least one son and one daughter also make pottery.

The Tsos live in a prefabricated house with a ceremonial hogan out back in Tuba City, Arizona.

ARTISTIC BACKGROUND
Emmett Tso explains that "fire, cloud and earth [all elements of Navajo pottery] are all part of the Navajo Way." When Faye Tso married Emmett, she entered a family of potters and soon became an active disciple. She learned pottery making from an "old, old Grandmother," probably a relative of her husband's, and worked with Rose Williams, a well-known Navajo potter, in the 1970s.[1]

Tso's pottery began to move away from the traditional almost immediately. She and her husband have not hesi-

Faye Tso, Head of Emmett, *c. 1985. Fired clay with piñon pitch, 10 × 6½ × 6½ in. Chuck and Jan Rosenak. Tso breaks Navajo taboo by placing her husband's image on an upside-down Navajo drum pot that normally would have been used for ceremonial purposes.*

tated to break taboos by reproducing likenesses of the sacred *Yéii bicheii* figures and horned toads on their pots, when tradition calls for virtually no ornamentation—and certainly no depictions such as these. The Tsos, although willing to be innovative, have had special sings conducted to protect themselves against the possible ramifications of the broken taboos.[2]

Tso markets her work through the Keams Canyon Trading Post in Keams, Arizona.

SUBJECTS AND SOURCES
Faye Tso has advanced the craft of utilitarian Navajo pottery making to an art form. She creates original shapes and adds her own designs and glazes; she also makes busts out of clay, something no other Navajo has done.

MATERIALS AND TECHNIQUES
Tso's pots are made in the traditional Navajo way. She uses clay dug from Black Mesa, forming it into coils that she winds upward into the desired shape. She then smoothes the pot with a burnished corncob, places it in an open pit, covers it with manure, and fires it with cedar. Where the wood ash comes in contact with the clay, "fire clouds" appear.[3] She coats the finished pottery inside and out with melted piñon pitch. When the pitch hardens, the pot is waterproof and can be used for cooking.

Tso has made more than two hundred pots, ranging in height from a few inches to 3 feet.

ARTISTIC RECOGNITION
Faye Tso was among the first Navajos to revolutionize traditional pottery making by changing shapes and designs, and she has taught others. Her work is a milestone in contemporary Navajo pottery, and her busts and portraits of her family and neighbors are unique in the history of the Navajo culture.

Faye Tso's reputation is rapidly expanding, and deservedly so. Her work appears in many collections of southwestern folk art and Native American pottery.

TERRY N. TURRELL—*"I'm a workaholic. I'm a dreamer. I've decided to be an artist."*

BIOGRAPHICAL DATA
Born November 4, 1946, Spokane, Washington. Graduated from Coeur d'Alene High School, Coeur d'Alene, Idaho; attended North Idaho Junior College for two years. Married Margaret ("Margey") Erikson, 1984; divorced 1987. No children. Now resides Seattle, Washington.

GENERAL BACKGROUND
Terry Turrell creates large, unconventional paintings with sculptural surfaces that he builds up from different materials.

After he left school, Turrell, like many others of his generation, joined the San Francisco scene. "It was the 1960s," he says, "and I had to see what was going down." For ten years, from 1966 to 1976, he supported himself as

a laborer in San Francisco and was part of the hippie movement. In 1976 he moved to Seattle, Washington, where he began making leather handbags and batik wall hangings to sell at the Pike Street Market.

Shortly after getting married, Turrell and his wife separated; he switched to painting houses for a year and then began hand-painting T-shirts. In 1986 he decided to pursue a career in art but continued to decorate T-shirts as well.

ARTISTIC BACKGROUND

Terry Turrell has been making purses and T-shirts for a long time, but he only started making art in 1986. "I can sell thousands of handmade T-shirts, each different," Turrell says. "But they aren't really art—I want to be an artist."

Mia McEldowney, the owner of the MIA Gallery in Seattle, discovered Turrell's large, textural pieces that are part sculpture, part painting, and gave him his first individual show at her gallery in 1989. The show was a success, and Turrell began to gain some recognition as an artist.

Terry N. Turrell, Black Board, *1989. Mixed media, 19 × 23¾ in. MIA Gallery, Seattle, Washington. Turrell expresses his daydreams through texture and abstract flat, sticklike figures.*

SUBJECTS AND SOURCES

"I walk around the city daydreaming," Turrell says. "I daydream messages that I can paint." He sees images—monsters, people, animals—that are almost abstract, then puts them as sticklike figures in his paintings. Usually the images are flat and the colors muted.

Just as dreams may not be clear to the dreamer, Turrell's paintings may not always be clear to the viewer. On a subconscious level the work is abstract, but the artist often prints words on the surface that, although they add interest, do not always fully explain the action shown in the picture.

MATERIALS AND TECHNIQUES

Turrell uses Masonite or canvas as his base and builds up the surface of his paintings with a material used to repair dents in automobiles, with dirt, and with sheets of aluminum and copper. Texture is central to his work. He paints the surfaces with acrylics when the textural work is complete.

The artist has completed thirty-five major pieces. The largest is 4 by 6 feet.

ARTISTIC RECOGNITION

Terry Turrell's art is a deliberate attempt at self-expression by an untrained artist who has rejected formal academic disciplines. Some collectors are supportive of Turrell's innovative talent, and his work is gaining an audience among the more adventurous admirers of folk art.

HORACIO VALDEZ—*"I make a living at it. I guess the early* [santeros] *had to sell or trade sheep or something, too. Being a* santero *is an honorable profession."*

BIOGRAPHICAL DATA

Born July 15, 1929, Dixon (south of Taos), New Mexico. Graduated from St. Joseph's Public High School, Dixon, New Mexico, 1946. Married Carmen Maez, January 2, 1951. One son, one daughter. Now resides Dixon, New Mexico.

GENERAL BACKGROUND

Horacio Valdez, a carver in the *santero* tradition,[1] grew up in the mountains of northern New Mexico, where the small mountain towns are isolated by language, religious custom, and terrain from the mainstream culture of the United States. Their inhabitants fight fiercely to preserve these small patches of beautiful land and find it difficult to leave; when, through necessity, they must, as did Valdez, they often return.

Valdez became a carpenter, but because there was no work in Dixon he had to leave home, sometimes for as long as a year at a time, in order to support himself. He worked at construction sites in California, Utah, Colorado, and Nevada; even after he married and built his present home overlooking a valley of fruit trees, he continued his gypsy life for more than twenty years—but always returned home.

Horacio Valdez, Death Cart, *c. 1979. Cottonwood, hair, and leather, 53 × 30 × 50 in. Chuck and Jan Rosenak. In 1979 this dramatic death cart made by Valdez was actually used by the Penitentes during a Good Friday procession in Lydon, New Mexico.*

In 1974 Valdez had a nearly fatal accident while he was working on the Nambe Dam, north of Santa Fe, New Mexico; his right hand was crushed so badly that he has never been able to hold a hammer since. That same year Valdez was initiated into the Brotherhood of the Penitentes, an important religious group in the Southwest,[2] and through his participation in this group he found a new meaning in life.

ARTISTIC BACKGROUND
Horacio Valdez decided to become a *santero* shortly after joining the Penitentes. "I saw the *santos* in the *morada*,"[3] he says. "I couldn't hold a hammer, but I could whittle." Valdez was successful from the start. The first three carv-

ings that he made were purchased by the Fine Arts Center in Colorado Springs, Colorado, and when he showed his work at Spanish Market in Santa Fe, New Mexico, in the late 1970s, he was an immediate success. He now declares that "I haven't needed [the Market] for a long time because I sell everything to collectors who come to my house in Dixon." His *santos* are also currently used in services at the *morada* in Lydon, New Mexico.

SUBJECTS AND SOURCES
Santeros play an important part in the religious tradition of the southwestern Hispanic culture, and Valdez is very much a part of this tradition.[4] He carves *bultos* (religious figures, usually saints, in the round) and *retablos* (relief panels) that are used for religious purposes. "I have added my own style," he explains. "Experience has taught me that the tradition must change as times change."

Valdez also makes traditional "death carts"; his have been used in recent Good Friday processions.

MATERIALS AND TECHNIQUES
Valdez carves in aspen, then covers the wood with gesso and paints it with acrylics and watercolors. He also uses real hair and leather fittings on his death carts.

Valdez's *santos* start at about 9 inches in height and go up to about 3 feet. He has made about 750 carvings to date.

ARTISTIC RECOGNITION
Horacio Valdez is regarded as one of the finest carvers of religious figures in the Southwest. His death carts are examples of the highest quality of carving produced within the contemporary *santero* tradition, and he has brought his own vision to this two-hundred-year-old art.

MANUEL VIGIL

BIOGRAPHICAL DATA
Born June 10, 1900, as a member of the Summer Clan, Tesuque Pueblo (north of Santa Fe), New Mexico. Attended school through fourth grade, St Catherine Indian School, Santa Fe, New Mexico. Married Vicenta Swazo, 1920s. Four daughters, one adopted son.[1] Now resides in a Santa Fe nursing home and in the pueblo of Tesuque.

GENERAL BACKGROUND
Manuel Vigil, one of the best known of the Pueblo figurative potters, speaks Tewa, the language of his pueblo, and only a little English and Spanish. He remembers the 1920s and 1930s as the heyday of the pottery industry in Tesuque. Then the pueblo was famous for its clay rain gods,[2] but by 1950 the industry had vanished, and Vigil was virtually the only figurative potter left working in Tesuque.

In addition to potting, Vigil also farmed and was an active participant in the traditional dances and ceremonial affairs of the pueblo. Although in 1948 he was struck by a car and lost one leg, he still loved to go into Santa Fe dressed in his ceremonial finery and sit in the plaza, a participant, even if limited to a more passive role.

Manuel Vigil, San Acacio, c. 1960. Fired clay with poster paint, 13⅜ × 17 in. Museum of International Folk Art, a unit of the Museum of New Mexico, Santa Fe; Girard Foundation Collection. Manuel Vigil, a Pueblo potter known for his striking figurative work, created this unique version of the crucifixion of San Acacio. In shape and color it is representative of his attention to detail.

ARTISTIC BACKGROUND
Manuel Vigil grew up working with clay; he says that he was making rain gods by the time he was a young man in the 1920s and achieved a degree of renown. In the early 1940s he was asked to perform a rain dance in a New York City nightclub, and it did indeed rain that night.

Until his grandson, Art Vigil, began making figurative pottery in 1985, Manuel Vigil was the Tesuque standard-bearer for the genre. His work is undated, but Vigil was the first Pueblo Indian to make Nacimientos[3] (around 1960),

and one of the first to make storyteller figures.[4]

Vigil sold his ware through galleries in Santa Fe, New Mexico, and also was exhibited at the Museum of International Folk Art there. The artist has been ill since 1985, however, and unable to work in clay.

SUBJECTS AND SOURCES
Manuel Vigil made figurative sculptures that portrayed pueblo life and ceremonies. Nacimientos and rain gods, elaborate tableaux of dancers, and the whole range of the busy pueblo daily life are shown in his work. The artist managed to capture all the color and ceremony of Indian life in his authentically costumed clay figures that he often placed against backgrounds appropriate for the activities shown.

MATERIALS AND TECHNIQUES
Vigil used the brown clay of Tesuque and sometimes the micaceous clay of Pojoaque, New Mexico, in making his

figures. He removed the impurities, then shaped and sanded the pieces. He fired the figures in an enamel refrigerator pan placed over a cedar fire; they were protected from smoke discoloration by pieces of roofing tin.

In keeping with Tesuque tradition, Vigil used poster paint for painting the faces and the body decorations of the figures, and his wife and other family members often added bits of cloth and feathers. Vicenta Vigil even sacrificed an old fur coat to make hair for his storyteller figures.

Vigil made a great many clay figures (some of his tableaux may contain as many as fifty), but not all of these small, fragile pieces have survived. The figures are rarely more than 9 inches in height.

ARTISTIC RECOGNITION
Manuel Vigil is one of the best known of the Pueblo figurative pottery makers of this century. His tableaux of dancers, his storytellers, and the *Nacimientos* are great achievements and virtually unsurpassed.

Vigil's figures are in many museum collections and on permanent display at the Museum of International Folk Art in Santa Fe. In 1973 the artist had the distinction of being the only southwestern Indian artist represented in a large exhibition of Nativity scenes in Eindhoven, the Netherlands.

ARTHUR ("ART") VIGIL—*"If made right [rain gods], they'll bring rain."*

BIOGRAPHICAL DATA
Born July 16, 1955, as a member of the Winter Clan, Santo Domingo Pueblo (between Albuquerque and Santa Fe), New Mexico. Attended classes in auto mechanics at Pojoaque High School, Pojoaque, New Mexico. Single. Two daughters. Now resides Tesuque Pueblo (north of Santa Fe), New Mexico.

GENERAL BACKGROUND
Art Vigil, a figurative potter, has revived the rain god tradition in Pueblo pottery making.

Vigil was adopted and raised by his grandfather, Manuel Vigil (see page 309), a famous figurative potter of Tesuque. Although Vigil learned to repair automobiles in school, he is so heavily involved in tribal events—religious ceremonies, feasts, and dances—that it is virtually impossible for him to take employment outside the pueblo. Besides, he says, "It's too greasy. I had it in my head all the time that I would make pottery."

Vigil does tend a small herd of cows (started with one that his grandmother won at bingo) but spends most of his time making figurative pottery.

ARTISTIC BACKGROUND
Art Vigil started helping his grandfather make figurative sculpture when he was three years old. Around 1984 or 1985, when his grandfather became too ill to work, Vigil started out on his own. In 1985 he began the revival of the

Tesuque rain god tradition in pottery, which had been dormant since the early 1940s.[1]

Vigil has been able to sell all of his work through galleries and shops in Santa Fe, New Mexico.

SUBJECTS AND SOURCES
Art Vigil makes figures of pueblo dancers, figurative tableaux, and single figures in the manner of his grandfather, but he has added his personal vision to the rain god figures that he creates. Vigil's gods are dissimilar to those made earlier in this century, which hold water jars on their laps. Vigil's rain gods are crafted with more precision and imagination—they perch atop churches overlooking the pueblo plazas where the traditional dances are performed.

MATERIALS AND TECHNIQUES
The potter uses Tesuque clay that he fires in an enamel pan (once an icebox drawer) placed on top of a fire fueled with cedar. Following the Tesuque tradition, Vigil paints his figures with poster paint after firing. With the help of family members, he sometimes dresses his dancers with bits of discarded clothing and feathers.

Vigil has made about 50 rain gods and possibly 150 other figures. All are small, no more than 10 inches tall.

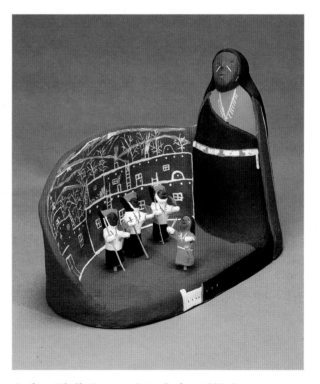

Arthur Vigil, Tesuque Rain God, *c. 1987. Poster paint on fired clay, cloth, and wood, 7½ × 9½ × 5½ in. Mr. and Mrs. Robert Linton. Here Vigil creates a tableau in clay depicting a major Pueblo ceremony, while an image of a sacred rain god oversees the ritual.*

ARTISTIC RECOGNITION

Art Vigil has revived a tradition and given it his own personal touch. His art is gaining acceptance, and his rain gods and tableaux of dance figures are of special interest to collectors of Native American art. Vigil's work was featured in a show of Pueblo pottery at the Wheelwright Museum of the American Indian in Santa Fe in 1990.

FELIX VIRGOUS—*"I have a gift from the Lord."*

BIOGRAPHICAL DATA

Born October 30, 1948, Woodstock (near Memphis), Tennessee. Attended elementary school for four years, Woodstock, Tennessee. Married Patricia Burges, December 1987. Two stepdaughters, one stepson. Now resides South Memphis, Tennessee.[1]

GENERAL BACKGROUND

Felix Virgous comments on black ghetto society by combining biblical stories with images from popular culture in his unusual paintings and assemblages.

When he was about twelve years old, Virgous fell from a swing and severely injured his back. "Since then," he says, "I can't take no heavy jobs. I just take a few easy ones like cutting grass." Patricia, his wife, supports the family by working outside the home as a domestic.

In the early 1980s Virgous converted a free-standing garage in an alley behind his parents' home into a "clubhouse," his private hideaway for making art.

ARTISTIC BACKGROUND

Felix Virgous says that the "Lord crawls into my head each day and tells me what to paint." The accident that Virgous suffered as a child may have have limited his work and physical activities, but it also served to interest him in art. He started to paint about 1960, shortly after his fall, and

Felix Virgous, Jesus, *c. 1988. Acrylic on wood panel, 11 × 17 in. Arnett Collection. This artist paints his own colorful interpretations of biblical stories, often depicted in contemporary urban settings.*

has continued ever since. When the artist moved into Memphis with his parents in the early 1980s, he set up his "clubhouse" so that he would have a more conducive environment in which to paint.

William Arnett, a folk art dealer from Atlanta, Georgia, discovered Virgous in 1987. He has been encouraging the artist and promoting him.

SUBJECTS AND SOURCES

"My paintings," Virgous says, "are about the teachings of Jesus and Moses and against the anti-Christ." The paintings contain biblical scenes from both the Old Testament and the New Testament, but Virgous combines them with elements of popular illustrations.

The central figures in a Virgous painting stand out from the background in a manner similar to some techniques used in advertising.

MATERIALS AND TECHNIQUES

Virgous has made some assemblages and cloth cutouts in addition to his drawings and paintings. Since meeting William Arnett, he has been working with more permanent materials than in his early days. He now uses paper and plywood, on which he paints with pencils, marker pens, and acrylics.

Virgous has completed approximately 150 objects, ranging from about 6 by 12 inches to 20 by 30 inches.

ARTISTIC RECOGNITION

Many folk artists are no longer content to paint only for personal gratification but are well on the way to becoming professional painters, even when they are untrained. Felix Virgous, although relatively unknown, is a member of this newly emerging group; he is a talented painter whose work is being taken seriously.

JOHN VIVOLO

BIOGRAPHICAL DATA

Born December 6, 1886,[1] Accri, Italy. No formal education. Married Teresa Palambo, 1907; she died 1931. Four daughters, three sons. Died March 28, 1987, Hartford, Connecticut.[2]

GENERAL BACKGROUND

John Vivolo carved winsome and appealing wood figures that are characterized by their welcoming, outstretched arms.

Vivolo was born in the impoverished village of Accri in southern Italy and sent to work in the wheat fields when he was only eight years old. When he was fourteen, his family shipped him off to America, where he was taken by a cousin to make his fortune in a mining camp in West Virginia.

After three years Vivolo "improved" his lot by joining an Italian railroad construction road gang in Maryland. He escaped from its armed guards as soon as he could and made his way to New York City, where he became a

John Vivolo, Man on Black Chicken, *c. 1974. Carved and painted wood, 18 in. high. Mr. and Mrs. Jules Laffal. Vivolo said that he remembered men riding chickens in his native Italian village, and this carving presents an interesting interpretation of the event. The outstretched arms are a typical element in the artist's work.*

bakery delivery boy, pulling a cart designed for a horse.

By 1906 Vivolo had saved two hundred dollars and spent it on passage home to Italy, where he again did farm work. He married and returned to America in 1907 with his bride. The couple went to Hartford, Connecticut, where misfortune seemed to follow them; their first house burned to the ground and the second was condemned after a flood. It was not until 1950 that Vivolo finally completed the home in Bloomfield (a suburb of Hartford) where he spent the remainder of his life. Even then, however, his troubles did not seem to be over. In 1980, the Catholic diocese of Hartford sent a bulldozer to level Vivolo's wife's grave in order to make grass cutting easier. He stood in front of the grave day after day until the diocese finally gave in.

After Vivolo returned to the United States, he spent most of his working life holding down several jobs at a time in order to support his large family. Bricklaying, carpentry, and demolition work were his specialties, and he worked for various construction companies in the Hartford area. Vivolo finally retired in 1957 with a small Social Security pension.

When he died, John Vivolo was more than one hundred years old.

ARTISTIC BACKGROUND
According to his daughter Jennie Maraschiello, who lived

with Vivolo after his retirement, "he just started going down into the basement and carving up firewood." Once started, Vivolo devoted an enormous amount of energy to making carvings that he called "his children"; he carved day and night, fearful that he did not have time to make all the "children" that he had in his head.

At first, Vivolo simply gave his carvings away, but after a few years he began selling them to supplement his income. Vivolo's work was discovered by Florence Laffal, the publisher of *Folk Art Finder;* he has been featured in this magazine, and his work has been used as its logo and in promotional materials.

SUBJECTS AND SOURCES
Vivolo referred to his sculpture as his children, but they were all of himself. In spite of the hardships in his life, he was a companionable man, and his figures repeat his characteristic gesture of welcome—arms outstretched as though waiting to hug. Vivolo's "central theme became people—riding [on horses and chickens], working, playing music, smoking, or simply standing. Outstretched arms became his trademark."[3]

In addition to his figures, Vivolo made about twenty large whirligigs that have wind-activated propellers. They depict men in action—slaughtering chickens, carving wood, or other such activities. He also carved a number of smaller animals, particularly brightly painted chickenlike birds, which are interesting but do not have the character of his other pieces.

MATERIALS AND TECHNIQUES
Vivolo used fireplace logs—oak, peach, birch, and pine—for his work, creating pieces with an ax and various hand tools. He incorporated cutouts from tin cans and other objects for fittings.

His early carvings were monotones, painted with multiple layers of latex house paint. In the 1970s he switched to bright colors but then returned to monotones as he grew older.

Vivolo made about four hundred carvings altogether. His figures range in size from 8 to 10 inches to about 4 feet tall; the whirligigs are somewhat larger. Those remaining when he died were boxed and stored by his heirs.

ARTISTIC RECOGNITION
John Vivolo's figures and his whirligigs are spirited, original, and appealing. They have been shown at various museums, where they rarely fail to delight viewers.

EUGENE VON BRUENCHENHEIN

BIOGRAPHICAL DATA
Born July 31, 1910, Marinette, Wisconsin. Attended grade school and several years of Catholic high school, Milwaukee, Wisconsin. Married Eveline Kalke, 1943; she died February 1989. No children. Died January 24, 1983, Milwaukee, Wisconsin.[1]

Eugene Von Bruenchenhein, The Danger We Face, *1954. Oil on board, frame by artist, 24⅜ × 36⅜ in. John Michael Kohler Arts Center, Sheboygan, Wisconsin; Eugene Von Bruenchenhein Collection. The artist is warning of the danger of a hydrogen bomb explosion.*

GENERAL BACKGROUND

Eugene Von Bruenchenhein filled his home with an amazing variety of art objects—from fantastic paintings to chicken bone sculptures—that he had created himself.

For most of his adult life, Von Bruenchenhein lived in a visionary world that only his wife shared; outwardly he held simple jobs and worked hard, first for a florist and later for a baker. He worked in the bakery for fifteen years, from 1944 until it closed in 1959. Von Bruenchenhein chose to retire that same year in order to devote more time to creating his fantastic artwork. His wife, who also worked, continued to support them.

During the late 1930s Von Bruenchenhein inherited a house on Ninety-fourth Place in Milwaukee, and he spent the remainder of his life transforming it into a very private and personal environment. He built a greenhouse to raise exotic plants (possibly an influence of his work with the florist) and painted the outside with bright patches of color —yellows, blues, oranges, and lavenders. Outside, large concrete masks resembling oriental gods leaned against the window wells; inside, the walls and all surfaces were covered with his artwork.

Until Von Bruenchenhein's death, no family member other than his wife was fully aware of all the artistic activity taking place within the house at Ninety-fourth Place.

ARTISTIC BACKGROUND

Eugene Von Bruenchenhein referred to his creative talent as "Genii," a combination of *Gene* and *genius,* and few artists better illustrate the drive to create than he did. The interior of his inherited home became the studio/gallery of the Genii when, from the moment he moved in during the 1930s, the artist began his lifelong project of quietly translating his personal visions into individual objects.

Soon after the artist's death in 1983, his wife brought the house and its contents to the attention of the personnel of the John Michael Kohler Arts Center. The center sponsored an exhibition to showcase this incredible work in 1984.

SUBJECTS AND SOURCES

Eugene Von Bruenchenhein was able to carry out many artistic projects simultaneously. He did fantastic paintings of nocturnal visions, monsters, atomic explosions, and flowers. He made gilded chairs and towers from chicken bones left from dinner. He created painted ceramic vases and concrete masks, and he took and developed photographs of his wife (who began to call herself Marie after their marriage) in costume and sometimes partially draped.

Except for the black-and-white photographs, this body of work was produced in vivid colors. It gives the impression of a dream sequence out of a science fiction movie.

MATERIALS AND TECHNIQUES

The artist worked in various media and with diverse materials. He painted with oils on Masonite, cardboard, and paper, sometimes applying the paint with his fingers. He created the chicken bone structures from the remnants of TV dinners and gilded them with gold paint. He made the ceramics from clay, usually coating them with aluminum paint after they dried. He made masks of cast concrete and used standard photographic materials for the photography.

The objects are as varied in size as in media. For example, the paintings are about 20 by 28 inches; the chicken bone chairs are tiny, only about 4 inches high, but the towers reach a height of more than 4 feet.

ARTISTIC RECOGNITION

The artist left a house filled with thousands of objects, but the environment was not preserved as a whole. Most of the pieces were given by Von Bruenchenhein's wife to the John Michael Kohler Arts Center in Sheboygan, Wisconsin, where they may now be seen.

Because of the variety in kind and concept of his art, Von Bruenchenhein does not fit into any definable category. Perhaps the best example of his talent is seen in his fantastic otherworldly paintings, but the chicken bone constructions have also generated a great deal of interest.

The artist is well known in Wisconsin and in the Chicago area.

INEZ NATHANIEL WALKER—*"I just draw by my own mission, you know. I just sit down and start to drawing."*[1]

BIOGRAPHICAL DATA

Born Inez Stedman,[2] 1911, Sumter, South Carolina. Received little formal education. Married (first name unknown) Nathaniel, 1924; married (first name unknown) Walker around 1972; separated. Three sons, one daughter. Died May 23, 1990, Willard, New York.

GENERAL BACKGROUND

Inez Nathaniel Walker began to draw her expressive, imaginatively colored portraits—usually of women—while she was in prison.

Firm facts about Walker's life are rare. It is believed that she was born in South Carolina, that her father died when she was twelve or thirteen years old, and that she was married to Nathaniel when she was around sixteen, but no confirmation of these dates or events is available.

Walker is quoted as saying that she moved north around 1930 to escape the "muck" of farm work. She worked for a time in a pickle factory in Philadelphia and around 1949 moved to Port Byron, New York, where she worked on apple farms.

In 1970 Walker was convicted of the "criminally negligent homicide" of a man who she felt had mistreated her. She explained her actions with the statement: "Some of these men folks is pitiful."[3] Walker was incarcerated in the Bedford Hills Correctional Facility, Bedford, New York, from 1971 through 1972 for her crime.

After she was released from prison, Walker returned to the Port Byron area and farm work; there she married for the second time.

ARTISTIC BACKGROUND

Inez Walker started drawing in 1972 while she was in prison. Elizabeth Bayley, who taught remedial English at the Bedford Hills facility, showed some of her drawings to Pat Parsons, an art dealer. Parsons bought most of the drawings and befriended the artist; she is the last person Walker is known to have contacted before she disappeared. Parsons received a phone call from her on Thanksgiving Day in 1980, and no one heard from her again.

Inez Nathaniel Walker, Two Women, *1977. Pencil and colored pencil on paper, 22½ × 28½ in. Webb & Parsons North, Burlington, Vermont. Walker called her compulsive renditions of female faces and figures "bad girls." Typically she has depicted a frontal view of the eyes in a profile.*

SUBJECTS AND SOURCES

Walker said that she drew to protect herself from "all those bad girls," but it is not clear if she was referring to the inmates or other women she knew (nor is it clear whether the women in her drawings are supposed to be inmates or others). For the most part, Walker drew women in single or double portraits, sometimes full-length but mostly head-and-shoulder views. The women are shown looking straight ahead or in profile, sometimes talking, drinking, or smoking. Their eyes always face front, regardless of the position of their heads. Walker concentrated on her subjects' hairstyles; the bodies are usually foreshortened and, when shown full length, have tiny feet, disproportionate to their body size.

MATERIALS AND TECHNIQUES

Walker's first efforts were on the back of the mimeographed pages of the prison newspaper. Later Pat Parsons supplied her with first-rate materials—good paper, watercolors, pencils (both colored and graphite), ink, crayons, and felt markers.

Walker did not concern herself with realistic color schemes; her faces and other visible areas of skin may be shown as solid red or blue, with details set off in black. The backgrounds contain boldly geometric and linear designs, and similar designs are often repeated on the subjects' clothing.

At some point after her remarriage, Walker stopped using "Nathaniel" on her drawings and began to sign them simply "Inez Walker."

Most of Walker's drawings are about 17 by 11 inches in size. Some are larger, and approximately twenty of them measure 42 by 30 inches. Walker is known to have completed three or four hundred drawings in total.

ARTISTIC RECOGNITION

Inez Nathaniel Walker's drawings are beautiful and timeless, and they deserve an important position in the history of black folk art. Her work has been shown in exhibitions in New York, Ohio, Pennsylvania, and elsewhere and is included in the collection of the Museum of American Folk Art in New York City.

VELOX WARD—*"I painted me a canvas and someone busted a hole in it, so I switched to Masonite."*

BIOGRAPHICAL DATA

Born December 21, 1901, Winfield (near Hopewell), Texas. Attended school through seventh grade, Hopewell and Growell, Texas, and Everton, northern Arkansas. Married Jessie Baines Howell, 1925. Two sons, one daughter. Now resides Longview, Texas.[1]

GENERAL BACKGROUND

Velox Ward, one of the few male memory painters, created realistic scenes of east Texas life in the early years of this century.

Velox was the name printed in gold letters on his moth-

Velox Ward, Mama Blows the Horn, *1967. Oil on wood panel, 20 × 24 in. Valley House Gallery, Dallas, Texas. A memory painter, Ward was inspired by his rural upbringing in east Texas. Here his mother calls the men in from the field for a meal.*

er's German-made sewing machine; it appealed to her, and so Velox was the name she gave her baby at his birth in the small east Texas town of Winfield.

"My Daddy died when I was in seventh grade, and I had to go to work," Ward says. "I worked at any job that would keep my head above water: farmhand, machinist, foundry worker, garage mechanic, salesman, plumber, wrestler [1931], and shoe repairman [1960]." Ward was constantly on the move, even after raising a family; when one of his children selected a college, he would move the whole family nearby and find employment.

The Wards eventually settled in Longview, Texas, and he built an 8-by-14-foot studio on their property.

ARTISTIC BACKGROUND
Velox Ward's children started him on his artistic career. In 1960, when he was working in a shoe repair shop, each of them asked for a painting for Christmas. He bought the necessary supplies—three brushes, five tubes of paint, and some small canvases—and worked at night to complete the gifts. He was so pleased with the results that he continued to paint after Christmas was over and hung his early work on the walls of the repair shop. First a leather salesman asked to buy a painting, then one person after another; soon Ward was able to give up his shoe service business for a career as painter.

Ward's work was discovered and represented by Donald and Margaret Vogel, owners of Valley House Gallery in

Dallas, Texas. He was given an individual show at the Amon Carter Museum in Fort Worth, Texas, in 1972, which traveled to six other Texas museums.

Ward is now in poor health and discontinued painting in 1989.

SUBJECTS AND SOURCES

Ward is one of the few contemporary male memory painters; he calls his art "buildups" because they develop slowly from his imagination, memories, and photographs. He documented the manner in which east Texans lived, worked, farmed, and worshiped during the first third of this century. The artist is a realist; his little figures set against colorful landscapes do not always express happiness. His subjects grow old with toil; his houses weather with time and the seasons.

Some of Ward's work can almost be considered surrealistic, with a haunting, dreamlike quality. *The Life of a Tree,* which was inspired by a double-exposure photograph, is a good example of this kind of work.

MATERIALS AND TECHNIQUES

Ward painted with oils on canvas or Masonite. He worked slowly, cutting out paper figures (he calls them "cutout dollies") and fitting them to the canvas in order to get the right perspective on the picture plane. Jessie, his wife, often posed for the "dollies," and she was his favorite model.

Ward made about two hundred paintings and some assorted sketches and paper cutouts. Most of his work is 20 by 24 inches or smaller in size.

ARTISTIC RECOGNITION

Velox Ward's canvases documenting life in east Texas are his most significant works, and his surrealistic painting *The Life of a Tree* is perhaps his best known. The artist is reclusive and has not attempted to sell or exhibit his paintings. He has had little exposure outside Texas, but his work is well regarded by those who know it.

WILLIAM ("WIBB") WARD

BIOGRAPHICAL DATA

Born May 14, 1911, Loman, Minnesota. Attended eight years of school, Sand Lake, Oregon. Married Bertha Apple, August 7, 1935. One son, one daughter. Died November 9, 1984, Sand Lake, Oregon.[1]

GENERAL BACKGROUND

"Wibb" Ward created a wonderland environment inhabited by carved wooden bears who often bore human features.

It seemed that Ward was destined to work with wood. At the age of seventeen he became a "timber topper," or "high climber"—the lumberjack who is responsible for taking the tops off the trees marked for cutting—and worked for various lumber companies. In his twenties, he had formed his own logging company, Smouse and Ward.

William Ward. Critic Bear, *1977. Cedar, house paint, and glass buttons, 34½ × 12½ × 15 in. Chuck and Jan Rosenak. Bears were a favorite subject of this artist, and* Critic Bear *was once part of his Bear Park. Attached is a sign explaining Ward's political view on taxes and bureaucrats.*

He continued in the lumber business for nearly another three decades, retiring in 1962 after he was injured in an automobile accident.

The Wards lived in a house on a 5-acre plot on Galloway Road, which leads from the town of Sand Lake, Oregon, to the beach. Initially, after his retirement, Ward spent his time at home or hunting, a favorite pastime. However, one day in 1964 he was hunting bear when his favorite dog, Randy, who always accompanied him, was injured. That hunting accident made Ward decide to stop shooting bears and start carving them.

ARTISTIC BACKGROUND
Once Wibb Ward started carving, he began to turn his 5-acre yard into a park inhabited by wooden bears; he also added swings to encourage children to enjoy the park. First neighborhood children and friends began to visit the park, but soon occasional tourists began coming too, as the Ward property fronts the beach road and makes an enticing diversion.

SUBJECTS AND SOURCES
Ward loved children and animals and hated rules, regulations, and taxes. His disaffections are evident in his work, for he often carved his bears with human features in order to illustrate his philosophy. (Some of the bears even have signs attached to them that denounce "taxes and bureaucrats.") But Ward also intended the bears to be loved and played with by children, so, of course, he included a grouping of *Goldilocks and the Three Bears*.

MATERIALS AND TECHNIQUES
Ward carved his wooden bears from redwood or pine logs with a gasoline-powered chain saw, sometimes using more than one log for a piece. He added buttons and marbles for eyes and painted almost all of the figures with flat black or brown paint. The exception is the figure of Goldilocks, who wears a white dress and has painted golden hair.

The bears range in size from Baby Bear size to ones 6 feet high. Altogether, there are more than fifty figures in the park.

ARTISTIC RECOGNITION
Wibb Ward was generally unwilling to part with his pieces, and very few collectors have acquired his work. Some of his carved bears from the park were included in "Folk Art of the Oregon Country," an exhibition sponsored by the Oregon Arts Commission that traveled to the Smithsonian Institution's Renwick Gallery in Washington, D.C.

The park still exists, maintained by Ward's daughter, Beverly Blum, and her children. The family says that visitors are always welcome, and the environment is well worth a trip to Sand Lake.

FLORETTA EMMA WARFEL—*"I'd go daffy if I couldn't do the painting, rugs, and things."*

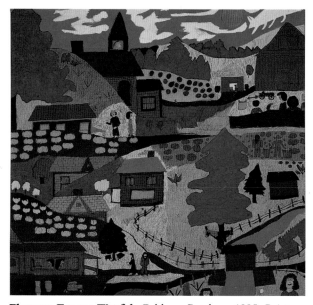

Floretta Emma Warfel, Cabbage Patch, *c. 1985. Paint on bed sheet, 38 × 40 in. George and Sue Viener. Warfel's vibrant paintings capture the flavor of farm life in rural Pennsylvania, as in this bright and lively work created in her typical bold blocks of color.*

BIOGRAPHICAL DATA
Born Floretta Emma Adams, April 5, 1916, Dushore (northwest of Scranton), Pennsylvania. Attended various schools through seventh grade. Married Grover Cleveland Warfle,[1] 1932; he died 1946. Five sons, five daughters; four stepsons. Now resides Norris Run (near Mansfield), Pennsylvania.

GENERAL BACKGROUND
Floretta Warfel uses cloth and embroidery paint to create her charming memory paintings that are distinguished by their bold use of color.

"I belong in the mountains," Warfel says. "The old Pennsylvania pine-tree hills. My daddy was a logger, and we moved around pretty much. I found myself sixteen years old and in the seventh grade, so I quit and got married. I never worked outside the home, except to sell my rugs and things."

Warfel's husband, Grover Cleveland, ran a blacksmith shop until his death in 1946, then Warfel was left a widow with fourteen children to care for. "Welfare helps," she says, "but we always need a little extra."

ARTISTIC BACKGROUND
From the time she married in 1932, Floretta Warfel made and sold knitted and braided rugs and quilts to augment the family income. She made a few early drawings on cloth but nothing came of her experiments until, as the artist says, "I went serious in 1952." At that time she began to

do scenes of Pennsylvania farms and to experiment with more color in her work.

Warfel would hang her drawings and paintings on her front porch, along with her rugs and quilts. Occasionally, tourists would stop and buy, but she made no real effort to sell the drawings over the more utilitarian pieces. In the 1970s Ruth Stall, an antiques dealer in Dalton, Pennsylvania, began to show her unusual work, and more recently Gene Epstein, a folk art dealer in New York, has also started to represent the artist.

SUBJECTS AND SOURCES
Warfel primarily paints scenes that she has observed during her life in the hills. "I see farms and remember them," she says. "Someone suggested that I paint nudes. And I said to myself, 'Naked people!' I'll put 'em behind bushes."

MATERIALS AND TECHNIQUES
Warfel has never been able to afford the luxury of wasting material. For many years, she painted on whatever piece of fabric was available—old skirts, blouses, pillowcases, or other irregularly shaped pieces of cloth. When she became successful, she started buying cheap yard goods at the local Ben Franklin to use as a base for her work. The artist draws and paints with ballpoint pens, indelible ink pens, and embroidery paint directly from the tube. She uses strong blocks of primary colors in her landscapes and does indeed hide her nudes behind bushes.

Her body of work now includes some several hundred paintings. Her pictures start small, but some are as large as 3 by 5 feet.

ARTISTIC RECOGNITION
Floretta Warfel's best works are the landscape paintings of Pennsylvania farms. Her use of bold blocks of color makes the paintings uniquely different and distinguishes them from the usual idyllic landscapes of the memory painters.

Although Warfel's work has received attention from collectors since the late 1970s, she has not yet become familiar to museum audiences.

DEREK WEBSTER—*"To find something different, I go into the alleys. Ideas come to me from the stuff others throw away." "I just do it my own way, I don't want to do it like anybody else's way."*

BIOGRAPHICAL DATA
Born April 26, 1934, Republic of Honduras. Attended school through sixth grade, Belize. Married Edith Piggee, December 2, 1971. One daughter. Now resides Chicago, Illinois.

GENERAL BACKGROUND
Derek Webster uses discarded materials and objects to create figures in energetic poses reminiscent of carnival dancers and masqueraders.

When he was only a child, Webster's family fled Honduras to escape a revolution. They settled in Belize, where

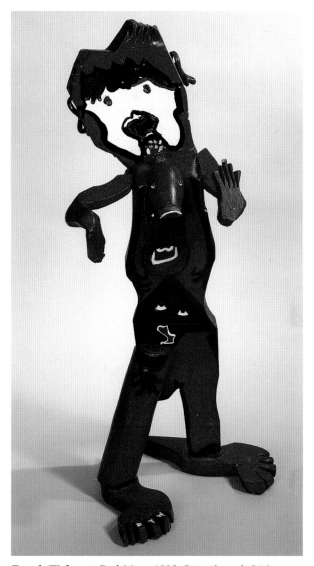

Derek Webster, Red Man, *1985. Painted wood, 26½ × 10½ × 11½ in. Arient Family Collection. This is a representative example of one of Webster's large figure assemblages, which often incorporate multiple faces and birdlike images.*

Webster grew up. When he grew older, Webster spent two years working on banana boats, but by 1964 he decided he wanted a different kind of life. He left the boat he was on when it docked in Florida, then immediately moved to Chicago.

In Chicago, Webster found employment as a janitor for the Michael Reese Hospital and worked there from 1964 to 1968. For the next twenty years he worked for the Veliscol Company, and currently he is employed by the Ontario Center.

In 1979 Webster bought a brick home in a working-class neighborhood on Chicago's west side and began "fixing it up." He placed colorful constructions on the front lawn and in the back because, he explains, "I like to look at something different."

ARTISTIC BACKGROUND
"Art critics tell me that my art is African," Derek Webster, who is black, says, "but I don't believe it. I have a gift, and they [the figures] just come out of me." When he began decorating his home in 1979, he says, "ideas came to me about how to decorate a yard. I could see the figures in my mind. I just went down in the basement and began making them."

In 1982 Paul Waggoner, who operated a gallery in Chicago, made a wrong turn while driving through the neighborhood and discovered Webster's house with all its bright trappings. He told art critics about the artist, and the Phyllis Kind Gallery began to show his work.

SUBJECTS AND SOURCES:
Webster makes brightly colored and highly decorated figurative assemblages. Most appear to be carnival dancers, many of them women, and may derive from his memories of Carnival when he lived in Belize. The artist has given them names like *Old Man Sambo* and *Wild Lady*. Some of the sculptural figures have more than one face: "I see faces all around, on elbows, fingers, and knees," the artist declares, and so he includes them in his work. Sometimes Webster incorporates birdlike appendages on his human figures, and he also sculpts birds that look like they, too, are carnival participants.

MATERIALS AND TECHNIQUES
The wood and basic materials for Webster's assemblages come from Chicago's alleys. He nails and glues the wood into the shapes he wants, paints the figures with house paint and aluminum radiator paint, and decorates them with cast-off costume jewelry, broken watches, tokens, and all sorts of bright throwaways. He then shellacs the finished products, partly to preserve them and partly to make them shine.

The artist has completed about three hundred works, ranging in size from 12 inches high to an impressive 7 feet.

ARTISTIC RECOGNITION
Derek Webster's highly decorated figures of black men and women are represented in most major collections of Chicago folk art. The artist has not been well known outside the Chicago area, but in 1989 he was included in "Black Art—Ancestral Legacy: The African Impulse in African-American Art" at the Dallas Museum of Art in Dallas, Texas.

PERLEY ("P. M.") WENTWORTH

BIOGRAPHICAL DATA
There is no specific biographical information available on this artist from any standard sources. All that is known is that he died around 1960.

GENERAL BACKGROUND
P. M. Wentworth created strange and mystical drawings of a fantastic world that only he could see.

Most of the information concerning Wentworth's life has unfortunately been lost over the years. All that is known for sure is that he was listed in the Oakland, California, telephone directory for the years 1955 to 1959.[1] Various sources have also indicated that he worked for some period as a night watchman at a local naval facility.

ARTISTIC BACKGROUND
It is generally believed that P. M. Wentworth worked from the late 1930s through the late 1950s. He is definitely known to have been active in California during the 1950s,[2] although he apparently worked in virtual isolation and his paintings received no attention until well after his death.

The artist's work was discovered around 1970 by Jim Nutt, a Chicago artist who was teaching in Sacramento, California, at the time. He bought Wentworth's paintings from the psychiatrist Tarmo Pasto (who had discovered Martin Ramirez [see page 253]), then brought them to the Phyllis Kind Gallery in Chicago in 1971 or 1972.[3]

SUBJECTS AND SOURCES
It is said that Wentworth recorded visions that came to him in the night sky. These visions were of strange, often free-form architecture—churches, temples, castles—and lands inhabited by virtually featureless people, frequently attired in long, close-fitting cloaks.

The artist left printed messages—sometimes a single word or two, sometimes more—on some of his drawings, which form part of the general design but do not shed much light on the artist or his philosophy. At some point Wentworth began to add the word *imagination* to many of his works.

MATERIALS AND TECHNIQUES
Wentworth drew with pencil, crayon, and watercolor washes on heavy paper. He mixed his colors by going over them with an eraser in a manner that also created texture. Some of his images were also created through pressure lines left after a figure had been erased.

There are approximately forty known drawings. Some are small; most are about 29 by 25 inches.

ARTISTIC RECOGNITION
P. M. Wentworth is well known among the visionary artists, and his strange and mystical drawings of a surreal world have been the focus of substantial interest among

Perley Wentworth, Untitled, *n.d. Crayola and pen and ink on paper, 30 × 26 in. Gladys Nilsson and Jim Nutt. This intriguing landscape is a noteworthy example of the work of this visionary artist who created exciting surreal drawings of otherworldly locations and people.*

IMAGINATION
JUPITER-PLANET

contemporary artists, as well as among folk art enthusiasts.

His work was included in "Transmitters: The Isolate Artist in America," an exhibition at the Philadelphia College of Art in 1981, and has been reproduced in a number of major books on twentieth-century folk art written during the last two decades.

FATHER MATHIAS WERNERUS

BIOGRAPHICAL DATA
Born September 10, 1873, Kettenis (Rhine Province), Germany. Studied for the priesthood in Liège, Belgium; in Italy; and at St. Francis Seminary, Milwaukee, Wisconsin. Ordained June 1907. Unmarried. No children. Died February 10, 1931, Dickeyville, Wisconsin.[1]

GENERAL BACKGROUND
Father Mathias Wernerus was a Catholic priest who built a folk art environment, mostly from simple materials, in tribute to his faith.

Wernerus spent his boyhood in Germany. After serving in the army, he went to Belgium to begin his studies for the priesthood. In 1904 he came to the United States, where he was ordained in 1907.

In 1918 Father Wernerus was appointed pastor of Holy Ghost Parish in the village of Dickeyville, Wisconsin, and "under his administration, the affairs of the parish began to take on a new look."[2] Shortly after he became pastor, he built a Crucifixion Group (which included Christ on the cross, Saint John, and the Blessed Mother) in honor of the young men of the parish who had died in World War I. That memorial was so successful that he was inspired to expand his original concept. Thus began the plans for a religious grotto and a series of shrines that became the important environment for which Father Wernerus is remembered today.

Father Mathias Wernerus, Holy Ghost Park *(detail), 1920s. Mixed-media environment (steel, wire, concrete, and found objects), 1 acre, Dickeyville, Wisconsin. Wernerus built Holy Ghost Park, now a tourist attraction, out of myriad cast-off materials. Pictured here is the main grotto.*

Work on the grotto began in 1924. Because money was scarce, Father Wernerus decided to build only with simple, readily available materials—mostly cement mixed with pieces of broken glass. With help donated by his parishioners, the grotto was completed in 1929 and the Sacred Heart Shrine and Patriotic Shrine in 1930. Father Wernerus had plans for other structures, but he developed pneumonia after a visit to a sick parishioner and died before he could carry them out.

ARTISTIC BACKGROUND
Working in stone, mortar, and a variety of brightly colored objects and aided by his parishioners—including schoolchildren—Father Wernerus built the grotto and shrines of Dickeyville, later to be known as Holy Ghost Park. In a booklet prepared about 1930, Father Wernerus stated, "I can only say that Almighty God and his Blessed Mother, in whose honor we worked, blessed us in such a way that we built better than we knew."

SUBJECTS AND SOURCES
"Religion in stone and Patriotism in stone" were the dual themes of Father Wernerus that are reflected in the park. The principal structure is a grotto dedicated to the Blessed Virgin. At one side of the entrance is the flag of the United States above the theme word "Patriotism," and on the other side is inscribed "Religion." Statues of the saints and the apostles are enshrined in wall niches in the grotto.

The Patriotic Shrine commemorates the discovery and founding of the United States. There are statues of Columbus, Washington, and Lincoln; a carved eagle made of Carrara marble atop a three-tiered fountain; and a series of anchors that symbolize hope. The Sacred Heart Shrine is a reproduction of the altar erected at Soldier Field in Chicago for the International Eucharistic Congress held there in 1926. The inscription on the shrine reads "Bless us O Sacred Heart now and forever."

Throughout, the park is decorated with a number of smaller statues of various types: figures of children, concrete animals, stone birdhouses, and even glass flowers.

MATERIALS AND TECHNIQUES
The structures making up the grotto and shrines are of shaped steel that was covered with wire, then with concrete and shell mosaics. Wernerus used whatever his parishioners brought or others donated as decoration for his work; stones, marbles, glass, cups, porcelain figurines—all found their places. Precious and semiprecious stones were inlaid in the interior of the grotto, and a group of Indians from the nearby Keshena reservation became interested in the project and donated numerous Indian artifacts that also became part of the environment. Father Wernerus himself searched for special stones and geologic specimens, descending alone into the Crystal Cave area of Iowa, which had not previously been explored.

The grotto itself is 25 feet high, 30 feet wide, and 25 feet deep; the grounds of the park, including the grotto, shrines, and other pieces, encompasses about an acre.

ARTISTIC RECOGNITION
A modest parish priest was able to create a lasting monument to his beliefs—a folk art environment executed with simplicity and sincerity. Every year thousands of visitors come to the village of Dickeyville (population 1,100) to pay homage to the grotto and shrines erected by Father Wernerus.

GEORGE W. WHITE, JR.

BIOGRAPHICAL DATA
Born September 3, 1903, Cedar Creek, Texas. Received some elementary school education, Cedar Creek, Texas (White left school in 1910). Married Lucille Williams, 1957. No children. Died January 1, 1970, Dallas, Texas; buried at Cedar Creek.[1]

GENERAL BACKGROUND
George White—part black, part Indian, and part Mexican—made mechanical tableaux that are valued both for their content and their charm.

White was a man who believed in new experiences, and his working life bore this out. He worked alongside his father in the Texas oil fields until 1920, then became a cowboy on the Douglas ranch. By the time he entered the army in 1932, he had become a veterinarian's assistant. After his discharge in 1936, White was a cowboy at the Wagner ranch in Vernon, Texas, where he became a well-known bronco rider. He then moved east and spent several years in Petersburg, Virginia, as a barber and deputy sheriff; he even claimed to have served a stint as an FBI detective in Washington, D.C.

In 1945 White moved to Dallas, Texas, and invented a bathtub brew that he called White's New Discovery Linament; he sold it on the streets, claiming it was "guaranteed to cure all." White hawked his product for twelve years, giving up the linament business only when he married.

White died in Dallas from blood poisoning caused by a minor foot infection.

ARTISTIC BACKGROUND
George White's marriage and move to Dallas coincided with a dream that he would become a "great artist"; he lost no time in proclaiming himself a genius and immediately began to produce art. His first painting, *Rodeo,* followed his dream, and there was no turning back from that point on.

Once he decided that he was an artist, White entered his new field with gusto. Earlier in his life he had done some carving of small items—mostly animals, pipes, and canes—but now he turned his attention to painting and sculpture (some of which he mechanized). With the encouragement of his wife, White turned their small house into a museum filled with his work, and it was there that Murray Smither, a Dallas art dealer, discovered this artist. Smither was overwhelmed by the scope of White's art and began to represent him and arrange for exhibition of his work.

In 1969 White stated that he had "reached his destination

George W. White, Jr., *Pig Butchering, 1968. Painted wood and mixed-media construction, 13½ × 13½ × 6½ in. Butler and Lisa Hancock. White's graphic carvings often reflect scenes of everyday life, such as this depiction of a pig butchering, which is supplemented by a magazine illustration on the back wall.*

in arts." He made himself a certificate stating this fact and hung it on the wall of his house. The lengthy proclamation reads in part: "This is to certify that G W White Jr has reached his destination in arts. . . . He is a great genius because he possessed high, mental powers or faculties of intellect, inventions, talent, taste, nature and character. . . . There are more historical inventions to be made by G W White Jr right at the standpoint he has more than his brains can hold now."

SUBJECTS AND SOURCES
White carved and painted wall reliefs showing adventurous outdoor scenes or other exciting events—rodeos, boxing

matches, cowboys and Indians, and more. He also made carved mechanical tableaux illustrating the southern black experience—a clapboard cabin with a photo of Lincoln, laborers working in the cotton fields, black washerwomen, and *Joe Louis in the Shoe Shine Parlor.*

MATERIALS AND TECHNIQUES

The wall reliefs are made of carved and painted pieces of flat wood—any wood that White could find. Occasionally he glued magazine illustrations to the boards for extra color or character.

The tableaux, some of which are electrically operated (although the motors have proved unreliable over the years), contain an enormous variety of materials. The basic figures or backgrounds are made of wood, but White added plastic toys, string, tin, bits of cloth, type from magazines, and other odds and ends to get the effects he wanted. Some of these mechanical constructions are coin operated; the artist charged admission to people who visited his home/museum.

White constructed fifty mechanical pieces, some of which are small (about 13 by 13 by 6 inches); others larger (approximately 19 by 23 by 18). His twenty-six wood relief paintings vary in size from 13 by 17 inches to 30 by 44 inches.

ARTISTIC RECOGNITION

George White's mechanical tableaux are excellent representations of the southern black experience in the early part of the century; they are his most important work, partly because of their documentary function and partly because of the creator's charm in presenting the subject matter. White's wall reliefs depict a lighter side of his thinking— adventures he had or would have liked to.

White had an individual show in Waco, Texas, in 1975 and was included in the 1982 exhibition "Black Folk Art: 1930–1980" at the Corcoran Gallery of Art in Washington, D.C.

ISIDOR ("POP" OR "GRANDPA") WIENER

BIOGRAPHICAL DATA

Born January 1, 1886, Dulesch (a small village outside Kishinev), Russia. Attended Cheder, a Jewish religious school. Married Dora Prylik, c. 1905; she died 1950. Three sons. Died October 2, 1970, Monticello, New York.[1]

GENERAL BACKGROUND

Isidor Wiener's paintings are always bright and optimistic. He is considered to be an important memory painter, although his subject matter covers a wide range.

Wiener came to this country in 1903 to escape the Russian pogroms and was able to bring little else but his faith with him. After arriving in New York, he spent nearly twenty years working hard at a variety of trades: he made ruffles in a garment factory, he was a gravedigger, he was a milliner and then a milkman, he drove cabs, and he

Isidor Wiener, Noah's Ark*, 1967. Oil on canvas, 24 × 30 in. New York State Historical Association, Cooperstown. Wiener's sprightly style is shown to good advantage in this vivid rendition of Noah's Ark.*

worked in the car-wrecking business. In the 1920s the Wieners opened their own grocery store on 181st Street in the Bronx, New York, and operated it until his retirement in 1950.

ARTISTIC BACKGROUND

When his wife, Dora, died shortly after his retirement in 1950, Wiener was devastated. During his bereavement he was encouraged by his son Danny to paint in order to forget his grief, and this effort proved to be just what Wiener needed to recover his spirits. He started with watercolors but soon rejected them as "too loose and runny." Although he took lessons at the Taft Art School in the Bronx for a short period, he continued to develop his own original and appealing style of painting; he also tried his hand at wood carving, with similar success.

Wiener was quite taken with his newly discovered talent and worked hard to produce the effects he wanted in his paintings. In 1961, when he heard that Grandma Moses had died, he dubbed himself "Grandpa."

After selling some work, Wiener entered a juried exhibition at the Bianchi Gallery in New York in 1963 and was selected as a participant. His work then became increasingly popular for the next few years.

SUBJECTS AND SOURCES

Although Wiener had seen a lot of suffering in his life, he was an incurable optimist, particularly in relation to his art. "Each new day," he once remarked, "is a wonderful day to work." He painted biblical scenes and pictures of Eastern Europe, his Jewish heritage, and life in New York City, using magazine illustrations, newspapers, and various other topical materials as sources. His carvings were usually of animals.

Wiener's biblical scenes and urban landscapes were done with enthusiasm and bright colors; his background environments often threatened to overpower the small, stiff figures inhabiting them.

MATERIALS AND TECHNIQUES

Although "Grandpa" Wiener painted a few watercolors, most of his major work was done on canvas with oil paints (he preferred Grumbacher oils). He used large brushes for skies and other bold backgrounds, and small brushes by the dozen for other subject matter, particularly for the tiny figures of people that appear in his work. The finished canvases were sprayed with varnish and linseed oil.

Wiener's carvings are of wood that he polychromed after finishing. The carvings are generally small—around 8 inches long—and have a charming, toylike quality.

About two hundred of Wiener's canvases and a good many small wood carvings have survived. The canvases measure about 20 by 24 inches.

ARTISTIC RECOGNITION

Isidor Wiener's gaily painted canvases were very much in vogue during the 1970s. He was considered one of the best memory painters, particularly of urban scenes, and his work has been compared with that of Grandma Moses, although their styles and subjects are quite different.

LIZZIE WILKERSON

BIOGRAPHICAL DATA

Born Lizzie Henderson, March 5, 1901,[1] near Covington, Georgia. Attended school for three grades, Spring Hill School, near Covington, Georgia. Married Devoy Wilkerson, 1920; he died 1968. No children. Died January 10, 1984, Atlanta, Georgia.[2]

GENERAL BACKGROUND

Lizzie Wilkerson painted beautifully colored and imaginatively composed scenes that she called "visualizations."

A black woman with some Indian blood, Wilkerson spent her childhood living with a stepsister in back-country Georgia poverty. Married at the age of nineteen, she and her husband were sharecroppers. Her husband, however, "got in with the wrong crowd," and in 1938 they moved to Atlanta, Georgia, just "ahead of the sheriff."

In Atlanta, Wilkerson worked in a mop factory and a sawmill and later as a domestic. She was called "Mother" by her friends and was active in church affairs. She liked to sew and made colorful patterns out of cloth. Her love of color, pattern, and design was an outstanding feature of her art in her later years.

ARTISTIC BACKGROUND

In 1978 Lizzie Wilkerson decided she wanted to learn how to make art. She attended a painting class at the Dunbar Day Care Center conducted by Jean Ellen Jones, a professor of art at Georgia State University in Atlanta; Jones encouraged her, furnished her with supplies, and in 1983 made a video about her and her work. Jones also curated a traveling one-person exhibition of Wilkerson's highly decorative paintings from 1983 through 1984.

SUBJECTS AND SOURCES

Wilkerson said she painted scenes she saw in her mind while she rested—scenes from her life, scenes imagined, and biblical scenes. She called this "visualizing," not daydreaming, and when she awoke, she would paint her "visualizations."

The artist's perception of space was extraordinary; in order to tell her stories to the fullest, she would open up such everyday shapes as houses and cars so that the viewer could see what was happening within. Elsewhere in her work, people and animals float in space, surrounded by borders of animals, vegetables, and flowers.

MATERIALS AND TECHNIQUES

Felt-tip marker pens, watercolors, and crayons on paper were the tools Wilkerson used to capture her visions on paper. Sometimes she traced patterns onto her paper (she once used a real fish as a pattern).

Wilkerson's works glow with bright blues, yellows, purples, and reds—the colors of her dreams—in bold shapes and brilliant patterns. Her later paintings are more complex, often filled edge to edge with floral and animal symbols.

Wilkerson worked for only six years before her death. She completed fewer than one hundred paintings, ranging in size from about 11 by 12 inches to around 23 by 29 inches.

ARTISTIC RECOGNITION

Because Lizzie Wilkerson's work relates to African-Amer-

Lizzie Wilkerson, Pink Angel, *n.d. Marker, watercolor, and ballpoint pen on paper, 22⅜ × 28¼ in. High Museum of Art, Atlanta, Georgia; Gift of Mr. and Mrs. Robert J. Freeman. Wilkerson's "visualizations" often included biblical content and religious symbols as well as floral motifs.*

ican traditions in quilt making, the artist is well known to students of black folk art. Her use of color and design to weave her tales of day-to-day life is highly original, and she was one of the most imaginative folk artists the South has produced in recent years.

WALLACE ("KNOX") WILKINSON, JR.—*"I dream of Loretta Lynn and I draw Loretta." "I want to make the best out of my life, to be the best I can be without stepping on anyone's toes."*

BIOGRAPHICAL DATA
Born June 12, 1954, Rome, Georgia. Attended program for the Educable Mentally Retarded, East Rome, Georgia. Single. No children. Now resides Rome, Georgia.[1]

GENERAL BACKGROUND
Although a slow learner, Knox Wilkinson is nevertheless able to carry on a full and creative life as an artist and produces extraordinary drawings. He maintains a studio and apartment in back of his parents' home in Rome, Georgia, where he spends most of the night drawing and most of the day sleeping. For a few years Wilkinson worked at a local K-Mart store in garden supplies and at McDonalds, but since the 1980s he has devoted most of his energy to being an artist.

ARTISTIC BACKGROUND
Knox Wilkinson's mother, Vera, recognized early that, although her son had limitations in some areas, he also had a very special talent, and she tried hard to see that it was encouraged. "I asked his teachers not to rigidly structure him in art class," she says. Thus his drawing skills were allowed to develop at an early age.

About 1980 Philip De Roy, who was teaching at Emory University in Atlanta, Georgia, heard about Wilkinson. He encouraged an individual show, which was held at the National City Bank in Rome, Georgia, in 1982, and the artist has subsequently had a number of one-person shows in Atlanta. In 1982 Wilkinson received a grant from the Georgia Council for the Arts in recognition of his talent.

SUBJECTS AND SOURCES
Wilkinson develops two themes in his drawings: female performers in country music (Loretta Lynn is his favorite), whom he depicts with elaborate hairstyles and outlandish western costumes; and bird's-eye views of imagined interiors that look as if they could be Victorian hotel lobbies or ballrooms. The artist has also drawn some miscellaneous animals, Statue of Liberty figures, and flowers, but these are not his most interesting work.

MATERIALS AND TECHNIQUES
Wilkinson draws on heavy rag paper with oil-base paint markers. He has a wonderful sense of line, space, and pattern, and his love of bright colors and geometric designs is evident in his work.

Wallace Wilkinson, Jr., Bo Derek's Beach House, *1986. Oil-base markers on paper, 18 × 24 in. High Museum of Art, Atlanta, Georgia; Gift of the artist. Wilkinson's detailed bird's-eye architectural renderings of elaborate interiors are imaginary visions, often of the homes of the rich and famous.*

The artist has completed several hundred drawings, which range from 5 by 7 inches to 18 by 24 inches.

ARTISTIC RECOGNITION
Knox Wilkinson's drawings are well known in the South. Some of his pieces are included in the collection of the High Museum of Art in Atlanta, Georgia, and his work is beginning to find its way into collections in other parts of the country.

CHARLIE WILLETO

BIOGRAPHICAL DATA
Born about 1905, near Nageezi, the Navajo Nation, New Mexico. Very little formal education (Willeto did not speak or write English). Married Elizabeth Willeto (now Elizabeth Willeto Ignazio, who carves under the name Ignazio). One daughter, three sons. (One son, Leonard, also became a carver; he committed suicide in 1984.[1] The other sons, Harold and Robin, recently began to carve.) Died 1965, Blanco Canyon (near Nageezi), the Navajo Nation, New Mexico.

GENERAL BACKGROUND
Charlie Willeto,[2] a Navajo wood carver, made taboo-breaking figures of Navajo men and women.

Willeto lived and died in one of the most sparsely populated and inaccessible areas of the Navajo Nation: a land of mountain peaks and parched high desert. Even today the canyon in which he lived can be reached only by a series of unmarked tracks. The Willeto family lived in a mud hogan and herded sheep and goats in the traditional Navajo manner.

Charlie Willeto, Two Navajo Men, *c. 1960. Pine board with house paint, 28 × 13 × 10 in. and 28¾ × 5 × 4 in. Chuck and Jan Rosenak. Willeto's sculptures have elements reminiscent of ceremonial figures, but the artist breaks taboos by representing Navajos.*

The Navajos are not very open with outsiders, and so, although the Willeto family was well known at the local trading post, not much is known of their personal life. It is evident, however, that Willeto had a unique talent for carving.

ARTISTIC BACKGROUND

Charlie Willeto started carving in 1961 and then carved for only four years. He brought his idiosyncratic work to Jim Mansey at Lybrook and Harry Bachelor, the trader at Nageezi, for barter (barter forms part of the Navajo way of life). The traders preferred rugs and jewelry and did not really like Willeto's carvings, but they exchanged food for them. Rex Arrowsmith, who ran a trading post in Santa Fe, did like the work, however, and bought what Willeto had to offer, loaded the carvings into the back of his pickup truck, and took them home to sell for a few dollars each.

SUBJECTS AND SOURCES

Willeto broke tribal taboos by carving representations of Navajo men and women. Although his figures often wear concho belts and are wrapped in blankets, they appear to be imaginary, not realistic; they seem to reflect personal rather than ceremonial spiritual references that only Willeto could translate.

Willeto also carved some animal figures, including owls, which are also taboo.

MATERIALS AND TECHNIQUES

The artist used cottonwood or abandoned boards (usually pine) for his carvings and worked with an ax and knives. If nails were embedded in the wood, he left them. He painted the wood with house paint or whatever he could find and occasionally decorated his pieces, especially the owls, with feathers.

Willeto made about two hundred carvings,[3] ranging from 1 foot high to life-size.

ARTISTIC RECOGNITION

Charlie Willeto's work is sought after by collectors of Native American art and by a growing number of folk art collectors interested in western and Indian subject matter. His carvings have been shown at the Wheelwright Museum of the American Indian in Santa Fe, New Mexico, and are in the permanent collection of the Smithsonian Institution's National Museum of American Art in Washington, D.C.

LEONARD WILLETO

BIOGRAPHICAL DATA

Born May 20, 1955, near Nageezi, the Navajo Nation, New Mexico. Attended school sporadically through eighth grade. Single. No children. Died August 2, 1984, the Navajo Nation, New Mexico.[1]

GENERAL BACKGROUND

Leonard Willeto, like his father, Charlie Willeto, carved Navajo figures, but in his own distinctive style.

Willeto led a short and tragic life. He was one of the many Navajos who, because of their isolation and lack of employment opportunities, came under the influence of alcohol and could not escape.

The Willeto family lived in a hogan that could be reached only by following a dirt track up a wash into Blanco Canyon. They lived a marginal existence, herding sheep and goats.

When Willeto was only about sixteen years old, he had too much to drink one day and fell in a muddy road in front of the trading post at Nageezi. He was run over by a pickup truck, and his injuries left him terribly scarred. He started carving a few years after the accident and continued until he ended his life with a revolver on August 2, 1984.

ARTISTIC BACKGROUND

Leonard Willeto made his first carvings when he was nine-

teen, after his father died. There was little market for the work, however, because Indian traders were looking for ceremonial objects, jewelry, and rugs rather than doll-like carvings.

Time has changed the market, however, and now Willeto's carvings can be seen in galleries in Santa Fe and Farmington, New Mexico. In 1987 his work was featured in "Folk Art of the People: Navajo Works" at the Craft Alliance Gallery and Education Center in St. Louis, Missouri.

SUBJECTS AND SOURCES
Willeto had two basic styles: he carved Navajo figures with foreshortened arms raised as though in prayer, which he painted but otherwise left unadorned, and he made flat, doll-like figures of Indians dressed in costumes, elaborate headdresses, and feathers. These "dolls" appear as though seen in dreams and are dressed in totally imaginary costumes invented by the artist, although elements of actual ceremonial costumes and designs can be detected.

Leonard Willeto, Two Navajo Dolls, *c. 1980. Pine board, poster paint, and chicken feathers, 14 × 4½ × 3 in. and 17 × 5½ × 3 in. Chuck and Jan Rosenak. The oldest son of Charlie Willeto, Leonard created imaginary spiritual figures that seem to be dressed like Navajo* yei *figures and Hopi kachinas.*

The colors favored by Willeto in his carvings—bright reds, oranges, greens and blues—are not the colors used in Navajo ceremonies.

MATERIALS AND TECHNIQUES
Willeto carved in cottonwood and pine with a pocketknife and painted with poster paints. He used chicken feathers for the headdresses of the dolls, most of which are not more than 14 inches high.

It is believed that Willeto carved fewer than one hundred pieces.

ARTISTIC RECOGNITION
The Willeto family has produced a body of Native American folk art that is unique.[2] Collectors who are knowledgeable in the field know Leonard Willeto's work, and his brightly colored and highly stylized dolls in ceremonial dress are included in a number of private collections.

PHILO LEVI ("CHIEF") WILLEY

BIOGRAPHICAL DATA
Born September 26, 1887,[1] Falls Village, Connecticut. Attended school for about six months. Willey's first wife (name and marriage date unknown) died around 1959; married Cecilia Seixas, April 1961. No children. Died July 7, 1980, New Orleans, Louisiana.

GENERAL BACKGROUND
Philo Willey captured the vitality and color of New Orleans and its environs in his bright and cheerful paintings.

At the age of twelve, Willey left the family farm with only a few dollars in his pocket. He found work at the F. D. Douglas Wholesale Grocery in New Haven, Connecticut, then became a deckhand on a steamboat running from Connecticut to New York City. Shortly thereafter, he set out to see the country and proceeded to work at a series of jobs along the way that almost boggles the imagination. He was everything from a lumberman to a farmer, from a wagon driver to a cowboy and a fireman, but the job he liked best was one he had around 1903 driving a team of horses for the Barnum & Bailey Circus.

Willey also tried professional boxing, but he had a job as chauffeur for a railroad president at the same time, and since it would not have looked right to appear for work with blackened eyes, he soon gave up the ring. He then went to work as a road service manager for the Chevrolet Division of General Motors in St Louis, Missouri, leaving that position in 1931 to become chief of security for the New Orleans Sewerage and Water Board. With that job it seemed that Willey had finally tired of wandering, for he stayed there for more than thirty years, retiring in 1965 with the honorary title of "Chief." Willey had come to love his new city as well and remained in New Orleans until his death.

ARTISTIC BACKGROUND
In the late 1960s Chief Willey took to painting old furni-

Philo Levi Willey, Mardi Gras, 1979. Paint on canvas, 24 × 36 in. Kurt A. Gitter and Alice Yelen. As seen in this depiction of a Mardi Gras parade, Willey's paintings reflect the exuberance and color of New Orleans, his adopted city.

ture and selling it at flea markets but found it unsatisfying. After he retired, he started to paint pictures and obtained a permit to sell his work on the fence at New Orleans's famous Jackson Square, a favorite showcase location for local artists. His work was immediately popular, and he was able to sell his first three pictures almost before he had them hung up.² The Chief had found a new career.

In the late 1970s, Willey's work came to the attention of Robert Bishop, director of the Museum of American Folk Art in New York City. In 1981 Bishop arranged for Willey to have an exhibition at the State University of New York, sponsored by the museum, and since then the artist's work has appeared in many places.

SUBJECTS AND SOURCES
Chief Willey captured the color, vitality, and romance of New Orleans in his paintings—the Mardi Gras, jazz parades and burials, the famous crescent of the Mississippi River with its ship traffic—all were subjects he depicted.

Willey also loved animals and usually managed to work them into his compositions; his skies are almost always filled with birds flying around fluffy clouds. He developed an entire series of paintings based on an imaginary roving bear he called "Preacher Bear"; these are usually bucolic scenes populated with a variety of animals, plants, and birds in addition to the bear.

There is a happy, childlike quality in Willey's work that reflects the essence of New Orleans, the "Land of Dreams."

MATERIALS AND TECHNIQUES
Willey's first paintings were done with watercolors, colored pencils, and crayons on paper. Later he turned to acrylics on Masonite to obtain more brilliant color.

Most of his works are about 16 by 20 inches, but he did a few paintings that are as large as 36 by 40 inches. Willey was an amazingly prolific artist and produced about eighteen hundred works in his fifteen years of painting.

ARTISTIC RECOGNITION
Collectors prize the work of the Chief, particulary his drawings done before 1976, which are quite rare. His work is in numerous museums, including the collections of the Museum of American Folk Art in New York City and the Museum of International Folk Art in Santa Fe, New Mexico, as well as in many private collections.

GEORGE WILLIAMS—*"I'm going to retire in about a month and a half [in July 1990]. Then I'll start up carving and have plenty on hand if people wants it."*

BIOGRAPHICAL DATA
Born February 3, 1910, Clinton, Louisiana (near the Mississippi border).[1] Attended school through seventh grade, Antioch School, Clinton, Louisiana. Married Ruby Taylor, 1931; separated 1936. Married Edna Tucker, 1946. Three sons by Taylor. Now resides Fayette, Mississippi.

GENERAL BACKGROUND
George Williams started carving heads, but now his most favored subject is a black couple that he sometimes shows dressed and sometimes undressed.

Williams spent most of his life trying to make a living. As a teenager he delivered meat for a butcher in McComb, Mississippi; then spent two years (1929–1931) laying rails for the Mississippi Central Railroad. After holding other odd jobs, he spent three years (1936-1938) stacking lumber for the Great Southern Lumber Company.

Williams had difficulty finding jobs during the Depression and was mostly unemployed between 1938 and the time he entered the army in 1942. While in the army, Williams served with the Thirty-fifth Engineering Corps and saw duty in Europe. After his discharge in 1946, he returned to Fayette and worked for several lumberyards. Today, at the age of eighty, he is still employed by the Pickens Brothers Company as a lumber grader.

ARTISTIC BACKGROUND
"During 'pression time, you know, from ole Hoover to Roosevelt, I was out of work some. One day while hitchin' on a train, I whittled up a head—wore it 'round my neck, like a locket. Some fellow wanted it, and I sold it for one dollar and made another," says the artist, relating the start

George Williams. ABOVE LEFT: Man and Woman, *1984. Wood and paint, 16½ × 4 × 4 in. and 17 × 5 × 5 in.* ABOVE RIGHT: Adam and Eve, *1984. 16 × 5½ × 3½ in. and 17 × 5 × 4 in. Sylvia and Warren Lowe. Stiff and*

formally posed figures that always look pleased with life, whether they are totally nude or dressed in Sunday finery, are typical of Williams's best work.

of his carving career. Williams was never able to devote all his time to carving; he became—and still is—a carve-when-he-can carver. "In the 1960s I drew night duty at the lumberyard and carved to keep awake," he remembers.

In 1975 Williams met Roland Freeman, a photographer and teacher at Howard University in Washington, D.C., and at the time director of the Mississippi Folklife Project. Freeman purchased many of Williams's carvings, photographed the artist, and helped him to get his work exhibited.

SUBJECTS AND SOURCES
Williams made a number of heads when he first started carving. Since the late 1970s he has been carving a couple —a black man and woman, "his wife." Each member of the striking pair is carved separately, and the figures stand stiff and straight, as though braced by a steel rod, on feet that are disproportionately small for their heads and torsos. They look directly ahead and are usually dressed in their best—the man with jacket, handkerchief, and tie; the woman wearing lipstick, heavy rouge, and mascara. Occasionally the figures are nude, but the woman always wears her makeup. Repetition of this subject matter has not brought about any deterioration in Williams's style or technique.

Williams has done other types of carvings as well—animals, crucifixes, Statues of Liberty, and even some small wheeled, almost toylike pieces.

MATERIALS AND TECHNIQUES
The artist uses a variety of woods for his work: "poplar, tupelo gum, cedar, and willow." He carves with a pocketknife, paints with enamel, and uses tar for the hair of his figures. His early pieces are mostly unpainted.

"I didn't count," says Williams, "but I guess I did between two and four hundred carvings—maybe three hundred." The work is mostly small, about 8 inches in height. A few pieces measure close to 24 inches tall.

ARTISTIC RECOGNITION
A growing interest in the art of rural black Americans has gradually been bringing George Williams to the attention of a wider audience. His work was included in the 1982 show, "Black Folk Art in America: 1930–1980," sponsored by the Corcoran Gallery of Art in Washington, D.C.

CLARA ("AUNT CLARA") WILLIAMSON—*"I honestly just inherited it [the ability to paint]. I didn't learn it, you know. I didn't go to school much."*[1]

BIOGRAPHICAL DATA
Born Clara Irene McDonald, November 20, 1875, Iredell, Texas. Attended a one-room school when she had the chance. Married John Williamson, 1903; he died August 1943. One son, one stepson, one stepdaughter. Died February 12, 1976, Dallas, Texas.[2]

GENERAL BACKGROUND
Clara Williamson's carefully detailed memory paintings give a sense of what life was like in a frontier community in Texas.

Williamson was born in a log cabin in the Texas frontier town of Iredell on the banks of the Bosque River, a river she would later make famous in her picture *The Day the Bosque Froze Over.* Until she was in her sixties, her life often seemed to be an endless round of hard work. Because she was the oldest child, she was frequently required to help out with chores and tasks at home, and thus her schooling was sketchy—she could usually attend no more than two or three days a week—but she threw herself into learning with enthusiasm whenever she could.

For a period of seven years, Williamson was able to escape from the drudgery of her family and household duties in Iredell when she went to work for her uncle Allen Lasswell, the county clerk of Ellis County, at Waxahachie, Texas. She considered herself an "emancipated woman" until family problems in 1903 demanded her return to Iredell.

Williamson married a widower with two children soon after her return home, and the couple ran a prosperous dry goods store in Iredell until 1920. In that year the Williamson family moved to Dallas, Texas, where they worked long hours operating both a rooming house and a store. When John Williamson died in 1943, Clara found that, at last, she was "left alone, with nothing especially to do."[3]

ARTISTIC BACKGROUND
Shortly after her husband died, Clara Williamson audited a drawing class at Southern Methodist University in Dallas and a few years later, in 1946, attended a class at the Dallas Museum School. She found she had a talent for painting, and she also finally had the time, as she put it, "to make some beauty."

Williamson was discovered by Donald Vogel, who runs the Valley House Gallery in Dallas, while she was taking classes at the museum. She gained her nickname, "Aunt Clara," in 1951 when she was attending a dinner party. Her host called her by the informal title of "Aunt," and the nickname stuck for the rest of her life.

SUBJECTS AND SOURCES
Williamson's intent was to tell stories of a time gone by. The artist painted remembrances of rural Texas life as though viewed through the innocent eyes of a child and caught in great detail a landscape and way of life that have disappeared. She chronicled her memories of growing up in a frontier town; farm work, her family, the town folk, church gatherings, noteworthy local events, and the landscape around Iredell all appear in her work.

MATERIALS AND TECHNIQUES
Williamson made a few charcoal drawings and a few watercolors and sketches, but most of her work was done with oils on canvas. She worked almost until the time of her death and completed about 168 paintings, most of them about 26 by 28 inches.

Clara Williamson, Chicken for Dinner, *1945. Oil on canvas, 22½ × 30¼ in. Courtesy Valley House Gallery, Dallas, Texas. Williamson's loving scenes of life in a rural Texas frontier town capture essential moments, such as the exciting chase that will culminate in a chicken for dinner.*

ARTISTIC RECOGNITION

Clara Williamson's homely, honest, and charming recollections of her Texas childhood have assured her a place in the history of western folk art. Her work is in the collection of the Museum of Modern Art in New York City.

LUSTER WILLIS—*" My life has not been glamorous, but I'm able to survive. I'm a deacon in my church—I live the good life. And I survive." "I could always sit down and create."*

BIOGRAPHICAL DATA

Born December 25, 1913, Terry (north of Jackson), Mississippi. Attended school through eighth grade, Egypt Hill (near Crystal Springs), Mississippi. Married Louvennia

Bozman, November 10, 1934. No children of their own, although the Willises raised two children of cousins. Now resides Egypt Hill, Mississippi.

GENERAL BACKGROUND

Luster Willis uses his drawings to tell imaginary stories that often serve as parables for local events and issues.

"I was discriminated against," Willis remembers. "I was born on Christmas day, but the spirit of Christmas wasn't extended by whites to blacks. I learned to live with it because I had a shelter in my head. That's where my drawings were."

Willis left school after the eighth grade to work his father's 60-acre farm in spring and summer; in winter he felled large trees and made cross ties for the Illinois Central Railroad. In 1943 Willis was drafted into the army and was assigned to the Transportation Corps. "I went to France, Germany, and Austria," he says, "but I never did see much." After his discharge from the service in 1947, Willis attended the Magnolia Trade School in Jackson, Mississippi, and learned to be a barber.

In 1963 Willis inherited his father's farm, where he still

Luster Willis, Mother and Child, *1983. Tempera, ink, and pencil on poster board, 15 × 11 in. Sylvia and Warren Lowe. Willis has set off these two images with contrasting tones of orange, yellow, and green, making this double portrait vivid and appealing.*

lives. However, in 1986, he suffered a stroke and has been able to work very little since then.

ARTISTIC BACKGROUND
Luster Willis started drawing when he was a child, and he remembers being scolded in school when he drew during classes. During the Depression, he became quite skillful at carving walking sticks. He did not produce many drawings, however, until after he inherited the family farm in 1963. At that time he began to paint seriously and to experiment with different types of material.

Willis's work was discovered by William Ferris, director of the Center for the Study of Southern Culture at the University of Mississippi, Oxford. Ferris wrote about Willis and collected his work for the university museum.[1]

SUBJECTS AND SOURCES
Willis tells "imaginary stories" in his drawings, but they are based on local lore and events. His themes deal with local churches, religious stories, prejudice and discrimination, death, parties, and celebrations. He has done portraits

as well. He explains that he "can see things and feel them" with his imagination, then sketch them; it helps him to understand people, he says.[2]

The paintings are more complex than a quick viewing might indicate, and there is a parable quality to many of the topics that Willis portrays.

MATERIALS AND TECHNIQUES
Willis is an expert draftsman, and his work reflects this skill. He draws with watercolor or tempera on paper, cardboard, poster board, and plywood. Occasionally he uses shoe polish or glitter. "I glue glitter onto the paper," he states, "to make the paint brighter."

Cedar was Willis's preferred wood for his carved walking sticks. "During the 1930s," he says, "I put a stick into the hands of nearly everyone in the county."

The artist sometimes repeats his painted stories, like the one about a large fish entitled *This Is It*. The earlier examples of his work are usually the better because he started drawing to order after 1983.

Willis has made approximately three hundred drawings and at least that many walking sticks. The drawings range from 9 by 12 inches to 30 inches square.

ARTISTIC RECOGNITION
Examples of Luster Willis's work have appeared in exhibitions of southern and black folk art over the years, and his drawings are included in collections at the University of Mississippi Art Museum and the Center for Southern Folklore in Tennessee. He is also included in private collections of southern black folk art.

JOSEPH ELMER YOAKUM—*"What I don't get, God didn't intend me to have, and what I get is God's blessing." "I paint in anything that will make a color. I don't care for oils, you have to be so particular with them. Pastels, you take a ball of bathroom tissue and polish so it looks like watercolor."*[1]

BIOGRAPHICAL DATA
Born February 20, 1886 or 1888,[2] Window Rock, the Navajo Nation, Arizona. No formal education. Married 1910 (wife's name unknown). Remarried 1929 (wife's name unknown). Five children. Died December 25, 1972, Chicago, Illinois.[3]

GENERAL BACKGROUND
Joseph E. Yoakum, the creator of intense and panoramic landscapes, was a man of mystery. He referred to himself

Joseph Elmer Yoakum, Red mtn and Red Clay pass in san juan Range near Telluride Colorado, *c. 1965–1970. Colored pencil, ink, and ballpoint pen on paper, 19 × 12 in. Sheldon and Jill Bonovitz. Whether or not Yoakum actually visited this turbulent landscape, as he claimed, his visionary panoramas done in strong colors are compelling.*

Red Mtn and Red Clay pass in san Juan Range
Near Telluride Colorado
by Joseph E Yoakum

both as an "old black man" and "a full-blooded Nava-joe [sic] Indian."[4]

After running away from home when he was in his early teens, Yoakum worked for various circuses; he claimed that he worked his way up from handyman to personal valet to John Ringling. Yoakum was also a sailor, a railroad porter, a hobo, and an inveterate traveler during his early manhood; he claimed to have visited every continent except Antarctica. During World War I, Yoakum was in the army, stationed for part of the time in Clermont-Ferrand, France; he subsequently was able to receive a small veteran's pension for his service.

During the late 1950s Yoakum finally settled in Chicago, Illinois. First he lived in a housing project and, he claimed, ran a small ice cream parlor with his second wife. In 1966 he moved into a storefront on Eighty-second Street on Chicago's South Side, where he lived for the rest of his life, supported by Social Security, his pension, and what he could make from his spectacular drawings, which he displayed in his shop window. In 1972, after an illness, he died in the Veterans Administration Hospital.

ARTISTIC BACKGROUND
Around 1962, when Joseph Yoakum was in his seventies, he had a dream in which the Lord told him to draw, and he started drawing immediately. By the time he moved into his storefront home in 1966, he was drawing for added income as well, hanging his drawings from clothespins in his store window with a "For sale" sign.

A small exhibition in a church coffeehouse and a newspaper article brought him to the attention of a wider audience.[5] Whitney Halstead, an art historian on the faculty of the Art Institute of Chicago, met Yoakum around this time and was instrumental in introducing him to other faculty and students from the institute as well as former students who were by then working artists. This group formed a strong core of supporter-patrons of Yoakum and regularly visited him and bought his work.

SUBJECTS AND SOURCES
Yoakum was a painter of landscapes, but his unique pastel-colored drawings show a dreamscape vision all his own. Yoakum said that he could only paint in the manner in which God told him to; he called it a process of "spiritual unfoldment," in which the images were revealed to him as he drew.

Many of the landscapes are labeled in a neat script, usually in the upper left-hand corner, identifying the exact locality that is depicted. Yoakum seemed compelled to title his work; almost every drawing carries some inscription—the place, his name in a flowing script, occasionally his address (complete with zip code), the date (frequently added with a date stamp), and often a copyright notice.

Yoakum did a very few portraits, usually of sports figures, show business personalities, or mythical-historical figures, but they are of a very different sensibility than his landscapes and seem more mannered in their execution.

Although Yoakum had a Bible, a set of the *Encyclopedia Britannica,* an atlas, and a number of travel and other books, he claimed that he had visited, with the exception of Antarctica, every locale that he painted.[6] Whether he actually did or not will never be known.

MATERIALS AND TECHNIQUES
Yoakum drew with ballpoint and felt-tipped pens, pencils, pastels, and watercolors on paper. Some of his early drawings are on manila paper, and they have turned a pale golden brown with age. (His friends at the Art Institute encouraged him to switch to a better grade of paper, with some success.) When Yoakum finished a drawing, he would rub it with a few sheets of toilet paper until it had a sheen; then, he said, "it looks like watercolor."

His drawings range in size from around 8 by 10 inches to 18 by 24 inches. The artist was an incredibly prolific—almost obsessive—painter; he made between 1,500 and 2,000 drawings in the ten years in which he is known to have worked.

ARTISTIC RECOGNITION
Joseph Yoakum was a storyteller who felt that "mystery" increased the value of his art. Whether his travels were real or imaginary, there is no question of the merit of the artist's flowing images laid out in landscapes of rich and amazing detail.

Virtually all Chicago folk art collections include Yoakum's work, and his drawings have found their way into major public and private collections in this country and abroad. His pieces have been included in such major exhibitions as "Transmitters: The Isolate Artist in America" at the Philadelphia College of Art in 1981 and "Black Folk Art in America: 1930–1980" at the Corcoran Gallery of Art in Washington, D.C., in 1982.

ALBERT ZAHN

BIOGRAPHICAL DATA
Born February 2, 1864, Pomerania, Germany. Attended school for eight years, Lutheran parochial schools, Germany. Married Louise Strege, date unknown; she died 1950. Four sons, five daughters. Died February 1953, Baileys Harbor, Wisconsin.[1]

GENERAL BACKGROUND
Albert Zahn's fascination with birds resulted in carvings that often combined figures of birds and men in unusual configurations.

Zahn came to the United States in 1880 in order to avoid military service in his native Germany. In his homeland he had been a sheepherder, but after settling in Baileys Harbor, Wisconsin, he worked for a few years as a well digger and saved enough money to buy a 160-acre dairy farm.

Zahn was Lutheran and intensely religious. One of his sons, Elmer, recalls that his father could not speak much English but taught the children more about the Bible "than we learned in church."

In 1924 Zahn turned the farm over to his eldest son and built a concrete house in Baileys Harbor where he and his

Albert Zahn, Family Tree, *c. 1945. Carved and painted wood, 31 × 16 × 12 in. Carl Hammer Gallery, Chicago. Zahn occasionally created pyramids representing what he called "family trees," and this grouping typifies his carving and includes several birds that are ubiquitous in his work.*

wife lived for the rest of their lives. He painted the house blue and white and decorated the outside with carved wooden birds. The neighbors called it the "Bird House."

ARTISTIC BACKGROUND
Elmer Zahn remembers that his father, sometimes called the "bird man," would sit all day on a cedar stump in a swamp carving birds. "But," he says, "none of us paid attention to him or asked him why."

Albert Zahn started to carve when he moved into the Bird House in Baileys Harbor. It seemed that he was inspired in part by visions, and that he originally did not intend to sell his carvings. However, even in the 1920s and 1930s Baileys Harbor was a popular resort area and tourists soon discovered the Bird House with its charming decor and sought to buy whatever Zahn had available. Elmer Zahn says that his father had virtually no other source of income during those years.

SUBJECTS AND SOURCES
The exterior of Zahn's house and his yard became an environment that he called "Birds' Park." The birds he carved were both those he had observed and those he had seen pictured in books. He also carved some other animals, such as deer, and mystical figures wearing large fur hats; these latter appear to be a combination of Hessian soldier and patriarch. Sometimes Zahn wired several carvings together to form unusual geometric configurations of animals and men, usually in the shape of a pyramid, or "family tree," as he sometimes called them.

MATERIALS AND TECHNIQUES
Zahn's favorite wood was cedar, which he carved with hand tools and pocketknives. His wife, Louise, painted all his carvings. She bought a book on wildlife just "so she would know how to paint them," according to their son.

In all, Zahn made several thousand carvings. They range in size from birds only a few inches high to life-size deer.

ARTISTIC RECOGNITION
The pyramidal combinations combining birds and men are Albert Zahn's most unique contribution to the folk art carving of his time, but he was a skilled and imaginative artist whose work is noteworthy, regardless of subject or composition. Zahn has not been widely exhibited in museum shows; his work has been scattered, making it difficult to find a significant grouping for a show.

MALCAH ZELDIS—*"I began to think of Abraham Lincoln and to paint him. At first, I used an old photograph, then scenes of his life began coming out of my imagination. Lincoln taught himself—I could too." "I have a very strong need to create. If I get involved in a painting, I can work eight, ten hours straight."*

BIOGRAPHICAL DATA
Born Mildred Brightman, September 22, 1931, Bronx, New York. Graduated from Central High School, Detroit, Michigan; received a bachelor of arts, Brooklyn College, 1974. Married Hiram Zeldis, June 1950; divorced 1974. One son, one daughter. Now resides New York City.

GENERAL BACKGROUND
Malcah Zeldis[1] creates vividly colored paintings that celebrate her life, her heroes, and historical and religious events.

Zeldis was born during the Depression, and shortly after

Malcah Zeldis, In Shul, *1986. Oil on Masonite, 30½ × 25¼ in. Museum of American Folk Art; Gift of Malcah Zeldis dedicated to the memory of her father, Morris Brightman. Capturing the solemnity and importance of a religious ritual, this painting is representative of the artist's style and use of color.*

her birth her father moved the family from New York to Detroit. "We were poor," Zeldis remembers. "Mother had to shovel coal, but I had the warm feeling of being cared for."

After graduation from high school, Zeldis became involved in Zionism and in 1948 she went to Israel. There she became a "plug" (one who fills in where needed) at Kibbutz Chatzerim, a collective farm. While in Israel she met Hiram Zeldis, a respected writer, who was also from Detroit. In 1950 the couple was married in Detroit, then returned to Israel.

In 1958 Zeldis left Israel with her children and took up residence in New York City. "Israel may have won its independence," she says. "But I wasn't liberated. My husband discouraged my painting."

In New York Zeldis was, at first, "a housewife and mother." Then in 1970 she was admitted to Brooklyn College, given "life credits" for some of her experience, and earned a degree in education in 1974.

That was a year of many changes for Zeldis. Not only did she receive her degree, but she also obtained a divorce, took a job as a teacher's aide, and began painting in earnest.

ARTISTIC BACKGROUND

As a child, Malcah Zeldis was fascinated by the Flemish masters. "They had these marvelous religious paintings," she recalls; "very colorful—filled with small, active figures." When she returned to New York, she was taken with the paintings by Haitian artists that she saw in the window of a Lexington Avenue gallery. She was thrilled by the similarity to her art, "even though" she says, "I felt I could never achieve their quality."

Zeldis had started painting when she was in Israel, where she was encouraged by Aaron Giladi, a well-known Israeli artist who once visited her kibbutz and saw her work. His comments and suggestions so overwhelmed her, however, that she gave up painting for a period, not going back to it seriously until she returned to the United States. In 1974 Zeldis showed a portfolio of her work to Lawrence Campbell, who was teaching art at Brooklyn College. Campbell recognized the importance of her paintings and recommended her to folk art collectors and galleries. As a result of his help, Zeldis soon obtained gallery representation in New York and Chicago.

SUBJECTS AND SOURCES

Zeldis has developed a visual narrative style that expresses her philosophy of life, her religious experiences, and her unique background and serves to romanticize her personal heroes. She will sometimes include herself as one of the characters in her paintings—even when she is showing past historical events or a fairy tale (in her painting of *Beauty and the Beast,* for example, she portrayed herself as "Beauty").

Paintings by Zeldis are generally about joyous celebrations, life events, historic moments, personal heroes (she is a great admirer of Abraham Lincoln), biblical stories and fairy tales, and religious events and rituals.

MATERIALS AND TECHNIQUES

Zeldis often rapidly sketches her design in pencil, then adds paint at once. The artist is known for her use of bold, bright colors. She prefers to work with oils and acrylics on canvas or Masonite coated with primer, but she has also painted with watercolors on paper. Zeldis does not mix her colors but uses paint right from the tube. "If I can't get a tube of green open," she says, "I'll use a blue one."[2]

Her watercolors are small, generally around 9 by 12 inches. Her oils are not overly large but may go up to 36 inches square. The artist estimates that she has completed several hundred oils and about the same number of drawings since she began her serious work.

ARTISTIC RECOGNITION

Malcah Zeldis has lived up to Giladi's comment upon seeing her work: "A great artist is living in this kibbutz." Her paintings have been widely exhibited, but of special note is the exhibition "Malcah Zeldis: American Self-Taught Artist," presented by the Museum of American Folk Art at New York University in 1988; it was the first one-person showing of a living twentieth-century folk artist sponsored by the museum.

Zeldis's work is included in the permanent collections of many museums both here and abroad, as well as in those of private collectors, and any book dealing with contemporary folk art is likely to contain a reproduction of a Zeldis painting.

JANKIEL ("JACK") ZWIRZ

BIOGRAPHICAL DATA
Born December 5, 1903, Radon, Poland.[1] Apprenticed in his youth as a shoemaker. Married Ruchla Kaczla, 1949; she died 1979. One son. Now resides Memphis, Tennessee.[2]

GENERAL BACKGROUND
Jack Zwirz was unconventional in his choice of topics to paint. His images range from Jewish life in prewar Europe and the horrors of Nazi concentration camps to futuristic space dreams.

Zwirz was a hero of World War II; the king of Belgium presented him with the Order of Leopold II for his heroism in the Resistance. As a young man, Zwirz, a shoemaker, had immigrated to Belgium in 1920. He was a strong believer in human rights and early in the war became a member of the Resistance. In 1942 he was arrested by the Nazis for his underground activities and endured cruel treatment as an inmate of several concentration camps, including Buchenwald, for the duration of the war.

Zwirz moved to the United States following the war and in 1950 settled in Memphis, Tennessee, where he owned and operated the Parkview Shoe Repair Shop. He ran his shoe shop for the next twenty-five years, until he retired in 1975. Today he lives in the B'nai B'rith Nursing Home in Memphis.

ARTISTIC BACKGROUND
Jack Zwirz began to paint when he was in his sixties. He attended a class conducted by Paul Penezner, but for the most part he learned on his own.

The artist's work was exhibited locally in Memphis in the 1960s, when Zwirz was at the peak of his painting prowess. He no longer paints today, but in 1987 his work was included in "Enisled Visions: The Southern Non-Tra-

Jankiel Zwirz, *Researcher's Dream of the Future in Space, 1964. Oil on canvas board, 24 × 36 in. Gasperi Folk Art Gallery, New Orleans, Louisiana. Zwirz combines elements of war with a pacific futuristic vision in this unusual painting that conveys a sense of terror and beauty.*

ditional Folk Artist" at the Fine Arts Museum of the South in Mobile, Alabama.

SUBJECTS AND SOURCES

Zwirz painted a range of subjects, some based on his own background and some on a different way of life. His scenes of Jewish life in Eastern Europe and of the horrors of the concentration camps came directly from his own experiences, while his landscapes, boats, still lifes, and architectural subjects came from a variety of sources. He also painted some fantasy pictures in which he showed futuristic dreams of travel in space.

The artist worked from memory, from photographs, and from newspaper clippings. His use of color and space imparts a dreamlike quality to many of the paintings.

MATERIALS AND TECHNIQUES

Zwirz painted with oils on canvas and canvas board. The usual size of his works is about 9 by 12 inches to 24 by 36 inches. The number of paintings that he produced is believed to be relatively small.

ARTISTIC RECOGNITION

Jack Zwirz's experience of horror in the Nazi death camps and visions of the future formed a rare combination of subject matter that was handled skillfully by this painter. While his landscapes and architectural subjects can be rather ordinary, Zwirz's futuristic visions and paintings of Jewish subjects are an important contribution. Zwirz is an artist well known to scholars of folk art, and his paintings appear in private collections.

Selected Public Collections

New England

CONNECTICUT: Barnum Museum, Bridgeport (hand-carved Brinley Five Ring Circus and circus memorabilia). Mystic Seaport Museum, Mystic (marine art; also changing shows of marine and folk art).

VERMONT: Vermont Folklife Center, Middlebury College, Middlebury (changing shows of folk art).

Mid-Atlantic

NEW JERSEY: Newark Museum, Newark (some 20th-century works, including paintings by David Butler, William Edmondson, Henry Thomas Gulick, and Joseph Pickett; frequent exhibitions of folk art).

NEW YORK: Museum of American Folk Art, New York

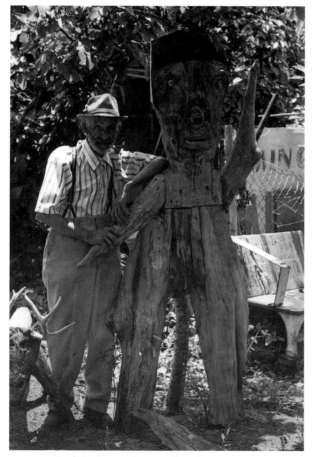

Jesse J. Aaron, Gainesville, Florida, c. 1975.

City (large and expanding in-depth collection of 20th-century and earlier works).

PENNSYLVANIA: Pennsylvania Academy of Fine Arts, Philadelphia (works by Horace Pippin).

WASHINGTON, D.C.: Smithsonian Institution, National Museum of American Art (broad collection of 20th-century works, including the Herbert W. Hemphill, Jr. Collection. Also James Hampton's *Throne*).

South

ALABAMA: Fine Arts Museum of the South, Mobile (carvings by Robert J. Marino).

ARKANSAS: Arkansas Arts Center, Little Rock (growing collection, particularly works on paper by such artists as Bill Traylor and Inez Nathaniel Walker; also works by William Edmondson and William Lawrence Hawkins).

FLORIDA: East Martello Gallery and Museum, Key West Art and Historical Society, Key West (carvings and other works by Mario Sanchez).

GEORGIA: High Museum of Art, Atlanta (substantial and growing collection of 20th-century folk art). Museum of Art, Columbus (works by Eddie Owens Martin).

KENTUCKY: Berea College, Berea (paintings by Carlos Cortez Coyle). Kentucky Museum, Western Kentucky University, Bowling Green (frequent exhibitions of folk art; small collection, primarily of Kentucky artists). Minnie Black's Gourd Craft Museum, East Bernstadt (gourd sculptures by Minnie Black). Morehead State University, Morehead (folk art, particularly Appalachian art).

LOUISIANA: New Orleans Museum of Art, New Orleans (works by Louisiana artists such as Clementine Hunter and Sister Gertrude Morgan).

MISSISSIPPI: University of Mississippi Art Museum, Oxford (extensive 20th-century collections, particularly of southern artists, including Theora Hamblett, Sultan Rogers, Jimmy Lee Sudduth, and Luster Willis).

NORTH CAROLINA: North Carolina Wesleyan College, Rocky Mount (Lynch Collection of Outsider Art—works by Vernon Burwell, Leroy Person, and others).

TENNESSEE: Fine Arts Center at Cheekwood, Nashville (sculptures by William Edmondson). Tennessee State Museum, Nashville (20th-century works by such artists as William Edmondson and Clarence Stringfield; also evangelical works and earlier folk art). Museum of Appalachia, Norris (numerous works by 20th-century Appalachian artists such as Loranzo Dow Pugh and Charlie

Fields; also tools and handmade instruments).

VIRGINIA: Miles B. Carpenter Museum, Waverly (sculptures by Miles Burkholder Carpenter). Abby Aldrich Rockefeller Folk Art Center, Williamsburg (primarily earlier folk art but also a substantial number of 20th-century pieces, particularly from the first half of the century; presently closed for remodeling but expected to reopen mid-1991; many works now circulating as part of the exhibition "Treasures of American Folk Art from the Abby Aldrich Rockefeller Folk Art Collection").

WEST VIRGINIA: Huntington Museum of Art, Huntington (growing collection of 20th-century folk art).

Midwest and Great Plains

ILLINOIS: Bishop Hill Heritage Association, Bishop Hill (works by Olof Krans). Museum of Contemporary Art, Chicago (works by Chicago folk artists such as Henry J. Darger, Lee Godie, and Joseph Elmer Yoakum).

KANSAS: Museum of Grass Roots Art, Vinland (environmental folk art of Kansas and the region; open on first Sunday of month, April through November).

MICHIGAN: Michigan State University Museum, East Lansing (quilts, Native American baskets, duck and fish decoys, folk carvings).

MISSOURI: Kansas City Art Institute, Kansas City (works by Jesse Howard).

OHIO: Columbus Museum of Art, Columbus (more than 100 works by Elijah Pierce).

OKLAHOMA: Philbrook Art Center, Tulsa (Native American paintings and objects, 20th century and earlier).

WISCONSIN: Circus World Museum, Baraboo (circus memorabilia, some folk art). John Michael Kohler Arts Center, Sheboygan (works by Eugene Von Bruenchenhein; also sculpture by Fred Smith and other Wisconsin folk artists). Viterbo College, La Crosse (paintings by Anna Louisa Miller). Milwaukee Art Museum, Milwaukee (some 20th-century objects; also Haitian art; recently acquired Michael and Julie Hall collection of folk art).

Rockies, Southwest, and West Coast

ARIZONA: Museum of Northern Arizona, Flagstaff (Native American art and folk art). Heard Museum, Phoenix (Native American art and folk art).

CALIFORNIA: Craft and Folk Art Museum, Los Angeles (small collection that frequently shows 20th-century art; closed until 1992 for construction of new facility; temporarily housed in Wilshire/Fairfax store of the May Company). Southwest Museum, Los Angeles (southwestern and Native American folk art). Richmond Museum, Richmond (works by John Roeder).

COLORADO: Taylor Museum, Colorado Springs (southwestern and Native American folk art). Denver Art Museum, Denver (southwestern and Native American folk art).

Edel and Ed Ambrose, Stephens City, Virginia, 1976.

NEW MEXICO: Maxwell Museum of Anthropology, University of New Mexico, Albuquerque (Native American and Hispanic art and folk art). Museum of International Folk Art, Santa Fe (broad collection of 20th-century works, partially in storage; Girard Collection of American folk art and folk art from other countries on display; new Hispanic wing). School of American Research, Santa Fe (Native American art and folk art). Wheelwright Museum of the American Indian, Santa Fe (Native American art and folk art, specializing in Navajo works, including a large number of carvings by Charlie Willeto). Millicent Rogers Museum, Taos (southwestern and Native American folk art).

TEXAS: Museum of African-American Life and Culture, Dallas (works by such artists as David Butler, Clementine Hunter, and Sister Gertrude Morgan). The Menil Collection, Houston (expanding collection includes works by such contemporary folk artists as Henry Ray Clark and Frank Albert Jones).

Other Collections

Earlier American folk art can be viewed at such museums as the Museum of Fine Arts (Karolik Collection), Boston, Massachusetts; Brooklyn Museum, Brooklyn, New York; Henry Ford Museum and Greenfield Village, Dearborn, Michigan (a few 20th-century paintings, duck and fish decoys); National Gallery of Art (Garbisch Collection), Washington, D.C.; New York State Historical Association, Fenimore House, Cooperstown, New York (a few 20th-century works); Old Sturbridge Village, Sturbridge, Massachusetts; Shelburne Museum, Shelburne, Vermont (some 20th-century objects such as carousel figures, circus carvings, and decoys); Springfield Art Museum, Springfield, Massachusetts; Wadsworth Atheneum, Hartford, Connecticut (some 20th-century works); and Winterthur Museum and Gardens, Wilmington, Delaware.

Major Exhibitions

The following is a selection of major folk art exhibitions or exhibitions including folk art from 1924 to January 1990 and the artists who participated. For the most part, group exhibitions are listed, but a few important one-artist shows are also included.

1924

"Early American Art"

Whitney Studio Club, New York. Opened 1924.

One of the first known exhibitions of folk art in this country, 45 works—paintings, carvings, and other objects—were included.

1930

"American Primitives: An Exhibit of the Paintings of Nineteenth-Century Folk Artists"

Newark Museum, New Jersey. Opened November 4, 1930.

Johnson Antonio, Lake Valley, Navajo Nation, New Mexico, 1986.

Eighty-three paintings, largely 19th century. Included some artists who worked in the 20th century, such as Joseph Pickett.

1932

"American Folk Art: The Art of the Common Man in America, 1750–1900"

Museum of Modern Art, New York (Traveled). Opened November 30, 1932.

Early American folk art including paintings and three-dimensional art.

1938

"Masters of Popular Painting: Modern Primitives of Europe and America"

Museum of Modern Art, New York. Opened April 27, 1938.

Emile Branchard	"Pa" Hunt
Vincent Canade	John Kane
Robert Cauchon	Lawrence Lebduska
Pedro Cervantez	Joseph Pickett
Chester Dalson	Horace Pippin
Edward Hicks	Patrick Sullivan
Thorvald Arenst Hoyer	

1940

"The Works of Bill Traylor"

New South Art Center, Montgomery, Alabama. Opened 1940.

Bill Traylor (one-person show)

1964

"Will Edmondson's Mirkels"

Fine Arts Center at Cheekwood, Nashville. Opened April 12, 1964.

William Edmondson (one-person show)

1965

"Folk Carvings by Will Edmondson"

Museum of American Folk Art, New York. Opened March 1, 1965.

William Edmondson (one-person show)

1966

"Seventeen Naive Painters"

Organized by Museum of Modern Art, New York. Opened March 1966 at Frye Art Museum, Seattle.

Louis Basciano
Emile Branchard
Vestie Davis
Joseph Fracarossi
Victor Joseph Gatto
Theora Hamblett
Morris Hirshfield
Thorveld Arenst Hoyer
John Kane

Lawrence Lebduska
Israel Litwak
Justin McCarthy
Horace Pippin
John Roeder
Patrick Sullivan
Gregorio Valdes
Clara McDonald Williamson

1970

"Twentieth-Century American Folk Art and Artists"

Museum of American Folk Art, New York. Opened September 9, 1970.

Felipe Benito Archuleta, Tesuque, New Mexico, 1977.

Many anonymous works. Several 20th-century folk artists also included. (See Herbert W. Hemphill and Julia Weissman, *Twentieth-Century American Folk Art and Artists.*)

1972

"McCarthy-Pierce Exhibition"

Pennsylvania Academy of Fine Arts, Philadelphia. Opened December 21, 1972.

Justin McCarthy Elijah Pierce

1973

"Louisiana Folk Paintings"

Museum of American Folk Art, New York. Opened September 17, 1973.

Bruce Brice Sister Gertrude Morgan
Clementine Hunter

"Elijah Pierce: Wood Carver"

Columbus Gallery of Fine Arts, Columbus, Ohio. Opened November 30, 1973.

Elijah Pierce (one-person show)

1974

"Naives and Visionaries"

Walker Art Center, Minneapolis. Opened 1974.

Samuel Perry Dinsmoor Herman Rusch
James Hampton Clarence Schmidt
Jesse Howard Fred Smith
Tressa Prisbrey Louis Wippich
Simon Rodia

1975

"Minnie Evans"

Whitney Museum of American Art, New York. Opened July 3, 1975.

Minnie Evans (one-person show)

"Folk Art of Kentucky"

University of Kentucky Fine Arts Gallery, Lexington. Opened November 23, 1975.

Theodore Clayton Carlos Cortez Coyle
Chester Cornett Edward Cress

Alfred Davis Noah Kinney
Evan Decker Roy May
Henry Dorsey H. Harrison Mayes
Clarence Ellis Willie Owsley
Leonard Fields Marvin Patrick
Marvin Finn Ernest Patton
T. A. Hay Loren Skaggs
Mack Hodge Fielden Sparks
John Hurst Lonnie Spencer
T. W. Hurst George Stacy
Elson Irvine Edgar Tolson
Unto Jarvie Seth Tuska
Arthur Jones Edwin P. Ward
Charles Kinney Henry C. Woolridge

1976

"Folk Sculpture USA"

Brooklyn Museum, Brooklyn, New York (Traveled). Opened March 6, 1976.

Included many earlier and anonymous works. Following are the 20th-century artists included:

Felipe Benito Archuleta Edgar Alexander McKillop
Fred Blair Frank Mazur
Miles Burkholder Carpenter Elijah Pierce
Clark W. Coe Daniel Pressley
Ed Davis Clarence Stringfield
William Edmondson Edgar Tolson
Joe Lee Augustus Wilson
José Dolores Lopez

"Two Centuries of Black American Art"

Los Angeles County Museum of Art, California (Traveled). Opened September 30, 1976.

Folk artists in the show included:

David Butler
William Edmondson
Minnie Evans
Clementine Hunter
Horace Pippin

"Missing Pieces: Georgia Folk Art, 1770–1976"

Atlanta Historical Society, Georgia (Traveled). Opened December 5, 1976.

Included many early and anonymous works as well as 20th-century art—textiles, pottery, environmental art, paintings, and sculptural objects. Among the 20th-century artists were the following:

E. M. Bailey Ulysses Davis

W. F. Dorsey
Howard Finster
Thomas Jefferson Flanagan
Laura Pope Forrester
William O. Golding
D. X. Gordy
William Gordy
C. P. Ligon
Eddie Owens Martin
Kent McEntyre

Columbus McGriff
Arie Meaders
Cheever Meaders
Quillian Lanier Meaders
Howard Miller
Mattie Lou O'Kelley
William Rogers
Nellie Mae Rowe
Jessie Telfair
Lucinda Toomer

1978

"Contemporary American Folk and Naive Art: The Personal Visions of Self-Taught Artists"

School of the Art Institute, Chicago. Opened January 13, 1978.

The following were among more than 50 artists:

Felipe Benito Archuleta
Eddie Arning
Steven Ashby
Peter Bochero (Besharo)
Frank Brito

Miles Burkholder Carpenter
Burlon Craig
Henry J. Darger
William Dawson
Minnie Evans

Steven Ashby, Delaplane, Virginia, 1975.

Albina Felski
Walter Flax
Harold Garrison
Lee Godie
Denzil Goodpaster
Jesse Howard
Shields Landon Jones
Gustav Klumpp
George T. Lopez
Quillian Lanier Meaders

Sister Gertrude Morgan
Leslie J. Payne
Elijah Pierce
Loranzo Dow Pugh
Martin Ramirez
Edgar Tolson
John Vivolo
Inez Nathaniel Walker
Perley Wentworth
Joseph Elmer Yoakum

1979

"Outsider Art in Chicago"

Museum of Contemporary Art, Chicago. Opened December 8, 1979.

Henry J. Darger
William Dawson
Lee Godie

Aldo Piacenza
Pauline Simon
Joseph Elmer Yoakum

1981

"Transmitters: The Isolate Artist in America"

Philadelphia College of Art, Pennsylvania. Opened March 6, 1981.

Fred Alten
Felipe Benito Archuleta
William Alvin Blayney
Peter Bochero (Besharo)
Miles Burkholder Carpenter
Henry J. Darger
William Edmondson
Howard Finster

Morris Hirshfield
Jesse Howard
Shields Landon Jones
Abraham Levin
John W. Perates
Elijah Pierce
Martin Ramirez
Drossos P. Skyllas

Leroy Ramon Archuleta, Tesuque, New Mexico, 1988.

Mose Tolliver
Edgar Tolson
Inez Nathaniel Walker

Perley Wentworth
Joseph Elmer Yoakum

"William Edmondson: A Retrospective"

Tennessee State Museum, Nashville. Opened June 18, 1981.

William Edmondson (one-person show)

"American Folk Art: The Herbert Waide Hemphill, Jr. Collection"

Milwaukee Art Museum, Wisconsin (Traveled). Opened September 17, 1981.

Contained many 19th-century works and works by unknown artists. The following 20th-century artists were included:

Felipe Benito Archuleta
Eddie Arning
Steven Ashby
Peter Bochero (Besharo)
Miles Burkholder Carpenter
John H. Coates
Clark W. Coe
Wilbur A. Corwin
Henry J. Darger
Ed Davis
John William Dey
William Edmondson
Albina Felski
Charlie Fields
Howard Finster
John Orne Johnson Frost
Harold Garrison
William O. Golding

J. C. Huntington
Shields Landon Jones
Gustav Klumpp
George T. Lopez
Alexander A. Maldonado
Peter Minchell
Sister Gertrude Morgan
John W. Perates
Elijah Pierce
Martin Ramirez
John Savitsky
Lewis Simon
Dana Smith
Edgar Tolson
Inez Nathaniel Walker
Charlie Willeto
Augustus Aaron Wilson
Joseph Elmer Yoakum

1982

"Black Folk Art in America: 1930–1980"

Corcoran Gallery of Art, Washington, D.C. (Traveled). Opened January 15, 1982.

Jesse J. Aaron
Steven Ashby
David Butler
Ulysses Davis
William Dawson
Sam Doyle
William Edmondson
James Hampton
Sister Gertrude Morgan
Leslie J. Payne

Elijah Pierce
Nellie Mae Rowe
James Thomas
Mose Tolliver
Bill Traylor
Inez Nathaniel Walker
George W. White, Jr.
George Williams
Luster Willis
Joseph Elmer Yoakum

"The Gift of Josephus Farmer"

Milwaukee Art History Gallery, University of Wisconsin. Opened November 1, 1982.

Josephus Farmer (one-person show)

1984

"Southern Folk Images"

University of New Orleans Fine Arts Gallery, Louisiana (Traveled). Opened April 1, 1984.

David Butler
Henry Speller

Bill Traylor

"Howard Finster: Man of Visions—The Garden and Other Creations"

Philadelphia Art Alliance, Pennsylvania. Opened May 25, 1984.

Howard Finster (one-person show)

"God, Man, and the Devil: Religion in Recent Kentucky Folk Art"

Mint Museum, Charlotte, North Carolina (Traveled). Opened June 3, 1984.

Minnie Black
J. Frank Byerly
Larry Campell

Chester Cornett
Homer E. Creech
Jim Feltner

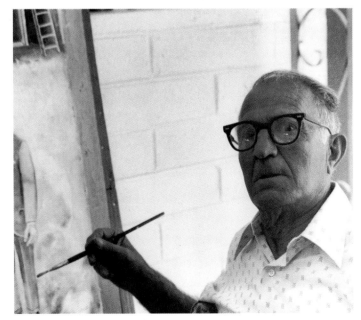

Andrea Badami, Tucson, Arizona, 1986.

Richard L. Fodor
Mack Hodge
John W. Hurst
Unto Jarvi
Clark Karsner
Charles Kinney
David Lucas
H. Harrison Mayes
Carl McKenzie

Anna Miller
Hazel Miracle
Earnest Patton
Lillie Short
Lonnie Spencer
Donald Lee Tolson
Edgar Tolson
Wayne Woolum

"Sermons in Paint: A Howard Finster Folk Art Festival"

University of Richmond, Virginia. Opened October 31, 1984.

Minnie Black, East Bernstadt, Kentucky, 1984.

Howard Finster (one-person show)

"Pioneers in Paradise: Folk and Outsider Artists of the West Coast"

Long Beach Museum of Art, Long Beach, California (Traveled). Opened November 25, 1984.

Calvin and Ruby Black
Andrew Block
Peter Mason Bond
Marcel Cavalla
Russell Childers
Jim Colclough
Richard Cole
Sanford Darling
Frank Day
Delia Ann Doud
Rose Erceg
Romano Gabriel
Robert E. Gilkerson
R. D. Ginther
Theodore Gordon
John Hoff
Effie Johnson
Harry Lieberman

Alexander A. Maldonado
James Miller
Louis Monza
Georgianna Orr
John Podhorsky
Irwin Rabinov
Martin Ramirez
Morton Riddle
John Roeder
David Rust
Jon Serl
John A. Sowell
Eliza Hart Spalding
Lizzie Twiss
Allen Van Hoecke
Carrie Van Wie
Hugo Wallin
Perley Wentworth

1985

"Eddie Arning: Selected Drawings, 1964–1973"

Abby Aldrich Rockefeller Folk Art Center, Williamsburg, Virginia. Opened 1985.

Eddie Arning (one-person show)

"Southern Visionary Folk Artists"

The Jargon Society/R. J. Reynolds Gallery, Winston-Salem, North Carolina. Opened January 11, 1985.

James Bright Bailey
Georgia Blizzard
Raymond Coins
Sam Doyle
Howard Finster
Dilmus Hall
Annie Hooper
James Harold Jennings

Clyde Jones
Carl McKenzie
Eddie Owens Martin
Rueben A. Miller
William Owens
Leroy Person
John E. Queen
Bernard Schatz

"Justin McCarthy"

Allentown Art Museum, Allentown, Pennsylvania. Opened March 10, 1985.

Justin McCarthy (one-person show)

Peter Bochero (Besharo), Leechburg, Pennsylvania, c. 1940s.

"The Heart of Creation: The Art of Martin Ramirez"

Goldie Paley Gallery, Moore College of Art, Philadelphia. Opened September 6, 1985.

Martin Ramirez (one-person show)

"A Time to Reap: Late Blooming Folk Artists"

Seton Hall University, South Orange, New Jersey. Museum of American Folk Art, New York. Opened November 9, 1985.

Jesse J. Aaron
Pat Annunziato
Felipe Benito Archuleta
Eddie Arning
Steven Ashby
Joseph P. Aulisio
Andrea Badami
Minnie Black
Andrew Block
David Butler
Miles Burkholder Carpenter
Jim Colclough
Sanford Darling
William Dawson
John William Dey
William Edmondson
Antonio Esteves
Josephus Farmer
Emanuele Giacobbe
Denzil Goodpaster
Henry Thomas Gulick
Esther Hamerman
William Lawrence Hawkins
Clementine Hunter
Shields Landon Jones

Gustav Klumpp
Leon Kuperszmid
Sadie Kurtz
Harry Lieberman
Alexander A. Maldonado
Sister Gertrude Morgan
Anna Mary Robertson Moses
Tressa Prisbrey
Matteo Radoslovich
Martin Ramirez
Enrique Rendon
Rodney Rosebrook
Alejandro Sandoval
Jon Serl
Benjamin Simpson
Fred Smith
"Queena" Stovall
Veronica Terrillion
Isadore Tolep
Mose Tolliver
Bill Traylor
Isidor Wiener
Lizzie Wilkerson
Charlie Willeto
Philo Levi Willey
Joseph Elmer Yoakum

"Ape to Zebra: A Menagerie of New Mexican Woodcarvings, the Animal Carnival Collection of the Museum of American Folk Art"

Museum of American Folk Art, New York. Opened December 10, 1985.

David Alvarez
Max Alvarez
Felipe Benito Archuleta
Leroy Archuleta
Frank Brito
Richard Luis Davila
Alonzo Jimenez
Ben Ortega
Mike Rodriguez
Ron Steve Rodriguez
Alejandro Sandoval
Luis Tapia

1986

"Heavenly Visions: The Art of Minnie Evans"

Mary Borkowski, Chillicothe, Ohio, 1983.

Bruce Brice, New Orleans, Louisiana, 1990.

North Carolina Museum of Art, Raleigh. Opened January 18, 1986.

Minnie Evans (one-person show)

"Cat and a Ball on a Waterfall: 200 Years of California Folk Painting and Sculpture"

Oakland Museum of Art, Oakland, California. Opened March 22, 1986.

Artists who worked in the 20th century included:

John Abduljaami	George F. Knapp
Peter Allegaert	Harold Kuettner
Arshag N. Amerkhanian	Harry Lieberman
Ursula Barnes	Martha Louise
Calvin and Ruby Black	Alexander A. Maldonado
Andrew Block	Louis Monza
Peter Mason Bond	John H. Newmarker
Duke Cahill	Bennett Newsom
Bob Carter	Tressa Prisbrey
Dalbert Castro	Irwin Rabinov
Marcel Cavalla	Martin Ramirez
Joseph Cholagian	Ruth Renick
Jim Colclough	Morton Riddle
Carlos Cortez Coyle	Simon Rodia
Urania Cummings	John Roeder
Emanuele Damonte	James Clyde Scott
Sanford Darling	Jon Serl
Frank L. Day	John A. Sowell
John Ehn	Pilot Thompson
Jack Forbes	Mrs. Kaying Thor
Romano Gabriel	Carrie Van Wie
Robert E. Gilkerson	Mark Walker
Esther Hamerman	Perley Wentworth
Louis J. Henrich	Marlene Zimmerman
Josephine J. Joy	

"Muffled Voices: Folk Artists in Contemporary America"

Museum of American Folk Art at PaineWebber Art Gallery, New York. Opened May 16, 1986.

Eddie Arning	Sister Gertrude Morgan
Peter Bochero (Besharo)	John Podhorsky
David Butler	Martin Ramirez
Miles Burkholder Carpenter	Ernest Reed
Raymond Coins	Nellie Mae Rowe
Henry J. Darger	Anthony Joseph Salvatore
Sam Doyle	Jon Serl
Minnie Evans	Robert E. Smith
Howard Finster	Simon Sparrow
Ted Gordon	Mose Tolliver
William Lawrence Hawkins	Inez Nathaniel Walker
Alexander A. Maldonado	Perley Wentworth
Justin McCarthy	Joseph Elmer Yoakum
Louis Monza	Malcah Zeldis

"The World's Folk Art Church: Reverend Howard Finster and Family"

Lehigh University Art Gallery, Bethlehem, Pennsylvania. Opened September 5, 1986.

Chuck Cox	Beverly Finster
Howard Finster	Michael Finster

"Word and Image in American Folk Art"

Bethel College, North Newton, Kansas (Traveled). Opened October 3, 1986.

Minnie Black	Robert E. Gilkerson
L. W. Crawford	Dilmus Hall
Alva Gene Dexhimer	Jesse Howard
Charles C. Eckert	M. L. Owen
Howard Finster	Nellie Mae Rowe

Frank Brito, Santa Fe, New Mexico, 1988.

David Butler, Morgan City, Louisiana, 1981.

Mary T. Smith Sarah Mary Taylor
Robert E. Smith

"The Ties That Bind: Folk Art in Contemporary American Culture"

Contemporary Arts Center, Cincinnati. Opened November 21, 1986.

Some environmental works represented by photo mural.

Felipe Benito Archuleta	Jessie Howard
Eddie Arning	Charles Kinney
Polski Artiste	Roy Kothenbeutal
Calvin and Ruby Black	John W. Perates
Rosetta Burke	Elijah Pierce
Miles Burkholder Carpenter	Anthony Joseph Salvatore
William Cartledge	Drossos P. Skyllas
Anna D. Celletti	Edgar Tolson
Chester Cornett	Valton Tyler
Julius and Hermina Dorcsak	Enoch Tanner Wickham
Josephus Farmer	Philadelphia Wireman
Howard Finster	J. B. Woodson
William Lawrence Hawkins	

1987

"Two Black Folk Artists: Clementine Hunter, Nellie Mae Rowe"

Miami University Art Museum, Oxford, Ohio. Opened January 10, 1987.

Clementine Hunter Nellie Mae Rowe

"Enisled Visions: The Southern Non-Traditional Folk Artist"

Fine Arts Museum of the South, Mobile, Alabama. Opened February 4, 1987.

David Butler	Sister Gertrude Morgan
Howard Finster	James Thomas
Theora Hamblett	Bill Traylor
Clementine Hunter	Luster Willis
O. W. Kitchens	Jankiel Zwirz
Robert J. Marino	

"A Separate Reality: Florida Eccentrics"

Museum of Art, Fort Lauderdale, Florida (Traveled). Opened April 23, 1987.

Jesse J. Aaron	Paul Marco
H. L. Archer	Langston Moffett
Buddy Boone	Stanley Papio
Earl Cunningham	Mario Sanchez
Ed Mumma	Haydee Scull
John D. Gerdes	George Voronovsky
Jacob J. Kass	Joe Wiser
Edward Leedskalnin	Purvis Young

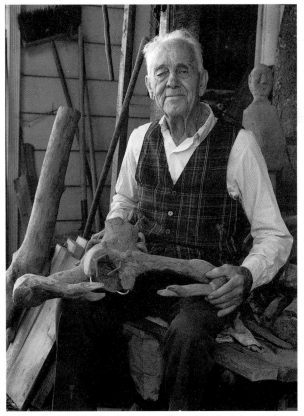

Miles Burkholder Carpenter, Waverly, Virginia, 1981.

"Hispanic Art in the United States: Thirty Contemporary Painters and Sculptors"

Museum of Fine Arts, Houston (Traveled). Opened May 3, 1987.

Folk artists in the show included:

Felipe Benito Archuleta Gregorio Marzan
Félix A. Lopez Martin Ramirez

"Baking in the Sun: Visionary Images from the South"

University Art Museum, Lafayette, Louisiana (Traveled). Opened June 13, 1987.

David Butler Royal Robertson
Raymond Coins Juanita Rogers
Sam Doyle Mary T. Smith
Burgess Dulaney Henry Speller
Howard Finster James Thomas
Bessie Harvey Mose Tolliver
James Harold Jennings George Williams
J. B. Murry Luster Willis

"Rambling on My Mind: Black Folk Art of the Southwest"

Museum of African-American Life and Culture, Dallas (Traveled). Opened September 1, 1987.

David Allen David Butler
John Willard Banks Carl A. Dixon
Carolyn Barry Milton A. Fletcher
Calvin J. Berry Ezekiel Gibbs
Josephine Burns Alma Gunter

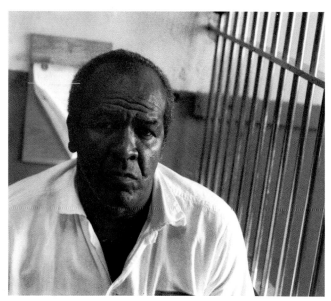

Henry Ray Clark, Huntsville, Texas, 1989.

Edward Harris Joseph Rougley
Clementine Hunter James Scott
Frank Jones Reverend Johnnie Swearingen
Arbie Major Rosie Lee Tompkins
Sister Gertrude Morgan Donald Washington
Ike Morgan Willard Watson
Emma Lee Moss George W. White
General Ponder Warren Wise
Azzie Roland Pauline Smith-Wylie

"Folk Art of the People: Navajo Works"

Craft Alliance Gallery and Education Center, Saint Louis. Opened September 4, 1987.

Johnson Antonio Faye Tso
Mamie Deschillie Charlie Willeto
Dan Hat (Hot) Leonard Willeto
Roger Hataalii family

1988

"Outside the Main Stream: Folk Art in Our Time"

High Museum of Art at Georgia-Pacific Center, Atlanta. Opened May 19, 1988.

Jesse J. Aaron Lonnie Holley
Leroy Almon, Sr. Clementine Hunter
Linda Anderson James Harold Jennings
Zebedee Armstrong, Jr. Clyde Jones
Eldren M. Bailey Shields Landon Jones
Georgia Blizzard Charles Kinney
Henry Brown Carolyn Mae Lassiter
Richard Burnside Joe Louis Light
Vernon Burwell Charlie Lucas
David Butler Eddie Owens Martin
Archie Byron Thomas May
Miles Burkholder Carpenter Carl McKenzie
William Cartledge Quillian Lanier Meaders
Raymond Coins Reuben A. Miller
Lawrence W. Crawford Sister Gertrude Morgan
Ulysses Davis J. B. Murry
Richard and Dan Dial Grover Nix
Thornton Dial, Sr. Mattie Lou O'Kelley
Thornton Dial, Jr. William Owens
Sam Doyle Leroy Person
William Edmondson Daniel Pressley
Minnie Evans Juanita Rogers
Howard Finster Nellie Mae Rowe
Carlton Elonzo Garrett Vollis Simpson
Denzil Goodpaster Mary T. Smith
Ralph Griffin Henry Speller
Dilmus Hall Georgia Speller
Bessie Harvey Q. J. Stephenson

Jessie Telfair
James Thomas
Mose Tolliver
Edgar Tolson

Bill Traylor
Lizzie Wilkerson
Knox Wilkinson, Jr.
Luster Willis

"Malcah Zeldis: American Self-Taught Artist"

Museum of American Folk Art at New York University's Washington Square Gallery, New York. Opened July 21, 1988.

Malcah Zeldis (one-person show)

"Gifted Visions: Black American Folk Art"

Atrium Gallery, University of Connecticut, Storrs. Opened September 1, 1988.

Leroy Almon, Sr.
Steven Ashby
Patsy Billups
David Butler
William Dawson
Minnie Evans
Walter Flax
Bessie Harvey
J. B. Murry
Elijah Pierce

Royal Robertson
Juanita Rogers
Nellie Mae Rowe
Mary T. Smith
Simon Sparrow
Henry Speller
Mose Tolliver
Bill Traylor
Inez Nathaniel Walker
Luster Willis

1989

"Another Face of the Diamond: Pathways through the Black Atlantic South"

INTAR Latin American Gallery, New York. Opened January 23, 1989.

Hawkins Bolden
Archie Byron
Thornton Dial, Sr.
Minnie Evans
Ralph Griffin
Dilmus Hall

Lonnie Holley
Joe Louis Light
Charlie Lucas
J. B. Murry
Mary T. Smith

"Black History/Black Vision: The Visionary Image in Texas"

University of Texas, Austin (Traveled). Opened January 27, 1989.

John Willard Banks
Ezekiel Gibbs
Frank Albert Jones

Naomi Polk
Reverend Johnnie Swearingen
Willard Watson

"Earl Cunningham: Folk Artist, 1893–1977 —His Carefree American World"

Monterey Peninsula Museum of Art, Monterey, California (Traveled). Opened February 18, 1989.

Earl Cunningham (one-person show)

"How the Eagle Flies: Patriotic Images in Twentieth-Century Folk Art"

Meadow Farm Museum, Richmond, Virginia. Opened June 11, 1989.

Ann Murfee Allen
Ed Ambrose
Eldridge Bagley
Raymond Coins
James Cook
Charlie Fields
Howard Finster
George Hardy
William Lawrence Hawkins
James Harold Jennings
Joe McFall
Carl McKenzie

Cynthia Massey
Earnest Patton
Leslie J. Payne
Reverend Benjamin Perkins
Loranzo Dow Pugh
John Savitsky
Jimmy Lee Sudduth
Mose Tolliver
John Vaughan
Arliss A. Watford, Sr.
Fred Webster
L. G. Wright

"A Density of Passions"

New Jersey State Museum, Trenton. Opened July 29, 1989.

The following folk artists were included:

Henry J. Darger
Howard Finster
Theodore Gordon
Gerald Hawkes
Frank Albert Jones

J. B. Murry
Philadelphia Wireman
Gregory Van Maanen
Joseph Elmer Yoakum

"Signs and Wonders: Outsider Art inside North Carolina"

North Carolina Museum of Art, Raleigh (Traveled). Opened July 29, 1989.

Silas Claw, Cow Springs, Arizona, 1987.

Herman Bridgers
Almetta Brooks
Vernon Burwell
Raymond Coins
Minnie Evans
Hermon Finney
Harold Garrison
Reverend Russell Gillespie
Annie Hooper
James Harold Jennings

Clyde Jones
Reverend McKendree Long
William Owens
Leroy Person
Vollis Simpson
Arthur Spain
Q. J. Stephenson
Arliss Watford
Jeff Williams

"The Road to Heaven Is Paved by Good Works: The Art of Reverend Howard Finster"

Museum of American Folk Art at PaineWebber Art Gallery, New York. Opened September 21, 1989.

Howard Finster (one-person show)

"New Traditions, Non-Traditions: Contemporary Folk Art in Ohio"

Organized by Columbus Museum of Art in cooperation with Ohio Arts Council, Columbus, Ohio. Opened December 2, 1989, at Riffe Gallery.

Mary Borkowski
Okey Canfield
Reverend St. Patrick Clay
William Lawrence Hawkins
Tella Kitchen
Reverend McCaffrey

Paul Patton
Elijah Pierce
Janis Price
Ernest Reed
Leonard L. St. Clair
Anthony Joseph Salvatore

Alice Cling, Shonto, Arizona, 1987.

Helen Cordero, Cochiti Pueblo, New Mexico, 1985.

"O, Appalachia: Artists of the Southern Mountains"

Huntington Museum of Art, Huntington, West Virginia (Traveled). Opened December 3, 1989.

Minnie Adkins
Carlton Elonzo Garrett
Dilmus Hall
Reverend Herman Lee Hayes
James Harold Jennings
Shields Landon Jones
Charles Kinney
Noah Kinney
Charlie Lucas

Connie and Tom McColley
Reverend Benjamin Perkins
Helen and Vernon Raaen
Elmer Richmond
Cher Shaffer
Oscar Spenser
Hugo Sperger
Clyde Whiteside
Fred Williamson

"Black Art—Ancestral Legacy: The African Impulse in African-American Art"

Dallas Museum of Art, Texas (Traveled). Opened December 3, 1989.

The following American folk artists were included:

William Edmondson
Minnie Evans
Bessie Harvey
Mr. Imagination
John Landry
David Philpot

Anderson Pigatt
Daniel Pressley
Sultan Rogers
Bill Traylor
Willard Watson
Derek Webster

1990

"The Artworks of William Dawson" (A Retrospective)

Chicago Public Library Cultural Center, Illinois. Opened January 27, 1990.

William Dawson (one-person show)

Notes

Jesse J. Aaron

1. Donald Van Horn, "Carve Wood: The Vision of Jesse Aaron," *Southern Folklore Quarterly* 42:1 (1978), 266.
2. Stuart R. Purser, *Jesse J. Aaron, Sculptor* (Gainesville, FL: Purser Publications, 1975), 27.
3. Van Horn, "Carve Wood," 267–268.
4. *Ibid.,* 260.
5. *Ibid.,* 267.
6. Purser, *Jesse J. Aaron,* Preface, 1, 3.

Beverly ("Gayleen") Aiken

1. The half-hour documentary *Gayleen,* produced by Jay Craven and Donald Sunseri, won honorable mention in the *Boston Globe*'s New England Film Festival.

Fred Alten

1. Some of the information in this entry was supplied by Joseph and Lee Dumas, collectors who purchased the bulk of Alten's carvings at the estate sale. See also Julie Hall, *The Sculpture of Fred Alten* (catalog of the Alten exhibition, organized by the Michigan Artrain, 1978).

Tobias Anaya

1. Hollis Engley, *The New Mexican* (Santa Fe, NM, November 3, 1985), F-1.
2. All quotes, unless otherwise attributed, are from a conversation between the authors and Clara Anaya, Tobias's sister-in-law, on March 26, 1989.

Stephen Warde Anderson

1. Biographical data were obtained from a personal interview with the artist and from William H. Bengston of the Phyllis Kind Gallery in Chicago, Illinois.

Felipe Benito Archuleta

1. *Santero* is the Spanish term for an artist who carves or paints religious images, or *santos.*

Leroy Ramon Archuleta

1. The Archuletas carve animals, not *santos* (religious images). See also Felipe Benito Archuleta, page 36.

Zebedee ("Z. B.") Armstrong, Jr.

1. Biographical data were supplied by Louanne La Roche, owner of the Red Piano Gallery, Hilton Head, South Carolina.

Eddie Arning

1. Barbara R. Luck and Alexander Sackton, *Eddie Arning: Selected Drawings, 1964–1973* (Williamsburg, VA: Colonial Williamsburg Foundation, 1985), 14. Much of the biographical data on Arning also came from the Luck and Sackton catalog for the Arning exhibition organized by the Abby Aldrich Rockefeller Folk Art Center in Williamsburg.

Steven Ashby

1. Ashby's birthdate has sometimes been given as July 3, 1904, and also as 1907. See Jane Livingston and John Beardsley, *Black Folk Art in America, 1930–1980* (Jackson: University Press of Mississippi, 1982). See also Charles Rosenak, "A Visit with Steve Ashby," *The Clarion* (winter 1981), 63.
2. Ashby referred to Earl, a boy he

Patrick Davis, Houston, Texas, 1989.

Ulysses Davis, Savannah, Georgia, 1988.

and Liza brought up, as his stepson. It appears, however, that Earl was actually the son of one of Ashby's relatives.

3. The information in this entry was obtained from numerous conversations between Ashby and the authors in the late 1970s. The authors have also interviewed Ashby's sister, Erlene Williams, and the owner and staff of the country store at Delaplane.

Joseph P. Aulisio

1. Biographical data were supplied by Julie R. Aulisio, the artist's daughter-in-law.

Andrea Badami

1. As quoted in Gregg N. Blasdel, *Symbols and Images: Contemporary Primitive Artists,* exhibition catalog (New York: American Federation of Arts, 1970).

John Willard Banks

1. Biographical data and other information were obtained from Mrs. John W. Banks and from Lynne Adele, *Black History/Black Vision: The Visionary Image in Texas,* exhibition catalog (Austin; Archer M. Huntington Art Gallery, University of Texas, 1989).

Larry Bissonnette

1. Biographical data were obtained from Pat Parsons of Webb & Parsons North, Burlington, Vermont.

Calvin (Cal) and Ruby Black

1. Ruby Black's date of birth is sometimes given as a year or two later; the one used here is that given on her death certificate.
2. From Light-Saraf Films, San Francisco, California, 1977.

"Prophet" William J. Blackmon

1. Biographical data were obtained from the artist with the assistance of the Metropolitan Gallery in Milwaukee and John Balsley,

William Dawson, Chicago, Illinois, 1980.

professor of art at the University of Wisconsin, Milwaukee.

William Alvin Blayney

1. Biographical data were furnished by David T. Owsley and the artist's brother, Charles Blayney.
2. David T. Owsley, "William A. Blayney/Self-taught Pittsburgh Painter," *Carnegie Magazine* 54:3 (March 1980).
3. *Ibid.*

Georgia Blizzard

1. Biographical data were supplied by the artist and her daughter, Mary Michael.

Andrew Block

1. Biographical data were obtained from Marshall Thomas, a longtime friend of Block's in Solvang, California, and it is his information that has been used in the case of discrepancies with other available data on Block. See also Barbara Wahl Kaufman

and Didi Barrett, *A Time to Reap: Late Blooming Folk Artists,* exhibition catalog (South Orange, NJ: Seton Hall University and Museum of American Folk Art, 1985), and Susan Larsen-Martin and Lauri Robert Martin, *Pioneers in Paradise: Folk and Outsider Artists of the West Coast,* exhibition catalog (Long Beach, CA: Long Beach Museum of Art, 1984).

Peter "Charlie" Bochero (Besharo)

1. Biographical information was obtained by Lee Kogan, senior research associate at the Museum of American Folk Art, with the help of Besharo's doctor, H. C. Fraley, and other residents who remembered him from the town of Leechburg, where the artist spent most of his life.
2. Since its discovery, this artist's work has been shown under the

name Peter Charlie Bochero, and he is sometimes referred to as simply "Peter Charlie," although no one is quite sure how he received the nickname of "Charlie" nor why he was called Bochero rather than Besharo. See, for instance, *Transmitters: The Isolate Artist in America,* exhibition catalog (Philadelphia: Philadelphia College of Art, 1981). Besharo was used on the artist's death certificate, all medical records, and an application for insurance and was confirmed by relatives.

3. Alfred Aiello, who as a teenager worked for Besharo, remembers that the artist told him that he was Armenian and had fought in World War I against Turkey.

Emile Branchard

1. As quoted in Sidney Janis, *They Taught Themselves: American Primitive Painters of the 20th Century* (New York: Dial Press, 1942), 197.
2. Biographical data were obtained from Holger Cahill, *Masters of Popular Painting* (New York: Museum of Modern Art, 1938),

and Janis, *They Taught Themselves.*

Frank Brito

1. *Santero* is the Spanish term for an artist who carves or paints religious images, or *santos.*

Bruce Burris

1. Biographical data were obtained from a personal interview with the artist and from Ruth Braunstein, Braunstein/Quay Gallery, San Francisco, California.

David Butler

1. Biographical data were obtained through personal interviews with the artist. Additional information was supplied by Richard Gasperi, a New Orleans gallery owner, sculptor John Geldersma, and the exhibition catalog by William A. Fagaly, *David Butler* (New Orleans: New Orleans Museum of Art, 1976).

Miles Burkholder Carpenter

1. Much of the biographical data was supplied by Miles S. Carpenter, the artist's son.
2. Interment was delayed until May 12, 1985, so that Carpenter could

be buried on his ninety-sixth birthday.

3. Miles Burkholder Carpenter, *Cutting the Mustard* (Tappahannock, VA: American Folk Art Company, 1982), 47.
4. "The Flowering of U.S. Folk Art," *Life* (June 1980), 118.
5. Carpenter, *Cutting the Mustard,* 70.

Russell Childers

1. Biographical data were furnished by Willamette Valley Rehabilitation Center, Lebanon, Oregon. See also Susan Larsen-Martin and Lauri Robert Martin, *Pioneers in Paradise: Folk and Outsider Artists of the West Coast,* exhibition catalog (Long Beach, CA: Long Beach Museum of Art, 1984).

Henry Church

1. See essay by Sam Rosenberg in Jean Lipman and Tom Armstrong, eds., *American Folk Painters of Three Centuries* (New York: Hudson Hills Press and Whitney Museum of American Art, 1980), 175–181. Also see Sidney Janis, *They Taught Themselves: American Primitive Painters of the 20th Century* (New York: Dial Press, 1942), 99–109. Additional information concerning the number of paintings extant was obtained from the artist's great-granddaughter, Francis Stem Bobinsky.
2. Rosenberg, in Lipman and Armstrong, *American Folk Painters,* 178.
3. "Henry Church: Enigmatic Folk Artist," *Folk Art Finder* (1982).
4. *Ibid.*
5. There is some question concerning the truth of this oft-repeated story. Church's granddaughter, Miriam Stem, denies that this happened and instead says that the work was sold or divided up among family members.

Mamie Deschillie, Fruitland, Navajo Nation, New Mexico, 1987.

Silas Claw

1. This clan is known for its pottery making. By tradition, however, it is taboo for men to pot.
2. Rose Williams had made traditional Navajo pots since she was a small girl. In the 1960s she started making pots 30 inches high and stylized her *biyo'*, a ring around the lip of a Navajo pot that contains a break—the *at'iin*, or way out—similar to the break in a Navajo basket. Stylizing the *biyo'*, traditionally the only decoration on a pot, was very important in the development of modern Navajo pottery. Williams is also the mother of Alice Cling, another well-known and creative contemporary Navajo potter (see page 76).
3. Beaver has promoted and sold the work of most of the innovative Navajo potters. See, for example, Alice Cling, page 76, Faye Tso, page 306, and Betty Manygoats, page 205.
4. See Betty Manygoats, page 205, for an explanation of this taboo.

Alice Cling

1. The Navajo Way is the ordained way of life on earth—harmony, balance, and order.
2. A traditional *biyo'* has a small break called *at'iin* (the way out), similar to the break in a Navajo basket.

Clark W. Coe

1. Biographical data were supplied by the Killingworth Historical Society and Mrs. Frank Fabiszak, who lives near the former site of the *Killingworth Images*.

("Suh") Jim Colclough

1. Biographical information was supplied by the artist's daughter, Mary Lou Ruth.

Helen Cordero

1. See, for example, Barbara A. Babcock and Guy and Doris Monthan, *The Pueblo Storyteller: Development of a Figurative*

Ceramic Tradition (Tucson: University of Arizona Press, 1986), foreword by Charlene Cerny, director, Museum of International Folk Art, Santa Fe, 10.
2. *Ibid.*, 24.

Chester Cornett

1. Some accounts give his birthdate as September 5, 1912. See, for example, James Smith Pierce, *God, Man and the Devil: Religion in Recent Kentucky Folk Art,* exhibition catalog (Lexington: Folk Art Society of Kentucky, 1984). The authors' information, however, supports the date of September 4, 1913. See also Ellsworth Taylor, *Folk Art of Kentucky,* exhibition catalog (Lexington: University of Kentucky Fine Arts Gallery, 1975).
2. Biographical data were supplied by Ellsworth Taylor, Lexington, Kentucky, and Herbert E. Smith, a filmmaker, Whitesburg, Kentucky.
3. There is some question whether Cornett made more than one crucifix. An examination of

photographs leads the authors to believe that there may have been more than the one currently in the collection of the Museum of American Folk Art in New York City.
4. His chairs are illustrated and discussed in Michael Owen Jones, *The Handmade Object and Its Maker* (Berkeley: University of California Press, 1975).
5. *Hand Carved,* an Appalshop film by Elizabeth Barret and Herbert E. Smith, 1976.

Carlos Cortez Coyle

1. Biographical data were provided by Walter Hyleck, chairman of the Art Department, Berea College, Kentucky, based in part on information he abstracted from the diary of Carlos Coyle, which is in the possession of Berea College. The artist's daughter-in-law, Bernice Coyle, was also contacted.

James Crane

1. Some background information on Crane was obtained from an article by John R. Wiggins, "James Crane and His Flying Machine," *The Ellsworth*

Charles Dieter and Lamont Alfred Pry, Weatherly, Pennsylvania, 1977.

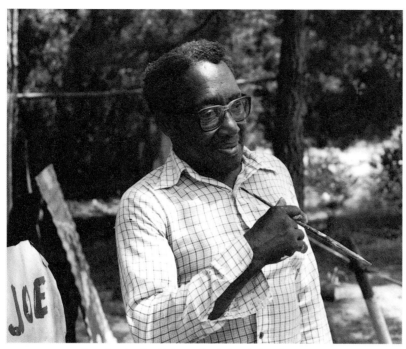

Sam Doyle, St. Helena Island, South Carolina, 1981.

American, 1967. Recent research by Lee Kogan and Ann Wrenn of the Museum of American Folk Art and Hale Joy of Ellsworth, Maine, added much to the background information on this artist.

Abraham Lincoln Criss

1. Biographical data were obtained from the artist and from Ann F. Oppenhimer. See also Alice J. Hoffman, "Contemporary Expression in Folk and Outsider Art: Why Abraham Lincoln Criss?" unpublished paper (New York: Museum of American Folk Art, Folk Art Institute, 1986).
2. Presumably he means "Red Stable": he has been quoted as stating the name was chosen because Jesus "started" in a stable.

Earl Cunningham

1. In 1969 Marilyn Mennello persuaded Cunningham to part with two paintings.
2. Diana Edwards, "A Peaceful Idyllic World on Canvas," *The Compass* (St. Augustine, FL, September 10, 1987).
3. See also Milton Wallace Bond, page 57, James Crane, page 87, and John Orne Johnson Frost, page 129, all painters of marine landscapes.

Henry J. Darger

1. Darger claimed to have been born in Brazil, but records from the Little Sisters of the Poor give his birthplace as Chicago and his surname as Dargarius. Some sources give his birthplace as Morton Grove, Michigan.
2. Much of the biographical information was supplied by Nathan Lerner. See also Nathan Lerner, *A Personal Recollection,* exhibition catalog (New York and Chicago, Rosa Esman and Phyllis Kind galleries, 1987).

Ulysses Davis

1. Biographical data are based on conversations between the artist and the authors during May 1989. Davis's date of birth is sometimes given as 1914, and one article indicates he left school in tenth grade. However, the artist's recollection is quite specific on these points, and his information is used here.

Vestie Davis

1. Biographical data were furnished by Darwin M. Bahm and Joan Landis Bahm. The Bahms met Vestie Davis in 1964 at an outdoor show in Greenwich Village. They became friends and collected and helped publicize Davis's work.

William Dawson

1. William Dawson died on July 1, 1990, in Chicago, Illinois, shortly before this book went to press.
2. Some sources give 1965 as Dawson's retirement date. Dawson, however, recalled the date as 1967.

Mamie Deschillie

1. See E. Sutherland, *The Diaries of John Gregory Bourke* (Ann Arbor, MI: University Microfilms International, 1964), 309, which refers to "dolls of adobe and mud baked in the sun" as early as 1881.

John William ("Uncle Jack") Dey

1. Biographical data were obtained from "Uncle Jack," an unpublished and undated paper by Dr. Lewis Wright, Jeff Camp, and Chris Gregson, and from a personal interview with the artist's widow in the late 1970s. See also Elinor Lander Horwitz, *Contemporary American Folk Artists* (Philadelphia: J. B. Lippincott Company, 1975), 31–34.

Thornton ("Buck") Dial, Sr.

1. See also Thornton Dial, Jr., page 102, and Richard Dial, page 103.
2. See Ronald Lockett, page 191.

Thornton ("Little Buck") Dial, Jr.
1. See page 100.

Richard Dial
1. See also Thornton Dial, Sr., page 100, and Thornton Dial, Jr., page 102.

Samuel Perry ("S. P.") Dinsmoor
1. S. P. Dinsmoor, *Pictorial History of The Cabin Home in Garden of Eden* (Lucas, KS: privately printed, n.d.), 41, 43.
2. Much of the biographical and general information is based on Dinsmoor's *Pictorial History.* See also Gregg N. Blasdel and Philip Larson, "S. P. Dinsmoor's Garden of Eden," in *Naives and Visionaries,* exhibition catalog (New York: E. P. Dutton and Walker Art Center, 1974), 32–41.
3. As quoted in Blasdel and Larson, "Garden of Eden," 36.
4. As of July 1, 1927. Dinsmoor, *Pictorial History,* 5.
5. See Simon Rodia, page 258.

William Doriani
1. See George M. Meyer, *Folk Artists Biographical Index* (Detroit: Gale Research Company, 1987).

2. Biographical data were obtained from Sidney Janis, *They Taught Themselves: American Primitive Painters of the 20th Century* (New York: Dial Press, 1942), 40–52.

Peter Paul ("Uncle Pete") Drgac
1. Biographical data were obtained from the artist's nephew, Joseph J. Skrivanek, Jr., Caldwell, Texas. See also Clinton Machann, "'Uncle Pete' Drgac, Czech-American Folk Artist," *Folk Art in Texas* (published by the Texas Folklore Society, Southern Methodist University Press), XLV (1985), 173–177.

William Edmondson
1. Louise LeQuire, *Smithsonian Magazine* (August 1981), 51–55.
2. As quoted in *William Edmondson: A Retrospective,* exhibition catalog (Nashville: Tennessee State Museum, 1981), 21.

Rose Erceg
1. Biographical data were supplied by Joseph Erceg, the artist's son.

Minnie Evans
1. Biographical data were based on an interview with Minnie Evans by Nina Howell Starr, in

Mitchell D. Kahan, *Heavenly Visions: The Art of Minnie Evans* (Raleigh: North Carolina Museum of Art, 1986), and on conversations between the authors and Nina Howell Starr, who taped a number of interviews with Evans between 1962 and 1973.
2. As quoted by Starr, in Kahan, *Heavenly Visions.*
3. *Ibid.,* 9.

Earl Eyman
1. Biographical data were supplied by Marshall Eyman, the artist's son, and by Joel Kopp, owner of America Hurrah Antiques in New York City.

Josephus Farmer
1. Joanne Cubbs, *The Gift of Josephus Farmer* (Milwaukee: Milwaukee Art History Gallery, University of Wisconsin, 1982), 10. Much of the biographical information was obtained from Cubbs.

Ralph Fasanella
1. The artist celebrates his birthday on Labor Day.
2. The authors are grateful for conversations they had with the artist and with Eva Fasanella, the artist's wife, who helped provide biographical details.
3. The artist spells his name Fasanella, but his birth certificate reads Fasanello.
4. As quoted in *New York Magazine* (October 30, 1972).

Albina Felski
1. Biographical information was furnished by Karen Lennox, an art dealer in Chicago, Illinois. Felski is a private person who will not give interviews.
2. She would not disclose the name of the firm or the nature of her employment.

("Cedar Creek") Charlie Fields
1. Biographical data were based on

Josephus Farmer, Milwaukee, Wisconsin, 1982.

Howard Finster, Philadelphia, Pennsylvania, 1984.

conversations with John Rice Irwin, Museum of Appalachia, Norris, Tennessee, and on Elinor Lander Horwitz, *Contemporary American Folk Artists* (Philadelphia: J. B. Lippincott Company, 1975), 118–126.

2. *Ibid.*

Howard Finster

1. Although there is some uncertainty concerning Finster's birthdate, the artist states that according to his mother he was born on December 2, 1916. For more information on Finster, see also J. F. Turner, *Howard Finster, Man of Visions: The Life and Work of a Self-Taught Artist* (New York: Alfred A. Knopf, 1989).

2. As quoted in Anna Wadsorth, ed., *Missing Pieces: Georgia Folk Art, 1770–1976,* exhibition catalog (Atlanta: Georgia Council for the Arts and Humanities, 1976), 106.

3. Unless otherwise noted, all quotations are from conversations between the authors and the artist.

4. "The Flowering of U.S. Folk Art," *Life* (June 1980). See also Miles Burkholder Carpenter, page 67, Ralph Fasanella, page 118, Mattie Lou O'Kelley, page 228, and Elijah Pierce, page 240.

5. Talking Heads, *Little Creatures* (New York: Fire Record Company, 1985). Finster has also designed album covers for the Georgia rock group R.E.M.

6. It is uncertain when Finster began his numbering system; a painting dated June 1977 bears the inscription "348 since January 1976." It is possible that he began numbering in 1977 but did not start with the number 1.

7. See, for example, Josephus Farmer, page 116, Sister Gertrude Morgan, page 219, and Elijah Pierce, page 240. These artists, along with Finster, all have deep roots in the rural South upon which they undoubtedly draw, but they are not part of a school or group.

Walter ("Captain") Flax

1. From a conversation between Flax and the authors.

2. Elinor Lander Horwitz, *Contemporary American Folk Artists* (Philadelphia: J. B. Lippincott Company, 1975), 113–117.

Joseph Fracarossi

1. Biographical data were obtained from Richard Fracarossi, the artist's son, and other family members.

2. Perforating machines were used in the garment business to make patterns, similar to lace, in women's dresses.

John Orne Johnson ("J. O. J.") Frost

1. As quoted in Martha B. Katz, "J.O.J. Frost: Marblehead Artist," unpublished thesis (Oneonta: State University of New York, 1971), 31.

2. Biographical information was partially obtained from *ibid.* See also Jean Lipman and Tom Armstrong, eds., *American Folk Painters of Three Centuries* (New York: Hudson Hills Press and Whitney Museum of American Art, 1980), 182–185.

Joseph Endicott Furey

1. Biographical data were supplied by Lee Kogan of the Museum of American Folk Art, who was among the first to view and study Furey's work. See also Lee Kogan, "Joseph Furey," *The Clarion* 15:2 (Spring 1990).

2. As this book goes to press, a potential buyer who is interested in preserving Furey's environment has been found for the apartment.

Romano Gabriel

1. Jan Wampler, *All Their Own: People and the Places They Build* (Cambridge, MA. Schenkman Publishing Company, 1977), 100.

2. As quoted in *ibid.,* 106.

3. *Ibid.,* 105

4. "Romano Gabriel," *Architecture Plus* (July–August 1974), 90–91. Men at a garage two blocks from

Gabriel's house claimed they had never heard of the garden.

5. See, for example, Michael Schuyt, Joost Elffers, and George R. Collins, *Fantastic Architecture: Personal and Eccentric Visions* (New York: Harry N. Abrams, 1980); Seymour Rosen, *In Celebration of Ourselves* (San Francisco: California Living Books, 1979); and Wampler, *All Their Own.*

Carlton Elonzo Garrett

1. As quoted in *Brown's Guide to Georgia* (December 1981), 54.

Victor Joseph Gatto

1. Much of the biographical information was furnished by Gene Epstein, Epstein/Powell Gallery, New York.
2. See, for example, "Victor Joseph Gatto, Retrospective," in gallery catalog, November 26–December 23, 1977, ACA Galleries, New York.
3. Gatto's work was reviewed by the *New York Times* (1943) and featured in *Collier's* (1944), *Esquire* (1946), and *Life* (1948).
4. Perhaps because of this

conversation, Gatto was only noted in the appendix of Janis's significant book on folk artists. See Sidney Janis, *They Taught Themselves: American Primitive Painters of the 20th Century* (New York: Dial Press, 1942).

Ezekiel Gibbs

1. Much of the biographical data was supplied by Norma R. Ory, director of Community Outreach Programs, Glassell School of Art, Museum of Fine Arts, Houston, Texas. Additional information was supplied by the artist's daughter, Mattie Young, and by Lynne Adele.

Sybil Gibson

1. A statement in the artist's autobiography, dated July 24, 1984, notes that the various accounts referring to her husband as "Bill" are erroneous.
2. Much of the biographical information is from an unpublished autobiography by Sybil Gibson that she wrote over many years and sent to Gordon Bryars, who had befriended her. Information was also supplied by

the Robert Cargo Folk Art Gallery, Tuscaloosa, Alabama.

Lee Godie

1. Pronounced "Go-day." She claims to be French.
2. Barbara J. Catania, "The Artistic Bent of A Bag Lady," *Chicago Tribune* (September 5, 1982).
3. Godie was featured in a front-page article in the *Wall Street Journal* (March 27, 1985) and included in articles by Carrie Rickey in *Art in America* (July–August 1979), 55.

Theodore Gordon

1. The books were Michel Thévoz, *Art Brut* (New York: Skira/Rizzoli, 1976), and Roger Cardinal, *Outsider Art* (New York: Praeger Publishers, 1972).
2. Note from a letter to Theodore Gordon in 1981.

Theora Hamblett

1. Theora Hamblett, in collaboration with Ed Meek and William S. Haynie, *Theora Hamblett Paintings* (Jackson: University Press of Mississippi, 1975), 8.

Walter Flax, near Yorktown, Virginia, c. 1974.

Esther Hamerman

1. Biographical data were supplied by Hamerman's daughter, Helen Breger.
2. There are other spellings of Hamerman (Hammerman and Hammermann), but this is the one the artist used in signing her paintings.

James Hampton

1. Biographical information is based on Lynda Roscoe Hartigan, *James Hampton: The Throne of the Third Heaven of the Nations' Millennium General Assembly,* exhibition catalog (Washington, DC: National Museum of American Art, Smithsonian Institution; originally published by Museum of Fine Arts, Boston, 1976), unpaginated.
2. According to Hampton, the word *millenium* means the return of Christ and a part of the Kingdom of God on earth (definition typed on paper adhered to the central altar table). See Lynda Roscoe, "James Hampton's Throne," in *Naives and Visionaries,* exhibition catalog (New York: E. P. Dutton and Walker Art Center, 1974), 13–19. Also, although Hampton used *Nations* without any indication of the singular or plural possessive, according to Lynda Roscoe Hartigan (March 1990), an apostrophe was added *(Nations')* at the point of the Throne's installation in the National Museum in accordance with the museum's editorial policy. Similarly, *millenium* was changed to *millennium.*
3. Hartigan, *James Hampton.*
4. *Ibid.*

Steve Harley

1. The original source for information on this artist is in the files of the Abby Aldrich Rockefeller Folk Art Center, Williamsburg, Virginia. See also Robert Bishop, *Folk Painters of America* (New York: E. P. Dutton, 1979), 212, 214.
2. *Ibid.,* 214.

Bessie Harvey

1. Her date of birth has been given as 1928, but Harvey says she was born in 1929. Census records give 1929 as her birthdate.

Gerald Hawkes

1. Biographical data were obtained from George Ciscle, a dealer in Baltimore, Maryland, and from a personal interview with the artist.
2. Another folk artist known to have used matchsticks is Nick Funicello, who lived in New Orleans, Louisiana. He made objects such as picture frames and boxes rather than sculpture.

William Lawrence Hawkins

1. Biographical data were obtained from Gary Schwindler, assistant professor of art history, Ohio University, Akron.

Reverend Herman Lee Hayes

1. Biographical data were obtained from a personal interview with the artist and from Liz Blackman, Outside-in, Los Angeles, California.

Morris Hirshfield

1. Biographical data were obtained from Sidney Janis, *They Taught Themselves: American Primitive Painters of the 20th Century* (New York: Dial Press, 1942), and from Jean Lipman and Tom Armstrong, eds., *American Folk Painters of Three Centuries* (New York: Hudson Hills Press and Whitney Museum of American Art, 1980). See also William Saroyan, *Morris Hirshfield* (Milan and Paris: Franco Maria Ricci editore, 1976).
2. As quoted in a letter to Sidney Janis, March 13, 1940, in Saroyan, *Morris Hirshfield.*
3. Essay by Sidney Janis in Lipman and Armstrong, *American Folk Painters,* 196.

Jesse Howard

1. Ann Klesener, *Missouri Artist Jesse Howard, with a Contemplation on Idiosyncratic Art* (Columbia: University of Missouri, 1983), 14. Dr. Klesener agrees with the

Joseph Endicott Furey, Brooklyn, New York, 1989.

June 4 date, acknowledging that there was a typographical error in the July 4 date originally given for the artist's birth.

2. Biographical data were based on visits with the artist by the authors and on Klesener, *Missouri Artist Jesse Howard.* See also Richard Rhodes, "Jesse Howard: Signs and Wonders," in *Naives and Visionaries,* exhibition catalog (New York: E. P. Dutton and Walker Art Center, 1974), 60–69.

3. Gregg N. Blasdel, "The Grass-Roots Artist," *Art in America* (September–October 1968).

4. See also Howard Finster, page 121, another artist whose work is often heavily dependent on words.

Clementine Hunter

1. James L. Wilson, *Clementine Hunter, American Folk Artist* (Gretna, LA: Pelican Publishing Company, 1988), 9.

2. *Ibid.,* 19–20. Supplemental information concerning the artist was obtained in a discussion between the authors and Dr. Mildred Hart Bailey in April 1989.

3. Wilson, *Clementine Hunter,* 24.

4. Foreword by Mildred Hart Bailey, in *ibid.,* 9.

5. For a detailed categorization of Hunter's themes (e.g., work, play, and religion), see *ibid.,* 44. See also Elinor Lander Horwitz, *Contemporary American Folk Artists* (Philadelphia: J. B. Lippincott Company, 1975).

6. Wilson, *Clementine Hunter,* 43.

7. See, for example, Mimi Read, *Times-Picayune* (New Orleans, April 14, 1965).

Katherine Ann Jakobsen

1. Jakobsen's birth certificate reads Jakobson, but since her father's name ended in *en,* she legally changed her name to conform.

2. Robert Bishop, *Folk Painters of America* (New York: E. P. Dutton, 1979), 215.

Ezekiel Gibbs, Houston, Texas, 1989.

Lee Godie, Chicago, Illinois, 1983.

Denzil Goodpaster, Ezel, Kentucky, 1979.

James Harold Jennings

1. For more biographical information, see Tom Patterson, "Roadside Art: Beating a Path to the Homemade World of James Harold Jennings," *Art Papers* (November/December 1987), 26–31.

Frank Albert Jones

1. Much of the biographical information was supplied by Murray Smither, an art dealer in Dallas, Texas.
2. Lynne Adele, *Black History/Black Vision: The Visionary Image in Texas,* exhibition catalog (Austin: Archer M. Huntington Art Gallery, University of Texas, 1989).

Shields Landon ("S. L.") Jones

1. See *Transmitters: The Isolate Artist in America,* exhibition catalog (Philadelphia: Philadelphia College of Art, 1981), dialogue by Michael and Julie Hall, 37.

John Kane

1. Around 1910 a bank clerk misspelled Cain's name, and the artist became Kane. "Kane or Cain, it makes no difference as long as the money is safe," Kane said.
2. Biographical data were largely based on Leon Anthony Arkus, comp., *John Kane, Painter,* which includes "Sky Hooks, The Autobiography of John Kane" (Pittsburgh: University of Pittsburgh Press, 1971).
3. All quotations from *ibid.,* unless otherwise noted.
4. In 1934 Kane became the subject of a scandal when it was discovered that he had painted over a photograph on a work to be exhibited at a Junior League art show.
5. Kane exhibited at all Carnegie Internationals from 1927 through 1934.

Lavern Kelley

1. William Salzillo, *A Rural Life: The Art of Lavern Kelley,* exhibition catalog (Clinton, NY: Hamilton College, 1989).
2. Biographical data were obtained from *ibid.* and from a personal interview with the artist.

Charles Kinney

1. See also Noah Kinney, page 173.

Noah Kinney

1. See also Charles Kinney, page 173.

Tella Kitchen

1. Biographical data were obtained from the artist's son Denny Kitchen.
2. As quoted in Robert Bishop, *Folk Painters of America* (New York: E. P. Dutton, 1979), 214.
3. *Ibid.,* 14, 105, 214.

O. W. ("Pappy") Kitchens

1. Biographical data were supplied by William R. Dunlop, the artist's son-in-law, and Richard Gasperi, Gasperi Folk Art Gallery, New Orleans, Louisiana.

Gustav Klumpp

1. Much of the biographical information was obtained from William Leffler, New York City. Letters of the artist were also examined.

Karol Kozlowski

1. Biographical information was obtained from Martha Taylor Sarno, *Karol Kozlowski, 1885–1969: Polish-American Folk Painter* (New York: Summertime Press, 1984).

Olof Krans

1. His date of birth is sometimes given as November 12, and Olsson is sometimes spelled with one *s,* but the official records of Bishop Hill confirm the information used here. Krans joined the army as "Olof Krans." According to Bishop Hill records, it is likely the Olssons changed their name to Krans shortly after coming to the United States. *Krans* is a Swedish word meaning "garland" or "crown." Olof's father had used the name during his military service in Sweden.
2. Biographical information was obtained from Bishop Hill and from George Swank, *Painter Krans of Bishop Hill Colony* (Galva, IL: Galvaland Press, 1976).

Elizabeth ("Grandma") Layton

1. The artist defines contour drawing as drawing done while looking at the subject matter and not at the paper.
2. Kay Larson, *New York Magazine* (June 20, 1983).

Paul ("P") Le Batard

1. Biographical data were largely based on personal interviews with the artist. After his death additional information was supplied by his son James M. Le Batard.

Lawrence Lebduska

1. Biographical data were partially based on Sidney Janis, *They Taught Themselves: American Primitive Painters of the 20th Century* (New York: Dial Press, 1942), 170–173.

Edward Leedskalnin

1. Biographical data were supplied by Clell Villella, director of Coral Castle. See also "Coral Castle: An Engineering Feat Almost Impossible to Believe," pamphlet published by Coral Castle, 1988.

Abraham Levin

1. Biographical data were supplied by Henry Niemann, an instructor at the Folk Art Institute of the Museum of American Folk Art in New York City.
2. From a news release, Galerie St. Etienne, New York, 1967.

Harry Lieberman

1. November 15, 1876, is the birthdate given by Lieberman's family and the one generally accepted. Some sources, however, state that Lieberman was born in 1877, and the Polish Archives list his birthdate as 1880.
2. All quotations not otherwise attributed are from conversations with Rose Lieberman Blake, the artist's daughter, during March 1989.

Joe Louis Light

1. When Light went into the army in 1951, he says, the captain told him, "'We don't take no initials here,' so I changed my name."

Ronald Lockett

1. See also Thornton Dial, Sr., page 100, Thornton Dial, Jr., page 102, and Richard Dial, page 103.

Félix Lopez

1. The Spanish spelling is López.
2. *Santero* is the Spanish term for an artist who carves or paints religious images, or *santos*.
3. A *morada* is the chapel used by the Brothers of Jesus of Nazareth, or the Penitentes (a religious group), for services; *alabados* are Spanish religious songs, unaccompanied by music.

José Dolores Lopez

1. The Spanish spelling is López.
2. Much of the biographical data was obtained from Charles L. Briggs, *The Wood Carvers of Cordova, New Mexico: Social Dimensions of an Artistic "Revival"* (Knoxville: University of Tennessee Press, 1980).
3. *Santero* is the Spanish term for an artist who carves or paints religious images, or *santos*.
4. The road into Cordova was paved in 1953.
5. Sometimes called the Brotherhood of Our Father Jesus, or the Pious Fraternity of Our Father Jesus Nazarite.
6. See, for example, George T. Lopez, page 193.

George T. Lopez

1. The Spanish spelling is López.
2. Some biographical data were obtained from Charles L. Briggs, *The Wood Carvers of Cordova, New Mexico: Social Dimensions of an Artistic "Revival"* (Knoxville: University of Tennessee Press, 1980). Other information was based on the authors' interviews with George Lopez and other family members.
3. *Santero* is the Spanish term for an artist who carves or paints religious images, or *santos*.
4. See José Dolores Lopez, page 192.
5. *Allimillo* is the Spanish word for aspen; cottonwood is *alamo,* but the words have often been confused by non-Hispanics. The wood used by the Cordova carvers is aspen, but they have given up trying to explain the difference and call it cottonwood.

Theodore Gordon, San Francisco, California, 1983.

George Edwin Lothrop

1. Biographical data were obtained from Sidney Janis, *They Taught Themselves: American Primitive Painters of the 20th Century* (New York: Dial Press, 1942), and from Parke-Bernet Galleries sales catalog, April 8, 1971, New York.

Emily Lunde

1. According to Lunde, the Swedish term *uff da* is used "when things get tough."

Justin McCarthy

1. This date is given on his driver's license. However, 1891 is entered on his University of Pennsylvania Law School registration form.
2. Biographical data were obtained from Nancy Karlins, "Justin McCarthy: 1891–1971: The Making of a Twentieth Century

Henry Thomas Gulick, Middletown, New Jersey, 1958.

Self-Taught Painter,"
unpublished doctoral thesis (New York University, 1986), and from many conversations with Sterling and Dorothy Strauser. See also N. F. Karlins, "Four From Coal Country: Friendships and the Contemporary Folk Artist," *The Clarion* 12:2/3 (Spring/Summer 1987), 54–61.

Christine McHorse

1 See, for example, Silas Claw, page 75, Alice Cling, page 76, Betty Manygoats, page 205, and Faye Tso, page 306.

Carl McKenzie

1. Biographical data were supplied by Le Raye Bunn, a folk art collector in Louisville, Kentucky.

Edgar Alexander McKillop

1. Some sources, including McKillop's death certificate, give 1878 as his birthdate; however, June 8, 1879, is the date given on his gravestone and in the family Bible.
2. Biographical data were taken from several sources. See, for example, Robert Bishop, *American Folk Sculpture* (New York: E. P. Dutton, 1974), 334.
3. *Ibid.*

Alexander A. Maldonado

1. Harriet Polt, "Painting the Impossible," *Image* (May 11, 1986). Maldonado used to say, "Sometimes I tell people I paint the impossible."
2. Biographical data were furnished by Bonnie Grossman, director of the Ames Gallery of American Folk Art in Berkeley, California.

Betty Manygoats

1. Hogan *(hooghan)* means "home" in Navajo. It is a log or mud dwelling, usually of six or eight sides but sometimes round, with one window and one door, facing east. Today only a few Navajos still live in hogans, but they are used for ceremonial purposes. The Manygoats's hogan has been converted into a studio.
2. See also Silas Claw, page 75, Alice Cling, page 76, and Faye Tso, page 306.
3. The horned, or horny, toad is really a lizard common in the Southwest. The Navajo name for it—*na'ashó'ii dich í'zhii*—literally means "my grandfather." Horned toads are thought to bring good luck if left alone, but it is taboo to step on or fool with them. (See also Silas Claw, page 75.)

Robert J. Marino

1. Biographical data and the quotation were supplied by Doris Allegri of Daphne, Alabama.

Information was also provided by the Fine Arts Museum of the South, Mobile, Alabama.

Eddie Owens Martin ("St. EOM")

1. Biographical information was largely obtained from Tom Patterson, *St. EOM in the Land of Pasaquan: The Life and Times and Art of Eddie Owens Martin* (Winston-Salem, NC: Jargon Society, 1987). See also Tom Patterson, "A Strange and Beautiful World," in *Brown's Guide to Georgia,* and Tom Patterson, "St. EOM's Pasaquan: A Promising Future," *The Clarion* (Winter 1988), 52–55.
2. *Ibid.,* 53.

Maria Martinez

1. Although no record was made of Maria's birthdate at the time, 1887 is generally accepted. See, however, Alice Mariott, *Maria: The Potter of San Ildefonso* (Norman: University of Oklahoma Press, 1948), which gives the date as 1881 but indicates there is no positive record.
2. Biographical data and other information were largely based on Richard L. Spivey, *Maria* (Flagstaff, AZ: Northland Publishing, 1979), and Mariott, *Maria: The Potter of San Ildefonso.*
3. Guaco is a substance made from beeweed, or wild spinach, that is widely used among the Pueblo potters. The plant is boiled into a sludge, hardened into a cake, and moistened for use.
4. Spivey, *Maria,* xii.

Gregorio Marzan

1. See, however, John Beardsley, Jane Livingston, and Octavio Paz, *Hispanic Art in the United States: Thirty Contemporary Painters and Sculptors* (New York: Abbeville Press, 1987), 100, which states that he "attended school until age 9." The authors' information was gained from

taped interviews with the artist and his daughter, Romana Cruz, in March 1989.

Willie Massey

1. While other dates have been given for Massey's birth, the artist gave the authors the date used here.
2. Biographical information was largely obtained through a personal interview with the artist and with the assistance of Le Raye Bunn, a collector in Louisville, Kentucky. Additional information was supplied by Kurt A. Gitter, also a folk art collector.

Quillian Lanier Meaders

1. Betty Jean Meaders told the authors in May 1989 that "Lanier attended various White County public schools," but "it's like it is, regardless of education."
2. There is a black tradition, dating from the time of slavery, of making grotesque and effigy jugs. Meaders and other white southern potters were undoubtedly influenced by these jugs.

Anna Miller

1. Biographical data were supplied by Tim Crane, chairman of the Art Department, Viterbo College, La Crosse, Wisconsin, and by Dr. A. A. Lorenz, Eau Claire, Wisconsin, who treated Miller.

Peter Minchell

1. Biographical data were obtained from Robert Bishop, *Folk Painters of America* (New York: E. P. Dutton, 1979), 176, 180, and Jay Johnson and William C. Ketchum, Jr., *American Folk Art of the Twentieth Century* (New York: Rizzoli, 1983), 198–199.
2. Bishop, *Folk Painters.*

Louis Monza

1. Biographical data, as well as information on the number of

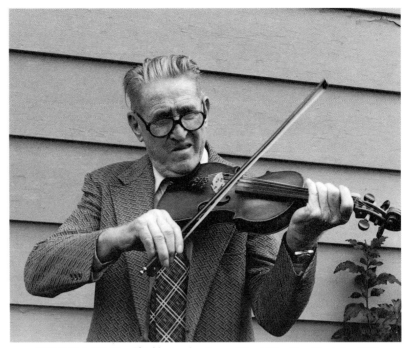

ABOVE AND BELOW: *Shields Landon Jones, Pine Hill, West Virginia, 1980.*

works, were supplied by the artist's widow, Heidi Monza, who carefully documented Monza's art.

Sister Gertrude Morgan

1. Biographical data were based largely on information supplied by Richard Gasperi, Gasperi Folk Art Gallery, New Orleans, Louisiana. See also Jane Livingston and John Beardsley, *Black Folk Art in America, 1930–1980* (Jackson: University Press of Mississippi, 1982), 97–103, and Elinor Lander Horwitz, *Contemporary American Folk Artists* (Philadelphia: J. B. Lippincott Company, 1975), 25–30.

Anna Mary Robertson ("Grandma") Moses

1. Biographical data were based largely on Moses's own account of her life, reproduced in part by Sidney Janis in *They Taught Themselves: American Primitive Painters of the 20th Century* (New

York: Dial Press, 1942), and on Otto Kallir, *Grandma Moses, American Primitive,* exhibition catalog (New York: Galerie St. Etienne, 1946).

Ed ("Mr. Eddy") Mumma

1. All quotations are based on a conversation between the authors and Lenny Kesl (April 10, 1989), who teaches at Santa Fe Community College, Gainesville, Florida. (The sign of Cancer is usually shown as June 21 to July 22.)

John ("J. B.") Murry

1. The authors are indebted to William Rawlings, Jr., for much of the biographical information contained in this entry. Murry's name is often spelled differently, but Dr. Rawlings asked the artist his preference, which is used here. Other information was provided by Andy Nasisse, a collector and assistant professor of art at the University of Georgia in Athens.

Nampeyo

1. Hopi betrothals usually lasted for several years. There is some question whether the marriage ceremony between Nampeyo and Kwivioya took place. In any event, the marriage lasted a very short time and they did not live together.
2. Biographical data and other information were largely based on *Nampeyo of Hano and Five Generations of Her Descendants,* exhibition catalog (Albuquerque, NM: Adobe Gallery, 1983), and *Seven Families in Pueblo Pottery,* exhibition catalog (Albuquerque: University of New Mexico Press and Maxwell Museum of Anthropology, 1974), 17–41. Additional information was furnished by M. E. and L. R. Blair, Pine, Colorado, and the Museum of Northern Arizona, Flagstaff. See also Barbara

Kramer, "Nampeyo, Hopi House, and the Chicagoland Show," *American Indian Arts Magazine* (Winter 1988).

Louis Naranjo

1. Naranjo is a Keres-speaking Indian. If his clan name is pronounced with the wrong intonation, the word then means "big balls."
2. See also Helen Cordero, page 82.
3. A kiva is usually a round underground structure that is entered by a ladder. Here the age-old religious practices of the Pueblo are carried on in secrecy.
4. Cochiti is known for its ceremonial drums. Today they are also used as tables.
5. The dancers are masked, and sometimes the masks contain real horns and fur of the animal represented. A *tableta* is a wooden headdress, often with feathers attached, worn by female dancers.

6. Beeweed is a type of wild spinach; it is boiled before its application to the pot and turns black during firing.

Saturnino Portuondo ("Pucho") Odio

1. Biographical data were supplied by Jay Johnson. See also Jay Johnson and William C. Ketchum, Jr., *American Folk Art of the Twentieth Century* (New York: Rizzoli, 1983), 218–220.

Mattie Lou O'Kelley

1. As quoted in Robert Bishop, *Folk Painters of America* (New York: E. P. Dutton, 1979), 182.
2. The date of her birth is sometimes given as 1907. See, for example, Anna Wadsworth, ed., *Missing Pieces: Georgia Folk Art, 1770–1976,* exhibition catalog (Atlanta: Georgia Council for the Arts and Humanities, 1976).
3. Some of her paintings, however, carry dates of the mid-1960s, and

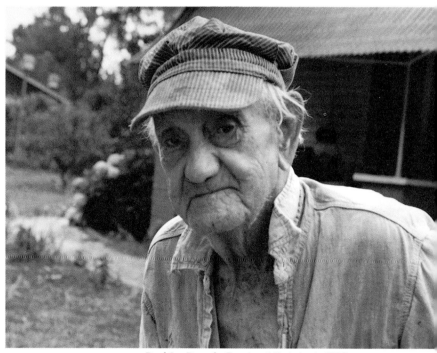

Paul Le Batard, Gautier, Mississippi, 1983.

Félix A. Lopez,
La Mesilla, New Mexico, 1990.

she may have been painting even earlier.

4. *From the Hills of Georgia, An Autobiography in Paintings* (1986); *Circus* (1986); and *Winter Place,* by Ruth Yaffe Radin, with paintings by Mattie Lou O'Kelley (1982). All three were published by Little, Brown and Company (Boston) in association with Atlantic Monthly Press.

5. "The Flowering of U.S. Folk Art," *Life* (June 1980).

Earnest Patton

1. Patton says, "I spell my name 'Earnest,' but lots of people drop the *a.*" The artist's preference is followed here.

Leslie J. ("Old Airplane") Payne

1. This is the date given by Payne in interviews and on his marriage license. His funeral program, however, lists his date of birth as October 1906.

2. Theresa Annas, "The Many Flights of 'Airplane' Payne," *Virginian Pilot/Ledger Star* (Norfolk, June 7, 1987), G-1.

John W. Perates

1. Biographical data were supplied by Perates's son Henry. See also Michael D. Hall, *Twentieth-Century American Icons, John Perates,* exhibition catalog (Cincinnati, OH: Cincinnati Art Museum, 1974).

2. "Pratt" instead of "Perates" was used for the sake of simplification.

Reverend Benjamin ("B. F.") Perkins

1. *Birmingham News* (July 10, 1987).

Oscar William ("Pelee") Peterson

1. Biographical data were largely based on Ronald J. Fritz, *Michigan's Master Carver: Oscar W. Peterson 1887–1951* (Boulder Junction, WI: Aardvark Publications, 1987).

2. Peterson is included in this volume for this reason. In addition, his carvings have been widely exhibited and have clear artistic merit.

3. Peterson had many nicknames; he was also called "Pete," "Pelio," and "Pikie."

Joseph Pickett

1. Biographical data were largely obtained from Sidney Janis, *They Taught Themselves: American Primitive Painters of the 20th Century* (New York: Dial Press, 1942), 110–116. See also Sidney Janis's essay on Joseph Pickett in Jean Lipman and Tom Armstrong, eds., *American Folk Painters of Three Centuries* (New York: Hudson Hills Press and Whitney Museum of American Art, 1980), 208–212.

Elijah Pierce

1. Some of the biographical information was supplied by the artist's widow, Estelle Pierce, who acted as Pierce's manager and was instrumental in gaining recognition for his work.

2. Many sources indicate there were thirty-three pages of wood reliefs. However, the Columbus Museum of Art, which now owns the work, states there are only eight pages but about thirty-three carvings. So far as is known, the Book is intact.

Horace Pippin

1. Biographical data were based on Selden Rodman, *Horace Pippin: A Negro Painter in America* (New

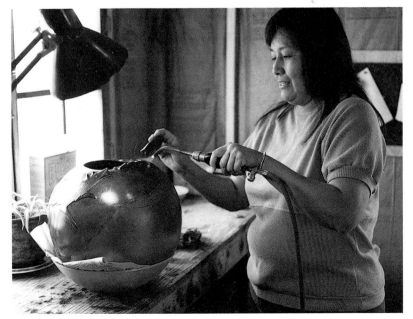

Christine McHorse, Santa Fe, New Mexico, 1988.

York: Quadrangle Press, 1947), and *H. Pippin,* exhibition catalog (Washington, DC: Phillips Collection, 1976).

Naomi ("Mrs. N. H.") Polk

1. Biographical data were supplied by the artist's daughter, Rosalie Taylor. See also Lynne Adele, *Black History/Black Vision: The Visionary Image in Texas,* exhibition catalog (Austin: Archer M. Huntington Art Gallery, University of Texas, 1989).

Daniel Pressley

1. Quotations were taken from the artist's diary.
2. Biographical information was obtained from Patrick Sariskey, Marcia Wilson, an artist, and Randall Morris, a New York gallery owner.
3. As quoted in Pressley's obituary, *New York Times* (February 18, 1971), 39.

Tressa ("Grandma") Prisbrey

1. Biographical data (including the spelling of Grandma's maiden name) were supplied by

Prisbrey's daughter, Othea Krieger, and by Helen Dennert of the Preserve Bottle Village Committee. Other information was based on Verni Greenfield, *Making Do or Making Art: A Study of American Recycling* (Ann Arbor: University of Michigan Research Press, 1984), 55–73.
2. Michael Schuyt, Joost Elffers, and George R. Collins, *Fantastic Architecture: Personal and Eccentric Visions* (New York: Harry N. Abrams, 1980), 157.
3. *Ibid.* Prisbrey herself claimed the number was 1,000,015.

Lamont Alfred ("Old Ironsides") Pry

1. From an interview with the authors. Some sources indicate that Pry had actually worked with a circus, but Pry did not verify this information in interviews.
2. Pry called himself and signed his paintings "Old Ironsides." There are other theories about how he got this name, including one that he made a model of the U.S.S. *Constitution* ("Old Ironsides")

while in grade school, and the name stuck to him as well.
3. The authors were unable to confirm the existence of Susan Maury.

Loranzo Dow Pugh

1. The authors wish to thank Le Raye Bunn for interviewing Dow Pugh. See also Elinor Lander Horwitz, *Contemporary American Folk Artists* (Philadelphia: J. B. Lippincott Company, 1975)

Matteo Radoslovich

1. Barbara Wahl Kaufman and Didi Barrett, *A Time To Reap: Late Blooming Folk Artists,* exhibition catalog (South Orange, NJ: Seton Hall University and Museum of American Folk Art, 1985), 28.
2. See, for example, Tressa Prisbrey, page 247, Simon Rodia, page 258, Clarence Schmidt, page 272, and Father Mathias Wernerus, page 322. But see Calvin and Ruby Black, page 47, Clark W. Coe, page 77, Howard Finster, page 121, and Jesse Howard, page 159, who also made art that can be viewed outside its original environment.

Martin Ramirez

1. Several sources give Ramirez's birthdate as 1885 and his date of death as 1960. The dates used here were obtained from the artist's death certificate, which also indicates Ramirez had a spouse in Mexico, a fact not published in prior accounts.
2. Elsa Weiner Longhauser, foreword in *The Heart of Creation: The Art of Martin Ramirez,* exhibition catalog (Philadelphia: Goldie Paley Gallery, Moore College of Art, 1985), 3–4.
3. Roberta Smith, "Radiant Space: The Art of Martin Ramirez," essay in *ibid.,* 8.
4. *Ibid.,* 6.

Carl McKenzie, Nada, Kentucky, 1979.

Alexander A. Maldonado,
San Francisco, California, 1980.

Ernest ("Popeye") Reed

1. Biographical data were supplied by the artist's son, Stephen Reed, Chillicothe, Ohio.

Enrique Rendon

1. Biographical data were obtained from personal interviews with the artist and from Rendon's sister, Candy Lopez.
2. The *hermano mayor,* or elder brother, holds overall responsibility for the organization. Rendon made the authors promise not to reveal this secret during his lifetime, and no other account mentions it.

"Prophet" Royal Robertson

1. The artist has given his birthdate orally as October 21, 1930, and October 21, 1936. When asked to write it, he wrote 1936. He also told Warren Lowe that he was born in 1936.
2. Robertson told Dr. Lowe that he had ten daughters and two sons, but he was not certain he was

the father. He made similar statements to the authors.
3. Biographical data were obtained from Dr. Lowe and through a personal interview with the artist, but the information supplied sometimes conflicted with other statements made by the artist.
4. The artist signs his name with various titles: "Prophet," "Patriarch," and "Libra."

Simon ("Sam") Rodia

1. Quoted in Calvin Trillin, "Simon Rodia: Watts Towers," in *Naives and Visionaries,* exhibition catalog (New York: E. P. Dutton and Walker Art Center, 1974), 21.
2. Little is known of Rodia's early life. The birth and death dates used here are given on his death certificate, which also gives his name as Sam Rodia. See also I. Sheldon Posen and Daniel Franklin Ward, "Watts Towers and the Giglio Tradition," *Folklife Annual* (1985), 143–157,

and Elinor Lander Horwitz, *Contemporary American Folk Artists* (Philadelphia: J. B. Lippincott Company, 1975), 132–138.
3. There was one exception to Rodia's silence on his project. At a showing of a film on the *Watts Towers,* which the artist reluctantly attended, he became excited and talked briefly with the audience (see Posen and Ward, "Watts Towers," 154).
4. See Trillin, in *Naives and Visionaries,* 23.
5. Posen and Ward, "Watts Towers."
6. The description of Rodia's materials is based on information provided by Calvin Trillin and Seymour Rosen (see Trillin, in *Naives and Visionaries,* 21–31, and Seymour Rosen and Cynthia Pansing, "Saving America's Contemporary Folk Art Environments," *Raw Vision* 1 [Spring 1989], 36–41; see also Michael Schuyt, Joost Elffers, and George R. Collins, *Fantastic*

Betty Manygoats, Cow Springs, Arizona, 1987.

Eddie Owens Martin, Land of Pasaquan, Marion County, Georgia, 1981.

Architecture: Personal and Eccentric Visions [New York: Harry N. Abrams, 1980], 78, and Seymour Rosen, *In Celebration of Ourselves* [San Francisco: California Living Books, 1979], 14).

7. Trillin, in *Naives and Visionaries,* 31.

John Roeder

1. Biographical data were supplied by Ruth C. Abbe, Roeder project coordinator, Richmond Art Center, Richmond, California, and by John Roeder, the artist's son.

2. Roeder claims that he had a vision of the Virgin Mary while kneeling by a pond. The vision caused water to rush from the pond and begin streaming from his eyes, after which he had a significant loss of eyesight.

Juanita Rogers

1. All quotations are from conversations with Anton Haardt during April 1989. Haardt furnished much of the biographical data.

2. The Rhodeses own the only Rogers funny brick sculpture not owned by Haardt.

Sultan Rogers

1. Biographical information was obtained from William Ferris, director, Center for the Study of Southern Culture, University of Mississippi, Oxford, and from a personal interview with the artist.

Nellie Mae Rowe

1. Rowe's long-time dealer, Judith Alexander, said, "She always celebrated her birthday on July 4" (from a telephone conversation in April 1988). The authors also interviewed Rowe on several occasions between 1977 and the early 1980s.

2. Judith Alexander, *Nellie Mae Rowe, Visionary Artist,* exhibition catalog (Atlanta, GA: privately published, 1983), 11.

3. *Ibid.,* 9.

Ida Sahmie

1. The only decoration acceptable on a Navajo pot is the *biyo',* a beaded necklace just below the rim. Traditionally, there is always a small break in the *biyo',* called *at'iin,* or "the way out." See also Silas Claw, page 75, Alice Cling, page 76, Christine McHorse, page 202, and Betty Manygoats, page 205.

2. The *Yeis* are Navajo spirits or gods. They appear in ceremonies as masked dancers.

3. Beeweed is a wild spinach that is boiled in water before use; it turns black during firing.

Anthony Joseph ("Tony Joe") Salvatore

1. Biographical information was obtained through an interview with the artist and his representative, David Colts. See also Barbara Tannenbaum, "Pillar of Fire: The Visionary Art of Anthony Joseph Salvatore," exhibition brochure (Akron, OH: Akron Art Museum, 1989).

Mario Sanchez

1. Kathryn Hall Proby, *Mario Sanchez: Painter of Key West Memories* (Key West, FL: Southernmost Press, 1981), 10.

2. Biographical data were obtained from Susan Olsen, director, Key West Art and Historical Society,

Gregorio Marzan, New York City, 1989.

and from telephone conversations with Sanchez. See also *ibid.*

John ("Jack") Savitsky

1. Savitsky often signs his paintings and refers to himself as "Coal Miner Jack."
2. Victor Joseph Gatto, page 135, Justin McCarthy, page 198, and Lamont Alfred Pry, page 248, were other artists whom Strauser encouraged.
3. From conversations with his son, Jack Savitt, who provided much of the biographical information in February 1989.

Clarence Schmidt

1. As quoted by Gregg N. Blasdel and Bill Lipke, "Clarence Schmidt: Toward Journey's End," in *Naïves and Visionaries,* exhibition catalog (New York: E. P. Dutton and Walker Art Center, 1974), 49.
2. Much of the biographical data and other information were based on *ibid.,* 43–51. See also Michael Schuyt, Joost Elffers, and George R. Collins, *Fantastic Architecture: Personal and Eccentric Visions* (New York: Harry N. Abrams, 1980), 200–201. Additional information was furnished by the Ulster Arts Alliance, Kingston, New York.

John Scholl

1. See Katherine C. Grier, *Celebrations in Wood: The Sculpture of John Scholl (1827–1916),* exhibition catalog (Harrisburg, PA: William Penn Memorial Museum, 1979).
2. His granddaughter emphasized that the "toys" were not meant to be played with, although Scholl loved to show them off. See *ibid.*
3. See Robert Bishop, *American Folk Sculpture* (New York: E. P. Dutton, 1974), 212.

Jon Serl

1. Much of this biographical information was obtained from the artist. Where possible, the information was confirmed from other sources.

Quillian Lanier Meaders, Mossy Creek, Georgia, 1979.

Herbert Singleton

1. Biographical data and quotations were obtained from Sainte-James Boudreaux, the Barrister's Gallery, New Orleans, Louisiana.

Drossos P. Skyllas

1. Some biographical data were supplied by the Phyllis Kind Gallery, Chicago, Illinois. See also *Transmitters: The Isolate Artist in America,* exhibition catalog (Philadelphia: Philadelphia College of Art, 1981).
2. See *Transmitters,* dialogue by Michael and Julie Hall, 50.
3. Phyllis Kind Gallery, Chicago, Illinois.

Fred Smith

1. Biographical data were supplied by Smith's daughter, Eileen Boho, in telephone conversations in May 1989. Information about the objects in the Park was supplied by Lisa Stone, who is involved in conservation work there.
2. William Bohne, "Fred Smith Interviewed." During the summer of 1970, Bohne taped five interviews with Fred Smith at the Pleasant View Rest Home, Phillips, Wisconsin. Quotations in the entry are from these interviews.

Fannie Lou Spelce

1. Biographical data were supplied by the artist's son, Bennett Spelce, Austin, Texas.
2. All quotations are from *Fannie Lou Spelce* (Austin, TX: Fannie Lou Spelce Associates, 1972), unpaginated.

Henry Speller

1. Biographical data were based on original research furnished by folklorist Ray Allen and visual artist Laurie Russell, who both live in Brooklyn, New York.

Hugo Sperger

1. Biographical data were supplied by the artist's wife, Faye Sperger, and by Morehead State University, Morehead, Kentucky.
2. Ramona Lampell and Millard Lampell, with David Larkin, *O, Appalachia: Artists of the Southern Mountains* (New York: Stewart, Tabori & Chang, 1989).

"Queena" Stovall

1. The authors wish to thank the artist's son, Bob Stovall, Lynchburg, Virginia, for furnishing biographical information. See also Guy Friddell, "A Compassionate Eye and a Talented Hand," *Commonwealth, The Magazine of Virginia* (May 1980), 30–37.
2. Louis C. Jones and Agnes Halsey Jones, introduction to *Queena Stovall: Artist of the Blue Ridge Piedmont,* exhibition catalog (Lynchburg, VA: Lynchburg College, 1974).

Clarence Stringfield

1. Biographical data were supplied by the artist's daughter, Lorene Lancaster, Nashville, Tennessee.

Jimmy Lee Sudduth

1. Robert Bishop, *Folk Painters of America* (New York: E. P. Dutton, 1979), 181.
2. Several different spellings have been used for the artist's surname. One possible explanation is given by Elaine S. Katz: "Collectors like to ask Jimmy Lee to sign the paintings they buy from him. Jimmy Lee, who's had about as much formal schooling as most seventy-year-old black men who grew up in the deep South, is happy to oblige. He usually signs 'Jimmy Lee Suddth,' omitting the vowel in an act of phonetic logic never thwarted in any classroom." From Katz, *Folklore for the Time of Your Life* (Birmingham, AL: Oxmoor House, 1978), 159. For another spelling of Sudduth, see also *ibid.,* 181.

3. *Fayette County Broadcaster* (September 23, 1971).
4. Quotation from the authors' 1978 interview with Jan McWater.
5. Sudduth is probably referring to pokeweed, whose berries give a red dye when boiled.

Patrick Sullivan

1. Biographical data were obtained from Gary E. Baker, *Sullivan's Universe: The Art of Patrick J. Sullivan, Self-Taught West Virginia Painter* (Wheeling, WV: Oglebay Institute, 1979). See also Sidney Janis, *They Taught Themselves: American Primitive Painters of the 20th Century* (New York: Dial Press, 1942), 53–75.

Reverend Johnnie Swearingen

1. Biographical data were obtained from the artist and from Lynne Adele, *Black History/Black Vision: The Visionary Image in Texas,* exhibition catalog (Austin: Archer M. Huntington Art Gallery, University of Texas, 1989).

Luis Tapia

1. *Santero* is the Spanish term for an artist who carves or paints religious images, or *santos.*
2. He won blue ribbons five years in a row.
3. In the Hispanic tradition, death is female. It is represented by a skeleton, called *Doña Sebastiana,* who carries a bow and arrow rather than a sickle and rides a farm cart. The death carts are used in church services on Good Friday.

Sarah Mary Taylor

1. A number of southern black women (particularly elderly women) are quilters. See, for example, Pattie Carr Black, *Made By Hand: Mississippi Folk Art* (Jackson: Mississippi Department of Archives and History, 1980); Roland L. Freeman, *Something to Keep You Warm: The Roland Freeman Collection of Black*

Ike Morgan, Austin, Texas, 1988.

American Quilts from the Mississippi Heartland, exhibition catalog (Jackson: Mississippi State Historical Museum, 1981); and Maude Southwell Wahlman and Ella King Torrey, *Ten Afro-American Quilters* (Oxford, MS: Center for the Study of Southern Culture, 1983).

2. There is a prevalent theory that this type of quilting has African origins and style similarities. See, for example, Wahlman and Torrey, *Ten Afro-American Quilters.*

3. Other black folk artists in this volume who have also made quilts on occasion are Clementine Hunter, page 160, and Nellie Mae Rowe, page 264.

Mose Tolliver

1. Tolliver's birthdate has also been given as 1915.

Bill Traylor

1. Biographical data and quotations were based on telephone conversations in May 1989 between the authors and Charles Shannon, an artist, teacher, and writer who recently retired as head of the Art Department at Auburn University, Montgomery, Alabama. Shannon discovered and befriended Traylor. See also Charles Shannon, introduction to *Bill Traylor, 1854–1947,* exhibition catalog (New York: Hirschl & Adler Modern, 1985). See also Jane Livingston and John Beardsley, *Black Folk Art in America, 1930–1980* (Jackson: University Press of Mississippi, 1982), 138–145.

2. So far as is known, Traylor did not draw during this period. No such work is extant.

Faye Tso

1. See also Silas Claw, page 75, and Alice Cling, page 76.

2. The *Yeibichai (Yéii bicheii),* or Night Chant, is the most sacred of Navajo ceremonies, and is considered preventive as well as curative. Continuing for nine days, it may take place only in fall, after the first frost, when snakes are in hibernation and there is no danger of lightning.

3. Brown or grayish discolorations that are part of the beauty of Navajo pottery.

Horacio Valdez

1. *Santero* is the Spanish term for an artist who carves or paints religious images, or *santos.*

2. *Los Hermanos Penitentes,* or the Pious Fraternity of Our Father Jesus Nazarite, is a lay religious organization related to the Roman Catholic church, and members are almost exclusively of Hispanic origin. Because his wife is not Catholic and they married outside the Church, Valdez had trouble gaining entry, but he got a dispensation from the archbishop and was able to join. Valdez was secretary of the brotherhood from 1978 through 1979, but he is not presently an active participant.

3. The small hidden chapel used by the Penitentes.

4. See also Frank Brito, page 62, José Dolores Lopez, page 192, George T. Lopez, page 193, Enrique Rendon, page 255, and Luis Tapia, page 299, among others.

Manuel Vigil

1. Vigil adopted and raised Arthur, the eldest son of his daughter Anna Marie Lovato. Arthur Vigil, page 311, is also a potter and sculptor.

2. The rain gods are seated clay figures that hold water vessels; they were usually painted with bright poster paints. Some art historians believe the inspiration for the figures is *Kokopelli,* the hunchbacked supernatural figure

Anna Mary Robertson Moses, Eagle Bridge, New York, 1958.

Virginia and Louis Naranjo,
Cochiti Pueblo, New Mexico, c. 1988.

associated with rain in the Pueblo culture.

3. *Nacimientos* is the Spanish term for creches or nativity scenes.

4. A tradition credited to Helen Cordero, page 82.

Arthur ("Art") Vigil

1. For a discussion of Tesuque rain gods, see Manuel Vigil, page 309.

Felix Virgous

1. Biographical data were obtained from William Arnett, a folk art dealer in Atlanta, Georgia, and from a personal interview with the artist.

John Vivolo

1. Elsewhere his birthdate has been given as December 3, 1886. See Ken Laffal, *Vivolo and His Wooden Children* (Essex, CT: Gallery Press, 1976), 10.

2. Some biographical information was obtained from the artist's daughter, Jenny Maraschiello, who lives in the Vivolo home in Hartford.

3. Laffal, *Vivolo,* 104 (essay by Florence Laffal).

Eugene Von Bruenchenhein

1. Biographical data were obtained from Adeline Pornath, Von Bruenchenhein's sister-in-law. See also Joanne Cubbs, *Eugene Von Bruenchenhein: Obsessive Visionary,* exhibition catalog (Sheboygan, WI: John Michael Kohler Arts Center, 1988).

Inez Nathaniel Walker

1. As quoted in Jane Livingston and John Beardsley, *Black Folk Art in America, 1930–1980* (Jackson: University Press of Mississippi, 1982), 147.

2. See "Self-Taught Artist Discovered in Prison," *Correctional Services News* 3:6 (August 1978). There Walker gave her father's name as Wallace Stedman.

3. *Ibid.,* 5.

Velox Ward

1. Biographical data were obtained from conversations with the artist and with Donald and Margaret Vogel during July 1989. See also Donald and Margaret Vogel, *Velox Ward,* exhibition catalog (Fort Worth, TX: Amon Carter Museum of Western Art, 1972).

William ("Wibb") Ward

1. Biographical data were supplied by Beverly Blum, Wibb Ward's daughter.

Floretta Emma Warfel

1. The artist's husband's name was Warfle and she uses that spelling in private life; however, she signs all her paintings Warfel.

Perley ("P. M.") Wentworth

1. See Christina Orr-Cahall, *Cat and a Ball on a Waterfall: 200 Years of California Folk Painting and Sculpture,* exhibition catalog (Oakland, CA: Oakland Museum Art Department, 1986), 100.

2. Susan Larsen-Martin and Lauri Robert Martin, *Pioneers in*

William Owens, Poplar Branch, North Carolina, 1978.

Paradise: Folk and Outsider Artists of the West Coast, exhibition catalog (Long Beach, CA: Long Beach Museum of Art, 1984), 57.

3. It is unclear why Tarmo Pasto had Wentworth's paintings, although he is known to have been interested in the art of mentally disturbed individuals. There is some speculation that Wentworth may have gone to Pasto as a patient.

Father Mathias Wernerus

1. Biographical data were supplied by the Holy Ghost Parish in Dickeyville. There are also various pamphlets that describe the work. See, for example, "Grotto and Shrines, Dickeyville, Wisconsin" (publisher and date not listed).
2. Unsigned statement commemorating "A Century of Growth in Holy Ghost Parish," May 2–6, 1973.

George W. White, Jr.

1. Much of the biographical information was obtained with the help of Murray Smither. See Murray Smither, *The World of George W. White, Jr.,* exhibition catalog (Waco, TX: Waco Creative Art Center, 1975), 9.

Isidor ("Pop" or "Grandpa") Wiener

1. Much of the biographical data was supplied by the artist's daughter-in-law, Sandra Wiener.

Lizzie Wilkerson

1. The date of birth given on Wilkerson's death certificate is March 5, 1907, but the 1901 date is more commonly accepted.
2. Biographical data were supplied by Jean Ellen Jones. See also Jean Ellen Jones, *Lizzie Wilkerson: Paintings,* exhibition catalog (Atlanta: Georgia State University Art Gallery, 1983).

Wallace ("Knox") Wilkinson, Jr.

1. Most of the biographical information was supplied by Vera Wilkinson, the artist's mother.

Charlie Willeto

1. See Leonard Willeto, page 328.
2. This artist has been exhibited under the name Alfred Walleto at the Wheelwright Museum of the American Indian in Santa Fe, New Mexico. However, the authors have visited his widow, Elizabeth Willeto Ignazio, and Indian trader Harry Bachelor, his former postmaster. These interviews convinced the authors that the artist's name was, in fact, Charlie Willeto, and his work is presently being shown under that name.
3. This figure is a rough estimate, arrived at with the help of Bruce Bernstein, former assistant director of the Wheelwright Museum.

Leonard Willeto

1. Biographical data were obtained from Lucy Willeto Charlie, the artist's sister; Elizabeth Willeto Ignazio, the artist's mother; and Jack Beasley, an Indian trader in Farmington, New Mexico.
2. Elizabeth Willeto helped her husband and children. Elizabeth and Harold, Leonard's brother, are both currently carving figures. While their styles are their own, they are somewhat reminiscent of Charlie's work.

Philo Levi ("Chief") Willey

1. Willey claimed he never had a birth certificate, only a picture

Elijah Pierce, Columbus, Ohio, 1976.

Tressa Prisbrey, Simi Valley, California, n.d.

when he was six months old. Various birthdates have been given (1886, 1889, and 1890) in other sources, but during his last illness Willey wrote that he was born on September 26, 1887 (from a conversation with Cecilia Willey, his widow, on July 10, 1989). See also Willey's papers in the archives of the Museum of American Folk Art, New York City, and "Recalling Countless Livelihoods," *Times-Picayune* (New Orleans, August 1, 1978), "Tuesday," 1–8.

2. Willey said, "As I got the last [painting] hung up on the fence, a lady came up and . . . she says, 'I want those pictures, and I'll give you seven and a half apiece for them.'"

George Williams

1. The artist twice confirmed to the authors (on March 27, 1989, and on April 18, 1989) that the date and place listed here are correct. See, however, Jane Livingston and John Beardsley, *Black Folk Art in America, 1930–1980* (Jackson: University Press of Mississippi, 1982), which gives his place of birth as Mississippi and the year as 1911. Perhaps some of the confusion is caused by the fact that there is also a Clinton, Mississippi.

Clara ("Aunt Clara") Williamson

1. Donald and Margaret Vogel, *Aunt Clara: The Paintings of Clara McDonald Williamson* (Austin: University of Texas Press and Amon Carter Museum of Western Art, 1966), 38.

2. Most of the biographical data were furnished by the Vogel family. See also *ibid*.

3. *Ibid.,* 100.

Luster Willis

1. William Ferris, *Local Color: A Sense of Place in Folk Art* (New York: McGraw-Hill, 1982).

2. *Ibid.,* 200.

Joseph Elmer Yoakum

1. As quoted in Whitney Halstead, "Joseph Yoakum," unpublished manuscript c. 1977, now in the archives of the Art Institute of Chicago.

2. The date usually given for Yoakum's birth is 1886, but one of his drawings, entitled *Back Where I Were Born,* gives an 1888 date.

3. Biographical data were based on Halstead, "Joseph Yoakum." See also Jacqueline M. Atkins, "Joseph E. Yoakum: Visionary Traveler," *The Clarion* 15:1 (Winter 1990).

4. Whether Yoakum was a Navajo cannot be determined because

records giving such data were rarely kept prior to the early 1900s.

5. Norman Mark, "My Dreams Are a Spiritual Unfoldment," *Chicago Daily News* (November 11, 1967).

6. That painting is *Mt. Golleia on North Portion of Antartica in so west Pacific Ocean.*

Albert Zahn

1. Biographical data were supplied by Elmer Zahn and Evelyn Langohr, the artist's children, who live in Baileys Harbor, Wisconsin.

Malcah Zeldis

1. Zeldis was called Malcah, a name that means "queen" in Hebrew, by her grandmother. When Zeldis went to live in Israel, she adopted this name.

2. Henry Niemann, "Malcah Zeldis: Her Art," *The Clarion* 13:3 (Summer 1988), 52.

Jankiel ("Jack") Zwirz

1. The artist sometimes celebrated his birthday on March 5, the date of his release from Nazi concentration camps, and his place of birth is sometimes given as Lodz, Poland.

2. Much of the biographical information was furnished by the artist's son, George Zwirz.

Bibliography

Adele, Lynne. *Black History/Black Vision: The Visionary Image in Texas*. Exhibition catalog. Austin: Archer M. Huntington Art Gallery, University of Texas, 1989.

American Folk Art from the Ozarks to the Rockies. Exhibition catalog. Tulsa, OK: Philbrook Art Center, 1975.

Another Face of the Diamond: Pathways Through the Black Atlantic South. Exhibition catalog. New York: INTAR Latin American Gallery, 1988.

Ape to Zebra: A Menagerie of New Mexican Woodcarvings, the Animal Carnival Collection of the Museum of American Folk Art. Exhibition catalog. New York: Museum of American Folk Art, 1985.

Archer, Barbara. *Outside the Main Stream: Folk Art in Our Time*. Atlanta: High Museum of Art at Georgia-Pacific Center, 1988.

Arkus, Leon Anthony, comp. *John Kane, Painter*. Includes "Sky Hooks, The Autobiography of John Kane," as told to Marie McSwigan. Pittsburgh: University of Pittsburgh Press, 1971.

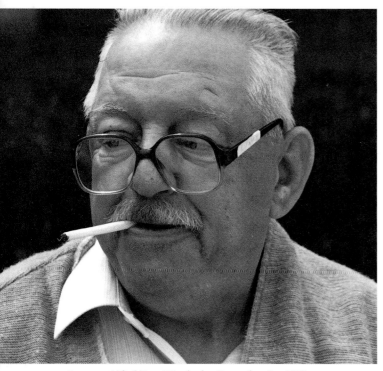

Lamont Alfred Pry, Weatherly, Pennsylvania, 1977.

Babcock, Barbara A., Guy Monthan, and Doris Monthan. *The Pueblo Storyteller: Development of a Figurative Ceramic Tradition*. Tucson: University of Arizona Press, 1986.

Baker, Gary E., cur. *Sullivan's Universe: The Art of Patrick J. Sullivan, Self-Taught West Virginia Painter*. Wheeling, WV: Oglebay Institute, 1979.

Baking in the Sun: Visionary Images from the South. Exhibition catalog. Lafayette: University Art Museum, University of Southwestern Louisiana, 1987.

Barrett, Didi. *Muffled Voices: Folk Artists in Contemporary America*. New York: Museum of American Folk Art, 1986.

Beardsley, John, Jane Livingston, and Octavio Paz. *Hispanic Art in the United States: Thirty Contemporary Painters and Sculptors*. New York: Abbeville Press, 1987.

Bernstein, Bruce D., and Susan Brown McGreevy, with Chuck Rosenak. *Anii Anaadaalyaa Igii: Continuity & Innovation in Recent Navajo Art*. Santa Fe, NM: Wheelwright Museum of the American Indian, 1988.

Bill Traylor, 1854–1947. Exhibition catalog. New York: Hirschl & Adler Modern, 1985.

Bishop, Robert. *The All-American Dog: Man's Best Friend in Folk Art*. New York: Avon Books and Museum of American Folk Art, 1977.

———. *American Folk Sculpture*. New York: E. P. Dutton, 1974.

———. *Folk Painters of America*. New York: E. P. Dutton, 1979.

Bishop, Robert, Judith Reiter Weissman, Michael McManus, and Henry Niemann. *Folk Art: Paintings, Sculpture and Country Objects*. New York: Alfred A. Knopf, 1983.

Black, Patti Carr. *Made by Hand: Mississippi Folk Art*. Jackson: Mississippi Department of Archives and History, 1980.

Black Art—Ancestral Legacy: The African Impulse in African-American Art. Exhibition catalog. Dallas: Dallas Museum of Art, 1989.

Blasdel, Gregg N. *Symbols and Images: Contemporary Primitive Artists*. Exhibition catalog. New York: American Federation of Arts, 1970.

Bowman, Russell, cur. *American Folk Art: The Herbert Waide Hemphill, Jr. Collection*. Milwaukee: Milwaukee Art Museum, 1981.

Briggs, Charles L. *The Wood Carvers of Cordova, New Mexico: Social Dimensions of an Artistic "Revival."* Knoxville: University of Tennessee Press, 1980.

Burrison, John A. *Brothers in Clay: The Story of Georgia Folk Pottery.* Athens: University of Georgia Press, 1983.

Cahill, Holger. *American Folk Art: The Art of the Common Man in America, 1750–1900.* New York: Museum of Modern Art, 1932.

———. *American Folk Sculpture.* Newark, NJ: Newark Museum of Art, 1931.

———. *Masters of Popular Painting.* New York: Museum of Modern Art, 1938.

Cahill, Holger, Maximilien Gauthier, Jean Cassou, Dorothy C. Miller, et al. *Masters of Popular Painting: Modern Primitives of Europe and America.* New York: Museum of Modern Art, 1938.

Cannon, Hal, ed. *Utah Folk Art.* Provo, UT: Brigham Young University Press, 1980.

Capers, Charlotte, and Olivia P. Collins, eds. *My Life in Pictures: Ethel Wright Mohamed.* Jackson: Mississippi Department of Archives and History, 1976.

Cardinal, Roger. *Outsider Art.* New York: Praeger Publishers, 1972.

Carpenter, Miles Burkholder. *Cutting the Mustard.* Tappahannock, VA: American Folk Art Company, 1982.

Coe, Ralph T. *Lost and Found Traditions: Native American Art 1965–1985.* Seattle: University of Washington Press and American Federation of Arts, 1986.

Cubbs, Joanne. *Eugene Von Bruenchenhein: Obsessive Visionary.* Exhibition catalog. Sheboygan, WI: John Michael Kohler Arts Center, 1988.

———. *The Gift of Josephus Farmer.* Milwaukee: Milwaukee Art History Gallery, University of Wisconsin, 1982.

Dewhurst, C. Kurt, Betty MacDowell, and Marsha MacDowell. *Artists in Aprons: Folk Art by American Women.* New York: E. P. Dutton and Museum of American Folk Art, 1979.

———. *Religious Folk Art in America: Reflections of Faith.* New York: E. P. Dutton and Museum of American Folk Art, 1983.

Dewhurst, C. Kurt, and Marsha MacDowell. *Rainbows in the Sky: The Folk Art of Michigan in the Twentieth Century.* East Lansing: Michigan State University, 1978.

Dinsmoor, S. P. *Pictorial History of The Cabin Home in Garden of Eden.* Lucas, KS: privately printed, n.d.

Driskell, David C. *Two Centuries of Black American Art.* New York: Alfred A. Knopf and Los Angeles County Museum of Art, 1976.

Earl Cunningham: The Marilyn L. and Michael A. Mennello Collection. Exhibition catalog. Monterey, CA: Monterey Peninsula Museum of Art, 1989.

Earnest, Adele. *Folk Art in America: A Personal View.* Exton, PA: Schiffer Publishing, 1984.

Elijah Pierce: Painted Carvings. Exhibition catalog. New York: Bernard Danenberg Galleries, 1972.

Elijah Pierce: Wood Carver. Exhibition catalog. Columbus, OH: Columbus Gallery of Fine Arts, 1973.

Fagaly, William A. *David Butler.* Exhibition catalog. New Orleans: New Orleans Museum of Art, 1976.

Faircloth, Stephen, and Susan Courtney, cur. *Enisled Visions: The Southern Non-Traditional Folk Artist.* Mobile, AL: Fine Arts Museum of the South [1987].

Fels, Catherine. *Graphic Work of Louis Monza.* Los Angeles: Plantin Press, 1973.

Ferris, William. *Local Color: A Sense of Place in Folk Art.* New York: McGraw-Hill, 1982.

Finster, Howard, as told to Tom Patterson. *Howard Finster, Stranger from Another World: Man of Visions Now on This Earth.* New York: Abbeville Press, 1989.

Folk Art in Oklahoma. Exhibition catalog. Oklahoma City: Oklahoma Museums Association, 1981.

Loranzo Dow Pugh, Monterey, Tennessee, 1976.

Four American Primitives: Edward Hicks, John Kane, Anna Mary Robertson Moses, Horace Pippin. New York: ACA Galleries, 1972.

Frank Jones. Exhibition catalog. Topeka, KS: Mulvane Art Center [1974].

Freeman, Roland L. *Something to Keep You Warm: The Roland Freeman Collection of Black American Quilts from the Mississippi Heartland.* Exhibition catalog. Jackson: Mississippi State Historical Museum, 1981.

Fritz, Ronald J. *Michigan's Master Carver: Oscar W. Peterson 1887–1951.* Boulder Junction, WI: Aardvark Publications, 1987.

Fuller, Edmund. *Visions in Stone: The Sculpture of William Edmondson.* Pittsburgh: University of Pittsburgh Press, 1973.

Glassie, Henry. *Pattern in the Material Folk Culture of the Eastern United States.* Philadelphia: University of Pennsylvania Press, 1968.

————. *The Spirit of Folk Art: The Girard Collection at the Museum of International Folk Art.* New York: Harry N. Abrams and Museum of New Mexico, 1989.

Grass Roots Art: Wisconsin. Exhibition catalog. Sheboygan, WI: John Michael Kohler Arts Center, 1978.

Greenfield, Verni. *Making Do or Making Art: A Study of American Recycling.* Ann Arbor, MI: University of Michigan Research Press, 1984.

Gregson, Chris. *How the Eagle Flies: Patriotic Images in Twentieth-Century Folk Art.* Richmond, VA: Meadow Farm Museum, 1989.

Grier, Katherine C. *Celebrations in Wood: The Sculpture of John Scholl (1827–1916).* Exhibition catalog. Harrisburg, PA: William Penn Memorial Museum, 1979.

Hall, Julie. *The Sculpture of Fred Alten.* Exhibition catalog. Michigan Artrain, 1978.

Halstead, Whitney. "Joseph Yoakum." Manuscript, Archives, Art Institute of Chicago, c. 1977.

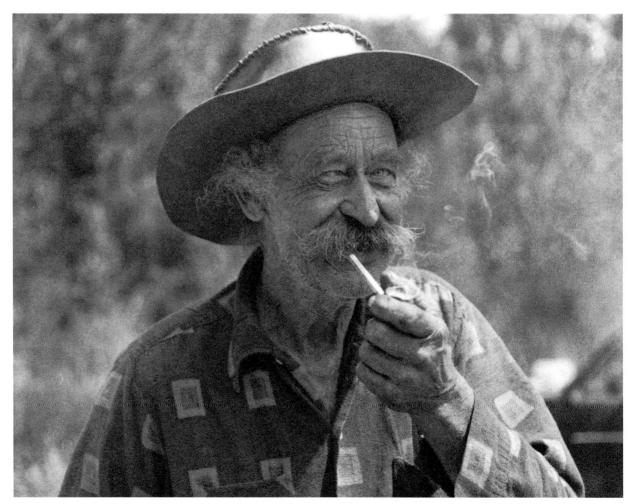

Ernest Reed, Jackson, Ohio, 1983.

Hamblett, Theora, in collaboration with Ed Meek and William S. Haynie. *Theora Hamblett Paintings*. Jackson: University Press of Mississippi, 1975.

Hartigan, Lynda Roscoe. *James Hampton: The Throne of the Third Heaven of the Nations' Millennium General Assembly*. Exhibition catalog. Washington, DC: National Museum of American Art, Smithsonian Institution, n.d. Reprint. Boston: Museum of Fine Arts, 1976.

———. *The Throne of the Third Heaven of the Nations Millenium General Assembly*. Montgomery, AL: Montgomery Museum of Fine Arts, 1977.

Hartman, Russell P., and Jan Musial. *Navajo Pottery: Traditions and Innovations*. Flagstaff, AZ: Northland Press, 1987.

The Heart of Creation: The Art of Martin Ramirez. Exhibition catalog. Philadelphia: Goldie Paley Gallery, Moore College of Art, 1985.

Hemphill, Herbert W., Jr., ed. *Folk Sculpture USA*. New York: Brooklyn Museum, 1976.

Hemphill, Herbert W., Jr., and Julie Weissman. *Twentieth Century American Folk Art and Artists*. New York: E. P. Dutton, 1974.

Hispanic Crafts of the Southwest. Exhibition catalog. Colorado Springs: Taylor Museum, 1977.

Horace Pippin. Exhibition catalog. Washington, DC: Phillips Collection, 1977.

Horwitz, Elinor Lander. *The Bird, The Banner, and Uncle Sam*. Philadelphia: J. B. Lippincott Company, 1976.

———. *Contemporary American Folk Artists*. Philadelphia: J. B. Lippincott Company, 1975.

———. *Mountain People, Mountain Crafts*. Philadelphia: J. B. Lippincott Company, 1974.

Hudson, Ralph M., cur. *Black Artists/South*. Huntsville, AL: Huntsville Museum of Art, 1979.

Janis, Sidney. *They Taught Themselves: American Primitive Painters of the 20th Century*. New York: Dial Press, 1942.

Johnson, Jay, and William C. Ketchum, Jr. *American Folk Art of the Twentieth Century*. New York: Rizzoli, 1983.

Jones, Jean Ellen. *Lizzie Wilkerson: Paintings*. Exhibition catalog. Atlanta: Georgia State University Art Gallery, 1983.

Jones, Michael Owen. *The Handmade Object and Its Maker*. Berkeley: University of California Press, 1975.

Jones, Suzi, ed. *Webfoots and Bunchgrassers: Folk Art of the Oregon Country*. Eugene: Oregon Arts Commission, 1980.

Kahan, Mitchell D. *Heavenly Visions: The Art of Minnie Evans*. Raleigh: North Carolina Museum of Art, 1986.

———. *Moze T*. Montgomery, AL: Montgomery Museum of Fine Arts, 1981.

Kalb, Laurie Beth. *Santos Statues Sculpture: Contemporary Woodcarving from New Mexico*. Los Angeles: Craft and Folk Art Museum, 1988.

Kallir, Jane. *The Folk Art Tradition: Naive Painting in Europe and the United States*. New York: Viking Press, 1981.

———. *John Kane: Modern America's First Folk Painter*. New York: Galerie St. Etienne, 1984.

Kallir, Otto. *Art and Life of Grandma Moses*. New York: Gallery of Modern Art, 1969.

———. *Grandma Moses*. New York: Harry N. Abrams, 1973.

Kaufman, Barbara Wahl, and Didi Barrett. *A Time to Reap: Late Blooming Folk Artists*. Exhibition catalog. South Orange, NJ: Seton Hall University and Museum of American Folk Art, 1985.

Kimball, Art, Brad Kimball, and Scott Kimball. *The Fish Decoy*. 2 vols. Boulder Junction, WI: Aardvark Publications, 1986, 1987.

La Chapelle, Greg. *Navajo Folk Sculpture: Alfred Walleto*. Santa Fe, NM: Wheelwright Museum of the American Indian, n.d.

Laffal, Ken. *Vivolo and His Wooden Children*. Essex, CT: Gallery Press, 1976.

Lampell, Ramona, and Millard Lampell, with David Larkin. *O, Appalachia: Artists of the Southern Mountains*. New York: Stewart, Tabori & Chang, 1989.

Enrique Rendon, Velarde, New Mexico, 1985.

Larsen-Martin, Susan, and Lauri Robert Martin. *Pioneers in Paradise: Folk and Outsider Artists of the West Coast.* Exhibition catalog. Long Beach, CA: Long Beach Museum of Art, 1984.

Leedskalnin, Edward. *A Book in Every Home.* Homestead, FL: privately printed, 1936.

Lions and Tigers and Bears, Oh My!: New Mexican Folk Carvings. Exhibition catalog. Corpus Christi: Art Museum of South Texas, 1986.

Lipman, Jean, and Tom Armstrong, eds. *American Folk Painters of Three Centuries.* New York: Hudson Hills Press and Whitney Museum of American Art, 1980.

Lipman, Jean, and Alice Winchester, eds. *The Flowering of American Folk Art 1776–1876.* New York: Viking Press, 1974.

———, eds. *Primitive Painters in America, 1750–1950.* New York: Dodd, Mead, and Company, 1950.

Livingston, Jane, and John Beardsley. *Black Folk Art in America, 1930–1980.* Jackson: University Press of Mississippi, 1982.

Locke, Raymond. *The Book of the Navajo.* Los Angeles: Mankind Publishing Company, 1976.

Luck, Barbara R., and Alexander Sackton. *Eddie Arning: Selected Drawings, 1964–1973.* Williamsburg, VA: Colonial Williamsburg Foundation, 1985.

Lunde, Emily. *Uff Da.* Grand Forks, ND: Lunde, 1974.

Manley, Roger. *Signs and Wonders: Outsider Art Inside North Carolina.* Raleigh: North Carolina Museum of Art, 1989.

Mariott, Alice. *Maria: The Potter of San Ildefonso.* Norman: University of Oklahoma Press, 1948.

Marshall, Howard W., ed. *Missouri Artist Jesse Howard, with a Contemplation on Idiosyncratic Art.* Exhibition catalog. Columbia: University of Missouri, 1983.

Metcalf, Eugene, and Michael Hall. *The Ties That Bind: Folk Art in Contemporary American Culture.* Cincinnati: Contemporary Arts Center, 1986.

Monthan, Guy, and Doris Monthan. *Nacimientos: Nativity Scenes by Southwest Indian Artisans.* Flagstaff, AZ: Northland Press, 1979.

Mordecai, Carolyn. *Gourd Craft: Growing, Designing, and Decorating Ornamental and Hardshelled Gourds.* New York: Crown Publishers, 1978.

Moses, Anna Mary Robertson. *My Life's History.* New York: Harper & Row, 1952.

Naive Art in Illinois, 1830–1976. Exhibition catalog. Bicentennial Exhibit Series, "200 Years of Illinois Art." Springfield: Illinois State Museum, 1976.

Naives and Visionaries. Exhibition catalog. New York: E. P. Dutton and Walker Art Center, 1974.

Nampeyo of Hano and Five Generations of Her Descendants. Exhibition catalog. Albuquerque, NM: Adobe Gallery, 1983.

Ned Cartledge. Exhibition catalog. Atlanta: Nexus Press, 1986.

Nosanow, Barbara Shissler. *More than Land or Sky: Art from Appalachia.* Washington, DC: Smithsonian Institution Press, 1981.

Ollman, John E. *Howard Finster: Man of Visions.* Philadelphia: Philadelphia Art Alliance, 1984.

One Space/Three Visions. Exhibition catalog. Albuquerque, NM: Albuquerque Museum, 1979.

Oppenhimer, Ann, and Susan Hankla, eds. *Sermons in Paint: A Howard Finster Folk Art Festival.* Richmond, VA: University of Richmond, 1984.

Orr-Cahall, Christina. *Cat and a Ball on a Waterfall: 200 Years of California Folk Painting and Sculpture.* Exhibition catalog. Oakland, CA: Oakland Museum Art Department, 1986.

Outsiders: An Art without Precedent or Tradition. Exhibition catalog. London: Arts Council of Great Britain, 1979.

Panzo, Nancy. *Navajo Sandpainting.* Tucson: University of Arizona Press, 1983.

Patterson, Tom. *St. EOM in the Land of Pasaquan: The Life and Times and Art of Eddie Owens Martin.* Winston-Salem, NC: Jargon Society, 1987.

Perry, Regenia A. *What It Is: Black American Folk Art from the Collection of Regenia Perry.* Richmond: Anderson Gallery, Virginia Commonwealth University, 1982.

Pierce, James Smith. *God, Man and the Devil: Religion in Recent Kentucky Folk Art.* Exhibition catalog. Lexington: Folk Art Society of Kentucky, 1984.

Proby, Kathryn Hall. *Mario Sanchez: Painter of Key West Memories.* Key West, FL: Southernmost Press, 1981.

Purser, Stuart R. *Jesse J. Aaron, Sculptor.* Gainesville, FL: Purser Publications, 1975.

Queena Stovall: Artist of the Blue Ridge Piedmont. Exhibition catalog. Lynchburg, VA: Lynchburg College, 1974.

Quimby, Ian M. G., and Scott T. Swank, eds. *Perspectives on American Folk Art.* New York: W. W. Norton, 1980.

Rambling on My Mind: Black Folk Art of the Southwest. Exhibition catalog. Dallas: Museum of African-American Life and Culture, 1987.

Rinzler, Ralph, and Robert Sayers. *The Meaders Family: North Georgia Potters.* Washington, DC: Smithsonian Institution Press, 1980.

Rodman, Selden. *Artists in Tune with Their World: Masters of Popular Art in the Americas and Their Relation to the Folk Tradition.* New York: Simon and Schuster, 1982.

Roessel, Robert A., Jr. *Navajo Arts and Crafts.* Rough Rock, AZ: Navajo Curriculum Center, 1983.

Royal Robertson, Baldwin, Louisiana, 1989.

Nellie Mae Rowe, Vinings, Georgia, 1979.

Rosen, Seymour. *In Celebration of Ourselves*. San Francisco: California Living Books, 1979.

Rosenak, Charles. *Folk Art of the People: Navajo Works*. St. Louis: Craft Alliance Gallery and Education Center, 1987.

Sarno, Martha Taylor. *Karol Kozlowski, 1885–1969: Polish-American Folk Painter*. New York: Summertime Press, 1984.

Schuyt, Michael, Joost Elffers, and George R. Collins. *Fantastic Architecture: Personal and Eccentric Visions*. New York: Harry N. Abrams, 1980.

A Separate Reality: Florida Eccentrics. Exhibition catalog. Fort Lauderdale, FL: Museum of Art, 1987.

Seven Families in Pueblo Pottery. Exhibition catalog. Albuquerque: University of New Mexico Press and Maxwell Museum of Anthropology, 1974.

Smither, Murray. *The World of George W. White, Jr.* Exhibition catalog. Waco, TX: Waco Creative Art Center, 1975.

Southern Folk Images: David Butler, Henry Speller, Bill Traylor. Exhibition catalog. New Orleans: University of New Orleans Fine Arts Gallery, 1984.

Southern Visionary Folk Artists. Exhibition catalog. Winston-Salem, NC: Jargon Society, 1985.

Spivey, Richard L. *Maria*. Flagstaff, AZ: Northland Publishing, 1979.

Stebich, Ute, cur. *Justin McCarthy*. Allentown, PA: Allentown Art Museum, 1985.

Steinfeldt, Cecelia. *Texas Folk Art: One Hundred Fifty Years of the Southwestern Tradition*. Austin: Texas Monthly Press, 1981.

Swank, George. *Painter Krans of Bishop Hill Colony*. Galva, IL: Galvaland Press, 1976.

Tate, Bill. *The Penitentes of the Sangre de Cristos*. Truchas, NM: privately printed, 1968.

Taylor, Ellsworth. *Folk Art of Kentucky*. Exhibition catalog. Lexington: University of Kentucky Fine Arts Gallery, 1975.

Thévoz, Michel. *Art Brut*. New York: Skira/Rizzoli, 1976.

Thompson, Robert Farris. *Flash of the Spirit: African & Afro-American Art & Philosophy*. New York: Vintage Books, 1983.

Toulouse, Betty. *Pueblo Pottery of the New Mexico Indians: Ever Constant, Ever Changing*. Santa Fe: Museum of New Mexico Press, 1977.

Transmitters: The Isolate Artist in America. Exhibition cata-

Ida Sahmie, Keams Canyon, Arizona, 1989.

Clarence Schmidt, Woodstock, New York, 1963.

log. Philadelphia: Philadelphia College of Art, 1981.

Trimble, Stephen. *Talking with the Clay: The Art of Pueblo Pottery*. Santa Fe, NM: School of American Research Press, 1987.

Turner, J. F. *Howard Finster, Man of Visions: The Life and Work of a Self-Taught Artist*. New York: Alfred A. Knopf, 1989.

Two Black Folk Artists: Clementine Hunter, Nellie Mae Rowe. Exhibition catalog. Oxford, OH: Miami University Art Museum, 1987.

Viera, Ricardo, and Girandot, Norman. *The World's Folk Art Church: Reverend Howard Finster and Family*. Bethlehem, PA: Lehigh University, 1986.

Vlach, John Michael. *The Afro-American Tradition in Decorative Arts*. Cleveland: Cleveland Museum of Art, 1978.

Vogel, Donald, and Margaret Vogel. *Aunt Clara: The Paintings of Clara McDonald Williamson*. Austin: University of Texas Press and Amon Carter Museum of Western Art, 1966.

———. *Velox Ward*. Exhibition catalog. Fort Worth, TX: Amon Carter Museum of Western Art, 1972.

Volkersz, Willem. *Word and Image in American Folk Art*. Kansas City, MO: Mid-America Arts Alliances, 1986.

Wadsworth, Anna, ed. *Missing Pieces: Georgia Folk Art, 1770–1976*. Exhibition catalog. Atlanta: Georgia Council for the Arts and Humanities, 1976.

Wahlman, Maude Southwell, and Ella King Torrey. *Ten Afro-American Quilters*. Oxford, MS: Center for the Study of Southern Culture, 1983.

Wampler, Jan. *All Their Own: People and the Places They Build*. Cambridge, MA: Schenkman Publishing Company, 1977.

Warren, Elizabeth V., cur. *Expressions of A New Spirit: Highlights from the Permanent Collection of the Museum of American Folk Art*. New York: Museum of American Folk Art, 1989.

Weatherford, Claudine. *The Art of Queena Stovall: Images of Country Life*. Ann Arbor, MI: UMI Research Press, 1986.

Weigle, Marta. *Brothers of Light, Brothers of Blood: The Penitentes of the Southwest*. Albuquerque: University of New Mexico Press, 1976.

———. *The Penitentes of the Southwest*. Santa Fe, NM: Ancient City Press, 1970.

Will Edmondson's 'Mirkels.' Exhibition catalog. Nashville: Tennessee Fine Arts Center at Cheekwood, 1964.

William Edmondson: A Retrospective. Exhibition catalog. Nashville: Tennessee State Museum, 1981.

Wilson, James L. *Clementine Hunter: American Folk Artist*. Gretna, LA: Pelican Publishing Company, 1988.

Zug, Charles G., III. *Turners and Burners: The Folk Potters of North Carolina*. Chapel Hill: University of North Carolina Press, 1986.

Index

(Page numbers in *italics* refer to illustrations.)

James Scott, Lafitte, Louisiana, 1989.

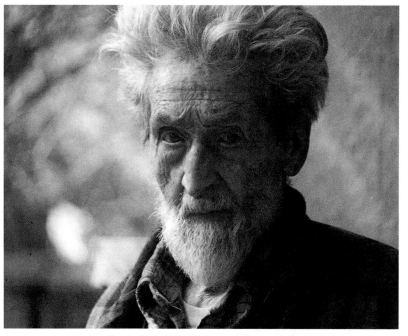

Jon Serl, Lake Elsinore, California, 1987.

OVERLEAF: *Vollis Simpson, Lucama, North Carolina, c. 1989.*

Mary T. Smith, Hazelhurst, Mississippi, 1987.

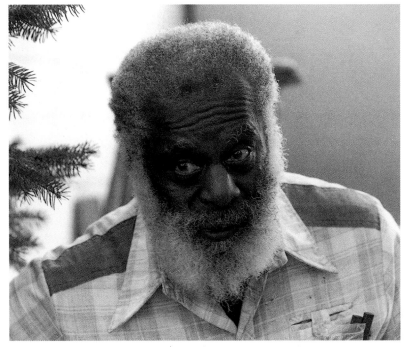

Simon Sparrow, Madison, Wisconsin, 1989.

Henry Speller, Memphis, Tennessee, 1984.

Lawrence Stinson, Charlottesville, Virginia, 1980.

"Queena" Stovall, Lynchburg, Virginia, 1979.

Jimmy Lee Sudduth, Fayette, Alabama, 1978.

Luis Tapia, Santa Fe, New Mexico, 1989.

Sarah Mary Taylor, Yazoo City, Mississippi, 1980.

s Henry Thomas, Leland, Mississippi, c. 1980.

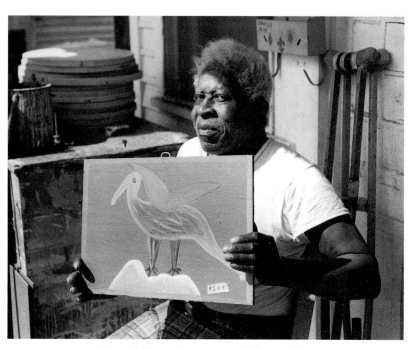

Mose Tolliver, Montgomery, Alabama, 1982.

Donny Tolson, Bethesda, Maryland, 1978.

Edgar Tolson, Bethesda, Maryland, 1973.

l Traylor, Montgomery, Alabama, c. 1948.

Faye Tso, Tuba City, Arizona, 19

Horacio Valdez, Dixon, New Mexico, 1985.

*Arthur Vigil, Tesuque Pueblo,
Tesuque, New Mexico, 1986.*

John Vivolo, Hartford, Connecticut, 1982.

Derek Webster, Chicago, Illinois, 1988.

Lizzie Wilkerson, Atlanta, Georgia, 1983.

George Williams, Fayette, Mississippi, 1984.

Photo Credits

The photographers and the sources of photographic material other than those indicated in the captions are as follows: Robert Amft: pages 282, 283; Gavin Ashworth: pages 56, 61, 114, 123, 137, 144, 211, 217, 228 (courtesy Mattie Lou O'Kelley); Fred W. Bauermeister, courtesy Preserve Bottle Village, Simi Valley, California: page 248; William H. Bengtson, courtesy Phyllis Kind Gallery, Chicago and New York: pages 33 (right), 34, 55, 119, 280, 281, 321; Norinne Betjemann: pages 91, 165, 253 (right; courtesy Janet Fleisher Gallery, Philadelphia), 335 (courtesy Janet Fleisher Gallery, Philadelphia); Ben Blackwell: page 205; © 1989 Jon Blumb: page 106; Courtesy Braunstein/Quay Gallery, San Francisco: page 64; Bill Buckner, courtesy Jay Johnson America's Folk Heritage Gallery, New York: pages 163, 227, 275 (left); Eduardo Calderon: page 244; Cynthia Carlson: pages 120, 126, 187, 208; Tracy R. Cate: page 16; Timothy Egert, courtesy Anton Gallery, Washington, D.C.: page 305; Courtesy George Ciscle: page 153; Prudence Cuming: jacket back, page 184; D. James Dee: page 263; Courtesy Dickeyville Grotto, Dickeyville, Wisconsin: page 322; Cheri Eisenberg: pages 286, 287; Valorie Fisher: page 209 (top and bottom); Alexander Frankfurter: page 192; Richard D. Gasperi: pages 2, 275 (right), 339; Kurt Gitter: page 164; © 1991 Grandma Moses Properties Co., New York: page 221; Horizons West, courtesy Museum of Northern Arizona Archives, Flagstaff: page 224; Tim Hunter: page 128; E. Inkeri: page 231; Courtesy Sidney Janis Gallery, New York: page 157; Stanley Jesudowich Studio: page 285; Rebekah Johnson: pages 71 (top and bottom), 113, 138, 201 (top and bottom), 229; Lisa Kahane: pages 185, 186; C. Kennedy: pages 25, 152, 190, 196; Lannen/Kelly: pages 155, 257 (left); Tom Leppert: page 29; Lynn Lown: jacket front, pages 1, 7, 35, 37, 38, 42, 44, 50, 62, 67, 75, 76, 97, 99, 100–101, 110 (left), 117, 122, 134, 159, 166, 178, 183 (top and bottom), 193, 198–99, 202, 206, 207, 210, 215, 230, 233, 249, 251 (right), 255, 266, 270, 292, 295, 296 (right), 303, 307, 309, 310, 317, 328, 329; Wit McKay: page 197; Bill Martin, courtesy University of Mississippi, University: page 300; Michel Monteaux: pages 194, 311; Owen Murphy: pages 161 (bottom), 212, 284, 296 (left), 330; Courtesy Museum of American Folk Art, New York: page 273 (gift in recognition of research, work, and continued meritorious contributions in the field of eighteenth- and nineteenth-century American folk art by Mrs. Adele Earnest, founding mem-

Luster Willis, Egypt Hill, Mississippi, c. 1983.

ber of the Museum); Edward Owen: pages 170, 242–43, 267; Courtesy Owings Dewey Fine Art, Santa Fe: page 299; John Parnell: pages 84, 161 (top), 277, 338; Pat Parsons: pages 46, 315; Marvin Rand: pages 12, 259; Courtesy Rainbow Man Gallery, Santa Fe: page 33 (left), 225; M.S. Renzy Photography, Inc.: page 85; Courtesy Roger R. Ricco/Frank Maresca American Art, New York: page 154; Andy Rovins, courtesy Dan Prince Art Consultants, Stamford, Connecticut: end papers; Gene Russell: pages 245, 298, 324; Mark Sexton: page 129; Beryl Sokoloff: page 272; Gregory R. Staley: page 53; Courtesy Bob Stovall: page 293; Studio O: pages 65, 200; Don Sunseri: page 27 (left and right); Ed Symmes: page 69; Bob Thomason: pages 45, 92, 218; Addison Thompson: page 131 (left and right); Richard Tomcala: pages 106, 110 (right); Steven Tucker: page 79; Richard Walker, courtesy Gallery 53 Artworks, Cooperstown, New York: page 172; University of

Malcah Zeldis, Brooklyn, New York, c. 1973.

Wisconsin, Milwaukee: pages 82 (left and right), 140, 141, 203, 319; Jan Wampler, *All Their Own: People and the Places They Build,* Scheneman Pub. Co. and Oxford Press, 1977: page 132; Katherine Wetzel: pages 31, 89, 173, 174; Ellen Page Wilson: page 246; © 1987 Bard Wrisley: pages 102, 103, 104, 191, 278, 279 (left); Warren Zuelke, courtesy University Art Museum, University of Southwestern Louisiana, Lafayette: pages 66, 257 (right), 331 (left and right), 334.

Photographs of the artists were taken by Chuck Rosenak and appear courtesy of the Rosenak Archives at the Museum of American Folk Art, with the exception of the following: Edward G. Atkins: page 350 (left); Peggy Bulger: page 341; Gene Campbell, courtesy Virginia Arts, Lynchburg, Virginia: page 399; Tracy R. Cate: 348; Bob Dawson, courtesy Preserve Bottle Village, Simi Valley, California: page 382; Judith Dupré: page 356; Fred Fussell: page 374; Joshua Horwitz: page 363; Allen Huffman: pages 394–95; Jean Ellen Jones: page 413; © 1960 Otto Kallir (renewed 1988), courtesy Grandma Moses Properties Co., New York: page 379; Lee Kogan: page 364; Albert Kraus, courtesy Tommy Giles Photographic Service: page 407; Eleanor Marko: page 368; Courtesy Davis Mather Folk Art Gallery, Santa Fe, New Mexico: page 344; Courtesy Charlotte Mullavey: page 349 (left); Arthur Reed: page 351 (right); Beryl Sokoloff: page 391; David Zeldis, page 416.